W9-AMV-910

FRANK LLOYD WRIGHT

**Recent Titles in
Bio-Bibliographies in Art and Architecture**

Paul Gauguin: A Bio-Bibliography
Russell T. Clement

Henri Matisse: A Bio-Bibliography
Russell T. Clement

Georges Braque: A Bio-Bibliography
Russell T. Clement

Willem Marinus Dudok, A Dutch Modernist: A Bio-Bibliography
Donald Langmead

J.J.P Oud and the International Style: A Bio-Bibliography
Donald Langmead

FRANK LLOYD WRIGHT

A Bio-Bibliography

Donald Langmead

Bio-Bibliographies in Art and Architecture, Number 6

Westport, Connecticut
London

NA
737
.W7
L362
2003

Library of Congress Cataloging-in-Publication Data

Langmead, Donald.
 Frank Lloyd Wright : a bio-bibliography / Donald Langmead.
 p. cm.—(Bio-bibliographies in art and architecture, ISSN 1055–6826 ; no. 6)
 Includes bibliographical references and indexes.
 ISBN 0–313–31993–6 (alk. paper)
 1. Wright, Frank Lloyd, 1867–1959—Bibliography. I. Title. II. Series.
Z8986.3.L36 2003
[NA737.W7]
016.72′092—dc21 2003052890

British Library Cataloguing in Publication Data is available.

Copyright © 2003 by Donald Langmead

All rights reserved. No portion of this book may be
reproduced, by any process or technique, without the
express written consent of the publisher.

Library of Congress Catalog Card Number: 2003052890
ISBN: 0–313–31993–6
ISSN: 1055–6826

First published in 2003

Praeger Publishers, 88 Post Road West, Westport, CT 06881
An imprint of Greenwood Publishing Group, Inc.
www.praeger.com

Printed in the United States of America

The paper used in this book complies with the
Permanent Paper Standard issued by the National
Information Standards Organization (Z39.48–1984).

10 9 8 7 6 5 4 3 2 1

52216284

Contents

Preface vii
Abbreviations xiii

Chronology 1

Annotated Bibliography

 1886-1899 41
 1900-1909 45
 1910-1919 51
 1920-1929 59
 1930-1939 71
 1940-1949 93
 1950-1959 113
 1960-1969 155
 1970-1979 185
 1980-1989 215
 1990-1999 271
 2000-2002 369

Index of Works 383

Index of Personal Names 401

Preface

Introduction

In the days when I was far more interested in comic strips than in architecture, a populist magazine, *The Australasian Post*, regularly published Al Capp's "Li'l Abner". Among the eccentric visitors to Dogpatch was an architect. All my searching has not relocated the strip, and I now forget the character's name. But I *do* remember that it sounded very like "Frank Lloyd Wright", and that the short figure in a cape and low-crowned hat was a creditable caricature of the Wisconsin architect. To have been relevant and recognizable in *any* comic strip, much less one that was syndicated internationally, Wright had to be, even in the 1950s, very well known. Indeed, Frank Lloyd Wright is probably the most famous of all modern architects. To resort to cliché, he was a legend in his own time.

Many biographies of varying quality have been published since Wright's immodest *An autobiography* first appeared in 1932. Among the more recent major general works are Brendan Gill, *Many masks. A life of Frank Lloyd Wright* (1987); Meryle Secrest, *Frank Lloyd Wright* (1992) and Neil Levine's monumental *The architecture of Frank Lloyd Wright* (1996). Others, such as Grant Carpenter Manson, *Frank Lloyd Wright to 1910: The first golden age* (1958) and Donald Leslie Johnson, *Frank Lloyd Wright versus America. The 1930s* (1990), have centered on periods within Wright's career. There have been juvenile biographies, too, including Wendy Buehr Murphy, *Frank Lloyd Wright* (1990), Alexander Boulton, *Frank Lloyd Wright, architect: an illustrated biography* (1993), and Susan Goldman Rubin, *Frank Lloyd Wright* (1994). In the light of so many publications, and because it is not our present purpose to re-examine the overabundant documentation, this volume does not include a biographical essay.

Nevertheless, the following short *curriculum vita* is offered to provide a background to this bibliography. A rather more detailed chronology can be found in the following pages.

In a career spanning seventy-four years, Frank Lloyd Wright produced about 450 buildings and almost 550 unrealized architectural projects. He was born in 1867 at Richland Center, Wisconsin. An elementary schooling in that state and in Massachusetts was followed by a short-lived study of civil engineering at the University of Wisconsin, and a hands-on introduction to architecture.

Moving to Chicago, Wright was employed in the office of architect Joseph Lyman Silsbee (1886-1887), then in the firm of Dankmar Adler and Louis Sullivan (1887-1893). After that he established his own practice in Chicago and suburban Oak Park, Illinois (1893-1911). He entered an ephemeral partnership with Webster Tomlinson (1901-1902), and from time to time collaborated with a few other Chicago architects.

After 1911 he worked from a home office, Taliesin, at Spring Green near Madison, Wisconsin, then for a while in Chicago and Tokyo (1914-1922) and in Los Angeles (1919-1924). In 1937 Wright opened another home office, Taliesin West, near Scottsdale, Arizona--his winter camp.

He received many national and foreign honorary degrees, awards, and honors, including Gold Medals from the RIBA in 1941 and, belatedly, the AIA in 1949. In 1932 he initiated the apprenticeship program that he called the Taliesin Fellowship. Since his death in April 1959, also at Richland Center, Wright's practice and the Fellowship (now an accredited school of architecture) have been continued by former employees.

It is understating the case to say that the literature on (and by) Wright is copious. More than forty years after his death, historical and critical comment and debate are increasing, and controversy continues to surround him. The last major English-language bibliography was the 300-page Robert L. Sweeney, *Frank Lloyd Wright: an annotated bibliography* (Los Angeles: Hennessey and Ingalls, 1978). While it was a very useful piece of work—all the more admirable because it was compiled before the days of personal computers and on-line catalogues—there are many omissions (especially of foreign-language literature) and not a few errors.

According to the US Library of Congress catalogue, subsequent English-language bibliographies have been short in length and often narrow in content, most being published by the former Vance Bibliographies of Monticello, Illinois. Augusto Rossari's *Frank Lloyd Wright: bibliografia e opere* (in Italian) was released by Alinea of Florence in 1992, and in 1999 the German-language *Architekten—Frank Lloyd Wright: Literatur-dokumentation; eine Fachbibliografie*, the last of a five-part series, was published in Stuttgart.

Sweeney's bibliography lists about 2,030 books and articles published until the end of 1977. Since that time, a further 1,500 *primary* works about Wright—excluding book reviews and correspondence about journal articles—have been published, more than 300 primary sources about (and a few *by*) Wright have appeared. The time is ripe for another bibliography.

Sources
The following document is not exhaustive. What bibliography is? However, it is the result of a careful search of the international literature and it

includes all major works on or by Wright. With the exception of a few key articles and reviews in quality publications, references to newspaper items are not included, because they are legion.

The substructure of the bibliography was assembled by reference to Sweeney (of course) and major English-language guides such as the *Avery Index to Architectural Periodicals*, the *Art Index*, and the *RIBA Architectural Periodicals Index*, in their hard-copy earlier editions, then CD-ROM versions, and finally the frequently updated on-line versions. In addition, other on-line resources proved invaluable: The DADAbase of the New York Museum of Modern Art, ICONDA (International Construction Database), Art Abstracts and ARTbibliographies Modern, as well as any number of on-line catalogues of national Libraries—Australia, Brazil, Denmark, Finland, France, Germany, Italy, Mexico, The Netherlands, Norway, Sweden, and the United States were consulted. These were all freely accessible through the ubiquitous National Information Standards Organization Z39.50 Information Retrieval Protocol. Finally, I also have had access to the catalogues of the world's universities, too numerous to name here.

The importance of the non-English language literature should be noted. Wright's uniqueness and the prophetic quality of his work were identified and celebrated beyond America well before his compatriots recognized them At home, for many years he remained a more-or-less parochial mid-western architect, while in Europe he was eulogized with "We do not have his like here!"

It is perhaps remarkable that the first foreign publication of his work, in 1900, was in Czechoslovakian. Ten years later the seminal folio *Ausgeführte Bauten und Entwürfe von Lloyd Wright* was published in Berlin. In 1912 the Dutch followed, and Japanese and French architectural journals began to publish his work, in 1923 and 1924 respectively. The first Italian article appeared in 1935, but despite a late start, the Italian architectural press has given Wright more coverage than any other country's, other than the United States. Although Charles Robert Ashbee mentioned Wright in his *Where the great city stands*, published in London in 1917, the xenophobic British journals took little notice of the American until 1939.

Structure of the bibliography

Entries are chronologically arranged. Within the major divisions by decades, each year is divided into two sections: "books, monographs and catalogues" and "journals". Each section is set out alphabetically by the surname of the author (if known), while anonymous items are located at the end of the section, arranged alphabetically by title of book or journal. There is a continuous numbering sequence from 001 to the end, the entry numbers being cross-referenced to an index of individual works and an index of personal names.

The format of each entry is *normally* as follows: author; title of book or article; bibliographical information; language and translation of title (if other than English); and an annotation that indicates textual content. Because of the

large number of entries, in many cases I have allowed the title of the work to explain the content; in others, the annotations simply identify the buildings or projects dealt with in the item.

In the case of periodical articles, bibliographical information provided by sources is frustratingly inconsistent and to avoid clutter, I have adopted the general rule that the amount of information in each entry should be the minimum required to locate the item, but the *normal* format is as follows: 113 (November 1935), 11-16 indicates that the item can be found in volume 113 of the named journal, the November 1935 issue, on pages 11-16. Any variations to that format are minor.

Space, as well as the need to limit already astronomical numbering, does not permit a separate entry for each item. As the bibliography stands, there are over 3,500 numbered entries; should every item be separate, that figure probably would be closer to 6,000. Therefore, some entries depart from the "normal" format described above. I believe that there are advantages for the user of the bibliography. The departures are of three main kinds.

First, books that were revised and republished and/or translated have all subsequent versions (and their reviews, arranged chronologically), together with any associated items, included in the entry for the first edition. For examples, see Wright, *Ausgeführte Bauten und Entwürfe von Lloyd Wright* (entry 083) or Wright, *Modern architecture, being the Kahn lectures for 1930* (entry 225).

Second, books, monographs and exhibition catalogues have reviews, arranged chronologically, included in the principal item. For example, see Terence Riley and Peter Reed eds. *Frank Lloyd Wright, architect: visions and revisions since 1910* (entry 2716).

Third, news items—often derivative—concerning such things as progress, completion or restoration of buildings have been grouped together. The principal entry has been chosen more or less arbitrarily (usually a piece whose author is known), and related or similar items are included in chronological order. For example, see John Haverstick, "To be or not to be," *Saturday Review of Literature*, 38(21 May 1955), 13 (entry 757), that reports progress and comments on the Solomon R. Guggenheim Museum, New York City.

Acknowledgements

Several people have helped in the preparation of the bibliography, and must be sincerely thanked. The University of South Australia provided encouragement and assistance, both in kind and financially through its supported researcher scheme and other mechanisms.

In particular, I record my appreciation for the assistance unstintingly proffered by Architecture Liaison librarian Wendy Spurrier, the helpful staff at the City West and Underdale campus libraries, and the unrelenting inter-library loans team who (mostly successfully) pursued hard-to-get items.

My wife Coby is high on the list of people to be thanked. Although she had, for a change, little active part in this latest literary effort, she was *there*, as always, providing moral support and graciously and patiently accepting my preoccupation.

My daughter Lisa saved me untold hours of tedious work, by reformatting

and making sense of data that had been gathered from many sources. Her resourcefulness sharpened my efficiency. Thank you, Lisa.

Philip Knight painstakingly prepared the black-and-white illustrations from my color slides, and skillfully removed distracting elements from the original photographs. I am thankful for his conscientious input.

Finally, but far from least importantly, I wish to thank my mentor, colleague and friend Donald Leslie Johnson—an internationally prominent Wright scholar—and his wife Sonia, who opened their house to me and provided access to his extensive, well-ordered collection of Wright literature. In it I found rare publications that otherwise would have remained mere titles in indexes and catalogues. This bibliography is dedicated to Don Johnson.

Donald Langmead
Paradise, South Australia
October 2002

Abbreviations

A+U	*Architecture + Urbanism*
AA	Architectural Association
ABC	American Broadcasting Company
AHF Review	*Architectural History Foundation Review*
AIA	American Institute of Architects
AIT	*Architektur, Innenarchitektur, Technischer Ausbau* (Germany)
AL	Alabama
ANZ	Australia and New Zealand
Architect	*De Architect* (Netherlands)
Architecture	*Architecture: the AIA Journal*
ATP Bulletin	*Association for Preservation Technology Bulletin.*
AZ	Arizona
BBC	British Broadcasting Corporation
Blauwe Kamer	*Blauwe Kamer; tijdschrift voor landschaps-ontwikkeling* (Netherlands)
Bouw	*Bouw. Centraal Weekblad voor het Bouwwezen* (Netherlands)
Bouwbedrijf	*Het Bouwbedrijf.* (Netherlands)
Builder	*The Builder*
CA	California
Casabella	variously *La Casa Bella* (1928-1932), *Casabella* (1933-37), *Casabella Costruzioni* (1938-1939), *Costruzioni Casabella* (1940-1943, 1946) and *Continuata* (1954-1964) (Italy)
CCA	Canadian Centre for Architecture
Center	*Center: a Journal for Architecture in America*

CIAM	(*Congrès Internationaux d'Architecture Moderne*) International Congresses of Modern Architecture
Cimaise	*Cimaise: Art et Architecture Actuels*
CO	Colorado
CT	Connecticut
D.C.	District of Columbia
Document	*Le Document. Organe de l'association des archi-tectes et dessinateurs d'art de Belgique*
FDM.	*Furniture Design And Manufacturing*
FL	Florida
Forum	*Forum. Maandschrift voor Letteren en Kunst* aka *Forum voor Architectuur en Daarmee Verbonden Kunsten* (Netherlands)
GA	Georgia
Graphic	*The Graphic*
Groene Amsterdammer	*De Groene Amsterdammer* aka *Nieuwe Amster-dammer* (Netherlands)
HI	Hawaii
(i.a.)	*inter alia* (among others)
IA	Iowa
ID	Idaho
IL	Illinois
IN	Indiana
Ingenieur	*De Ingenieur* (Netherlands)
Inland Architect	*Inland Architect and News Record*
JSAH	*Journal of the Society of Architectural Historians*
KS	Kansas
KY	Kentucky
L' Architecture Vivante	*L' Architecture Vivante : documents sur l'activité constructive dans tous les pays* (France)
L'Architettura	*L'Architettura: Cronache e Storia* (Italy)
Lotus	*Lotus International* (Italy)
MA	Massachusetts
MD	Maryland
ME	Maine
Metron	*Metron-architettura* (Italy)
MI	Michigan
MIT	Massachusetts Institute of Technology
MN	Minnesota
MO	Missouri
MoMA	Museum of Modern Art, New York
MS	Mississippi
MT	Montana
NBC	National Broadcasting Company
n.d.	no date (of publications)
n.l.	no location (of publications)
n.p.	no publisher identified

NE	Nebraska
New Directions	*New Directions in Prose and Poetry*
NH	New Hampshire
NJ	New Jersey
NY	New York
NYT Magazine	*New York Times Magazine*
NYTBR	*New York Times Book Review*
OH	Ohio
OK	Oklahoma
OR	Oregon
PA	Pennsylvania
PBS	Public Broadcasting Service (US)
Pencil Points	later *Progressive Architecture* (after 1944)
Places	*Places: a forum of environmental design*
RAI Canada Journal	*Royal Architectural Institute of Canada Journal*
RAICanada	Royal Architects Institute of Canada
RI	Rhode Island
RIBA	Royal Institute of British Architects
RIBAJournal	*Journal of the Royal Institute of British Architects*
RSA Journal	*Journal of the Royal Society of Arts*
RSI	*Roofing Siding Insulation*
SAH Newsletter	*Society of Architectural Historians Newsletter*
SC	South Carolina
SITES	Smithsonian Institution Traveling Exhibition Service
Studio	*The Studio,* later *Studio International*
TLS	*The Times Literary Supplement* (London)
TN	Tennessee
Traditional Building	*Clem Labine's Traditional Building*
T-Square Club Journal	*T-Square Club Journal of Philadelphia.* Vol. 1 (1931) was so named; vol. 2(nos. 1-2, 1932) was *T-Square*; thereafter, it was *Shelter*
TX	Texas
UK	United Kingdom
unp	unpaginated
US	United States of America
USC	University of Southern California
USIS	United States Information Service
UT	Utah
VA	Virginia
V. and A. Museum	Victorian and Albert Museum (London)
VT	Vermont
WA	Washington
Wasmuths Monatshefte	*Wasmuths Monatshefte für Baukunst und Städtebau* (Germany)
WI	Wisconsin
WV	West Virginia
WY	Wyoming

Chronology

This chronology draws upon several published versions, both print and electronic. It is arranged thus: a brief summary of events that significantly affected Frank Lloyd Wright (FLW) in any given year is followed, first by an alphabetical list of unrealized projects (in italic font), and then by another of completed buildings (in Roman font). Where sources are at odds about dates, the project or building has been included in the earliest contended year, and variations are noted. Settlement of such arguments is beyond the scope of this work.

1867 FLW (originally Frank *Lincoln* Wright) born in Richland Center, WI, on 8 June, the first child of widowed Baptist preacher and musician William Russell Cary Wright (1825-1904), and his second wife, teacher Hannah (Anna) Lloyd Jones Wright (1838?-1923)

1869 *Wright family moves to McGregor, IA. FLW's sister Mary Jane born (d. 1953).*

187? *Family moves to Pawtucket, RI.*

1874 Family moves to Weymouth, MA.

1876 Hannah introduces FLW to Friedrich Froebel's "gifts".

1877 FLW's sister Margaret Ellen (aka Maginel) born (d. 1966).

1878 Family moves to Madison, WI. William Wright becomes secretary of the Wisconsin Conference of Unitarians and Independent Societies. FLW spends summers from 1878 onwards on the farm of his maternal uncle, James Lloyd Jones' (1850-1907), Helena Valley near Spring Green WI—"the valley of the almighty Joneses".

1883 FLW's parents separate.

1885 FLW's parents divorce, after which he changes his name from Frank *Lincoln* to Frank *Lloyd*. He leaves Madison High School to work part-time as a draftsman for Professor Allan D. Conover, Dean of the University of Wisconsin's Civil Engineering department.

> *University Ave. power house, Madison, WI*

1886 Beginning in March, FLW takes civil engineering courses at the University of Wisconsin, but only for two semesters.

> Lloyd Jones family chapel (Unity Chapel), Helena Valley, Spring Green, WI (with architect Joseph Lyman Silsbee, 1848-1913)

1887 FLW moves to Chicago in January. After trying a few other firms, he starts with Silsbee in February, and remains about a year.

> *Nell and Jane Lloyd Jones house I, Helena Valley*
> *Unitarian chapel, Sioux City, IA*

> Hillside Home school building I for Misses Nell and Jane Lloyd Jones, Helena Valley (with Silsbee; dem. 1950).
> Nell and Jane Lloyd Jones house II, Helena Valley

1888 FLW is employed as a draftsman in the partnership of Dankmar Adler (1844-1900) and Louis Henry Sullivan (1856-1924), and remains for six years.

1889 On 1 June, FLW marries Catherine Lee (Kitty) Tobin (1871-1959), daughter of a prosperous businessman. Borrows $5,000 from Sullivan to build a house

> FLW house, 428 Forest Ave., Oak Park, IL. Additions and alterations followed at intervals

1890 FLW is entrusted with all residential design in Adler and Sullivan's practice. Birth of son Frank Lloyd Jr. (Lloyd) (d. 1975).

> *Henry N. Cooper house and stable, La Grange, IL.*

> James Charnley summer house, 507 East Beach Rd., Ocean Springs, MS (for Adler and Sullivan)
> James Charnley octagon guest house, 509 East Beach Rd., Ocean Springs (for Adler and Sullivan) .
> Louis Sullivan house, servant's cottage and stable, 100 Holcomb Bvd., Ocean Springs, MS (for Adler and Sullivan)
> Rollin Furbeck house, 515 Fair Oaks Ave., Oak Park, IL (for Adler and Sullivan). Some sources give 1897 or 1898.
> W.S. MacHarg house, 4632 Beacon Ave., Chicago, IL (for Adler and Sullivan) (dem.). Some sources give 1891.

1891 James Charnley house, 1365 North Astor St., Chicago, IL (for Adler and Sullivan)

1892 Discovered undertaking private work for Allison Harlan, one of the firm's clients, FLW is dismissed by Adler and Sullivan for "moonlighting". Birth of son John Lloyd (d. 1972).

Charles E. Roberts house, Oak Park, IL.

Albert Sullivan house, 4575 Lake Ave., Chicago, IL (dem. 1970)
Allison W. Harlan house, 4414 Greenwood Ave., Chicago, IL (dem. 1963)
George Blossom house, 4858 Kenwood Ave., Chicago, IL
Robert G. Emmond house, 109 South Eighth Ave., La Grange, IL.
Robert P. Parker house, 1027 Chicago Ave., Oak Park, IL
Thomas H. Gale house, 1019 Chicago Ave., Oak Park, IL
Victoria Hotel, Chicago Heights, IL (for Adler and Sullivan) (dem.)
Warren McArthur house, 4852 Kenwood Ave., Chicago, IL.
W. Irving Clark house, La Grange, IL.

1893 FLW establishes his own practice, first from an office in the Schiller Building, Chicago, then from his Oak Park home.

Library and museum competition, Milwaukee, WI.

Francis Wooley house, 1030 Superior St., Oak Park, IL. Some sources give 1894.
Frank Lloyd Wright playroom additions, (Fisherman and Genie mural), 428 Forest Ave., Oak Park, IL. Some sources give 1895.
Meyer Building, 307 West Van Buren St., Chicago, IL (for Adler and Sullivan)
Municipal boathouse, Lake Mendota, Madison, WI (dem. 1928).
Peter Goan house, 108 South 8th Ave., LaGrange, IL. Some sources give 1904.
Robert M. Lamp cottage, Rocky Roost, Governor's Island, Lake Mendota, WI (dem.). Some sources give 1901.
Walter Gale house, 1031 Chicago Ave., Oak Park, IL.
William H. Winslow house and stable, 515 Auvergne Pl., River Forest, IL. Some sources give 1894.

1894 Exhibition of FLW's work at the Chicago Architectural Club. Birth of daughter Catherine Dorothy (d.1979).

A.C. McAfee house, Lake Michigan Chicago, IL.
Bagley baptismal font, Chicago, IL.
Bagley common room sculpture, Chicago, IL.
Belknap apartments, Austin, IL.
James L. McAfee house.
Monolithic concrete bank.
Orrin S. Goan house, La Grange, IL

Four houses for Robert W. Roloson, 3213-3219 Calumet Ave., Chicago, IL.

Frederick Bagley house, 121 County Line Rd., Hinsdale, IL.
H.W. Bassett house, 125 South Oak Park Ave., Oak Park, IL
(remodeling; dem.).

1895 Exhibition of FLW's work at the Chicago Architectural Club. Birth of
son David Samuel (d. 1997).

Amusement park for Warren McArthur, Wolf Lake, Chicago, IL.
House for unidentified client. Published in (Boston) *Architectural
Review* (June 1900)
Jesse Baldwin house, Oak Park, IL.
Luxfer Prism Co. office building I and II, Chicago, IL.

Apartments for Edward C. Waller, 253-257 Francisco Ave.,
Chicago, IL (dem. 1974).
Apartments for Edward C. Waller, 2840-2858 West Walnut St.,
Chicago, IL (partially dem.).
Chauncey L. Williams house, 520 Edgewood Place, River Forest,
IL.
Francis Apartments for Terre Haute Trust Co., 4304 Forestville
Ave., Chicago, IL (dem. 1971).
Frank Lloyd Wright studio addition, 951 Chicago Ave., Oak Park,
IL. Some sources give 1897.
Harrison R. Young house, 334 North Kenilworth Ave., Oak Park,
IL (remodeling).
Nathan G. Moore house and stable, 329 Forest Ave., Oak Park, IL
rebuilt after fire, 1923).

1896 FLW composes his lecture, "Architecture, architect, and client," and a
statement of belief, "Work song"

Aline Devin house, Lake Michigan, Chicago, IL.
*Apartment house for Robert Perkins, West Monroe St., Chicago,
IL. Some sources give 1897.*
Charles E. Roberts summer house.
Five houses for Charles E. Roberts, Ridgeland, IL.

Charles E. Roberts house and stables, 317 North Euclid Ave., Oak
Park, IL (interior remodeling).
George W. Smith house, Oak Park, IL.
Harry C. Goodrich house, 534 North East Ave., Oak Park, IL.
Isidore Heller house, 5132 Woodlawn Ave., Chicago, IL. Some
sources give 1897.
Romeo and Juliet windmill tower for Misses Nell and Jane Lloyd
Jones, Hillside, Spring Green, WI.

1897 FLW moves his office to Steinway Hall, Chicago.

*All Souls Building, Oakwood Bvd. and Langley Ave.,Chicago, IL
(with Dwight Heald Perkins). See Abraham Lincoln Center,
1900*

Charles E. Roberts quadruple block plan, Oak Park, IL.
Chicago Screw Co. factory building, Chicago, IL.

George Furbeck house, 223 North Euclid Ave., Oak Park, IL.
Henry Wallis boathouse, 3407 South Shore, Lake Delavan, WI
(dem.). Some sources give 1900.
Thomas H. Gale summer house, 5318 South Shore Dr., Whitehall,
MI.

1898 Exhibition of FLW's work at the Chicago Architectural Club. Birth of
daughter Frances (d. 1959). FLW opens office in the Rookery, Chicago.

Edward C. Waller house, River Forest , IL.
"Home typical of American architecture" for Trans-Mississippi
Exposition (with George R. Dean, Robert C. Spencer, Jr.)

George W. Smith house, 404 Home Ave., Oak Park, IL.
Mozart Garden restaurant for David Meyer, State and 55th Sts.,
Chicago, IL (remodeling; dem.).
River Forest Golf Club, Bonnie Brae Ave., River Forest, IL
(additions 1901; dem. 1905).

1899 Exhibition of FLW's Work at the Chicago Architectural Club

Cheltenham Beach Resort for Norman B. Ream and Edward C.
Waller, 75th-79th Sts. on the lake, Chicago, IL.
House for unidentified client. Published in (Boston) Architectural
Review (June 1900).
Robert Eckhart house I and II, River Forest, IL.

Edward C. Waller house, River Forest, IL (remodeling of hall and
dining room; dem.).
Joseph W. Husser house, 180 Buena Ave., Chicago, IL (dem.).

1900 In May Robert Spencer Jr.'s article, "The Work of Frank Lloyd Wright"
is published in the [Boston] *Architectural Review.* FLW delivers a
lecture "The architect" at the Architectural League of America's annual
convention, and writes "A philosophy of fine art" and "What is architec-
ture?" Work is exhibited at the Chicago Architectural Club. In Decem-
ber FLW meets Charles Robert Ashbee (1863-1942), apostle of the
British Arts and Crafts movement.

Abraham Lincoln Center, Oakwood Bvd. and Langley Ave.,
Chicago, IL (project with Dwight Heald Perkins). Some sources
give 1901.
Cinema, Los Angeles, CA.
Francis W. Little house I, Peoria, IL.
"Home in a prairie town" for Ladies' Home Journal.
House for unidentified client, Oakland, CA
School, Crosbyton, TX. Some sources give 1910.
"Small house with lots of room in it" for Ladies' Home Journal.

Harley Bradley house and stables, Glenlloyd, 701 South Harrison
Ave., Kankakee, IL.

E. H. Pitkin summer cottage, Sapper Island, Ontario, Canada.

Edward R. Hills house, 313 Forest Ave., Oak Park, IL (remodel-
ing). Sources vary as to date: 1900-1906.

Fred B. Jones house, Penwern, 3335 South Shore, Lake Delavan,
WI (boathouse dem.). Sources vary as to date: 1900-1903.

George Blossom garage, 4858 Kenwood Ave., Chicago, IL. Some
sources give 1906 or 1907.

H. Goodsmith summer cottage, South Shore Rd., Lake Delavan,
WI (built for Henry Wallis; boathouse dem.).

William Adams house, 9326 South Pleasant Ave., Chicago, IL.

Stephen A. Foster house and stables, 12147 Harvard Ave., Chi-
cago, IL.

Susan Lawrence Dana house, 301-307 East Laurence Ave., Spring
field, IL. Some sources give 1902, some 1903.

Warren Hickox house, 687 South Harrison Ave., Kankakee, IL.

Warren McArthur house, Chicago, IL (remodeling and stable).

1901 FLW delivers lecture "The art and craft of the machine" to the Arts and
Crafts Society, Hull House, 6 March, and to the Western Society of
Engineers, 20 March. An exhibition of his work is held at the Chicago
Architectural Club. FLW enters into a partnership with Henry Webster
Tomlinson (until 1902).

Henry Wallis house, Lake Delavan, WI

M.H. Lowell studio-house, Matteawan, NY.

*Victor Metzger House, Desbarats, Ontario, Canada Some sources
give 1902.*

Village bank built of cast concrete.

A.W. Herbert house, Evanston, IL(remodeling; dem.).

E. Arthur Davenport house, 550 Ashland Ave., River Forest, IL.

Edward C. Waller gateway, gardener's cottage, poultry house, and
stables, Auvergne Ave., River Forest, IL (stables dem.).

F.B. Henderson house, 301 South Kenilworth Ave., Elmhurst, IL.

Frank Wright Thomas house, The Harem, 210 Forest Ave., Oak
Park, IL.

Henry Wallis gate-lodge, South Shore Rd., Lake Delavan, WI
(remodeling; partly dem.)

Hillside Home School building II for Misses Nell and Jane Lloyd
Jones, Spring Green, WI. Some sources give 1902.

Terrace apartments I for Edward C. Waller, Lexington St., Spauld
ing Ave., Polk St. and Homan Ave., Chicago, IL.

T.E. Wilder stables, Elmshurst, IL(dem.).

Universal Portland Cement Co. pavilion, Pan-American exposi
tion, Buffalo, NY (dem.).

Ward W. Willits house, gardener's cottage and stables, 715 South Sheridan Rd., Highland Park, IL. Some sources give 1902.

William G. Fricke house, 540 Fair Oaks Ave., Oak Park, IL. Some sources give 1902.

1902 Exhibition of FLW's work at the Chicago Architectural Club. FLW publishes "A home in a prairie town" in *Ladies' Home Journal*.

Dial Office, Chicago, IL(remodeling).
Edward C. Waller summer house I, Charlevoix, MI
Francis W. Little house II, Wayzata, MN.
House for unidentified client, Oak Park, IL
Lake Delavan Yacht Club, Lake Delavan, WI.
Yahara Boat Club, Lake Mendota, Madison, WI. Some sources give 1905.

Arthur Heurtley house, 318 Forest Ave., Oak Park, IL.

Arthur Heurtley summer house, Les Chenaux Club, Marquette Island, MI (remodeling).

Charles S. Ross house, South Shore Rd., Lake Delavan, WI.

Francis W. Little house II and stable, 1505 West Moss St., Peoria, IL. Some sources give 1903.

George E. Gerts double cottage, Bridge Cottage, Whitehall, MI (mostly dem.).

George W. Spencer house, 3209 South Shore Rd., Lake Delavan, WI.

John A. Mosher house.

Walter Gerts cottage, Whitehall, MI (remodeled 1911; mostly dem.)

William E Martin house, 636 North East Ave., Oak Park, IL. Some sources give 1903.

1903 Birth of son Robert Llewellyn (d. 1986).

Chicago and Northwestern Railroad. Station I, II and III, Oak Park, IL.
Edward C. Waller summer house II, Charlevoix, MI
Frank Lloyd Wright house and studio, Oak Park, IL.
House for unidentified client.
Quadruple Block Plan (24 houses) I and II for Charles E. Roberts, Chicago, Fair Oaks, Superior and Ogden Aves, Oak Park, IL.
Robert M. Lamp house I, Madison, WI

Abraham Lincoln Center for Jenkin Lloyd Jones, Oakwood Bvd. and Langley Ave., Chicago, IL (with Dwight Heald Perkins).

Edwin Cheney house, 520 North East Ave., Oak Park, IL. Some sources give 1904.

George Barton house, 118 Summit Ave., Buffalo, NY.

J. J. Walser Jr. house, 42 North Central Ave., Chicago, IL.
Larkin Co. administration building, 680 Seneca St., Buffalo, NY
(dem. 1949-1950).
Scoville Park Fountain, Lake St. Oak Park, IL
W.H. Freeman house, 106 North Grant St., Hinsdale, IL (dem.).

1904 FLW attends Louisiana Purchase Exposition (World's Fair), St. Louis.
FLW's father dies. Berlin modernist architect and planner Bruno Möhring (1863-1929) visits FLW's office (in his absence).

Charles W. Barnes house, McCook, NE. Some sources give 1905.
First National Bank I for Frank L. Smith, Dwight, IL
Frank Martin house, Buffalo, NY.
H.J.Ullman house, North Euclid Ave. and Erie St., Oak Park, IL.
Hiram Baldwin house I, 205 Essex Rd., Kenilworth, IL.
House for unidentified client, Highland Park, IL
J.A. Scudder house, Campement d'Ours Island, Desbarats, Ontario, Canada
Larkin Co. workmen's rowhouses, Buffalo, NY. Some sources give
 1905
O.D Owens house (remodeling).
Soden house.

Darwin D. Martin house and ancillary buildings, 125 Jewett Park
 way, Buffalo, NY (garage and conservatory dem.).
Ferdinand F. Tomek house, 150 Nuttall Rd., Riverside, IL Some
sources give 1907. (Gardener's cottage, 1911).
Mrs. Thomas H. Gale house, 6 Elizabeth Court, Oak Park, IL.
 Some sources give 1909.
Robert D. Clarke house, Moss Ave., Peoria, IL.
Robert M. Lamp house II, 22 North Butler St., Madison, WI.

1905 FLW and Catherine make a five-week trip to Japan with clients Mr. and
Mrs. Ward W. Willits, via Hawaii and the American Pacific Northwest,.
FLW begins collecting Japanese prints.

Cinema, San Diego.
*Concrete apartment building for Warren McArthur, Kenwood,
 Chicago, IL.* Some sources give 1906.
Double residence for unidentified client, Oak Park, IL
House for Mrs. Darrow, Chicago, IL
House on a lake for an unidentified client
M.H. Adams house (remodeling).
Nathan G. Moore pergola and pavilion, Oak Park, IL.
Office building for C. Buckingham, Chicago, IL.
Varnish factory, Buffalo, NY.

A.P. Johnson house, 3455 South Shore Rd., Lake Delavan, WI.
Charles E. Brown house, 2420 Harrison Ave., Evanston, IL.

Darwin D. Martin gardener's cottage, 285 Woodward Ave., Buffalo, NY.

E. W. Cummings office, Harlem Ave. and Lake St., River Forest, IL (dem.). Some sources give 1907.

E-Z Polish factory for W.E. and D.D. Martin, 3005-3017 West Carroll Ave., Chicago, IL.

First National Bank for Frank L. Smith II, 122 West Main St., Dwight, IL. Some sources give 1906.

Harvey P. Sutton house I and II, McCook, NE.

Hiram Baldwin house II, garage, 205 Essex Rd., Kenilworth, IL.

Lawrence Memorial Library interior for Mrs. R.D. Lawrence, Springfield, IL.

Mary M. Adams house, 103 Lake Ave., Highland Park, IL.

Mrs. Thomas Gale summer house, Whitehall, MI.

Mrs. Thomas H. Gale Duplicate I and II, Whitehall, MI (duplicate II mostly dem.). Some sources give later dates.

River Forest Tennis Club, 615 Lathrop Ave., River Forest, IL (with Charles E. White Jr. and Vernon S. Watson). Some sources give 1906.

Rookery Building, 209 South LaSalle St., Chicago, IL (remodeling lobbies and balcony court).

T.E. Gilpin house, Kenilworth Ave. and North Bvd., Oak Park, IL.

Thomas P. Hardy house, 1319 South Main St., Racine, WI.

Unity Temple and parish house, Lake St. and Kenilworth Ave., Oak Park, IL. Some sources give 1906.

William A. Glasner house, 850 Sheridan Rd., Glencoe, IL.

William R. Heath house, 76 Soldiers Place, Buffalo, NY.

1906 In March, FLW exhibits his collection of Ando Hiroshige (1797-1858) prints at the Art Institute of Chicago.

Aline Devin house, Eliot, ME.

C. Thaxter Shaw house I, Kenmont, Montreal, Quebec, Canada.

Elizabeth Stone house, Glencoe, IL.

Fireproof house for $5,000 for Ladies' Home Journal.

Frazer house

Harry Brown house I and II, Genesco, IL.

Joseph Seidenbecker house, Chicago, IL.

R.S. Ludington house, Dwight, IL. 1995

Richard Bock studio house, Maywood, IL.

Walter Gerts house, Glencoe, IL.

A.W. Gridley house and barn, 605 North Batavia Ave., Geneva, IL

C. Thaxter Shaw house II, 3466 Peel St., Montreal, Quebec, Canada (remodeling).

Frederick Nicholas house, 1136 Brassie Ave., Flossmoor, IL.

George M. Millard house, 410 Lake Ave., Highland Park, IL.

Grace Fuller house, Glencoe, IL (dem.).

Harvey P. Sutton house III, 602 Main St., McCook, NE. Some sources give 1907.

K.C. DeRhodes house, 715 West Washington St., South Bend, IN.

P.D. Hoyt house, 318 South Fifth Ave., Geneva, IL.

Peter A. Beachy house, 238 Forest Ave., Oak Park, IL (remodeling).

William H. Pettit Memorial Chapel, Belvidere Cemetery, IL.

1907 FLW's work. *in* November exhibition at Pittsburgh Architectural Club

Andrew T. Porter house I, Spring Green, WI.
Harold McCormick house and ancillary buildings, Lake Forest, IL
Lake Delavan cottages, Lake Delavan, WI.
Municipal Art Gallery for Sherman Booth, Chicago, IL

Andrew T. Porter house II, TanyDeri, Spring Green, WI.

Avery Coonley house and coachhouse, 300 Scottswood Rd., River side, IL. Some sources give 1908.

Emma Martin house (additions to Fricke house) and new garage, 540 Fair Oaks Ave., Oak Park, IL.

Fox River Country Club for George Fabyan, Geneva, IL (remodeling; destroyed by fire ca. 1912).

George Fabyan house, 1511 Batavia Rd., nr Geneva, IL (remodeling).

Larkin Co. pavilion, Jamestown Tercentenary exhibition, Sewell Point, Jamestown, VA (dem.).

Pebbles and Balch decorating shop, 1107 Lake St., Oak Park, IL (remodeling; dem.).

Stephen M. Hunt house, 345 South Seventh Ave., La Grange, IL.

1908 Japanese prints from FLW's collection are exhibited at the Art Institute of Chicago. FLW's essay, "In the cause of architecture", is published in *Architectural Record*. Kuno Francke visits Wright at Oak Park.

Cinema for unidentified client
Edmund.D. Brigham stables, Glencoe, IL
Frank J. Baker house I, Wilmette, IL.
Horseshoe Inn for Willard H. Ashton, Estes Park, CO.
J.G. Melson house, Mason City, IA.
William H. Copeland house I, Oak Park, IL.
William Norman Guthrie house, Sewanee, TN.

Bitter Root Inn, Stevensville, MT (destroyed by fire 1924). Some sources give 1909.

Blythe-Markley City National Bank and Hotel Law Office, 5 West State St., Mason City, IA (part dem.). Some sources give 1909, 1910 or 1911.

Browne's Bookstore, Fine Arts Building, 410 South Michigan Ave., Chicago, IL (dem.).

Como Orchards Summer Colony, Darby, MT (mostly dem.). Some sources give 1909 or 1910.

Darwin D. Martin summer cottage, Lake Erie, NY. Some sources give 1909.

Edward E. Boynton house, 16 East Bvd., Rochester, NY.

Eugene A. Gilmore house, Airplane House, 120 Ely Place, Madison, WI.

Francis W. Little house, Wayzata, MN.

Frederick C. Robie house, 5757 Woodlawn Ave., Chicago, IL. Some sources give 1909.

G.C. Stockman house, 311 First St. Southeast, Mason City, IA

Isabel Roberts house, 603 Edgewood Place, River Forest, IL.

L.K. Horner house, 1331 Sherwin Aenvue, Chicago, IL (dem.).

Meyer May house, 450 Madison Ave., S.E. Grand Rapids, MI. Some sources give 1909.

Robert W. Evans house, 9914 Longwood Drive, Chicago, IL.

Walter V. Davidson house, 57 Tillingham Place, Buffalo, NY.

William Ashton house, Horseshoe Inn, Estes Park, CO (dem.).

1909 FLW leaves his practice and abandons his family to travel to Europe, accompanied by Martha "Mamah" (Borthwick) Cheney (1869-1914) wife of client Edwin H. Cheney. At Fiesole, near Florence, Italy, FLW, his son Lloyd and apprentice Taylor Wooley prepare illustrations for *Ausgeführte Bauten und Entwürfe von Frank Lloyd Wright.* Cheney works at the University of Leipzig, Germany. FLW's work is included in an exhibition at the Minneapolis Architectural Club.

Avery Coonley study, 300 Scottswood Rd., Riverside, IL.

Bitter Root town master plan I and II for BitterRoot Irrigation Co., Stevensville, MT.

City dwelling with glass front.

Edward C. Waller bathing pavilion, Charlevoix, MI.

Glencoe town hall forSherman Booth, Glencoe, IL.

Harry E. Brown house, Geneva, IL

Lawton Parker studio.

Lexington Terrace apartments II for Edward C. Waller and Oscar Friedman, Lexington St., Spaulding Ave., Polk St. and Homan Ave., Chicago, IL.

Mary Roberts house, River Forest, IL.

Mrs. Larwill house, Muskegan, MI

Three small rental houses for Edward C. Waller, River Forest, IL

Edward P. Irving house, 2 Millikin Pl., Decatur, IL. Some sources give 1910.

Frank J. Baker house II, 507 Lake Ave., Wilmette, IL.

George C. Stewart house, 196 Hot Springs Rd., Montecito, CA.

Hiram Baldwin house, Kenilworth, IL.

J. Kibben Ingalls house, 562 Keystone Ave., River Forest, IL.

J.H. Amberg house, 505 College Ave. Southeast, Grand Rapids, MI. Some sources give 1910.

Jesse R. Ziegler house, 509 Shelby St., Frankfort, KY. Some sources give 1910.

Oscar M. Steffens house, 7631 Sheridan Rd., Chicago, IL (dem.).

Peter C. Stohr arcade building, Wilson Ave., Chicago, IL (dem.).

Puppet playhouse, Oak Park, IL.

Robert Clark house (additions to Francis W. Little house), 1505 West Moss St., Peoria, IL.

Robert Mueller house, 1 Millikin Place, Decatur, IL.

W. Scott Thurber art gallery, Fine Arts Building, 410 South Michigan Ave., Chicago, IL (dem.).

W.E. Martin pergola, Oak Park, IL

William H. Copeland house II and garage, 400 Forest Ave., Oak Park, IL (alterations).

1910 Ernst Wasmuth of Berlin publishes *Ausgeführte Bauten und Entwürfe von Frank Lloyd Wright*. FLW and Cheney travel to Bavaria, Vienna, Paris and London .

Frank Lloyd Wright house-studio, Viale Verdi, Fiesole, Italy.

J.R. Zeigler house, 509 Shelby St., Frankfort, KY

Ingwald Moe house, Gary, IA. Some challenge the attribution.

Universal Portland Cement Co. pavilion, Madison Square Garden, NY (dem.).

1911 Wasmuth publishes *Frank Lloyd Wright: ausgeführte Bauten*. FLW begins building a new home and studio, Taliesin (Welsh for "shining brow"), near Spring Green, on land bought for him by his mother. The Dutch *bouwmeester* Hendrik Petrus Berlage (1856-1934) visits the US and returns home to eulogize FLW's work.

Andrew T. Porter house III, Hillside, Spring Green, WI.
Arthur M.Cutten house, Downer's Grove, IL.
Avery Coonley greenhouse and kindergarten I, Riverside, IL.
Banff National Park railroad. station, Alberta, Canada.
Christian Catholic church, Zion City, IL. Some sources give 1915.
E. Esbenshade house, Milwaukee, WI.
Edward Schroeder house, Milwaukee, WI. Frank Lloyd Wright house and studio, Goethe St., Chicago, IL.
Glencoe Park, Glencoe, IL.
Glencoe railroad. station I and II, art gallery and town hall for Sherman Booth, Glencoe, IL (projects).
Harry S. Adams house I, Oak park, IL. Some sources give 1912.
Madison Hotel for Arthur L. Richards, Madison, WI.
North Shore electric tram stations, Chicago, IL.
Sherman M. Booth house I, Glencoe, IL.
Sherman M. Booth summer cottage.

Suburban house for unidentified client
William R.Heath house, garage and stables, Buffalo, NY.

American Systems Ready-Cut houses (prototypes} for Richards
 Co., Milwaukee, WI.
Avery Coonley gardener's cottage, 300 Scottswood Rd., Riverside,
 IL. Some sources give 1912.
Banff National Park recreation building, Alberta, Canada (with
 Francis W. Sullivan; dem. 1938). Some sources give 1913.
Frank Lloyd Wright house, 428 Forest Ave., Oak Park, IL
 (remodeling).
Herbert Angster house, 605 Blodgett Rd., Lake Bluff, IL (dem.).
Lake Geneva Inn for Arthur L. Richards, Lake Geneva, WI (dem.
 1971). Some sources give 1912.
Oscar B. Balch house, 611 North Kenilworth Ave., Oak Park, IL.
Taliesin I house, studio and farm buildings for Anna Lloyd Wright,
 Spring Green, WI (living quarters destroyed by fire, 1914).
Taliesin hydro house, Spring Green, WI (dem.). Some sources give
 1920.

1912 FLW opens an office in Orchestra Hall, Chicago. He publishes *The
Japanese print: an interpretation.*

Dress shop, Oak Park, IL.
Jerome Mendelson house, Albany, NY. Some sources give 1913.
Kehl dance academy house and shops, Madison, WI
San Francisco Call *newspaper building I and II for Spreckels*
 Estate, Market St., San Francisco, CA.
Schoolhouse, LaGrange, IL.
Sherman Booth stable, Glencoe, IL.
Taliesin cottages (2), Spring Green, WI.
Urban house, Milwaukee, WI.
William Koehne cottage, Palm Beach, FL. Some sources give
 1913.

Avery Coonley playhouse, 350 Fairbanks Rd., Riverside, IL.
Francis W. Little house II, Northome, garage and boathouse,
 R.F.D. 3, Wayzata, MN (dem. 1972)
Park Ridge Country Club, Park Ridge, IL (remodeling; dem.).
William B. Greene house, 1300 Garfield Ave., Aurora, IL.

1913 FLW visits Japan to secure commission for the Imperial Hotel and to
acquire Japanese prints for American clients. Exhibition of FLW's (i.a.)
work at the Chicago Architectural Club.

Art museum for unidentified client.
Chinese restaurant for Arthur L. Richards, Milwaukee, WI. Some
 sources give 1915.
Double residence, Ottawa, Canada.
J.W. Kellogg house, Milwaukee, WI.

M.B. Hilly house, Brookfield, IL
Office building and shops for Arthur Richards, Milwaukee, WI.
Post office, Ottawa, Canada.
Row houses, Chicago, IL

Carnegie Library, Pembroke, Ottawa, Ontario, Canada (with Francis W. Sullivan; project).
Harry S. Adams house II, 710 Augusta Ave., Oak Park, IL.
Midway Gardens for Edward C. Waller Jr. and Oscar Friedman, Cottage Grove Ave., Chicago, IL (dem. 1929). Some sources give 1914.

1914 "The work of Frank Lloyd Wright" exhibition is held at the Art Institute of Chicago. "In the cause of architecture, second paper" is published in *Architectural Record*. Mid-year, FLW is visited by Dutch architect Robert van 't Hoff (1887-1979), who becomes his first European imitator. A servant, Julian Carleton, sets fire to Taliesin and murders Mamah, her two children and four employees. FLW begins to rebuild. He meets sculptress (Maud) Miriam Noel (1869-1930), "a schizophrenic alcoholic and morphine addict", who wrote to him after the fire.

Fairgrounds, Spring Green, WI.
Farmers and Merchants Bank, Spring Green, WI.
Imperial Hotel I, Tokyo, Japan. Some sources give 1915.
John Vogelsang dinner gardens, hotel and house I and II, Chicago, IL
Park kiosk, Ottawa, Canada.
State Bank of Spring Green, Spring Green, WI.
Three houses for Honoré J. Jaxon.
United States Embassy Building, Tokyo, Japan.

S.H. Mori Japanese print shop, Fine Arts Building, 410 South Michigan Ave., Chicago, IL.
Taliesin II, Route 23, Taliesin, Spring Green, WI (destroyed by fire 1925).

1915 *American System Ready-cut standardized houses and apartments for Richards Co., Milwaukee, WI*
Chinese hospital for Rockefeller Foundation.
Lake shore residence for unidentified client.
M.W. Wood house, Decatur, IL.
Model Quarter Section development, Chicago, IL.
Theater for Aline Barnsdall, Olive Hill, Los Angeles, CA (studies).

A.D. German warehouse, 300 South Church St., Richland Center, WI.
Arthur L. Richards bungalow, 1835 South Layton St., Milwaukee, WI. Some sources give 1916.
Arthur L. Richards house, 2714 West Burnham St., Milwaukee, WI.

Charles E. Perry house, Glencoe, IL.
Edmund D. Brigham house, 790 Sheridan Rd., Glencoe, IL.
Emil Bach house, Chicago, IL.
Henry J. Allen house, 255 Roosevelt Bvd., Wichita, KS. Some
 sources give 1916 or 1917.
Hollis R. Root house, Glencoe, IL.
Lute F. Kissam house, Glencoe, IL.
Ravine Bluffs bridge, entry sculptures and three houses for Sher-
 man Booth, Meadow Rd., Glencoe, IL.
Sherman M. Booth house II, 265 Silvan Rd., Glencoe, IL.
William F. Kier house, Glencoe, IL.
William F. Ross house, Glencoe, IL.

1916 Contract signed for the Imperial Hotel commission. FLW sails to Japan
 with Miriam Noel and opens a office in Tokyo. Until 1922 he spends
 two-thirds of his time in Japan.

Clarence Converse cottage, Palisades Park, MI.
Imperial Hotel power house, Tokyo, Japan.
Miss Behn (Voight) house, Grand Beach, MI.
William Allen White house, Emporia, KS (remodeling).

Arthur L.Richards house, 1835 South Layton Bvd., Milwaukee,
 WI.
Duplex apartments (4) for Arthur Munkwitz, 1102-1112 North
 27th St., Milwaukee, WI (dem.).
Duplex apartments for Arthur L. Richards, 2720-2734 West Burn
 ham St., Milwaukee, WI.
Ernest Vosburgh house, 46208 Crescent Rd., Grand Beach, MI.
Frederick C. Bogk house, 2420 North Terrace Ave., Milwaukee,
 WI.
Imperial Hotel, Tokyo, Japan. (burned 1919 and dem.; redesigned
 1920 and dem. 1968; entrance lobby reconstructed Meiji
 Village near Nagoya 1976). Some sources give 1917.
Imperial Hotel annexe, Tokyo, Japan (dem. 1923).
Joseph J. Bagley house, 47017 Lakeview Ave., Grand Beach, MI.
 Some sources give 1916.
Wilbur Wynant house, Gary, IN. Some challenge attribution.
William S. Carr house, 46039 Lakeview Ave., Grand Beach, MI.

1917 "Antique colour prints from the collection of Frank Lloyd Wright"
 exhibition at the Arts Club in Chicago.

Odawara Hotel, Nagoya, Japan.
William Powell house, Wichita, KS.

Aizaku Hayashi house, Komazawa, Tokyo, Japan (remodeling).
American System Ready-cut houses, Richards Co., Lake Bluff, IL.
American System Ready-cut houses for Richards, Milwaukee, WI.
American System Ready-cut houses for Richards, Wilmette, IL.

American System-built duplexes for Richards, Milwaukee, WI.
American System-built two-story houses for Richards, Chicago, IL.
Arinobu house, Hakone, Japan (destroyed by earthquake, 1923).
 Some sources give 1918.
Charles C. Heisen house, Villa Park, IL.
Stephen M.B. Hunt house, 685 Algoma Ave., Oshkosh, WI.

1918 FLW visits China as a guest of the philosopher Ku Hung Ming (1857-1928). Dutch art journals *De Stijl, Levende Kunst, Wendingen* and *Elsevier's Geïllustreerd Maandschrift* publish articles about FLW, continuing through 1921.

Eiga cinema, Ginza, Japan .
Mihara house, Japan .
Viscount Immu house, Tokyo, Japan .
Viscount Shiro Inouye house, Tokyo, Japan

Tazacmon Yamamura house, Ashiya near Osaka, Japan.

1919 FLW receives *Kenchiko Ho* citation from the Japanese emperor.

Japanese print gallery for the Spaulding Collection, Boston, MA .
Monolith homes (18) for Thomas P. Hardy, Racine, WI .
Wenatchee town plan, Wenatchee, WA

J.P. Shampay house, Chicago, IL .

1920 FLW's mother visits him in Tokyo.

Andrew T. Porter house, Chicago, IL (project: remodeling).
C.E. Staley house, Waukegan, IL .
Cantilevered steel skyscraper .
Theater, shops and rental terraced houses for Aline Barnsdall, Sunset Bvd., Los Angeles, CA .
W.J. Weber house, 9th Ave. and 4th St., Los Angeles, CA (later built by Lloyd Wright).

Hollyhock house and garage for Barnsdall, 4808 Hollywood Bvd., Los Angeles, CA.
Olive Hill studio residence A for Barnsdall, Hollywood Bvd.and Edgemont St., Los Angeles, CA (dem.).
Olive Hill studio residence B for Barnsdall, 1645 Vermont Ave., Los Angeles, CA (dem.).

1921 Berlage writes glowingly of FLW in the Dutch journal *Wendingen*.

Desert complex and shrine for A. M. Johnson, Death Valley, CA Some sources give 1922, others 1923 or 1924.
Baron Shinpei Goto house, Tokyo, Japan .
Concrete block house I and II for unknown client, Los Angeles, CA.
Two-story concrete block house for unknown client, Los Angeles..
Concrete, glass and copper skyscraper, Los Angeles, CA . Some sources give 1923.

Department store, Tokyo, Japan .
Frank Lloyd Wright desert compound, Mojave, CA .
Ranch development for Edward H. Doheny, Sierra Madre, CA .
 Some sources give 1923.
Triangular building, Hibiya, Japan .

Jiyu Gakuen Girls' School of the Free Spirit, Tokyo, Japan.
Little Dipper kindergarten for Aline Barnsdall, Olive Hill, Los
 Angeles, CA (dem.). Some sources give 1922 or 1923.
Mrs. Thomas H. Gale house(s), Birch Brook, Whitehall, MI.

1922 FLW returns from Japan, opens a Los Angeles office. He and Catherine
are divorced.

Arthur Sachse cottage, Deep Springs, Mojave Desert, CA .
Butterfly roof house .
G.P.Lowes house, Eagle Rock, CA (later designed and built by
 Rudolf Schindler.).
Lake Tahoe summer colony, Emerald Bay, Lake Tahoe, CA .
Merchandising building, Los Angeles, CA .

Frank Lloyd Wright Harper Ave. studio, Los Angeles, CA.

1923 FLW's mother dies and is buried in Unity Chapel cemetery, Oak Park.
Kanto earthquake (1 September 1923) demolishes many Tokyo build-
ings, but the Imperial Hotel survives. FLW publishes "Experimenting
with human lives". He marries Miriam Noel in November, but they
separate only five months later.

Dorothy Martin Foster house, Buffalo, NY .

Alice Millard house, La Miniatura, 645 Prospect Cres., Pasadena,
 CA.
Charles Ennis house, 2607 Glendower Rd., Los Angeles, CA.
 Some sources give 1924.
John Storer house, 8161 Hollywood Bvd., Hollywood, CA.
Samuel Freeman house, 1962 Glencoe Way, Hollywood, CA.
 Some sources give 1924.

1924 FLW meets divorcee Olga Ivanovna (Olgivanna) Milanov Lazovich
Hinzenburg (1897-1985), daughter of the Chief Justice of Montenegro.
Jean Badovici's "L'art de Frank Lloyd Wright" published in *L'Arch-
itecture Vivante* (France).

Nakoma Country Club and Winnebago Camping Ground Indian
 Memorial, Madison, WI .
National Life Insurance Company skyscraper for A.M. Johnson,
 Water Tower Square, Chicago, IL .
Phi Gamma Delta fraternity house, University of Wisconsin, Madi
 son, WI . Some sources give 1925.
Planetarium and automobile objective for Gordon Strong, Sugar
 loaf Mountain, MD . Some sources give 1925.

Mrs. Samuel.W. Gladney house I and II, Fort Worth, TX.

1925 Olgivanna and Svetlana (1917-1946), her daughter from a previous marriage, move to Taliesin. Second major fire at Taliesin, but FLW again rebuilds. Daughter Iovanna born to FLW and Olgivanna in December. H.Th. Wijdeveld, editor of *Wendingen*, devotes seven consecutive issues to FLW, reprinted as *The life-work of the American architect Frank Lloyd Wright, with contributions by Frank Lloyd Wright, an introduction by architect H. Th. Wijdeveld and many articles by famous European architects and American writers.* FLW's work is widely published in Germany.

> *Mary Herron house, Oak Park, IL (project: remodeling).*
> *Mrs. Samuel William Gladney house III, Fort Worth, TX.*
> *Art gallery extension for Alice Millard, Pasadena, CA. Some sources give 1930.*

Taliesin III living quarters, Spring Green, WI (rebuilding).

1926 Bank of Wisconsin forecloses on Taliesin. FLW and Olgivanna are arrested, accused of violating the *Mann Act* (prohibiting taking women over state borders for immoral purposes). FLW starts his autobiography. Wasmuth publishes *Frank Lloyd Wright: Aus dem Lebenswerke eines Architekten.* His work has wide press in France and Germany.

> *Commercial Arts Festival, NY City.*
> *Kinder Symphony playhouses for Oak Park Playground Association, Oak Park, IL.*
> *Standardized copper and concrete gas station.*
> *Steel cathedral to contain a million people, for William Guthrie, NY City. Some sources give 1926.*

1927 In January FLW is obliged to sell, for financial reasons, prints from his collection through Anderson Galleries, New York. FLW and Miriam Noel divorce. FLW and Olgivanna travel to Puerto Rico. FLW is made an honorary member of the *Academie Royale des Beaux Arts*, Belgium. German, French and Czechoslovakian journals publish his work, continuing through 1930. FLW begins desultory consultancy for Leerdam Glass Factory in Holland. The Dutch engineer Alphons Siebers visits Taliesin.

> *Low cost concrete block houses for Alexander Chandler, Chandler, AZ. Some sources give 1928.*
> *Owen D. Young house, San Marcos in the Desert, Chandler, AZ. Some sources give 1928.*
> *San Marcos in the Desert resort for Alexander, Chandler, Chandler, AZ. Some sources give 1928.*
> *San Marcos water gardens motel hotel for Alexander Chandler, Chandler, AZ. Some sources give 1928, some 1929.*

Wellington Cudney and Alexander Chandler house, Chandler, AZ

Arizona Biltmore Hotel, East Sahuaro Drive, Phoenix, AZ (with Albert McArthur).

Beach resort cottages, Damiette, Ras-el-Bar Island, Egypt (dem.). Some sources give 1928.

Darwin D. Martin house and garage, Graycliff, Derby, NY.

Ocotillo desert camp, Salt Range near Chandler, AZ (dem.). Some sources give 1928.

1928 FLW and Olgivanna marry at Rancho Santa Fe, CA. To rescue FLW financially, some friends form Wright Inc., to regain title to Taliesin for him.

Blue Sky mausoleum for Darwin D. Martin, Buffalo, NY..
Colonial equivalent (residence)
Exhibition markets for Walter Davidson, Buffalo, NY
Hillside Home School for the Allied Arts, Spring Green WI.
Schoolhouse for Afro-American children for Rosenwald Foundation, La Jolla, CA.
Standardized village service stations and city gasoline stations.

1929 FLW is installed as an extraordinary honorary member of the *Akademie der Kunst*, Berlin.

Alice Millard house, Pasadena, CA.
Elizabeth Noble apartment house, Los Angeles, CA. Some sources give 1930.
San Marcos golf clubhouse, Chandler, AZ.
San Marcos polo stable, Chandler, AZ.
Tower for the Vestry of St-Mark's-in-the-Bouwerie, NY City

Cabins for Chandler Land Improvement Co., Chandler, AZ (dem.).

Richard Lloyd Jones house I and II, Westhope, 3700 Birmingham Ave., Tulsa, OK.

1930 FLW delivers the Kahn lectures at Princeton University, and publishes them as *Modern architecture* in 1931. FLW continues work on his autobiography and *The disappearing city*. He devises "The Show"—a self-promoting exhibit of his work—mounted in New York, Chicago, Eugene, Seattle and (later) Milwaukee. FLW approaches Wijdeveld about joining forces to establish a school of the allied arts.

Cabins for desert or woods, YMCA, Chicago, IL.
Corner service station prototype.
Grouped apartment towers, Chicago, IL

Exhibition USA (design for The Show).

1931 The Wrights visit Rio de Janeiro as guests of the Pan American Union to judge designs for the Columbus Memorial. "The Show" moves to Europe, organized by Wijdeveld, and is mounted in Amsterdam, Berlin,

Stuttgart, Frankfurt, Brussels and Antwerp. FLW publishes "The Hill-side Home School of the Allied Arts: Why we want this school." In November, at Taliesin, FLW andWijdeveld formulate plans for the Taliesin Fellowship, with FLW as Founder and Wijdeveld as Director.

Capital Journal *newspaper building, Salem, OR*.
House on the mesa, Denver, CO.
Monolithic filling station.
Three schemes for A Century of Progress *skyscraper, 1933 World's Fair, Chicago, IL*.
Three schemes for a new theater, Woodstock, NY

1932 The Wrights, using many of Wijdeveld's ideas (albeit unacknow-ledged), found the Taliesin Fellowship. Hillside Home School buildings are converted to the Taliesin Fellowship Complex. As soon as "The Show" returns from Europe, FLW rejects Wijdeveld as Director of the Fellowship. *An autobiography* and *The disappearing city* are published. FLW is made an honorary member of the National Academy of Brazil. His work is included in the "International Style Exhibition" at MoMA.

Automobile and aircraft filling station, Michigan City, IN.
Cinema and shops, Michigan City, IN.
Conventional house.
Highway overpass, Michigan City, IN.
Prefabricated glass and steel sheet roadside markets for Walter Davidson, Minneapolis, MN.
Prefabricated steel farm units for Walter Davidson, Minneapolis, MN
Standardized overhead service station, Minneapolis, MN.
Theater, Minneapolis, MN.
Malcolm M. Willey House I, Minneapolis, MN.

Factory for Dr. Chase, Madison, WI.
Taliesin Fellowship complex, Spring Green, WI. Some sources give 1933.

1934 FLW and apprentices begin a scale model of Broadacre City. The first issue of *Taliesin* is published by Taliesin Press.

A.D. German warehouse, Richland Center, WI (conversion to warehouse and apartments).
Broadacre city model and exhibition plans.
Memorial to the Soil chapel, Cooksville, WI. *Some sources give 1937.*
Zoned houses for city, suburb and country I. *Some sources give 1935.*

1935 Completed Broadacre City model exhibited at "National Alliance of Arts and Industry Exposition", Rockefeller Center, New York City.

Robert Lusk house I, Huron, SD. *Some sources give 1936.*

Stanley Marcus house, Dallas, TX.

Edgar J. Kaufmann house, Fallingwater, Bear Run, PA. Some sources give 1936.

1936 *Gatehouse and roadsign, Hillside School, Spring Green, WI. Some sources give 1946.*

H.C.Hoult house, Wichita, KS.

Little San Marcos in the Desert inn for Alexander Chandler, Chandler, AZ

Abby Beecher Roberts house, Deertrack, County Highway 492, Marquette, MI (unsupervised).

Edgar J. Kaufmann office, First National Bank Building, Pitts burgh, PA (reconstructed in Victoria and Albert Museum, London). Some sources give 1937 or 1938.

Herbert Jacobs house, 441 Toepfer St., Westmoreland (now Madi son), WI. Some sources give 1937.

Paul and Jean Hanna house, Honeycomb House, 737 Frenchman's Rd., Stanford, CA. Some sources give 1937.

S.C. Johnson and Son administration building, 1525 Howe St., Racine, WI.

1937 The Wrights are invited to the World Conference of Architects in Russia. FLW and Baker Brownell publish *Architecture and modern life.* FLW buys about 800 acres of government land at Scottsdale AZ. Design and construction of Taliesin West commences Taliesin Fellowship begins its annual seasonal migration between the two sites.

100 all steel houses, Los Angeles, CA.

Frances Wright gift shop.

George Parker garage, Jamesville, WI.

Leo Bramson dress shop, Oak Park, IL.

Ben Rebhuhn house, 9a Myrtle Ave., Great Neck Estates, Long Island, NY. Some sources give 1938.

Gutzon Borglum studio, Black Hills, SD.

Herbert Fisk Johnson house, Wingspread, 33 East 4 Mile Rd., Wind Point, Racine, WI. Some sources give 1938.

Sleeping boxes, Taliesin West, Scottsdale, AZ.

Stanley Rosenbaum house, 117 Riverview Drive, Florence, AL. Some sources give 1939.

Sun trap, temporary residence for Taliesin West, Scottsdale, AZ. Taliesin West, Scottsdale, AZ. Some sources give 1938.

1938 January issue of *Architectural Forum* is dedicated to FLW's work. He appears on the cover of *Time* magazine.

E.A. Smith house, Piedmont Pines, CA. Some sources give 1939.

Edith Carlson house, Below Zero, Superior, WI. Some sources give 1939.

George Bliss McCallum house, Northampton, MA . Some sources give 1939.

Herbert F. Johnson gate house and farm group, Wind Point, WI

Lewis N. Bell house, Los Angeles, CA . Some sources give 1940.

Life house for a family with a $5000- $6000 a year income. Minneapolis, MN.

Martin Pence house I and II, Hilo, HI . Some sources give 1940.

Monona Terrace Civic Center I, Madison, WI . Some sources give 1942. Realized 1997.

Ralph Jester house, Palos Verdes, CA . Later executed for Arthur and Bruce Brooks Pfeiffer, Scottsdale, AZ.

Royal H. Jurgenson house, Evanston, IL .

Annie M. Pfeiffer Chapel, Florida Southern College, Lakeland, FL.

Auldbrass Plantation buildings for Leigh Stevens, 7 River Rd., Yemassee, SC. Some sources give 1940.

Charles L. Manson House, 1224 Highland Bvd., Wausau, WI. Some sources give 1940.

Fallingwater guest house for Edgar J. Kaufmann, Bear Run, PA. Some sources give 1939. (Additions 1948).

Florida Southern College Master Plan for Dr. Ludd M. Spivey, South Johnson Ave., Lakeland, FL.

John Clarence Pew house, 3650 Mendota Drive, Shorewood Hills, WI. Some sources give 1940.

Sidney Bazett house, 101 Reservoir Rd., Hillsborough, CA. Some sources give 1939 or 1940.

Sun Top Homes quadruple house for Otto Mallery (Tod Co.), 152-158 Sutton Rd., Ardmore, PA. Some sources give 1939.

Taliesin Farm Group (Midway Barns), Spring Green, WI.

1939 FLW is invited to London to deliver lectures at The Sulgrave Manor Board, published as *An organic architecture*. FLW is awarded an honorary M.A. by Wesleyan University, Middletown, CT.

Alexis Panshin house, Lansing, MI .

C.D. Hause house, Lansing, MI . Some sources give 1946.

Clarence R. van Dusen house, Lansing, MI . Some sources give 1946.

Crystal Heights hotel, shops and theaters, Connecticut and Florida Aves., Washington, D.C. . Some sources give 1940.

Edgar A. Mauer house, Los Angeles, CA .

Erling Brauner house I, Lansing, MI .

Frank A. Rentz house, Madison, WI . Some sources give 1940.

Front gates for Taliesin, Spring Green, WI .

Gordon Lowenstein house, Libertyville, IL .

J.J. Garrison house, Lansing, MI . Some sources give 1946.

Ludd M. Spivey house, Fort Lauderdale, FL .

Sidney H. Newman house, Lansing, MI . Some sources give 1946.

Usonian house development (seven buildings), Okemos, MI .
Usonian house for Edgar J. Kaufmann, Pittsburgh, PA . Some
sources give 1956.
Usonian master plan, Lansing, MI .

Andrew F.H. Armstrong house, Cedar Trail, Ogden Dunes, IN.
Bernard Schwartz house, 3425 Adams Sweet, Two Rivers, WI.
Clarence Sondern house, 3600 Bellview Ave., Kansas City, MO.
 Some sources give 1940.
George Sturges house, 449 Skyeway Dr., Brentwood Heights, CA.
Goetsch-Winkler house, 2410 Hulett Rd., Okemos, MI.
Joseph Euchtman house, 6807 Cross Country Bvd., Baltimore,
 MD. Some sources give 1940.
Lloyd Lewis house, 153 Little Saint Mary's Rd., Libertyville, IL.
 Some sources give 1940.
Pope-Leighey house, Woodlawn Plantation, 9000 Richmond High
 way, Mount Vernon, VA. Some sources give 1940.
Rose and Gertrude Pauson house, Shiprock, Orange Rd., Phoenix,
 AZ (dem.). Some sources give 1940.

1940 A retrospective exhibition "The Work of Frank Lloyd Wright," held at
 MoMA, New York. FLW establishes Frank Lloyd Wright Foundation.

Franklin Watkins studio, Barnegat City, NJ .
Gate lodge I and farm unit for Fallingwater, Bear Run, PA.
John Nesbitt house, Cypress Point, Carmel Bay, CA. Some sources
give 1941.
Methodist Church, Spring Green, WI .
Model House, Museum of Modern Art exhibition, NY.

Arch Oboler house, Eaglefeather, Malibu, CA.
Arch Oboler gatehouse, 32436 West Mulholland Highway, Mal
 ibu, CA. Some sources give 1941.
Gregor Affleck house I, 1925 North Woodward Ave., Bloomfield
 Hills, MI. Some sources give 1941.
James B. Christie house and shop, 190 Jockey Hollow Rd.,
 Bernardsville, NJ.
Kansas City Community Christian Church, 4601 Main St., Kansas
 City, MO.
Stuart Richardson house, 63 Chestnut Hill Place, Glen Ridge, NJ.
 Some sources give 1941.
Theodore Baird house and shop, 38 Shays St., Amherst, MA.

1941 FLW is made an honorary member of the RIBA and receives its Royal
 Gold Medal. He is also awarded the Sir George Watson Chair by the
 RIBA and honored by the Sulgrave Manor Board. FLW and Frederick
 A. Gutheim publish *On architecture*. The second issue of *Taliesin* is
 published. Five issues of *A Taliesin Square-Paper: a nonpolitical voice*

from our democratic minority are published by Taliesin Press. FLW, because of his isolationist dogmatism about the war in Europe, falls out with Lewis Mumford.

> *Cloverleaf, Pittsfield housing for the Federal Works Agency . Some sources give 1942.*
> *Horlick-Racine airport, Racine, WI .*
> *John Barton cottage, Oak Shelter, Pine Bluff, WI .*
> *Margaret Schevill house, Tucson, AZ .*
> *Mary Waterstreet Studio, near Soring Green, WI .*
> *Parker B. Field house, Peru, IL .*
> *Roy Peterson house, Racine, WI . Later executed for Haddock, Ann Arbor, MI (1979).*
> *Sigma Chi fraternity house, Hanover, IN .*
> *Vigo Sundt house, Madison, WI .*
> *Walter Dayer Music Studio, Detroit, MI .*
> *William Guenther house, East Caldwell, NJ*

Alfred Ellinwood house, Deerfield, IL .
Arch Oboler studio, 32436 West Mulholland Highway, Malibu, CA.
Carlton Wall house, Snowflake, 12305 Beck Rd., Plymouth, MI.
Cora Carter, Charles W. Hawkins, and Isabel Wallbridge seminar buildings, Florida Southern College, Lakeland, FL
E.T. Roux Library, Florida Southern College, Lakeland, FL (re-named Thad Buckner Building, 1968)
Martin Blue Sky Mausoleum, Buffalo, NY.

1942 FLW is made an honorary member of the National Academy of Architects, Uruguay.

> *Carlton D. Wall gatehouse and farm unit, Plymouth, MI .*
> *Circle Pines resort, Cloverdale, WI .*
> *Clark Foreman house, Washington,D.C..*
> *Cooperative berm-type homesteads for auto workers, Detroit, MI.*
> *Defense plant, Pittsfield, MA .*
> *George D. Sturges house, Brentwood Heights, CA (additions).*
> *Herbert Jacobs house II, Middleton, WI .*
> *Lloyd Burlingham pottery house, El Paso, TX . Two versions were later built: one in Santa Fe, NM; one in Phoenix, AZ.*
> *Robert S. Miller house, Fremont, OH.*

Bernard Schwartz boathouse and pergola, Two Rivers, WI .

1943 FLW publishes a revised edition of *An autobiography* and writes "Book Six: Broadacre City." FLW is made an honorary member of Mexico's National Academy of Architects.

> *Solomon R. Guggenheim Museum I, NY, (first design).*
> *Herbert Jacobs house II, Middleton, WI .*

M.N. Hein house, Chippewa Falls, WI .
T.L. McDonald house, Washington D.C. Some sources give 1945.
Richardson restaurant and service station , Spring Green, WI .

Lloyd Lewis farm unit, Libertyville, IL.

1944 An issue of *A Taliesin Square-Paper* is published

Glass house, Opus 497 for Ladies Home Journal. *Some sources
give 1945.*
P.K. Harlan house, Omaha, NE .
Stuart Wells house, Minneapolis, MN . Some sources give 1945.

Gerald Loeb pergola house, Redding, CT.
Herbert Jacobs solar house, 7033 Old Sauk Rd., Middleton, WI.
Hillside theater foyer, Spring Green, WI.
Midway barns and cottage, Spring Green, WI.
S.C. Johnson and Son Company research tower, Racine, WI.

1945 FLW publishes *When democracy builds.* Two issues of *A Taliesin
Square-Paper* are published.

Adelman laundry for Benjamin Adelman, Milwaukee, WI .
*Elizabeth Arden Desert Spa, Phoenix, AZ . Some sources give
1947.*
Frank Wheeler house, Hinsdale, IL .
George Berdan house, Ludington, MI .
George Prout house, Columbus, IN . Some sources give 1948
John Stamm summer cottage and boathouse, Lake Delavan, WI
Malcolm Dana house, Olivet, MI .
*Nicholas P. Daphne Funeral Chapels, San Francisco, CA . Some
sources give 1947, some 1948*
Stuart Haldorn house, The Wave, Carmel, CA .
*V.C. Morris house I, Seacliff, San Francisco, CA . Some sources
give 1946.*
Vito Grieco house, Andover, MA . Some sources give 1947.
William Slater house, Warwick, RI . Some sources give 1946.

Arnold Friedman gate-lodge, The Fir Tree, Pecos, NM. Some
sources give 1947 or 1952.
Hillside garden center, Spring Green, WI.
Lowell E. Walter house, 2611 Quasqueton Diagonal Bvd., Quas
queton, IA.
Taliesin Dams, Spring Green, WI

1946 FLW is made an honorary member of the National Academy of Finland.
Olgivanna's daughter Svetlana dies in an automobile accident on 30
September. An issue of *A Taliesin Square-Paper* is published.

A. and C. Miller clinic, Charles City, IA .
Albert Adelman house I and II, Fox point, WI .

Arch Oboler Studio, Los Angeles, CA .
Ayn Rand house, Hollywood, CA . Some sources give 1947.
Ben Feenbert house I, Fox Point, WI .
Housing for State Teachers' College, Lansing, MI .
Pinderton house, Cambridge, MA .
President's house, Olivet College, MI .
Rogers Lacy Hotel, Dallas, TX .
Sarabhi Calico Mills offices and store, Ahmenabad, India .
Walter Dayer house and music pavilion, Bloomfield Hills, MI .
William M. Pinkerton house, Fairfax County, VA .

Alvin L. Miller house, 1107 Court St., Charles City, IA. Some
 sources give 1951.
Amy Alpaugh house, 71 North Peterson Park Rd., Northport, MI.
 Some sources give 1948.
Benjamin Fine Administration Building, Florida Southern College,
 Lakeland, FL.
Chauncey Griggs house, 7800 John Dower St. Southwest, Tacoma,
 WA.
Douglas Grant house, 3400 Adel Drive Southeast, Cedar Rapids,
 IA. Some sources give 1951.
Emile E. Watson Administration Building, Florida Southern Col
 lege, Lakeland, FL.
Erling Brauner house II, Arrowhead Rd., Okemos, MI. Some
 sources give 1948.
Esplanades, Florida Southern College, Lakeland, FL.
First Unitarian Society meeting house, 900 University Bay Drive,
 Shorewood Hills, WI. Some sources give 1947 or 1951.
Herman Mossberg house, 1404 Ridgedale Rd., South Bend, IN.
 Some sources give 1948 or 1951.
Joe Munroe house, Know County, OH .
Melvyn Maxwell Smith house, 5045 Pon Valley Rd., Bloomfield
 Hills, MI. Some sources give 1951.
Paul and Jean Hanna house, Stanford, CA (additions).
Stanley Rosenbaum house additions, Florence, AL.

1947 FLW is awarded an honorary doctorate of Princeton University.

B. Marden Black House, Rochester, MN .
Berta Hamilton house, Brookline, VT .
Boomer-Pauson house, Phoenix, AZ .
Butterfly Bridge over the Wisconsin River, Spring Green, WI .
Charles Bell house, East St. Louis, IL .
*Cottage Group Resort Hotel I, for Huntington Hartford, Los
 Angeles, CA .*
*C.W. Muehlberger house, East Lansing, MI . Some sources give
 1948.*
Donald Wilkie house, Hennepin County, MN .

E.L. Marting house, Northampton, OH.
Huntington Hartford house, Hollywood Hills, CA..
John J. Pike house, Los Angeles, CA .
Paul V. Palmer house, Phoenix, AZ.
Pittsburgh Point Civic Center I, Pittsburgh, PA, for Edgar J.
* Kaufmann.*
Polo stables for Huntington Hartford, Hollywood, CA .
Ruth Keith house I and II, Oakland County, MI .
San Antonio Transit Company depot, San Antonio, TX .
Sports club and play resort for Huntington Hartford, Hollywood,
* CA.*
Thomas E. Keys house I, Rochester, MN .
Valley National Bank and shopping center, Tucson, AZ .
Walter Houston house, Schuyler County, IL. Some sources give
* 1950.*
Wetmore Auto display room and workshop, Detroit, MI .

A.H. Bulbulian house, 1229 Skyline Drive, Rochester, MN. Some
 sources give 1951.
Carroll Alsop House, 1907 A Ave. East, Oskaloosa, IA. Some
 sources give 1948.
Dairy and machine shed, Midway Barns, Taliesin, WI.
Fallingwater additions for Edgar Kaufnmann, Bear Run, PA.
Galesburg country homes, Galesburg, MN.
Jack Lamberson house, 511 North Park Ave., Oskaloosa, IA. Some
 sources give 1948.
Parkwyn Village Housing master plan, Kalamazoo, MI. Some
 sources give 1948.
Usonia II Housing master plan, Pleasantville, NY. Some sources
 give 1948.

1948 January issue of *Architectural Forum* is dedicated to FLW's work. The
 brochure *Taliesin to friends* is published by Taliesin Press.

Alfred Bergman house, St. Petersburg, FL .
Arthur Hageman house, Peoria, IL .
Cottage Group Resort Hotel II, for Huntington Hartford, Los
* Angeles, CA.*
Fred Margolis house, Kalamazoo, MI.
Glen McCord house, North Arlington, NJ.
Harry Ellison house, Bridgewater Township, NJ.
Hawkins apartments, Auburn, CA.
Hawkins studio-residence, Auburn, CA.
Lloyd Lewis guest house, Libertyville, IL.
Maginel Wright Barney cottage, Spring Green, WI.
Meteor Crater Resort, Meteor Crater, AZ.
Sydney Miller house, Pleasantville, NY. Some sources give 1949.
Mrs Walter Bimson penthouse, Phoenix, AZ.

Nicholas Daphne house, San Francisco, CA.
Pittsburgh Point Civic Center II, Pittsburgh, PA.
Sidney Miller house, Pleasantville, NY.
Sun cottage, Taliesin West, Scottsdale, AZ.
Talbot Smith house, Ann Arbor, MI.
Valley National Bank and shopping center, Sunnyslope, AZ.
Vincent Scully house, Woodbridge, CT.

Albert Adelman house, 7111 North Barnett St., Fox Point, WI.

Arnold Adler house, 3600 Bellview Ave., Kansas City, MO (additions to Sondern house).

Charles Weltzheimer house, 127 Woodhave Drive, Oberlin, OH. Some sources give 1950.

Curtis Meyer house, 11108 Hawthorne Drive, Galesburg Village, MI (completed 1951).

David I. Weisblat house, 11185 Hawthorne Drive, Galesburg, MI. Some sources give 1951.

Eric Pratt house, 11036 Hawthorne Drive, Galesburg Village, MI.

H.T. Ward Greiner house, 2617 Taliesin Drive, Kalamazoo, MI. Some sources give 1951.

Howard Anthony house, 1150 Miami Rd., Benton Harbor, MI. Some sources give 1950 or 1951.

Iovanna Lloyd Wright cottage, Taliesin West, Scottsdale, AZ.

James Edwards house, 2504 Arrowhead Rd., Okemos, MI. Some sources give 1949, others 1951.

Lowell Walter boathouse and river pavilion, Quasqueton, IN.

Maynard Buehler house, 6 Great Oak Circle, Orinda, CA.

Mrs. Clinton Walker house, Scenic Rd. and Martin St., Carmel, CA. Some sources give 1949 or 1952.

Robert Levin house, 2816 Taliesin Drive, Kalamazoo, MI. Some sources give 1951.

Samuel Eppstein house, 11098 Hawthorne Drive, Galesburg , MI. Some sources give 1953.

Sol Friedman house, 11 Orchard Brook Drive, Pleasantville, NY. Some sources give 1950.

V.C. Morris shop, 140 Maiden Lane, San Francisco, CA.

Willis J. Hughes house, Fountainhead, 306 Glenway Drive, Jackson, MS. Some sources give 1949, some 1950.

1949 FLW publishes *Genius and the mobocracy*. He is made an honorary member of the American National Institute of Arts and Letters. He is awarded the AIA Gold Medal and the Gold Medal of the Philadelphia Chapter of the AIA. He receives the Peter Cooper Award for the Advancement of Art.

Alan Drummond house, Santa Fe, NM.
Bloomfield theater, Tucson, AZ.
Charles Dabney house, Chicago, IL.

George Griswold Sr. house, Greenwich, CT.
George Jacobsen house I, Montreal, Canada.
Goetsch-Winkler house II, Okemos, MI.
Harry John house, Oconomowoc, WI.
I. Auerback house, Pleasantville, NY. Some sources give 1950.
Louis Bloomfield house, Tucson, AZ.
Robert Publicker house, Haverford, PA. Some sources give 1951.
Robert Windfohr house, Crownfield, Fort Worth, TX.
San Francisco Bay Bridge, southern crossing , CA.
Self-service garage for Edgar Kaufmann, Pittsburgh, PA.
Shops for Lloyd Kiva, Scottsdale, AZ.
Theater for the New Theater Corporation, Hartford, CT.
Thomas Lea house, Ashville, NC.
YMCA building I and II, Racine, WI.

Achuff-Carroll house, Wauwatosa, WI. Some sources give 1950.
Cabaret theater 3803, Taliesin West, Scottsdale, AZ.
Edward Serlin house, 12 Laurel Hill Drive, Pleasantville, NY.
 Some sources give 1950.
Eric V. Brown house, 2806 Taliesin Drive, Kalamazoo, MI.
Henry J. Neils house, 2815 Burnham Bvd., Minneapolis, MN.
 Some sources give 1951.
Hillside Home buildings, Spring Green, WI.
Kenneth Laurent house, Spring Brook Rd., Rockford, IL. Some
 sources give 1951.
Ward McCartney house, 2662 Taliesin Drive, Kalamazoo, MI.
 Some sources give 1955.

1950 FLW receives honorary doctorate from Florida Southern College, and
 Popular Mechanics magazine's Centennial Award.

Arnold Jackson house, Madison, WI.
Arthur Stevens house, Park Ridge, IL.
Brainerd Sabin house, Battle Creek, MI.
Clinic for Dr. L. Small, West Orange, NJ.
Dale O'Donnell house, Lansing, MI.
Donald Grover house, Syracuse, NY.
George Jacobsen house II, Montreal, Quebec, Canada.
George Montooth house, Rushville, IL.
How to live in the Southwest house, Phoenix, AZ.
John Haynes house, Fort Wayne, IN. Some sources give 1951.
Kenneth Hargrove house, Berkeley, CA.
Laurence Strong house, Kalamazoo, MI.
Lawrence Swan house, Detroit, MI. Some sources give 1951.
Leon Small house, West Orange, NJ.
Louis B. Hall house, Ann Arbor, MI. Some sources give 1951.

Richard Hanson house, Corvalis, OR.
Robert Bush house, Palo Alto, CA.
*Southwest Christian Seminary for Peyton Canary, Glendale, AZ
 (later executed for First Christian Church, 6750 North 7th
 Ave., Phoenix, AZ).*
Thomas Conklin house, Ulm, MN.
William Wassel house, Philadelphia, PA .

A. K. Chahroudi house I, Petra Island, Lake Mahopac, NY.
Arthur C. Mathews house, 83 Wisteria Way, Atherton, CA. Some
 sources give 1952.
David Wright house, 5212 East Exeter Rd., Phoenix, AZ. Some
 sources give 1952.
Donald Schaberg house, 1155 Wrightwind Drive, Okemos, MI.
Ina Morriss Harper house, 207 Sunnybank, St. Joseph, MI. Some
 sources give 1951.
Isadore J. Zimmerman house, 201 Myrtle Way, Manchester, NH.
 Some sources give address as 223 Heather St.
J. A. Sweeton house, 375 Kings Highway, Cherry Hill, NJ.
John A. Gillin house, 9400 Rockbrook, Dallas, TX. Some sources
 give 1957-58.
John C. Carr house, 1544 Portago Run, Glenview, IL. Some
 sources give 1951.
Karl A. Staley house, 6363 West Lake Rd., North Madison, OH.
 Some sources give 1955.
Industrial Arts Building, Florida Southern College, Lakeland, FL.
 (renamed Lucius Pond Ordway Building, 1956)
Raymond Carlson house, 1123 West Palo Verde Drive, Phoenix,
 AZ.
Richard Davis house, Woodside, Marion, IN. Some sources give
 1954.
Richard Smith house, 332 East Linden Drive, Jefferson, WI. Some
 sources give 1951.
Robert Berger house, 259 Redwood Rd., San Anselmo, CA. Some
 sources give 1952-59.
Robert D. Winn house, 2822 Taliesin Drive, Kalamazoo, MI.
Robert Muirhead house, Rohrsen Rd., Plato Center, IL. Some
 sources give 1952.
S.P. Elam house, 107 Eastwood Rd., Austin, MN. Some sources
 give 1951.
Seamour Shavin house, 334 North Crest Rd., Chattanooga, TN.
 Some sources give 1952.
"Sixty Years of Living Architecture" exhibition (dem.).
Thomas E. Keys house II, 1243 Skyline Drive, Rochester, MN.
 Some sources give 1951.

Wilbur C. Pearce house, 5 Bradbury Hills Rd., Bradbury, CA.
William Palmer house, 227 Orchard Hills Drive, Ann Arbor, MI.
Some sources give 1951.

1951 FLW and apprentices design and construct "Sixty Years of Living Architecture" exhibition. After preview in Gimbel's store, Philadelphia, it opens at the Palazzo Strozzi, Florence, Italy and the city presents FLW with the Medici Medal. He receives the Star of Solidarity from Venice. FLW opens a San Francisco office with Aaron Green.

Gabrielle Austin house, 9 West Avondale Drive, Greenville, SC.
George Clark cottage, Carmel, CA.
Gifford Concrete Block factory, Middleton, WI.
House for G.I. couple with infant.
J. J. Vallarino house I, Panama City, Panama.
Kaufmann house, Boulder house, Palm Springs, CA.
Schevill studio, Tucson, AZ.
Victor Stracke house I, Appleton, WI . Some sources give 1956.

A. K. Chahroudi cottage II, Petra Island, Lake Mahopac, NY. Some sources give 1952.
Benjamin Adelman house, BRd. Margin, 5710 North 30th St., Phoenix, AZ. Some sources give 1953.
Charles F. Glore house, 170 North Mayflower, Lake Forest, IL. Some sources give 1955.
Nathan Rubin house, 518 44th St. N.W., Canton, OH. Some sources give 1953.
Patrick Kinney house, Tacosa Rd., Amarillo, TX. Some sources give 1952.
Roland Reisley house, 44 Usonia Rd., Pleasantville, NY. Some sources give 1954.
Roy Wetmore showroom, Ferndale, MI (remodeling).
Russell W. M. Kraus house, 120 North Ballas Rd., Kirkwood, MO. Some sources give 1953.
S.C. Johnson and Son factory, Racine, WI (additions).
Welbie L. Fuller house, Pass Christian, MS (destroyed 1969).

1952 "Sixty Years of Living Architecture" exhibition travels to Zurich, Paris, Munich, and Rotterdam. Hillside Home buildings are damaged by fire.

Alexis Wainer house, Valdosta, GA.
Ben Rebhuhn house, Fort Meyers, FL. Some sources give 1954.
Benjamin Affleck house II, Bloomfield Hills, MI.
Andrew B. Cooke house I, Virginia Beach, VA.
Edgar Lee house, Midland, MI. Some sources give 1953.
Elizabeth Morehead house, Marin City, CA.
Floating Gardens for the U.S. Plywood Co., Leesburg, FL.
Horace Sturtevant house, Oakland, CA.
Lewis H. Goddard house I, Plymouth, MI.
Paradise on Wheels trailer park, Paradise Valley, AZ.

Paul Bailleres house, Acapulco, Mexico.

Point View Residences apartment tower I and II for Edgar Kauf mann Charitable Trust, Pittsburgh, PA . Some sources give 1953 for scheme II.

Rhododendron chapel, Mill Run, PA . Some sources give 1953.

William Clifton house, Oakland, NJ.

Zeta Beta Tau fraternity house, University of Florida, Gainesville, FL.

Anderton Court shopping center, 332 North Rodeo Drive, Beverley Hills, CA. Some sources give 1953.

Archie Boyd Teater studio-residence, Old Hagerman Highway, Bliss, ID. Some sources give 1955.

Arthur Pieper house, 6642 East Cheney Rd., Paradise Valley, AZ.

Frank S. Sander house, Springbough, 121 Woodchuck Rd., Stamford, CT. Some sources give 1955.

George Lewis house, 3117 Okeeheepkee Rd., Tallahassee, FL.

H.C. Price Company tower, Bartlesville, OK. Some sources give 1953-1956.

Hillside kitchen, Spring Green, WI.

Hillside theater, Spring Green, WI (redesign and rebuilding).

Louis Penfield house I, 2203 River Rd., Willoughby Hills, OH. Some sources give 1953, some 1955.

Luis Marden house, 600 Chainbridge Rd., McLean, VA. Some sources give 1953.

Polk County Science and Cosmography Building, Florida Southern College, Lakeland, FL. Some sources give 1953.

Quentin Blair house, Greybull Highway, Cody, WY. Some sources give 1953.

R.W. Lindholm house, Mäntylä, Route 33, Cloquet, MI. Some sources give 1955.

Ray Brandes house, 212th Ave. and 24th St., Issaquah, WA.

Robert Llewellyn Wright house, 7927 Deepwell Drive, Bethesda, MD. Some sources give 1953, some 1955.

1953 "Sixty Years of Living Architecture" moves to Mexico City and New York. FLW is made an honorary member of the Swedish *Akademie Royal des Beaux Arts*. He publishes *The future of architecture*.

FM radio station for William Proxmire, Jefferson County, WI.

Hillside godown, Spring Green, WI.

Joseph E. Bewer house, Fishkill, NY.

Masieri memorial building, Grand Canal, Venice, Italy.

V.C. Morris house II, Seacliff, San Francisco, CA . Some sources give 1955.

Pieper and Montooth office building, Scottsdale, AZ.

Restaurant, Yosemite National Park, CA . Some sources give 1954.

Taliesin viaduct, Spring Green, WI.

Abraham Wilson house, 142 South River Rd., Millstone, NJ. Some sources give 1954.

Andrew B. Cooke house I, 403 Crescent St., Virginia Beach, VA. Some sources give 1958.

Harold C. Price, Jr. house, Hillside, Silver Lake Rd., Bartlesville, OK. Some sources give 1956.

John J. Dobkins house, 5120 Plain Center Ave. N.E., Canton, OH. Some sources give 1959.

Jorgine Boomer cottage, 5808 North 30th St., Phoenix, AZ.

Lewis H. Goddard house II, 12221 Beck Rd., Plymouth, MI. Some sources give 1955.

Riverview Terrace restaurant for Willard H. Keland, Route 23, Stevens Point, Spring Green, WI.

"Sixty Years of Living Architecture" pavilion, Los Angeles, CA (dismantled).

Taliesin West Sign, Taliesin, Scottsdale, AZ.

Usonian exhibition house and pavilion for "Sixty Years of Living Architecture" New York (dismantled).

William Thaxton, Jr. house, 12024 Tall Oaks, Bunker Hill, TX. Some sources give 1954.

1954 "Sixty Years of Living Architecture" concludes its tour at Hollyhock House, Los Angeles. FLW receives a citation and the Brown Medal from the Franklin Institute of Philadelphia, and an honorary doctorate of Yale University. FLW publishes *The natural house.*

Continuation for Arch Oboler, Malibu, CA.

Barnsdall Park municipal gallery, Olive Hill, Los Angeles, CA. Some sources give 1957.

Benjamin Adelman house, Whitefish Bay, WI. Some sources give 1955.

Christian Science Reading Room I and II, Riverside, IL.

Freund y Cia department store, San Salvador, El Salvador. Some sources give 1955.

G.M. Hoffman house, Winnetka, IL.

Gibbons Cornwell house I, West Goshen, PA.

Hagan Ice Cream Co. building, Uniontown, PA.

J.L. Smith house, Kane County, IL . Some sources give 1955.

Korricks department store, Phoenix, AZ.

Monona Terrace Civic Center II, Madison, WI . Some sources give 1942 (realized 1997).

Roger Schwenn house, Verona, WI.

Tipshus medical clinic, Stockton, CA.

Beth Sholom Synagogue, Old York Rd., Elkins Park, PA.

Cedric G. Boulter house, 1 Rawson Woods Circle, Cincinatti, OH.

David Wright guest house, Phoenix, AZ.

Donald Lovness house, 10121 83rd St. North, Stillwater, MN. Some sources give 1955.

E. Clarke Arnold house, 954 Dix St., Columbus, WI. Some sources give 1955.

Ellis A. Feiman house, 452 Santa Clara Dive N.W., Canton, OH. Some sources give 1955.

Frank Lloyd Wright apartment interior, Hotel Plaza, NY (dem. 1968).

Gerald B. Tonkens house, 6980 Knoll Rd., Amberly Village, OH.

Gloria Bachman and Abraham Wilson house, 142 South River Rd., Millstone, NJ.

Harold C. Price Sr. house, 7211 North Tatum, Paradise Valley, AZ. Some sources give 1956.

I.N. Hagan house, Kentuck Knob, Ohiopyle Rd., Chalk Hill, PA.

John E. Christian house, Samara, 1301 Woodland Ave., West Lafayette, IN.

John L. Rayward house, Tirranna, 432 Frog Town Rd., New Canaan, CT. Some sources give 1955, some 1956.

Karen Johnson house, 1425 Valley View Drive, Racine, WI.

Karl Kundert Medical Center, 1106 Pacific St., San Luis Obispo, CA. Some sources give 1955, others 1959.

Louis B. Frederick house, County Line Rd., Barrington Hills, IL. Some sources give 1957-1958.

Maurice Greenberg House, 3902 Highway 67, Dousman, WI. Some sources give 1955.

Maximilian Hoffman automobile showroom, 430 Park Ave., New York City. Some sources give 1955.

Maximilian Hoffman house, 58 Island Drive, North Manursing Island, Rye, NY. Some sources give 1955.

William H. Danforth Chapel, Florida Southern College, Lakeland, FL.

Willard H. Keland house, Valley View Drive, Racine, WI. Some sources give 1958.

William B. Tracy house, 18971 Edgecliff Drive S.W., Normandy Park, WA. Some sources give 1955, some 1956.

1955 FLW receives an honorary doctorate from the University of Wisconsin, Madison, and honorary degrees from *Technische Hochschules* of Darmstadt, Germany and Zürich, Switzerland. FLW and Edgar Kaufmann, Jr. publish *An American architecture*. FLW opens office and residence at the Plaza Hotel, New York City.

One room house, Phoenix, AZ.

A.D. Barton house, Downer's Grove, IL.

Air Force Academy, Boulder, CO.

C.R. Pieper house, Phoenix, AZ.

Chester Trowbridge house, Oak Park, IL.

Christian Science church I and II, Bolinas, CA. Some sources give 1956, some 1957.

George Dlesk house I, Manastee, MI. Some sources give 1958.

Gerald Sussman house, Rye, NY.

Gibbons Cornwell house II, West Goshen, PA.

J.J. Vallarino house II, Panama City. Some sources give 1956.

J.L. Smith house, Kane County, IL. Some sources give 1955.

Jay Roberts house, Seattle, WA.

John Gillin house, Alladin, Hollywood, CA. Some sources give 1956.

L. Jankowski house I and II, Oakland City, MI.

Lenkurt Electric Company administration and manufacturing building I, San Mateo, CA.

Mel Blumberg house, Des Moines, IA.

Motel for Daniel Wieland, Hagerstown, MD. Some sources give 1956.

Neuroseum hospital for Wisconsin Neurological Foundation, Madison, WI.

Oboler house II, Los Angeles, CA.

Oscar Miller house, Milford, MI.

Robert Coats house, Hillsborough, CA

Robert Herberger house I and II, Maricopa City, AZ. Some sources give 1957.

Stanley Hartman house, Lansing, MI. Some sources give 1957, some 1958.

Sterling Kinney house I, Amarillo, TX. Some sources give 1957.

V.C. Morris guest house, San Francisco, CA.

William Boswell house I, Cincinnati, OH.

Cora Carter, Isabel Wallbridge, and Charles W. Hawkins seminar buildings; Florida Southern College, Lakeland, FL.

Dorothy H. Turkel house, 2760 West Seven Mile Rd., Detroit MI.

Kalita Humphreys Theater Center, 3636 Turtle Creek Bvd., Dallas, TX. Some sources give 1958.

Randall Fawcett house, 21200 Center Ave., Los Banos, CA.

Robert H. Sunday house II, Woodfield Rd., Marshalltown, IA. Some sources give 1958-1959.

Theodore A. Pappas house, 865 South Masonridge Rd., St. Louis, MO.

Toufic H. Kalil house, 117 Heather St., Manchester, NH. Some sources give 1957.

Warren Scott house, River Forest, IL (alterations).

1956 Chicago mayor Richard Daley declares 17 October "Frank Lloyd Wright Day." FLW publishes *The story of the tower*. FLW presents the

"Mile High Illinois" at an exhibition, Hotel Sherman, Chicago.

Alan Zieger house, Grosse Island, MI . Some sources give 1957.

Andrew B. Cooke house II, Virginia Beach, VA.

Arthur Levin house, Palo Alto, CA.

Arthur O'Keeffe house, Santa Barbara, CA.

Bradford Mills house I, Princeton, NJ.

Bramlett motel, Memphis, TN.

Calvin Stillman house I and II, Cornwall on Hudson, NY. Some
* sources give 1957.*

David Hunt house, Scottsdale, AZ.

Fiberthin model village for U.S. Rubber Co., Mishawake, IN.
* Some sources give 1957.*

Gate lodge, Usonian housing for Edgar Kaufmann, Bear Run, PA.

Gerald Tonkens loan office, Cincinnati, OH . Some sources give
* 1957.*

Golden Beacon apartment tower for Charles Glore, Chicago, IL.

Helen Sottil house, Cuernavaca, Mexico. Some sources give 1956.

Jack Hennesy house I, Smoke Rise, NJ.

Lee Adams house, St. Paul, MN. Some sources give 1957.

Lenkurt Electric Company administration and manufacturing
* building II, San Mateo, CA.*

Lillian Morris house, Quiet water, Stinson Beach, CA.

Mile high (The Illinois) skyscraper, Chicago, IL.

Nelson Gross house, Hackensack, NJ.

Post Office, Spring Green, WI . Some sources give 1957.

Robert Boebel house, Boscobel, WI

Robert Moreland house, Austin, TX . Some sources give 1957.

Roberts house, Seattle, WA.

T. Henry Wilson house, Morgantown, NC. Some sources give
* 1957.*

The New Sports Pavilion, Belmont Park, Long Island, NY.

Victor Stracke house II, Appleton, WI.

Victoria Schuck house, South Hadley, MA.

Allen Friedman house, 200 Thornapple, Bannockburn, IL

Annunciation Greek Orthodox Church, 9400 West Congress St.,
 Wauwatosa, WI.

Arnold Jackson house, Skyview, 7655 Indian Hills Trail, Beaver
 Dam, WI. Some sources give 1957.

Carl Post house, 265 Donlea Rd., Barrington IL. Some sources
 give 1957.

Conrad Edward Gordon house, 303 S.W. Gordon Lane, Aurora,
 OR. Some sources give 1957.

Dudley Spencer house, 619 Shipley Rd., Wilmington, DE.

Duey Wright house II, 904 Grand Ave., Wausau, WI. Some
 sources give 1957.

Erdman prefab #1, Madison, WI.

Eugene Van Tamelen house, 5817 Anchorage Rd., Madison, WI.

Exhibition building for Wright exhibit, near Hollyhock house, Los
Angeles, CA (now Municipal Art Center of Los Angeles).

Frank Bott house, 3649 North Briarcliff Rd., Kansas City, MO.

Frank Iber house, Stevens Point, WI. Some sources give 1957.

Hotel Sherman exhibition, Chicago, IL (demounted).

Joseph Mollica house, 1001 West Jonathon Lane, Bayside, WI.
Some sources give 1958, some 1959.

Kenneth Meyers clinic, 5441 Far Hills Ave., Dayton, OH. Some
sources give 1958-59.

Music pavilion, Taliesin West, Scottsdale, AZ

Paul Trier house, 6880 North West Beaver Dve., Des Moines, IA.
Some sources give 1958.

R.W. Lindholm Service Station, Route 45, Cloquet, MN. Some
sources give 1957, some 1958.

Restoration of the Frank Lloyd Wright studio, Oak Park, IL.

Solomon R. Guggenheim Museum, final revised scheme, 5th Ave.,
New York City.

William Cass house, The Crimson Beech, Richmond, NY.

William P. Boswell house II, 8805 Camargo Club Drive, Indian
Hill, OH. Some sources give 1957, some 1958.

Wyoming Valley School, Route 23, Wyoming Valley, WI. Some
sources give 1957.

1957 FLW commissioned design an opera house, two museums, a post office
and telecommunications building for Baghdad, Iraq. The Wrights visit
London, Paris and Cairo. FLW publishes *A testament*.

ArthurMiller house, Roxbury, CT.

Bimson housing, Phoenix, AZ.

Bradford Mills house II, Princeton, NJ.

Claremont Hotel wedding chapel I and II, Berkeley, CA.

Darryl McKinney house, Cloquet, MN.

Development plan and buildings for Greater Baghdad, Iraq.

Gate lodge II for Edgar Kaufmann, Bear Run, PA.

Hennesy house I and II, Smoke Rise, NJ.

Housing for Afro-American families, Whiteville, NC.

Motel for Erdman and Associates, Madison, WI.

Motel for Zeckendorf, NY.

Oasis for Arizona State capitol, Papago Park, Phoenix, AZ.

Prefab for Erdman and Associates, Madison, WI.

Schanbacher store, Springfield, IL.

Unity Temple for Taliesin Valley, Spring Green, WI.

Wilson Shelton house I and II, Long Island, NY.

Nezam Ameri Palace, Tehran, Iran .

Carl Hoyer house, Maricopa County, AZ.

Carl Schultz house, 2704 Highland Court, St. Joseph, MI. Some sources give 1958.

Erdman prefab #1, Barrington, IL.

Erdman prefab #1, Madison, WI.

Erdman prefab #1, Richmond, NY.

Erdman prefab #1, Stevens Point, WI.

Erdman prefab #2, Rochester, MN.

Frank Iber house, Springville Drive, Stevens Point, WI.

Harry F. Corbin Juvenile Cultural Study Center, Building B, University of Wichita, KS. Some sources give 1958.

Herman T. Fasbender medical cinic, Pine St., Hastings, MN.

Hillside grounds plan, Spring Green, WI.

James B. MacBean house, 1532 Woodland Drive S.W., Rochester, MN.

Marin County Civic Center and Post Office, North San Pedro Rd., San Raphael, CA (completed posthumously).

Playhouse for Victoria Rayward, New Haven, CT.

Robert G. Walton house, 417 Hogue Rd., Modesto, CA.

Walter Rudin house, 110 Martinette Trail, Madison, WI.

1958 FLW publishes *The living city*. He is awarded the National Concrete Masonry AssociationGold Medal.

Civic center, Spring Green, WI.

Crosby-Lambert house, Colbert County, AL.

Frank Logomarsino house, San Jose, CA.

Hanley airplane hangar, Benton Harbor, MI. Some sources give 1959.

Jack Hennesy house II, Smoke Rise, NJ.

James Guttierez house, Albuquerque, NM.

Jesse Franklin house, Louisville, KY.

Jones (Trinity) Chapel, University of Oklahoma, Norman, OK

Leuchauer clinic, Fresno, Califonia. Some sources give 1959.

Medical clinic, Spring Green, WI.

Ralph Colgrove house, Hamilton, OH.

Three cottages forDonald Lovness, Stillwater, MN . Built 1976.

Unity Chapel, Taliesin Valley, Spring Green, WI.

Universal Todd-AO cinema I and II , Los Angeles, CA.

Wesley Libbey house, Grand Rapids, MI.

Don M. Stromquist house, 1151 E. North Canyon Rd., Bountiful, UT.

George Ablin house, 2460 Country Club Drive, Bakersfield, CA.

John L. Rayward house additions, New Canaan, CT.

Lockridge, McIntyre and Whalen Medical Center, Whitefish, MT.

Paul Olfelt house, 226 Parkland Lane, St. Louis Park, MN.
Pilgrim Congregational church, 2850 Foothill Bvd., Redding, CA.
(completed posthumously).
Rainbow Springs Lodge, East Troy, WI.
Seth Condon Peterson cottage, Hastings Rd., Lake Delton, WI.

1959 FLW begins to write a history of architecture for teenagers, titled "The wonderful world of architecture." FLW dies on 9 April in Phoenix, AZ. Funeral service, officiated by the Madison Unitarian Society minister, is held 12 April 12 at Taliesin.

Airplane hanger for Pat Hanley, Benton Harbor, MI.
Daniel Wieland house, Hagerstown, MD.
Fine arts center and gallery, AZ State University, Tempe, AZ.
Gilbert Wieland house, Hagerstown, MD.
Harvey Furgatch house, San Diego, CA.
Helen Donohoe house, Phoenix, AZ.
Holy Trinity Greek Orthodox church, San Francisco, CA.
John Mann house, Putnam County, NY.
Key project, hotels, apartments, shops and civic center, Ellis Island, NY.
Louis Penfield house II, Willoughby, OH.

Edgar Wall Waterdome, Florida Southern College, Lakeland, FL.
Enclosed garden, Spring Green, WI.
Erdman prefab #1, Madison, WI.
Grady Gammage Memorial Auditorium, Arizona State University, Apache Bvd., Tempe, AZ (completed posthumously).
Norman Lykes house, 6836 North 36th St., Phoenix, AZ.

1960 Edward LaFond house, St Joseph, MN (completed posthumously).

1961 Socrates Zaferiou house, Blanvert, NY (completed posthumously).

1992 Hemicycle House, Big Island, HI (completed posthumously).

ANNOTATED BIBLIOGRAPHY

Before 1900

1886
Periodicals
001. Gannett, William Channing. "Christening a country church." *Unity* [Chicago], 17(28 August 1886), 356-57. Unity Chapel, Helena Valley, Wisconsin, designed by Joseph Lyman Silsbee. Reprinted in Graham, *A Lloyd Jones retrospective*, Spring Green: 1986.

1887
Books, monographs and catalogues
002. "Unity Chapel, Helena, Wis." in *All Souls Church. Fourth Annual.* Chicago: 1887. Perspective drawing, signed by Wright.

Periodicals
003. *Inland Architect.* "Country residence for Hillside Estate, Helena Valley, Wis." 10(August 1887), unp. Misses Lloyd Jones house II; drawings only.

004. *Inland Architect.* "Unitarian chapel for Sioux City, Iowa." 9(June 1887), 111. Perspective and plan, signed "F.L. Wright."

1888
Periodicals
005. *Inland Architect..* "House for Victor Falkenau, Chicago. Adler and Sullivan, architects, Chicago." 11(June 1888). Drawing signed by Wright.

006. *Inland Architect.* "House for William Waller, Chicago. J.L. Silsbee, architect." 11(May 1888). Perspective drawing by Wright.

007. *Inland Architect.* "Residence at Helena Valley, Wis." *Inland Architect*, 11 (February 1888). Hillside Home School building I. Perspective drawings signed by Wright.

008. *Inland Architect*. "Residence for J.L. Cochrane Esq. J.L. Silsbee, architect."
11(March 1888), unp. Perspective drawing and plan, signed F.Ll. Wright. See
also "Residence for J.L. Cochran, Edgewater, Ill. J. L. Silsbee, Architect," *ibid.*,
11(July 1888).

1890
Periodicals
009. *Engineering and Building Record*. "New offices of Adler and Sullivan,
architects, Chicago." 22(7 June 1890), 5.

1891
Periodicals
010. *Inland Architect*. "Residence for Mr. James Charnley, Chicago. Adler and
Sullivan, architects." 18(August 1891). Perspective drawing, also in *Architec-
tural Record*, 1(January-March 1892), 348.

1892
Periodicals
011. *American Architect and Building News*. "House of James Charnley, Esq.,
Astor Street, Chicago, Ill." 38(October-December 1892), 211, pl. 887. Also
published in *Architectural Record*, (January-March 1892), 348.

1894
Periodicals
012. *Inland Architect*. "Competition, Robert Clark testimonial." 24(September
1894), 17. Advice of a drawing competition for which Wright was a jury
member. Also in *Brickbuilder*, 3(September 1894), 181-82. "Association notes,"
Inland Architect, 24(December 1894), 48, announces the winners.

013. *Inland Architect*. "Residence of W.I. Clark, La Grange, Illinois."
24(August 1894), loose plate. See also *The W. Irving Clark residence: a
catalogue of drawings by Frank Lloyd Wright*, Scottsdale: Frank Lloyd Wright
Foundation, 1970. The house was designed by E. Hill Turnock.

1895
Periodicals
014. *Inland Architect*. "Residence by architect Frank L. Wright, for himself,
Oak Park, Ill." 24(January 1895), loose plate.

1896
Books, monographs and catalogues
015. Gannett, William Channing. *The house beautiful. In a setting designed by
Frank Lloyd Wright and printed by hand at the Auvergne Press in River Forest
by William Herman Winslow and Frank Lloyd Wright during the winter months
of the year eighteen hundred ninety six and seven.* River Forest, Illinois:
Auvergne Press, 1896-97. The essay was first published in 1895. Wright

decorated the book, a limited edition of ninety copies.

Facsimile, Park Forest: W.R. Hasbrouck, 1963. Reviewed Grant Carpenter Manson, "An evocative experience," *Progressive Architecture*, 44(December 1963), 172, 174; Lloyd Henri Hobson, *The Prairie School Review*, 1(no. 1, 1964), 17; and Harold Allen Brooks, *JSAH*, 24(May 1965), 178-80. The text is reprinted in John Lloyd Wright, *My father who is on earth*, New York: 1946. See also "House beautiful: an example of fine bookmaking in which Wright collaborated," *AIA Journal*, 84(August 1960), 60. Another modified reprint was published Rohnert Park: Pomegranate, 1996.

016. Keats, John. *The eve of St. Agnes by John Keats; with an appreciation by Leigh Hunt*. River Forest: Auvergne Press, 1896. Reprinted from Leigh Hunt, *The seer; or, common-places refreshed*, London: Moxon, 1840. The title page of this limited edition is designed by Wright.

1897
Periodicals
017. *American Architect and Building New*s. "Rose-garden and residence of Louis H. Sullivan, architect, Ocean Springs, Miss." 55(January-March 1897), following 31. Image only.

018. *House Beautiful.* "Successful houses, III." 1(15 February 1897), 64-69. Wright's own house, Oak Park.

019. *Inland Architect.* "A Chicago residence. Frank L. Wright, architect." 29(July 1897). Harlan house; image only.

020. *Official Gazette, U. S. Patent Office.* "Designs." 60(7 December 1897), 1773-79. Patented designs by Wright for the Luxfer Prism Company, Chicago; images only.

1898
Books, monographs and catalogues
021. *Frank Lloyd Wright, architect. The Rookery, Chicago. Room 1119. Hours twelve to two. Telephone Main 2668. Draughting rooms and studio at the corner of Forest and Chicago Avenues. Oak Park, Illinois* Chicago: n.d. [1898?]. The brochure includes plans of Wright's Chicago office, and a plan and perspective drawing of his Oak Park studio. Reprinted in Bolon, Nelson and Seidel eds. *The nature of Frank Lloyd Wright,* Chicago; London: 1988.

Periodicals
022. Wright, Frank Lloyd. "Art in the home." *Arts for America*, 7(June 1898), 579-88. Paper presented to the Home Decorating and Furnishing Department of the Central Art Association's third annual conference, Chicago, May 1898. The Association functioned from 1894 through 1910.

023. *American Architect and Building New*s. "Competitive design for the New York Public Library." 59(8 January 1898), 14, pl. 1150. The recently established New York firm of Carrere and Hastings won the 1897 design competition;

the libarary was completed in 1911.

024. *Brickbuilder*. "Brick and terra-cotta work in American cities, and manufacturers' department." 7(May 1898), 106-108. The Central Art Association of Chicago had chosen Wright, George R. Dean, and Robert Closson Spencer Jr. to design a "typical American home" for the Trans-Mississippi and International Exposition, planned for Omaha, Nebraska, June-October 1898.

025. *Brickbuilder*. "Brick and terra-cotta work in American cities, and manufacturers' department." 7(November 1898), 239-41. Abraham Lincoln Center, Chicago.

026. *Forms and Fantasies*. "Interior by Frank Lloyd Wright." 1(November 1898), 87. Winslow house; image only.

027. *Inland Architect*. "An interesting competition." 30(January 1898), 63-64. Luxfer Prism office building, Chicago (project). Cf. *American Architect and Building News*, 59(12 February 1898), 1-3.

028. *Inland Architect*. "Residence at Oak Park, Illinois. Frank L. Wright, architect." 31(June 1898), loose plate. Moore house (the illustration appears only in the photogravure edition).

1899
Periodicals
029. Granger, Alfred Hoyt. "An architect's studio." *House Beautiful*, 7(December 1899), 36-45. Wright studio, Oak Park. Reprinted in Joy Wheeler Dow, *The book of a hundred houses*. Chicago: Herbert S. Stone, 1902.

030. *Brickbuilder*. "Brick and terra-cotta work in American cities, and manufacturers' department." 8(January 1899), 16-19. All Souls Building, Chicago (project).

031. *Inland Architect*. "Apartment building, Chicago, Frank L. Wright, architect." 32(January 1899, following 59. Image only of Francis Apartments (it appeared only in the photogravure edition).

032. *Inland Architect*. "Residence for Mr. Furbeck, Oak Park, Illinois." 3(February 1899), following 59. Photograph only of Rollin Furbeck house (it appeared only in the photogravure edition).

1900-1909

1900

Books, monographs and catalogues

033. Chicago Architectural Club. *Annual of the Chicago Architectural Club, being the book of the thirteenth annual exbibition 1900.* Chicago: The Club, 1900. The catalogue illustrates the Wright studio, Moore house, and several unbuilt projects: McAfee, Eckart, Devin and Waller houses and All Souls Building. The exhibition is announced in *American Architect and Building News*, 68(14 April 1900), 12-14, and reviewed in *Inland Architect*, 35(April 1900) and *Architectural Review*, 7(June 1900), 75, with illustrations of exhibits.

034. Wright, Frank Lloyd. *Hillside home school: a collection of views in and about the home, the school, the surrounding country and characteristic bits of class work.* Hillside, Wisconsin: s.n., 1900.

Periodicals

035. Jiránek, Milos. "Architektura v. America: z dopisu." *Volné Smery*, 4(1900), 177-80. Czechoslovakian: "American architecture: from letters." Images of Wright's Oak Park studio.

036. Spencer, Robert Closson Jr. "The work of Frank Lloyd Wright." [Boston] *Architectural Review*, 7(June 1900), 61-72. Reprinted as a book, *The work of Frank Lloyd Wright...*, Park Forest: Prairie School Press, 1964; reviewed Lloyd Henri Hobson, *Prairie School Review*, 1(no. 4, 1964), 24; and Harold Allen Brooks, *JSAH*, 24(December 1965), 330-31.

037. Wright, Frank Lloyd. "The architect." *Brickbuilder*, 9(June 1900), 124-28. Transcribes a speech given to the Architectural League of America's annual convention, Chicago, June 1900. Also published in *Construction News*, 10(16 June 1900), 518-19 and (23 June 1900), 538-40. For comment see *American*

Architect and Building News, 68(16 June 1900), 87, and *Inland Architect,* 35(June 1900). Reprinted in Meehan ed. *Truth against the world,* New York: 1987; and Pfeiffer ed. *Frank Lloyd Wright collected writings. Vol. 1.* New York: 1992.

038. Wright, Frank Lloyd. [Comment on George R. Dean, "Progress before precedent"]. *Brickbuilder,* 9(May 1900), 96-97.

039. *Inland Architect.* "Selections from Chicago Architectural Club exhibition of 1900." 35(April 1900), unp. Images of Oak Park studio.

1901
Books, monographs and catalogues
040. Ashbee, Charles Robert. *A report by Mr. C.R. Ashbee to the Council of the National Trust for Places of Historic Interest and Natural Beauty, on his visit to the United States* London: Essex House Press, 1901.

041. Wright, Frank Lloyd. "The art and craft of the machine." In *Catalogue of the fourteenth annual exhibition of the Chicago Architectural Club. In the Galleries of the Art Institute, Michigan Ave. and Adams Street, from Thursday, March twenty-eighth, to Monday, April fifteenth, A.D. MDCCCCI.* Chicago: The Club, 1901. Text of a speech to the Arts and Crafts Society, Hull House, 6 March 1901, and to the Western Society of Engineers, 20 March 1901. The essay is also published in *Journal of the Western Society of Engineers,* (1901), reprinted *Brush and Pencil,* 8 (May 1901), 77-90, and revised in General Society of the Daughters of the Revolution, Illinois, *The new industrialism,* Chicago: National League of Industrial Art, 1902, Pt. III, 79-111 (limited edition). Again reprinted (in various forms) in Gutheim ed. *Frank Lloyd Wright on architecture,* New York: 1941; Mumford ed. *Roots of contemporary American architecture,* New York: 1952; Kaufmann and Raeburn eds. *Frank Lloyd Wright: writings and buildings,* New York: 1960; Meehan ed. *Truth against the world,* New York: 1987; Pfeiffer ed. *Frank Lloyd Wright collected writings. Vol. 1,* New York: 1992; and Frank ed. *The theory of decorative art: an anthology of European and American writings, 1750-1940,* New Haven; London: 2000.

For a discussion of the variations of the paper, see Appendix A of Menocal, "Frank Lloyd Wright as the anti-Victor Hugo," in Zabel and Munshower eds. *American public architecture: European roots and native expression,* Pennsylvania: 1989.

Periodicals
042. Wright, Frank Lloyd. "A home in a prairie town." *Ladies' Home Journal,* 18(February 1901), 17. Reprinted in Hasbrouck ed. *Architectural essays from The Chicago School,* Park Forest: 1967; and Pfeiffer ed. *Frank Lloyd Wright collected writings. Vol. 1,* New York: 1992. See Kathryn Dethier, "The spirit of progressive reform: the *Ladies Home Journal* house plans 1900-1902," *Journal of Design History,* 6(no. 4, 1993), 247-61.

043. Wright, Frank Lloyd. "A small house with lots of room in it." *Ladies' Home*

Journal, 18(July 1901), 15. Reprinted in Hasbrouck ed. *Architectural essays from The Chicago School*, Park Forest: 1967; and Pfeiffer ed. *Frank Lloyd Wright collected writings. Vol. 1,* New York: 1992. See Kathryn Dethier, "The spirit of progressive reform: the *Ladies Home Journal* house plans 1900-1902," *Journal of Design History*, 6(no. 4, 1993), 247-61.

044. Wright, Frank Lloyd. "The 'Village Bank' series, V." *Brickbuilder*, 10(August 1901), 160-61. Cast concrete village bank. Reprinted in Hasbrouck ed. *Architectural essays from The Chicago School*, Park Forest: 1967; and Pfeiffer ed. *Frank Lloyd Wright collected writings. Vol. 1,* New York: 1992.

045. *Brickbuilder.* "Selected miscellany." 10(January 1901), 17-21. Announces new partnership of Wright and Webster Tomlinson. Cf. *Inland Architect*, 37(March 1901), 16.

1902
Books, monographs and catalogues
046. Chicago Architectural Club. "The work of Frank Lloyd Wright." In *The Chicago Architectural Annual published by the Chicago Architectural Club: a selection of works exhibited at the Art Institute in March of the year one thousand nine hundred and two.* Chicago: The Club, 1902. Images of Sullivan house, Ocean Springs; Wright playroom and studio; Hillside Home School building II; Winslow house and stable; River Forest Golf Club; Bradley, Henderson, Hickox, Metzger and Thomas (Rogers) houses; and projects: "A small house with lots of room in it" and "A home in a prairie town" (both from *Ladies' Home Journal*); cast concrete village bank; Abraham Lincoln Center; and Lexington Terrace apartments. Reviewed "Chicago," *American Architect and Building News*, 76(26 April 1902), 29-30.

Periodicals
047. *Inland Architect.* "Residence, Oak Park, Illinois." 39(July 1902), loose plate. The image appeared only in the photogravure edition.

1903
Books, monographs and catalogues
048. Harper, William Hudson. *In the valley of the clan: the story of a school.* n.l., n.p. (1903?). Illustrated pamphlet about Hillside Home School .

Periodicals
049. Spencer, Robert Closson Jr. "Brick architecture in and about Chicago." *Brickbuilder*, 12(September 1903), 178-87. Includes Winslow stable; Francisco Terrace, Francis Apartments, and the Charnley, Heller, and Husser houses.

1904
Periodicals
050. Colson, Ethel M. "A yellow dining room." *House Beautiful*, 15(March 1904), 208-210. McArthur house.

051. David, Arthur C. "The architecture of ideas." *Architectural Record*, 15(April 1904), 361-84.

1905
Periodicals
052. Smith, Lyndon P. "The home of an artist-architect: Louis H. Sullivan's place at Ocean Springs, Miss." *Architectural Record*, 17(June 1905), 471-90. Wright is not mentioned.

053. *Architectural Record.* "The work of Frank Lloyd Wright, its influence." 18(July 1905), 61-65.

054. *Inland Architect.* "Residence of W.G. Fricke, Oak Park, Ill." 46(August 1905), unp. Image only.

1906
Books, monographs and catalogues
055. Johonnot, Rodney F. *The new edifice of Unity Church, Oak Park, Illinois. Frank Lloyd Wright, architect.* Illustrated pamphlet designed by Wright. Revised and reissued by the Unitarian Universalist Church, Oak Park, 1961.

056. Wright, Frank Lloyd. *Hiroshige: an exhibition of colour prints from the collection of Frank Lloyd Wright. The Art Institute of Chicago, March the twenty-ninth, nineteen hundred six.* Chicago: The Institute, 1906. The catalogue includes Wright's introduction , reprinted in Gutheim ed. *Frank Lloyd Wright on architecture*, New York: 1941; and Pfeiffer ed. *Frank Lloyd Wright collected writings. Vol. 1*, New York: 1992.

Periodicals
057. Heath, William R. "The office building and what it will bring to the office force." *Larkin Idea*, 6(November 1906), 10-14. Text of a speech about the Larkin Company administration building.

058. Percival, C.E. "A house on a bluff." *House Beautiful*, 20(June 1906), 11-13. Hardy house.

059. Percival, C.E. "A house without a servant." *House Beautiful*, 20(August 1906), 13-14. Glasner house.

060. Percival, C.E. "Solving a difficult problem: making the most of a narrow lot: a house at South Bend, Indiana; Frank Lloyd Wright, architect." *House Beautiful*, 20(July 1906), 20-21. DeRhodes house.

061. Wright, Frank Lloyd. "The new Larkin administration building." *Larkin Idea*, 6(November 1906), 2-9 and cover. Reprinted in *Prairie School Review*, 7(no. 3, 1970); and Quinan, *Frank Lloyd Wright's Larkin Building, myth and fact*, New York: 1987.

062. *Inland Architect.* "Front view of residence, D. D. Martin, Buffalo, N.Y." 47(July 1906), unp. Image only.

063. *Inland Architect.* "Street front, residence of Wm. R. Heath, Buffalo, N.Y." 48(October 1906), unp. Image only.

1907
Books, monographs and catalogues
064. Pittsburgh Architectural Club. *Fourth exhibition to be held in the Carnegie Institute Galleries November, 1907.* Pittsburgh: The Club, 1907. The catalogue illustrates the Adams, Hardy, and Francis Little houses; Unity Temple; and the Ullman house (project). The show is reviewed *American Architect and Building News*, 92(30 November 1907), 175-81.

Periodicals
065. Illsley, Charles E. "The Larkin administration building, Buffalo." *Inland Architect*, 50(July 1907), 4, 12 ff. For comment see *Architectural Review*, 14(July 1907), 184.

066. Twitmyer, George E. "A model administration building." *Larkin Idea*, 7(August 1907), 1-8. Larkin administration building. A condensed version appears in *Businessman's Magazine*, 19(April 1907), 43-49.

067. Wright, Frank Lloyd. "A fireproof house for $5,000." *Ladies' Home Journal*, 24 (April 1907), 24. Reprinted in Hasbrouck ed. *Architectural essays from The Chicago School*, Park Forest: 1967; and Pfeiffer ed. *Frank Lloyd Wright collected writings. Vol. 1,* New York: 1992.

068. *American Architect and Building News.* "House and studio of Mrs. Mary Lawrence, Springfield, Illinois." 92(24 August 1907). Image only.

069. *American Architect and Building News.* "House on Lake Avenue, Chicago, Ill." 91(25 May 1907). Albert Sullivan house; image only.

070. *Inland Architect.* "Remodeled entrance, Rookery building, Chicago." 50(September 1907). Loose plate.

071. *Inland Architect.* "Residence of Arthur Heurtley, Oak Park, Illinois" and "Residence of P.A. Beachy, Oak Park, Illinois." 50(November 1907). Loose plates.

072. *Inland Architect.* "Residence of Mr. Moore, Oak Park, Illinois." 50(December 1907). Loose plate.

073. *Larkin Idea.* "The inscriptions on the court of the [Larkin] administration building." 7(May 1907), 1-2.

074. *Larkin Idea.* "Our Jamestown exhibit." 7(August 1907), 16-17.

1908
Periodicals
075. Sturgis, Russell. "The Larkin building in Buffalo." *Architectural Record*, 23(April 1908), 310-21. See Quinan, "Frank Lloyd Wright's reply to Russell Sturgis," *JSAH*, 41(October 1982), 238-44.

076. Tallmadge, Thomas E. "The 'Chicago School'." *Architectural Review*, 15(April 1908), 69-74. Reprinted in Hasbrouck ed. *Architectural essays from the Chicago School*, Park Forest: 1967.

077. Wright, Frank Lloyd. "In the cause of architecture." *Architectural Record*, 23(March 1908), 155-221. Wright's seminal credo was reprinted as a booklet. For comment, see [Boston] *Architectural Review*, 15(April 1908), 78-80.

Revised in Wright, *Ausgeführte Bauten und Entwürfe von Lloyd Wright*, Berlin: 1910 (German); Wijdeveld, *The life-work of the American architect Frank Lloyd Wright*, Santpoort: 1925 (translated into Dutch as "In het belang der architectuur," *Architectura*, 30[20, 27 March 1926], 133-40, 145-52); Gutheim ed. *Frank Lloyd Wright on architecture*, New York: 1941; *Mostra di Frank Lloyd Wright: catalogo itinerario*, Florence: 1951 (an Italian translation was reissued as *Sovranità dell'individuo—in the cause of architecture, prefazione a Ausgeführte Bauten und Entwürfe pubblicata da Wasmuth, Berlino 1910*. Florence: 1951); Gutheim et al. eds. *In the cause of architecture, Frank Lloyd Wright*, New York: 1975 (reprinted 1987); Pfeiffer ed. *Frank Lloyd Wright collected writings. Vol. 1,* New York: 1992; and Eric Uhlfelder, *The origins of modern architecture*, New York: Dover, 1998. Also published in anthology as *Per la causa dell'architettura*, Rome: Gangemi, 1989 (Italian).

Abridged as "How the movement for democratic architecture is developing in America," *Building* [Australia], (11 April 1914), 67, 79 ff.

078. *Inland Architect.* "Living room, house for H.J. Ullman, Oak Park, Ill., F.L. Wright, architect." 51(January 1908). Loose plate.

079. *Inland Architect.* "Unity Temple and Unity House, Oak Park, Ill." 52(December 1908), 77.

1909
Books, monographs and catalogues
080. Vogel, F. Rud. *Das Amerikanische Haus*. Berlin: Wasmuth, 1909. German: *The American house.*

Periodicals
081. *Oak Leaves.* "On ornamentation: Frank Lloyd Wright pleads for a new culture." (16 January 1909), 20. Reprinted as "Ethics of ornament," *Prairie School Review*, 4(no. 1, 1967); and in Meehan ed. *Truth against the world*, New York: 1987.

082. *Western Architect.* "Minneapolis Architectural Club exhibition." 12(1909), 51-55. Includes notice of Wright's participation.

1910-1919

1910
Books, monographs and catalogues
083. Wright, Frank Lloyd. *Ausgeführte Bauten und Entwürfe von Lloyd Wright.* Berlin: Ernst Wasmuth, 1910. German: *Executed works and designs of Lloyd Wright.* Two portfolios of 100 loose sheets in a limited deluxe edition and a standard version, illustrating 73 buildings and projects, 1893-1909.

Wasmuth produced a US edition, *Studies and executed buildings*, with the original text of Wright's introduction (cf. "In the cause of architecture," *Architectural Record*, 23[March 1908]). It is reviewed Montgomery Schuyler, "An architectural pioneer," *Architectural Record*, 31(April 1912), 427-36 (reprinted *idem.*, *American architecture and other writings*, Cambridge, Mass.: 1961).

Published in Japan (under its German title), Osaka: Seikizen-Kart-Honten, 1916. See also Kusaba Nobuyoshi ed. "Furanku Roido Raito-shi kenchi-kugo," *Kenchiku Gaho*, 8(November 1917), the issue.

Wasmuth reprinted the portfolios, Berlin, 1924. A German edition appeared as *Frank Lloyd Wright, ausgeführte Bauten und Entwürfe*, Tubingen: Wasmuth, 1986; reviewed Immo Boyken, *Architectura*, 17(no. 1, 1987), 97-101; and Björn Linn, *Arkitektur*, (no. 2, 1987), 50-51.

Later English language editions proliferate, beginning with *Frank Lloyd Wright, buildings, plans and designs*, New York: Horizon, 1963; reviewed Harold Allen Brooks, *JSAH*, 24(May 1965), 178-80; Lloyd Henri Hobson, *Prairie School Review*, 1(1964), 24; Mildred F. Schmertz, "Wasmuth's great portfolio on Wright reprinted," *Architectural Record*, 135(January 1964), 84-, 90; and Edgar Tafel, "Precious monograph," *Progressive Architecture*, 46 (February 1965), 240, 244.

Ausgeführte Bauten und Entwürfe von Frank Lloyd Wright: studies and executed buildings by Frank Lloyd Wright, Palos Park: Prairie School Press, 1975, is a reduced photo-reprint of the 1910 Berlin edition, with the German as

well as the English introduction (the latter was included in sets of the original plates distributed in the US by Ralph Fletcher Seymour, Chicago). Reviewed John Vinci, "More on the work of Frank Lloyd Wright," *Chicago History*, 5(Fall 1976), 171-72; and Joseph Connors, *JSAH*, 36(December 1977), 269-70.

See also *Drawings and plans of Frank Lloyd Wright: the early period (1893-1909)*, New York: Dover, 1983; Vincent Scully intro., *Studies and executed buildings by Frank Lloyd Wright*, London: Architectural Press; New York: Rizzoli, 1986 (reviewed Philip Kennedy-Grant, *Architecture New Jersey*, 23[1987], 44-45).

Also published in Italian as *Frank Lloyd Wright: gli anni della formazione: studi e realizzazioni*, Milan: Jaca, 1986 (there was a second edition, and a third: Anthony Michael Alofsin, intro. *Frank Lloyd Wright: gli anni della formazione: studi e realizzazioni*: Milan: Jaca, 1998). Also in French as *Projets et realizations de Frank Lloyd Wright*, Paris: Herscher, 1986.

See also *Studies and executed buildings by Frank Lloyd Wright*, New York: Rizzoli, 1998; reviewed Federico Bucci, *Domus*, (December 1999), 104-105.

Five plates are reprinted in Jean Badovici ed. *La maison d'aujourdhui. Maisons individuelles*, Paris: Morance, 1925.

The introductory essay is reprinted in Wijdeveld, *The life-work of the American architect Frank Lloyd Wright*, Santpoort: 1925 (and subsequent editions), and translated into Dutch as "In het belang der architectuur," *Architectura*, 30(20 and 27 March 1926), 133-40, 145-52. It is also reprinted in Gutheim ed. *Frank Lloyd Wright on architecture*, New York: 1941; *Mostra di Frank Lloyd Wright: catalogo itinerario*. Florence: Palazzo Strozzi, 1951 (an Italian translation was reissued as *Sovranità dell'individuo—in the cause of architecture, prefazione a Ausgeführte Bauten und Entwürfe pubblicata da Wasmuth, Berlino 1910*, Florence: Studio Italiano di Storia dell'Arte, 1951); Gutheim et al. eds. *In the cause of architecture, Frank Lloyd Wright*, New York: 1975 (reprinted 1987); and Pfeiffer ed. *Frank Lloyd Wright collected writings. Vol. 1*, New York: 1992.

084. Universal Portland Cement Co. *Representative cement houses*. Chicago: The Company, 1910. Includes Wright houses.

Periodicals
085. "A University Man." "Two remarkable Bitter Root Valley orchards." *Western News*, (May 1910), supp. 18-21. Como Orchards. For images of the Bitter Root Inn, see also *Bitter Root Valley: the aristocrat of irrigated projects*, Chicago: Bitter Root Valley Irrigation Co., 1911; and McIntosh-Morello Orchards brochure, *Your opportunity in Montana*, Darby: n.l., 1924, reproduced in *Prairie School Review*, 6 (no.2, 1969),12.

086. *International Studio*. "Art Gallery designed by Frank Lloyd Wright, architect." 39(February 1910), 95-96. Thurber Art Gallery.

1911
Books, monographs and catalogues
087. Wright, Frank Lloyd. *Frank Lloyd Wright: ausgeführte Bauten*. Berlin:

Wasmuth, 1911. German: *Frank Lloyd Wright: executed buildings.* Number 8 in the series 'Sonderheft der Architektur des XX Jahrhunderts' comprises mostly photographs and some plans of Wright's pre-1909 buildings; there is a foreword by Charles Robert Ashbee, "Frank Lloyd Wright: eine Studie zu seiner Würdigung [Wright, a study and an appreciation]."

There are two versions. A European edition, *Frank Lloyd Wright—Chicago*, has 113 pages, with 148 illustrations. Wright was dissatisfied with it, so it was sold only in Europe; reviewed Walter Curt Behrendt, *Kunst und Kunstler*, 11(May 1913), 487. A modified US 141-page edition, with 193 illustrations, retained the German title.

Reprinted as Edgar Kaufmann ed. *Frank Lloyd Wright: the early work*, New York: Horizon, 1968, that includes Ashbee's essay in the original English text. Reviewed Harold Allen Brooks, *Prairie School Review*, 6(no. 1, 1969), 24-25; Edgar Tafel, "Europe's first knowledge of Wright," *Architectural Record*, 145(March 1969); *Library Journal*, 94(1 April 1969), 1482; Wilbert R. Hasbrouck, *Architectural Forum*, 130(June 1969), 84-85; 148; *Choice*, 6(June 1969), 504. Bramhall House, New York: produced a cheaper version (1968).

Again reprinted as Grant Carpenter Manson ed. *The early work of Frank Lloyd Wright*, New York: Dover, 1982; and as an unabridged reproduction of Wasmuth's European edition; Nancy Frazier ed. *Frank Lloyd Wright: early visions: the great achievements of the Oak Park years: the complete 'Frank Lloyd Wright: ausgeführte Bauten' of 1911*, New York: Gramercy, 1995,

Periodicals

088. *Architectural Record.* "A departure from classic tradition: two unusual houses by Louis Sullivan and Frank Lloyd Wright." 30(October 1911), 326-38. Babson (Sullivan) and Coonley houses. Cf. "A comparison of master and pupil seen in two houses," *Western Architect*, 17(November 1911), 95.

089. *Western Architect.* "City National Bank of Mason City, Iowa, Frank Lloyd Wright, architect." 17(December 1911), 105. Reprinted in Brooks, *Prairie School architecture: studies from 'The Western Architect'*, Toronto: 1975. See also *American Architect*, 100(27 December 1911), 274 and *Architectural Review*, 18(January 1912), 11.

1912

Books, monographs and catalogues

090. June, Frank H. and George R. Hemingway. *Glimpses of Oak Park. Views by Eugene J. Hall.* Oak Park: n.p., 1912. The book of images includes an essay "The secret of the charm of Oak Park" by William E. Barton.

091. Key, Ellen. *Love and ethics.* Chicago: Ralph Fletcher Seymour, 1912. Translation by Mamah Borthwick Cheney and Wright. See Lena Johannesson, "Ellen Key, Mamah Bouton Borthwick and Frank Lloyd Wright: notes on the historiography of non-existing history," *NORA*, 2(1995), 126-36.

092. Wright, Frank Lloyd. *The Japanese print: an interpretation.* Chicago: Ralph Fletcher Seymour, 1912. Reviewed Henry Blackman Sell, "The artist as

master," *Little Review*, 1(January 1915), 17-19.

A later edition, New York: Horizon, 1966 (reprinted 1967), includes the introduction from the Chicago Arts Club catalogue *Antique colour prints from the collection of Frank Lloyd Wright* (1917), and that from Anderson Galleries catalogue, *The Frank Lloyd Wright collection of Japanese antique prints* (1927). The latter is partly reprinted in Wright, *An autobiography* (1932). Reprinted in Pfeiffer ed. *Frank Lloyd Wright collected writings. Vol. 1*, New York: 1992. Excerpts in *Daidalos*, (15 March 1986), 100-101 (German and English).

For comment and review see Robert Kostka, *Prairie School Review*, 4(no. 4, 1967), 27-30 and Gordon Washburn, *NYTBR*, 72(24 December 1967), 5; *Library Journal*, 93(15 February 1968), 746; and *Choice*, 5(June 1968), 479.

Periodicals
093. Ames, Robert Leonard. "A western suburban home." *American Homes and Gardens*, 9(March 1912), 86-89. Baker house.

094. Berlage, Hendrik Petrus. "Neuere amerikanische architektur." *Schweizerische Bauzeitung*, 60(14, 21, 28 September 1912), 148-50, 165-67, 178. German: "Recent American architecture." Text of lecture delivered in Zürich, reporting Berlage's 1911 US tour. Reissued as a booklet. Partially reprinted in de Fries ed. *Frank Lloyd Wright: aus dem Lebenswerke eines Architekten*, Berlin: 1926. For an English translation see Don Gifford ed. *The literature of architecture: the evolution of architectural theory and practice in nineteenthcentury America*, New York: Dutton, 1966; for a summary see Brooks ed. *Writings on Wright*, Cambridge, Mass.: 1981.

095. Berlage, Hendrik Petrus. "Voordracht over Amerika." *Architectura*, 20(1912), 12-14. Dutch: "Lecture about America." Cf. "Moderne bouwkunst in Amerika. Frank Lloyd Wright, architect te Chicago," *ibid.*, 20(23 March 1912), 91-94; (30 March 1912), 98-100; (6 April 1912), 106-107. The lecture is announced in "De Berlage avond en Berlage's voordracht over Amerika," *ibid.*, 34-35, and *Bouwkundig Weekblad*, 32(1912), 13, 37, 60. For summaries see "Frank Lloyd Wright: een moderne bouwmeester van Amerika [Wright: a modern American master-architect]," *Bouwwereld*, 11(1912) 20-22; 27-29; "Indrukken over Amerikaansche architectuur [Impressions of American architecture]," *Ingenieur*, 27(1912), 385-97, and "Voordracht Berlage over Amerika," *Bouwkundig Weekblad*, 32(1912), 68-69. All are in Dutch.

See also *idem.*, *Amerikanische reisherinneringen* [*Recollections of an American vacation*]. Rotterdam: W.L. and J. Brusse, 1913.

096. *Architectural Record*. "Daniel Hudson Burnham: an appreciation." 23(August 1912), 175-85. Includes a eulogy by Wright, 184.

1913
Books, monographs and catalogues
097. Chicago Architectural Club. *Book of the twenty-sixth annual exhibition of the Chicago Architectural Club in the galleries of the Art Institute, Chicago. May 6 to June 11, 1913*. Chicago: The Club, 1913. Wright works on exhibit included Lake Geneva Inn, and Madison Hotel (project). The show is reported

and reviewed in Roy Lippincott, *Architectural Record*, 32(June 1913), 567-73.

098. Harland, Marion. *My trip thru the Larkin Factories by "Marion Harland".* Buffalo: Larkin, 1913.

Periodicals
099. Ashbee, Charles Robert. "Taliesin, the home of Frank Lloyd Wright, and a study of the owner." *Western Architect*, 19(February 1913), 16-19.

100. *Architectural Record.* "The studio-home of Frank Lloyd Wright." 33(January 1913), 45-54. Taliesin.

101. *Western Architect.* "Residence for D.M. Amberg, Grand Rapids, Mich. H.V. von Holst, architect." 20(October 1913), 88, 17. Wright made preliminary sketches for the house.

102. *Western Architect.* "Residence for E.P. Irving, Decatur, Illinois." 19(April 1913), 38 and plates. Cf. *Architectural Review*, 19(May 1913), 194.

1914
Books, monographs and catalogues
103. Art Institute of Chicago. *The work of Frank Lloyd Wright.* Chicago: The Institute, 1914. Wright's work 1911-1914 was shown (i.a.) at the twenty-seventh annual exhibition of the Chicago Architectural Club. There is an essay about Japanese prints and "In the cause of architecture."

104. The Midway Gardens Co. *Midway Gardens.* Chicago: The Company, n.d. [ca.1914]. A promotional brochure includes a description and photographs.

Periodicals
105. Wright, Frank Lloyd. "In the cause of architecture, second paper." *Architectural Record*, 35(May 1914), 405-413. Reissued as a booklet. For comment see "Architectural philosophy of Frank Lloyd Wright," *Western Architect*, 20(June 1914), 58. Reprinted in Wijdeveld, *The life-work of the American architect Frank Lloyd Wright*, Santpoort: 1925 (and subsequent editions) and translated into Dutch as "In het belang der architectuur," *Architectura*, 30(24 April 1926), 193-304. Again reprinted Gutheim ed. *Frank Lloyd Wright on architecture*, New York: 1941; Kaufmann and Raeburn eds. *Frank Lloyd Wright: writings and buildings*, New York: 1960; and Pfeiffer ed. *Frank Lloyd Wright collected writings. Vol. 1*, New York: 1992. Published in anthology in Italian as *Per la causa dell'architettura*, Rome: Gangemi, 1989.

1915
Periodicals
106. Goethe, Johann Wolfgang von. "A hymn to nature." *Little Review*, 1(February 1915), 30-32. Translated from German by Wright and Mamah Borthwick Cheney. Wright immodestly commented, "The fragment ... unknown to us in the published works of Goethe, was found in a little bookshop in Berlin, and translated into English by a strong man and a strong woman whose lives and

whose creations have served the ideals of all humanity in a way that will gain deeper and deeper appreciation."

107. Sell, Henry Blackman. "Interpretation, not imitation." *Studio*, 55(May 1915), 79-83. Midway Gardens.

108. Wight, Peter B. "Country house architecture in the middle west." *Architectural Record*, 38(October 1915), 385-421. Taliesin.

109. Wright, Frank Lloyd. "In response to a request from the editor for an article on Midway Gardens." *National Architect*, 5(March 1915), 118, 155; pls. 41-43.

110. *Architectural Record.* "Estate of Frank Lloyd Wright, Spring Green, Wis." 46(October 1915), 309-310. Cf. *ibid.*, 38(October 1925), 391-95.

111. *Rock Products and Building Materials.* "Decorative features of Midway Gardens." 15(7 January 1915), 26-27.

1916
Books, monographs and catalogues
112. Wright, Frank Lloyd. "Non-competitive plan." In Alfred B. Yeomans ed. *City residential land development: studies in planning; competitive plans for subdividing a typical quarter section of land in the outskirts of Chicago.* University of Chicago Press, 1916. Reviewed Robert Craik McLean, "City residential land development," *Western Architect*, 25(January 1917), 6-8. Reprinted in Pfeiffer ed. *Frank Lloyd Wright collected writings. Vol. 1*, New York: 1992.

113. *American System-built Houses, designed by Frank Lloyd Wright.* Milwaukee: The Richards Co., 1916. A pamphlet describes the prefabricated houses; there are woodcut illustrations by Antonin Raymond. Reprinted in Meehan ed. *Truth against the world*, New York: 1987. See also Wright, "The American System of house building," *Western Architect*, 24(September 1916), 121-23.

Periodicals
114. Wright, Frank Lloyd. "A word from real art." *Little Review*, 3(September 1916), 26. Reprinted in Margaret Anderson, *The Little Review anthology*, New York: Hermitage House, 1953.

115. *Architectural Review.* "Mueller House, Decatur, Ill." 21(November 1916), 198. Photograph only. The house has been attributed to H.V. von Holst and Marion Mahoney Griffin.

1917
Books, monographs and catalogues
116. The Arts Club of Chicago. *Antique colour prints from the collection of Frank Lloyd Wright. The Arts Club of Chicago exhibition, Fine Arts Building, beginning November Twelve, ending December Fifteen.* Chicago: The Club, 1917. The introduction by Wright is reprinted in Gutheim ed. *Frank Lloyd Wright on architecture*, New York: 1941; Diamond ed. *Frank Lloyd Wright,*

Japanese prints, Los Angeles: 1962; Wright, *The Japanese print: an interpretation*, New York: 1967; and Pfeiffer ed. *Frank Lloyd Wright collected writings. Vol. 1*, New York: 1992.

117. Ashbee, Charles Robert. *Where the great city stands. A study in the new civics*. London: Essex House Press; Batsford, 1917. There are references to Wright, 19-21.

Periodicals
118. *Western Architect*, 25(January 1917), 4. Reports Wright's December 1916 departure for Japan to begin the Imperial Hotel.

1918
Periodicals
119. Oud, Jacobus Johannes Pieter. "Architectonische beschouwing bij bijlage VIII." *De Stijl*, 1(1918), 38-41. Dutch: "Architectural exposition of [illustration] VIII." Robie house. For English translations see Jane Beckett et al., *The original drawings of J.J.P. Oud, 1890-1963*, London: AA, 1979; Sergio Polano, "Notes on Oud," *Lotus International*, (no. 16, 1977); and Brooks ed. *Writings on Wright*, Cambridge, Mass.: 1981. For discussion see Langmead and Johnson, *Architectural excursions: Frank Lloyd Wright, Holland and Europe*, Westport: 2000.

120. Wils, Jan. "De nieuwe bouwkunst bij het werk van Frank Lloyd Wright." *Levende Kunst*, 1(1918), 207-19. Dutch: "The new architecture [as seen in] the work of Wright."

1919
Periodicals
121. Hoff, Robert van 't. "Architectuur en haar ontwikkeling (bij bijlage VIII)." *De Stijl*, 2(no. 4, 1919), 40-43. Dutch: "Architecture and its development (*re* [illustration] VIII)." Unity Temple.

122. Kimball, Sidney Fiske. "The American country house, 1. Practical conditions: natural, economic, social." *Architectural Record*, 46(October 1919), 307, 309-310. Taliesin.

123. Wils, Jan, "De nieuwe tijd. Eenige gedachten bij het werk van Frank Lloyd Wright." *Wendingen*, 2(no. 6, 1919), 14-17. Dutch: "The new time. a few thoughts on Wright's work." For an Italian translation see Fanelli and Godoli eds. *Wendingen: grafica e cultura in una rivista olandese del Novecento*, Milan: 1986.

1920-1929

1920
Books, monographs and catalogues
124. *The jewel of the orient, the Imperial Hotel, Tokyo, Japan.* Tokyo: n.p., n.d. [ca 1920). Promotional brochure, illustrated with photographs.

Periodicals
125. Baxter, Sylvester. "The Miller Stile Inn, Quincy, Mass.: Frank B. [*sic*] Wright, arch." *Architectural Record*, 48(July 1920), 15-30.

1921
Periodicals
126. Berlage, Hendrik Petrus. "Frank Lloyd Wright." *Wendingen*, 4(no. 11, 1921), 2-18. Dutch. Reissued as a booklet (in English), Amsterdam: De Hooge Brug, 1921. See also Wijdeveld ed. *The life-work of the American architect Frank Lloyd Wright*, Santpoort: 1925 (and subsequent editions). Cf. "H.P. Berlage: Frank Lloyd Wright," *Styl*, 4(no. 1, 1922) 10, 12-15 (Czechoslovakian).

127. Wils, Jan. "Frank Lloyd Wright." *Elsevier's Geïllustreerd Maandschrift*, 61(1921), 216-27. Dutch. For an abridged English translation see Brooks ed. *Writings on Wright*, Cambridge, Mass.: 1981. For an analysis see Langmead and Johnson, *Architectural excursions: Frank Lloyd Wright, Holland and Europe*, Westport: 2000.

1922
Books, monographs and catalogues
128. Wils, Jan. *Het woonhuis: zijn bouw.* Amsterdam: Elsevier, 1922. Dutch: *The dwelling: its construction.* Wright's drawing of the dining area of the Richards Co.'s American Systems Ready-Cut houses (1914-15), is reproduced.

Periodicals
129. Bragdon, Claude. "Towards a new theater." *Architectural Record*, 52(September 1922), 171-82. "Little Dipper" project, reprinted from Norman Bel Geddes magazine, *In Which* (1915).

130. Mullgardt, Louis Christian. "A building that is wrong." *Architect and Engineer*, 71(November 1922), 81-89. Critique of the Imperial Hotel. For comment see "Approves Mr. Mullgardt's criticism," *ibid.*, 71(December 1922), 107; and F.W. Fitzpatrick, "More anent the New Imperial Hotel ... ," *ibid.*, 72(February 1923), 83-84 (reprinted *from The Washington State Architect*).

131. Wright, Frank Lloyd. "The new Imperial Hotel." *Kagaku Chishiki*, (April 1922). Reprinted in Pfeiffer ed. *Frank Lloyd Wright collected writings Vol. 1*, New York: 1992.

1923
Books, monographs and catalogues
132. Wils, Jan, *Het woonhuis: indeeling en inrichting*. Elsevier, Amsterdam, 1923. Dutch: *The dwelling: subdivision and furnishing*. Wils' "simple country house" is a Robie house clone, modified for Dutch domestic organization.

133. Wright, Frank Lloyd. *Experimenting with human lives*. Chicago: Ralph Fletcher Seymour, n.d. [1923?]. Pamphlet written after the Tokyo earthquake. Partially reprinted in Gutheim ed. Frank *Lloyd Wright on architecture*, New York: 1941; and Pfeiffer ed. *Frank Lloyd Wright collected writings. Vol. 1*, New York: 1992.

Periodicals
134. Sakurai, Kotaru. [Seeing the Imperial Hotel]. *Kenchiku Sekai*, (November 1923), 48-51. Japanese.

135. Stady, Stanley E. "How buildings acted in the Japan quake." *American Contractor*, 44(29 December 1923), 16-18. Imperial Hotel.

136. Sullivan, Louis Henry. "Concerning the Imperial Hotel, Tokyo, Japan." *Architectural Record*, 53(April 1923), 332-52. Reprinted in Wijdeveld ed. *The life-work of the American architect Frank Lloyd Wright*, Santpoort: 1925 (and subsequent editions). Translated into Czechoslovakian in *Styl*, 4(no. 2-3, 1922), 28-31, 57-58. Adapted as "Imperial Hotel, Tokyo, Japan," *Architect*, 109(8 June 1923), 395-97, and cited at length in Jabez K. Stone, "The monument: the most talked about hotel in the world; Tokyo's unique survival of disaster," *Japan*, 13(January 1924), 13-17, 37ff.

137. Wright, Frank Lloyd. "In the cause of architecture: the new Imperial Hotel, Tokio. Frank Lloyd Wright, architect." *Western Architect*, 32(April 1923), 39-46, pls. 1-14. See also *idem.*, "In the cause of architecture: in the wake of the quake; concerning the Imperial Hotel, Tokio, *ibid.*, 32(November 1923), 129-32 and 33(February 1924), 17-20. All the essays are reprinted in Pfeiffer ed. *Frank Lloyd Wright collected writings. Vol. 1*, New York: 1992. Cf. "The effect of the earthquake in Japan upon construction," *Western Architect*, 32(October 1923),

117-18. See also Wright, "Why the Japanese earthquake did not destroy the Hotel Imperial," *Liberty*, 4(3 December 1927), 61-66; cf. *idem.*, "Why the great earthquake did not destroy the Imperial Hotel," *Creative Art*, 10(April 1932), 268-77 (reprinted in *An autobiography* [1932]).

138. Wright, Frank Lloyd. "The new Imperial Hotel, Tokio. A message from the architect." *Kagaku Chisihiki*, (March 1922), 66-71. Japanese and English.

1924
Periodicals
139. Badovici, Jean. "L'art de Frank Lloyd Wright." *L'Architecture Vivante*, 2(Autumn-Winter 1924), 26-27, pls. 34-35. French: "The art of Frank Lloyd Wright."

140. Floto, Julius. "Imperial Hotel, Tokyo, Japan." *Architectural Record*, 55(February 1924), 119-23.

141. Sullivan, Louis Henry. "Reflections on the Tokyo disaster." *Architectural Record*, 55(February 1924), 113-18. Reprinted in Wijdeveld ed. *The life-work of the American architect Frank Lloyd Wright*, Santpoort: 1925 (and subsequent editions).

142. Wright, Frank Lloyd. "Louis Henry Sullivan, beloved master." *Western Architect*, 33(June 1924), 64-66. Reprinted in Brooks, *Prairie Scbool architecture: studies from 'Tbe Western Architect'*, Toronto: 1975; Pfeiffer ed. *Frank Lloyd Wright collected writings. Vol. 1*, New York: 1992; and Christian K. Narkiewicz-Laine et al., *Inspiration: nature and the poet: the collected poems of Louis H. Sullivan*, Chicago: 1999.

143. Wright, Frank Lloyd. "Louis H. Sullivan, his work." *Architectural Record*, 56(July 1924), 28-32. Reprinted in Pfeiffer ed. *Frank Lloyd Wright collected writings. Vol. 1*, New York: 1992.

1925
Books, monographs and catalogues
144. Wijdeveld, Hendrikus Theodorus ed. *The life-work of the American architect Frank Lloyd Wright, with contributions by Frank Lloyd Wright, an introduction by architect H. Th. Wijdeveld and many articles by famous European architects and American writers.* Santpoort [Holland]: C.A. Mees, 1925. Mostly English. Seven consecutive issues of the journal of the Amsterdam architects' and artists' group *Architectura et Amicitia* (*Wendingen*, 7[1925], 1-24, 25-52, 53-76, 77-94, 95-118, 119-40, 141-64), are reissued as a book. It illustrates, with about 200 drawings and photos, the Larkin administration building, Unity Temple, the Coonley, Martin, Robie and Willits and Hollyhock houses, Taliesin, Midway Gardens, and the Imperial Hotel.

Wijdeveld's "Some flowers for architect Frank Lloyd Wright" introduces the text (for a Dutch translation see "Uit *Wendingen:* het Wright-boek," *Architectura*, 29[28 November 1925]). Wright's "In the cause" essays are reprinted (the first abridged from *Architectural Record*, 23[March 1908] and the second from

ibid., 29[May 1914]), with a specially written sequel "The third dimension," a postscript "To my European co-workers" (all reprinted in Pfeiffer ed. *Frank Lloyd Wright collected writings. Vol. 1*, New York: 1992) and "Facts regarding the Imperial Hotel". H.P. Berlage's "Frank Lloyd Wright" (*Wendingen*, 4[no. 11, 1921]) is translated into English. Louis Sullivan's "Concerning the Imperial Hotel, Tokyo" and "Reflections on the Tokyo disaster" are reprinted from *Architectural Record*, 53(1923), and 55(1924), respectively.

Erich Mendelsohn's original "Frank Lloyd Wright" is in German (for a Spanish translation, see *Arquitectura*, [no. 317, 1999], 94) and Robert Mallet-Stevens' "Frank Lloyd Wright et l'Esprit Nouvelle [Wright and the new spirit]," written specially for *Wendingen*, is in French. There are two other original essays in English: "The social background of Frank Lloyd Wright" by Lewis Mumford (translated into Japanese in *Kokusai Kentiku*, 32[March 1965], 63-72) and the widely-translated "The influence of Frank Lloyd Wright on the architecture of Europe" by J.J.P. Oud. (See Oud, *Hollandische Architektur*, Munich: 1926). An advertised deluxe, half-leather bound, numbered edition never appeared.

For a discussion of the genesis and success of the *Wrightnummers*, as they were called, see Langmead and Johnson, *Architectural excursions: Frank Lloyd Wright, Holland and Europe*, Westport: 2000.

The first *Wendingen* issue is reviewed Jan Pieter Mieras, *Bouwkundig Weekblad*, 43(25 November 1925), 478 and the bound set is reviewed *ibid.*, 47(2 January 1936), 8-10. For further comment see Andrew N. Rebori, "Frank Lloyd Wright's textile-block slab construction." *Architectural Record*, 62(December 1927), 448-56.

The "*Wendingen* book" was reissued in a different binding by A. Kroch and Son, Chicago, 1948; reviewed John Fabian Kienitz, *Wisconsin Magazine of History*, 32(December 1948), 204-206.

A new edition was published (without consulting Wijdeveld) as *The work of Frank Lloyd Wright: the life-work of the American architect Frank Lloyd Wright*, New York: Horizon, 1965; reviewed *Antiquarian Bookman*, 36(December 1965), 2283; *Scientific American*, 215(August 1966), 112; Harold Allen Brooks, *Prairie School Review*, 3(no. 4, 1966), 24; and Marchal E. Landgren, *Library Journal*, 91(1 March 1968), 1215. A lower-priced version, *The work of Frank Lloyd Wright: the* Wendingen *edition*, New York: Bramhall House, 1965, includes Olgivanna Wright's account of Wright's reaction to the original version.

See also *The complete 'Wendingen' series*, New York: Dover, 1992 and Nancy Frazier intro. *Frank Lloyd Wright: the early work of the great architect*, New York: Gramercy, 1994, that includes English translations of Mallet-Stevens' and Mendelsohn's articles, and omits Olgivanna's essay.

145. *For sale at Oak Park: a Forest Avenue property and a Chicago Avenue property: Semi-detached dwellings for sale separately or together, partly finished.* n.l.: n.d. [1925?]. Sale brochure with descriptions and plans of the Wright house and studio in Oak Park.

Periodicals
146. Hegemann, Werner. "Holland, Wright, Breslau." *Wasmuths Monatshefte*, 9(no. 4, 1925), 165-67.

147. Shand, Philip Morton. "Holland and Frank Lloyd Wright." *Architectural Review*, 67(February 1925), 61-64. Reprinted in *AA Journal*, 75(January 1959), 179-83.

148. Mendelsohn, Erich. "Das Schiff." *Architectura*, 29(18 April 1925), 145-46. German: "The ship." Reprinted from *Berliner Tageblatt*.

149. Mendelsohn, Erich. "Frank Lloyd Wright." *Architectura*, 29(25 April 1925), 153-56. German. Reprinted from *Berliner Tageblatt*.

150. Moser, Werner. "Frank Lloyd Wright und amerikanische Architektur." *Werk*, 5(May 1925), 129-51. German: "Wright and American architecture."

151. Wattjes, Jannes Gerhardus. "Amerikanische architectuur." *Bouwbedrijf*, 2(August 1925), 294-306. Dutch: "American architecture." Continued *ibid.*, (November 1925), 401-404.

1926
Books, monographs and catalogues
152. Fries, Heissenrich de ed. *Frank Lloyd Wright: Aus dem Lebenswerke eines Architekten.* Berlin: Wasmuth, 1926. German: *Frank Lloyd Wright: from the life-work of an architect.* Includes "Anmerkungen des Architekten Frank Lloyd Wright zu seinen Zementblockhäusern [Wright's comments on his cement block houses]" by de Fries; "Eine Bauweise in bewehrtem Beton an Neubauten von Frank Lloyd Wright [A reinforced concrete construction method in Wright's new buildings]" by Richard Neutra (reprinted in *Wie baut Amerika?* Stuttgart: Julius Hoffman, 1927); and excerpts from Berlage, "Neuere Amerikanische architektur," *Schweizerische Bauzeitung*, 60(14, 21 September 1912). Illustrations include pre-1909 work; and buildings and projects in Japan and California. Drawings of the Millard and Freeman houses, Doheny Ranch Resort and Tahoe Summer Colony are reproduced in color. Reviewed *Baumeister*, 25(April 1927), B50-51 (German); and "Literatura," *Styl*, 7(no. 2, 1926), 40 (Czechoslovakian).

153. Mendelsohn, Erich. *Amerika, Bilderbuch eines Architekten. Mit 77 photographischen Aufnahmen des Verfassers.* Berlin: R. Mosse, 1926. German: *America, architectural picture-book.* Enlarged and reprinted Berlin: 1928; and in facsimile, New York: Da Capo Press, 1976; reviewed Reyner Banham, *JSAH*, 38(October 1979), 300-301. Also republished Braunschweig: Vieweg, 1991. An English translation appeared as *Erich Mendelsohn's "Amerika": 82 photographs*, New York: Dover, 1993.

154. Oud, Jacobus Johannes Pieter. "Der Einfluss von Frank Lloyd Wright auf die Architektur Europas." In *Hollandische Architektur*, Munich: Albert Langen 1926. German: "Wright's influence on European architecture." Expanded edition, 1929. The essay is reprinted in Wend Fischer ed. *J.J.P.Oud: Bauten 1906-1963*, Munich: 1965.

First published in English in *Wendingen*, 7(1925), 85-91, and reprinted in Wijdeveld ed. *The life-work of the American architect Frank Lloyd Wright* (and subsequent editions).

For a Dutch translation see *Architectura*, 30(February 1926), 85-89, reprinted in Hans Ludwig C. Jaffé ed. *De Stijl, 1917-1931: the Dutch contribution to modern art*, Amsterdam: Meulenhoff, 1956; Karel Wiekart ed. *Ter wille van een levende bouwkunst*, The Hague: Nijgh and van Ditmar, 1962; and Oud, *Hollandse Architectuur*, Nijmegen: SUN, 1983. For a Polish translation, see "Wplyw Franka Wright'a na architekture europejska," *Architektura i Budownictwo*, (1933), 188-89. For Italian, see *Architettura Olandese*, Milan: Angeli, 1976; Rome: 1981. For Spanish, see *Mi trayectoria en "De Stijl"*, Murcia: Colegio Oficial de Aparejadores y Arquitectos Técnicos, 1986.

Reyner Banham, *The architecture of the well-tempered environment*, London: Architectural Press, 1969, challenges Oud's conclusions.

Periodicals

155. Badovici, Jean. "Frank Lloyd Wright." *Cahiers d'Art*, 1(February 1926), 30-33. Cf. *American Architect*, 136(December 1929), 53-54.

156. Mendelsohn, Erich. "Frank Lloyd Wright." *Wasmuths Monatshefte*, 10(no. 6, 1926), 244-46. See also Leo Adler, "F.L. Wrights neue baukunst und Mendelsohns neue logik [Wright's new architecture and Mendelsohn's new logic]," *ibid.*, (no. 7, 1926), 308-309.

157. Sörgel, Herman ed. "Ein internationaler Entwicklungsquerschnitt." *Baukunst*, 2(February 1926), 44-65. German: "A cross-section of international development." A rather odious comparison of Wright, Willem Marinus Dudok and Erich Mendelsohn includes "Bemerkungen zu Wright [Comments on Wright]" by Sörgel; "Frank Lloyd Wright" by Barry Byrne (translated by Sörgel); and "Besuch bei Wright [A visit with Wright]" by Mendelsohn.

158. Wright, Frank Lloyd. "An die europäischen Kollegen." *Werk*, 13(1926), 375, 377-80. "To the European colleagues."

1927
Books, monographs and catalogues
159. Anderson Galleries. *The Anderson Galleries...489 Park Avenue at Fifty-ninth Street, New York announce the sale by auction of the Frank Lloyd Wright collection of Japanese antique prints... .* New York: The Gallery, 1926. Includes excerpts from Wright's introduction to the catalogue, *The Frank Lloyd Wright collection of Japanese antique prints. Sale Number 2120 ...* The prints went on display 29 December 1926 and the auction, ordered by the Bank of Wisconsin, took place on 6-7 January 1927. Wright's introduction is reprinted in *The Japanese print; an interpretation*, New York: 1967; and in Pfeiffer ed. *Frank Lloyd Wright collected writings. Vol. 1*, New York: 1992.

See also "Auction reports," *Art News*, 25(15 January 1927), 12, for prices and the purchasers of important items; and *New York Times*, 7 January 1927, 19.

Periodicals
160. Dvorák, Vilém. "Úcel, konstruke a materiál v teorii moderni architektury." *Styl*, 7(1927), 207-214. Czechoslovakian: "Purpose, construction and materials in the theory of modern architecture."

161. Hilberseimer, Ludwig. "Internationale neue baukunst." *Moderne Bauformen*, 26(1927), 325-64. German: "New international architecture." Taliesin.

162. Rebori, Andrew N. "Frank Lloyd Wright's textile-block slab construction." *Architectural Record*, 62(December 1927), 448-56. Also reviews Wijdeveld ed. *The life-work of the American architect Frank Lloyd Wright*, Santpoort: 1925.

163. Rowell, Guy. "Arizona's new and distinctive hotel." *Progressive Arizona and the Great Southwest*, 7(November 1928), 21-22. Arizona-Biltmore hotel.

164. Vreeland, Francis William. "A new art center for the Pacific coast." *Arts and Decoration*, 28(November 1927), 64-65. Project for Aline Barnsdall.

165. Wright, Frank Lloyd. "In the cause of architecture. I: the architect and the machine." *Architectural Record*, 61(May 1927), 394-96. Reprinted Gutheim et al. eds. *In the cause of architecture, Frank Lloyd Wright*, New York: 1975 (reprinted 1987); and Pfeiffer ed. *Frank Lloyd Wright collected writings. Vol. 1*, New York: 1992. Published in anthology as *Per la causa dell'architettura*, Rome: Gangemi, 1989 (Italian).

166. Wright, Frank Lloyd. "In the cause of architecture. II: standardization, the soul of the machine." *Architectural Record*, 61(June 1927), 478-80. Reprinted Gutheim et al. eds. *In the cause of architecture, Frank Lloyd Wright, New* York: 1975 (reprinted 1987); and Pfeiffer ed. *Frank Lloyd Wright collected writings. Vol. 1*, New York: 1992. Published in anthology as *Per la causa dell'architettura*, Rome: Gangemi, 1989 (Italian).

167. Wright, Frank Lloyd. "In the cause of architecture. III: steel." *Architectural Record*, 62(August 1927), 163-66. Reprinted Gutheim et al. eds. *In the cause of architecture, Frank Lloyd Wright, New* York: 1975 (reprinted 1987); and Pfeiffer ed. *Frank Lloyd Wright collected writings. Vol. 1*, New York: 1992. Published in anthology as *Per la causa dell'architettura*, Rome: Gangemi, 1989 (Italian).

168. Wright, Frank Lloyd. "In the cause of architecture. IV: fabrication and imagination." *Architectural Record*, 62(October 1927), 318-21. Reprinted Gutheim et al. eds. *In the cause of architecture, Frank Lloyd Wright, New* York: 1975 (reprinted 1987); and Pfeiffer ed. *Frank Lloyd Wright collected writings. Vol. 1*, New York: 1992. Published in anthology as *Per la causa dell' architettura*, Rome: Gangemi, 1989 (Italian).

169. Wright, Frank Lloyd. "In the cause of architecture. V: the New World." *Architectural Record*, 62(October 1927), 322-24. Reprinted Gutheim et al. eds. *In the cause of architecture, Frank Lloyd Wright, New* York: 1975 (reprinted 1987); and Pfeiffer ed. *Frank Lloyd Wright collected writings. Vol. 1*, New York: 1992. Published in anthology as *Per la causa dell'architettura*, Rome: Gangemi, 1989 (Italian).

170. *Cahiers d'Art*. "Etats-Unis." 2(1927), 12. French: "The U.S.A."

171. *Cahiers d'Art*. "Frank Lloyd Wright." 2(1927), 322-28. Images only, later used to illustrate Hitchcock, *Frank Lloyd Wright*. Paris: 1928.

172. *L'Architecture Vivante*, (Autumn-Winter 1927), pl. 31. Millard house; image only.

1928
Books, monographs and catalogues
173. Frankl, Paul Theodore. *New dimensions: the decorative arts of today in words and pictures*, New York: Payson and Clarke, 1928. The book is dedicated to Wright, and has a foreword by him.

174. Hitchcock, Henry-Russell Jr. and André Lurcat. *Frank Lloyd Wright*. Paris: Cahiers d'Art, 1928. French. Mostly a photographic study (in the series *Les maîtres de l'architecture contemporaine*), this includes work 1902-1923. Reviewed Lewis Mumford, "Frank Lloyd Wright and the new pioneers," *Architectural Record*, 65(April 1929), 414-16. The brief text is reprinted in Hitchcock, *Modern architecture: romanticism and reintegration*, New York: 1929 and subsequent editions.

Periodicals
175. Haskell, Douglas. "Organic architecture; Frank Lloyd Wright." *Creative Art*, 3(November 1928), 51-57.

176. Hitchcock, Henry-Russell Jr. "Modern architecture I: the traditionalists and the new tradition." *Architectural Record*, 63(April 1928), 337-349.

177. Mumford, Lewis. "American Architecture today, II." *Architecture*, 62(June 1929), 301-308.

178. Wright, Frank Lloyd. "Fiske Kimball's new book: a review." *Architectural Record*, 64(August 1928), 172-73. Review of (Sidney) Fiske Kimball, *American Architecture*, Indianapolis; New York: Bobbs-Merrill, 1928 (reprinted New York: AMS Press, 1970). Wright's review is reprinted in Pfeiffer ed. *Frank Lloyd Wright collected writings. Vol. 1*, New York: 1992. See also "American architecture: correspondence of Walter Pach, Paul Cret, Frank Lloyd Wright and Erich Mendelsohn with Fiske Kimball," *ibid.*, 65(May 1929), 431-34, which includes Wright's 30 April 1928 statement and Kimball's response.

179. Wright, Frank Lloyd. "In the cause of architecture, I. The logic of the plan." *Architectural Record*, 63(January 1928), 49-57. Partially reprinted in Kaufmann and Raeburn eds. *Frank Lloyd Wright: writings and buildings*, New York: 1960; and in full in Gutheim ed. Frank *Lloyd Wright on architecture*, New York: 1941; Gutheim et al. eds. *In the cause of architecture, Frank Lloyd Wright, New* York: 1975 (reprinted 1987); and in Pfeiffer ed. *Frank Lloyd Wright collected writings. Vol. 1*, New York: 1992. Published in anthology as *Per la causa dell'architettura*, Rome: Gangemi, 1989 (Italian).

180. Wright, Frank Lloyd. "In the cause of architecture, II: what 'styles' mean to the architect." *Architectural Record*, 63(February 1928), 145-51. Partially

reprinted in Kaufmann and Raeburn eds. *Frank Lloyd Wright: writings and buildings*, New York: 1960; and in full in Gutheim ed. *Frank Lloyd Wright on architecture*, New York: 1941; Gutheim et al. eds. *In the cause of architecture, Frank Lloyd Wright, New* York: 1975 (reprinted 1987); and in Pfeiffer ed. *Frank Lloyd Wright collected writings. Vol. 1*, New York: 1992. Published in anthology as *Per la causa dell'architettura*, Rome: Gangemi, 1989 (Italian).

181. Wright, Frank Lloyd. "In the cause of architecture, III: the meaning of materials—stone." *Architectural Record*, 63(April 1928), 350-56. Partially reprinted in Kaufmann and Raeburn eds. *Frank Lloyd Wright: writings and buildings*, New York: 1960; and in full in Gutheim ed. *Frank Lloyd Wright on architecture*, New York: 1941; Gutheim et al. eds. *In the cause of architecture, Frank Lloyd Wright, New* York: 1975 (reprinted 1987); and in Pfeiffer ed. *Frank Lloyd Wright collected writings. Vol. 1*, New York: 1992. Published in anthology as *Per la causa dell'architettura*, Rome: Gangemi, 1989 (Italian).

182. Wright, Frank Lloyd. "In the cause of architecture, IV: the meaning of materials—wood." *Architectural Record*, 63(May 1928), 481-88. Partially reprinted in Kaufmann and Raeburn eds. *Frank Lloyd Wright: writings and buildings*, New York: 1960; and in full in Gutheim ed. *Frank Lloyd Wright on architecture*, New York: 1941; Gutheim et al. eds. *In the cause of architecture, Frank Lloyd Wright, New* York: 1975 (reprinted 1987); and in Pfeiffer ed. *Frank Lloyd Wright collected writings. Vol. 1*, New York: 1992. Published in anthology as *Per la causa dell'architettura*, Rome: Gangemi, 1989 (Italian).

183. Wright, Frank Lloyd. "In the cause of architecture, V: the meaning of materials—the kiln." *Architectural Record*, 63(June 1928), 555-61. Reprinted in Gutheim ed. *Frank Lloyd Wright on architecture*, New York: 1941; Gutheim et al. eds. *In the cause of architecture, Frank Lloyd Wright, New* York: 1975 (reprinted 1987); and in Pfeiffer ed. *Frank Lloyd Wright collected writings. Vol. 1*, New York: 1992. Published in anthology as *Per la causa dell'architettura*, Rome: Gangemi, 1989 (Italian).

184. Wright, Frank Lloyd. "In the cause of architecture, VI: the meaning of materials—glass." *Architectural Record*, 64(July 1928), 10-16. Reprinted in Gutheim ed. *Frank Lloyd Wright on architecture*, New York: 1941; Gutheim et al. eds. *In the cause of architecture, Frank Lloyd Wright, New* York: 1975 (reprinted 1987); and in Pfeiffer ed. *Frank Lloyd Wright collected writings. Vol. 1*, New York: 1992. Published in anthology as *Per la causa dell'architettura*, Rome: Gangemi, 1989 (Italian).

185. Wright, Frank Lloyd. "In the cause of architecture, VII: the meaning of materials—concrete." *Architectural Record*, 64(August 1928), 98-104. Partially reprinted in Kaufmann and Raeburn eds. *Frank Lloyd Wright: writings and buildings*, New York: 1960; and in full in Gutheim ed. *Frank Lloyd Wright on architecture*, New York: 1941; Gutheim et al. eds. *In the cause of architecture, Frank Lloyd Wright, New* York: 1975 (reprinted 1987); and in Pfeiffer ed. *Frank Lloyd Wright collected writings. Vol. 1*, New York: 1992. Published in anthology as *Per la causa dell'architettura*, Rome: Gangemi, 1989 (Italian).

186. Wright, Frank Lloyd. "In the cause of architecture, VIII: sheet metal and a modern instance." *Architectural Record*, 64(October 1928), 334-42. Partially reprinted in Kaufmann and Raeburn eds. *Frank Lloyd Wright: writings and buildings*, New York: 1960; and in full in Gutheim ed. *Frank Lloyd Wright on architecture*, New York: 1941; Gutheim et al. eds. *In the cause of architecture, Frank Lloyd Wright, New* York: 1975 (reprinted 1987); and in Pfeiffer ed. *Frank Lloyd Wright collected writings. Vol. 1*, New York: 1992. Published in anthology as *Per la causa dell'architettura*, Rome: Gangemi, 1989 (Italian).

187. Wright, Frank Lloyd. "In the cause of architecture, IX: the terms." *Architectural Record*, 64(December 1928), 507-514. Reprinted in Gutheim ed. *Frank Lloyd Wright on architecture*, New York: 1941; Gutheim et al. eds. *In the cause of architecture, Frank Lloyd Wright, New* York: 1975 (reprinted 1987); and in Pfeiffer ed. *Frank Lloyd Wright collected writings. Vol. 1*, New York: 1992. Published in anthology as *Per la causa dell'architettura*, Rome: Gangemi, 1989 (Italian).

188. Wright, Frank Lloyd. "Towards a new architecture." *World Unity*, 2(September 1928), 393-95. Review of Le Corbusier, *Towards a new architecture.* New York: Payson and Clarke, 1927. Reprinted in Pfeiffer ed. *Frank Lloyd Wright collected writings. Vol. 1*, New York: 1992.

1929
Books, monographs and catalogues
189. Hitchcock, Henry Russell Jr. *Modern architecture; romanticism and reintegration.* New York: Payson and Clarke, 1929. Reprints text of *idem.*, *Frank Lloyd Wright*, Paris: 1928. Reprinted New York: Hacker Art Books, 1970 and again *as Modern architecture; romanticism and reintegration. New York, Payson and Clarke, 1929*, New York: AMS Press, 1972. New edition, New York: Da Capo, 1993. For comment see Paolo Scrivano, "Hitchcock's humanism: some notes on two seminal books," *Design Book Review*, (Winter-Spring 2000), 80-83.
 Cf. *idem.*, "Modern architecture, I-II." *Architectural Record*, 63(April 1928), 337-49 ; (May 1928), 452-60.

190. Onderdonk, Francis S. Jr. *The ferro-concrete style. Reinforced concrete in modern architecture.* New York: Architectural Book Publishing, 1929. Unity Temple, Midway Gardens, Ennis, Freeman and Millard houses.

Periodicals
191. Drought, Jim and Wortley Munroe. "Not without honor." *Wisconsin Literary Magazine*, 28(February 1929), 14-19. The authors' real names are Frederick L. Jochern and Frederick A. Gutheim, editor of the journal.

192. Hegemann, Werner. "Bemerkungen, Baumeister, I, Frank Lloyd Wright." *Die Weltbühne*, 25(25 June 1929), 982. German: "Remarks on master architect Frank Lloyd Wright." See Erich Mendelsohn, "Frank Lloyd Wright und seine historische bedeutung [Frank Lloyd Wright and his historical significance]," *Das*

Neue Berlin, 4(September 1929), 180-81.

193. J.Z., "Ontwerp van een skyscraper van Frank Lloyd Wright." *Bouwkundig Weekblad*, 49(1929), 297-300. Dutch: "Design for a skyscraper by Wright." St. Mark's-in-the-Bouwerie tower (project).

194. Scharfe, Siegfried. "Theorie und praxis bei Frank Lloyd Wright." *Wasmuths Monatshefte*, 13(August 1929), 331-32. German: "Theory and practice [in the work] of Wright"

195. Wright, Frank Lloyd. "A building adventure in modernisrn. A successful adventure in concrete." *Country Life*, 56(May 1929), 40-41. Millard house. Reprinted in *An autobiography*, 1932.

196. Wright, Frank Lloyd. "The limits of our skyscraping." *NYT Magazine*, (17 November 1929).

197. Wright, Frank Lloyd. "Surface and mass—again!" *Architectural Record*, 64(July 1929), 92-94. Reprinted in part in Kaufmann and Raeburn eds. Frank *Lloyd Wright: writings and buildings*, New York: 1960; and in full in Gutheim ed. *Frank Lloyd Wright on architecture*, New York: 1941.

198. Wright, Frank Lloyd. "Taliesin: the chronicle of a house with a heart." *Liberty*, 6(23 March 1929), 21-22, 24, 26-29. Reprinted as a booklet.

199. Wright, Frank Lloyd. "Über das Blech in der Baukunst." *Wasmuths Monatshefte*, 13(August 1929), 333-41. German: "About metal in architecture." Translation of "In the cause of architecture, VIII: sheet metal and a modern instance," *Architectural Record*, 64(October 1928).

200. *Architectural Forum*. [Photo-essay on Arizona-Biltmore Hotel]. 51(December 1929), 655-59.

201. *Architectural Record*. "The Arizona-Biltmore Hotel, Phoenix, Arizona. Albert Chase McArthur, architect." 66(July 1929), 19-55.

202. *Outlook and Independent*. "Modern pyramids." 153(30 October 1929), 336. St. Mark's-in-the-Bouwerie tower. See also "Wright's pyramids," *Time*, 14(28 October 1929), 62 and "What architects are talking about" *American Architect*, 136(December 1929), 53-54.

203. *Time*. "Genius, Inc." 14(7 October 1929), 45-46.

1930-1939

1930
Books, monographs and catalogues
204. Delftschen Bouwkundigen Studiekring. *Jaarboek van den Delftschen Bouwkundigen Studiekring*. Delft: 1930. Dutch. This yearbook of the Delft Building Industry Study Circle has a mimeographed supplement, "Frank Lloyd Wright."

Periodicals
205. Badovici, Jean. "Frank Lloyd Wright." *L'Architecture Vivante*, 8(Summer 1930), 49-76, pls. 26-50. Reprinted as a booklet, *idem*. ed. *Frank Lloyd Wright: architecte américain*. Paris: Morance, 1932.

206. Boyd, John Taylor Jr. "A prophet of the new architecture: an interview with Frank Lloyd Wright." *Arts and Decoration*, 33(May 1930), 56-59, 100 ff.

207. Brock, H. I. "A pioneer in architecture that is called modern." *NYT Magazine*, (29 June 1930), 11, 19.

208. Fries, Heissenrich de. "Neue Pläne von Frank Lloyd Wright" *Die Form*, 5 (July 1930), 342-43. German: "New plans from Frank Lloyd Wright." Includes an essay: [Modern concepts concerning an organic architecture from the work of Wright], and illustrates San Marcos and St. Marks-in-the-Bouwerie projects.

209. Haskell, Douglas. "Frank L. Wright and the Chicago Fair." *Nation*, 131(3 December 1930), 605. Comment on Wright's exclusion from the imminent 1933-34 "Century of Progress" Chicago World's Fair. Cf. Lewis Mumford, "Two Chicago fairs," *New Republic*, 65(21 January 1931), 271-72; Henry Stern Churchill, "Wright and the Chicago fair," *New Republic*, 65(4 February 1931), 329; "Wrightites v. Chicago," *Time*, 17(9 March 1931), 63-64; and "American architect," *Outlook and Independent*, 162(11 March 1931), 358.

Wright joined the public debate. See his "All's fair, as the architects view the lake front," *Chicagoan*, 11(23 May 1931), 12 and "Another pseudo," *Architectural Forum*, 59(July 1933), 25 (both reprinted in Pfeiffer ed. *Frank Lloyd Wright collected writings. Vol. 3*, New York: 1993). See also "Wright's rival fair," *Architectural Forum*, 58(April 1933), commenting on his threat to build a glass and steel tower facing the "Century of Progress" fair's main entrance.

210. Lønberg-Holm, Knud. "The weekend home." *Architectural Record*, 68(August 1930), 177-92. See especially "Desert camp for Frank Lloyd Wright, Arizona. Frank Lloyd Wright, architect", 188-91.

211. Scharfe, Siegfried. "Wright's naturalismus." *Wasmuths Monatshefte*, 14(January 1930), 34-36. German: "Wright's naturalism."

212. Voynow, Romola. "Chicagoans, truth against the world?" *Chicagoan*, 8(15 March 1930), 21-22, 24, 26-27.

213. Woollcott, Alexander. "The prodigal father." *New Yorker*, 6(19 July 1930), 22-25. Condensed in *Reader's Digest*, 17(September 1930), 388-90 and reprinted in *idem.*, *While Rome Burns*, New York: Viking, 1934 (also 1935 and reprinted Grosset and Dunlap, 1936).

214. Wright, Frank Lloyd. "Beton." *Wasmuths Monatshefte*, 14(January 1930), 35-42. German: "Concrete." Translated from *Architectural Record*, 64(August 1928).

215. Wright, Frank Lloyd. "Architecture as a profession is all wrong." *American Architect*, 138(December 1930), 22-23, 84, 86, 88. Reprinted in Pfeiffer ed. *Frank Lloyd Wright collected writings. Vol. 1*, New York: 1992. An earlier draft is reprinted in Gutheim ed. *Frank Lloyd Wright on architecture*, New York: 1941.

216. Wright, Frank Lloyd. "Glas." *Wasmuths Monatshefte*, 14(March 1930), 135-38. German: "Glass." Translated from *Architectural Record*, 64(July 1928).

217. Wright, Frank Lloyd. "In order to be modern." *Architectural Progress*, 3(December 1930), 6-7. Reprinted in Pfeiffer ed. *Frank Lloyd Wright collected writings. Vol. 1*, New York: 1992.

218. Wright, Frank Lloyd. "The logic of contemporary architecture as an expression of this age." *Architectural Forum*, 52(May 1930), 637-38. Reissued as a booklet. Reprinted in Gutheim ed. *Frank Lloyd Wright on architecture*, New York: 1941.

219. Wright, Frank Lloyd. "Why I love Wisconsin." *Industrial Wisconsin* (1930). Reprinted in Gutheim ed. *Frank Lloyd Wright on architecture*, New York: 1941; Pfeiffer ed. *Frank Lloyd Wright collected writings. Vol. 3*, New York: 1993; and *Frank Lloyd Wright Quarterly*, 8(Spring 1997), 4-7.

220. *Architectural Forum*. "Frank Lloyd Wright and Hugh Ferriss discuss this modern architecture." 53(November 1930), 535-38. Transcript of radio broad-

cast in connection with the Contempora exhibition, New York.

221. *Architectural Record.* "St. Mark's Tower; St. Mark's-in-the-Bouwerie, New York City." 67(January 1930), 1-4. Includes color images.

222. *Wasmuths Monatshefte.* "Zwei kleine wolkenkratzer." 14(June 1930), 281-83. German: "Two small skyscrapers." Apartment houses in New York (projects).

223. *Western Architect.* "Frank Lloyd Wright to the fore!" 39(September 1930), 152. Reviews a traveling exhibition—Wright called it "The Show"—of 600 photographs, 1000 drawings and four models of Wright's work, mounted in New York City before moving to Chicago (reviewed in Dutch, *Bouwkundig Weekblad*, 51[1930], 408); Eugene, Oregon; Seattle; and then to several European centers. On return to the USA it again appeared in Milwaukee's Layton Gallery. Cf. "Wright's time," *Time*, 15(9 June 1930), 30.

1931
Books, monographs and catalogues
224. Wright, Frank Lloyd. *The Hillside Home School of the Allied Arts: why we want this school.* Spring Green: Frank Lloyd Wright, 1931. Prospectus dated October 1931. Reprinted in Pfeiffer ed. *Frank Lloyd Wright collected writings. Vol. 3*, New York: 1993.

225. Wright, Frank Lloyd. *Modern architecture, being the Kahn lectures for 1930.* Princeton University Press, 1931. Related to an exhibition at the Architectural League of New York, this comprises the text of lectures delivered at Princeton in 1930: "Machinery, materials and men"; "Style in industry"; "The passing of the cornice"; "The cardboard house"; "The tyranny of the skyscraper"; and "The city" (reprinted *Architectural Progress*, 5[October 1931], 4-6, 23; and [November 1931], 12-15).

Reviewed Talbot Faulkner Hamlin, "Living for the beautiful," *Outlook and Independent*, 162(29 April 1931), 598-99 and "Artist and prophet," *Saturday Review of Literature*, 7(11 July 1931), 957; *Architectural Forum*, 54(May 1931), supp. 15; *Parnassus*, 3(May 1931), 38-39; "Tyranny of the skyscraper," *NYTBR*, (31 May 1931), 1, 28; Catherine Bauer, "The 'exuberant and romantic' genius of ... Wright," *New Republic*, 67(8 July 1931), 214-15; John Irwin Bright, *American Magazine of Art*, 23(August 1931), 170-72; *Kunst und Kunstler*, 29(August 1931), 439 (German); *Landscape Architecture*, 22(October 1931), 77-78; Harvey Watts, "Don Quixote: atilt at his world," *T-Square Club Journal*, 1(November 1931), 14, 34-35 (see response by Yuan-Hsi Kuo, *ibid.*, 2[January 1932], 30-31); Irving F. Morrow, "A modern prophet," *California Arts and Architecture*, 40(November 1931), 42; and *Studio*, 105(January 1933), 59.

A British edition was published by Oxford University Press, 1931. Excerpts are translated into Czechoslovakian as "O mestu budouchosti [City of the future]," *Styl*, 16(no. 6, 1931), 93-98, and into German as "Frank Lloyd Wright über die Stadt der Zukunft [Wright on the future city]," *Baugilde*, (no. 14, 1931),

1156-57. Also published in full in Italian as *Architettura e democrazia*, Milan: Rosa e Ballo, 1945.

Partially reprinted in Kaufmann and Raeburn eds. Frank *Lloyd Wright: writings and buildings*, New York: 1960. Reprinted as *Modern architecture: being the Kahn lectures for 1930*, Carbondale: Southern Illinois University Press, 1987 and reviewed Robert Twombly, "Word glut: marketing Frank Lloyd Wright," *Design Book Review*, (Spring 1990), 61-65. The lectures are reprinted in full in Wright, *The future of architecture*, New York: 1953 and in Pfeiffer ed. *Frank Lloyd Wright collected writings. Vol. 2*, New York: 1993.

226. Wright, Frank Lloyd. *Two lectures on architecture*. Chicago: Art Institute, 1931. Comprises the texts of the Scammon Lectures, "In the realm of ideas" and "To the young man in architecture" delivered at the Art Institute, 1 and 2 October 1930, in conjunction with a September-October season of "The Show". The forthcoming exhibit is announced in *Bulletin of the Art Institute of Chicago*, (30 May 1930), 80; the lectures are announced in *ibid.*, 24(October 1930), 91. For a review see "Chicago," *Art News*, 29(4 October 1930), 24; Howard Robertson, "Frank Lloyd Wright lectures at the Art Institute of Chicago," *Architect and Building News*, 128(16 October 1931), 62-63; and Dimitri Tselos, *Art in America*, 29(January 1931), 42-43.

"To the young man in architecture" is reprinted in *Architectural Record*, 70(August 1931), 121, and in Gutheim ed. *Frank Lloyd Wright on architecture*, New York: 1941. Both lectures are reprinted in Wright, *The future of architecture*, New York: 1953 and in Pfeiffer ed. *Frank Lloyd Wright collected writings. Vol. 2*, New York: 1993.

Periodicals

227. Bauer, Catherine. "The Americanization of Europe." *New Republic*, 67(24 June 1931), 153-54. Wright's influence.

228. Goff, Bruce. "Frank Lloyd Wright, architect, 1931: the Richard Lloyd Jones house, Tulsa." *Tulsart*, (1 August 1931), 7.

229. Wijdeveld, Hendikus Theodore. "Architect Frank Lloyd Wright naar Europa. Een tentoonstelling van zijn werk te Amsterdam." *Bouwkundig Weekblad*, 52(1931), 117. Dutch: "Wright in Europe. An exhibition of his work in Amsterdam." As well as an announcement of the opening of "The Show" at Amsterdam's Stedelijk Museum, the issue includes Dutch translations of three previously unpublished Wright essays: "Technique and imagination"; "The New World" and "The architect and the machine."

For reviews see *Bouwkundig Weekblad*, 52(9 May 1931), 174; Jan Boterenbrood, *ibid.*, 52(23 May 1931), 196-97; and W. Jos. de Gruyter, *Elsevier's Geïllustreerd Maandschrift*, 82(August 1931), 145-47, pl. 27 (all in Dutch).

Under Erich Mendelsohn's guidance, it was also mounted at the Prussian Academy of Arts in Berlin, before moving to Stuttgart and Frankfurt. Reviewed *Art Digest*, 5(1 July 1931), 12; *Bauwelt*, 22(2 July 1931), 914 (German); Siegfried Scharfe, *Baugilde*, 13(25 July 1931), 1164-71, 1190 (German); F.

Turkel-Deri, "Models by Frank Lloyd Wright in Berlin exhibition," *Art News*, 29(15 August 1931), 16; Dora Landau, "An American architect exhibits in Berlin," *American Magazine of Art*, 23(August 1931), 165; Paul F. Schmidt, "Gröse und niedergang eines Balinbrechers der modernen Architektur [Gretness and fall of a crusher of modern architecture]," *Baukunst*, 7(August 1931), 278-79 (German); Harry Adsit Bull, *Studio*, 99(August 1931), 54; and *Kunst und Kunstler*, 29(August 1931), 439 (German).

"The Show" remained in Europe for about nine months; after Germany it was mounted at the *Palais des Beaux Arts*, Brussels and Antwerp; for French language reviews see J. Moutschen, "Souvenirs sur Frank Lloyd Wright," *Cité et Tekhne*, 10(November 1931), 41-43; and Marcel Schmitz, "L'oeuvre de Frank Lloyd Wright," *ibid.*, 43. Following a brief showing in Rotterdam the exhibit returned to Spring Green before mid-February 1932. It is also reviewed in Japanese in *Kokusai-Kenchiku*, 7(August 1931), 1.

230. Wright, Frank Lloyd. "American architecture today." *Weekly Bulletin of the Michigan Society of Architects*, (14, 21 July 1931). Text of speech at the Society's annual convention. Reprinted in Gutheim ed. *Frank Lloyd Wright on architecture*, New York: 1941; and Pfeiffer ed. *Frank Lloyd Wright collected writings. Vol. 3*, New York: 1993. Cf. Wright, "Highlights," *Architectural Forum*, 55(October 1931), 409-10.

231. Wright, Frank Lloyd. "Die mechanisierung und die materialien." *Die Form*, 6(September 1931), 341-49. German: "Mechanization and materials." This is a translated, expanded version of "The architect and the machine," from *Bouwkundig Weekblad*, 52(1931). See also Wilhelm Lotz, "Unter der Lupe, Frank Lloyd Wright und die Kritik [Under the magnifying glass, Wright and the critics]," *ibid.*, 356-58.

232. Wright, Frank Lloyd. "Eclecticism by way of 'taste' is America's substitute for culture." *Inland Topics*, 2(May 1931), 19.

233. Wright, Frank Lloyd. "The man who grew whiskers." *New Freeman*, 3(25 March 1931), 38-39. Reprinted in Pfeiffer ed. *Frank Lloyd Wright collected writings. Vol. 3*, New York: 1993.

234. Wright, Frank Lloyd. "Principles of design." *Annual of American Design*, (1931), 101-104.

235. Wright, Frank Lloyd. "To the young architect in America." *Architects' Journal*, 74(8 July 1931), 48-50. Reprinted from *Modern architecture*, Princeton: 1931. Cf. *idem.*, "Advice to the young architect," *Architectural Record*, 70(August 1931), 121.

236. Wright, Frank Lloyd. "The tyranny of the skyscraper." *Creative Art*, 8(May 1931), 324-32. Reprinted from *Modern architecture*, Princeton: 1931. See comment in "Skyscrapers," *Nation*, 133(30 September 1931), 324. For Wright's

subsequent comment see "Wright's prophesy," *Art Digest*, 6(1 February 1932), 8 (reprints an interview with S.J. Woolf, *New York Times*, [17 January 1932]).

237. *Advertising and Selling*. "We pause to honor." 17(July 1931), sup. 40.

238. *Progressive Arizona and the Great Southwest*. "The Arizona-Biltmore's new swimming pool" and "The Arizona-Biltmore's new pueblo stables." 9(July 1931), 6-11.

239. *Art Digest*. "Wright on a jury." 6(1 October 1931), 18. Wright visited Rio de Janeiro as guest of the Pan American Union to judge the design competition for the Columbus Memorial Lighthouse, Santo Domingo.

1932
Books, monographs and catalogues
240. Arkin, David. *Arkhitektura sovremennogo zapada: Le Korbiuz'e, Bruno Taut, V. Gropius, I.P. Aud, Frank Reit, L. G'ilberseimer, i drugie.* Moscow: Izogiz, 1932. Russian: *Modern Western Architecture. Le Corbusier, Bruno Taut, Walter Gropius, J.J.P. Oud, Frank Lloyd Wright, Ludwig Hilbersheimer, and others*. Title also in French, German, and English.

241. Hitchcock, Henry-Russell Jr. "Frank Lloyd Wright." In Alfred Hamilton Barr Jr., Hitchcock, Philip Cortelyou Johnson and Lewis Mumford, *Modern architecture*. New York: Museum of Modern Art; London: George Allen and Unwin, 1932. See also "Historical note by Philip Johnson" and "Extent of modern architecture" by Hitchcock. This catalog of an exhibition at the Museum, February-March 1932, and then in other US museums and institutions is also published as *Modern architects*, New York: The Museum; Norton, 1932. The only variation between the US editions occurs on the title page and in the colophon. Reprinted in *Museum of Modern Art Reprints* series, New York, 1980.

242. Wright, Frank Lloyd. *An autobiography*. London, New York; Toronto: Longmans Green, 1932. This edition is reviewed George Howe, "Creation and criticism," *Shelter*, 2(April 1932), 27; Amy Loveman, *Saturday Review of Literature*, 8(April 16, 1932), 667; Sheldon Cheney, "A prophetic artist," *Saturday Review of Literature*, 8(23 April 1932), 677-78; Susan Wilbur, "The life of Frank Lloyd Wright," *Chicagoan*, 12(April 1932), 52; "The autobiography of a fighting architect," *NYTBR*, (3 April 1932), 4; *Architectural Forum*, 56(May 1932), sup. 32; (Sidney) Fiske Kimball, "Builder and poet—Frank Lloyd Wright," *Architectural Record*, 71(June 1932), 379-80; *American Architect*, 141(June 1932), 6; *Wisconsin Library Bulletin*, 28(May 1932), 163; John Wheelwright, "Truth against the world," *New Republic*, 71(29 June 1932), 186; Samuel Gaillard Stoney, "Portrait of an artist as prophet," *Virginia Quarterly Review*, 8(July 1932), 435-38; Frederick Gutheim, "An autobiography: from generation to generation," *American Modern Arts*, 25(July 1932), 72-73; *Pittsburgh Monthly Bulletin*, 37(July 1932), 50; Louise Phelps Kellogg, *Wisconsin Magazine of History*, 16(September 1932), 117; *Pratt*, (Autumn 1932), 40.

Partially reprinted in Kaufmann and Raeburn eds. Frank *Lloyd Wright: writings and buildings*, New York: 1960; and Pfeiffer ed. *Frank Lloyd Wright collected writings. Vol. 2*, New York: 1993.

Excerpts are published in "Recollections: United States, 1893-1920," *Architects' Journal*, 84(16, 23 and 30 July 1936), 76-78, 111-12, 141-42; (6 August), 173-74. For other comment on the first edition, see Robert Bingham Downs, "Master builder: Frank Lloyd Wright's autobiography, 1932," in *Famous American books*, New York: McGraw-Hill, 1971.

A partially rewritten, expanded edition was published New York: Duell, Sloan and Pearce; London: Faber and Faber, 1943 (reprinted in its entirety in Pfeiffer ed. *Frank Lloyd Wright: collected writings. Vol. 4*, New York: 1994). Between Summer 1943 and Spring 1944 Wright privately published *An autobiography, book six: Broadacre City*, intended for, but not used in, the 1943 edition. The 1943 edition is reviewed: Rice Estes, *Library Journal*, 68(May 1943), 363; Clifton Fadiman, *New Yorker*, 19(22 May 1943), 70; J.N. North, *Book Week*, (6 June 1943), 7; *Booklist*, 39(15 June 1943), 431; Barry Byrne, *America*, 69(19 June 1943), 305; Elisabeth Coit, *Architectural Record*, 94(July 1943), 26 ff.; Henry Stern Churchill, *New Republic*, 109(19 July 1943), 84; *Wisconsin Library Bulletin*, 39(July 1943), 107; *Architectural Forum*, 79(September 1943), 120 ff.; Catherine Bauer, *Survey Graphic*, 32(November 1943), 461; Talbot Faulkner Hamlin, *Wisconsin Magazine of History*, 27(December 1943), 227-29; and Sara Rossi, *L'Architettura*, 9(December 1943), 647 (Italian).

Also published London: Hyperion Press, 1945; reviewed "Ego by Frank Lloyd Wright," *Architects' Journal*, 103(2 May 1946), 336-37; *Studio*, 131(May 1946), 160; John Pinckheard, *RIBA Journal*, 53(June 1946), 355; Herbert Read, *Architectural Review*, 100(July 1946), 29; Victor Rienaecker, "The philosophy of an architect," *Apollo*, 43(June 1946), 137-39 and 44(July 1946), 7-9, 22; and Nikolaus Pevsner, *Burlington Magazine*, 89(June 1947), 169.

A further revision, probably the least reliable, was published in 1977 by Horizon, New York. Of course, any editing by Wright must precede 1959. It is reviewed Paul Goldberger, "He had an answer for everything," *NYTBR*, (19 June 1977), 13, 43; *AIA Journal*, 66(July 1977), 90; G.K. Rensch, *Library Journal*, 102(July 1977), 1485; *Choice*, 14(October 1977), 1037; Donald Hoffmann, *JSAH*, (December 1977), 268-69; and Martin Filler, "Writing on Wright," *Art in America*, 67(October 1979), 77-79. See also Filler, "Lives of the modern architects," *New Republic*, (21 June 1999), 32-38.

Also published in French as *Mon autobiographie*, Paris: Librairie Plon, 1955. Published in Italian as *Io e l'architettura* [*Me and architecture*], Milan: Mondadori, 1955, revised as Maria Antonietta Crippa and Marina Loffi Randolin eds. *Frank Lloyd Wright: una autobiografia*, Milan: Jaca, 1985; reprinted 1998. For an Italian and English review of the revised Italian edition see *Spazio e Societa*, 9(June 1986), 77-78. Published in Spanish as *Autobiografía*, Madrid: El Croquis, 1998; reviewed Manuel Lopez Blazquez, *Diseño Interio*, no. 80(1998), 54-55; (Spanish); Francoise Harmel, *L'Architecture d'Aujourdhui*, 322(May 1999), 12 (French); and Antonio Fernández Alba, "Cantos wrightianos

[Songs of Wright]," *Astragalo*, (May 1999), 97-99 (Spanish; English summary).

See also Linn Ann Cowles, *An index and guide to* An autobiography, *the 1943 edition by Frank Lloyd Wright*, Hopkins: Greenwich Design, 1976.

243. Wright, Frank Lloyd. *The disappearing city.* New York: W.F. Payson, 1932. Reviewed *Saturday Review of Literature*, 9(1 October 1932), 149; *Books*, (6 November 1932), 13; Walter R. Agard, *American Modern Art*, 25(December 1932), 364; Henry Stern Churchill, *Architectural Record*, 73(January 1933), 12, 14; Douglas Haskell, *Creative Art*, 12(January 1933), 63; Catherine Bauer, "When is a house not a house?" *Nation*, 136(25 June 1933), 99-100; and *Plan It (Portland Oregon City Planning Commission)*, 8(December 1934), 3. The text is reprinted in Pfeiffer ed. *Frank Lloyd Wright collected writings. Vol. 3*, New York: 1993.

Revised and enlarged as *When democracy builds*, University of Chicago Press, 1945 (reprinted 1947, 1951). Reviewed Ely Jacques Kahn, "Realistic dreams for tomorrow," *Saturday Review of Literature*, 28 (19 May 1945), 26; *Architectural Record*, 97(May 1945), 120; Lawrence E. Mawn, *Arts and Architecture*, 62(June 1945), 14, 44 ff.; *Architectural Forum*, 83(July 1945), 156 ff.; *Liturgical Arts*, 13(August 1945), 86; Thomas H. Creighton, *Pencil Points*, 26(September 1945), 118 ff.; Arthur C. Comey, *Landscape Architecture*, 36(October 1945), 38-39; *Design*, 47(January 1946), 24; Adrian Ashton, *Building and Engineering* [Australia], (25 February 1946), 17-19 (same as *Architecture*, [January-March 1946], 281-83); Paul Zucker, *Journal of Aesthetics and Art Criticism*, 4(March 1946), 196; *Connoisseur*, 117(March 1946), 61; John Pinckheard, *RIBA Journal*, 53(June 1946), 355; Talbot Faulkner Hamlin, *Gazette des Beaux Arts*, 30(September 1946), 187; Elizabeth McCausland, *Magazine of Art*, 39(December 1946), 385-86; and Eric Russell Bentley, *Kenyon Review*, (Winter 1946), 160-63.

Also published in Britain by Cambridge University Press, 1945; reviewed *Studio*, 130(October 1945), 128. A German version appeared as *Usonien: when democracy builds,* Berlin: Gebr. Mann, 1950.

The foreword is reprinted as "On an architecture for democracy," *A Taliesin Square-paper: a nonpolitical voice from our democratic minority*, (25 January 1951), to coincide with the preview of Wright's "Sixty Years of Living Architecture" exhibition in Gimbel Brothers department store, Philadelphia.

A further version is *The living city*, New York: Horizon, 1958 (also in a popular edition). The original was revised and enlarged as *The industrial revolution runs away*, New York: Horizon, 1969, with a note: "facsimile of Frank Lloyd Wright's copy of the original 1932 edition of *The disappearing city* as subsequently revised in his hand [and including] the new text complete with his revisions on facing pages". Reviewed Masami Tanigawa, *Japan Architects Association Northeast Area Research Reports*, (October 1971), unp. (Japanese).

Periodicals
244. Duiker, Johannes. "Frank Lloyd Wrights manifesto." *De 8 en Opbouw*, 1(1932), 177-84. Dutch. The editorial cites and comments upon Wright's response to German criticism of the 1931 traveling exhibition, and a reply from

Sigfried Giedion, "Les problémes actuels de l'architecture a l'occasion d'un manifeste de Wright aux architectes et critiques d'Europe [The current problems of architecture on the occasion of Wright's manifesto to European architects and critics]," reprinted from *Cahiers d'Art*, 7(1932), 69-73. English translations of all the texts are published in *Forum*, 22(no. 3, 1971), 5 ff.

245. Haskell, Douglas. "Architecture: news from the field." *Nation*, 135(14 December 1932), 598. Taliesin Fellowship.

246. Stone, Peter. "Tooling up: the reproducible shelter industry gets under way." *Shelter*, 2(May 1932), 27-29.

247. Williams, William. "A la mode horizontale." *Pencil Points*, 13(April 1942), 271-72.

248. Wright, Frank Lloyd. "America tomorrow." *American Architect*, 141(May 1932), 14-17, 76. Reprinted in Gutheim ed. *Frank Lloyd Wright on architecture*, New York: 1941.

249. Wright, Frank Lloyd. "Books that have meant most to me." S*cholastic*, 21(24 September 1932), 11. Wright's favorite books included *Arabian nights*, *The man without a country*, *Gulliver's travels*, *Robinson Crusoe*, *Wilhelm Meister*, and *Sartor resartus*. His favorite authors were William Blake, Samuel Butler, Thomas Carlyle, Ralph Waldo Emerson, Edward Everett Hale, Victor Hugo, Ring Lardner, Edna St. Vincent Millay, Westbrook Pegler, Carl Sandburg, William Shakespeare, Percy Bysshe Shelley, Henry David Thoreau, Leo Tolstoy, Walt Whitman and Alexander Woollcott. Reprinted in Gutheim ed. *Frank Lloyd Wright on architecture*, New York: 1941; and Pfeiffer ed. *Frank Lloyd Wright collected writings. Vol. 3*, New York: 1993.

250. Wright, Frank Lloyd. "Caravel or motorship?" *Architectural Forum*, 62(August 1932), 90. Part of "The future of the architect as expressed by eight forward-looking men." Reprinted in Pfeiffer ed. *Frank Lloyd Wright collected writings. Vol. 3*, New York: 1993.

251. Wright, Frank Lloyd. "For all may raise the flowers now for all have got the seed." *T-Square Club Journal of Philadelphia*, 2(February 1932), 6-8. See response by George Howe, "Moses turns pharaoh," *ibid.*, 9. Both pieces are reprinted in *USA Tomorrow*, 1(January 1955), 8-11. Wright's essay is reprinted in Gutheim ed. *Frank Lloyd Wright on architecture*, New York: 1941; and Pfeiffer ed. *Frank Lloyd Wright collected writings. Vol. 3*, New York: 1993.

252. Wright, Frank Lloyd. "Frank Lloyd Wright tells of the broad acre [*sic*] city." *City Club [of Chicago] Bulletin*, 16(15 February 1932), 27, 29.

253. Wright, Frank Lloyd. "The house of the future." *National Real Estate Journal*, 33(July 1932), 25-26. Excerpts from a talk to the National Association of Real Estate Boards convention, Cincinnati. Condensed in *National Real Estate and Building Journal*, 58(October 1957), 43. The text is reprinted in full

in Meehan ed. *Truth against the world*, New York: 1987; and Pfeiffer ed. *Frank Lloyd Wright collected writings. Vol. 3*, New York: 1993.

254. Wright, Frank Lloyd. [Letter. *T-Square Club Journal of Philadelphia*, 2(February 1932), 32. A response to an article by Norman N. Rice, *ibid.*, (January 1932).

255. Wright, Frank Lloyd. "Myslenky o architekture." *Styl*, 2(1932), 205-207. Czechoslovakian: "Reflections on architecture." Translated from *Architectural Forum*.

256. Wright, Frank Lloyd. "Of thee I sing." *Shelter*, 2(April 1932), 10-12. Written in connection with the MoMA International Architecture exhibition, February-March 1932. Reissued as a booklet. Reprinted in Pfeiffer ed. *Frank Lloyd Wright collected writings. Vol. 3*, New York: 1993.

257. Wright, Frank Lloyd. "The Taliesin Fellowship: a modern artists guild." *Studio*, 4(December 1932), 348-49.

258. Wright, Frank Lloyd. "Taste and autobiography." *Chicagoan*, 12(April 1932), 23. Reprinted in Gutheim, ed. *Frank Lloyd Wright on architecture*, New York: 1941; and Pfeiffer ed. *Frank Lloyd Wright collected writings. Vol. 3*, New York: 1993.

259. Wright, Frank Lloyd. "To the students of the Beaux-Arts Institute of Design, all departments." *Architecture*, 66(October 1932), 230. A comment on the poor standard of design seen in "the current exhibition", in response to a notice to the Institute's architecture students and correspondents by Ely Jacques Kahn, 20 April 1932 (also published).

260. Wright, Frank Lloyd. "A treatise on ornament." *Saturday Review of Literature*, 8(21 May 1932), 744. Reviews Claude Bragdon, *The frozen fountain*, New York: Alfred A. Knopf, 1932. Reprinted in Gutheim ed. *Frank Lloyd Wright on architecture*, New York: 1941; and Pfeiffer ed. *Frank Lloyd Wright collected writings Vol. 3*, New York: 1993.

261. Wright, Frank Lloyd. "Why the great earthquake did not destroy the Imperial Hotel." *Creative Art*, 10(April 1932), 268-77.

262. Woznicki, Stanislaw T. "USSR—on the problems of architecture." *Shelter*, 2(November 1932), 80-83.

263. *Architectural Record*. "The architects' library." 71(April 1932), sup. 30. Announces publication of *An autobiography* and *Two lectures on architecture.*

264. *Architectural Record*. "Frank Lloyd Wright honored again." 71(January 1932), sup. 40. Thomas Jefferson High School, Brooklyn.

265. *Art Digest*. "Taliesin." 6(1September 1932), 27. Cf. "Bookless school started by ... Wright," *American Architect*, 142(October 1932); 26; and Douglas

Haskell, "News from the field." *Nation*, 135(14 December 1932), 598.

266. *Art Digest*. "Wright's prophesy." 6(1 February 1932), 8. Wright's comments on skyscrapers, from an interview with S. J. Woolf, *New York Times*, (17 January 1932).

267. *City Club [of Chicago] Bulletin*." Frank Lloyd Wright tells of the Broadacre City." 25(15 February 1932), 27, 29. Cf. Wright, "Broadacre City: an architect's vision," *NYT Magazine*, (20 March 1932), 8-9.

268. *Publishers' Weekly*. "Copyright window displays; Frank Lloyd Wright designs displays of his own book." 121(2 April 1932), 1563.

269. *Time*. "People." 20(14 November 1932), 52. Note about Wright's scuffle with C.R. Sechrest, a former workman at Taliesin, over money.

270. *Time*. "Wright apprentices." *Time*, 20(5 September 1932), 33.

1933
Books, monographs and catalogues
271. Holme, C.G. ed. *Decorative art* [Studio *year book*]. London; New York: The Studio, 1933. House on a mesa.

272. Wright, Frank Lloyd. *The Taliesin Fellowship*. Spring Green: The Author, 1933. A prospectus-cum-application form, dated 1 January 1933, illustrates the proposed remodeling of the Hillside Home School building, and lists charter applicants. Reprinted in Pfeiffer ed. *Frank Lloyd Wright collected writings. Vol. 3*, New York: 1993. Cf. *The Taliesin Fellowship*, a prospectus dated December 1933.

Periodicals
273. Kostanecki, Michal. "Tworczosc ó arch. Frank Lloyd Wright'a." *Architektura i Budownictwo*, 9(no. 6, 1933), 179-87. Polish: "The work of architect Frank Lloyd Wright."

274. Watrous, James. "Taliesin Fellowship." *American Magazine of Art*, 26(December 1933), 552-53.

275. Wright, Frank Lloyd. "The Chicago World Fair." *Architects' Journal*, 78(13 July 1933), 36, 45-47.

276. Wright, Frank Lloyd. "The city of tomorrow." *Pictorial Review*, 34(March 1933), 4, 61. Reprinted in Gutheim, ed. *Frank Lloyd Wright on architecture*, New York: 1941; and Pfeiffer ed. *Frank Lloyd Wright collected writings. Vol. 3, New York: 1993*.

277. Wright, Frank Lloyd. "In the show window at Macy's." *Architectural Forum*, 59(November 1933), 419-20. Reprinted in Pfeiffer ed. *Frank Lloyd Wright collected writings. Vol. 3*, New York: 1993, and in part in Gutheim ed. *Frank Lloyd Wright on architecture*, New York: 1941.

278. *Studio*. "The new decoration in America." 105(January 1933), 22-23.

Ramon Navarro house interiors.

1934
Books, monographs and catalogues
279. Craven, Thomas. "An American architect. Frank Lloyd Wright." In *Modern art: the men, the movements, the meaning.* New York: Simon and Schuster, 1934. Reprinted 1940. Revised, Garden City: Halcyon, 1950. Republished as *Modern art; the men, the movements, the meaning. New York, Simon and Schuster, 1934,* St. Clair Shores: Scholarly Press, 1976. See also *idem.*, "An American architect, Frank Lloyd Wright," *Modern Art*, (1934), 273-89.

Periodicals
280. Beal, George Malcolm. "The Taliesin experiment." *University of Kansas Graduate Magazine*, 33(November 1934), 18-19.

281. M.S. "Quelques oeuvres de Frank Lloyd Wright." *Le Document*, 10(1934), 148-54. French: "Some works by Wright." Allen, Coonley, Ennis, Martin and Robie houses; and Ullman house (project).

282. Wright, Frank Lloyd. "How I work." *Architecture of the U.S.S.R.*, (February 1934), 70-71.
283. Wright, Frank Lloyd. "Opinion in American architecture. 1—Response to four questions put by the editor" *Trend*, 2(March-April 1934), 55-60. Reprinted in Pfeiffer ed. *Frank Lloyd Wright collected writings. Vol. 3*, New York: 1993.

284. Wright, Frank Lloyd. "The Taliesin Fellowship." *Wisconsin Alumni Magazine*, 35(March 1934), 152-53, 176.

285. Wright, Frank Lloyd ed. *Taliesin, Journal of the Taliesin Fellowship*, 1(no. 1, 1934). This is the first issue of a promised annual publication; the second of only three numbers did not appear until October 1940. Besides an editorial by Wright, it includes his "Matter: in the cause of architecture"; "Architectural education in Germany" by Heissenrich de Fries; "Architecture of the present and the Taliesin standpoint" by Stamo Papadaki; "A mother looks at Taliesin" by Pauline Schubart; "Colossus" by Yen Liang; "The modern museum show: institutionalized poverty" by Edgar Tafel; and a letter from Dorothy Johnson Field. Wright's "The two-zone house—suited to country, suburb, and town" is reprinted in Gutheim ed. *Frank Lloyd Wright on architecture*, New York: 1941; and Pfeiffer ed. *Frank Lloyd Wright collected writings. Vol. 3*, New York: 1993.
286. Wright, Frank Lloyd. "What is the modern idea?" *Liberty*, 2(10 February 1934), 49. See also *Physical Culture*, (24 June 1924). Reprinted in Gutheim ed. *Frank Lloyd Wright on architecture*, New York: 1941; and Pfeiffer ed. *Frank Lloyd Wright collected writings. Vol. 3, New York: 1993.*

1935
Books, monographs and catalogues
287. Wright, Frank Lloyd. "Messagio a Frank Lloyd Wright." In *Atti ufficiali: XIII Congresso Internazionale Architetti, Roma, 22-28 Settembre 1935—XII,*

Rome: National Academy of San Luca, 1935. Italian: "Message from Wright."

Periodicals

288. Alexander, Stephen. "Frank Lloyd Wright's utopia." *New Masses*, 15(18 June 1935), 28-29. Wright's response, "Freedom based on form," to this review of Broadacre City exhibit at the National Alliance of Arts and Industry Exposition, New York, appears in *ibid.*, 16(23 July 1935), 23-24. See also Wright, "Broadacre City: Frank Lloyd Wright, architect," *American Architect*, 146(May 1935), 55-62, with photographs of models.

289. Gloag, John. "Design in America. VII. Frank Lloyd Wright." *Architects' Journal*, 81(3 January 1935), 16. Cf. *idem.*, "Frank Lloyd Wright," *ibid.,* 81(31 January 1935), 202 (excerpts from a lecture about Wright); and *idem.*, "Frank Lloyd Wright and the significance of the Taliesin Fellowship," *Architectural Review*, 77(January 1935), 1-2.

290. Roos, Frank J. Jr. "Concerning several American architectural leaders." *Design*, 37(December 1935), 3-5, 40.

291. Safford, Virginia. "Home of the month." *Golfer and Sportsman*, 17(June 1935), 37-39, 58. Willey house.

292. Schindler, Pauline G. "Modern architecture acknowledges the light which kindled it." *California Arts and Architecture*, 47(January 1935), 17. Tribute to Wright.

293. Schindler, Pauline G. [Editorial]. *Architect and Engineer*, 123(December 1935), 13-15.

294. Shand, Philip Morton. "Scenario for a human drama, VI: La machine-á-habiter to the house of character." *Architectural Review*, 77(February 1935), 61-64. Sixth in a series about the early Modern Movement. Most of it is about Wright; the others relate to him, directly or indirectly. See also "I—Foreword," 76(July), 9-16; "II—Immediate background," 76(August), 39-42; "III—Peter Behrens," 76(September), 83-86; "IV—Van de Velde to Wagner," 76(October), 131-34; "V—Glasgow Interlude,"77(January), 23-26; and "VI—Looping the Loop,"77(March), 99-102.

295. Wright, Frank Lloyd. "Broadacre City: a new community plan." *Architectural Record*, 77(April 1935), 243-54. Reissued as a booklet. Reprinted in Richard T. LeGates and Frederic Stout eds. *The city reader*, London; New York: 1996. See also "An architect visualizes 'Broadacre City'," *American City*, 50(April 1935), 85, 87.

296. Wright, Frank Lloyd. "The creed of a modern architect." *Architectural Review*, 77(January 1935), 41. Reprinted from (i.a.) "In the Cause of Architecture" series in *Architectural Record*.

297. Wright, Frank Lloyd. "Form and function." *Saturday Review of Literature*,

13(14 December 1935), 6. Reviews Hugh Morrison, *Louis Sullivan: prophet of modern architecture*, New York: Museum of Modern Art and W.W. Norton, 1935 (reprinted New York: P. Smith, 1952; Norton, 1962). The review, including a response by G.G. Elmslie (dated 1936), is reprinted *JSAH*, 20(October 1961), 141-42. Also reprinted in Gutheim ed. *Frank Lloyd Wright on architecture*, New York: 1941; and Pfeiffer ed. *Frank Lloyd Wright collected writings. Vol. 3*, New York: 1993. The Morrison book was reprinted Westport: Greenwood, 1971, and in a revised edition 1998.

298. Wright, Frank Lloyd. "Louis Sullivan's words and work." *Architectural Record*, 77(March 1935), 116. Reviews Claude Bragdon ed. *Kindergarten chats on architecture, education and democracy, by Louis H. Sullivan*, Lawrence, Kansas: Scarab Fraternity Press, 1934. Reprinted in Pfeiffer ed. *Frank Lloyd Wright collected writings. Vol. 3*, New York: 1993. *Kindergarten chats* was originally serialized in *Interstate Architect and Builder*, 1901-1902; republished New York: Wittenborn, Schultz, 1947 (reprinted New York: Dover, 1979).

299. *Architect and Engineer* "Chicago Century of Progress." 123(December 1935), 7.

300. *Architect and Engineer*. [Portrait.] 123(December 1935), 1.

301. *Architectural Record*. "Portfolio of houses: house of Prof. Malcolm Willey in Minneapolis, Frank Lloyd Wright, architect." 78(November 1935), 313-15.

302. *Architectural Record*. "1900-10, House at Oak Park, Illinois." 77(April 1935), 231. Ullman house (project). Perspective and plan reproduced from the Wasmuth portfolio, 1910

303. *Interior Decorator*. "Frank Lloyd Wright addresses N.Y. decorators." 95(December 1935), 12-13, 42-44. Review of speech.

304. *Professional Art Quarterly*. "Taliesin Fellowship." 2(December 1935), 6-8.

305. *Time*. "People." 26(15 July 1935), 44. Wright's comment on Pittsburgh.

1936
Periodicals
306. Bodley, Ronald V.C. "Imperial Hotel, Tokyo, Japan." *Town and Country*, 91(April 1936), 64-65, 113-14.

307. Dos Passos, John. "Grand old man." *New Republic*, 87(3 June 1936), 94-95. Cf. *idem.*, *The big money*, New York: Harcourt Brace, 1936, 428-33.

308. Wright, Frank Lloyd. "Apprenticeship training for the architect." *Architectural Record*, 80(September 1936), 207-210. Reprinted in Pfeiffer ed. *Frank Lloyd Wright collected writings. Vol. 3*, New York: 1993.

309. Wright, Frank Lloyd. "Organic architecture." *Architects' Journal*, (August 1936).

310. Wright, Frank Lloyd. "Plan: a modern home." *Inland Topics*, 7(August 1936), 16-17. Reprinted in Pfeiffer ed. *Frank Lloyd Wright collected writings. Vol. 3,* New York: 1993.

311. Wright, Frank Lloyd. "Skyscrapers doomed? yes!" *Rotarian*, 48(March 1936), 10-11, 46-47. Reissued as a booklet. Reprinted in Pfeiffer ed. *Frank Lloyd Wright collected writings. Vol. 3,* New York: 1993.

312. Wright, Frank Lloyd. "Taliesin: our cause." *Professional Art Quarterly*, 2(March 1936), 6-7, 24; *ibid.,* (June 1936), 39-41.

1937
Books, monographs and catalogues
313. Brownell, Baker and Frank Lloyd Wright. *Architecture and modern life.* New York; London: Harper and Brothers, 1937. Brownell, head of Northwestern University's Department of Contemporary Thought, and Wright co-authored chapters 1 and 7. Chapters 2 and 4 are Wright's; 3, 5, and 6 are Brownell's.

Reviewed Talbot Faulkner Hamlin, "Building for the future," *Saturday Review of Literature*, 17(18 December 1937), 10; *Architectural Forum*, 68(January 1938), 18; R. Duffus, "Frank Lloyd Wright's way to a better world," *NYTBR*, (2 January 1938), 2; John Harbeson, *Pencil Points*, 19(February 1938), sup. 42; A. Philip McMahon, *Parnassus*, 10(February 1938), 30; Thomas Tallmadge, *Architect's World*, 1(March 1938), 131-34 (reprinted from *Evanston Review*, [27 January 1938]); and Meyer Schapiro, "Architect's Utopia," *Partisan Review*, 4(March 1938), 42-47.

Partly reprinted in Wright, *The future of architecture*, New York: 1953; Kaufmann and Raeburn eds. Frank *Lloyd Wright: writings and buildings*, New York: 1960; and in Pfeiffer ed. *Frank Lloyd Wright collected writings. Vol. 3*, New York: 1993.

Periodicals
314. Breines, Simon. "First Congress of Soviet Architects." *Architectural Record*, 82(October 1937), 63-65, 94, 96.

315. Hitchcock, Henry-Russell Jr. "The architectural future in America." *Architectural Review*, 82(July 1937), 1-2. Comments on Wright's career. For replies see Eugene Masselink, *ibid.,* (September 1937), 114; and John E. Lautner Jr., *ibid.,* (November 1937), 221-22 (with Hitchcock's rejoinder).

316. Levin, Meyer. "Master-builder: concerning Frank Lloyd Wright, stormy petrel of architecture." *Coronet*, 3(December 1937), 171-84.

317. Putzel, Max. "A house that straddles a waterfall." *St. Louis Post-Dispatch Magazine*, (21 March 1937), 1, 7. Fallingwater.

318. Wright, Frank Lloyd. "Architecture and life in the U.S.S.R." *Soviet Russia Today*, 6(October 1937), 14-19. Reprinted in Gutheim ed. *Frank Lloyd Wright on architecture*, New York: 1941. Same as *Architectural Record*, 82(October 1937), 57-63.

319. Wright, Frank Lloyd. "Building against doomsday." *Reader's Digest*, 31(September 1937), 70-74. Imperial Hotel. Condensed from *An autobiography*, 1932.

320. Wright, Frank Lloyd. "Frank Lloyd Wright (USA)." *Architecture of the U.S.S.R.*, (July-August 1937), 49-50.

321. Wright, Frank Lloyd. "The man St. Peter liked." *Coronet*, 3(December 1937), 91.

322. Wright, Frank Lloyd. "Per la causa dell'architettura." *Casabella*, 10(June 1937), 2-3. Italian: "In the cause of architecture."

323. Wright, Frank Lloyd. [Speech of the American architects. 1. Frank Lloyd Wright]. *Pravda*, (26 June 1937), 4. Russian. Cf. *Architecture C.C.C.P.*, (July-August 1937), 49-50.

324. Wright, Frank Lloyd. "What the cause of architecture needs most." *Architectural Review*, 81(March 1937), 99-100.

325. *Architect and Engineer.* "A Frank Lloyd Wright house at Palo Alto, California designed to resist earthquakes." 130(August 1937), 3. Hanna house.

326. *Architects' Journal.* "Office building in Wisconsin designed by Frank Lloyd Wright." 85(18 February 1937), 289. S.C. Johnson and Son administration building.

327. *Architectural Forum.* "Frank Lloyd Wright tests a column, attends a convention, visits the Paris fair." 67(August 1937), 10. S.C. Johnson and Son administration building. There is also a note about Wright's invitation to attend the All-Union Congress of Soviet Architects, Moscow, 1937. Cf. "66 tons with ease," *Architectural Record*, 82(July 1937), 38.

328. *Architectural Record.* "Office building for S.C. Johnson and Son, Inc., at Racine, Wisconsin. Frank Lloyd Wright, architect." 81(February 1937), sup. 36. Perspective drawing.

329. *Architectural Record.* "This month." 82(October 1937), 5.

330. *ENR.* "Office building without precedent." 119(9 December 1937), 956-60. S.C. Johnson and Son administration building. See also "Pictures in the news," *ibid.*, 924.

331. *Science Newsletter.* 'Windowless building built by 'organic' architecture." 32(9 October 1937), 227, 239. S.C. Johnson and Son administration building.

332. *Scientific American.* "Unique office structure." 156(May 1937), 316-17. S. C. Johnson and Son administration building.

333. *Time.* "People." 30(25 October 1937), 68. Wright's comment on Detroit.

334. *Town and Country.* "Frank Lloyd Wright." 92(July 1937), 56, 85 and cover.

1938
Books, monographs and catalogues
335. Museum of Modern Art. *A new house by Frank Lloyd Wright on Bear Run, Pennsylvania.* New York: The Museum, 1938. Fallingwater. Mostly images, published in conjunction with an exhibition of photographs, January-March 1938. Also appears in part in *Architectural Forum*, 68(January 1938), sup. 1-102. The exhibit is reviewed Jay Peterson, "Nature's architect," *New Masses*, 26(8 February 1938), 29-30; and "Fairs and furbelows," *Time*, 31(21 February 1938), 53.

336. Wright, Frank Lloyd. *Structural glass: U.S. Patent Office 2, 124,809 Edition: Application August 14, 1937, Serial No. 159,117* s.l.: U.S. Patent Office, 1938. Patented July 26, 1938. S.C. Johnson and Son administration building.

Periodicals
337. Finetti, Giuseppe de. "L'America di Frank Lloyd Wright." *Rassegna di Architettura*, 10(February 1938), 49-61. Italian: "Wright's America."

338. Giolli, Raffaello. "L'ultimo Wright." *Casabella*, 10(March 1938), 1, 4-19, 40. Italian: "The ultimate Wright." Reprinted in Cesare de Seta ed. *Raffaelo Giolli: l'architettura razionale*, Bari: Laterza, 1972.

339. Hamlin, Talbot Faulkner Faulkner. "F.L.W.—an analysis." *Pencil Points*, 19(March 1938), 137-44. Includes discussion of Fallingwater, Hanna house and S.C. Johnson and Son administration building. Condensed in *Architect's World*, 1(April 1938), 159-63.

340. Meyer, Ernest L. "Frank Lloyd Wright." *Scholastic*, 32(February 12, 1938), 21E, 24E. Also published in the *New York Post.*

341. Mieras, Jan Pieter. "Fallingwater, een landhuis van Frank Lloyd Wright." *Bouwkundig Weekblad*, 56(1938), 137-38. Dutch: "Fallingwater, a country house by Frank Lloyd Wright."

342. Mumford, Lewis. "The sky line—at home, indoors and out." *New Yorker*, 13(12 February 1938), 31. Fallingwater and Willey house.

343. Patterson, Augusta Owen. "Three modern houses, no. 3: owner, Edgar J. Kaufmann, Pittsburgh; architect, Frank Lloyd Wright." *Town and Country*, 93(February 1938), 64-65, 104. Fallingwater.

344. Seckel, Harry. "Frank Lloyd Wright." *North American Review*, 246(August 1938), 48-64.

345. Wright, Frank Lloyd. "Frank Lloyd Wright." *Architectural Forum*, 68(January 1938), sup. 1-102. The special issue includes several buildings: Taliesin and the Taliesin Fellowship complex; Willey house; Barnsdall kindergarten and the "Little Dipper"; Fallingwater; Kaufmann office, Pittsburgh; Johnson house and farm group; Ocotillo desert camp; Jacobs house I; and S.C.

Johnson and Son administration building. Projects include: San Marcos in the Desert; "Memorial to the Soil" chapel; Marcus house; St. Mark's tower; Hanna house; "House on the Mesa"; Lusk house; Bramson dress shop; Parker garage; *Capitol Journal* office building; and Midway Gardens furniture. Reprinted as a book, *Frank Lloyd Wright: new and unpublished works*, New York: Time, 1938. For comment see *Architectural Forum*, "Letters," 68(February 1938), 42, 86; (March 1938), 22 and (April 1938), 38.

Wright's accompanying text is reprinted in part in Kaufmann and Raeburn, eds. Frank *Lloyd Wright: writings and buildings*, New York: 1960; Gutheim ed. *Frank Lloyd Wright on architecture*, New York: 1941; and Pfeiffer ed. *Frank Lloyd Wright collected writings. Vol. 3*, New York: 1993. See also "Frank Lloyd Wright," *Arkkitehti Arkitekteno*, (no. 8, 1938), 120-21 (Finnish).

346. Wright, Frank Lloyd. "Ideas for the future." *Saturday Review of Literature*, 32(17 September 1938), 14-15. Review of Richard Buckminster Fuller, *Nine chains to the moon*, Philadelphia: Lippincott, 1938. Reprinted in Thomas T.K. Zung, *Buckminster Fuller: anthology for the new millennium*, New York: 2001.

347. Wright, Frank Lloyd. "No real honor." *Magazine of Art*, 31(June 1938), 368. Letter about Thomas Jefferson memorial, Washington, D.C., designed by John Russell Pope in 1937.

348. *Architect's World*. "Frank Lloyd Wright." 1(February 1938), 6-7.

349. *Architectural Forum*. "Frank Lloyd Wright, architect: house for $5,000-$6,000 income." 69(November 1938), 331-35. Cf. "*Life* presents in collaboration with the *Architectural Forum* eight houses for modern living especially designed by famous American architects for four representative families earning $2,000 to $10,000 a year," *Life*, 5(26 September 1938), 45-65. For Wright's designs, see 60-61. Reprinted as *The 1940 book of small homes*, New York: Simon and Schuster, 1940. See also Robert Gerloff, "Unbuilt Minnesota," *Architecture Minnesota*, 16(May-June 1990), 67.

350. *Architectural Forum*. "Wright and center." 68(June 1938), sup. 10. Florida Southern College, Lakeland.

351. *Architectural Record*, "Frank Lloyd Wright designs a honeycomb house." 84(July 1938), 59-74. See also Paul and Jean Hanna, "Frank Lloyd Wright builds us a home," *ibid.*, 74.

352. *Art Digest*. "Wright dissents again." 13(1 October 1938), 23.

353. *Art Digest*. "Wright's newest." 12(1 February 1938), 13. Fallingwater.

354. *The Bulletin Index: Pittsburgh Weekly News Magazine*. "Wright western Pennsylvania landmark completed." (27 January 1938), 10. Fallingwater.

355. *Federal Architect*. "The conic dwelling; appropriate in that territory commonly known as USA, but often referred to by certain prophets as Usonia." 8(April 1938), 31-32, 52. Reprinted from *Charette*.

356. *Kokusai-Kentiku.* "Fallingwater: Kaufmann House, Pennsylvania, Frank Lloyd Wright." 14(April 1938), pls. 149-56. Japanese. Images only, reprinted from *Architectural Forum*, 68(January 1938).

357. *Nuestra Arquitectura.* "'Fallingwater', vivienda en Pensilvania, arq. Frank Lloyd Wright." (October 1938). 336-45. Spanish. Mostly images.

358. *Pencil Points.* "Frank Lloyd Wright exhibition planned at the College of William and Mary." 19(September 1938), sup. 40. See also "Frank Lloyd Wright at Williamsburg," *Magazine of Art*, 31(October 1938), 597. For Wright's comment on Williamsburg see "People," *Time*, 32(7 November 1938), 37.

359. *Taliesin Eyes*, 1(1 October 1938). Another Taliesin Fellowship ephemeral, the single sheet publication by the Taliesin apprentices ran to eight consecutive weekly issues (except for 29 October) until the end of November 1938.

360. *Technical America.* "Architect turns engineer." 5(January 1938), 7. Subtitled "Frank Lloyd Wright does some pioneering in reinforced concrete design for [Johnson Wax]."

361. *Time.* "Usonian architect." 31(17 January 1938), 29-32. Readers' responses are published *ibid.*, (31 January), 2, 4-5 and (21 February), 10, 12.

362. *We the People: Pennsylvania in Review.* "Modern home built over a mountain brook." 3(1 February 1938), 12-13. Fallingwater.

1939
Books, monographs and catalogues
363. Chase, Mary Ellen. "The Hillside Home School." In *A goodly fellowship*, New York: MacMillan, 1939. The chapter describes the school once conducted by Wright's aunts, Jane and Nell Lloyd Jones.

364. Wright, Frank Lloyd. *An organic architecture: the architecture of democracy. The Sir George Watson Lectures of the Sulgrave Manor Board for 1939.* London: Lund Humphries, 1939. Reprinted 1941. The texts of four lectures delivered at the RIBA, London, May 1939.

For comment see *Builder*, 156(8 May 1939), 856, (12 May 1939), 907-909, and (19 May 1939), 953-54; Patrick Abercrombie, *RIBA Journal*, 47(11 December 1939), 44; *Architect and Building News*, 158(12 May 1939), 141; "Frank Lloyd Wright," *Architects' Journal.* 89(11 May 1939), 756-57 (reprinted as "Frank Lloyd Wright takes England," *Architectural Forum*, 71[August 1939], sup. 22-23); Edward Julian Carter and Naum Gabo, *Focus*, 1(Summer 1939), 49-52; and Peter F. R. Donner, *Architectural Review*, 90(August 1941), 68-70. See also "Frank Lloyd Wright's itinerary," *Builder*, 156(23 April 1939), 789.

The book is reviewed Ernestine Carter, "The prophet of Taliesin," *Architectural Review*, 87(April 1940), 148; *Cahiers d'Art*, 15(1940), 76; *Art and Industry*, 28(June 1940), 190.

The lectures are reprinted in Wright, *The future of architecture*, New York: 1953 and Pfeiffer ed. *Frank Lloyd Wright collected writings. Vol. 3*, New York:

1993. Excerpts are reprinted in *New Directions*, 5(1940), 266-72; Gutheim ed. *Frank Lloyd Wright on architecture*, New York: 1941; and Kaufmann and Raeburn eds. Frank *Lloyd Wright: writings and buildings*, New York: 1960.

A facsimile was published by Lund Humphries, London and MIT Press, Cambridge, Mass., 1970; reviewed Alastair Beet, *Design Magazine*, (July 1970), 80; Martin Pawley, "FLW, 1939," *Architectural Design*, 40(September 1970), 473-74; E. Sovik, *Liturgical Arts*, 39(February 1971), 53; Thomas Yanul, *Prairie School Review*, 8(no. 1, 1971), 19; and *Choice*, 8(May 1971), 379-80.

Published in Italian as *Architettura organica, architettura della democrazia*, Milan: Muggiani, 1945. Excerpts are translated into Spanish as "La palabra sobre disenso," *Revista de Arquitectura*, 3(1953), 73-76.

365. *The George and Alice Millard collection illustrating the evolution of the book. Acquired for the Huntington Library by a group of their friends.* San Marino: The Library, 1939. The pamphlet includes a description of the Millard house. Limited edition of 75.

366. *Taliesin.* Spring Green: Taliesin Fellowship, 1939. The illustrated folded single-sheet brochure describes the Fellowship and invites visitors to attend Sunday afternoon programs at the Taliesin playhouse.

Periodicals
367. "Astragal". "Other buildings chosen. ... " *Architects' Journal.* 89(13 April 1939), 599.

368. Castagna, John F. "Bertram G. Goodhue and Frank Lloyd Wright: their ideals and their influence in the arts." *New York University. Bulletin of the work of graduate students in the School of Architecture and Allied Arts*, 2(1 September 1939), 35-44.

369. Delafon, S. Gille. "L'architecte américain Frank Lloyd Wright présente à Paris un film de ses oeuvres." *Beaux Arts*, (9 June 1939), 1. French: "American architect Frank Lloyd Wright presents a film of his work in Paris."

370. Farrar, Benedict. "Answers Frank Lloyd Wright." *Architect and Engineer*, 136(February 1939), 74-75. Response from the St. Louis chapter president of the AIA to Wright's criticism of St. Louis buildings.

371. Fry, E. Maxwell. "Frank Lloyd Wright." *Listener*, 218(18 May 1939), 1050-52.

372. Fuller, Kathryn Handy. "Home of the month." *Golfer and Sportsman*, 24(November 1939), 24-25, 45-46. Taliesin.

373. Gloag, John. "Frank Lloyd Wright." *RIBAJ*, 4(20 November 1939), 17.

374. Herrick, George. "A 'functional' office building, U.S.A." *Builder*, 156(5 May 1939), 857-58. S.C. Johnson and Son administration building.

375. Kahn, Albert. "The wizard of Taliesin." *Architect and Engineer*, 139(December 1939), 75. S.C. Johnson and Son administration building.

376. "Murus". "Frank and free." *Builder*, 156(12 May 1939), 890.

377. Newnham, Peter. "Letter from America." *Arena*, 66(October 1939), 59-63.

378. Pevsner, Nikolaus. "Frank Lloyd Wright's peaceful penetration of Europe." *Architects' Journal*, 89(4 May 1939), 731-34. Reprinted in Dennis Sharp, *The Rationalists. Theory and design in the modern movement*, London: Architectural Press, 1978.

379. Scholberg, Philip. "The year's work abroad." *Architects' Journal*, 89(19 January 1939), 147-49.

380. Wright, Frank Lloyd. "Mr. Frank Lloyd Wright at the A.A." *AA Journal*, 54(May 1939), 268-69. Text of Wright's address to the school. Reprinted in Meehan ed. *Truth against the world*, New York: 1987.

381. Wright, Frank Lloyd. "The man who paid cash." *Coronet*, 5(January 1939), 175-76. Reprinted in Pfeiffer ed. *Frank Lloyd Wright collected writings. Vol. 3*, New York: 1993.

382. Wright, Frank Lloyd. "Organic architecture, Mr. Lloyd Wright's first-fourth Watson lectures." *Builder*, 156(5 May 1939), 856. Further instalments appeared under various titles: (12 May), 907, 909-910; (19 May), 932, 951-954.

383. Wright, Frank Lloyd. "Speech to the A.F.A.; 600 Federal architects assembled in the ballroom of the Mayflower Hotel at Washington, D.C., October 25, 1938." *Federal Architect*, 9(January 1939), 20-23. Text of the speech includes comments on Williamsburg, the Jefferson Memorial, and government buildings. Reprinted in Gutheim ed. *Frank Lloyd Wright on architecture*, New York: 1941; Meehan ed. *Truth against the world*, New York: 1987; and Pfeiffer ed. *Frank Lloyd Wright collected writings. Vol. 3*, New York: 1993. For Wright's replies in a forum following the lectures see "Frank Lloyd Wright again answers questions," *Architect and Engineer*, 136(March 1939), 4.

384. *Architect and Engineer.* "Rural housing project." 136(January 1939), 58. Houses for six Michigan State College faculty members at East Lansing.

385. *Architectural Design and Construction.* "Offices and factories." 9(June 1939), 232-33. S.C. Johnson and Son administration building.

386. *Architectural Forum.* "Usonia comes to Ardmore when Frank Lloyd Wright invents a four-family house with kitchens as control rooms, floors as radiators." 71(August 1939), 142-43, sup. 30. Suntop Homes, Ardmore. For Vernon Harrison's reply see *ibid.*, (October 1939), sup. 82.

387. *Architectural Record.* "New dwelling units. Nursery." 86(October 1939), 51-58.

388. *Arkady.* [Illustrated article]. (No. 2, 1939), 71. Polish. Taliesin, and Honeycomb house. See also *RIBA Journal*, 46(May 1939), 740.

389. *Builder.* "Frank Lloyd Wright." 156(28 April 1939), 789. See also "Frank Lloyd Wright, Architecture Club dinner," *ibid.*, (8 May 1939), 858; "Exhibition at building centre," *ibid.*, (12 May 1939), 890; and "Mr. Frank Lloyd Wright's drawings at the AA," *ibid.*, (26 May 1939), 953.

390. *Business Week.* "Office building goes functional." (6 May 1939), 24, 29-30. S.C. Johnson and Son administration building.

391. *Life.* "New Frank Lloyd Wright office building shows shape of things to come." 6(8 May 1939), 15-17. S.C. Johnson and Son administration building.

392. *RIBA Journal.* "Mr. Frank Lloyd Wright." 46(8 May 1939), 643. Comment on Wright's visit to London. See also "Frank Lloyd Wright," *ibid.*, (22 May 1939), 700 (discussion of the London lectures); and P. Morley-Horder, "Mr. Frank Lloyd Wright's visit," *ibid.*, (22 May 1939), 743 (summarized as "American architecture," *Journal of the Royal Society of Arts*, 87[26 May 1939], 732). For Wright's rsponse to criticisms, see "To the fifty-eighth," *ibid.*, (16 October 1939), 1005-1006. Cf. *Architectural Review*, 86(November 1939), 223-24 (reprinted in Gutheim ed. *Frank Lloyd Wright on architecture*, New York: 1941).

393. *Spectator.* "The future of cities." 162(12 May 1939), 793-94. Comment on Wright's opinion of cities.

1940-1949

1940

Books, monographs and catalogues

394. Hudnut, Joseph intro. *Frank Lloyd Wright: a pictorial record of architectural progress*. Boston: Institute of Modern Art, 1940. Published for an exhibition sponsored by the Institute and the Boston Architectural Club, January-March 1940. Includes selections from Wright's writings. For review and comment on the show and Wright's lecture see Mary C. Udall, "Wright: great U.S. architect; first comprehensive exhibition at Boston's Modern Institute," *Art News*, 38(24 February 1940), 6-7; "Bostonians turn out for Wright," *Pencil Points*, 21(February 1940), sup. 60; and "Wright in Boston," *Art Digest*, 14(15 February 1940), 28.

Periodicals

395. Decker, Paul. "Prophet not without honor." *California Arts and Architecture*, 57(February 1940), 15. Comment on Wright's speech at the dedication of the May Omerod Harris Hall of Architecture and Fine Arts, USC. See also Paul Hunter, "Mr. Wright goes to Los Angeles," *Pencil Points*, 21 (March 1940), sup. 34, 36.

396. Gloag, John. "Frank Lloyd Wrght [letter]." *RIBA Journal*, 47(5 January 1940), 65.

397. Hamlin, Talbot Faulkner. "Frank Lloyd Wright." *Nation*, 151(30 November 1940), 541-42. Review of "Two great Americans" (the other was filmmaker David W. Griffith) exhibit, Museum of Modern Art, New York. No catalogue was published, but see Henry- Russell Hitchcock Jr., *In the nature of materials: 1887-1941, the buildings of Frank Lloyd Wright*, New York: 1942 (published in Spanish as *Frank Lloyd Wright: obras 1887-1941*, Barcelona: Gustavo Gili, 1978, and reprinted with revised bibliographies 1979 and 1982).

The show is also reviewed: "Fall exhibit," *Pencil Points*, 21(October 1940), sup. 58; "A city for the future," *Time*, 36(25 November 1940), 58; Bruce Blivin Jr., "Frank Lloyd Wright." *New Republic*, 103(9 December 1940), 790-91; Milton Brown, "Frank Lloyd Wright's first fifty years," *Parnassus*, 12(December 1940), 37-38 (for Alfred Barr's reply see *ibid.*, [13 January 1941], 3); Alan Mather, "The perennial trail blazer," *ibid.*, 21(December 1940), sup. 16; Hamlin, "A pot pourri for architects," *Pencil Points*, 22(January 1941), 55-58; Frederick A. Gutheim, "First reckon with his future," *Magazine of Art*, 34(January 1941), 32-33; Hitchcock, "Frank Lloyd Wright at the Museum of Modern Art," *Art Bulletin*, 23(March 1941), 73-76 (reissued as a booklet); Dimitri Tselos, "Frank Lloyd Wright," *Art in America*, 29(January 1941), 42-43.

398. Hamlin, Talbot Faulkner. "Recent developments in school design." *Pencil Points*, 21(December 1940), 768-82. Includes Taliesin West.

399. Hitchcock, Henry-Russell Jr. "Wrights influence abroad." *Parnassus*, 12(December 1940), 11-15.

400. Patterson, Augusta Owen. "Three modern houses, no. 1: owner, Herbert F. Johnson, Jr., Racine; architect, Frank Lloyd Wright." *Town and Country*, 95(February 1940), 52-57. Wingspread.

401. Robertson, Howard. "The romance of American architecture." *Studio*, 120(September 1940), 90-95.

402. Schelling, H.G.J. "De Amerikaansche architect Frank Lloyd Wright." *Bouwkundig Weekblad*, 61(17 August 1940), 255-61. Dutch: "The American architect Frank Lloyd Wright."

403. Wright, Frank Lloyd. [Letter about US non-involvement in the European war]. *Christian Century*, 57(13 November 1940), 1419-20.

404. Wright, Frank Lloyd. "Louis Sullivan and the Chicago Auditorium; Frank Lloyd Wright's reminiscences." *Builder*, 159(27 December 1940), 617. Cf. Wright, "Chicago's auditorium is fifty years old," *Architectural Forum*, 73(September 1940), sup. 10, 12.

405. Wright, Frank Lloyd, ed. *Taliesin, Journal of the Taliesin Fellowship.* 1(October 1940). This second edition, devoted to Broadacre City, includes an editorial and "A new success ideal", both by Wright (the latter is reprinted in part, *Berkeley*, [March 1948], 2); "Mr. Wright talks on Broadacre City to Ludwig Mies van der Rohe" (reprinted in part in Gutheim ed. *Frank Lloyd Wright on architecture*, New York: 1941; and in Meehan ed. *Truth against the world*, New York: 1987); and "A way to beat Hitler" by Charles Stanley Nott.

406. *Architects' Journal*. "Notes and topics." 91(11 April 1940), 379. Describes the Taliesin Fellowship's annual migration between Wisconsin and Arizona.

407. *Architectural Forum*. "Rumor has promoter Roy S. Thurman about to launch a smaller edition of Rockefeller Center ... for the nation's capital with F.L. Wright as designer." 73(October 1940), sup. 2. Crystal Heights project. Cf.

"Wright goes to Washington with a $15,000,000 surprise," *Newsweek*, 16(25 November 1940), 48.

408. *Arizona Highways.* "Mr. Frank Lloyd Wright, the Taliesin Fellowship, and Taliesin West." 16(May 1940), 4-15. Includes an introduction by Raymond Carlson, and "To Arizona," by Wright. Reprinted as "Frank Lloyd Wright and Taliesin West," *ibid.*, 25(October 1949), 4-9, together with Wright's "Living in the desert: we found paradise," 12-15 (reprinted in part in *Frank Lloyd Wright Quarterly*, 9[Winter 1998]).

409. *California Arts and Architecture.* "Frank Lloyd Wright: the residence of Mr. and Mrs. George D. Sturges, Brentwood, Calif." 57(April 1940), 14-15. Photographs only.

410. *Interior Decorator.* "In the general office." 99(January 1940), 28-30. S.C. Johnson and Son administration building.

411. *Lead.* "Lead flashing for an ultra-modern office building." 10(January 1940), 10. S.C. Johnson and Son administration building.

412. *New Directions.* "Frank Lloyd Wright's home, 'Taliesin West'." 5(1940), 273-78.

413. *Newsweek.* "New design for worship." 16(1 July 1940), 38. Community Church, Kansas City. Cf. "Something new in churches," *Time*, 36(2 December 1940), 38, 40.

414. *Time.* "People." 35(5 February 1940), 40. Wright's comment on Los Angeles.

1941
Books, monographs and catalogues
415. Gutheim, Frederick Albert ed. *Frank Lloyd Wright on architecture: selected writings, 1894-1940.* New York: Duell, Sloan and Pearce; London: Meridian, 1941. Reprints published material, and previously unpublished speeches and essays: "Architecture and the machine" (1894); "Architecture, architect and client" (1896); "A philosophy of fine art" (1900); "The modern home as a work of art" (1902); "Chicago culture" (1918)"; "The pictures we make" (1927); "In the cause of architecture: purely personal" (1928); "The use of metal plates in the art of building" (1928); "Terra cotta" (1930); "Raymond Hood" (1931); "Concerning skyscraper" (1931); "The designing partner" (1932); "The house on the mesa/the conventional house" (1932); letters to *Pravda* and *Architecture of the U.S.S.R.* (1933); "What shall we work for?" (1934); "To Arizona" (1935); "These critics" (1935); "An architect speaking for culture" (1936); "Room for the dead " (1936): "From an architect's point of view" (1938); and "Dinner talk [at Hull House]" (1939). There are a few short pieces.

Reviewed *Architectural Forum*, 74(June 1941), sup. 34, 88; Elisabeth Coit, *Architectural Record*, 89(June 1941), 28; John E. Lautner Jr., *California Arts and Architecture*, 58(June 1941), 14; Elizabeth Bauer Mock, "Frank Lloyd Wright's writings," *Magazine of Art*, 34(June-July 1941), 330, 332; *Liturgical*

Arts, 9(August 1941), 83; R.L. Duffus, "Frank Lloyd Wright on men and stones," *NYTBR*, (3 August 1941), 3, 10; John C. Seward, *Pencil Points*, 22(November 1941), sup. 66; and W. van Gelderen, *Bouw*, (no. 2, 1947), 152 (Dutch).

Reprinted as *Frank Lloyd Wright on architecture*, New York: Grosset and Dunlap, 1959 and 1960 (paperback); reviewed B. Benson, *New Mexico Quarterly*, 30(Spring 1960), 107; Robert C. Weinberg, "A distillation of FLLW." *AIA Journal*, 34(November 1960), 62-64; and *idem.*, *American Institute of Planners Journal*, 27(November 1961), 354.

Periodicals

416. Argan, Giulio Carlo. "L'autobiografia di Wright." *Casabella*, 14(June 1941), 2-3. Italian: "Wright's autobiography."

417. Gutheim, Frederick Albert. "Frank Lloyd Wright: prophet of decentralization." *Free America*, 5(April 1941), 8-10.

418. Kantorowich, Roy. "Architectural utopias: the city planning theories of Frank Lloyd Wright and Le Corbusier," *Task*, 1(1941), 30-35. Cf. *idem.*, "The modern theorists of planning: Le Corbusier, Frank Lloyd Wright, etc." *South African Architectural Record*, 27(January 1942), 6-15.

419. McArthur, Albert Chase. [Letter about the designer of the Arizona-Biltmore Hotel]. *Architectural Record*, 89(June 1941), 7. A statement by Wright follows.

420. Reilly, Charles H. "Modern movements in architecture." *Listener*, 25(20 March 1941), 399-401.

421. Wright, Frank Lloyd. "America! Wake up!" *Progressive*, 5(21 June 1941), 2.

422. Wright, Frank Lloyd. "The American quality; with a picture section of outstanding works." *Scribner's Commentator*, 10(October 1941), 35-46.

423. Wright, Frank Lloyd. "Defense. A statement on World War II." *A Taliesin Square-Paper: a nonpolitical voice from our democratic minority*, (4 July 1941). The *Square-Paper* was one of the Taliesin Fellowship's ephemerals, published sporadically in sixteen editions, 1941-1953, mostly as a broadsheet.

424. Wright, Frank Lloyd. "Good afternoon, editor Evjue." *A Taliesin Square-Paper: a nonpolitical voice from our democratic minority*, (June 1941). Reprints an article on U.S. non-involvement in the war in Europe, first published in the *Madison Capital Times*, (29 May 1941). See also "Again 'good afternoon,' Mr. editor'," *ibid.*, first published in the *Madison Capital Times*, (6 June 1941).

425. Wright, Frank Lloyd. "Mumford lectures." *Saturday Review of Literature*, 24(23 August 1941), 15-16. Reviews Lewis Mumford, *The south in architecture: the Dancy lectures, Alabama college, 1941*, New York: Harcourt, Brace, 1941. The book was republished as *The South in architecture.*, New York: Da Capo, 1967.

426. Wright, Frank Lloyd. "Of what use is a great navy with no place to hide?" *A Taliesin Square-Paper: a nonpolitical voice from our democratic minority.* (15 May 1941).

427. Wright, Frank Lloyd. "Organic architecture." *Common Sense*, 10(April 1941), 108-109, 118.

428. Wright, Frank Lloyd, ed. *Taliesin. Journal of the Taliesin Fellowship*, 1(February 1941). This final issue included, besides an editorial and "Our work" by Wright, "How to stay out of the war (the American way)" by Burton J. Goodrich; "The playhouse and its visitors" and "Concerning superintendence" by Eugene Masselink; "Music" by Robert Carroll May; "In the Arizona desert. Taliesin West" by Robert Mosher; "An Englishman looks at Taliesin" by Charles Stanley Nott; "Fellowship at work: significance and direction" by William Wesley Peters; and "Social life" by Olgivanna Lloyd Wright.

429. Wright, Frank Lloyd."'Taliesin West', Arizona." *Architects' Journal*, 93(13 March 1941), 177-78.

430. Wright, Frank Lloyd. "To beat the enemy."*A Taliesin Square-Paper: a nonpolitical voice from our democratic minority.*(July 1941).

431. Wright, Frank Lloyd. "To London." *A Taliesin Square-Paper: a nonpolitical voice from our democratic minority*, (25 January 1941). The piece on postwar reconstruction of London was written for the London *News Chronicle* and widely published in other British newspapers. Excerpts are reprinted as "Wright over London," *Architectural Forum*, 75(August 1941), sup. 68.

432. Wright, Frank Lloyd. "Usonia, Usonia South and New England. A declaration of independence." *A Taliesin Square-Paper: a nonpolitical voice from our democratic minority.*(24 August 1941). Wright's plan for reorganizing the USA into a tri-state Federal Union.

433. *RIBA Journal.* "The Royal Gold Medal." 48(13 January 1941), 37-38. See also *ibid.*, (April 1941), 95; and "The RIBA Council 1940-41," *ibid.*, 47(15 July 1940), 222. For more about Wright's award of the RIBA Royal Gold Medal, see "The Royal Gold Medal: nomination of Mr. Frank Lloyd Wright," *Builder*, 160(10 January 1941), 26; "Britain honors Wright," *Architect and Engineer*, 144(January 1941), 56; "Frank Lloyd Wright," *Architect and Building News*, 165(10 January 1941), 16; "A major prophet of architecture," *Country Life*, 89(18 January 1941), 49; "Frank Lloyd Wright: a leader in American art," *Design*, 42(January 1941), 19-20; H. Granville Fell, "An American architect honoured," *Connoisseur*, 107(February 1941), 80-81; R.H., "Royal Gold Medal for architecture," *Studio*, 121(February 1941), 60; "Royal Medal comes to America," *Architectural Forum*, 74(February 1941), sup. 10; and *Pencil Points*, 22(March 1941), sup. 17.

434. *Architect and Engineer.* "Frank Lloyd Wright's newest creation: a college chapel designed to express the significance of a name—Florida." 146(July 1941), 34-36. Pfeiffer Chapel. See also Wm. S. Chambers Jr., "Innovation in

college chapel architecture," *Architectural Concrete*, 8(1942), 16-17.

435. *Architect and Engineer.* "Wright plans community church." 144(February 1941), 6. Community Church, Kansas City. Reprinted from *Illinois Society of Architects. Bulletin.*

436. *Architects' Journal.* "The immobile idea: home grown." 94(24 July 1941), 56-57. Taliesin West.

437. *Arizona Highways.* "An Arizona dwelling by Frank Lloyd Wright." 17(October 1941), 6-11. Pauson house.

438. *National Geographic.* "Tulsa home of editor Richard Lloyd Jones." 79(March 1941), 305. Photograph only.

439. *Real Estate.* "New home is Frank Lloyd Wright product." 16(22 March 1941), 17. Lewis house, Libertyville.

1942
Books, monographs and catalogues
440. Derleth, August. "The shining brow." In *The Wisconsin: river of a thousand isles.* New York; Toronto: Farrar and Rinehart, 1942. There is a brief biography of Wright.

441. Hitchcock, Henry-Russell Jr. *In the nature of materials: 1887-1941, the buildings of Frank Lloyd Wright.* New York: Duell, Sloan and Pearce, 1942. A survey of Wright's work 1887-1941, prepared under his supervision, was meant to replace the never-published catalogue of a 1940 MoMA exhibition, "Two great Americans", that also included film work of David W. Griffith. For other essays intended for the catalogue, see Mies van der Rohe in Johnson, *Mies van der Rohe*, New York: 1947 and Harris, *Architecture as an art.* Clinton: 1969.

For review and comment see "Usonian evolution," *Time*, 39(4 May 1942), 67; Frances Hartwell, *California Arts and Architecture*, 59(May 1942), 4-5; Elisabeth Coit, *Architectural Record*, 91(June 1942), 80; John C. Seward, *Pencil Points*, 23(June 1942), 128, 130; Christopher Tunnard, *Landscape Architecture*, 32(July 1942), 168-69; *American Artist*, 6(September 1942), 39; *Architectural Forum*, 76(June 1942), sup. 14; Barry Byrne, *Liturgical Arts*, 11(February 1943), 49; Lionel Brett, "The cyma and the hollyhock," *Architectural Record*, 93(March 1943), 80-81; Rexford Newcomb, *JSAH*, 3(October 1943), 51-52 and Robert L. Townsend, *RIBA Journal*, 56(March 1949), 236-37.

Also published London: Elek, 1958; reviewed Donald Tomkinson, *RIBA Journal*, 66(October 1959), 438-39. Republished in London, 1973, and by Da Capo, New York, 1973 (paperback 1975). The new edition includes Hitchcock's essay, "The later work of Frank Lloyd Wright, 1942-1959" (reprinted from *Architecture: nineteenth and twentieth centuries*, Maryland: 1963); reviewed David G. de Long, *Architecture Plus*, 1(May 1975), 13-14.

Periodicals
442. Goodman, Paul and Percival Goodman. "Frank Lloyd Wright on architec-

ture." *Kenyon Review*, 4 (Winter 1942), 7-28. Includes sections on organic architecture, domestic architecture, and Wright's conflict with the international style.

443. Moser, Werner Max. "Over het werk van architect F.L. Wright." *De 8 en Opbouw*, 13(November 1942), 137-40. Dutch: "About the work of architect F.L. Wright."

444. Not used.

445. *California Arts and Architecture*. "Frank Lloyd Wright builds a desert house for Miss Rose Pauson in Phoenix, Arizona." 59(April 1942), 18-19.

446. *Harper's Bazaar*. "Flight to the Valley of the Sun." 76(January 1942), 40-41, 45-47. Fashion photos, with the Pauson house as a background.

447. *Life.* [Portrait.] 13(November 9, 1942), 109.

1943
Books, monographs and catalogues
448. Fogg Museum of Art, Harvard University. *In memory of Frederick Randolph Grace, masters of four arts: Wright, Maillol, Picasso, Strawinsky.* Cambridge: The Museum, 1943. Catalogue of an exhibition, May 1943.

449. Rand, Ayn (Alisa Zinovievna Rosenbaum). *The fountainhead.* Philadelphia: Blakiston, 1943. The novel, whose main character, Howard Roark, is based on Wright, was also published Indianapolis; New York: Bobbs-Merrill, 1943. Reviewed Lorine Pruette, "Master builder," *NYTBR*, (16 May 1943) (abridged *ibid.*, [6 October 1996]). The book was reissued by Bobbs-Merrill, 1946, 1962 and 1968. It then went through 36 printings until a 25th anniversary edition, 1974, with a special introduction by Rand.

Other US editions include New York: New American Library, 1972; New York: Macmillan, 1972; New York: Simon and Schuster, 1972; New York: Macmillan, 1986; Norwalk: Easton Press, 1989, illustrated by Victoria Vebell; New York: Plume, 1994, with an afterword by Leonard Peikoff; Madison: Demco Media, 1995; Minneapolis: Econo-Clad Books, 1999; New York: Scribner, 2000, and New York: Simon and Schuster, 2000.

Also published in English in Canada: Toronto: New American Library of Canada, 1959; and in braille Toronto: CNIB, 1970; and in the UK: London: Cassell, 1947, 1958; London: Hamilton, 1961; and London: Grafton, 1986.

Published in Dutch as *De eeuwige bron* (translated by Jan van Rheenen), Laren: Luitingh, 1975, 1979; and Amsterdam: Luitingh-Sijthoff, 1993, 1999.

Published in two volumes in French as *La source vive* (translated by Jane Fillion), Geneva: J.-H. Jeheber, 1945; also Paris: Orban, 1981 and as a single volume Paris: Plon, 1997.

Published in German as *Der ewige Quell*, Zürich: Morgarten-Verlag, 1946. Also Munich: Goldmann, 1978, 1985, 1993; Rheda-Wiedenbrück: Bertelsmann-

Club, 1995; and Hamburg: GEWIS, 2000 (translation by Werner Habermehl).

Published in Italian as *La fonte meravigliosa,* Milan: Accademia, 1975 (translated by G. Colombo Taccani and M. Silvi); Milan: Corbaccio, 1996.

Published in Norwegian as *Kildens utspring* , Oslo: Aschehoug, 1949 (translated by Johan Hambro) and in Swedish as *Urkällan,* Köping: Lindfors, 1987; and Höganäs: Wiken, 1993 (translated by Ylva Spångberg) (reviewed Rasmus Waern, "Myten, moralem och Howard Roark," *Arkitekture,* 94[March 1994], 58-59).

Published in Spanish as *El manantial*; , Barcelona: Planeta, 1958 (translated by Luis de Paola). Further editions 1960, 1966, 1968, 1970, 1973, 1975, 1979, Barcelona: Orbis, 1984 and 1988. Also in Buenos Aires: Argonauta, 1948.

For commentaries see Michael Bierut, "A textbook case," *Interiors,* (July 1996), 88; Peter Reidy, "From Fallingwater to *The fountainhead*," *Journal of the Taliesin Fellows,* (Spring 1997), 22-24; Leon Krier, "Howard Roark defended against some of his admirers," *Classicist,* (1998-1999), 7-10; and Douglas J. Den Uyl, The Fountainhead*: an American novel.* New York: Twayne, 1999. See also David Kelley and Stephen Cox, Fountainhead*: a fiftieth anniversary celebration*, Poughkeepsie: Objectivist Center, 1993; Edward Gunts, "The fountainhead at 50," *Architecture,* 82(May 1993), 35-37; and Ellen Perry Berkeley, "On being Roarkian," *Oculus,* 55(March 1993), 11.

A 1949 film version, directed by King Vidor, starred Gary Cooper, Raymond Massey and Patricia Neal. See George Nelson, "Mr. Roark goes to Hollywood: a comment on Warner Brothers' attempt to interpret Frank Lloyd Wright to the masses," *Interiors,* 108(April 1949), 106-111; excerpts reprinted in "FLLW: the Hollywood version," *Interior Design,* 65(August 1994), 64-69; and "Requiem notes on *The fountainhead*," *AIA Journal,* 12(September 1949), 129-30. The movie was re-released in 1988: see Demetrios Matheou, "Architecture's only hero," *RIBA Journal,* 105(November 1988), 24-25.

1944
Books, monographs and catalogues
450. Mock, Elizabeth Bauer. *Built in USA, 1932-1944.* New York: Museum of Modern Art, 1944. Catalog of an exhibition held May 24-Oct. 22, 1944 Revised second edition, 1944. For a German translation of the second edition see *In USA erbaut,* Wiesbaden: Metopen-Verlag, 1948.

451. Wright, Frank Lloyd. *Taliesin to friends.* Spring Green: Taliesin Fellowship, 1944. The folded single-sheet tract includes Wright's "Four organic commandments." There have been several reprints.

Periodicals
452. Hitchcock, Henry-Russell Jr. "Frank Lloyd Wright and the 'academic tradition' of the early eighteen-nineties." *Journal of the Warburg and Courtauld Institutes,* 7(January-June 1944), 46-63. Reissued as a book, Worcester: Ebenezer, Vaylis and Sons, 1944. Includes discussion of the Charnley and Blossom houses and projects for Milwaukee Library and Museum, and Wolf Lake amusement park. Reprinted (Sidney) Fiske Kimball et al., *Nineteenth and*

twentieth century architecture, New York: 1976.

453. Kienitz, John Fabian. "The romanticism of Frank Lloyd Wright." *Art in America*, 32(April 1944), 91-101.

454. Pope, Loren. "Wright's influence on housing." *Michigan Society of Architects Weekly Bulletin*, 18(5 September 1944), 3.

455. Wright, Frank Lloyd. "American forum of the air—what are the air waves saying?" *AIA Journal*, 1(April 1944), 176-82. Excerpts from a nationally broadcast radio discussion about decentralization, 29 February 1944. Reprinted in Meehan ed. *The master architect: conversations with Frank Lloyd Wright.* New York: 1984.

456. Wright, Frank Lloyd. "Viewpoints: to the mole." *Magazine of Art*, 37(December 1944), 310, 312-15. *The New York Times* declined to publish this reply to Robert Moses' editorial in *NYT Magazine*, (18 June 1944). Cf. *idem.*, "To the mole," *A Taliesin Square-Paper: a nonpolitical voice from our democratic minority*, (14 August 1944).

457. *Architectural Forum.* "New York discovers an architect." 80(April 1944), 70. Guggenheim Museum. See also *Museum News*, 22(15 April 1944), 1; and "Frank Lloyd Wright is designing building for Guggenheim collection." *Architect and Engineer.* 157(June 1944), 4.

458. *Architectural Forum.* "Slum of the soul." 80(January 1944), 104, 106. Wright's comments on Chicago.

459. *Arizona Highways* "The sun country." 20(November 1944), 2-9. Arizona-Biltmore Hotel; photographs only.

460. *Pencil Points.* [Portrait photo by Terence Harold Robsjohn-Gibbings]. 25(April 1944), 14.

1945
Periodicals
461. Boswell, Peyton. "Comments: Frank Lloyd Wright's museum." *Art Digest*, 44(1 August 1945), 3. Guggenheim Museum.

The design was widely published and discussed throughout the year; see "Museum à la Wright," *Time*, 46(23 July 1945), 72; *Art News*, 44(August 1945), 6-7; *Architectural Forum* 83(August 1945), 8; "Post-war buildings," "Guggenheim museum plans spiral building," *Museum News*, 23(1 September 1945), 1-2; "Solomon R. Guggenheim museum of non-objective art, New York," *ibid.*, (1 October 1945), 1; "Optimistic ziggurat," *Time*, 46(1 October 1945), 74; "Monolithic masterpiece," *Architectural Forum*, (October 1945), 9 (illustrates models of the building); "Speaking of pictures. New art museum will be New York's strangest building," *Life*, 19(8 October 1945), 12-13, 15; "New museum plan based on logarithmic spiral," *Art News*, 44(15 October 1945), 15, 29; "Architects on the ramp-age," *Harper's Bazaar*, 191(October 1945), 388, 390; and Theodore Cook, "Museum in a spiral," *Christian Science Monitor*, (3 November 1945), 7.

Foreign interest was also stirred: "Un musée en spirale: le musée d'art Guggenheim." *Mouseion*, 101(December 1945), 3-4 (French).

462. Kienitz, John Fabian. "Fifty-two years of Frank Lloyd Wright's progressivism, 1893-1945." *Wisconsin Magazine of History*. 29(September 1945), 61-71.

463. Patterson, Augusta Owen. "A Frank Lloyd Wright house for Connecticut." *Town and Country*, 100(December 1945), 129-31, 219. Loeb house project. See also "Country house in Connecticut, U.S.A., designed by Frank Lloyd Wright," *Architects' Journal*, 104(19 September 1946), 213-14; "Wright makes it right," *Time*, 48(1 July 1946), 73; "Hilltop house for G. Loeb," *Architectural Forum'* 84(June 1946), 83-88; "Men against Wright [letters to the editor]," *ibid.*, 85(August 1946), 34; John Lloyd Wright and Donald Koehler, [Letters], *ibid.*, (November 1946), 44; and Norbert Troller, [Letter], *ibid.*, 86(April 1947), 22.

464. Ponti, Gio. "Un sogno, una realtà." *Stile*, (1945), 2-5. Italian: "One dream, one truth."

465. Pratt, Richard. "Opus 497." *Ladies' Home Journal*, 62(June 1945), 138-139. Glass house, "Opus 497" (project). See also Henrietta Murdock, "Accent on living," *ibid.*, 141; "Glass house, 'Opus 497'," and "American small house exhibition at [MoMA]," *Architects' Journal*, 102(30 August 1945), 159; "Houses for the people," *Pencil Points*, 26(September 1945), 59-66; and "Het kleine huis van morgen in Amerika [the small house of tomorrow in America]," *Bouw*, 1(1946), 239-43 (Dutch).

466. Wright, Frank Lloyd. "Nature." *A Taliesin Square-Paper: a nonpolitical voice from our democratic minority*, (August 1945).

467. Wright, Frank Lloyd. "On organic architecture." *National Council of Architectural Registration Boards. Weekly Bulletin*, 19(10 April 1945), 8-9. The text of a lecture to the Michigan Society of Architects, 22 March 1945. Reprinted in Meehan ed. *Truth against the world*, New York: 1987.

468. *Architectural Forum*. "Monolithic masterpiece." 83(October 1945), 9. Notes the Imperial Hotel's survival of wartime bombing. But see "Made in Japan, U.S. designed," *Time*, 46(24 September 1945), 46, about damage.

469. *Milwaukee Art Institute Bulletin*. "When democracy builds." 18(November 1945), 1-2. Description of exhibit at Milwaukee Art Institute.

470. *South African Architectural Record*. "Developments and trends in American architecture 1939-1944: houses." 30(December 1945), 266-73.

471. *South Australian Homes and Gardens*. "A practical approach to the home-making problem." (1 November 1945), 24-25 ff. Fallingwater.

1946
Books, monographs and catalogues
472. Japanese Ministry of Transportation. *A short history of the Imperial Hotel*. Tokyo: The Ministry, 1946.

473. Usonia Homes: a Cooperative, Inc. *Usonia Homes: a Cooperative.* n.l.: n.p., [1946?]. Brochure.

474. Wright, John Lloyd. *My father who is on earth.* New York: Putnam, 1946. It includes the text of *The house beautiful*, 1896. Reviewed Lloyd Lewis, *Book Week*, (31 March 1946), 40; Iris Barry, *Weekly Book Review*, (31 March 1946), 14; "Great papa," *Time*, 47(1 April 1946), 55; "Life with Father Wright," *Newsweek*, 27(3 April 1946), 90; Ely Jacques Kahn, "Life, more or less, with father," *Saturday Review of Literature*, 29(13 April 1946), 52; *New Yorker*, 22(13 April 1946), 119; *Best Sellers*, 6(15 April 1946), 14; Mary Sanders, *Architectural Forum*, 84(May 1946), 156, 158; "Fabulous father," *Architectural Record*, 99(May 1946), 26; and *La Jollan*, 1(23 October 1946), 11.

Reprinted Carbondale: Southern Illinois University Press, 1994; reviewed Mark Heyman, *Journal of the Taliesin Fellows*, (Spring 1995), 26-28.

Also published as *My father, Frank Lloyd Wright*, New York: 1992, edited by Narciso G. Menocal, with additional material by the author and Frank Lloyd Wright, and a postscript by Elizabeth Wright Ingraham. Reviewed B. Alexander, *TLS*, (16 October 1992), 32.

Periodicals
475. Carlo, Giancarlo de. "L'insegnamento di Frank Lloyd Wright." *Domus*, (March 1946), 21-24. Italian: "The lesson of Wright."

476. Gordon, Elizabeth. "One man's house." *House Beautiful*, 87(December 1946), 186-196, 235. Taliesin West.

477. Harriman, Georges. "Die Bauten Frank L. Wrights." *Bauhelfer*, 1(July 1946), 17-18. German: "Wright's buildings."

478. Middeldorf, Ulrich. "Architecture as an art." *College Art Journal*, 6(August 1946), 37-40. Prologue to a lecture by Wright at the University of Chicago, Spring 1946.

479. Mies van der Rohe, Ludwig. "A tribute to Frank Lloyd Wright." *College Art Journal*, 6(August 1946), 41-42. Reprinted in Philip Cortelyou Johnson, *Mies van der Rohe*, New York: MoMA, 1947 and subsequent editions; and Fritz Neumeyer, *The artless word. Mies ... on the building art*, Cambridge, Mass.: MIT Press, 1991. For an abridged Italian translation see *Emporium*, 107(March 1948), 119.

480. Nelson, George. "Wright's houses. two residences, built by a great architect for himself, make the landscape look as if it had been designed to fit them." *Fortune*, 34(August 1946), 116-25. Reprinted in *idem., Problems of design*, New York: Whitney 1957 (also published 1969, 1975).

481. Pica, Agnoldomenico. "Frank Lloyd Wright e l'architettura Europa." *Stile*, (May 1946), 7-13. Italian: "Frank Lloyd Wright and European architecture."

482. Sargeant, Winthrop. "Frank Lloyd Wright: the titan of modern architecture still flings his houses and his insults at backward colleagues." *Life*, 21(12 August

1946), 84-88, 90ff. Condensed as "Titan of modern architecture," *Reader's Digest*, 49(November 1946), 31-35. For an Italian translation see *Nuova Citta*, 1(October-November 1946), 22-31.

483. Veronesi, Giulia, "L'ora di Wright e la voce di Le Corbusier." *Il Politecnico*, 31-32(1946), 76-77. Italian: "Wright's hour and Le Corbusier's voice."

484. Wright, Frank Lloyd. "Antologia di Frank Lloyd Wright." *Stile*, (January 1946), 1-5. Italian: "Wright anthology." Translations of unidentified excerpts from Wright's writings.

485. Wright, Frank Lloyd. "Building a democracy." *A Taliesin Square-Paper: a nonpolitical voice from our democratic minority*, (29 October 1946). T ext of a speech at the Fifteenth Annual *New York Herald Tribune* forum on current thought. Also published as "The right to be one's self," *Husk*, 26(December 1946), 37-40; in *Albright [Buffalo] Art Gallery notes*, 11(June 1947), 14-18; and in *Marg* [Mumbai, India], 1(January 1947), 20-24, 47. Reprinted in Meehan ed. *Truth against the world*, New York: 1987. See also "Work and theories of Frank Lloyd Wright," *Listener*, 36(12 December 1946), 837-40.

486. Wright, Frank Lloyd. "Democratie et architecture." *Chantiers*, 1(December 1946), 3. French: "Democracy and architecture." Excerpt, translated from *When democracy builds*. University of Chicago Press, 1945.

487. Wright, Frank Lloyd. "The modern gallery." *Architectural Forum*, 84(January 1946), 82-88. Cf. *idem.*, "The modern gallery for the Solomon R. Guggenheim Foundation: New York City," *Magazine of Art*, 39(January 1946), 24-26; and *Architectural Forum*, 86(January 1948), 136-38. See also "New York modern art gallery models," *Architect and Engineer*, 166(August 1946), 8, that includes a note on Dr. Jaroslav Joseph Polivka, the project engineer.

Interest in the museum was sustained in the 1946 literature. See "The modern gallery: the world's greatest architect, at 74, designs the boldest building of his career," *Architectural Forum*, 84(February 1946), 81-88; and Edgar J. Kaufmann Jr., "The violent art of hanging pictures," *Magazine of Art*, 39(March 1946), 108-113.

There was also foreign interest; see "Le musée en spirale [The museum in a spiral]," *Arts*, (22 March 1946), 1 (French); "Una original concepção arquitectonica [An original architectural concept]," *Arquitectura Portuguesa*, 39(April 1946), 19-21 (Portuguese, translated from *A Revista de Arquitectura)*; V.-G., "De S.R. Guggenheim foundation te New York," *Phoenix*, 1(no. 2, 1946), 27 (Dutch); "Eclairage d'un musée [Lighting a museum]," *Techniques et Architecture*, 6(1946), 66-67 (French); and M.A. Stranger, "Ronde huizen en een rond museum [Round houses and a round museum]," *Kroniek van Kunst en Kultuur*, 8(no. 3, 1946), 85-86, 95 (Dutch).

488. Wright, Frank Lloyd. "To a hero nation: Ireland." *Architecture in Ireland. Yearbook of the Institute of Architects for 1946*, 29-30.

489. *Architects' Journal.* "Project for a week-end house by Frank Lloyd

Wright." 104(25 July 1946), 67. Model displayed at the "Regional Building in the United States" exhibition, Heal's gallery, London.

490. *Architectural Forum.* "Another Frank Lloyd Wright building is planned by Johnson Wax." 84(February 1946), 10. S.C. Johnson and Son research tower. See also "A haven for work," *Northwest Architect,* 10(no. 4, 1946), 16-17.

491. *Building and Engineering* [Australia]. "Frank Lloyd Wright again." (24 August 1946), 27. Model of Johnson Wax research tower, reprinted from *New York Times.*

492. *Forum* [Netherlands]. "Frank Lloyd Wright *en famille.*" 1(no. 2, 1946). Dutch: "Frank Lloyd Wright at home." Brief excerpt from John Lloyd Wright, *My father who is on earth,* New York: 1946.

493. *House Beautiful.* "Meet Frank Lloyd Wright." 88(June 1946), 76-77, 163.

494. *House Beautiful.* "The most influential design source of the last 50 years." 88(December 1946), 185.

495. *Listener.* "Work and theories of Frank Lloyd Wright." 36(12 December 1946), 837-40. Includes "Influence in this country [England]" by Lionel Brett; "Organic architecture" by James Maude Richards; and "The right to be oneself" by Wright. Reprinted in Elkan Allan, *Living opinion; a collection of talks from the B.B.C.'s third programme,* London: Hutchinson, 1949.

496. *Progressive Architecture.* "House at Bloomfield Hills, Michigan." 27(October 1946), 67-70. Gregor Affleck house.

1947
Books, monographs and catalogues
497. Mies van der Rohe, Ludwig. "Frank Lloyd Wright." In Philip Cortelyou Johnson, *Mies van der Rohe,* New York: Museum of Modern Art, 1947. The essay was intended for a never-published catalogue of a MoMA exhibition, "Two great Americans" (1940), that included the work of Wright and filmmaker D.W. Griffith. See also Hitchcock, *In the nature of materials: 1887-1941,* New York: 1942 and Harris, *Architecture as an art.* Clinton: 1969 for other essays meant for the catalogue.

498. Wright, Frank Lloyd. "The architect." In Robert B. Heywood, Mortimer J. Adler et al. eds. *The works of the mind. For the Committee on Social Thought,* University of Chicago Press, 1947.

499. Zevi, Bruno Benedetto. *Frank Lloyd Wright.* Milan: Il Balcone, 1947. Reviewed *Emporium,* 107(June 1948), 279; Franca Maurogordato, *Progressive Architecture,* 29(October 1948), 138, 140. Revised 1954. Also published in Spanish, Buenos Aires: Infinito, 1956 and Barcelona: Gustavo Gili, 1985. Cf. Zevi ed. *Frank Lloyd Wright,* Bologna: Zanichelli, 1979 (also published in German and French, Zürich: Artemis, 1980; reprinted 1981).

Periodicals

500. Argan, Giulio Carlo. "Introduzione a Wright." *Metron*, (no. 18, 1947), 9-24. Italian: "Introduction to Wright."

501. Baldwin, Guy H. "Modernism, 1906, Part I." *Empire State Architect*, 7(January-February 1947), 8, 21. Larkin Company administration building. See also Part II, (March-April), 8, 19 (Darwin D. Martin house).

502. Danes, Gibson. "Architectural sculpture today." *Magazine of Art*, 40(May 1947), 170-75.

503. Hadley, Homer M. [Letter]. *Architectural Forum*, 86(February 1947), 22. Imperial Hotel.

504. Hansen, Preben. "Fra Wren til Wright." *Bonytt*, 7(1947), 127-31. Danish: "From Wren to Wright."

505. Hitchcock, Henry-Russell, Jr. "The architecture of bureaucracy and the architecture of genius." *Architectural Record*, 101(January 1947), 3-6.

506. Hitchcock, Henry-Russell, Jr. "Notes on Wright buildings in Buffalo." *Albright Art Gallery notes*, 11 (June 1947), 18-21. Larkin Company administration building; Barton, Davidson, Heath and Martin houses.

507. Huggler, Max and Georg Schmidt. "Das Guggenheim-Museum von Frank Lloyd Wright in New York: zwei Museumsdirektoren äuszern sich zu einer gründsätzlechen Idee." *Werk*, 34(June 1947), 188-92. German: "... Guggenheim Museum in New York: two museum directors concerned with a basic idea."

508. Kaufmann, Edgar J., Jr. and Philip Cortelyou Johnson. "Four new buildings." *Horizon*, (October 1947), 62-65. Includes Guggenheim museum; sports club for Huntington Hartford, Hollywood.

509. Kaufmann, Edgar J., Jr. "Undampened Wright." *Architectural Forum*, 87(July 1947), 22. Fallingwater.

510. Portela, Francisco V. "La arquitectura di Frank Lloyd Wright." *Norte*, 7(January 1947), unp. Spanish: "The architecture of Frank Lloyd Wright."

511. Salter, L.J. [Letter.] *Architectural Forum*, 86(January 1947), 34. Notes that Lehmann Hisey's account of the 1923 Tokyo earthquake was published in *Pasadena Star-News*, (26 September 1923).

512. Sholta, Jan. [Letter about Wright's houses.] *Architectural Forum*, 86(May 1947), 26, 28. Replies from Edgar Kaufmann and Gregor Affleck, *ibid.*, (July 1947), 22.

513. Troller, Norbert. [Letter.] *Architectural Forum*, 86(April 1947), 22. Guggenheim Museum; Loeb house.

514. Winston, Elizabeth. "Advocates of modern design rally strongly to the defense of Frank Lloyd Wright." *Weekly Bulletin of the Michigan Society of Architects*, 21(22 July 1947), 1. Reprinted from the *New York Herald Tribune*.

515. Wright, Frank Lloyd. "Mimic no more." *A Taliesin Square-Paper: a nonpolitical voice from our democratic minority*, (6 March 1947). Text of a speech at the Princeton conference, "Planning Man's Physical Environment", 6 March 1947. See also *Architectural Record*, 101(April 1947), 98; 517 below.

516. Wright, Frank Lloyd. "Notes and comments [on the design for the United Nations headquarters, New York]." *Architects' Journal*, 106(28 August 1947), 183. See also *idem.*, "We must shape true inspiration," *NYT Magazine*, (20 April 1947), 59.

517. Wright, Frank Lloyd. "Planning man's physical environment." *Berkeley, a Journal of Modern Culture*, (1947), 5, 7. Reprinted in Meehan ed. *Truth against the world*, New York: 1987.

518. *Architect and Building News*. "Design for the Solomon R. Guggenheim Foundation: New York." 190(25 April 1947), 70-73.

519. *Architects' Journal*. "Florida Southern College, designed by Frank Lloyd Wright." 106(25 December 1947), 559-61.

520. *Architectural Forum*. "Awards." 87(July 1947), 64. Wright elected to National Institute of Arts and Letters. See also *Architectural Forum*, 86(February 1947), 12; and *National Architect*, 3(February 1947), 4.

521. *Architectural Forum*. "Glass hotel in Dallas." 87(August 1947), 12. Rogers Lacy Hotel (project).

522. *Architectural Forum*. "Houses U.S.A., the modern pioneers." 86(May 1947), 81-88.

523. *Architectural Forum*. "Planners' platform." 86(April 1947), 13.

524. *Bouwkundig Weekblad*. "Nieuwere Amerikaansche architectuur." 65(1947), 171-73. Dutch: "Latest American architecture."

525. *Buffalo Fine Arts Academy Gallery Notes*. "Notes on Wright buildings in Buffalo." (11 June 1947), 19-22.

526. *Horizon*. "The modern gallery: bequest of Solomon R. Guggenheim." 16(October 1947), unp. See also *ibid.*, "Sports club for Huntingdon Hartford, Hollywood, California."

527. *RIBA Journal*. "Presentation of Royal Gold Medals for the war years." 54(May 1947), 351-57.

528. *Time*. "Happy mortuary." 49(27 January 1947), 63. Daphne Funeral Chapels, San Francisco (project).

1948
Periodicals
529. Churchill, Henry Stern. "Notes on Frank Lloyd Wright." *Magazine of Art*, 41(February 1948), 62-66.

530. Churchill, Henry Stern. "Un notable arquitecto: Frank Lloyd Wright." *Revista Excelsior*, 14 (June-July 1948), 43. Spanish: "A notable architect"

531. Gilmore, William. "Frank Lloyd Wright: architecte du nouveau monde." *Art et Industrie*, (no. 11, 1948), 31-34. French: "Wright: architect of the new world."

532. Hicks, Clifford B. "Architecture from the ground up." *Popular Mechanics*, 89(April 1948), 164-68, 256. Taliesin Fellowship.

533. Kennedy, Sighle, "Color film: five California houses by Wright." *Architectural Forum*, 89(September 1948), 200. Review.

534. Mock, Elizabeth Bauer. "Taliesin West." *House and Garden*, 94(August 1948), 52-55.

535. Pope, Loren. "The love affair of a man and his house." *House Beautiful*, 90(August 1948), 32-34, 80, 90. Pope-Leighey house.

536. R.M.C. "Frank Lloyd Wright on hospital design." *Modern Hospital*, 71(September 1948), 51-54.

537. Stillman, Seymour. "Comparing Wright and Le Corbusier." *AIA Journal*, 9(April 1948), 171-78; (May 1948), 226-33. Condensation of the winning entry in the MIT Architecture and Planning School's annual essay competition, 1948.

538. Stowell, Kenneth K." Basis for the highest honor." *Architectural Record*, 104(November 1948), 91. AIA Gold Medal. See also "Architects in the news this month," *National Architect*, 4(December 1948), 3-4.

539. Thomas, Mark Hartland. "American review: Frank Lloyd Wright." *Architectural Design*, 18(April 1948), 83-88.

540. Whitcomb, Mildred. "Begin with a hoe: an interview with Frank Lloyd Wright." *Nation's Schools*, 42(November 1948), 20-24.

541. Wright, Frank Lloyd. "Die moderne Galerie der Guggenheim Stiftung in New York." *Kunst*, 1(1948), 111-13. German: "The Guggenheim Foundation's modern gallery in New York."

542. Wright, Frank Lloyd. "Harum-scarum." *A Taliesin Square-Paper: a nonpolitical voice from our democratic minority*, (5 May 1948).

Store; Rogers Lacy Hotel; Clover543. *Architectural Forum*. "Frank Lloyd Wright." 88(January 1948), 65-156, editor's note and portrait of Wright, 54. The second issue of the *Forum* devoted to Wright's work included the following buildings: Usonian houses; Taliesin West; "Auldbrass"; Johnson research tower; Florida Southern College, Lakeland; Guggenheim Museum, New York; Parkwyn Village master plan; Usonia I master plan; and Madison Unitarian Church. Several projects were also published: Huntington Hartford play resort and sports club; Adelman laundry plant; Butterfly Bridge, Spring Green; Daphne Funeral Chapels; Sarabliai Calico Mills leaf Housing Project; Co-operative Homesteads,

Detroit; and Elizabeth Arden desert spa. Reissued as *Frank Lloyd Wright*, New York: Time, 1948. For comment see "Ahead of his time," *Time*, 51(9 February 1948), 68-69.

544. *Architectural Forum*. "Usonia homes: every family has an acre." 89(October 1948), 16. Pleasantville. Cf. "Wright homes for Westchester," *Architectural Record*, 104(November 1948), 10, 170.

545. *Builder*. "Frank Lloyd Wright: a reassessment." 174(5 March 1948), 274-76. A reply from P. Taylor and a rejoinder appeared *ibid.*, (26 March), 367-68 and (9 April), 431.

546. *Byggmästaren*. "Taliesin West, arkitekten Frank Lloyd Wrights vinterbostad i Arizona." 1(1948), 8-12. Swedish: "Taliesin West, Wright's Arizona winter retreat."

547. *Harper's Bazaar*. [Portrait by Henri Cartier-Bresson.] 82(March 1948), 200.

548. *House and Home*. "Three new houses by Frank Lloyd Wright." 14(August 1948), 101-113.

549. *L'Architecture d'Aujourdhui*. "Frank Lloyd Wright et FO. N. U." 19(January 1948), xv. French. Wright's comment on the United Nations building, New York.

1949
Books, monographs and catalogues
550. Chicago Art Institute. Burnham Library of Architecture. *Buildings by Frank Lloyd Wright in six middle western states: Illinois, Indiana, Iowa, Michigan, Minnesota, Wisconsin*. Chicago: The Library, 1949. Revised 1954, and again in 1963 as *The Chicago Art Institute. Guide to Chicago and midwestern architecture*, which also included buildings in Ohio and "a selective guide to Chicago architecture adapted from lists prepared by John Replinger and Allan Frumkin." Reviewed *Prairie School Review*, 1(no. 3, 1964), 17.

551. Conant, Kenneth John. *Tres conferencias sobre arquitectura moderna en los Estados Unidos*. Buenos Aires: Universidad de Buenos Aires, Facultad de Arquitectura y Urbanismo, Instituto de Arte Americano e Investigaciones Esteticas, 1949. Spanish: *Three cectures on modern architecture in the United States*. Transcribes lectures presented in August 1947, including "Frank Lloyd Wright, innovador de la arquitectura moderna [Wright, innovator of modern architecture]."

552. New Theatre Corporation. *The new theatre. Frank Lloyd Wright, architect*. Hartford: The Corporation, 1949. A pamphlet describes a never-realized theater for Hartford, Connecticut, with a statement by Wright and images of the design. Excerpts are reprinted in *American Theatre*, 17(September 2000), 30-31.
 For comment see "Wright's first theater design, to be erected on the outskirts

of Hartford, Conn.," *Interiors*, 108(January 1949), 12; "Museum shows large model of Wright's theater," *Architectural Record*, 105 (May 1949), 156; Sighle Kennedy, "Wright's Hartford Theater shown in a New York City museum exhibit," *Architectural Forum*, 90(May 1949), 162-63; Lloyd Lewis, "The new theater," *Theatre Arts*, 33(July 1949), 32-34; David Pleydell Bouverie, *Architectural Review*, 106(September 1949), 193; "Down with the East," *Time*, 56(25 September 1950), 77; and "Théâtre à Hartford, Frank Lloyd Wright," *Architecture d'Aujourd'hui*, 20(May 1949), 26 (French).

See also Wright, "Tribute to L. Lewis," *Theatre Arts*, 33(July 1949), 32 (reprinted Pfeiffer ed. *Frank Lloyd Wright collected writings. Vol. 5*, New York: 1995).

553. Wright, Frank Lloyd. "Education, individualism, and architecture." In Thomas Hawk Creighton, ed. *Building for modern man; a symposium.* Princeton University Press, 1949. Reprinted Freeport: Books for Libraries Press, 1969.

554. Wright, Frank Lloyd. *Genius and the mobocracy.* New York: Duell, Sloan and Pearce, 1949. Biography of Louis Sullivan. One chapter was reprinted as "Sullivan against the world," *Architectural Record*, 105(June 1949), 295-98.

Reviewed "Frank Lloyd Wright on Louis Sullivan," *Architectural Forum*, 91(August 1949), 94-97; "Wright's Sullivan," *Architectural Record*, 106(August 1949), 28; David Spitz, *Saturday Review of Literature*, 32(3 September 1949), 21; "Sullivan recalled," *Progressive Architecture*, 30(October 1949), 106; Hugh Morrison, *Magazine of Art*, 44(April 1951), 154-55; Talbot Faulkner Hamlin, "A great American architect pays tribute to his teacher," *NYTBR*, (10 July 1949), 3.

A Canadian edition was published by William Collins Sons, Toronto; reviewed *RAICanada Journal*, 26(September 1949), 304.

An enlarged edition was published New York: Horizon, 1971; reviewed *Choice*, 8(January 1972), 1447.

A third (again enlarged) version was published London: Secker and Warburg, 1972. Reviewed Wilbert Hasbrouck, *Prairie School Review*, 8(no. 3, 1971), 14-18; *Bookman's Weekly*, 48(20 September 1971), 736; R.R. Harris, *Library Journal*, 96(1 November 1971), 3596; *Choice*, 8(January 1972), 1447; Edgar A. Tafel, *AIA Journal*, 57(March 1972), 62-63; *TLS*, (19 May 1972), 568; Caroline Tisdall, "A howl of rage," *Guardian*, 108(20 May 1972), 22; Dennis Sharp, "In his master's steps," *Design*, (August 1972), 73. Excerpts are reprinted as "The master's work," *American Art Review*, 2(May- June 1975).

Periodicals
555. Blake, Peter. "Architect from the prairies." *NYT Magazine*, (5 June 1949), 24-25. Summary of Wright's career.

556. Caballeros, Damas Y. "Frank Lloyd Wright." *Proyectos y Materiales*, 5(September-October 1949), 18-20, 60- 61. Spanish.

557. Downs, G.A. "F.LL.W. at Carnegie Tech [letter]." *Architectural Forum*, 106(September 1949), 26-27.

558. Johnson, Philip Cortelyou. "The frontiersman." *Architectural Review*, 106(August 1949), 105-110.

559. Laporte, Paul M. "Architecture and democracy." *Architects' Yearbook*, 3(1949), 12-19. Fallingwater.

560. Moloobhoy, Sherrif. "Offices and stores for calico mills, Ahmedabad." *Marg* [Mumbai, India], 3(1949), 14-16. Sarabhai Calico Mills store (project).

561. Pellegrini, Enrico. "Il gusto del liberty." *Domus*, (October 1949), 10-11, 47. Italian: "The taste of liberty."

562. Roche, Mary. "Chairs designed for sitting." *NYT Magazine*, (21 August 1949), 34-35.

563. Stoddard, Donna M. "Frank Lloyd Wright designs a college." *Design*, 50(June 1949), 12-13, 23. Florida Southern College.

564. Towndrow, F.E. "Homage to Frank Lloyd Wright." *Architecture* [Australia], 37(July 1949), 95.

565. Townsend, Robert L. "Frank Lloyd Wright: on his eightieth birthday." *AA Journal*, 65(October 1949), 64-69.

566. Wright, Frank Lloyd. "A los jovenes arquitectos." *Arquitectura*, 17(November 1949), 315. Spanish: "To the young architects."

567. Wright, Frank Lloyd. "I don't like hardware." *Hardware Consultant and Contractor*, 13(May 1949), 22 ff. Text of a speech to the Pacific Coast regional conference of the National Contract Hardware Association, Arizona-Biltmore Hotel, Phoenix. The issue includes other references to Wright. Also in *Michigan Society of Architects Weekly Bulletin*, 23(16 August 1949), 1-3, and reprinted in Meehan ed. *Truth against the world*, New York: 1987.

568. *Architects' Journal*. "The new curiosity shop." 110(10 November 1949), 512, 516. Morris gift shop. A comparison with the Glessner house, Chicago (architect, H.H. Richardson), is published *ibid.*, (8 December), 639.

569. *Architectural Forum*. [Portrait.] 91(July 1949), 14.

570. *Architectural Forum*. "Frank Lloyd Wright: A.I.A. will give belated honor to world's great architect." 90(January 1949), 14. The announcement of the medal and its conferral were widely reported. See "Architect Wright given Gold Medal," *Architect and Engineer*, 176(January 1949), 31; "The prophet honored in his own country," *Esquire*, 31(January 1949), 42-43; "Wright to receive Gold Medal," *Architectural Record*, 105(February 1949), 158; "Medal for a titan," *Newsweek*, 33(28 March 1949), 74-75; "To Frank Lloyd Wright, the Gold Medal," *AIA Journal*, 11(March 1949), 114-15; "Citation with the Gold Medal to Frank Lloyd Wright," *ibid.*, 11(April 1949), 163; "A.I.A. meets in Houston," *Architectural Forum*, 90(April 1949), sup. 17; and "The eighty-first convention

of the A.I.A., Houston, Texas, March 15th to 18th, 1949," *Architectural Record*, 105(May 1949), 86-87. The occasion was also reported in France: *L'Architecture d'Aujoudhui*, 20(June1949), v.

For Wright's formal reply see *A Taliesin Square-Paper: a nonpolitical voice from our democratic minority*, (17 March 1949); "Acceptance speech of Frank Lloyd Wright upon receiving the Gold Medal for 1948," *AIA Journal*, 11(May 1949), 199-207; and a condensation in *Progressive Architecture*, 30(May 1949), 24, 26 (edited and reprinted in Meehan ed. *Truth against the world*, New York: 1987).

571. *Architectural Record*. "Mr. Wright spanks education." 105(February 1949), 168.

572. *Arquitectura*. "Homenaje al Maestro Frank Lloyd Wright." 17(June 1949), 185-187. Spanish: "Homage to the master Frank Lloyd Wright."

573. *Brick and Clay Record*. "Brick—known and loved best." 115(November 1949), 33, 68, 70.

574. *Interiors*. [Theater for Patterson Price]. 108(no. 10, 1949), 18.

575. *L'Architecture d'Aujourdhui*. "Frank Lloyd Wright." 20(June 1949), v. French.

576. *L'Architecture d'Aujourdhui*. [Portrait.] 20(March 1949), ix. French.

1950-1959

1950

Books, monographs and catalogues

577. Kaufmann, Edgar J. Jr. *V. C. Morris.* [n.p.: 1950?]. A pamphlet about the Morris gift shop includes articles by Mr. and Mrs. Morris; Kaufmann (same as "The Wright setting for decorative art," *Art News*, 48[February 1950], 42-44); and Elizabeth Bauer Mock (same as "China and gift shop for V.C. Morris," *Architectural Forum* 92[February 1950], 79-85; see *ibid.*, 92(April 1950), 54 ff.

578. Wright, Frank Lloyd. "Building for the sick." In *Proceedings of the Southern Conference on Hospital Planning, Hotel Buena Vista, Biloxi, Mississippi.* Montgomery, Alabama: The Conference, 1950. Reprinted in Meehan ed. *Truth against the world*, New York: 1987.

579. Wright, Frank Lloyd. *A demonstration of the Gurdjieff movements by the Taliesin Fellowsbip at Taliesin in Wisconsin on October 29th, 1950.* Spring Green: The Fellowship, 1950. The program includes the text of Wright's talk at the demonstration. Cf. *idem., Fourth demonstration of the Gurdjieff movements by the Taliesin Fellowship at Taliesin West, Easter, 1951; The art and knowledge in the ritual exercises of Gurdjieff, presented by the Taliesin Fellowship at the Unitarian Church of Madison on Tuesday, November 6, 1951;* and *Music, ritual exercises, and temple dances by Georges Gurdjieff* (Goodman Theatre, 3 November 1953), all published by the Taliesin Fellowship.

580. Zevi, Bruno Benedetto. *Towards an organic architecture.* London: Faber and Faber, 1950. Originally *Verso un'architettura organica.* Torino: 1945.

Periodicals

581. Dibbits, ——. "Bouw der bruggen." *Bouw*, 5(1950), part 2, 816-18. Dutch: "The building of bridges."

582. Graaff, C. de. "The man is what he does." *Bouw*, 5(1950), part 1, 741-42. Dutch.

583. Hartsuyker, Hendrick. "Ontmoeting met Frank Lloyd Wright." *Forum* [Amsterdam], 5(1950), 309-11. Dutch: "Meeting Wright." Cf. H.C., "Frank Lloyd Wright in Zürich," *Werk*, 37(September 1950), 128-29 (German).

584. Jordan, Robert Furneaux. "A great architect's visit to Britain." *Listener*, 44(28 September 1950), 415-16. Announces that Wright is guest of honor at the AA School prize-giving. See also "Lloyd Wright in Britain, [Mr. Jordan's] radio talk," *Builder*, 179(24 November 1950), 540; "Annual prize-giving, presentations by Mr. Frank Lloyd Wright," *AA Journal*. 66(August-September 1950), 32-42; "Dinner to Mr. and Mrs. Frank Lloyd Wright," *ibid.*, 44-46 (both reprinted in Meehan ed. *Truth against the world ...* , New York: 1987); and "July 14. AA school annual prizegiving, Bedford Square, W.C.1," *Architects' Journal*, 112(27 July 1950), 86-87.

 The text of Wright's speech is published in *Architectural Design*, 20(August 1950), 219, 232; *Builder*, 179(21 July 1950), 97; and reprinted *AA Quarterly*, 5(January-March 1973), 46-47.

585. Lamoreaux, Jeanne. "Taliesin ... rural workshop for master builders." *Harvester World*, 91(August 1950), 2-8. See also *Charette*, (September 1950), 14-17.

586. Loeb, Gerald. "A stockbroker meets F.LL.W." *Architectural Forum*, 93(August 1950), 24, 28. Reprinted in *Architecture and Arts* [Australia], (November 1956), 15, 33.

587. Maza, Aquiles. "Miguel Angel del siglio XX." *Arquitectura*, 18(April 1950), 122-35. Spanish: "Twentieth century Michelangelo."

589. Moya, Luis. "Frank Lloyd Wright." *Revista Nacional de Arquitectura*, 10(March 1950), 103-108. Spanish. Wright and Gaudi compared.

590. Wright, Frank Lloyd. "An adventure in the human spirit." *Motive*, 11(November 1950), 30-31. An address given during Founder's Week at Florida Southern College. Reprinted as a booklet, *An address by Frank Lloyd Wright: in connection with the Founders Week*, Lakeland: The College, 1950. Reprinted in Meehan ed. *Truth against the world*, New York: 1987.

591. Wright, Frank Lloyd. [Speech at Southern conference on hospital planning, Biloxi, Mississippi, 1949.] *Proceedings, Southern Conference on Hospital Planning*, (22 February 1950), 103-114. Same as 578,

592. Zevi, Bruno Benedetto. "Frank Lloyd Wright and the conquest of space." *Magazine of Art*, 43(May 1950), 186-91. Translated from the introduction to *idem., Frank Lloyd Wright*, Milan: 1947.

593. Zevi, Bruno Benedetto. "Mies van der Rohe e Frank Ll. Wright, poeti dello

spazio." *Metron*, (July-August 1950), 6-18. Italian: "Mies van der Rohe and Frank Ll. Wright, poets of space."

594. *Architect and Building News*. "Laboratory tower for S.C. Johnson and Company." 198(1 December 1950), 582-83.

595. *Architect and Engineer*. "Solomon R. Guggenheim Memorial Museum designed by Frank Wright." 180(February 1950), 6.

596. *Architect and Engineer*. "Wax research and development tower, Racine, Wisconsin." 183(December 1950), 20-24. S.C. Johnson and Son research tower.

597. *Architects' Journal*. [Chinese statue on Taliesin roof]. 111(13 April 1950), 445.

598. *Architects' Journal*. "Research tower at Wisconsin designed by Frank Lloyd Wright." 111(2 February 1950), 150-52. S.C. Johnson and Son research tower.

599. *Architectural Record*. "Wright's core-supported tower unveiled in photographs: research and development tower added to group designed for S.C. Johnson and Son" 108(December 1950), 1 la-11b.

600. *Art Digest*. "Wright campus blooms in Florida." 24(15 April 1950), 13. Florida Southern College.

601. *Empire State Architect*. "The end of an era." 10(March-April 1950), 27. Demolition of the Larkin administration building. See also "Early Wright structure goes under hammer," *Northwest Architect*, 14(1950), 43.

602. *Fortune*. "Glass house for researchers." 41(February 1950), 16. S.C. Johnson and Son research tower.

603. *Harper's Bazaar*. "American landscape, III." 200(March 1950), 98-100.

604. *Interiors*. "Cooper Union honors Wright." 109(March 1950), 166, 168. Wright received the Peter Cooper Medal for the Advancement of Art at the Cooper Union Convocation, 2 November 1949. His acceptance speech, written but undelivered, was published as "Ye want the truth," *A Taliesin Square-Paper: A Nonpolitical Voice from Our Democratic Minority*. (2 November 1949).

605. *Interiors*. "The contemporary domestic interior: Frank Lloyd Wright." 109(July 1950), 66-69. Pauson house.

606. *National Architect*. "Unusual research tower under construction in Racine." 6(August 1950), 7. S.C. Johnson and Son research tower.

607. *RIBA Journal*. "Mr. FLW." 57(August 1950), 373.

608. *Time*. [Portrait.] 56(24 July 1950), 38.

609. *Werk*. "Frank Lloyd Wright in Zürich." 37(September 1950), sup. 128-29 (German).

1951

Books, monographs and catalogues

610. First Unitarian Society. Committee on publications and publicity. *Meeting house of the First Unitarian Society of Madison, Wisconsin.* Madison: The Society, 1951. Pamphlet.

611. Palazzo Strozzi. *Mostra di Frank Lloyd Wright: catalogo itinerario.* Florence: The Palazzo, 1951. Italian: *Frank Lloyd Wright exhibition; Strozzi Palace* Catalogue of the inaugural European showing of the "Sixty Years of Living Architecture" traveling exhibition. In 1949 Arthur C. Kaufmann of Gimbel Brothers department stores, conceived and sponsored the exhibition of Wright's work, assembled by architect Oskar Stonorov. Before it traveled around western Europe and Mexico, the show was mounted for a month from 27 January 1951 in Gimbel's Philadelphia store. It comprised models, drawings, and photographs—about 1,000 items in all.

For reviews of the preview see Talbot Faulkner Hamlin, "Frank Lloyd Wright in Philadelphia," *AIA Journal*, 15(April 1951), 169-72; "Business and culture," *Newsweek*, 37(5 February 1951), 76; "Architect F.L. Wright," *Art Digest.* 25(15 February 1951), 16; and Dorothy Grafly, "The artist and the architect," *American Artist*, 15(May 1951), 45, 59-61..

The 16-page Italian catalogue is condensed from that for the preview. It includes Wright's "The sovereignty of the individual—in the cause of architecture" (from *Ausgeführte Bauten und Entwürfe*, Berlin: 1910) and "To young Italy" (reprinted in Pfeiffer ed. *Frank Lloyd Wright collected writings. Vol. 5*, New York: 1995), as well as the edited text of a January 1951 conversation about Broadacre City between Wright and Stonorov (for a full version see Meehan ed. *The master architect: conversations with Frank Lloyd Wright*, New York: 1984).

The essays were separately published in Italy as *Sovranità dell'individuo—in the cause of architecture, prefazione a Ausgeführte Bauten und Entwürfe pubblicata da Wasmuth, Berlino, 1910*, Florence: Studio Italiano di Storia dell'Arte, 1951; and *Frank Lloyd Wright; dialogo: 'Broadacre City',* Florence: Studio Italiano di Storia dell'Arte, 1951, respectively. The catalogue was reprinted as "Progetti ed edifici di Frank Lloyd Wright" in *Metron*, (March-August 1951).

For comment and reviews see: "La grande mostra di Wright a Firenze." *Metron*, (no. 40, 1951), 4; Edgar J. Kaufmann Jr. "Frank Lloyd Wright at the Strozzi," *Magazine of Art*, 44(May 1951), 190-92; "Frank Lloyd Wright," *Arts*, (27 July 1951), 8; Giovanni Astengo, "Frank Lloyd Wright in Italia," *Urbanistica*, 21(no. 7, 1951), 57-60 (Italian); Giulio Carlo Argan, "De tentoonstelling van F.L. Wright te Florence," *Forum* [Amsterdam], 6(November 1951), 298-303 (Dutch); Carlo Ludovico Ragghianti, "Letture di Wright," *Edilizia Moderna*, (December 1951), 17-28 (Italian); and Giusta Nicco Fasola, "Wright a Firenze," *Panorami della Nuova Città*, no. 5(1951), n.p. (Italian); For comment on the tour see Giancarlo de Carlo, "Wright e l'Europa," *Sele Arte*, 1(September-October 1952), 17-24 (Italian); and Alfons Leitl, "Frank Lloyd Wright in Europa," *Baukunst und Werkform*, (1952), 82-84 (German).

612. MacAgy, Douglas ed. "The Western round table on modern art (1949)." In *Modern artists in America.* New York: Wittenborn Schultz, 1951.

613. Troedsson, Carl Birger. *Two standpoints of modern architecture: Wright and Le Corbusier.* Gothenberg: Gumperts, 1951.

614. Wright, Frank Lloyd. *The arts and industry in a controlled economy.* Chicago: Henry George School of Social Science, 1951. Reprinted in Meehan ed. *Truth against the world,* New York: 1987.

Periodicals
615. Bottoni, Piero. "Alla direzione della rivista *Metron,* Roma." *Metron,* 43(September-December 1951), 6. Italian: "To the review *Metron,* Rome."

616. Gilbert, Katharine. "Clean and organic: a study in architectural semantics." *JSAH,* 10(October 1951), 3-7.

617. Goulder, Grace. "Home by Frank Lloyd Wright, architectural innovator." *Cleveland Plain Dealer Pictorial Magazine,* (28 October 1951). Weltzheimer house.

618. Roth, Alfred. "Geschenkartikel-Laden in San Francisco." *Werk,* 38(December 1951), 379-82. German: "Gift shop in San Francisco." Morris gift shop.

619. Wright, Frank Lloyd. "Force is a heresy." *Wisconsin Athenaean,* 2(Spring 1951), 10-11. Reprinted in Pfeiffer ed *Frank Lloyd Wright collected writings. Vol. 5,* New York: 1995.

620. Wright, Frank Lloyd. "Quality, not quantity, seen as big need by Mr. Wright." *Southern* [organ of Florida Southern College], 65(23 November 1951), 2. Reprinted in Meehan ed. *Truth against the world,* New York: 1987.

621. Wright, Frank Lloyd. "Sir Edward [*sic*] Lutyens: the memorial volumes [book review]." *Building,* 26(July 1951), 260-62.

622. Wright, Frank Lloyd. "When free men fear." *Nation,* 172(2 June 1951), 527-28.

623. *Architectural Forum.* "Desert house is roofed with a movable dome to shade it in summer, open it in winter." 95(June 1951), 150-52. See also "House of contrasts plays textured concrete block against smooth redwood finishes," *ibid.,* 153-55.

624. *Architectural Forum.* "A four-color portfolio of the recent work of the Dean of contemporary architects, with his own commentary on each building." 94(January 1951), 73-108. There is an essay by Wright, entitled, "A dialogue" (reprinted as "Whatever his age ... to the young man in architecture" in Pfeiffer ed. *Frank Lloyd Wright collected writings. Vol. 5,* New York: 1995). Photographs by Ezra Stoller include the S.C. Johnson and Son research tower (Wright's comments are reprinted in Kaufmann and Raeburn, eds., *Frank Lloyd Wright: writings and buildings,* New York: 1960); Adelman , Friedman, Jacobs, Pew, and Lowell Walter houses; and Florida Southern College chapel.

Also issued as a 32-page booklet, distributed in connection with a preview the "Sixty Years of Living Architecture" exhibition, Gimbel's department store, Philadephia. There is an essay by Wright: "Dear children" (reprinted in Pfeiffer ed *Frank Lloyd Wright collected writings. Vol. 5*, New York: 1995). A 16-page Italian version, *Mostra di Frank Lloyd: catalogo itinerario*, was published for the Florence showing, and reprinted in *Metron*, (May- August 1951). French and German editions were published for the Paris and Zürich seasons, respectively.

625. *Architectural Forum*. [News item: Wright receives Italian Star of Solidarity]. 95(August 1951), 68.

626. *Architectural Forum*. "People." 95(December 1951), 64. Wright elected to the American Academy of Arts and Letters. See also "New honors for FLW," *Architectural Record*, 111(January 1952), 22.

627. *House and Garden*. "Lots are circular in this 50-house group." 49(February 1951), 52-55, 100, 111. Pleasantville.

628. *Interiors*. "A tradition to preserve: Wright's Robie house." 116(May 1951), 10-12.

629. *L'Architecture d'Aujourd'hui*. "Laboratoire de recherches à Racine, Wisconsin." 22(October 1951), vi-vii. French: "Research laboratory, Racine." S.C. Johnson and Son research tower.

630. *Metron*. "Messagio a Frank Lloyd Wright." (March-August 1951), 20. Italian: "Message from Wright."

631. *Metron*. "La polemica su Wright". (September-December 1951), 8-10. Italian: "The controversy over Wright."

632. *Metron*. "Progetti e edifici di Frank Lloyd Wright." (March-August 1951), 44-87. Italian: "Wright's projects and buildings." Reprinted from *Mostra di Frank Lloyd: catalogo itinerario*, Florence. Translates Wright's 1908 *Architectural Record* piece, "In the cause of architecture", as revised for *Ausgeführte Bauten und Entwürfe*, Berlin: 1910. Also includes Giuseppe Samonà, "Sull' architettura di Frank Lloyd Wright [On Wright's architecture]", 33-42 (translated into English as "Man, matter and space: on the architecture of Frank Lloyd Wright," in *Architects' Yearbook*, 5[1953], 110-22 and reprinted in Samonà and Mayor eds. *Drawings for a living architecture*, New York: 1959). See also *L'Architettura*, 40(October 1994), 721-27.

633. *Museum News*. "Museum of non-objective art buys property." 19(15 June 1951), 2. Guggenheim Museum

634. *National Architect*. "The architecture of Frank Lloyd Wright at Florida Southern College; architecture of Robert Law Weed, A.I.A. at Florida Southern College." 7(April 1951), 4-6.

635. *Seminary News*. "The Southwest Christian seminary." 5(August 1951), 14.

1952
Books, monographs and catalogues
636. Academie van Beeldende Kunsten en Technische Wetenschappen. *Frank Lloyd Wright*. Rotterdam: Gemeente-Drukkerij, 1952. Dutch and English. Catalogue for the "Sixty Years of Living Architecture" traveling exhibit, Ahoygebouw, Rotterdam, July-August 1952. It includes Wright's "To Holland" (in English), dated 1 June 1952 that is reprinted in Pfeiffer ed *Letters to architects. Frank Lloyd Wright*, Fresno: 1984; *idem*. ed. *The complete Frank Lloyd Wright letters trilogy*, Fresno: California State University, 1987 (also in German as *Briefe von Frank Lloyd Wright an Architekten, Schüler, Bauherren*, Basel: Birkhäuser, 1992); and *idem*. ed. *Frank Lloyd Wright collected writings. Vol. 5*, New York: 1995). "FLLW" by J.J.P. Oud is reprinted as "Wright's betekenis voor het Nieuwe Bouwen [Wright's meaning for the New Building]," *Groene Amsterdammer*, [1 July 1952]). Holland was not included in the show's original itinerary but Wright met Oud during the Paris season, and persuaded him to organize it.

Reviewed H.G.J. Schelling, "Tentoonstelling Frank Lloyd Wright te Rotterdam [Wright exhibition in Rotterdam]," *Bouwkundig Weekblad*, 70(22 July 1952), 231-32; and [Cornelis] M[us], "Tentoonstelling Frank Lloyd Wright," *Ons Huis*, (1952), 757-65. See also Oud, "Frank Lloyd Wright," *Groene Amsterdammer*, (17 May 1952), written (in part) to publicize the exhibition.

637. Behrendt, Walter Curt. "The example of Frank Lloyd Wright." In Lewis Mumford ed. *Roots of contemporary American architecture*, New York: Reinhold, 1952. The book is subtitled *A series of thirty-seven essays dating from the mid-nineteenth century to the present. Contains an introductory essay and biographies of the twenty-nine writers whose work appears herein.* It includes two Wright essays: "Nature as architect" and "The art and craft of the machine" (1901). Reprinted New York: Grove Press, 1959. Cf. an unabridged republication of the second edition, New York: Dover, 1972, illustrated for the first time.

638. Ecole Nationale Superieure des Beaux-Arts. *Exposition de l'oeuvre de Frank Lloyd Wright, avril 1952*. Paris: L'Ecole, 1952. French: *Exhibition of the work of Frank Lloyd Wright, April 1952*. The 32-page booklet was distributed in connection with the "Sixty Years of Living Architecture" traveling exhibit. The French version includes Wright's "Message to France", that is reprinted in Pfeiffer ed *Letters to architects. Frank Lloyd Wright*, Fresno: 1984; *idem*. ed. *The complete Frank Lloyd Wright letters trilogy*, Fresno: California State University, 1987 (also in German as *Briefe von Frank Lloyd Wright an Architekten, Schüler, Bauherren*, Basel: Birkhäuser, 1992); and *idem*. ed. *Frank Lloyd Wright collected writings. Vol. 5*, New York: 1995). There are also translated extracts from the preface of *When democracy builds*, Chicago: 1945; and "Broadacre City."

For comment and review see Michel Dufet, "L'architecte le plus ètonnant: F.L. Wright presente a bientot ses travaux a Paris [The very exciting architect Wright soon to present his works in Paris]," *Arts*, (28 March 1952), 9; Bernard Champigneulle, "Frank Lloyd Wright est venu à Paris [Wright has come to

Paris]...," *Le Figaro Literaraire*, (12 April 1952), 9; and "Frank Lloyd Wright à Paris," *Art et Décoration*, (1952), 21-24; A.H. Martinie, "Frank Lloyd Wright, inventeur de la maison dans l'espace triomphe a Paris [Wright, inventor of the house in space, triumphs in Paris]," *Arts*, (17-23 April 1952), 7; "Frank Lloyd Wright à Paris," *L'Architecture d'Aujourdhui*, 22(April 1952), xxxiii; "Frank Lloyd Wright, architecte américain," *Construction Moderne*, 68(June 1952), 224-25; and Henry Hope Reed, Jr., "Frank Lloyd Wright conquers Paris and vice versa," *Architectural Record*, 112(July 1952), 22.

"Frank Lloyd Wright," *L'Architecture Francaise*, 13(no. 123-124, 1952), published to coincide with the exhibit, includes articles by Wright, Jean Morey and L.-Q. Noviant.

639. Kunsthaus Zürich. *Frank Lloyd Wright: 60 Jahre lebendige Architektur: Ausführliches Verzeichnis mit 6 Abbildungen*. Zürich: Kunsthaus Zürich, 1952. German: *Frank Lloyd Wright: Sixty Years of Living Architecture: detailed guide with six figures*. The exhibit was in Zürich, February-March 1952. The 32-page booklet includes Wright's "To Switzerland" (reprinted in Pfeiffer, ed. *Frank Lloyd Wright collected writings. Vol. 5*, New York: 1995); and excerpts from "When democracy builds, Chicago: 1945" and "Broadacre city".

The Swiss show is reviewed H.C., "Frank Lloyd Wright: Zürich," *Werk*, 39(March 1952), sup. 26-28 (German); and John Torcapel, "Á propos de Frank Ll. Wright [Concerning Wright]," *ibid.*, (October 1952), 330-32 (French).

640. Moser, Werner Max ed. *Frank Lloyd Wright. Sechzig Jahre lebendige Architektur*. Winterthur; Munich: Verlag Buchdruckerei Winterthur, 1952. German: *Frank Lloyd Wright: Sixty Years of Living Architecture*. After the U.S. Office of Military Government agreed to sponsor the exhibition in Germany, its itinerary was revised. When it moved to the Haus der Kunst, Munich, in May 1952 this new catalogue was published.

It includes Wright's "To Germany" (reprinted in Pfeiffer ed. *Frank Lloyd Wright collected writings. Vol. 5*, New York: 1995); "Gedanken über die Architektur Frank Ll. Wrights [Thoughts on Wright's architecture]" and "Anmerkungen zur Charakteristik der Bauten Frank Ll. Wrights [Remarks on the character of Wright's buildings]", both by Moser; "Aus einem Dialog uber "Broadacre City [From a conversation about Broadacre City]" by Wright and Oskar Stonorov; "Notizen über die Frank Lloyd Wright Ausstellung [Notes on the Wright exhibition]," by Stonorov; "Zum Katalog für die Frank Lloyd Wright-Ausstell-ung in München, Mai 1952 [On the catalogue for the Wright exhibition ...]" by Otto Bartning; "Wir bauen mit Frank Lloyd Wright [We built with Wright]" by Herbert Jacobs; "Frank Lloyd Wright baut uns ein Heirn [Wright built us a home]" by Paul and Jean Hanna; and "Leben der Studenten in Taliesin West [The life of students at Taliesin West]," by Peter Steiger.

There are other pieces by Wright: "Fallingwater" (in English); and translations of excerpts from *When democracy builds*, Chicago: 1945; "Apprenticeship training for the architect," *Architectural Record*, 80(September 1936) (reprinted in *Neue Stadt*, 6[September 1952], 396-97); "Der Romantik in der Architektur und über die Funktion der Maschine im menschlichen Leben [The romantic in architedture and about the function of the machine in human lives]"; and "Zur

Frage, warum die Fachleute das Wesen seiner Architektur [On the question, why specialists in the essence of architecture?]". There was also a paperback edition.

For review see Hans Eckstein,.."Zu den F. L. Wright-Ausstellungen in Europa [On the Wright exhibition in Europe]," *Bauen und Wohnen*, (June 1952), 159; Heinrich Henning, *Neue Stadt*, 6(no. 9, 1952), 388-97; Lisbeth Sachs, *Werk*, 39(August 1952), sup. 111-12; and "Der amerikanische Ausdruck [The American expression]," *Der Spiegel*, 6(17 September 1952), 28-33. Also reviewed in English, *Architectural Forum*, 97(December 1952), 158, 166 and in Dutch, Rien B[lijstra], *Forum* [Amsterdam], 7(no. 11, 1952), 349-50.

There was no special catalogue when the exhibit opened at the Colegio Nacional De Arquitectura, Mexico City, in October 1952, conciding with the Pan-American Congress of Architects. Wright's "Saludo amigos" is reprinted in Pfeiffer ed. *Frank Lloyd Wright collected writings. Vol. 5*, New York: 1995. Cf. Wright, "To Espacios," *Espacios*, no. 13(1953), unp.

641. Wright, Frank Lloyd. *Taliesin drawings: recent architecture of Frank Lloyd Wright selected from his drawings.* New York: Wittenborn Schultz, 1952. Only about half the buildings had been previously published. Reviewed *Architectural Forum*, 98(January 1953), 168; *House and Home*, 3(February 1953), 146; Herbert L. Smith Jr., "Wright's renderings," *Architectural Record*, 113(March 1953), 48; James W. Strutt, *RAICanada Journal*, 30(August 1953), 243; James Thrall Soby, "Unaging Frank Lloyd Wright," *Saturday Review of Literature*, 35 (4 October 1953), 58-59; W. Andrews, *Commonweal*, 59(1 January 1954), 337; *Architecture and Arts* [Australia], (January 1954), 38-39; *Domus*, (September 1954), 55.

Periodicals

642. Gaebler, Max David et al. "A Church designed and built in the attitude of prayer, a form that serves as chapel, spire and parish hall in one" *Architectural Forum*, 97(December 1952), 85-92. Reprinted as a booklet, New York: Time, 1952. Cf. "Meeting house of the First Unitarian Society of Madison, Wisconsin," *Perspecta*, (Summer 1952), 16-17.

643. Hitchcock, Henry-Russell Jr. "The evolution of Wright, Mies and Le Corbusier." *Perspecta*, (Summer 1952), 8-15.

644. Kaufmann, Edgar J. Jr. "Three new buildings on the Pacific Coast." *Architects' Yearbook*, 4(1952), 55-63. Morris gift shop.

645. Kaufmann, Edgar J. Jr. ed. "The word on design." *Interiors*, 112(December 1952), 116, 150 ff. Includes remarks from Wright's *An organic architecture*, London: 1939.

646. Leitl, Alfons. "Baukunst zwischen Mies und Frank Lloyd Wright." *Baukunst und Werkform*, (1952), 36-60. German: "Architecture between Mies and Wright."

647. Ottolenghi, Marinella. "Instantànee da un viaggio negli U.S.A." *Metron*, 7(December 1952), 15-21. Italian: "Snapshots of a US trip." Unitarian church, Madison.

648. Wright, Frank Lloyd. "Frank Lloyd Wright's masterwork, the Solomon R. Guggenheim Memorial Museum." *Architectural Forum*, 96(April 1952), 141-44.

649. Wright, Frank Lloyd. "Frank Lloyd Wright on architecture." *Architectural Forum*, 96(April 1952), 212 ff. Reprints Wright's article for Franklin Julius Meine ed. *The American peoples encyclopedia yearbook*, Chicago: Spencer Press, 1951. Reprinted in Pfeiffer ed. *Frank Lloyd Wright collected writings. Vol. 5*, New York: 1995.

650. Wright, Frank Lloyd. "Organic architecture looks at modern architecture." *Architectural Record*, 111(May 1952), 148-54. The "propositions were set down in 1894." Reprinted in Fernando Puma ed. *7 Arts*, New York: Permabooks, 1953; and Pfeiffer ed. *Frank Lloyd Wright collected writings. Vol. 5*, New York: 1995. For a Swedish translation see *Byggekunst*, 34(1952), 192-95; for an Italian translation see *Metron*, 8(no. 48, 1953), 7-10 (reprinted in *L'Architettura*, 39[November 1993], 804-806).

651. *Architectural Forum*. "Florida Southern College revisited for glimpses of the administration group in Wright's organic campus." 97(September 1952), 120-27. Includes essays by Wright and college President Ludd M. Spivey.

652. *Architectural Forum*. "New display method reveals FLW's work in 3 dimensions." 96(March 1952), 78. Buildings for S.C. Johnson and Son, exhibited at MoMA. Cf. "FLW in new kind of exhibit," *Architectural Record*, 111(March 1952), 374.

653. *Architectural Record*. "FLW plans block house. Any man can build it." 111(February 1952), 26.

654. *Architectural Record*. "'Honestly arrogant' F.LL.W. restates lifelong creed." 111(May 1952), 14.

655. *Building Digest*. "15-story glass research tower built on concrete core." 12(December 1952), 404-405. S.C. Johnson and Son research tower.

656. *Cortijos y Rascacielos*. "Arquitectura moderna norteamericana." 2(no. 72, 1952), 37-40. Spanish: "Modern architecture in North America."

657. *Frank Lloyd Wright Quarterly*. "A Usonian classic; architect (1952): Frank Lloyd Wright." 1(Spring 1990), 3-5. Zimmerman house

658. *Harper's Bazaar*. [Portrait.] 85(June 1952), 70-71.

659. *House and Home*. "A house by Frank Lloyd Wright for Mr. and Mrs. Herman T. Mossberg in South Bend, Ind." 2(December 1952), 66-73.

660. *Interiors*. "New American Houses: exhibition at the Museum of Modern Art." 112(November 1952), 8, 10. Reviews the exhibition and compares Wright and Mies van der Rohe.

661. *Look*. "Journey to Taliesin West." 16(1 January 1952), 28-31.

662. *Metron.* "Residenza F. Ll. Wright a Taliesin East." 7(no. 47, 1952), 19. Italian: "Wright's house at Taliesin East."

663. *Museum News.*"Guggenheim Museum files revised building plans." 30(15 May 1952), 1.

664. *New Yorker.* "Nautilus's prune." 28(12 July 1952), 20-21.

665. *Northwest Architect.* "That haunted house." 16(November-December 1952), 3,16,18. Hills house.

1953
Books, monographs and catalogues
666. Wright, Frank Lloyd. *Frank Lloyd Wright at the National Institute of Arts and Letters by the recipient of the Gold Medal for Architecture, May 27, 1953.* The Institute, n.l.: 1953. See also "Another gold medal for Wright," *Architectural Record,* 113(July 1953), 16; "Frank Lloyd Wright receives National Institute's Medal," *Architect and Engineer,* 194(July 1953), 5. The occasion is also reported in Ralph Walker, "Presentation to Frank Lloyd Wright of the Gold Medal for Architecture," *Proceedings of the American Academy of Arts and Letters and the National Institute of Arts and Letters,* second series (1954), 14-15; and Wright, "Acceptance," *ibid.,* 16-17 (reprinted in Meehan ed. *Truth against the world,* New York: 1987).

667. Wright, Frank Lloyd. *The future of architecture.* New York: Horizon, 1953. Statements on architecture, 1930-1953, include: "Modern architecture" (1931); "Two lectures on architecture" (1931); "Some aspects of the past and present of architecture" and "Some aspects of the future of architecture" (both 1937); "An organic architecture" (1939); "A conversation with Hugh Downs" (transcript of an NBC broadcast, 17 May 1953); and "The language of an organic architecture" (slightly revised and reprinted as a booklet, *Organic architecture: language of an organic architecture,* 1955; also reprinted in *Structurist,* [1971], 80-82).

Reviewed Wayne Andrews, "Great uncompromiser," *Saturday Review of Literature,* 36(14 November 1953), 15-16; *House and Home,* 5(March 1954), 174; Max David Gaebler, *USA Tomorrow,* 1(October 1954), 90, 919; Emerson Goble, "Wright lectures on architecture," *Architectural Record,* 114(December 1953), 46, 48; Talbot Faulkner Hamlin, "To be victoriously himself," *NYTBR,* (1 November 1953), 7; Herbert Read, "Against the betrayal of architecture," *New Republic,* 129(2 November 1953), 20-21; William Knapp, "The testament of Frank Lloyd Wright," *Reporter,* 10(19 January 1954), 38-40; Adeline Tintner, "Wright speaks," *Art Digest,* 28(1 February 1954), 33; Mat Kauten, *Progressive Architecture,* 35(February 1954), 174 ff.; *House and Home,* 5(March 1954), 174; Irena Mittelman, *Journal of the Association of Engineers and Architects in Israel,* 12(May-June 1954), 7-8; Alan Colquhoun, *Architectural Review,* 118(December 1955), 401-402.

An undated less expensive edition was issued New York: New American Library, 1963. Excerpts are reprinted in "Frank Lloyd Wright: some answers," *Art News*, 52(October 1953), 42-43; "Organic," *Edge*, (August 1957), 4-5; and Pfeiffer ed. *Frank Lloyd Wright collected writings. Vol. 5*, New York: 1995.

A British edition, London: Architectural Press, 1955 is reviewed Thomas Stevens, *RIBA Journal*, 63(February 1956), 159; and Tamas Bojthe, *Magyar Epitomuveszet*, 8(1959), 205 (Hungarian).

The book was translated into Russian as *Buduschee arkhitektury*, Moscow: State Publishing House of Plans and Construction Materials, 1960; into French as *L`Avenir de l'architecture*. Paris: Denöel-Gonthier, 1966 (reprinted 1982) and into Spanish as *El futuro de la arquitectura*, Barcelona: Poseidon, 1978 (reprinted 1979). A German edition, *Die Zukunft der Architektur*, Munich; Vienna: Albert Langen-Georg Muller, 1966, is reviewed in *Das Kunstwerk*, 20(February 1967), 65-66. Also published in Slavic, Ljubljana: Mladinska Knjiga, 1969 and in Italian as *Il futuro dell'architettura*, Bologna: Zanichelli, 1985. The latter is reviewed, Luca Basso Peressut, *Domus*, (October 1986), xii, and excerpts were reprinted as "Wright/organico: definizioni da Frank Lloyd Wright, *Il futuro dell'architettura*, 1953," *L'Architettura*, 32(April 1986).

668. Wright, Frank Lloyd. *Sixty Years of Living Architecture*. New York: The Guggenheim Museum, 1953. Catalogue of the traveling exhibit, mounted on the projected site of the Guggenheim Museum. Wright's dedication is reprinted in Pfeiffer ed. *Frank Lloyd Wright collected writings. Vol. 5*, New York: 1995.

Reviewed "Wright makes New York!" *Architectural Record*, 114(October 1953), 20; "Frank Lloyd Wright exhibits 60 years' work," *Architectural Forum*, 99(October 1953), 45; "Wright, continued," *New Yorker*, 29(31 October 1953), 25-27; "Exhibition at Guggenheim Museum," *Art News*, 52(October 1953), 44; Jack Roth, "The Heritage of Lao-Tse," *Art Digest*, 28(1 November 1953), 17; "Sixty years of living architecture": the work of Frank Lloyd Wright," *Architectural Forum*. 99(November 1953), 152-55; "Frank Lloyd Wright builds in the middle of Manhattan," *House and Home*, 4(November 1953), 118-21 (also refers to Neils house); Lionel Brett, "Wright in New York," *New Republic*, 129(16 November 1953), 19-20; "Wright's might," *Time*, 62(9 November 1953), 74; and Lewis Mumford, "A phoenix too infrequent," *New Yorker*, 29(28 November 1953), 80-82 ff. and (12 December 1953), 105-110 ff.

669. Wright, Frank Lloyd. *Taliesin Tract, Number One*. n.l., 1953. "Man." Dated Christmas 1953, this ephemeral is the first of a annual series promised by the Taliesin Fellowship; no further issues were published. See also *Man: Frank Lloyd Wright Birthday*, a slightly revised version of 8 June 1956. Reprinted in Pfeiffer ed. *Frank Lloyd Wright collected writings. Vol. 5*, New York: 1995. Cf. *idem.*, "Man," *Monthly Bulletin, Michigan Society of Architects*, 28(April 1954), 33-48, that also illustrates Wright's work.

670. *Schumacher's Taliesin line of decorative fabrics and wallpapers / designed by Frank Lloyd Wright*. New York: F. Schumacher and Co., 1955. Textile and wallpaper samples designed for Taliesin West are bound with the text.

671. *The Usonian House, souvenir of the exhibition: 60 Years of Living Architecture, the work of Frank Lloyd Wright.* New York: The Solomon R. Guggenheim Museum, 1953. A pamphlet about the Usonian house built as part of the "Sixty Years of Living Achitecture" exhibit, New York, includes Wright's "Concerning the Usonian house," written in 1953.

Periodicals

672. Andrews, Wayne. "Looking at the latest of Frank Lloyd Wright." *Perspectives USA*, (Summer 1953), 115-25. Cf. *idem.*, "The recent work of Frank Lloyd Wright," *Marg*, 7(December 1953), 5-10.

673. Blake, Peter. "Les architectes de la jeune generation aux Etats-Unis." *L'Architecture d'Aujourdhui*, 50-51(December 1953), 86-90. French: "Architects of the young generation in the USA."

674. Cederna, Antonio. "Wright s'adatta a Venezia." *L'Europeo*, 403(5 July 1953), 35. Italian: "Wright adapts to Venice." Wright's proposal for the Masieri Memorial, a students' library and hall of residence on the Grand Canal, Venice.

The project caused a stir in Italy. See Elio Zorzi, "Ingiustificato allarme a Venezia per la nuova casa sul Grande Canall progettata dal famos architetto Wright [Unjustified alarm in Venice about the projected house on the Grand Canal by famous architect, Wright]," *Metron*, 8(no. 48, 1953), 64; Ernesto Nathan Rogers, "Polemica per una polemica [Controversy for a controversy]," *Casabella*, (May-June 1954), 1-4; Mario Deluigi, [Letter], *ibid.*, 202(August-September 1954), ii (with Rogers' response); Alfonso Gatto, "Destino di Angelo Masieri [The destiny of Angelo Masieri]," *Metron*, 9(January-April 1954), 35; "Frank Lloyd Wright: la casa sul Canal Grande [Wright: the house on the Grand Canal]," *ibid.*, 5-13; Sergio Bettini, "Venezia e Wright [Venice and Wright]," *ibid.*, 14-26 (reprinted as "Eventi dell' architettura, 1945-1955," *Architettura*, 39[October 1993], 713-27); Giovanni Michelucci, "Le ragioni di una polemica [The reasons for a controversy]," *Nuova Città*, (June 1954), 48-52 and "Lettere: la casa sul Canal Grande," *Metron*, (May-June 1954), 2; Carlo Ludovico Ragghianti, "Cronache: Italia moderna [Chronicles: modern Italy]," *Critica d'Arte*, 4(March 1954), 197-99 and *ibid.*, "Cronache ... eja!" *ibid.*, (July 1954), 397-400 (reprinted *Sele Arte*, 2[May-June 1954], 77-80.

Others joined the debate: see "Astragal", "Early Wright," *Architects' Journal*, 119(4 February 1954), 145, 156; "Projekt Frank Lloyd Wrights fur ein Studentenheim in Venedig [Wright's project for student housing in Venice]," *Werk*, 41(March 1954), sup. 43 (German); "Wright in Venice," *Architectural Review*, 115(April 1954), 223; John Barrington Bayley, "Frank Lloyd Wright and the grand design," *Landscape: Magazine of Human Geography*, 4(Summer 1954), 30-32; and James Maude Richards, "Venice preserv'd," *RAICanada Journal*, 31(August 1954), 281-83 (reprinted from *The Listener*).

There was also interest in the US: see "A new debate in old Venice," *NYT Magazine*, (21 March 1954), 8-9; "Wright or wrong," *Time*, 63(22 March 1954), 92; "Question: is Venice ready for an FLLW palazzo?" *Architectural Forum*, 100(May 1954), 39; and Henry Saylor, "The editor's asides," *AIA Journal*, 22(July 1954), 24-25, 44.

675. Giedion, Sigfried. "Aspects de l'architecture aux Etats-unis en 1953." *L'Architecture d'Aujourdhui*, 50-51(December 1953), 7-9. French: "Aspects of US architecture in 1953."

676. Gumpert, Martin. "Ten who know the secret of age." *NYT Magazine*, (27 December 1953), 10-11. Brief biography.

677. Manson, Grant Carpenter. "Frank Lloyd Wright and the Fair of '93." *Art Quarterly*, 16(Summer 1953), 114-23.

678. Manson, Grant Carpenter. "Wright in the nursery: the influence of Froebel education on [Wright's work]." *Architectural Record*, 113(June 1953), 349-51.

679. Nichols, Lewis. "Talk with Mr. Wright." *NYTBR*, (1 November 1953), 24.

680. Persitz, Alexandre. "Frank Lloyd Wright." *L'Architecture d'Aujourdhui*, 24(December 1953), 10-25. French. Mostly images: Boulder house; Johnson Wax research tower; Guggenheim Museum. Interest in the latter project, although diminished, continued throughout 1953; see "Naughty nautilus," *Time*, 62(10 August 1953), 70; and "Solomon R. Guggenheim Museum," *Museums Journal*, 53(December 1953), 230-31.

681. Portela, Francisco V. "Frank Lloyd Wright, arquitecto y creador." *La Prensa*, (1 November 1953). Spanish: "Wright, architect and creator."

682. Samonà, Guiseppe. "Man, matter and space: on the architecture of Frank Lloyd Wright." *Architects' Yearbook*, 5(1953), 110-22. Translated from "Sull' architettura di Frank Lloyd Wright", *Metron*, (May-August 1951), 34-43 and reprinted in Samonà and Mayor eds. *Drawings for a living architecture*, New York: 1959.

683. Sisi, Enrico. "L'urbanistica di F.L. Wright." *Bolletino Tecnico* 10(1951), unp. Italian: "Wright's city planning."

684. Thomas, Mark Hartland. "F.L.W. again." *Architectural Design*, (December 1953), 347-49. David Wright house; Price Tower.

685. Tselos, Dimitri. "Exotic influences in the architecture of Frank Lloyd Wright." *Magazine of Art*, 46(April 1953), 160-69, 184.

686. Völckers, Otto. "Über die Baukunst Frank Lloyd Wright's." *Glas Forum*, (1953), 39-40. German: "About Wright's architecture." For an English translation sse *AIA Journal*, 28(August 1957).

687. Wright, Frank Lloyd. "Against the steamroller." *Architectural Record*, 113(May 1953), 283-84. See also comment by James Maude Richards, 284-85.

688. Wright, Frank Lloyd. "For a democratic architecture." *House Beautiful*, 95(October 1953), 316-17. Reprinted in Pfeiffer ed. *Frank Lloyd Wright collected writings. Vol. 5*, New York: 1995.

689. Wright, Frank Lloyd. "Frank Lloyd Wright talks on his art." *NYT Magazine*, (4 October 1953), 26-27, 47.

690. Wright, Frank Lloyd. "The future: four views." *NYT Magazine*, (1 February 1953), 64.

691. Wright, Frank Lloyd. "In the cause of architecture: the "International Style." *A Taliesin Square-Paper: a nonpolitical voice from our democratic minority*, (February 1953). There is debate about whether this was a *bona fide* issue in the *Taliesin Square-Paper* series or a separate tract. Wright's criticism of the International Style was also published as "Frank Lloyd Wright speaks up," *House Beautiful*, 95(July 1953), 86-88, 90; and in part as "Excerpts from the 'International Style'," *Architectural Record*, 113(June 1953), 12, 332, together with an editorial attacking his views (for Rene d'Harnoncourt's response see *ibid.*, 114[September 1953], 12 and *Interiors*, 113[September 1953], 163-65). Reprinted in Pfeiffer ed. *Frank Lloyd Wright collected writings. Vol. 5*, New York: 1995). See also "Modern Architecture: mobocratic or democratic?" *Art Digest*, 27(August 1953), 20-21.

692. Wright, Frank Lloyd. "The language of organic architecture." *Architectural Forum*, 98(May 1953), 106-107. Also issued as *A Taliesin Square-Paper: a nonpolitical voice from our democratic minority*. See also *The future of architecture*. New York: 1953.

693. Wright, Frank Lloyd. [Letter to Talmadge C. Hughes]. *Monthly Bulletin. Michigan Society of Architects*, 27(October 1953), 35.

694. Wright, Frank Lloyd. "Progress in architectural education." *Line Magazine*, (1953), unp. Excerpts from a talk to a student seminar at the AIA annual convention. Cf. "Fighting the box," *New Yorker*, 28(5 July 1952), 16. Reprinted in Meehan ed. *Truth against the world*, New York: 1987. For further comment see Meehan ed. *The master architect: conversations with Frank Lloyd Wright*, New York: 1984.

695. *Architectural Forum*. "Frank Lloyd Wright talks to and with the Taliesin Fellowship." 98(April 1953), 194, 198. Reviews three sound recordings released by Caedmon. They include (i.a.) a discussion about acoustics with the Fellows (April 1951); "Man or machine?" with the Fellows (July 1951); and Wright's reading of an address to the Junior AIA (June 1952). For transcriptions see Meehan ed. *The master architect: conversations with Frank Lloyd Wright*. New York: 1984. The records are reviewed *Architectural Forum*, 98(April 1953), 197-98. See also "Recordings by ... Wright," *RIBA Journal*, 60(April 1953), 214; *House and Home*, 3(May 1953), 200, 204; and Aline B. Louchheim, "Frank Lloyd Wright talks of his art," *NYT Magazine*, (4 October 1953), 47.

696. *Architectural Forum*. "Our new Crystal Towers." 98(February 1953), 142-45. S.C. Johnson and Son research tower.

697. *Architectural Forum*. "Frank Lloyd Wright's concrete and copper skyscraper on the prairie for H.C. Price Co." 98(May 1953), 98-105 and cover.

698. *Bouw*. "Nieuw kantoorgebouw van Frank Lloyd Wright." 8(10 October 1953), 792. Dutch: "Wright's new office building."

699. *Bouw*. "Woestijnhuis van Wright." 8(3 October 1953), 774-75. Dutch: "Desert house by Wright." David Wright house; translated from *House and Home*, 3(June 1953), 99-107. See 704 below.

700. *Bulletin of Florida Southern College, Lakeland*. "The Frank Lloyd Wright campus: Florida Southern College, 1953." 69(April 1953), the issue. Includes a reprint from *Architectural Forum*, 97(September 1952).120-27.

701. *Business Week*. "Frank Lloyd Wright: at 84, still fighting." (17 October 1953), 30-31.

702. *Harper's Bazaar*. "Himself." 207(December 1953), 87-89.

703. *House and Home*. "Frank Lloyd Wright and 1,000,000 houses a year." 3(March 1953), 105.

704. *House and Home*. "Frank Lloyd Wright: this new desert house for his son is a magnificent coil of concrete block." 3(June 1953), 99-107. David Wright house.

705. *House and Home*. "A new house by Frank Lloyd Wright opens up a new way of life on the old site." 4(November 1953), 122-27. Neils house.

706. *House and Home*. "This new house by ... Wright is a rich textbook of the principles he pioneered." 3(March 1953), 106-113. Brown house, Kalamazoo.

707. *Journal of Housing*. "Usonia homes." 10(October 1953), 318-20, 344-45. Pleasantville.

708. *L'Architecture d'Aujourd'hui*. [Special issue: 20th century US architecture]. 24(December 1953).

709. *Life*. "Give me land, lots of land." 34(15 June 1953), 48.

710. *Newsweek*. "Man of culture." 42(2 November 1953), 64.

711. *Newsweek*. "Wright is right." 41(11 May 1953), 97-98. Speech to Western Hospitals Association annual conference, Salt Lake City.

712. *Newsweek*. [Portrait.] 42(10 August 1953), 43.

713. *Northwest Architect*. "Wright labels architecture totalitarian." 17(July-August 1953), 43.

714. *RAICanada Journal*. "Helio-laboratory for Johnson Wax Co., Racine, Wis." 30(April 1953), 104-107.

715. *Time*. "Prairie skyscraper." 61(25 May 1953), 94. Price Tower. See also "Very village-like," *ibid.*, 25.

1954
Books, monographs and catalogues
716. Robsjohn-Gibbings, Terence Harold. "Organic architecture: Frank Lloyd Wright." In *Homes of the brave*. New York: Alfred A. Knopf, 1954.

717. Taro, Amano ed. *Frank Lloyd Wright.* Tokyo: Shokokusha, 1954. Japan-
ese. Also in published in softcover.

718. Wright, Frank Lloyd. *The natural house.* New York: Horizon, 1954.
"Book 1: 1936-1953" includes previously published essays: "Organic architec-
ture" (*Architects' Journal*, 1936); "Building the new house"; "In the nature of
materials: a philosophy"; "The Usonian house I"; and "The Usonian House II"
(from *An autobiography*, 1943). "Concerning the Usonian house" was written in
1953. "Book 11: 1954" contains specially written chapters: "Integrity: in a house
as in an individual"; "From the ground up"; "Grammar: the house as a work of
art"; "The Usonian automatic"; and "Organic architecture and the Orient."
 Reviewed Wayne Andrews, "Architect's creed," *Saturday Review of Litera-
ture*, 37(18 December 1954), 17, 41; Lionel Brett, "Wright's houses," *Arts
Digest*, 29(1 January 1955), 16; Emerson Goble, "FLlW tells how to build your
own," *Architectural Record*, 117(January 1955), 46; "Frank Lloyd Wright and
the natural house," *House and Home*, 7(January 1955), 166-68; Lawrence E.
Mawn, "Unrestrained as usual," *Progressive Architecture*, 36(March 1955), 216,
218; Frederick A. Gutheim, *Perspectives USA*, (August 1955), 150-55; *Architec-
ture and Arts* [Australia], (November 1955), 40 (excerpts are cited *ibid.*, [May
1956], 21); and Robert Woods Kennedy, *New Republic*, (30 October 1971),
30-32.
 A less expensive edition was issued by Bramhall House, New York. Also
published New York: New American Library, 1963; and London: Pitman, 1972.
Reprinted in part in Kaufmann and Raeburn eds. *Frank Lloyd Wright: writings
and buildings*, New York: 1960; and in its entirety in Pfeiffer ed. *Frank Lloyd
Wright collected writings. Vol. 5*, New York: 1995. A Japanese edition was
published Tokyo: Shokokusha, 1967.
 See also Robert Woods Kennedy, "The 'natural house'," *New Republic*,
165(30 October 1971), 30-32.

719. Wright, Frank Lloyd. *Sixty Years of Living Architecture.* Los Angeles: The
Municipal Art Patrons and the Art Commission of Los Angeles, 1954. A
catalogue for the "Sixty Years of Living Architecture" traveling exhibit that was
mounted, May 1954, in a special building in the garden of Hollyhock house. See
also "Art on Olive Hill," *Art News*, 53(October 1954), 56.

Periodicals
720. Brest, Rend. "A 84 ans, Frank Lloyd Wright est l'architecte le plus
moderne." *Science et Vie*, 86(July 1954), 62-69. French: "At age 84, Frank
Lloyd Wright is a very modern architect."

721. Campo, Santiago del. "An afternoon with Frank Lloyd Wright." *Américas*,
6(April 1954), 9-12, 44-46 .

722. Guerrero, Pedro E. and Robert H. Miller [photographers]. "Frank Lloyd
Wright." *Lincoln Mercury Times*, 6(March-April 1954), 5-7. Includes color
photographs of two Lincoln Continentals restyled by Wright.

723. Henken, Priscilla J. "A 'broad-acre' project: a description by a resident of a co-operative house-building scheme, under the influence of Frank Lloyd Wright." *Town and Country Planning*, 23(June 1954), 294-300. Pleasantville.

724. Ragghianti, Carlo Ludovico. "Letture di Wright [1 and 2]."*Critica d'Arte*, (January 1954), 67-82; (July 1954), 355-83. Italian: "Readings of Wright."

725. Reed, Henry Hope Jr. "Viollet-le-Duc and the USA: a footnote to history." *Liturgical Arts*, 23(November 1954), 26-28.

726. Scully, Vincent Joseph Jr. "Wright vs. the International Style." *Art News*, 53(March 1954), 32-35, 64-66. A discussion of the mutual influence of Wriight and European architects. Comments by Elizabeth Gordon, Edgar J. Kaufmann Jr. and Terence Harold Robsjohn-Gibbings, with Scully's response, are published *ibid.*, 53(September 1954), 48-49.

727. Tunnard, Christopher. "The future of Frank Lloyd Wright." *Landscape*, 3(Spring 1954), 6-8.

728. Wright, Frank Lloyd. "An address under auspices of American Institute of Architects, Detroit Chapter." *Monthly Bulletin, Michigan Society of Architects*, 28(June 1954), 9 ff. Reprinted in Meehan ed. *Truth against the world*, New York: 1987. The imminent lecture is announced *ibid.*, 28(May 1954), 17.

729. Wright, Frank Lloyd. "American architecture." *Journal of the Franklin Institute*, 258(September 1954), 219-24. Acceptance speech for the Frank P. Brown Medal. See also "Presentation of the Frank P. Brown Medal," *ibid.*, 217-18; "Wright awarded Brown Medal," *Architect and Engineer*, 195(October 1953), 33. The speech is reprinted in Meehan ed. *Truth against the world*, New York: 1987. See also *idem.*, "American architecture," *United States Lines Paris Review*, (June 1954), n.p.

730. Wright, Frank Lloyd. "More than the turtle's shell." *Phi Delta Kappan*, 35(May 1954), 297-99, 302. Based on "Some aspects of the past and present of architecture" from *The future of architecture.* New York: 1953.

731. *Architectural Forum*. "Glass-towered synagogue, Frank Lloyd Wright's first." 100(June 1954), 145. Beth Sholom Synagogue. See also "Errata," *ibid.*, 101(September 1954), 86. Cf. "Frank Lloyd Wright has designed his first synagogue," *Architectural Record*, 116(July 1954), 20; and "Promised hosanna," *Time*, 63(31 May 1954), 54.

732. *Architectural Forum*. "Wright and Mies open New York offices." 101(December 1954), 41.

733. *Architectural Forum*. "Wright threatens to forsake Wisconsin because of taxes." 101(December 1954), 45. Cf. "Frank Lloyd Wright says he'll quit Wisconsin," *House and Home*, 6(December 1954), 53. But see also "Wright stays in Wisconsin," *Architectural Forum*, 102(March 1955), 29 and "Wisconsin

makes peace with Wright," *Architectural Record*, 117(April 1955), 18. See also *Architecture and Arts* [Australia], (July 1955), 16.

734. *Art Digest*. "Drawing for the Solomon R. Guggenheim Museurn." 28(January 1, 1954), 11.

735. *Architecture and Arts* [Australia]. "Frank Lloyd Wright on ornament." (July 1955), 19. Citation from *The natural house.*

736. *Building Materials Digest*. "18-story tower cantilever structure of concrete and glass: dramatic Frank Lloyd Wright design." 14(December 1954), 425. H.C. Price Tower. The interest of editors in the building continued through the year. See "Wright completes skyscraper," *Progressive Architecture*, 37(February 1956), 87-90; "Frank Lloyd Wright: after 36 years his tower is completed," *Architectural Forum*, 104(February 1956), 106-113; "The H.C. Price tower," *Architectural Record*, 119(February 1956), 153-60 (includes essays by Wright, Edgar J. Kaufmann Jr., Harold C. Price and Joe D. Price. Reissued as a booklet and reprinted in William A. Coles and Henry Hope Reed Jr., *Architecture in America: a battle of styles*, New York: Appleton-Century-Crofts, 1961).

See also "Frank Lloyd Wright: la 'Price Tower'," *Casabella*, (June-July 1956), 8-21 (Italian); and "Gratte-ciel a Bartlesville, cité de 25,000 habitants, U.S.A [Skyscraper in Bartlesville, city of 25,000 inhabitants]," *L'Architecture d'Aujourdhui*, 27(October 1956), xxiii (French).

737. *House and Home*. "A planning lesson from Frank Lloyd Wright. How big can a tiny house be?" 5(March 1954), 98-105 . Walker house.

738. *House and Home*. "Seven lessons from Frank Lloyd Wright." 6(November 1954), 98-105. Anthony house.

739. *House Beautiful*. "*House Beautiful* dedicates this exhibition to Frank Lloyd Wright." 96(October 1954), 176-77. "The arts of daily living" exhibit mounted by the magazine and the Los Angeles County Fair.

740. *Look*. [Portrait.] 18 (September 7, 1954), 58.

741. *Newsweek*. [Portrait.] 43(14 June 1954), 73.

742. *Newsweek*. [Portrait.] 44(22 November 1954), 63.

743. *Photography*. "Frank Lloyd Wright talks about photography." 34(February 1954), 40-41, 118.

744. *Time*. "The Wright word." 64(2 August 1954), 61.

1955
Books, monographs and catalogues
745. Karpel, Bernard. *What men have written about Frank Lloyd Wright: a bibliography arranged by decades from 1900 to 1955*. New York: House

Beautiful, 1955. Published with the November 1955 issue of *House Beautiful*. It is augmented and updated by *idem.*, *Frank Lloyd Wright: selected works by Wright*, published with the October 1959 edition of the journal, and by James Muggenburg, *Frank Lloyd Wright in print: 1959-1970; a bibliography*, Chicago: 1970.

746. Kaufmann, Edgar J. Jr. ed. *An American architecture.* New York: Horizon, 1955. An anthology of Wright's statements (some previously unpublished) 1894- 1954. Citations are reprinted in the *Formgivers at mid-century* exhibition catalogue, New York: Time, 1959 (again reprinted 1960).

Reviewed Hilton Kramer, "Architecture and rhetoric," *New Republic*, 133(26 December 1955), 20; Elizabeth Pokorny, "Use, form and art," *Nation*, 182(14 January 1956), 35-36; Vincent Joseph Scully Jr., "Architecture and ancestor worship," *Art News*, 54(February 1956), 26, 56; Aline B. Saarinen, "Frank Lloyd Wright discusses ... ," *Architectural Record*, 119(April 1956), 62, 66, 446; Peter Blake, "Our elder spacernan," *Saturday Review of Literature*, 39(4 August 1956), 22-23; and Paul Zucker, *Journal of Aesthetics and Art Criticism*, 15(March 1957), 362-363.

Also published London: Architectural Press, 1956; reviewed Reyner Banham, "Wright anthology," *Architectural Review*, 120(October 1956), 264; Clough WIlliams-Ellis, *RIBA Journal*, 64(September 1957), 468; and Laszlo Gero, *Magyar Epitomuveszet*, (1961), 63 (Hungarian). A Japanese edition was published Tokyo: Shokokusha, 1970.

747. Rogers, Ernesto Nathan. "The tradition of modern architecture in Italy." In G.E. Kidder Smith, *Italy builds; its modern architecture and native inheritance.* New York: Reinhold; London: Architectural Press, 1955. Includes Wright's introduction to Gutheim ed. *Frank Lloyd Wright on architecture,* New York, 1941.

748. Scully, Vincent Joseph Jr. "Frank Lloyd Wright." In *The Shingle Style. architectural theory and design, from Richardson to the origins of Wright.* New Haven; London: Yale University Press, 1955. Reviewed William Henry Jordy, *New England Quarterly*, 28(September 1955), 499-503; and James Marston Fitch, *JSAH*, 17(March 1958), 36. Revised and reprinted as *The shingle style and the stick style: architectural theory and design from Richardson to the origins of Wright*, 1971.

749. Tedeschi, Enrico. *Frank Lloyd Wright.* Buenos Aires: Editorial Nueva Vision, 1955. Spanish.

750. Thrift, Charles Tinsley Jr. *Through three decades at Florida Southern College, Lakeland, Florida.* Lakeland: The College Press, 1955.

751. Wright, Frank Lloyd. *Greater Madison, the Monona Terrace project: Frank Lloyd Wright, architect.* Spring Green: F.L. Wright, 1955. Brochure.

752. Wright, Olgivanna Lloyd. *The struggle within.* New York: Horizon, 1955. Reprinted 1971.

Periodicals

753. Alford, John. "Modern architecture and the symbolism of creative process." *College Art Journal*, 14(Winter 1955), 102-123.

754. Bohrer, Florence Fifer, "The Unitarian Hillside Home school." *Wisconsin Magazine of History*, 37(Spring 1955), 151-55.

755. Carillo, René. "Two very different houses." *Interiors*, 114(February 1955), 8. Boomer house.

756. Edwards, Folke. "Frank Lloyd Wright." *Paletten*, (1955), 114-27. Swedish.

757. Haverstick, John. "To be or not to be." *Saturday Review of Literature*, 38(21 May 1955), 13. Guggenheim Museum. See also "Inhoud van tijdschriften [What's in the journals]." *Bouwkundig Weekblad*, 73(1 November 1955), 527. (Dutch), citing *Werk*, (September 1955); "Un musée en spirale: le musée d'art Guggenheim [A museum in a spiral: the Guggenheim art museum]," *Mouseion*, 51(December 1955), 3-4 (French); and "Approve spiral-ramp museurn," *ENR*, 155(29 December 1955), 24.

758. Manson, Grant Carpenter. "Sullivan and Wright; an uneasy union of Celts." *Architectural Review*, 118(November 1955), 297-300.

759. Morassutti, Bruno. "Considerazioni sugli uffici Johnson, di Frank Lloyd Wright." *Domus*, 24(April 1955), 2-6. Italian: "Reflections on Wright's Johnson offices." Cf. *Bouwkundig Weekblad*, "Inhoud van tijdschriften [What's in the journals]." 74(1956), 264 (Dutch).

760. Pieper, Iovanna Lloyd. "Contemporary living." *Diplomat*, 7(October 1955), 25-27.

761. Shear, John Knox. "F.L. Wright and the design for the Air Force Academy." *Architectural Record*, 118(August 1955), 132a-132b.

762. Wright, Frank Lloyd. "Ein Dialog." *Der Aufbau*, 10(January 1955), 75. German: "A dialog."

763. Wright, Frank Lloyd. "Frank Lloyd Wright on restaurant architecture," *Food Service Magazine*, 20(November 1958), 17-21, 32. Text of an interview, reprinted in Meehan ed. *The master architect: conversations with Frank Lloyd Wright*. New York: 1984.

764. Wright, Frank Lloyd. "Future of the city." *Saturday Review of Literature*, 38(21 May 1955), 10-13. Reprinted in Pfeiffer ed. *Frank Lloyd Wright collected writings. Vol. 5*, New York: 1995.

765. *Architectural Forum*. "Frank Lloyd Wright completes a long, low industrial arts building for Florida Southern University ... and begins a civic center for the capital of his home state." 102(April 1955), 114-21. Monona Terrace.

766. *Architectural Forum*. "Frank Lloyd Wright designs a small commercial installation" 103(July 1955), 132-33. Max Hoffman Jaguar showroom.

767. *Architectural Forum.* [Monona Terrace]. 102(April 1955), 120-21.

768. *Architectural Forum.* "World's greatest architecture." 102(June 1955), 139. Excerpts from Wright's speech to the Wisconsin Architects Association Convention. See also *Architecture and Arts* [Australia], (September 1955), 19.

769. *Architectural Record.* "New era for Wright at 86: the marketplace redeemed?" 118(October 1955), 20. Soft furnishings for F. Schumacher and Co.; carpets for Karastan. See also "FLLW designs home furnishings," *House and Home*, 9(January 1956), 188, that mentions furniture for Heritage-Henredon.

770. *Design.* "Frank Lloyd Wright." 56(June 1955), 103-104.

771. *Diplomat.* "Frank Lloyd Wright discusses taste, inheritance, and creative environment in an exclusive interview with I. Monte Radlovic, editor." 7(October 1955), 24, 68.

772. *House and Home.* "FLlW'S characteristic double-decker flat top." 7(April 1955), 116-21. See also "FLlW's double-decker flat-top idea was adapted in Utah builder house," *ibid.*, 122-25. Miller house.

773. *House Beautiful.* "The dramatic story of Frank Lloyd Wright." 98(November 1955), the issue. Includes an introduction by Wright, "Faith in your own individuality" (reprinted Pfeiffer ed. *Frank Lloyd Wright collected writings. Vol. 5*, New York: 1995), and articles by Joseph A. Barry, James Marston Fitch, Elizabeth Gordon, John de Koven Hill, Robert Mosher, Cecile Starr, Richard Williams, and Bruno Zevi. Reissued in hard cover. Much of the content is reprinted in *Architecture and Arts* [Australia], (January 1956). See also Karpel, *What men have written about Frank Lloyd Wright,* New York: 1955.

774. *National Parks Magazine.* "Wright architecture rejected by park service." 29(January-March 1955), 4. Yosemite National Park restaurant (project).

775. *Newsweek.* "The atomic Mr. Wright" 45(15 May 1955), 98. Reports speech at Institute of Contemporary Art, Boston.

776. *Werk.* [Portrait.] 42(December 1955), sup. 241-42.

1956
Books, monographs and catalogues
777. Nestingen, Ivan A. [*Report of Ivan A. Nestingen] to members of the Mayor's Monona Terrace Commission.* Madison: The Commission, 1956.

778. Wright, Frank Lloyd. *Sixty years of living architecture, series nine, Chicago: early Chicago buildings; later cantilever structures including Mile-High Illinois.* Chicago, 1956. Catalogue of Chicago's "Frank Lloyd Wright Day" celebrations, 17 October 1956, includes images of Wright's work, a list of awards, references to an exhibition at the Hotel Sherman, and an insert about the

mile-high skyscraper project. See also "Frank Lloyd Wright Day proclaimed in Chicago ... ," *Architectural Forum*, 105(November 1956), 21. Cf. "Milestones and memoranda on the work of Frank Lloyd Wright," *Land Economics*, 32(November 1956), 361-68, which publishes the captions from the exhibition.

779. Wright, Frank Lloyd. *The story of the tower: the tree that escaped the crowded forest.* New York: Horizon, 1956. A monograph purporting to include all Wright's writings on the H.C. Price Tower, revised and updated. Reprinted in Pfeiffer ed. *Frank Lloyd Wright collected writings. Vol. 5*, New York: 1995.

780. *The Price Tower, Bartlesville, Oklahoma, February 9, 1956.* n.l: n.p. An illustrated promotional brochure includes photographs and plans of the tower, with Wright's commentary.

Periodicals
780. Eaton, Leonard Kimball. "Louis Sullivan and Hendrik Berlage: a centennial tribute to two pioneers." *Progressive Architecture*, 37(November 1956), 138-41, 202-204 ff.

781. Hill, John de Koven. "A fine old stable becomes a fine new house." *House Beautiful*, 98(February 1956), 104-107, 142. Coonley stables.

782. Hill, John de Koven. "The look of American life at the top level." *House Beautiful*, 98(November 1956), 258-65. Harold Price and Harold Price Jr. houses.

783. Kennedy, Warnett. "Famous living architects: Frank Lloyd Wright." *RAI Canada Journal*, 33(May 1956), 187-88. Transcription of one of a series of CBC radio broadcasts.

784. Kaufmann, Edgar J. Jr. and John Knox Shear. "Ward Willitts house" In *Architectural Record*, 120(July 1956), 194. See also Kaufmann and Pietro Belluschi, "S.C. Johnson and Son buildings ... ," *ibid.*, 205.

785. McCoy, Esther. "Roots of California contemporary architecture" *Arts and Architecture*, 73(October 1956), 14-17, 36-39. Comments on an exhibition of the 1900- 1935 work of Wright (i.a), sponsored by the Los Angeles City Art Department. See also "Roots of contemporary California architecture," *Pacific Architect and Builder*, 62(December 1956), 10-11.

786. Pellegrin, Luigi. "Alla ricerca del primo Wright." *L'Architettura*, 2(June 1956), 126-31. Italian: "In search of the early Wright." See also *idem.*, "La decorazione funzionale del primo Wright [The functional decoration of early Wright]," *ibid.*, 2(July 1956), 198-203.

787. Robinson, Kenneth J. "From Taliesin to Shepherds Bush: *The Journal* entertains—and is entertained by—Frank Lloyd Wright." *Architects' Journal*, 124(26 July 1956), 109-111.

788. Rowe, Colin. "Chicago frame." *Architectural Review*, 120(November

1956), 285-89. Includes Wright's office and residential buildings and projects. Revised in *Architectural Design*, 40(December 1970), 641-47 and reprinted in *idem.*, *The mathematics of the ideal villa and other essays*, Cambridge, Mass.; London: MIT Press, 1976, 89-117.

789. Tselos, Dimitri. "Frank Lloyd Wright e arquitetura mundial." *Habitat*, 6(February 1956), 11-15. Portuguese: "Frank Lloyd Wright and world architecture." Cf. *idem.*, "Frank Lloyd Wright: Klassiker der modernen Weltarchitektur [Wright: classics of modern world architecture]," *Universitas*, (1959), 355-62 (German) and "Frank Lloyd Wright and world architecture," *JSAH*, 28(March 1969), 58-72.

790. Walker, Ralph A. "Frank Lloyd Wright: his contribution to our American culture." *Land Economics*, 32(November 1956), 357-60.

791. Wright, Frank Lloyd. "Arizona and Taliesin". *Arizona Highways*, 32(February 1956), 1-4. See also Wright, "Architecture: organic expression of the nature of architecture," *ibid.*, 12-29 . There is an introduction by Raymond Carlson.

792. Wright, Frank Lloyd. "Frank Lloyd Wright a suoi critici." *Casabella*, (June-July 1956), 6-7. Italian: "Wright to his critics."

793. Wright, Frank Lloyd. "The shape of the city." *American Municipal Association. Proceedings*, (1956), 30-34. Text of a speech, 26 November 1956.

794. *Architects' Journal.* [Portrait.] 124(2 August 1956), 150.

795. *Architectural Forum.* "Cities: medieval or modern." 105(August 1956), 151, 168, 172. Excerpts from a discussion between Wright and real estate developer William Zeckendorf, telecast by NBC.

796. *Architectural Forum.* "Proposed Greek Orthodox church in Milwaukee, Wis." 105(October 1956), 17. Annunciation Greek Orthodox Church.

797. *Architectural Forum.* "Skies clearing for Wright's ramp museum, synagogue." 104(February 1956), 9. Guggenheim Museum; Beth Sholom Synagogue. See also "Spiral museum: work begins after 12-year delay on Wright's design." *ENR*, 156(10 May 1956), 27; "Guggenheim Museum to rise: victory for Wright in 12-year design battle," *Architectural Forum*, 104(June 1956), 13; and Hilton Kramer, "The new Guggenheim Museum," *Arts*, 30(June 1956), 11.

798. *Architectural Forum.* "Taliesin endowment begun." 105(November 1956), 21.

799. *Architectural Forum.* "Wright sketches 510-story office tower; round, blue roof Greek Orthodox Church." 105(October 1956), 17. Mile High skyscraper (project); Annunciation Greek Orthodox Church.

800. *Architectural Record.* "Bust of Wright presented to him at convention of Architectural Woodwork Institute." 120(December 1956), 28.

801. *Architectural Record.* "Churches." 120(December 1956), 177-80. Unity Temple. See comment by Alan Burnham and Burford Pickens in "One hundred years of significant building," *ibid.*, 180.

802. *Architectural Record.* "Ward W. Willitts house, Highland Park, Illinois, 1902." 120(October 1956), 194.

803. *Architecture and Arts* [Australia]. "Exhibition house by Frank Lloyd Wright." (January 1956), 44. Usonian house, "Sixty Years of Living Architecture" exhibition, New York.

804. *Arquitecto Peruano.* "Un peruano visita Taliesin en Arizona." 22(January-February 1956, 222-23. Spanish: "A Peruvian visits Taliesin in Arizona." Images only.

805. *Builder.* "Broadside from FLW." 191(27 July 1956), 132. Cf. Clough Williams-Ellis, *Architect errant*, London: Constable, 1971, 187-88; 209-210.

806. *Bulletin of Florida Southern College.* "The Frank Lloyd Wright campus." 72(January 1956), 1-17, 20 .

807. *Bulletin of the American Institute of Architects. Chicago Chapter.* "Frank Lloyd Wright." 4(no. 3, 1956), 24.

808. *Colliers.* "Listen to ... Frank Lloyd Wright." 138(3 August 1956), 20-21.

809. *ENR.* "Famous designers disagree." 156(3 May 1956), 27. Differences between Wright and Italian engineer Pier Luigi Nervi.

810. *House and Home.* "Four houses." 9(May 1956), 164-68. Mossberg, Walker, Neils, and David Wright houses.

811. *House and Home.* "Frank Lloyd Wright." 9(June 1956), 164-68.

812. *House and Home.* "Here is prefabrication's biggest news for 1957." 10(December 1956), 117-21 . Van Tamelen house.

813. *House and Home.* "Merchandising." 9(April 1956), 140-41.

814. *House and Home.* "This rich and rhythmic house expresses 32 simple and basic design ideas of Frank Lloyd Wright ... Zimmerman house, Manchester, N.H." 10(September 1956), 136-41. Cf. "Architecture of ideas," *ibid.*, 21(March 1962), 116-27; see also 174.

815. *House Beautiful.* "How fresh and fitting is the furniture of Frank Lloyd Wright in traditional rooms." 98(June 1956), 114-17.

816. *Household.* "A modern house in the old west." 56(June 1956), 25-27, 70 . Blair house.

817. *L'Architettura.* "Frank Lloyd Wright a Roma." 2(October 1956), 456. Italian: "Wright in Rome."

818. *New Yorker.* "Wright revisited." 32(15 June 1956), 26-27.

819. *Newsweek.* "Tall tale: Wright's dream for Chicago." 48(10 September 1956), 98 ff. "The Illinois" mile-high skyscraper. See also "Wright sketches 510-story office tower ... ," *Architectural Forum*, 105(October 1956), 17; "Wright proposes mile-high skyscraper," *Science Digest*, 40(November 1956), 77; "Frank Lloyd Wright's mile-high office tower," *Architectural Forum*, 105(November 1956), following 107; "The Illinois," *Architectural Record*, 120(November 1956), 11; "La contraddizione che non c'è [The contradiction that isn't]," *L'Architettura*, 2(February 1957), 740 (Italian); "The mile high Illinois." *Architectural Record*, 121(March 1957), 250; "Frank Lloyd Wright will 1600 Meter hohen Wolken Kratzer in Chicago bauen [Wright wants to build a 1,600 meter high skyscraper in Chicago]," *Neue Heimat* (1957), 31-33 (German).

820. *Sinkentiku.* [Emergence of new constructivism.] 31(June 1956), 57-62. Japanese.

821. *Time.* [Portrait.] 67(11 June 1956), 69.

822. *Time.* [Portrait.] 68(2 July 1956), 51.

1957
Books, monographs and catalogues
823. Schumacher, F. *Schumacher's Taliesin line of decorative fabrics and wallpapers. Designed by Frank Lloyd Wright.* Chicago: E.W. Bredemeier and Co. Sample Books, 1955. The book contains samples of thirteen fabric and four wallpapers designed or chosen by Wright.

For comment see "A master architect creates fabric and wallpaper designs," *American Fabrics and Fashions*, (Winter 1955-56), 50-51; "New era for Wright at 86: the marketplace redeemed?" *Architectural Record*, 118(October 1955), 20; "Frank Lloyd Wright projects," *Interiors*, 114(June 1955), 130; "Taliesin to the trade," *ibid.*, 115(October 1955), 130-33; "FLLW designs home furnishings," *House and Home*, 9(January 1956), 188.

824. Scott, Edward B. *The saga of Lake Tahoe: a complete documentation of Lake Tahoe's development over the last one hundred years.* Crystal Bay, Lake tahoe, Nevada: Sierra-Tahoe Publishing, 1957.

825. Wright, Frank Lloyd. *Oasis: plan for Arizona State Capitol submitted by Frank Lloyd Wright, architect. February 15, 1957.* Phoenix: s. n. [The Author?], 1957. A publicity announcement intended to enlist voter support for Wright's design. The building was not realized. See also "FLLW fighting to design new Arizona Capitol," *Architectural Forum.* 106(April 1957), 7, 9 and insert "Proposed state capitol for Arizona by Frank Lloyd Wright"; "Wright picks a fight in Arizona: architect scorns a skyscraper and offers a weird substitute," *Life*, 42(13 May 1957), 59; and "Una democrazia festosa e aderente alle tradizioni: il 'Capitol' dell'Arizona [A joyful democracy faithful to traditions; the Arizona Capitol]." *L'Architettura*, 3(August 1957), 250 (Italian). See also John H. Fisher, "Arizona ethics [letter]," *Architectural Forum*, 106(July 1947), 89.

826. Wright, Frank Lloyd. *A testament.* New York: Horizon, 1957. The first part of te book is autobiographical, the other about architecture.

Reviewed Henry-Russell Hitchcock, "Architecture and the architect," *NYTBR*, (17 November 1957), 44; John La Farge, "The master of Taliesin," *America*, 98(30 November 1957), 297-98; Frank Getlein, *New Republic*, 137(December 1957), 28; *House and Home*, 13(January 1958), 135-41; Barry Byrne, "On Frank Lloyd Wright," *Liturgical Arts*, 26(February 1958), 61; Charles Moore, "Gospel according to Wright," *Architectural Record*, 123(February 1958), 58, 62; Edgar J. Kaufmann, Jr., "Constructive vision," *Progressive Architecture*, 39(March 1958), 246-48; and Sibyl Moholy-Nagy, "Frank Lloyd Wright's testament," *College Art Journal*, 18(Summer 1959), 319-29.

Excerpts are reprinted in "A master builder's philosophy... ," *House and Home*, 13(January 1958), 135-41. Also reprinted in part in Kaufmann and Raeburn eds. *Frank Lloyd Wright: writings and buildings*, New York: 1960, and in its entirety in Pfeiffer ed. *Frank Lloyd Wright collected writings. Vol. 5*, New York: 1995.

A less expensive edition was issued by Bramhall House, New York. A British edition, published by Architectural Press, London, 1959, is reviewed Fello Atkinson, *Architectural Record*, 128(August 1960), 99 and Martin Brace, *RIBA Journal*, 67(July 1960), 340. Excerpts are translated into Italian as "La memoria, l'abuso e l'apostasia [The memory, the abuse and the apostasy]." *L'Architettura*, 6(December 1960), 551. A full Italian translation, *Testamento*, was published Turin: Einaudi, 1963; reviewed Sara Rossi, *Architettura*, 9(December 1963), 647. It was reprinted 1973.

Also in German as *Ein Testament: zur neuen Architektur*, Reinbek: Rowholt, 1966. A Japanese translation was published Tokyo: Shokokusha, 1966 and a Hungarian version, *Testamentum*, Budapest: Gondolat, 1973.

827. *The first hundred years, 1857-1957: Spring Green's official centennial booklet.* Baraboo, Wisconsin: Sauk County Publishing, 1957

Periodicals
828. Adams, Richard P. "Architecture and the romantic tradition: Coleridge to Wright." *American Quarterly*, 9(Spring 1957), 46-62.

829. Boyd, Robin. "Two ways with modern monuments." *Architects' Journal*, 125(April 1957), 523, 525. Fallingwater; Robie house.

830. Buitenhuis, Peter. "Aesthetics of the skyscraper: the views of Sullivan, Jarnes and Wright." *American Quarterly*, 9(Fall 1957), 316-24.

831. Elken, Ants. "Pilgrimage to the midwest." *RAICanada Journal*, 34(November 1957), 420-21.

832. Gross, Martin L. "Master of the broken rule." *True*, 38(May 1957), 18-26, 122-26.

833. Huxtable, Ada Louise. "Larkin Company administration building, 1904, Buffalo, New York" *Progressive Architecture*, 38(March 1957), 141-42.

834. Johnson, Philip Cortelyou. "100 years, Frank Lloyd Wright and us." *Pacific Architect and Builder*, 63(March 1957), 13, 35-36. Partial transcript of a talk to the Washington State Chapter, AIA. Reprinted *idem.*, *Writings*, New York: Oxford University Press, 1979.

835. Johnson, Philip Cortelyou and Eero Saarinen. "Conversations regarding the future of architecture." *Print*, 11(February-March 1957), 37-39. Includes a discussion of Wright; based on the sound recording of the same name.

836. Kaufmann, Edgar J. Jr. "Frank Lloyd Wright: three new churches." *Art in America*, 45(Fall 1957), 22-25. Beth Sholom Synagogue; Annunciation Greek Orthodox Church; and Christian Science Church, Bolinas (project).

837. Kaufmann, Edgar J. Jr. and Alan Burnham. "F.C. Robie house" *Architectural Record*, 121(February 1957), 200. See also *ibid.*, 121(May 1957), 203-208.

838. Pellegrin, Luigi. "La sintesi culturale del primo Wright." *L'Architettura*, 2(January 1957), 666-71. Italian: "The cultural synthesis of early Wright."

839. Pellegrin, Luigi. "L'ora 'classica' di Wright." *L'Architettura*, 11(February 1957), 742-45. Italian: "Wright's 'classical' hour."

840. Saarinen, Aline B. "Tour with Mr. Wright." *NYT Magazine*, (22 September 1957), 22-23, 69-70. Guggenheim Museum. Reprinted in *The Solomon R. Guggenheim Museum. Architect: Frank Lloyd Wright*. New York: 1960.

841. Schall, James V. "An architect in the capital." *America*, 98(30 November 1957), 265. Wright's speech at the Washington Institute of Contemporary Arts, 14 October 1957.

842. Stengade, Erik. "Frank Lloyd Wright," *Arkitekten*, 59(no. 10, 1957), 145-55. Danish.

843. Tawfiq Ahmad 'abd al-Gawad. [Frank L. Wright visits Cairo]. *Majállat al-'Imara*, 3(1957), 37-41. Arabic

844. Völckers, Otto. "Save the Robie house!" *AIA Journal*, 28(August 1957), 247-48. The house was threatened with demolition. See response from Karl Kamrath, *ibid.*, (November 1957), 20. Cf. David Ray, "Epitaph for a landmark," *Nation*, 185(28 September 1957), 196 and inside cover (response: Albert Guerard, "Move the house," *ibid.*, [26 October 1957], inside cover).
 But see also "Chicagoans rally to save Wright's Robie house," *Architectural Forum*, 106(March 1957), 9; "The value of used architecture: Robie house, Chicago," *Architectural Forum*, 106(April 1957), 107-108; and "A tradition to preserve: Wright's Robie house," *Interiors*, 116(May 1957), 10, 12.
 The attenuated saga had a happy ending: see "Robie house saved." *Historic Preservation*, 10(no. 1, 1958), 14; "A famous house rescued," *Architectural*

Forum, 108(February 1958), 69; and "'House of the century' gets a reprieve from demolition," *House and Home*, 13(February 1958), 68.

845. Wiener, Paul Lester. "Titan of Taliesin." *Saturday Review of Literature*, 40(21 December 1957), 18-19.

846. Wright, Frank Lloyd. "Architecture and music." *Saturday Review of Literature*, 40(28 September 1957), 72-73.

847. Wright, Frank Lloyd. "Frank Lloyd Wright town hall lecture, Ford Auditorium, Detroit, October 21, 1957." *Monthly Bulletin, Michigan Society of Architects*, 31(December 1957), 23 ff. Reprinted in Meehan ed. *Truth against the world*, New York: 1987.

848. *Architectural Forum*. "Spite bill hits at FLLW Madison civic center." 107(August 1957), 7. Monona Terrace. Cf. "Wisconsin governor signs spite bill that kills Frank Lloyd Wright's Madison civic center," *ibid.*, (November 1957), 7, 9.

849. *Architectural Forum*. "Wedding chapel by FLLW with fountain below." 107(October 1957), 7. Hotel Claremont, Berkeley (project).

850. *Architectural Forum*. "Wright, Sandburg steal Chicago dynamic show." 107(December 1957), 12, 14. See also "Chicago dynamic," *AIA Journal*, 29(January 1958), 18-20, that publishes excerpts from a conversation among Alistair Cooke, Wright and Carl Sandburg.

851. *Architectural Forum*. "Wright to design Baghdad opera: opera and poetry." 106(March 1957), 97.

852. *Architectural Record*. "One hundred years of significant building, 9: houses since 1907." 121(February 1957), 199-206. Includes: Robie and Coonley houses; Taliesin West and Fallingwater.

853. *Architectural Record*. "Perspectives." 121(April 1957), 9. Robie house.

854. *Architecture and Arts* (Australia). "City in the sky—one mile high!" (June 1957), 62. Image only.

855. *Bouwkundig Weekblad*. "Verjaardagsportret van een bouwmeester." 75(25 May 1957), 340-41. Dutch: "Birthday portrait of a master architect." Translation of Relman Morin, "Wright: much-slandered, much-acclaimed but justly arrogant at 88 years old," *Los Angeles Times*, (4 June 1956).

856. *Coronet*. "Frank Lloyd Wright: architecture's stormy colossus." 42(August 1957), 83-93.

857. *ENR*. "At 88, Frank Lloyd Wright still has a ... career on the upgrade." 159(5 December 1957), 108 ff.

858. *House and Home*. "1900's: birth of an idea." 11(May 1957), 116. Robie house.

859. *House Beautiful.* "Our strongest influence to enrichment." 99(January 1957), 40-47, 99, 105-106.

860. *Interiors.* "View into unboxed space at Wright's Taliesin West." 117(August 1957), 101.

861. *Look.* "A visit with Frank Lloyd Wright." 21(17 September 1957), 28-34, 37.

862. *New Yorker.* "Lunch hour." 33(10 August 1957), 17-18. Guggenheim Museum.

863. *Newsday.* "Meeting of the Titans." (20 April 1957), 1M-4M. Transcribes a conversation between Wright and Carl Sandburg. Reprinted in Meehan ed. *The master architect: conversations with Frank Lloyd Wright.* New York: 1984.

864. *Time.* [Portrait.] 70(11 November 1957), 47.

1958
Books, monographs and catalogues
865. Breiner, Don E. *The V.C. Morris shop.* Berkeley: 1958.

866. Hitchcock, Henry-Russell Jr. "Frank Lloyd Wright and his California contemporaries." In *Architecture: nineteenth and twentieth centuries.* Harmondsworth: Penguin, 1958. Reprinted Harmondsworth; Baltimore: 1963, 1968 and Harmondsworth; New York, 1977.

867. Jackson, J.W. *The Metzner law, facts and fiction?* Madison: The Author, [1958?]. Monona terrace (tract).

868. Manson, Grant Carpenter. *Frank Lloyd Wright to 1910: The first golden age.* New York: Reinhold; London: Chapman and Hall, 1958. Based on Manson's PhD thesis, Harvard University. Reviewed *Architectural Forum,* 108(April 1958), 157; Harold Allen Brooks, "The spontaneous genius," *Progressive Architecture,* 39(September 1958), 226-230; David Gebhard, *College Art Journal,* 18(Spring 1959), 277-79; William Henry Jordy, *Arts,* 32(September 1958), 16; Edgar J. Kaufmann Jr., "Manson's Wright, Volume I," *Interiors,* 117(March 1958), 20; Hugh Morrison, "Wright's early years portrayed," *Architectural Record,* 125(January 1959), 60, 64; A.D. Foise, *Library Journal,* 83(1 March 1958), 758; *Booklist,* 54(15 April 1958) 474; Dirnitri Tselos, *JSAH,* 17(Winter 1958), 39; and *Werk,* 46(October 1959), sup. 222-23 (German). New edition, New York: van Nostrand Reinhold, 1979. The promised two additional volumes never appeared.

Published in Italian as *Frank Lloyd Wright: la prima era d'oro,* Rome: Officina, 1969; reviewed Agnoldomenico Pica, *Domus,* (April 1970), 10.

869. Midland Art Association. *The work of Frank Lloyd Wright: the Midland Art Association, Midland, Michigan, January 11th to 31st, 1959.* Midland: The Association, 1958. Single sheet catalog.

870. Mumford, Lewis. *From the ground up*. New York: Harcourt Brace, 1958. Reprints Mumford's essays (some are revised). See especially chapter 9, "A Fujiyama of architecture" and chapter 10, "A phoenix too infrequent," from *New Yorker*, 29(28 November 1953), 80-82 ff. and (12 December 1953), 105-110 ff.

871. Wright, Frank Lloyd. "Frank Lloyd Wright." In Charles Preston and Edward A. Hamilton eds. *Mike Wallace asks: highlights from 46 controversial interviews*. New York: Simon and Schuster, 1958. Wright appeared on the ABC's *The Mike Wallace Interview* TV program in September 1957. Fully transcribed in Meehan ed. *The master architect: conversations with Frank Lloyd Wright*. New York: 1984).

872. Wright, Frank Lloyd. *The living city*. New York: Horizon, 1958. This revises *The disappearing city*, New York: 1932 and *When democracy builds*, Chicago: 1945. A less expensive edition was issued by Bramhall House, New York. Reviewed Marchal E. Landgren, *Library Journal*, 84(15 January 1959), 186; *Bookmark*, 18(February 1959), 120; *Booklist*, 55(15 March 1959), 398; Carl Feiss, "Broadacre city revisited: FLW's restatement, with embellishments," *Progressive Architecture*, 40(July 1959), 181-82, 188; Walter Thabit, *American Institute of Planners Journal*, 25(August 1959), 163-64; and Robert C. Weinberg, *ibid.*, 27(November 1961), 352-54.

Republished New York: New American Library, 1963, 1970. Reprinted in part in Kaufmann and Raeburn eds. *Frank Lloyd Wright: writings and buildings*, New York: 1960; and in its entirety in Pfeiffer ed. *Frank Lloyd Wright collected writings. Vol. 5*, New York: 1995.

Also published in Spanish as *La ciudad viviente*, Buenos Aires: Compañía General Fabril Editora, 1961; and in Italian as *La città vivente*, Turin: Einaudi, 1966 (new edition, 1991). A Japanese translation was published by Shokokusha, Tokyo, 1968.

Periodicals
873. Bendiner, Alfred. "How Frank Lloyd Wright got his medal." *Harper's Magazine*, 216(May 1958), 30-35. Wright receives the Gold medal of the AIA's Philadelphia Chapter.

874. Berton, Pierre. "Frank Lloyd Wright and the Toronto City Hall [interview]." *Builder*, 195(10 October 1958), 615.

875. Blake, Peter. "Frank Lloyd Wright: master of architectural space." *Architectural Forum*, 109(September 1958), 120-25, 196-97. For readers' responses, see *ibid.*, (November 1958), 86-87.

876. Buffinga, A. "De profeet Lloyd Wright." *Bouw*, 13(8 March 1958), 246. Dutch: "Wright the prophet."

877. Cohen, George. "Frank Lloyd Wright's Guggenheim Museum." *Concrete Construction*, 3(March 1958), 10-13. See also "The Guggenheim progresses," *Progressive Architecture*, 39(January 1958), 77; *Architectural Record*, 123(May 1958), 10-13; Herbert Mitang, "Sidewalk views of that museum," *NYT Maga-*

zine, (12 October 1958), 14, 73; and Edgar J. Kaufmann Jr., "The form of space for art: Wright's Guggenheim Museum," *Art in America*, 46(Winter 1958-1959), 74-77.

878. Kultermann, Udo. "Frank Lloyd Wright und seine Nachfolge" *Bauen und Wohnen*, 12(October 1958), 253-54. German: "Wright and his successors."

879. Oboler, Arch. "He's always magnificently Wright." *Reader's Digest*, 72(February 1958), 49-54. Arch Oboler house.

880. Robie, Frederick C. and Frederick C. Robie Sr. "Mr. Robie knew what he wanted." *Architectural Forum*, 109(October 1958), 126-27, 206, 210. Robie house.

881. Scully, Vincent Joseph Jr. "Modern architecture: towards a redefinition of style." *Perspecta*, 4(1958), 5-10. Transcribes a talk on Wright's influence on the Dutch group De Stijl. Reprinted *College Art Journal*, (no. 2, 1958), 140-59. See also *idem.*, *Modern architecture. The architecture of democracy* (New York: 1961; London: 1968), in which the ideas are expanded.

882. Sekler, Eduard F. "Frank Lloyd Wright zum Gedächtnis" *Der Aufbau*, 14(August 1958), 299-302. German: "Remembering Frank Lloyd Wright." See also "Frank Lloyd Wright," *ibid.*, 303-306.

883. Wright, Frank Lloyd. "Away with the realtor." *Esquire*, 50(October 1958), 179-80. Reprinted in Pfeiffer ed. *Frank Lloyd Wright collected writings. Vol. 5*, New York: 1995.

884. Wright, Frank Lloyd. "Education and art in behalf of life." *Arts in Society*, 1(January 1958), 5-10. Reprinted in Meehan ed. *Truth against the world*, New York: 1987.

885. Wright, Frank Lloyd. "Frank Lloyd Wright designs for Baghdad." *Architectural Forum*, 108(May 1958), 89-101. Text from Wright's submission to the Development Board of Iraq.

886. Wright, Frank Lloyd. "Frank Lloyd Wright talks on prefabrication." *House and Home*, 13(April 1958), 120-22. Marshall Erdman houses. Reprinted in Pfeiffer ed. *Frank Lloyd Wright collected writings. Vol. 5*, New York: 1995.

887. Wright, Frank Lloyd. "Is it goodbye to Gothic?" *Together*, (May 1958). Reprinted in Pfeiffer ed. *Frank Lloyd Wright collected writings. Vol. 5*, New York: 1995; and *Frank Lloyd Wright Quarterly*, 8(Winter 1997).

888. Wright, Frank Lloyd. "Mr. Wright's agronomy." *Architectural Forum*, 108(February 1958), 150.

889. Wright, Frank Lloyd. "This is American architecture." *Design*, 59(January-February 1958), 112-13, 128. Text of speech to Chicago high school students. Revised and reprinted in Meehan ed. *Truth against the world*, New York: 1987.

890. Wright, Frank Lloyd. "What is architecture?" *Architectural Forum*, 108(May 1958), 102. Excerpts from *An organic architecture,* London: 1939.

891. Wright, John Lloyd. "In my father's shadow." *Esquire*, 49(February 1958), 55-57. For further comment, see "Story of an architectural conflict," *Capital Times* [Madison], (3 January 1958).

892. *Architectural Forum.* "No Oscar for Wright." 108(May 1958), 79, 81. Wright was offered a part in Charles Vidor's film "A Farewell to Arms."

893. *Architectural Forum.* "Wright designs an elementary school 'teaching laboratory' for Wichita University." 109(July 1958), 9. Juvenile Cultural Study Center, University of Wichita. See also "Four current projects in the news," *Architectural Record*, 124(July 1958), 148-49 and "P/A news bulletins." *Progressive Architecture*, 39(July 1958), 45.

894. *Architectural Forum.* "Wright to design dome theater for Mike Todd." 108(February 1958), 61. Todd-AO Universal Theatre (project).

895. *Architectural Record.* "Frank Lloyd Wright: a selection of current work." 123(May 1958), 167-90. Includes several buildings—Dallas Theater Center; Annunciation Greek Orthodox Church; Beth Sholom Synagogue; Guggenheim Museum (with a statement by Wright, "The Solomon R. Guggenheim Memorial.")—and projects: Monona Terrace; Florida Southern College Music Building; Bramlett motel, Memphis; and Christian Science Church, Bolinas.

896. *Architectural Record.* "Frank Lloyd Wright employs Revere copper [advertisement]." 123(March 1958), 66-67. Hagan house.

897. *Architectural Record.* "Meetings and miscellany." 123(May 1958), 24. Wright receives a medal from the National Concrete Masonry Institute.

898. *ENR.* "Autoist gets eyeful for tankful." 161(30 October 1958), 28. Lindholm service station. Cf. "New art form in Minnesota," *Fortune*, 58(October 1958), 71.

899. *Esquire.* "The latter days of Frank Lloyd Wright." 49(February 1958), 52-54.

900. *House and Home.* "3 new houses by Frank Lloyd Wright." 14(August 1958), 101-113. Schultz, Austin houses.

901. *House and Home.* "America's foremost architect speaks on prefabrication and the role of creative man in the machine age." 13(April 1958), 120-22. Marshall Erdman houses. Reprinted in Meehan ed. *Truth against the world,* New York: 1987.

902. *New Republic.* "Flat on our faces." 139(8 September 1958), 14-15. Interview.

903. *New Yorker.* "Commencement." 34(14 June 1958), 26-27. Note on Wright's appearance at Sarah Lawrence College, New York City.

904. *Pacific Architect and Builder.* "FLLW has friends, foes in civic center feud." 64(May 1958), 8. Marin County Civic Center.

1959
Books, monographs and catalogues
905. American Federation of Arts. "Frank Lloyd Wright." In *Formgivers at mid-century.* New York: Time Inc., 1959. Catalogue of a traveling exhibition sponsored by *Time* magazine. There are citations from *An American architecture*, New York: 1955 and *A testament*, New York: 1957.

906. Cohen, Mortimer Joseph. *Beth Sholom synagogue: a description and interpretation.* Elkins Park: The Synagogue, 1959. Also in paperback. Reviewed *Prairie School Review*, 2(no. 1, 1965), 26.

907. Forsee, Aylesa. *Frank Lloyd Wright—rebel in concrete.* Philadelphia: Macrae Smith, 1959. Juvenile biography. Reviewed *Kirkus*, 27(1 July 1959), 454; T.C. Kelly, *Library Journal*, 84(15 November 1959), 3639; *Wisconsin Library Bulletin*, 56(January 1960), 74; and *Booklist*, 569(15 January 1960), 299. Also published in Italian as *Frank Lloyd Wright—architetto ribelle*, Rome: Opere Nuove, 1961 and in Portuguese as *Frank Lloyd Wright, vida e obra*, Belo Horizonte: Editora Italiana, 1962.

908. F. Schumacher and Co. *A collection of wall coverings, companion fabrics and borders.* N.p., n.l., 1959. Photographic catalogue of decorative designs by Wright. See "Architects as wallpaper designers," *Architectural Review*, 128 (August 1960), 140.

909. Marshall Erdman and Associates. *Frank Lloyd Wright prefabricated houses manufactured by Marshall Erdman and Associates, Inc.* Madison: Marshall Erdman and Associates, Inc., 1959. Brochure.

910. Mumford, Lewis. *Frank Lloyd Wright y otros escritos.* Buenos Aires: Infinito, 1959. Spanish: *Frank Lloyd Wright and other writings.*

911. Neutra, Richard Joseph. *A la muerte de un gran hombre, Frank Lloyd Wright.* Madrid : n.p., 1959. Spanish: "On the death of a great man" Reprinted from *Revista Informes de la Construcción*, no. 116 (1959), organ of the *Instituto Técnico de la Construcción y del Cemento.*

912. Samonà, Giuseppe and A. Hyatt Mayor eds. *Frank Lloyd Wright. Drawings for a living architecture.* New York: Horizon, 1959. A selection of original sketches and presentation drawings 1885-1958, published for the Edgar J. Kaufmann Charitable Foundation and the Bear Run Foundation. There are essays: "The architecture of Frank Lloyd Wright" by Samonà (reprints "Man, matter and space: on the architecture of Frank Lloyd Wright," *Architects' Yearbook*, 1953) and "Frank Lloyd Wright's drawings" by Mayor.
 Reviewed Frederick Gutheim, "Wright's creative process shown in drawings," *Architectural Record*, 126(December 1959), 66, 70; "FLLW's drawings,"

Architectural Forum, 3(December 1959), 119-26; Fello Atkinson, *Architectural Review*, 128(August 1960), 99; D.J. Hurley, "Wrightian triplet ... ," *Liturgical Arts*, 28(August 1960), 114-15; John M. Jacobus Jr., *College Art Bulletin*, 42(June 1960), 166-67; William Henry Jordy, *Arts*, 34(May 1960), 19, 71; Henry-Russell Hitchcock Jr., *JSAH*, 19(October 1960), 129-31; and Edgar A. Tafel, *Progressive Architecture*, 41(December 1960), 184, 190.

913. Solomon R. Guggenheim Foundation. *The Solomon R. Guggenheim Museum 1959.* New York: The Foundation, 1959. Souvenir booklet of the opening.

914. Wright, Olgivanna Lloyd. *Our house.* New York: Horizon, 1959. Selections from a Madison Capital Times column. Reviewed *Booklist*, 55(1 May 1959), 475; *Architectural Forum*, 110(June 1959), 193; Iola Haverstick, *Saturday Review of Literature*, 42(11 July 1959), 32; *Wisconsin Library Bulletin*, 55(September 1959), 444; and Lincoln Kirstein, *Nation*, 189(12 December 1959), 448.

915. *Florida Southern College, Lakeland, Florida: The Frank Lloyd Wright campus.* Lakeland: The College, 1959. Illustrated brochure.

Periodicals
916. Atkinson, Fello. "Frank Lloyd. Wright, 1869-1959." *Architects' Journal*, 129(16 April 1959), 571-73. Wright died on 9 April 1959. Tributes and obituaries proliferated in the USA and elsewhere; see separate entries.

917. Banham, Reyner. "Master of freedorn." *New Statesman*, 57(18 April 1959), 543-44. Eulogy.

918. Blake, Peter. "The Guggenheim: museum or monument?" *Architectural Forum*, 111(December 1959), 86-93, 180, 184. Translated into Japanese, *Kokusai Kentiku*, 27(March 1960), 48-54 and partly reprinted Sweeney, "Chambered nautilus on Fifth Avenue," *Museum News*, 38(January 1960). See also "Guggenheim Museum spirals toward completion: photographs reveal interiors at last," *Progressive Architecture*, 40(July 1959), 75-77.
The opening caught the attention of the US architectural press but the building had a varied reception. See Robert M. Coates, "The art galleries: the Guggenheim and Zorach," *New Yorker*, 35(31 October 1959), 179-82; George McAuliffe, "The Guggenheim: great architecture, difficult installation," *Industrial Design*, 6(November 1959), 66-69; Thomas B. Hess, "First view of the Guggenheim," *Art News*, 58(November 1959), 46-47 (reprinted in part, *ibid.*, 91[November 1992], 112); "Last monument," *Time*, 74(2 November 1959), 67; Katharine Kuh, "Architecturally successful but the paintings died," *Saturday Review of Literature*, 42(7 November 1959), 36-37; Russell Lynes, "Mr. Wright's museum," *Harper's Magazine*, 219(November 1959), 96-100; Lewis Mumford, "What Wright hath wrought," *New Yorker*, 35(5 December 1959), 105-106 ff. (reprinted in *idem.*, *The highway and the city*, New York: 1963, and

partly reprinted Sweeney, "Chambered nautilus on Fifth Avenue," *Museum News*, 38[January 1960]; Hilton Kramer, "New Guggenheim Museum," *Arts*, 34(December 1959), 48-51; Matthew Peters, "Two domes," *Architectural Forum*, 111(December 1959), 205; "A westerner views the museum," *Pacific Architect and Builder*, 65(December 1959), 50; "Frank Lloyd Wright's sole legacy to New York," *Interiors*, 119(December 1959), 88-95; "Buildings in the news," *Architectural Record*, 126(December 1959), 12; and Edgar J. Kaufmann Jr., "The form of space for art: Wright's Guggenheim Museum," *Architectural Forum*, 46(Winter 1958-59), 74-77.

There was also international interest: see "Il Museo Guggenheim si e aperto al pubblico [Guggenheim Museum open to the public]," *Casabella.*, (December 1959), 50 (Italian); and "Art d'aujourd'hui, musée de demain [Art of today, museum of tomorrow]," *L'Oeil*, 60(December 1959), 106-111 (French).

919. Bloc, Andre, Marcel Lods and Alexandre Persitz. "Frank Lloyd Wright 1869-1959." *L'Architecture d'Aujourdhui*, 30(April 1959), 2-3. French. Obituaries.

920. Bloc, Andre. "Depuis Wright, quoi de neuf?" *Arts*, (22-29 April 1959), 1, 9. French: "Since Wright, what is new?"

921. Boyd, Thomas J. "Seamless-roll terne roofing." *Progressive Architecture*, 40(June 1959), 170-75. Claremont hotel wedding chapel.

922. Bush-Brown, Albert. "The honest arrogance of Frank Lloyd Wright." *Atlantic*, 204(August 1959), 23-26. For Robert Lloyd Wright's reply see *ibid.*, (October 1959), 32-33.

923. Carlos, John James. "Frank Lloyd Wright: Michelangelo of the 20th century." *Architectural and Engineering News*, 1(May 1959), 7. Eulogy.

924. Cooke, Alistair. "Memories of Frank Lloyd Wright." *AIA Journal*, 32(October 1959), 42-44. Reprinted from *Manchester Guardian Weekly*, (16 April 1959), and reprinted in *idem.*, *Memories of the great and the good*. New York: Arcade Publishing, 1999, 31-38.

925. Dudok, Willem Marinus. "Bij het overlijden van Frank Lloyd Wright." *Bouwkundig Weekblad*, 77(7 November 1959), 532-34. Dutch: "On the death of Frank Lloyd Wright."

926. Eaton, Leonard Kimball. "Frame of steel." *Architectural Review*, 126(November 1959), 289. E Z Polish Factory.

927. Ferraz, Geraldo. "Posição de Frank Lloyd Wright." *Habitat*, 9(March 1959), 1. Portuguese: "The position of Wright."

928. Fitch, James Marston. "Frank Lloyd Wright, 1869-1959." *Architectural Forum*, 110 (May 1959), 108-115. The tribute is followed by brief comments from architects and clients: Alvar Aalto, Anshen and Allen, Pietro Belluschi, Robert Dowling, Albert M. Greenfield, Walter Gropius, Joseph Hudnut, H.P.

Johnson, Philip Johnson, A. Quincy Jones, Louis Kahn, Edgar J. Kaufmann, Robert Moses, Lewis Mumford, Richard Neutra, Harold C. Price, Ludwig Mies van der Rohe, John Wellborn Root, Eero Saarinen, Jose Luis Sert, Ludd M. Spivey, Edward Durell Stone, Oskar Stonorov, James Johnson Sweeney, William W. Wurster, William Zeckendorf, and Bruno Zevi.

929. Gebhard, David. "A note on the Chicago Fair of 1893 and Frank Lloyd Wright." *JSAH*, 18(May 1959), 63-65. Includes a rare image of the Cummings Real Estate office, River Forest.

930. Gill, Brendan. "Notes and comment." *New Yorker*, 35(18 April 1959), 33-34. Obituary. Also published in German as "Eine begegnung mit Frank Lloyd Wright [A meeting with Frank Lloyd Wright]," *Bauen und Wohnen*, 13(June 1959), 66, 68.

931. Hitchcock, Henry-Russell. "Frank Lloyd Wright, 1867-1959." *RIBA Journal*, 66(August 1959), 341-42. Cf. *idem.*, "Frank Lloyd Wright, 1867(?)-1959," *Art News*, 58(May 1959), 25.

932. Holden, Arthur Cort. "Is this death? for Frank Lloyd Wright [poem]." *AIA Journal*, 31(June 1959), 33.

933. Huxtable, Ada Louise. "Triple legacy of Mr. Wright." *NYT Magazine*, (15 November 1959), 18-19.

934. Jones, Cranston. "Pride and prejudices of the master." *Life*, 46(27 April 1959), 54-56. See also "The finale at 89 for a fiery genius," *ibid.*, 53.

935. Jordan, Robert Furneaux. "Frank Lloyd Wright: a personal impression." *Architect and Building News*, 215(15 April 1959), 464-67.

936. Jordy, William Henry. "Frank Lloyd Wright, 1869-1959." *Arts*, 33(May 1959), 15, 68.

937. Kellogg, Cynthia. "Wright ready-made." *NYT Magazine*, (25 October 1959), 62-64. Rudin house. Cf. "Frank Lloyd Wright designed this big 'one-space' prefab," *House and Home*, 16(August 1959), 176-77.

938. Kiesler, Frederick. "Frank Lloyd Wright." *It Is*, (Autumn 1959), 27. Obituary.

939. Levin, Earl A. "Frank Lloyd Wright: an appreciation." *Habitat*, 2(May-June 1959), 21-24. Eulogy.

940. McQuade, Walter. "Architecture." *Nation*, 189(7 November 1959), 335-38.

941. Moholy-Nagy, Sibyl. "Frank Lloyd Wright and the ageing of modern architecture." *Progressive Architecture*, 40(May 1959), 136-42. For reader's responses see "Critique of Wright's contribution draws comment," *ibid.*, (July 1959), 51 ff; *ibid.*, (September 1959), 40. Also in *Perspective*, (1959), 40-45.

942. Morassutti, Bruno. "Ricordo di Frank Lloyd Wright." *Domus*, (July 1959),

25-26. Italian: "In memory of Frank Lloyd Wright." Obituary.

943. Moser, Werner Max. "Frank Lloyd Wright." *Bouwkundig Weekblad*, 77(7 November 1959), 535-43. Dutch. Obituary.

944. Moser, Werner Max. "Die Bedeutung Frank Lloyd Wrights für die Entwicklung der Gegenwartsarchitektur." *Werk*, 46(December 1959), 423-27. German: "Wright's meaning for the development of modern architecture."

945. Moser, Werner Max. "Hommage à Frank Lloyd Wright, 1867-1959." *Architecture: Formes et Fonctions*, 6(1959), 115. French: "Homage to Wright, 1867-1959." Obituary.

946. Oud, Jacobus Johannes Pieter. "Frank Lloyd Wright." *Groene Amsterdammer* (18 April 1959), 9. Dutch. Obituary.

947. Perkins, G. Holmes. "Tributes to Frank Lloyd Wright 1869-1959." *Architectural Forum*, 110(June 1959), 234. Obituary.

948. Rago, Louise Elliott. "Spirit of the desert—Frank Lloyd Wright's last interview: why people create." *School Arts*, 58(June 1959), 27-30. Reprinted in Meehan ed. *The master architect: conversations with Frank Lloyd Wright*, New York: 1984.

949. Reus, Jim de. "What we learned from Frank Lloyd Wright." *House and Home*, 15(February 1959), 126-33. Lamberson house.

950. Richards, John Noble. "Frank Lloyd Wright's funeral, April 12, 1959: impressions written on an airplane." *AIA Journal*, 31(May 1959), 44. See also "Frank Lloyd Wright," *ibid.*, 42-43. Obituary.

951. Roth, Alfred. "Frank Lloyd Wright 8. Juni 1869 bis 9. April 1959." *Werk*, 46(May 1959), front. German. Obituary.

952. Samton, Claude. "Frank Lloyd Wright." *Cuadernos de Arquitectura*, (April-June 1959), 61-64. Portuguese. Obituary.

953. Seaux, J. "Frank Lloyd Wright."*Habiter*, 10(November 1959), 389-90. French. Obituary.

954. Sekler, Eduard F. "Frank Lloyd Wright zum Gedächtnis" *Der Aufbau*, 14(August 1959), 299-302. German: "In memory of Frank Lloyd Wright." Obituary.

955. Sostres Maluquer, J. M. "Frank Lloyd Wright, el genio de la transicion." *Cuadernos de Arquitectura*, (no. 35, 1959), 2-4. Spanish: "Frank Lloyd Wright, genius of the transition." Obituary.

956. Stone, Edward Durell. "Hero, prophet, adventurer." *Saturday Review of Literature*, 42(7 November 1959), 15-17, 43. Obituary.

957. Strutt, James W., Harold Allen Brooks and Inigo Adamson. "Frank Lloyd

Wright, 1869-1959." *RAICanada Journal*, 36(June 1959), 202-204. Obituary.

958. Thunnissen, A.W.P. "Frank Lloyd Wright." *Katholiek Bouwblad*, 26(4 April 1959), 209-215. Dutch. Obituary.

959. Vriend, Jacobus Johannes. [Obituary for Wright]. *Groene Amsterdammer*, (18 April 1959), 9. Dutch.

960. Wright, Frank Lloyd. "A culture of our own." *Progressive Architecture*, 23(January 1959), 70-72. Reprinted in Pfeiffer ed *Frank Lloyd Wright collected writings. Vol. 5*, New York: 1995.

961. Wright, Frank Lloyd. "Frank Lloyd Wright: ein Testament." *Werk*, 46(December 1959), 427-28. German. Translated excerpts from *A testament*. New York: 1957.

962. Zevi, Bruno Benedetto. "Taliesin continua." *L'Architettura*, 5(October 1959), 366-67. Italian: "Taliesin goes on." See also "Taliesin continua," *ibid.*, 6(March 1961), 732-33.

963. *Architect and Building News*. "Frank Lloyd Wright." 215(15 April 1959), 467. Note on Wright's death.

964. *Architectural and Engineering News*. "Taliesen [*sic*] workshops." 1(May 1959), 4-5. Note that Wright's work will be continued by the Frank Lloyd Wright Foundation.

965. *Architectural Forum*. "Frank Lloyd Wright." 110(June 1959), 115-46. Special portfolio reviewing Wright's career. Reprinted as a book, *Frank Lloyd Wright: a special portfolio*. New York: Time Inc., 1959.

966. *Architectural Forum*. "FLIW's drawings." 111(December 1959), 119-26. Color illustrations from Wright, *Drawings for a Living Architecture*, New York: 1959.

967. *Architectural Forum*. "Wright dies at 89." 110(May 1959), 5. Note on Wright's death.

968. *Architectural Forum*. "Wright's Imperial Hotel, Tokyo." 110(June 1959), 11.

969. *Architectural Forum*. "Wright's legacy: culture in the southwest." 111(August 1959), 9. Grady Gammage Auditorium; Dallas Theater Center.

970. *Architectural Record*. "Frank Lloyd Wright, 1869-1959." 125(May 1959), 9. Note on Wright's death.

971. *Architectural Record*. "Watch on Wright landmarks." 126(September 1959), 9. Sixteen buildings recommended as landmarks by the AIA and the National Trust for Historic Preservation.

972. *Architectural Review*. [Obituary]. 125(June 1959), 373.

973. *Arquitectura México.* "Frank Lloyd Wright y México." (June 1959), 119. Spanish: "Frank Lloyd Wright and Mexico."

974. *Arts and Architecture.* [Obituary]. 76(May 1959), 12.

975. *Arts.* "Frank Lloyd Wright est mort." (22-29 April 1959), 1. French: "Wright is dead."

976. *Baukunst und Werkform.* "Zum Tode Frank Lloyd Wrights." 12(June 1959), 330. German: "On Wright's death."

977. *Baumeister.* "Zum Tode von Frank Lloyd Wright." 56(June 1959), 410-11. German: "On Wright's death."

978. *Bouw.* "Frank Lloyd Wright†." 14(18 April 1959), 417; (25 April 1959), 447. Dutch. Note on Wright's death.

979. *Bouwwereld.* "Architect Frank Lloyd Wright." 7(21 April 1959), 3. Dutch. Note on Wright's death.

980. *Builder.* [Obituary]. 196(17 April 1959), 735.

981. *Casabella.* [Frank Lloyd Wright]. (May 1959), 1-28. Italian. Includes "L'ultimo incontro con Frank Lloyd Wright [The last encounter with Wright]" by Ernesto Nathan Rogers; "Wright e lo 'spazio vissuto' [Wright and the live-in space]" by Enzo Paci; "La tecnica e Frank Lloyd Wright [Technique and Wright]" by Sibyl Moholy-Nagy; "Il divenire di Wright [The coming of Wright]" by Gilio Dorfles; "Wright e l'opinione comune [Wright and public opinion]" by Filippo Sacchi; "Della profezia dell'architettura [On the profession of architecture]" by E. Persico; and "Il museo Solomon R. Giggenheim of New York [The Guggenheim Museum in New York]". For a Japanese translation of the latter see *Kokusai Kentiku*, 27(January 1960), 22-31.

982. *Commonwealth.* [Obituary]. 70(24 April 1959), 94.

983. *House and Home.* "Frank Lloyd Wright (1869-1959)." 15(May 1959), 95, 98. Obituary.

984. *House and Home.* "Frank Lloyd Wright's own home in the desert." 15(June 1959), 88-98. Taliesin West.

985. *House Beautiful.* "Your heritage from Frank Lloyd Wright." 101(October 1959). Special issue includes: "How Frank Lloyd Wright used music" and "Shelter that encloses without confining" by Curtis Besinger; "The essence of Frank Lloyd Wright's contribution", "Wright's way with little things", and "Exploding the box to gain spaciousness" all by Elizabeth Gordon; "The open plan—a way to gain spaciousness" by Guy Henle; and "Interior space as architectural poetry" by John de Koven Hill. Also published in hardcover as, *Your heritage from Frank Lloyd Wright*, New York: House Beautiful, 1959.

986. *Japan Architect.* [Obituary]. 34(July 1959), 3. Japanese.

987. *L'Architettura.* "Frank Lloyd Wright." 5(August 1959), 282. Obituary.

988. *L'Architettura.* "[Obituary]." 5(May 1959), 4-5.

989. *L'Architettura.* "Le ultime creazioni di Frank Lloyd Wright." 5(November 1959), 472-83. Italian: "Frank Lloyd Wright's last creations." Projects for Jones Trinity chapel; Lenkurt Electric administration building and factory; Donahoe house.

990. *L'Architettura.* [Portrait]. 5(August 1959), 282.

991. *Life.* "The finale at 89 for a fiery genius." 46(27 April 1959), 53. Obituary.

992. *Life.* "The house one man built." 47(28 December 1959), 92. Berger house.

993. *Monthly Bulletin, Michigan Society of Architects.* "Frank Lloyd Wright." 33(January 1959), 34-35. Notice of an exhibition at Midland, Michigan, January 1959.

994. *Monthly Bulletin, Michigan Society of Architects,* "Work of Frank Lloyd Wright in Michigan." 33(December 1959), 17-32. Includes photographs of the Affleck, Anthony, Goetsch-Winkler, McCartney, Meyer, Meyer May, Palmer, Smith and Wall houses. Provides a complete list of houses built in the state. Reissued as a booklet; (reprinted, March 1969).

995. *Nation's Schools.* "Frank Lloyd Wright." 63(June 1959), 47-48.

996. *New Republic.* "Frank Lloyd Wright." 140(20 April 1959), 4. Obituary.

997. *Newsweek.* "The great dissenter." 53(20 April 1959), 98-99. Obituary.

998. *Pacific Architect and Builder.* "Two projects in California's Marin County, one in Montana among Frank Lloyd Wright's last." 65(June 1959), 12-13. Marin County Civic Center; Christian Science Church, Bolinas; Lockridge Medical Clinic.

999. *Pacific Architect and Builder.* "Who's W(right) in Montana?" 65(August 1959), 48.

1000. *Pacific Arts Association Bulletin.* "Frank Lloyd Wright." (Summer 1959), 2-19, 21-27. Special issue on Wright. Includes articles by Walter R. Bimson, Eugene Masselink and Harry Wood.

1001. *Progressive Architecture.* "Christmas present for Dallas: a theater by Wright." 40(December 1959), 79. Dallas Theater Center.

1002. *Progressive Architecture.* "Frank Lloyd Wright 1869-1959." 40(May 1959), 135. Obituary.

1003. *Progressive Architecture.* "P/A news report." 40(August 1959), 79. Cass house, Staten Island.

1004. *RIBA Journal*. [Obituary]. 66(August 1959), 369.

1005. *Sele Arte*. "Frank Lloyd Wright." 7(July-August 1959), 3-14. Italian. Obituary.

1006. *South African Architectural Record*. [Special issue.] 44(September 1959), 18-40. Includes "Frank Lloyd Wright" by John Fassler; "After the great man's death" by Richard Neutra; "Form and function: a study of Frank Lloyd Wright's theory of organic architecture" by Gilbert Herbert; and a letter by Montie Simon.

1007. *Southwest Builder and Contractor*. "Local contractor, architect, discuss home built by Frank Lloyd Wright fifty years ago." 133(24 April 1959), 13.

1008. *Time*. "Native genius." 73(20 April 1959), 80, 83. Obituary.

1960-1969

1960

Books, monographs and catalogues

1009. Andrews, Leonard E.B. ed. *Dallas Theater Center*. Dallas: The Center, 1960. There are articles by Paul Baker, Allen R. Bromberg, Eliot Elisofon, Aline de Grandchamp, Harwell Hamilton Harris, Gene McKinney, Virgil Miers, W. Kelly Oliver, John Rosenfield, Jane Scholl, Robert D. Stecker, Lon Tinkle and Ramsey Yelvington. Also published in paperback.

1010. Blake, Peter. *The master builders*. New York: Alfred A. Knopf; London: Gollancz, 1960, reprinted 1961. Reviewed *TLS*, (11 November 1960), 720; Albert Christ-Janer, *Saturday Review of Literature*, 43(12 November 1960) 28; Wolf Von Eckhardt, *Library Journal*, 85(15 November 1960), 4134; *AIA Journal*, 34(November 1960), 84; *Booklist*, 57(15 December 1960), 234; Lincoln Kirstein, *Nation*, 191(24 December 1960), 509; Reyner Banham, *New Statesman*, 60(31 December 1960), 1044; Gerald Barry, *Architectural Review*, 129(April 1961), 227; George Fitch, "Hero of the future: the city," *Progressive Architecture*, 421(April 1961), 204, 210; D.J. Hurley, *Liturgical Arts*, 299(May 1961), 82-83; Robert C. Weinberg, *Journal of the American Institute of Planners*, 27(November 1961), 352-53; Theodore M. Brown, *JSAH*, 20 (December 1961), 200-201; and Luciano Semerani, *Casabella*, (October 1962), 56 (Italian).

Revised and reissued in paperback as *The master builders. Le Corbusier, Mies van der Rohe, Frank Lloyd Wright*, New York: Norton, 1976. Reprinted with a new preface, 1996.

Published in Spanish as *Maestros de la arquitectura: Le Corbusier, Mies van der Rohe, Frank Lloyd Wright*, Buenos Aires: Victor Lerú, 1963 (reprinted 1973). For an Italian translation see *Tre maestri dell'architettura moderna*, Milan: Rizzoli, 1963; for German see *Drei Meisterarchitekten: Le Corbusier,*

Mies van der Rohe, Frank Lloyd Wright, Munich: Piper, 1962.
 The Wright section appeared as a separate paperback edition, *Frank Lloyd Wright: architecture and space*, Baltimore; Harmondsworth: Penguin, 1964; reviewed *Prairie School Review*, 2 (no. 1, 1965), 25; and Jiri Hruia, *Architektura CSR*, 24(1965), 615-16 (Czechoslovakian). Translated into Portuguese as *Frank Lloyd Wright e o dominio do espaco*, Rio de Janeiro: Record, 1966; and into Polish as *Frank Lloyd Wright—architektura i przestrzeñ*, Warsaw: Wydawnictwa Artystyczne i Filmowe, 1990.

1011. Caronia, Giuseppe. *L'opera e il messaggio di Frank Lloyd Wright.* Palermo: Editrice Artigiana Italiamondo, 1960. Italian: *The work and message of Frank Lloyd Wright.* Published in conjunction with a conference held in the Architecture Faculty, University of Palermo, Sicily, 26 March 1960.

1012. Kaufrnann, Edgar J. Jr. and Ben Raeburn eds. *Frank Lloyd Wright: writings and buildings.* London; New York: Meridian, 1960. An anthology of Wright's writings is grouped into seven sections, each introduced by the editors. It includes "Roots—to 1893"; "Roots—prairie architecture 1893-1910"; "Prairie architecture"; "The art and craft of the machine" (reprinted in full for the first time); "Designing Unity Temple"; "Discovery"; "The sovereignty of the individual"; "Taliesin 1911-1916. Taliesin"; "In the cause of architecture"; "Japan 1916-1922. The Imperial Hotel"; "Great projects and small houses 1920-1929. La Miniatura"; "The concept and the plan"; "The nature of materials"; "Style"; "Fellowship 1930-1945. To the young man in architecture"; "Chicago's century of progress"; "The city"; "Democracy in overalls"; "Fallingwater"; "St. Mark's-in-the-Bouwerie"; "What is architecture?"; "World architecture 1946-1959. The destruction of the box" (previously unpublished); "The new theater"(previously unpublished); "On the Johnson Laboratory"; "On the Price Tower"; "Integrity"; "The grammar of architecture"; "Organic architecture and the Orient"; "Influences and inferences"; and "The new architecture: principles". Also published in paperback. Reprinted 1968, 1974.
 Reviewed *Kirkus*, 28(1 April 1960), 322; A.D. Poise, *Library Journal*, 85(1 June 1960), 2164; *Booklist*, 56(1 July 1960), 649; *Wisconsin Library Bulletin*, 56(July 1960), 219; D.J. Hurley, "Wrightian triplet," *Liturgical Arts*, 28(August 1960), 114-15; Mildred F. Schmertz, "A Wright anthology," *Architectural Record*, 129(August 1960), 84; Harry Wood, *School Arts*, 60(November 1960), 49; Robert C. Weinberg, "A distillation of FLLW." *AIA Journal*, 34(November 1960), 62-64; and *idem., American Institute of Planners Journal*, 27(November 1961), 354.
 Also published in Spanish as *Frank Lloyd Wright: sus ideas y sus realizaciones*, Buenos Aires: Victor Lerú, 1962 and in German as *Frank Lloyd Wright: Schriften und Bauten*, Munich: Langen, Müller, 1963 (reviewed Silvia Kogler, *Du*, 24[1964], 64-65). Published in Japanese, Tokyo: ADA Edita, 1976.

1013. Linder, Paul; Luis Mior Quesada and Hector Velarde. *Frank Lloyd Wright: un homenaje.* Lima: Sociedad de Arquitectos del Peru, 1960. Spanish: *Frank Lloyd Wright: a tribute.*

1014. Porro, Ricardo. *Forma y contenido en Wright*. Caracas: Universidad Central de Venezuela. Facultad de Arquitecture y Urbanismo, 1960. Spanish: *Form and content* [*in Wright's work*].

1015. Robbins, I.D. *The lighting of a great museum*. Hackensack: American Lighting Corporation, 1960. Pamphlet: lighting plan for the Guggenheirn Museum.

1016. Sacriste, Eduardo. *"Usonia": aspectos de la obra de Wright*. Buenos Aires: Ediciones Infinito, 1960. Spanish: *"Usonia": aspects of Wright's work*. Second edition, Buenos Aires: Libreria Tecnica CP67, 1976.

1017. Scully, Vincent Joseph Jr. *Frank Lloyd Wright*, New York: George Braziller, 1960. Reviewed *Kirkus*, 28(15 April 1960), 354; Wolf von Eckhardt, *Library Journal*, 85(15 April 1960), 1560; 6; Edgar J. Kaufmann Jr., *Saturday Review of Literature*, 43(14 May 1960), 21; *Booklist*, 56(15 May 1960), 571; Reyner Banham, *Arts*, 34(June 1960), 12-13, 65; D.J. Hurley, *Liturgical Arts*, 28(August 1960), 114-15; Grant Carpenter Manson, *JSAH*, 19(December 1960), 182-83; David Gebhard, *Art Journal*, 20(Winter 1960-61), 118, 120. Also published in paperback. Reprinted as *Masters of world architecture: Frank Lloyd Wright*. New York: Braziller, 1990.
 Also published London: Mayflower, 1960; in Italian, Milan: Il Saggiatore, 1960, 1961; in German, Ravensburg: O. Maier, 1961 and in Spanish, Barcelona: Bruguera, 1961, 1966.

1018. Solomon R. Guggenheim Foundation. *The Solomon R. Guggenheim Museum. Architect: Frank Lloyd Wright*. New York: The Foundation and Horizon Press, 1960. Includes an introduction by Harry F. Guggenheim; "Tour with Mr. Wright" by Aline B. Saarinen (from *NYT Magazine*, 22 September 1957); and "An experiment in the third dimension" and other comments by Wright (reprinted in Pfeiffer ed. *Frank Lloyd Wright collected writings. Vol. 5*, New York: 1995). Also published in paperback.
 See also *The Solomon R. Guggenheim Museum: Frank Lloyd Wright*, New York: The Foundation, 1975; a new edition was published New York; Florence: Officine Grafiche, 1980.
 Published in Spanish as *Museo Guggenheim*, Madrid: 1960, reprinted from *Revista Informes de la Construcción*, no. 121(1960), organ of the *Instituto Técnico de la Construcción y del Cemento*.

1019. Grotz, Paul and Walter McQuade eds. *L'Uomo al di sopra della macchina. Frank Lloyd Wright: una mostra della sua opera nell'ultimo decennio presentata dagli Stati uniti d'America alla 12 Triennale di Milano-1960*. Racine; Milan: Cera Johnson and Son Italiana 1960. Italian: *Man over the machine. Frank Lloyd Wright: an exhibition of his work of the last decade presented by the USA at the Twelfth Milan Trienniale, 1960*. Catalogue. See also Edward Durell Stone. *Le grandi idee di Frank Lloyd Wright* [*Wright's grand idea*], Rome: US Information Service, 1960.

1020. Wright, Olgivanna Lloyd. *The shining brow*. New York: Horizon, 1960.

Reviewed *Kirkus*, 28(1 March 1960), 212; "Paean sung too soon," *Progressive Architecture*, 41(June 1960), 250, 256; A.D. Poise, *Library Journal*, 85(July 1960), 2582.

1021. *Arquitetura de Frank Lloyd Wright*. Rio de Janeiro: Museo de Arte Moderna, 1960. Portuguese: *Frank Lloyd Wright's architecture*. Pamphlet for an exhibition at the mueum, February-March 1960.

1022. *Frank Lloyd Wright, master architect*. Washington, D.C.: USIS, 1960. Published for international distribution; includes excerpts from the architect's writings.

1023. *Monona Terrace Auditorium and Civic Center, Madison, Wisconsin: designed by Frank Lloyd Wright, William Wesley Peters, architect, Taliesin Associated Architects*. Madison: *Capital Times*, 1960. Brochure.

Periodicals
1024. Barrett, William. "Observations: Frank Lloyd Wright's pictorama." *Commentary*, 29(March 1960), 249-52. Guggenheim Museum. The US press continued to comment. See *AIA Journal*, 33(January 1960), 124; Michael Jennings, "The Guggenheim Museum: Frank Lloyd Wright's legacy to New York," *Light and Lighting*, 53(February 1960), 34-37; Edward F. Pierce, "New York's new house of art," *Think*, 26(August 1960), 30-34; and Francis Steegmuller, "Battle of the Guggenheim," *Holiday*, 28(September 1960), 60-61, 105-106.

For German comment see A. Rannit, "Das neue museum der ungegenständ lichen Kunst in New York [The new museum for non-representational art]," *Das Kunstwerk*, 13(January 1960), 24 ff.; "Das-Salomon-R.-Guggenheirn-museurn [*sic*]," *Baukunst und Werkform*, 13(no. 1, 1960), 6-7; and Carola Giedion-Welcker, "Zum neuen Guggenheim-museum in New York [On the new Guggenheim Museum]," *Werk*, 47(May 1960), 178-81.

Italian reviews include Bruno Benedetto Zevi, "L'incessante polemica sul Museo Guggenheim [The incessant controversy over the Guggenheim]," *L'Architettura*, 5(April 1960), 798-99; "Il Museo Guggenheim a New York," *Edilizia Moderna*, 69(April 1960), 39-46; and Henry-Russell Hitchcock Jr., "Notes of a traveller: Wright and Kahn," *Zodiac*, (no. 6, 1960), 14-21 (English).

For Scandinavian critiques see Bodil Kjoer, "Frank Lloyd Wright's Guggenheim-bygning," *Arkitekten*, 62(July 1960), 255-57 (Danish); Christian Norberg-Schulz, "Wright or wrong?" *Byggekunst*, 42(1960), 80-84 (English, Swedish).

See also *Kokusai Kentiku*, 27(January 1960), 22-31 (Japanese, translated from *Casabella*, [May 1959] and *Architectural Forum*, 110[June 1959]); *Architect and Building News*, 218(27 July 1960), 105-110; "Museu Guggenheim, Nova York," *Habitat*, 11(July 1960), 12-17 (Portuguese); and F.E. Röntgen, *Polytechnische Tijdschrift (B)*, (11 August 1960), 580-83 (Dutch).

1025. Brooks, Harold Allen, Jr. "The early work of the Prairie architects." *JSAH*, 19(March 1960), 2-10.

1026. Cole, Wendell. "The theater projects of Frank Lloyd Wright." *Educational Theater Journal*, 12(May 1960), 86-93.

1027. Eaton, Leonard Kimball. "Jens Jensen and the Chicago School." *Progressive Architecture*, 41(December 1960), 144-50.

1028. Fitch, James Marston. "Frank Lloyd Wright's war on the fine arts." *Horizon*, 3(September 1960), 96-103, 127-28.

1029. Gutheim, Frederick Albert et al. "The Wright legacy evaluated." *Architectural Record*, 128(October 1960), 147-86. The introduction is reprinted in Gutheim et al. eds. *In the cause of architecture*, New York: 1975.

1030. Kaufmann, Edgar J. Jr. "Centrality and symmetry in Wright's architecture." *Architects' Yearbook*, 9(1960), 120-31.

1031. Pellegrin, Luigi. "Wright in Norvegia; disegni di F. Ll. Wright." *L'Architettura*, 6(May 1960), 39-40. Italian: "Wright in Norway; drawings by Wright."

1032. Ragon, Michel. "L'Architecture américaine." *XXe Siécle*, 22(June 1960), sup. 1-3. French: "American architecture"; English summary.

1033. Stone, Edward Durell. "A tribute to a personal hero." *Pacific Architect and Builder*, 66(March 1960), 20. Remarks on the occasion of the groundbreaking for Marin County Civic Center. Cf. "Wright eulogized at Marin County groundbreaking," *Pacific Architect and Builder*, 66(March 1960), 13; and "Ground is broken for Wright's Marin County Center," *Progressive Architecture*, 41(April 1960), 82.

1034. Sweeney, James Johnson. "Chambered nautilus on Fifth Avenue." *Museum News*, 38(January 1960), 14-15. Guggenheim Museum. Reprints excerpts from Mumford "What Wright hath wrought," *New Yorker*, 35(5 December 1959); Blake, "The Guggenheim: museum or monument?" *Architectural Forum*, 111(December 1959); and Alfred Frankenstein, *San Francisco Chronicle* (29 November 1959). Cf. Emilio Lavagnino, "Conferma la condanna a Sweeney [Confimation of Sweeney's sentence]," *L'Architettura*, 6(August 1960), 262-263 (Italian). See also Philip Cotelyou Johnson, "Letter to the museum director," *ibid.*, 25.

1035. Wheeler, Robert C. "Frank Lloyd Wright filling station, 1958." *JSAH*, 19(December 1960), 174-75. Lindholm service station.

1036. Whelan, Dennis. "Mr. Wright makes himself clear: a recollection." *Horizon*, 3(September 1960), 128.

1037. Wright, John Lloyd. "Appreciation of Frank Lloyd Wright." *Architectural Design*, 30(January 1960), 1-34. For a Dutch translation of excerpts see Röntgen, "Het Solomon R. Guggenheim Museum te New York," *Polytechnische Tijdschrift (B)*, (11 August 1960).

1038. *Architectural Design*. "Father: Frank Lloyd Wright, June 8, 1869-April 9, 1959." 29(January 1960), 1-30.

1039. *Architectural Record*. "A theater by Wright: Kalita Humphreys Theater of

the Dallas Theater Center." 127(March 1960), 161-66. Cf. *Architectural Forum*, 112(March 1960), 130-35; and *Architectural Design*, 30(September 1960), 367.

There was international interest in the building: see "Kalita Humphrey's [*sic*] Theater in Dallas, Texas," *Werk*, 47(September 1960), 301-303 (German); "Das-Kalita-Humphreys-theater in Dallas ... ," *Baukunst und Werkform*, 13(no. 6, 1960), 314-15 (German); "Il teatro di Wright: gli spettatori agganciati [Wright's theater: the coupled spectators]," *L'Architettura*, 6(July 1960), 185 (Italian); and "Un'opera postuma di Frank Lloyd Wright [A posthumous work by Wright] ... ," *Casabella*, (May 1960), 52-54 (Italian).

1040. *Builder*. "A prefabricated house by Frank Lloyd Wright." 199(August 19, 1960), 313. Cass house.

1041. *Domus*, "Airhouse." (March 1960), 17-18. Air-inflated structure designed by Wright exhibited at the International Home Exhibition, New York.

1042. *House and Home*. "A portfolio of houses by Frank Lloyd Wright." 18(September 1960), 113-23. Davis, Hagan, Palmer and Sanders houses.

1043. *Kokusai Kentiku*. "Synagogue for the Beth Sholom congregation, Pennsylvania; Frank Lloyd Wright, architect." 27(January 1960), 32-33. Re-printed from "Frank Lloyd Wright," *Architectural Forum*, 110(June 1959).

1044. *L'Architecture d'Aujourdhui*. "Frank Lloyd Wright: ses derniers projets et sa derniere oeuvre." 5(February 1960), 56-59. French: "Wright: his last projects and his last work." Projects: Art Museum, Baghdad; Arizona State Capitol, ("Oasis"); "The Illinois," mile-high skyscraper; works: Annunciation Greek Orthodox Church and Guggenheim Museum.

1045. *L' Architecture d'Aujourd'hui*. "In memoriam Frank Lloyd Wright." 31(September-November 1960), 11-19. French. Guggenheim Museum; Kalita Humphreys Theater.

1046. *L'Architettura*. "Carlo Levi e Frank Lloyd Wright." 6(September 1960), 292-93. Italian: "Carlo Levi and Wright."

1047. *Progressive Architecture*. "Wright still builds with California Church." 41(November 1960), 70. Pilgrim Congregational Church.

1048. *Zodiac*. "Il laisse son oeuvre." (no. 5, 1960), 28-37. French title: "He leaves his work." Subtitled, "A photographic survey of Wright's work and a few lines on Wright by Le Corbusier."

1961
Books, monographs and catalogues
1049. Booth, Ramon L. *Morris shop*. Berkeley: n.p., 1961

1050. Farr, Finis. *Frank Lloyd Wright: A biography*. New York: Scribner, 1961. Reviewed *Kirkus*, 29(15 August 1961), 776; Marchal E. Landgren, *Library*

Journal, 86(15 October 1961), 347; *Bookmark*, 21(November 1961), 41; *Booklist*, 58(1 December 1961), 224; *Wisconsin Library Journal*, 58(January 1962), 49; Grant Carpenter Manson, "The unvarnished truth," *Progressive Architecture*, 43(April 1962), 206ff; Reyner Banham, *New Statesman*, 63(6 April 1962), 492; and M.S. Kuhn, *Social Education*, 26(October 1962), 352.

Also serialized as "Frank Lloyd Wright: defiant genius," in *The Saturday Evening Post* 234(1961) on (7, 14 21 and 28 January and 4 February.

A British edition was published London: Cape, 1962; reviewed Sean Kenny, "A master builder," *Spectator*, 208(23 March 1962), 358-59; and Peter Matthews, "Honest vulgarity," *Time and Tide*, *43*(29 March 1962), 45.

1051. Peters, William Wesley et al. *Monona Terrace Auditorium and Civic Center for the city of Madison, Wisconsin: designed by Frank Lloyd Wright, William Wesley Peters, architect (Taliesin Associated Architects).* Madison: Citizens for Monona Terrace, Inc., 1961.

1052. University of Chicago. *The Midway Gardens, 1914-1929: an exhibition of the building by Frank Lloyd Wright, and the sculpture by Alfonso Iannelli.* Chicago: The University, 1961. A pamphlet published for an exhibition by the College of Humanities, Lexington Hall Gallery, April-May 1961 includes "The Midway Gardens" by Alan M. Fern and "Architect and sculptor in the making of Midway Gardens" by Alfonso Iannelli. For comment see Barry Byrne, "Wright and Iannelli," *Architectural Record*, 129(January 1961), 242, 246.

Periodicals
1053. Bancroft, Dick. "From the publisher's desk." *Building Construction*, 31(September 1961), 5. S.C. Johnson and Son research tower. See also *ibid.*, (November), 5.

1054. Cooke, Alistair. "A letter from Bath: the city and Frank Lloyd Wright." *Listener*, 66(6 July 1961), 26-27.

1055. Jacobs, Herbert Austin. "A light look at Frank Lloyd Wright." *Wisconsin Magazine of History*, 44(Spring 1961), 163-76.

1056. Pyron, Bernard. "Wright's diamond module houses." *College Art Journal*, 21(Winter 1961-1962), 92-96. See also *idem.*, "Wright's small rectangular houses: his structures of the forties and fifties," *ibid.*, 23(Fall 1963), 20-24.

1057. Scully, Vincent Joseph Jr. "The heritage of Wright." *Zodiac*, (no. 8, 1961), 8-13. Italian and French summaries. Also published in the Voice of America Forum Lectures, architecture series, n.p., n.d.

1058. *Architectural Forum*. "FLLW job resumed after halt; another advancing." 114(February 1961), 9, 11. Marin County Civic Center; Monona Terrace. Cf. "Half a Wright project may be better than none," *ibid.*, 115(December 1961), 10.

1059. *Architectural Forum*. "Spirit of Byzantium: FLLW's last church." 115(December 1961), 82-87. Church of the Annunciation. See also "Teacup

dome," *Time*, 78(18 August 1961), 50.

1060. *Architectural Record.* "Frank Lloyd Wright in posthumous recording." 130(October 1961), 24. Reviews "Frank Lloyd Wright on Record", released by Caedmon Records.

1061. *Architektur und Wohnform.* "Theater in Dallas, Texas." 69(April 1961), 83-86. Kalita Humphreys Theater.

1062. *Bauen und Wohnen.* "F.L.Wright und der Begriff der organischen Architektur." 15(October 1961), 364-65. German: "Wright and the concept of organic architecture."

1063. *Building Construction.* "Frank Lloyd Wright's Johnson Wax building finally made dry." 31(November 1961), 20-23.

1064. *L'Architettura.* "Taliesin continua." 6(March 1961), 732-33. Italian: "Taliesin goes on." Cf. Bruno Benedetto Zevi, "Taliesin continua," *ibid.*, 5(October 1959), 366-67.

1065. *Western Architect and Engineer.* "Mr. Wright and his successors." 221(March 1961), 21-33. Includes Marin County Civic Center; Pilgrim Congregational Church; Grady Gammage auditorium, Fawcett, Walton and Ablin houses; and Donahue triptych near Phoenix (project).

1962
Books, monographs and catalogues
1066. Busch, Noel F. *Two minutes to noon.* Lomdon: Arthur Barker, 1962. Imperial hotel.

1067. Canadian Broadcasting Corporation. *Architects of modern thought, 3rd and 4th series: 12 talks for CBC radio.* Toronto: The Corporation, 1962. Texts of two series of six half-hour talks, first broadcast in 1958.

1068. Cary, Charles Lynn. *V.C. Morris gift shop.* n.l., n.p., 1962.

1069. Currier Gallery of Art. *Frank Lloyd Wright in Manchester.* Manchester, NH: The Gallery, 1962. Announces a photographic exhibition.

1070. Diamond, Mary ed. *Frank Lloyd Wright, Japanese prints.* Los Angeles: Municipal Art Commission, 1962. Exhibition catalogue, Municipal Art Gallery, Barnsdall Park, January-February 1962. Includes "Frank Lloyd Wright on Japanese prints," a reprint of the introduction from The Arts Club of Chicago, *Antique colour prints from the collection of Frank Lloyd Wright*, Chicago: 1917.

1071. Drexler, Arthur ed. *The drawings of Frank Lloyd Wright.* New York: Horizon Press for the Museum of Modern Art, 1962. Catalogue of original drawings, 1895-1959, exhibited at MoMA in 1962.
 The show is reviewed by Ada Louise Huxtable, "Drawings and dreams of Frank Lloyd Wright," *NYT Magazine*, (11 March 1962), 24-25; "The master

builder," *Cue*, 31(24 March 1962), 10; "Wright drawings at the Modern," *Arts Magazine*, 36(March 1962), 69; "Drawings of a master designer," *Industrial Design*, 9(April 1962), 12; "Wright and the organic tradition," *Industrial Design*, 9(April 1962), 39; "Important show at the Museum of Modern Art." *Apollo*, 76(April 1962), 148; Walter McQuade, "Architecture," *Nation*, 194(14 April 1962), 338-39; Harold Allen Brooks, "Architectural drawings by Frank Lloyd Wright," *Burlington Magazine*, 104(May 1962), 210-12; Mildred F. Schmertz, "FLW, draftsman," *Architectural Record*, 131(June 1962), 42,48; "Frank Lloyd Wright et son école [Wright and his school] ..." *L'Architecture d'Aujourdhui*, 33(June 1962), 14-15 (French). See also Barry Byrne, *JSAH*, 22(May 1963), 108-109 and Edgar A. Tafel, *Progressive Architecture*, 44(May 1963), 192.

The catalog was also published as *The Drawings of Frank Lloyd Wright.* New York: Bramhall House, 1962 and London: Thames and Hudson, 1963 (reviewed Hugh Casson, *Architectural Review*, 133[June 1963], 386-87).

1072. Herzog, William T. *Unity Church and Frank Lloyd Wright*. Oak Park: Unitarian Universalist Church, 1962.

1073. Marin County, California. Board of Supervisors. *Marin County Civic Center*. San Rafael, California: The Board, 1962. Illustrated pamphlet published to celebrate the dedication of the building, October 1962.

1074. Ransohoff, Doris. *Living architecture: Frank Lloyd Wright.* Chicago: Britannica Books, 1962. Juvenile biography.

1075. Weisse, Rolf. "Broadacre City, a project designed by Frank Lloyd Wright, 1935; a new regional settlement pattern designed by Ludwig Hilberseimer, 1944; S. Germany: developments in the well forested Munich region." In Harvard University. Graduate School of Design, *Intercity; comparative analysis of intercity developments*. Cambridge, Mass.: The School, 1962.

1076. White, Morton Gabriel, and Lucia White. "Architecture against the city: Frank Lloyd Wright." In *The intellectual versus the city: from Thomas Jefferson to Frank Lloyd Wright*. Cambridge, Mass.: Harvard University Press and MIT Press, 1962. 189-99. Reprinted Oxford University Press, 1977. Also published in Spanish as *El intelectual contra la ciudad: de Thomas Jefferson a Frank Lloyd Wright.* Buenos Aires: Infinito, 1967.

1077. Wright, Iovanna Lloyd. *Architecture: man in possession of his earth. Frank Lloyd Wright*. Garden City, New York: Doubleday, 1962. Reprints Wright's preamble to *The wonderful world of architecture* (1959) (again reprinted in Pfeiffer ed. *Frank Lloyd Wright collected writings. Vol. 5*, New York: 1995).

Reviewed Frank Getlein, *New Republic*, 14(17 November 1962), 35; K.G. Jackson, *Harper's Magazine*, 226(January 1963), 96; R.L. Enequist, *Library Journal*, 88(15 February 1963), 769; *Architectural Forum*, 118(May 1963), 182; and Bradley Ray Storrer, *Progressive Architecture*, 44(June 1963), 185-86, 191.

A British edition was published London: MacDonald, 1963, and reviewed Reyner Banham, *New Statesman*, 66(8 November 1963).

Periodicals

1078. Armitage, Merle. "Frank Lloyd Wright. An American original." *Texas Quarterly*, 5(Spring 1962), 85-90. Bound with Hugh Leipziger-Pearce, "The roots and directions of organic architecture," *ibid.*, and reissued as a booklet, 1962.

1079. Farr, Finis. "The countenance of principle." *Arts In Virginia*, 3(Fall 1962), 2-9.

1080. Kaufman, Edgar J. Jr. "Venticinque anni nella Casa sulla Cascata" *L'Architettura*, 8(August 1962), 222-80. Italian and English: "Fallingwater 25 years after" (Italian, German, French, Spanish summaries). Reissued as a book, Milan: 1962. Reprinted in Zevi and Kaufmann, *La casa sulla cascata di F. Ll. Wright*, Milan: 1963 and in Brooks ed. *Writings on Wright*, Cambridge, Mass.: 1981.

1081. Mumford, Lewis. "Megalopolis as anti-city."*Architectural Record*, 132(December 1962), 101-108. Includes Broadacre City.

1082. Scully, Vincent Joseph Jr. "Wright, International Style and Kahn." *Arts Magazine*, 36(March 1962), 67-71, 77. Abridged form of "Frank Lloyd Wright and twentieth century style", later published in *International Congress of the History of Art, problems of the 19th and 20th centuries*. Princeton: 1963.

1083. Smith, C. Ray. "Rehousing the drama." *Progressive Architecture*, 43(February 1962), 96-109. Guggenheim. Museum.

1084. Wright, Olgivanna Lloyd. "The ideas of education." *Architecture Plus*, no. 5(1962-1963), unp.

1085. Wright, Olgivanna Lloyd. "The living heritage of Frank Lloyd Wright." *Arizona Highways*, 38(April 1962), 2-3.

1086. Zevi, Bruno Benedetto. "Il vaticinio del Riegl e la casa sulla cascata." *L'Architettura*, 8(August 1962), 218-21. Italian: "The Riegl vaticinio and the house on the waterfall." Fallingwater. Reprinted in Zevi and Kaufmann, *La casa sulla cascata di F. Ll. Wright*, Milan: 1963.

1087. *Architectural Forum*. "FLLWs legacy: projects and sketches." 117(July 1962), 9. Grady Gammage Memorial Auditorium.

1088. *Architectural Record*. "First building in Wright's Marin Center to be completed this month." 131(June 1962), sup. 4-5. Administration Building, Marin County Civic Center. Cf. "First phase of Marin County Center is completed," *ibid.*, 132(November 1962), 12. See also "Wright post office," *Progressive Architecture* 43(September 1962), 76; "Rolling shapes for rolling Marin Hills," *Architecture West*, 68(October 1962), 6-7; and "The good building is one that makes the landscape more beautiful than it was before ... ," *Architectural Forum*, 117(November 1962), 122-29.

1089. *Architectural Review.* "Unity restored." 131(January 1962), 5-6. Unity temple.

1090. *House and Home.* "On the rolling prairie, Oskaloosa, Iowa." 21(March 1962), 130-33. Alsop and Lamberson houses.

1091. *Let's See.* "Taliesin revisited." 6 (May 1962), 21-25, 43-44.

1092. *Nuestra Arquitectura.* "La casa de la cascada: historia de una epopeya." (December 1962), 8, 10. Spanish: "The house on the waterfall: history of an epic." Fallingwater.

1963
Books, monographs and catalogues
1093. Angrisani, Marcello. *Lo spazio interno architettonico da Frank L. Wright a Louis I. Kahn.* Naples: L'Arte Tipografica, 1963. Italian: *The internal architectectural spaces of Wright and Louis Kahn.*

1094. Columbia University School of Architecture. *Four great makers of modern architecture: Gropius, Le Corbusier, Mies van der Rohe, Wright. The verbatim record of a symposium held at the School of Architecture, Columbia University, from March to May, 1961.* New York: Trustees of the University, 1963. Includes: "The social implications of the skyscraper" by Henry Stern. Churchill; "Broadacre City: Wright's utopia reconsidered" by George Roseborough Collins; "The continuity of idea and form" by Alden B. Dow; "Wright and the spirit of democracy" by James Marston Fitch; "The fine arts and Frank Lloyd Wright" by Edgar J. Kaufmann, Jr.; "Frank Lloyd Wright and the tall building" by Grant Carpenter Manson; and "The domestic architecture of Frank Lloyd Wright" by Norris Kelly Smith. Reprinted by Da Capo Press, New York, 1970.

1095. Gebhard, David. *Four Santa Barbara houses: 1904-1917.* Santa Barbara: University of California, 1963. A pamphlet for an exhibition at the University of California, Santa Barbara, September-November 1963 includes the Stewart house, Montecito.

1096. Hitchcock, Henry-Russell Jr. et al. "Frank Lloyd Wright and architecture around 1900." In *International Congress of the History of Art, problems of the 19th and 20th centuries.* Princeton University Press, 1963. The anthology includes an introduction by Hitchcock; "The Prairie School, the midwest contemporaries of Frank Lloyd Wright" by Harold Allen Brooks; "California contemporaries of Frank Lloyd Wright, 1885-1915" by Stephen W. Jacobs; "Wright's eastern-seaboard contemporaries: creative eclecticism in the United States around 1900" by Carroll Meeks; "Frank Lloyd Wright and twentieth century style" by Vincent Joseph Scully Jr.; and "The British contemporaries of Frank Lloyd Wright" by John Summerson.

1097. Mumford, Lewis. "What Wright hath wrought." In *The highway and the city.* New York: Harcourt, Brace and World, 1963, 124-38. See also "Postscript: in memoriam: 1869-1959," 139-42.

1098. Pérez Palacios, Augusto. *Estadio olímpico, Ciudad universitaria, México. Augusto Pérez Palacios.* Mexico: Universidad Nacional Autónoma de México, 1963. Spanish, English and French: *Olympic stadium, University City, Mexico, Augusto Pérez Palacios.* Opinions about the stadium from international architects include six pages by Wright.

1099. Replinger, John and Allan Frumkin comp. *Buildings by Frank Lloyd Wright in seven middle western states, 1887-1959; Illinois, Wisconsin, Indiana, Michigan, Minnesota, Iowa, Ohio.* Chicago: Burnham Library of Architecture; Art Institute of Chicago, 1963.

1100. Wright, Olgivanna Lloyd. *The roots* of *life.* New York: Horizon, 1963. This collection of Wright's writings and Olgivanna's lectures also form part of a boxed set with *idem.*, *Our house,* New York: 1959 and *The shining brow,* New York: 1960, published as *When past is future,* New York: Horizon, 1963.

1101. Zevi, Bruno Benedetto and Edgar J. Kaufmann, Jr. *La casa sulla cascata di F. Ll. Wright: F. Lloyd Wright's Fallingwater.* Milan: Etas Kornpass, 1963. Italian and English; German, French and Spanish summaries. Reprints Kaufmann, "Frank Lloyd Wright's Fallingwater 25 years after" and Zevi, "Il vaticinio del Riegl e la casa sulla cascata [The Riegl vaticinio and the house on the waterfall]," *L'Architettura,* 8(August 1962). Reviewed Robert Kostka, *Prairie School Review,* 1(no. 3, 1964), 17.

Periodicals
1102. Brooks, Harold Allen. "Steinway Hall, architects and drearns." *JSAH,* 22(October 1963), 171-75.

1103. Byrne, Barry. "On Frank Lloyd Wright and his atelier." *AIA Journal,* 39(June 1963), 109-112. Also in *Journal of Architectural Education,* 18(June 1963), 3-6. Cf. *idem.*, "Frank Lloyd Wright e il suo studio," *L'Architettura,* 10(May 1964), 48-49 (Italian).

1104. Fern, Alan M. "The Midway Gardens of Frank Lloyd Wright" *Architectural Review,* 134(August 1963), 113-16. See also *idem.*, "The Midway Gardens", in *The Midway Gardens, 1914-1929,* Chicago: n.p., 1961.

1105. Geiger, Martin. "Marin-Center, ein Beispiel Wrightscher Architektur, ausgeführt nach seinem Tode." *Werk,* 50(October 1963), sup. 224. German: "Marin Center, an example of Wright's architecture realized after his death."
 See also "Marin Center: Frank Lloyd Wright's last work?" *Architectural Review,* 133(February 1963), 83; "Centre civique de Marin County, Californie, États-Unis]," *L'Architecture d'Aujourd'hui* 34(February-March 1963), 10-17 (French); "Uffici amministrativi e biblioteca [administrative offices and library] di Marin County, San Rafael, California, 1959-62." *Casabella,* (April 1963), 44-55 (Italian); "L'ultima opera di Wright costruita negli Stati Uniti [Wright's last work is built in the US]," *Domus,* (September 1963), 1-6 (Italian); and "Marin County Civic Center—a monument to a great architect," *Expanded Shale Concrete Facts.* 9(1963), 2-3 .

1106. Griswold, Ralph E. "Wright was wrong." *Landscape Architecture*, 53(April 1963), 209-214. Pittsburgh's parks.

1107. Huxtable, Ada Louise. "'Natural houses' of Frank Lloyd Wright." *NYT Magazine*, (17 November 1963), 78-79.

1108. Kaufmann, Edgar J. Jr. "Frank Lloyd Wright and the fine arts." *Perspecta*, 8(1963), 40-42. Cf. *idem.*, "The fine arts and Frank Lloyd Wright" in Columbia University School of Architecture, *Four great makers of modern architecture*, New York: 1963.

1109. Pedio, Renato. "L'ultima opera di F. Ll. Wright riletta: il tempio di Filadelfia." *L'Architettura*, 9(June 1963), 90-102. Italian: "Frank Lloyd Wright's last work: the temple in Philadelphia." Beth Sholom synagogue.

1110. Tentori, Francesco. "Wrightiana." *Casabella*, (April 1963), 38-43. Italian.

1111. Wright, Iovanna. "Masselink." *Point West*, 5(April 1963), 30-32 .

1112. *Architectural Record.* "Fallingwater saved before it is imperiled: Kaufmann makes a gift of house at Bear Run." 134(October 1963), 24. Cf. "Wright masterpiece preserved," *Interiors,* 123(October 1963), 12.

1113. *Habitat.* "Continuadora da obra de Frank Lloyd Wright." 13(March 1963), 61. Portuguese: "Continuation of [Wright's] work." Taliesin Associated Architects.

1114. *House Beautiful.* " How a great Frank Lloyd Wright house changed, grew, came to perfection." 105(January 1963), 6, 8, 53-113, 117-20. Hanna house; includes "Our love affair with our house" by Paul and Jean Hanna, and an article by Curtis Besinger. Reissued as a book.

1115. *L'Architecture d'Aujourd'hui.* "La maison Robie de F.L. Wright sera sauvée [Robie house will be saved]." 34(February 1963), xi (French). See also "Committee plans restoration of Robie House," *Architectural Record*, 133(April 1963), 29; "A house stays in Chicago," *Interiors*, 122(April 1963), 10; "Die rettung des 'Robie House' in Chicago [Rescuing the Robie house]," *Werk*, 50(May 1963), sup. 101 (German); [Editorial: international effort to preserve Robie house], *Arts and Architecture*, 80(July 1963), 6; and "News," *AIA Journal*, 40(August 1963), 114.

1116. *Point West.* "The ship." 5(April 1963), 11. Pauson house

1964
Books, monographs and catalogues
1117. Oliver, William. *The Johnson Foundation and its Wingspread.* n.l., n.p., 1964[?]. Reprinted from *Wisconsin Tales and Trails* (Autumn 1964).

1118. Peisch, Mark L. *The Chicago School of architecture: early followers of Sullivan and Wright.* New York: Random House, 1964. Includes a chapter on

Wright's Oak Park home and studio. Reviewed Leonard Kimball Eaton, *Prairie School Review*, 2(no. 1, 1965), 20.

1119. Smith, Dean ed. *Grady Gammage Memorial Auditorium, designed by Frank Lloyd Wright.* Tempe: Arizona State University, 1964. Illustrated pamphlet; reviewed *Prairie School Review*, 2(no. 1, 1965), 26. New edition, June 1970, revised and abridged as *Gammage*, Tempe: The University, 1989.

Periodicals

1120. Champion, Roberto A. "A cerca de la significación de la obra de Wright." *Nuestra Arquitectura*, (March 1964), 25-28. Portuguese: "On the meaning of Wright's work."

1121. Cuscaden, Robert R. "FLlW's drawings preserved." *Prairie School Review*, 1(no. 1, 1964), 18. Reproductions of working drawings of seventeen Wright buildings from the AIA archives, Washington, D.C. See also Karl Kamrath, "Frank Lloyd Wright drawings in the AIA archives," *AIA Journal*, 42(July 1964), 50-51.

1122. Engel, Martin. "The ambiguity of Frank Lloyd Wright: Fallingwater." *Charette*, 44(April 1964), 17-18.

1123. Globus, Gordon G. and Jeff Gilbert. "A metapsychological approach to the architecture of Frank Lloyd Wright." *Psychoanalytic Review*, 51(Summer 1964), 117-29. Reissued as a booklet.

1124. Goff, Bruce. "Frank Lloyd Wright." *L'Architecture d'Aujourdhui*, 34(April-May 1964), 64-71.

1125. Hayeem, Abe. "F. Lloyd and Lloyd." *Architects' Journal*, 140(21 October 1964), 897, 899. Wright's buildings in California.

1126. Insolera, Italo. "Wright in Italia: 1921-1963." *Comunità*, (1964), 118. Italian: "Wright in Italy."

1127. Kalec, Donald G. "The Prairie School furniture." *Prairie School Review*, 1(no. 4, 1964), 5-21.

1128. Lewis, Charles F. "Doors open at Fallingwater." *Carnegie Magazine*, 37(September 1964), 237-40.

1129. Makiguchi, Ginshiro. [Scratched bricks of the Imperial Hotel]. *Nihon Kuriningu-Kai*, (July 1964-March 1966), unp. Japanese.

1130. Montooth, Charles. "Frank Lloyd Wright's theatre at Taliesin West." *Cue*, (Fall 1964), 4-6. See also "A roundup of recent theatre buildings," *Theatre Design and Technology*, (December 1968), 10-23.

1131. Perrin, Richard W.E. "Frank Lloyd Wright in Wisconsin: prophet in his own country." *Wisconsin Magazine of History*, 48(Autumn 1964), 32-47. Also in *idem., The architecture of Wisconsin,* Madison: State Historical Society of Wisconsin, 1967.

1132. Radd, William J. "Frank Lloyd Wright's first independent commission." *Prairie School Review*, 1(no. 3, 1964), 5-11. The issue is devoted to the Winslow house; see also "W.H. Winslow and the Winslow house" by Leonard Kimball Eaton, 12-14.

1133. Trump, James D. van. "Frank Lloyd Wright in Western Pennsylvania [and] a house of leaves: the poetry of Fallingwater" *Charette*, 44(April 1964), 12-[16]. See also *idem.*, "Caught in a hawk's eye: the house of I. N. Hagan at Kentuck Knob." *ibid.*, 17-18.

1134. Veronesi, Giulia and Bruno Alfieri, eds. "Civic center, Marin County, San Rafael, California." *Lotus*, (1964-1965), 18-25.

1135. *AIA Journal.*"Preservation/saving what's Wright." 41(May 1964), 12. Robie and Pope-Leighey houses.

1136. *Architectural Forum.* "Udall aids FLLW landmarks." 120(May 1964), 7. Robie and Pope-Leighey houses; Imperial Hotel.

1137. *Architecture de Lumiére.*" Frank Lloyd Wright: l'architecture organique." (no. 11, 1964), 2-24 . French: "Wright: organic architecture." Includes translated citations from Wright and a transcription of an interview with H. Downs on NBC.

1138. *Berliner Bauwirtschaft.* "Grosse baumeister—Frank Lloyd Wright." 20(1 June 1964), 274-76. German: "Great master architect—Frank Lloyd Wright."

1139. *Builder.*" Frank Lloyd Wright's architectural legacy." 206(22 May 1964), 1058. Taliesin Associated Architects.

1140. *L'Architecture d'Aujourd'hui.* "Frank Lloyd Wright." 35(April-May 1964), 64-71. French.

1141. *Progressive Architecture.* "Another Wrightean farewell performance." 45(November 1964), 54-55. Grady Gammage Auditorium

1142. *Progressive Architecture.* "Perils of Frank Lloyd Wright: his Tokyo Imperial Hotel threatened." 45(September 1964), 89, 91.

1965
Books, monographs and catalogues
1143. Avery Architectural Library. *Catalogue of the Frank Lloyd Wright Collection of drawings by Louis Henri Sullivan: 122 drawings; 84 drawings hitherto unpublished.* Frank Lloyd Wright Foundation, 1965. See also *Architectural Record*, 139(March 1966), 147-54. Cf. Paul E. Sprague, *The drawings of Louis Henry Sullivan. A catalogue of the Frank Lloyd Wright Collection at the Avery Architectural Library*, Princeton University Press, 1979.

1144. Barney, Maginel Wright and Tom Burke. *The valley of the God-almighty Joneses*, New York: Appleton-Century, 1965. This history of the Lloyd Jones clan is subtitled "reminiscences of Frank Lloyd Wright's sister". Reviewed

Library Journal, 90(15 April 1965), 1892; Sr. M. Marguerite, *Best Sellers*, 25(1 June 1965), 107; K.T. Willis, *Virginia Quarterly Review*, 41(Fall 1965), 131; J.G. Jackson, *Harper's Magazine*, 231(December 1965), 136; and *Prairie School Review*, 12(no. 4, 1965), 25.

1145. Brunati, Mario. *Il rapporto materiale: architettura nell'opera di Frank Lloyd Wright: la sua ultima costruzione: Marin County (1963)*. Rome: Associazione Italiana Tecnico-economica del Cemento, 1965. Italian: *The material relationship: architecture in the work of Frank Lloyd Wright: his last construction: Marin County (1963)*.

1146. Cresti, Carlo. *Wright: il Museo Guggenheim*. Florence: Sadea, 1965. Italian: *Wright: the Guggenheim Museum*. Mostly images.

1147. Hertz, David Michael. *Frank Lloyd Wright: America's greatest architect*. New York: Harcourt, Brace and World, 1965. Reviewed Wayne Andrews, *Book Week*, (7 November 1965), 18; Alice Dalgliesh, *Saturday Review of Literature*, 48(13 November 1965), 61; Emily Maxwell, *New Yorker*, 419(4 December 1965), 246; Rolf Nyller, *Library Journal*, 90(15 December 1965), 5526; August Derleth, *Wisconsin Magazine of History*, 49(Winter 1965-1966), 168; and *Prairie School Review*, 2(no. 4, 1965), 25.

Revised as *Frank Lloyd Wright in word and form*, New York: G.K. Hall, 1995; reviewed V.M. Jean-Pierre, *Libraries and Culture*, 35(Spring 2000), 382-83.

1148. Wright, Frank Lloyd. *Frank Lloyd Wright, Marin County Civic Center*. San Rafael[?]: n.p., 1965.

1149. Wright, Olgivanna Lloyd. *Taliesin*. Scottsdale: Taliesin West, 1965. The brochure describes the Taliesin Fellowship and Taliesin Associated Architects. There is an article by Olgivanna and quotations from Wright.

1150. *Hall of Justice, Marin County Civic Center, Marin County, California: preliminary drawings and specifications / designed by Frank Lloyd Wright ; [prepared] by Taliesin Associated Architects of the Frank Lloyd Wright Foundation*. S.l.: The Foundation, 1965

Periodicals
1151. Brooks, Harold Allen. "La Prairie School." *Edilizia Moderna*, (1965), 65-82 . Italian.

1152. Burgess, Helen. "Some aspects of historic preservation the U.S.A." *Historic Preservation*, 17(1965), 18-19.

1153. Dennis, James M. and Lu B. Wenneker. "Ornamentation and the organic architecture of Frank Lloyd Wright." *Art Journal*, 25(Fall 1965), 2-14.

1154. Griggs, Joseph et al. "Alfonso Iannelli, the prairie spirit in sculpture." *Prairie School Review*. 2(no. 4, 1965), the issue.

1155. Kaufmann, Edgar J. Jr. "Frank Lloyd Wright's years of modernism, 1925-1935." *JSAH*, 24(March 1965), 31-33. Reprinted in *idem., Nine commentaries on Frank Lloyd Wright*, Cambridge, Mass.: 1989.

1156. Kaufmann, Edgar J. Jr. et al. [Pope-Leighey house]. *Historic Preservation*, 17(May-June 1965), the issue. Includes essays, "The Usonian Pope-Leighey House" by Kaufmann; "Preservation and the quality of American life" by Stewart L. Udall and "Twenty-five years later: still a love affair" by Loren Pope. See also *ibid.*, 21(April-September 1969), the issue, reissued as Helen Duprey Bullock and Terry Brust Morton, eds. *The Pope-Leighy* [*sic*] *house.* Washington, D.C.: 1969, in which the Kaufmann and Pope essays are reprinted.

1157. Messer, Thomas M. "The growing Guggenheim. editorial: past and future." *Art in America*, 53(June 1965), 24-27. See also "Evolution of a museum," *ibid.*, 28-32.

1158. Morgan, Don L. "A Wright house on the prairie." *Prairie School Review.* 2(no. 3, 1965), 5-19, 23. The issue is devoted to the Sutton house. See also J. H. Donaldson, [Letter] , *ibid.*, 26.

1159. Mumford, Lewis. "The social background of Frank Lloyd Wright." *Kokusai Kentiku*, 32(March 1965), 63-72. Japanese. Translation of an essay in Wijdeveld ed. *The life-work of the American architect Frank Lloyd Wright*, Santpoort: 1925, and subsequent editions. See also Shizutaro Urabe, "A personal view on Frank Lloyd Wright," *ibid.*, 55-62.

1160. Smith, Dean E. "Grady Gammage Memorial Auditorium, Arizona State University, designed by Frank Lloyd Wright." *Arizona Highways*, 41(February 1965), 38-47.

1161. Stitt, F. Allen. "Frank Lloyd Wright—a temple to man." *Verdict Magazine*, 2(May 1965), 15-19 .

1162. *AIA Journal.* "Melody in the glen." 44(August 1965), 82. Pope-Leighey house.

1163. *American Registered Architect.* [Quotation from Wright], 3(Autumn 1965), 10.

1164. *Architectural Record.* "Robie House still threatened by lack of contributions." 137(April 1965), 342. Cf. "Robie House still imperiled," *Progressive Architecture*, 46(March 1965), 53. But see also "Robie house restoration underway," *ibid.*, 44(October 1965), 55-56.

1165. *L'Architettura.* "Centro di Marin County." 11(June 1965), 108-109. Italian: "Marin County [Civic] Center."

1166. *Fortune.* "Gold in the hills of California." 72(August 1965), 162-64. Marin County Civic Center.

1167. *Fortune.* "A late Frank Lloyd Wright is completed in Kansas." 71(June

1965), 186. Juvenile Cultural Study Center, University of Wichita.

1168. *Japan Architect.* "The Imperial Hotel problem again." 40(May 1965), 9-10.

1169. *Progressive Architecture.* "Gammage: from generals to particulars." 44(October 1965), 210-11.

1966
Books, monographs and catalogues
1170. Brandon, Henry. "Beyond modern architecture: a conversation with Frank Lloyd Wright." In *Conversations with Henry Brandon*, London: Deutsch, 1966. Also published Boston: Houghton Mifflin, 1968.

1171. Committee of Architectural Heritage. *Frank Lloyd Wright: vision and legacy.* Urbana: University of Illinois, 1966. Pamphlet for an exhibition of Wright's Prairie School furniture, University of Illinois, September-October 1965. The show is reviewed "Robie fund sketches," *Prairie School Review*, 3(no. 1, 1966), 23. See also Herman G. Pundt, "Academia sparked," *AIA Journal*, 48(October 1967), 53-56.

1172. Hammad, Muliammad. *Frank Luyd Rayt.* Cairo: 1966. Arabic.

1173. Hasbrouck Wilbert R. et al. *A guide to the architecture of Frank Lloyd Wright in Oak Park and River Forest, Illinois.* Oak Park: Public Library, 1966. Reviewed Lloyd Henri Hobson, *Prairie School Review*, 3(no. 3, 1966), 25.

1174. Heyer, Paul. "Frank Lloyd Wright." In *Architects on architecture: new directions in America.* New York: Walker, 1966. Also published London: Allen Lane, 1967. Enlarged edition, New York: Walker, 1978 (reprinted New York: Van Nostrand Reinhold, 1993).

1175. Rudd, J. William, comp. *Historic American Buildings Survey, Chicago and nearby Illinois areas: list of measured drawings, photographs and written documentation in the survey.* Park Forest: Prairie School Press, 1966.

1176. Smith, Norris Kelly. *Frank Lloyd Wright: a study in architectural content.* Englewood Cliffs: Prentice Hall; Fairhaven [UK]: Spectrum, 1966.

Reviewed Peter Collins, "Frankleudreit?" *Progressive Architecture*, 47(October 1966), 262, 268 (reply by Mendel Glickman, "Frank Lloyd Wright and antisemitism: two views," *ibid.*, 48[February 1967], 10 ff.); Sherman Paul, *Nation*, 204(23 January 1967), 121-22; *Choice*, 4(April 1967), 157; Olgivanna Lloyd Wright, *Science Books*, 3(May 1967), 78; Harold Allen Brooks, *Architectural Record*, 142(July 1967), 238; Paul Zucker, *Journal of Aesthetics and Art Criticism*, 26(Fall 1967), 133; Robert C. Twombly, *Wisconsin Magazine of History*, 50(Winter 1967), 173-74; Leonard Kimball Eaton, *Prairie School Review*, 4(no. 3, 1967), 21 and Alan Gowans, *JSAH*, 28(May 1969), 140-43.

A revised, expanded edition was published Watkins Glen, New York: American Life Foundation and Study Institute, 1979. Also in Italian as *Frank Lloyd Wright*, Bari: Dedalo, 1983.

1177. Tanigawa, Masami. *Frank Lloyd Wright.* Tokyo: Kajima Institute, 1966. Japanese.

1178. University of Chicago Special Events Office. *Robie House: architectural and historical guide. Architect: Frank Lloyd Wright.* Chicago: The Office, 1966.

1179. Wofford, Theodore J. and W. Philip Cotton. *Recommendations for restoring and rejuvenating the Wainwright Building* St. Louis: Committee for the Preservation of Historic Buildings, St. Louis Chapter of the AIA, 1966. Includes "Frank Lloyd Wright on the Wainwright Building".

1180. Wright, Olgivanna Lloyd. *Frank Lloyd Wright: his life, his work, his words.* New York: Horizon, 1966. Reviewed Hugh Hardy, "Super-wright," *Progressive Architecture*, 48(May 1967), 200, 208; Harold Allen Brooks, *Architectural Record*, 142(July 1967), 238; and Thomas S. Hines, *Prairie School Review*, 4(no. 3, 1967), 27-29.

 Also published London: Pitman, 1970 and reviewed John Warren, *Journal of the Royal Town Planning Institute*, 58(September 1972), 386. Also in Spanish as *Frank Lloyd Wright. Su vida, su obra, sus palabras*, Buenos Aires: Troquel, 1970 and in Japanese, Tokyo: Shokokusha, 1977.

Periodicals

1181. Banham, Reyner. "Frank Lloyd Wright as environmentalist." *Arts and Architecture*, 83(September 1966), 26-30. Reprinted *Architectural Design*, 37(April 1967), 174-77. See Banham, *The architecture of the well-tempered environment,* London: Architectural Press, 1969 and Marcello Agrisani, "Reyner Banham e l'enviromentalism," *Casabella,* (no. 350-351, 1970), 67-74; and (no. 353, 1970), 41-46 (Italian; English summary).

1182. Brooks, Harold Allen. "Chicago School"; metamorphosis of a term." *JSAH*, 25(May 1966),115-18.

1183. Brooks, Harold Allen. "Frank Lloyd Wright and the Wasmuth drawings." *Art Bulletin* , 48(June 1966), 193-202.

1184. Endo, R. [Form: by Frank Lloyd Wright]. *Kenchiku Bunka*, 21(May 1966), 74-78. Japanese.

1185. Evanoff, Alexander. "Frank Lloyd Wright: organic form and individuality." *Michigan Quarterly Review*, 5(Summer 1966), 181-90.

1186. Jencks, Charles. "Gropius, Wright and the intentional fallacy." *Arena: the AA Journal*, 82(June 1966), 14-20.

1187. Kaufmann, Edgar J. Jr. "Crisis and creativity: Frank Lloyd Wright, 1904-1914." *JSAH*, 25(December 1966), 292-96. Reprinted in *idem., Nine commentaries on Frank Lloyd Wright*, Cambridge, Mass.: 1989.

1188. Kostka, Robert. "Frank Lloyd Wright in Japan." *Prairie School Review*, 3(no. 3, 1966), 1-2, 5-23, 27. Imperial Hotel.

1189. Lambertucci, Alfredo. "Tendenze evolutive del concetto di spazic, nell'architettura contemporanea." *L'Architettura*, 12(October 1966), 400-401. Italian: "Evolutionary tendencies of the concept of space in contemporary architecture."

1190. Lucie-Srnith, Edward. "Pragmatists and theoreticians." *Studio*, 172(December 1966), 314-15. Guggenheim Museum.

1191. Nyman, Thor. "Frank Lloyd Wright and his vision." *California Architecture*, 2(October 1966), 8, 25.

1192. Robbins, Eugenia S. "Taliesin: bard and builder." *Art in America*, 54(May-June 1966), 120; 124.

1193. Ross, Irwin. "What nature teaches man." *Science Digest*, 59(January 1966), 89-91.

1194. Zanten, David van. "The early work of Marion Mahony Griffin." *Prairie School Review*, 3(no. 2, 1966), 5-24.

1195. Zevi, Bruno Benedetto. "Los arquitectos americanos buscan el espacio perdido." *Punto*, (August-September 1966), 41-43. Spanish: "American architects look for lost space."

1196. *American Registered Architect*. [Quotation from Wright]. 4(1966), 10.

1197. *California Architecture*. "Wright's last great stab at immortality." 2(October 1966), 10-12. Administration building, Marin County Civic Center. See also "Future projects at civic center," *ibid.*, 13, 25.

1198. *Progressive Architecture*. "Doghouse, Berger house, San Anselmo." 47(May 1966), 114.

1199. *Progressive Architecture*. "Frank Lloyd Wright and the 17 plaques." 47(September 1966), 59-60. Seventeen Wright houses awarded AIA commemorative plaques.

1200. *Progressive Architecture*. "Good use for Robie." 47(August 1966), 61. Robie house used for headquarters of the Adlai E. Stevenson Institute of International Affairs, University of Chicago. Cf. "Robie House, home of the Stevenson Institute," *University of Chicago Magazine* 59(October 1966), 14-15.

1201. *Progressive Architecture*. "The stamp of Frank Lloyd Wright." 47(June 1966), 47. US Post Office issues Wright stamps. See also "The Guggenheim backs up Frank Lloyd Wright," *AIA Journal*, 45(June 1966), 36; and "Wright remembered," *Architectural Forum*, 124(June 1966), 30.

1202. *RIBA Journal*. "Recent acquisitions by the RIBA drawings collection." 73(January 1966). Francis Apartments; All-steel houses, Los Angeles (project); and Yahara Boat Club (project).

1203. *Studio*. "Guggenheim Museum as a subject for pop art." 172(December 1966), 314-15.

1204. *Wood.* "The Pope-Leighey House, Virginia USA: Historic Cypress House re-sited due to threat of destruction." 31(December 1966), 34.

1967
Books, monographs and catalogues

1205. Blaffer, Catherine. "A development of individual freedom, from Claude-Nicholas Ledoux to Frank Lloyd Wright." In Cornell University Department of Architecture, *Design 109: research papers,* Ithaca: The Department, 1967.

1206. Cornell, Henrik. *Varldens vack raste byggnadsverk. Arkitekturen som konst. Fran Perikles till Frank Lloyd Wright.* Stockholm: Natur och kultur, 1967. Swedish: *World building works. Architecture as art from Perikles to Wright.*

1207. Futagawa, Yukio and Tsutomu Ikuta and Hiroshi Misawa, *Furanku Roido Raito.* Tokyo: Bijutsu Shuppansha, 1967-1968. 2 Volumes. Japanese: *Frank Lloyd Wright.* Volume I (1967) considers public buildings, volume II (1968), private commissions. An English-language edition of the first volume was published as Futagawa and Martin Pawley, *Frank Lloyd Wright. Vol. 1. Public buildings,* London: Thames and Hudson; New York: Simon and Schuster, 1970. It is reviewed *Best Sellers,* 30(15 November 1970), 358; P.S. Anderson, *Library Journal,* 95(1 December 1970), 461; Bruce F. Rade, *Prairie School Review,* 17(no. 4, 1970), 24-25; and *Choice,* 8(March 1971), 54. The promised second volume did not appear.

1208. Gropius, Walter. *Apollo in der Demokratie. Ausgewählt, geordnet und redigiert: Ise Gropius.* Mainz: Berlin: Kupferberg, 1967. German: *Apollo in the democracy. Selected, arranged and revised by Ise Gropius.* Published in English as *Apollo in the democracy; the cultural obligation of the architect.* New York: McGraw-Hill, 1968. See "on Frank Lloyd Wright," 167-70.

1209. Hasbrouck, Wilbert R. ed. *Architectural essays from The Chicago School; Thomas Tallmadge, Louis H. Sullivan, Jens Jensen and Frank Lloyd Wright from 1900 to 1909.* Park Forest: Prairie School Press, 1967. Reprints "The 'Village Bank' Series, V" (*Brickbuilder,* August 1901); "A home in a prairie town," (*Ladies' Home Journal,* February 1901); "A small house with lots of room in it" (*ibid.,* July 1901); and "A fireproof house for $ 5,000" (*ibid.,* April 1907). Reviewed *Prairie School Review,* 4(no. 3, 1967), 29.

1210. Peters, William Wesley et al. *Schematic master plan for the city of Madison, Wisconsin: Monona Basin Project / The Frank Lloyd Wright Foundation.* n.l.: Taliesin Associated Architects, 1967.

1211. Ripon College Art Gallery. *Frank Lloyd Wright: an exhibition of drawings.* n.d. Announcement of the exhibition, with a note by college president Bernard S. Adams.

1212. Sharp, Dennis. "Frank Lloyd Wright." In *Sources of modern architecture: a bibliography.* London: Lund Humphries; New York: Wittenborn, 1967. Brief biographical notes; revised and enlarged as *Sources of modern architecture: a*

critical bibliography, London; New York: Granada, 1981

1213. Tummers, Nicolaas H.M. et al. *Robert van 't Hoff.* Eindhoven: Stedelijk van Abbemuseum, 1967. Dutch. Illustrated broadsheet catalog/poster of an exhibition at the museum, March-April. The show moved to the architecture faculty of Delft *Technische Hogeschool*, May-June. Van 't Hoff was the first Hollander to meet Wright, and the designer of Europe's first mimetic building.

Periodicals
1214. Cohen, Martin. "Peril of the Imperial." *Progressive Architecture*, 48(September 1967), 66, 68.

1215. DeNevi, Donald D. "Educational thoughts of Frank Lloyd Wright and their implications for education." *Educational Theory*, 17(April 1967), 154-59. Cf. *idem.*, "Frank Lloyd Wright on college teaching," *Improving College and University Teaching*, 15(Winter 1967), 48-49. See also *idem.*, *The educational thoughts of Frank Lloyd Wright and their implications for the education of teachers*, Ann Arbor: University Microfilms International, 1967.

1216. Dickey, Paula. "Exploding the box." *Arts and Activities*, 62 (September 1967), 18-21.

1217. Engel, Martin. "Frank Lloyd Wright and Cubism: a study in ambiguity." *American Quarterly*, 19(Spring 1967), 24-38.

1218. Gerigk, Herbert. "An den jungen Mann in der Architektur." *Deutsche Baumeister*, 28(1967), 1024. German: "To the young man in architecture."

1219. Higuchi, Kiyoshi. "The significance for today of Wright's architecture." *Japan Architect*, (October 1967), 17-20; and (November 1967), 17-20. Japanese and English.

1220. Hines, Thomas S. "Frank Lloyd Wright—the Madison years: records versus recollections." *Wisconsin Magazine of History*, 50(Winter 1967), 109-119. Reprinted *JSAH*, 26(December 1967), 227-33. For response see Robert E. Koehler, "The Wright record," *AIA Journal*, 48(July 1967), 3-4. For a Japanese translation see *Kentiku*, (June 1970), 13-24.

1221. Hitchcock, Henry-Russell Jr. "Frank Lloyd Wright 1867-1967." *Zodiac*, (no. 17, 1967), 6-10. English and Italian. Includes references to Johnson Wax buildings; V.C. Morris shop; Marin County Civic Center. See also *ibid.*, "Rilettura di tre opere di Frank Lloyd Wright [Re-reading three Wright works]". The former piece is revised and reprinted, *Prairie School Review*, 4(no. 4, 1967), 5-9.

1222. Meisenheimer, Wolfgang. "Der Raum in der Architektur: Strukturen, Gestalten, Begriffe." *Kunstwerk*, 21 (October 1967), 78. German: "Space in architecture: structures, shapes, concepts." Extracts from the author's thesis, Aachen, 1964.

1223. Morton, Terry Brust. "Wright's Pope-Leighey house." *Prairie School Review*, 4(no. 4, 1967), 20-26.

1224. Novinger, Virginia B. "Finding his own way: hero story." *Instructor*, 77(December 1967), 63.

1225. Pearson, Michael. "Pneumatic structures." *Architectural Review*, 142(October 1967), 313. Includes an image of "Air House", International Home Exhibition, New York.

1226. Smith, Norris Kelly. "Frank Lloyd Wright and the problem of historical perspective." *JSAH*, 26(December 1967), 234-37.

1227. Tummers, Nicolaas H.M. "Robert van 't Hoff en het werk van Wright." *Cobouw*, (16 June 1967), 25. Dutch: "Van 't Hoff and the work of Wright."

1228. Weisberg, Gabriel. "Frank Lloyd Wright and pre-Columbian art—the background for his architecture." *Art Quarterly*, 30(Spring 1967), 40-51.

1229. Wilson, Stuart. "The gifts of Friedrich Froebel." *JSAH*, 26(December 1967), 238-41.

1230. Wright, Frank Lloyd. "Ethics of ornament." *Prairie School Review*, 4(no. 1, 1967), 16-17. Excerpts from a lecture, first published as "On ornamentation," *Oak Leaves*, (16 January 1909); reprinted in Meehan ed. *Truth against the world*, New York: 1987.

1231. *Architectural Forum.* "Milestone in Madison." 127(November 1967), 30-31. Monona Terrace.

1232. *Architectural Forum.* "Squaring the circle." 127(December 1967), 46. Guggenheim Museum addition.

1233. *L'Architettura.* "L'a editoriali in breve. Ottusita in Giappone; l'Imperial Hotel di Tokio sara demolito." (June 1967), 75. Italian: "Obtuseness in Japan; the Imperial Hotel in Tokyo demolished." See also "Demolizioni e falsi storici [Demolition and spurious history]," *Casabella*, (June 1967), 69 (Italian); Karl Kamrath, "The stubborn hotel is shaking," *AIA Journal*, 48(November 1967), 70-72; "Down comes the landmark," *Time*, (8 December 1967); Frank Riley, "Deathwatch in Tokyo,".*Saturday Review of Literature*, (16 December 1967), 40-45; "Donations may save Wright's Imperial Hotel," *Progressive Architecture*, 48(December 1967), 29; "Vandalismus in Tokyo [Vandalism in Tokyo]," *Baumeister,* 64(December 1967), 1494-95 (German); Hajimi Shimizu, [Imperial Hotel], *Sinkenchiku*, (December 1967), 248-49 (Japanese); and "Committee for the preservation of the Imperial Hotel," *Inland Architect*, 11(December 1967), 12-13. See also Shindo Akashi, "The Imperial comes tumbling down," *AIA Journal*, (December 1968), 42-47 and Mary E. Osman, "P.S.," *ibid.*, 49.

1234. *Newsweek.* "Wright's 'teahouse'." 70(October 23, 1967), 78. Riverview Terrace Restaurant, Spring Green.

1235. *Prairie School Review.* "Frank Lloyd Wright, 1867-1959" 4(no. 4, 1967), 5-9.

1236. *Prairie School Review.* "Frederick C. Robie House, Frank Lloyd Wright, architect." 4(no. 4, 1967), 1-2, 10-19.

1237. *Prairie School Review.* "Wright drawings at Texas A. and M. University." 4(no. 4, 1967), 31. Booth house (project) and Stewart house.

1238. *Preservation News.* "Visitors react to controversial Trust house." 7(February 1967), 5. Pope-Leighey House.

1239. *Progressive Architecture.* "Wright's Martin house to be restored." 48(November 1967), 63.

1240. *Progressive Architecture.* "Wright's ship of state." 48(February 1967), 30. Marin County Civic Center

1968
Books, monographs and catalogues
1241. Fanelli, Giovanni. *Architettura moderna in Olanda 1900-40* Florence: Marchi and Bertolli, 1968. Italian: *Modern architecture in Holland.* Translated into Dutch, with a turgid English summary, as *Moderne Architectuur in Nederland 1900-1940*, The Hague: Staatsuitgeverij, 1978. Discusses Wright's influence in Holland. Reprinted 1981.

1242. Ferrell, Wilfred A. and Nicholas A. Salerno eds. *Strategies in prose.* New York: Holt, Rinehart and Winston, 1968. Includes "Taliesin" by Frank Lloyd Wright (from *An autobiography*, 1932) and "Frank Lloyd Wright" by Ashley Montagu. Reprinted 1970, 1973 and 1978 and in 1983 as *Strategies in prose: a thematic reader.*

1243. Historic American Buildings Survey. *The Robie house: Frank Lloyd Wright.* Palos Park: Prairie School Press, 1968. Reproduces measured drawings completed by the Survey, August 1963. Reviewed Robert R. Cuscaden, *Prairie School Review*, 5(no. 4, 1968), 28.

1244. James, Cary. *The Imperial Hotel: Frank Lloyd Wright and the architecture of unity.* Rutland, Vermont: Charles E. Tattle, 1968. Mostly photographs (taken 1965); includes a brief introduction, and quotations from Wright's *An autobiography*. Reprinted as *Frank Lloyd Wright's Imperial Hotel*, New York: Dover, 1988. First edition reviewed Edgar A. Tafel, *Prairie School Review*, 5(no. 4, 1968), 27; *TLS*, (28 November 1968), 1330; David Gebhard, *Library Journal*, 93(15 December 1968), 4643; Lawrence Alloway, *Nation*, 207(16 December 1968), 663; Wolf von Eckardt, *Book World*, (29 December 1968), 11; *idem.*, *Choice*, 6(March 1969), 47; Harold Allen Brooks, "Preserved within a book," *Progressive Architecture*, 50(July 1969), 150, 156; and Alan M. Fern, *Landscape*, 18(Fall 1969), 37.

1245. Naden, Corinne J. *Frank Lloyd Wright, the rebel architect.* New York: Franklin Watts, 1968. Juvenile biography.

1246. Peters, William Wesley et al. *Madison Civic Auditorium for Madison,*

Wisconsin: designated first stage of construction, Monona Basin Project, Madison, Wisconsin. Spring Green: Frank Lloyd Wright Foundation, 1968.

1247. Richards, Kenneth G. *People of destiny: Frank Lloyd Wright.* Chicago: Childrens Press, 1968. Juvenile biography.

1248. Watanabe, Yoshio, Tachu Naito et al. [*Imperial Hotel 1921-67.*] Tokyo: Kajima Institute, 1968. Japanese. Mostly images.

Periodicals
1249. DeNevi, Donald D. "The education of a genius: analyzing major influences on the life of America's greatest architect." *Young Children*, 23(March 1968), 233-40.

1250. DeNevi, Donald D. "The Taliesin thesis and Frank Lloyd Wright." *Art Education*, 21(December 1968), 13-15.

1251. Licht, Ira. "Stained glass panels of Frank Lloyd Wright." *Arts Magazine*, 43(November 1968), 34-35. Exhibition of panels from Darwin D. Martin house at Richard Feigen Gallery, New York. Cf. "Reviews and previews," *Art News*, 67(November 1968), 79; "On exhibition," *Studio*, 176(December 1968), 274. The windows were again exhibited at the Gallery late in 1970.

1252. MacCormac, Richard Cornelius. "The anatomy of Wright's aesthetic." *Architectural Review*, 143(February 1968), 143-46. A comment by Derek Bottomley, with MacCormac's reply, is published *ibid.*, 144 (August 1968), 148. The original article is also published in Japanese (with English summary) in *A+U*, (March 1979), 3-6. Reprinted in Brooks ed. *Writings on Wright*, Cambridge, Mass.: 1981.

1253. McCoy, Robert E. "Rock Crest/Rock Glen: prairie planning in Iowa." *Prairie School Review*, 5(no. 3, 1968), 5-39. City National Bank and hotel, Stockman house, and Melson house (project).

1254. Ragon, Michel. "Wright, un genio solitario." *Punto*, 7(June 1968), 10-22. Italian: "Wright: a solitary genius."

1255. Rubino, Luciano. "Flashes su Frank Lloyd Wright." *L'Architettura,* 13(February 1968), 690-94; (March 1968), 758-64; (April 1968), 830-34; (May 1968), 60-64; (June 1968), 130-34; (August 1968), 340-44; (September 1968), 410-14; (October 1968), 480-84; (December 1968), 620-24. Italian: "Flashes of Wright." Includes Wright's Oak Park house and studio, Walter Gale, Thomas H. Gale, R.P. Parker, Robie, Sturges, Pew and Christian houses, Unity Temple, Hillside Home School II, Taliesin East, "Wingspread", Jacobs house II, Usonia house I, and Johnson Wax buildings.

1256. Tafel, Edgar A. and R.C. Haskett. "Tragedy of the Imperial." *Architectural Forum*, 128(January-February 1968), 15. Following its demolition, the Imperial Hotel continued to attract international attention. See Shinjiro Kirishiki, "The story of the Imperial Hotel," *Japan Architect*, 138(January-February 1968), 132-38 [Japanese and English]; Gio Ponti and Maurice Hogenboom, "Tokyo:

Imperial Hotel, 1922-1967," *Domus*, (February 1968), 5-11 (English and Italian); *Architectural Review*, 143(March 1968), 175 and 178; "L'Hotel Imperiale di Tokyo: estremi soccorsi [extreme assistance]," *L'Architettura*, (March 1968), 704 (Italian); Bunji Kobayashi, "Frank Lloyd Wright's Imperial Hotel in Tokyo," *Historic Preservation,* 20(April-June 1968), 62-68; Priscilla Dunhill, "Requiem for a masterpiece," *Architectural Forum*, (May 1968), 70, 75; [The now destroyed Imperial Hotel], *Japan Architect*, (July 1968), 14 (Japanese); "Requiem per l'Imperial Hotel," *L'Architettura,* 14(September 1968), 385 (Italian); and *Japan Illustrated,* (1968), 61-65 (Japanese).

1257. Twombly, Robert C. "Frank Lloyd Wright in Spring Green, 1911-1932." *Wisconsin Magazine of History*, 51(Spring 1968), 200-217. Reprinted in *Wisconsin stories*, Madison: State Historical Society of Wisconsin, 1980.

1258. *Architectural Forum.* "Playful precedent." 128(March 1968), 84-85. Coonley playhouse stained glass windows.

1259. *Architecture Canada.* "Four unitarian churches." 45(February 1968), 31-42. Unity Temple.

1260. *North Carolina Architect.* "Frank Lloyd Wright items offered for sale by his son." 15(October 1968), 20-22.

1261. *Progressive Architecture.* "Drums along Monona." 49(December 1968), 48.

1262. *Progressive Architecture.* "FLW." 49(September 1968), 140-43.

1263. *Progressive Architecture.* "Wright's Madison plan comes to life." 49(May 1968), 66-67. Monona Terrace.

1969
Books, monographs and catalogues
1264. Andrews, Wayne. "Frank Lloyd Wright." In *Architecture in New York: a photographic history.* New York: Atheneum, 1969. Includes Boynton, Davidson, Friedman, Heath, and Martin houses, Larkin administration building; and Guggenheim Museum. Reprinted, Syracuse University Press, 1995.

1265. Braatz, Wolfgang ed. *Frank Lloyd Wright: humane architecture*, Gutersloh; Berlin: Bertelsmann, 1969. German. Includes a list of buildings compiled by Bruce F. Radde originally published in Kaufrnann and Raeburn eds. *Frank Lloyd Wright: writings and buildings.* New York: 1960.

1266. Bullock, Helen Duprey and Terry Brust Morton eds. *The Pope-Leighy [sic] House.* Washington, D.C.: National Trust for Historic Preservation, 1969. Reprinted from *Historic Preservation*, 21(April-September 1969), the anthology includes: "Documents" by Ellen Beasley; "Frank Lloyd Wright: his concepts and career" by Harold Allen Brooks; "The challenge of being a Taliesin Fellow" by Gordon Chadwick; "The Usonian Pope-Leighey House" by Edgar J. Kaufmann, Jr.; "A testimony to beauty" by Marjorie F. Leighey; "The threat, rescue and

move" by Morton; "Furniture and decoration" by John N. Pearce; "Twenty-five years later: still a love affair" by Loren B. Pope; "The challenge of constructing a Wright House" by Howard C. Rickert; and "Siting and landscaping" by Joseph Watterson. Reviewed Donald G. Kalec, *Prairie School Review*, 8(no. 1, 1971), 20-21; correction: 8 (no. 3, 1971), 18.

1267. Eaton, Leonard Kimball. *Two Chicago architects and their clients: Frank Lloyd Wright and Howard van Doren Shaw.* Cambridge, Mass.; London: MIT Press, 1969. Reviewed David Gebhard, *Library Journal*, 95(1 February 1970), 485; *TLS*, (19 March 1970), 302; *Virginia Quarterly Review*, 46(Spring 1970), 71; Robert L. Townsend, *RIBA Journal*, 77(May 1970), 232-33; *Choice*, 7(June 1970), 593; J.E. Burchard, *Journal of American History*, 57(June 1970), 179; Harold Allen Brooks, *Progressive Architecture*, 51(August 1970), 100; Martin Pawley, "To carrying through one architectural revolution—$30-40,000,000," *Architectural Design*, 40(August 1970), 414-15; Norris Kelly Smith, *JSAH*, 29(May 1970), 205-206; J. Carson Webster, *Prairie School Review*, 7(no. 1, 1970), 20-21; John Summerson, *Encounter*, 35(September 1970), 38; and James F. O'Gorman, *Art Quarterly*, 33(Winter 1970), 446-47.

1268. Frank Lloyd Wright Foundation. *Selected drawings for the Cloverleaf Housing Project, Pittsfield, Massachusetts.* Scottsdale: The Foundation, 1969. Over the next ten years the Foundation produced several similar publications. Apart from *General index to the work of Frank Lloyd Wright* (1970), they comprise mostly images, and vary in size: *Skyscraper regulation, 1926* (1969); The Frank L. Smith Bank Building: a catalogue of drawings (1970); *The W. Irving Clark residence: a catalogue of drawings* (1970); *The Pittsburgh Point Park Community Center: a catalogue of drawings* (1971); *Frank Lloyd Wright: fifty-nine drawings* (1976); *Frank Lloyd Wright drawings: the Warren Hickox house* (1977); *Frank Lloyd Wright: nineteen Arizona drawings* (1978); *Frank Lloyd Wright drawings: the Arthur Heurtley house* (1978); *Frank Lloyd Wright drawings: the Capital Journal building.* (1979); *Frank Lloyd Wright drawings: Administration building, S. C. Johnson and Son, Inc. (1979); Frank Lloyd Wright drawings: research building and tower, S. C. Johnson and Son, Inc.* (1979); and *Frank Lloyd Wright drawings: the Robert Roloson houses* (1979).

1269. Gowans, Alan. *King Carter's church.* Victoria, B.C.: University of Victoria Maltwood Museum, 1969. The lengthy subtitle reads "*being a study in depth of Christ Church, Lancaster County, Virginia as an image of American living through two centuries considering the origins and meaning of its forms as originally conceived by Robert Carter and designed byChristopher Wren and their metamorphosis for later cultural expression from Jefferson to Frank Lloyd Wright*". Reviewed Marcus Whiffen, *JSAH*, 29(May 1970), 202-204.

1270. Harris, Harwell Hamilton. *Architecture as an art.* Clinton, Iowa: Finger-nail Moon Press, 1969. Privately printed, limited edition essay about Hollyhock house, originally intended for the never-published catalogue of a MoMA exhibition, "Two great Americans" (1940), that included the work of Wright and filmmaker David W. Griffith. See Hitchcock, *In the nature of materials: 1887-*

1941, New York: 1942 and Mies van der Rohe in Johnson, *Mies van der Rohe*, New York: 1947, for other essays meant for the catalogue.

1271. Herbert, Gilbert. *Frank Lloyd Wright, the architect and his era*. Haifa: Technion, Israel Institute of Technology, 1969. Technion pamphlet series, no. 8.

1272. Nott, Charles Stanley. "Taliesin and the Frank Lloyd Wrights." In *Journey through this world: the second journal of a pupil; including an account of meetings with G.L Gurdjieff, A.R. Orage, and P.D. Ouspensky*. London: Routledge and Kegan Paul, 1969. See also *idem., Teachings of Gurdjieff, the journal of a pupil; an account of some years with G.I. Gurdjieff and A R. Orage in New York and at Fontainebleau-Avon*, London: Routledge and Kegan Paul, 1961.

1273. Oak Park Public Library. *Frank Lloyd Wright, a bibliography: the local authors collection*. Oak Park, Illinois: The Library, 1969.

1274. Parke-Bernet Galleries. *Japanese prints; including, Masanobu, Harunobu, Koryusai, Shunsho, Shunko, Shunei, Kiyonaga, Utamaro, Toyokuni II, Hokusai, Hiroshige and works by other artists. Formerly in the Frank Lloyd Wright collection, now the property of the estate of the late Blanche B. McFetridge*. New York: The Galleries, 1969. Catalogue of an auction held 20-21 November 1969.

1275. Sanderson, Warren ed. *Frank Lloyd Wright festival. Oak Park-River Forest, Ill. May 30-July 4, 1969*. Oak Park: Oak Park-River Forest Chamber of Commerce, 1969. An undated edition, titled *Frank Lloyd Wright architecture: Oak Park [and] River Forest, Illinois* was published in 1973.

1276. Wright, Frank Lloyd. *Skyscraper regulation, 1926 Frank Lloyd Wright*. Frank Lloyd Wright Foundation, c1969. See 1268 above.

Periodicals
1277. Banham, Reyner. "The wilderness years of Frank Lloyd Wright." *RIBA Journal*, 76(December 1969), 512-19. A reply from Sandra Millikin, with Banham's rejoinder, is published in *ibid.*, 77(January 1970), 3. Banham's piece is reprinted in Mary Banham et al. eds. *A critic writes: essays by Reyner Banham*, Berkeley: University of California Press, 1996.

1278. DeNevi, Donald D. "Nature as a teacher." *Science and Children*, 7(November 1969), 11-14. Wright's theory on nature as architectural inspiration.

1279. Fanelli, Giovanni. "Wright oltre il mito organico." *Necropoli*, (March-June 1969), 55-74. Italian: "Wright beyond the organic myth."

1280. Finch, Christopher. "Frank Lloyd Wright." *Design Quarterly*, (no 74-75, 1969), 13-15.

1281. Greenberg, Allan. "Lutyens' architecture restudied." *Perspecta*, (1969), 144-47. Includes a section, "Lutyens and Frank Lloyd Wright."

1282. Hoffmann, Donald. "Frank Lloyd Wright and Viollet-le-Duc." *JSAH*, 28(October 1969), 173-83.

1283. Kaufman, Edgar J. Jr. "Frank Lloyd Wright: the eleventh decade" *Architectural Forum*, 130(June 1969), 38-41. Reprinted in Gutheim ed. *In the cause of architecture*, New York: 1975, 1987.

1284. Marlin, William. "Taliesin 1969: sagging and cracking, but alive with a message of man." *Inland Architect*, 13(July 1969), 22-25.

1285. O'Gorman, James F. "Henry Hobson Richardson and Frank Lloyd Wright." *Art Quarterly*, 32(Autumn 1969), 292-315.

1286. Olson, Allen R. and Albert L. Hoffmeyer, eds. "Frank Lloyd Wright." *Northwest Architect*, 33(July-August 1969), 23-56, 59 ff. Includes "Reflections of Taliesin" by John Henry Howe.

1287. Patrulius, Radu. "Frank Lloyd Wright: 100 ani de la nastere." *Architectura*, 17(1969), 26-29. Romanian: "Frank Lloyd Wright: birth centenary."

1288. Ragghianti, Carlo Ludovico. "Architettura liberatrice." *Critica d'Arte*, (September 1969).

1289. Rebay, Roland von. "Der aktuelle hundertjahrige." *Baumeister*, 66(June 1969), 804-808. German: "The current century."

1290. Saltzstein, Joan W. "Taliesin through the years." *Wisconsin Architect*, 40(October 1969), 14-18 .

1291. Segal, Walter. "Great original: Frank Lloyd Wright 1869-1959." *Architects' Journal*, 149(11 June 1969), 1546-48.

1292. Short, Ramsay. "Taliesin intact: Frank Lloyd Wright." *Listener*, 82(20 November 1969), 699. Short produced a BBC-TV documentary on Wright.

1293. Spade, Rupert. "The other side of Mayor Daley, or the day Frank Lloyd Wright changed trains." *Architectural Design*, 39 (November 1969), 583.

1294. Tselos, Dimitri. "Frank Lloyd Wright and world architecture." *JSAH*, 28(March 1969), 58-72. A belated follow-up of *idem.*, "Exotic influences in the architecture of Frank Lloyd Wright," *Magazine of Art*, 46(April 1953) includes Wright's previously unpublished response.

1295. Wille, Peter. "Frank Lloyd Wright." *Building Ideas* [Australia], 4(December 1969), 2-11.

1296. Wille, Peter. "Frank Lloyd Wright in Victoria: one hundred years after his birth he still practises vicariously in Melbourne." *Architect* [Victoria, Australia], 3(November-December 1969), 21-25.

1297. Wright, Henry. "Unity Temple revisited" *Architectural Forum*, 130(June 1969), 28-37.

1298. Zevi, Bruno Benedetto. "Frank Lloyd Wright, domani." *L'Architettura*, 15(November 1969), 422-484. Italian: "Frank Lloyd Wright tomorrow"; French, German, Spanish, English summaries. See also Edward Frank, "Filosofia organica, architettura organica e Frank Lloyd Wright [Organic philosophy, organic architecture and Wright]," *ibid.*

1299. *AIA Journal.* "High bids cloud future of Madison auditoriurn." 51(June 1969), 24, 28. Monona Terrace.

1300. *AIA Journal.* "Wright centennial to give Oak Park a festive look: tours set for architects." 51(May 1969), 12, 16.

1301. *Historic Preservation.* [Pope-Leighey House]. 21(April-September 1969), the issue. Reprinted as Bullock and Morton eds. *The Pope-Leighy [sic] House.* Washington, D.C.: 1969; see 1266.

1302. *Inland Architect.* "Sandbags in Racine." 13(August-September 1969), 18-19. S.C. Johnson and Son administration building.

1303. *Inland Architect.* "Wright on Sheridan Road." 13(October 1969), 14-15. Bach house.

1304. *Interiors.* "Chicago resurrections: Frank Lloyd Wright's Robie house." 128(May 1969), 114-117. Reissued as a booklet. Cf. "Resurrection of Robie house," *Architectural Design*, 39(August 1969), 411.

1305. *L'Architettura.* "Lo scempio del Guggenheim Museum." 14(January 1969), 634. Italian: "Destruction of the Guggenheim Museum."

1306. *Sunset.* "Frank Lloyd Wright was also a gifted landscape architect." 142(February 1969), 70-73. Taliesin West.

1970-1979

1970

Books, monographs and catalogues

1307. Cavanaugh, Tom R. and Payne E.L. Thomas. *A Frank Lloyd Wright house: Bannerstone House, Springfield, Illinois.* Springfield: Charles C. Thomas, 1970. Dana house. Reprinted 1972, 1975.

1308. Culmsee, Carlton Fordis. "Wright and his helix." In *Shapes for the deep unrest, three essays: the radiant apex, Wright and his helix, mold of fire.* Logan: Utah State University Press, 1970. Guggenheim Museum.

1309. Dezzi Bardeschi, Marco. *Frank Lloyd Wright.* Florence: Sansoni, 1970. Italian. Second edition 1977. Also published in German: Lucerne; Freudenstadt; Vienna: Kunstkreis, 1971; in English: London; New York; Sydney; Toronto: Hamlyn, 1972; and in Spanish: Barcelona: Nauta, 1972, 1974.

1310. Futagawa, Yukio and Arata Isozaki. *Frank Lloyd Wright: Johnson and Son, administration building and research tower, Racine, Wisconsin. 1936-9.* Tokyo. A.D.A. Edita, 1970. Japanese. Mostly images.

1311. Futagawa, Yukio and Paul Rudolph. *Frank Lloyd Wright: Kaufmann house, Fallingwater, Bear Run, Pennsylvania, 1936. Tokyo:* A.D.A. Edita, 1970. Japanese and English. Mostly images. Reprinted 1974.

1312. Hitchcock Henry-Russell Jr. et al. *The rise of an American architecture.* New York: Praeger; London: Pall Mall Press, 1970. "This book was conceived as counterpart to an exhibition opening under the same name ... at the Metropolitan Museum of Art in May of 1970."

1313. Moses, Robert. "Frank Lloyd Wright." In *Public works: a dangerous trade.* New York: McGraw-Hill, 1970. Guggenheim Museum, Kinney house.

1314. Reif, Rita. "Darwin D. Martin House, Buffalo, New York, Frank Lloyd Wright's 'Prairie House'." In *Treasure rooms of America's mansions, manors and houses*. New York: Coward-McCann, 1970, 294-98.

1315. Tiltman, Hubert Hessell. *The Imperial Hotel story.* n.l., n.p. [Tokyo: The Hotel?], 1970. Printed on the occasion of the opening of the new main building of the Imperial Hotel, March 1970. There was a second edition.

Periodicals

1316. Angrisani, Marcello. "Architettura: forma o funzione?: Reyner Banham e l'environmentalism." *Casabella*, 34(August 1970), 67-74; 34(October 1970), 41-46. Italian: "Architecture: form or function?: Reyner Banham and environmentalism."

1317. Baldridge, J. Alan. "Wright House for the right buyer." *AIA Journal*, 53(January 1970), 68. Walser house. Cf. "Wright house in danger of dissection," *Progressive Architecture*, 51(January 1970), 25.

1318. Crawford, Alan. "Ten letters from Frank Lloyd Wright to Charles Robert Ashbee." *Architectural History*, 13(1970), 64-73. Letters written between 3 January 1902 and 11 May 1939. Reprinted as a booklet.

1319. Eerhart, Ben. "Het voormalig Imperial Hotel van Frank Lloyd Wright te Tokyo." *Tijdschrift van A. en B.K.*, (no. 2, 1970), 35-37. Dutch: "The former Imperial Hotel."

1320. Glueck, Grace. "New York gallery notes." *Art in America*, 58(September-October 1970), 39. Exhibition of stained glass windows from the Darwin D. Martin house at the Feigen Gallery. See also "Recent acquisitions 1968-1969," *Bulletin of Rhode Island School of Design*, 56(Summer 1970), 55-56; *Architectural Record*, 148(October 1970), 36; and *Art News*, 69(November 1970), 71.

1321. Hartwell, Patricia. "Gala at Taliesin—brightest easter in the valley." *Phoenix*, 5(March 1970), 20-23 .

1322. Johnson, Donald Leslie. "Notes on W.B. Griffin's 'Knitlock' and his architectural projects for Canberra." *JSAH*, 29(May 1970), 189-90.

1323. Koppes, Neil. "Frank Lloyd Wright's circular sun house." *Phoenix*, 5(July 1970), 54-56. Lykes house.

1324. Kostka, Robert. "Bruce Goff and the new tradition." *Prairie School Review*, 7(no. 2, 1970), 5-15.

1325. March, Lionel. "Imperial city of the boundless west: the impact of Chicago on the work of Frank Lloyd Wright." *Listener*, 83(30 April 1970), 581-84.

1326. Mix, Sheldon A. "The Oak Park years: a walking tour of the Frank Lloyd Wright houses in Oak Park and River Forest." *Chicago*, 7(April 1970), 31-35, 79-80, 82.

1327. Montgomery, Roger and Lucille Dandelet. "Frank Lloyd Wright's Hall of Justice." *Architectural Forum*, 133(December 1970), 54-[59]. Subtitled "Two personal responses to the Hall of Justice, latest completed element in Frank Lloyd Wright's ambitious Marin County Civic Center Complex in California."

1328. Rowe, Colin. "Chicago frame." *Architectural Design*, 40(December 1970), 641-47.

1329. Shank, Wesley I. "The residence in Des Moines."*JSAH*, 29(March 1970), 56-59. Reviews the Sedgwick S. Brinsmaid house (architect Arthur Heun, 1898), with references to Wright's contemporary work.

1330. Sorell, Susan Karr. [Joseph Lyman Silsbee issue]. *Prairie School Review*, 7(no. 4, 1970), the issue. Includes "Silsbee: the evolution of a personal architectural style" and "A catalogue of work by ... Silsbee", both by Sorell, and "The earliest work of Frank Lloyd Wright" by Wilbert R. Hasbrouck.

1331. Turak, Theodore. "Jenney's lesser works: prelude to the prairie style." *Prairie School Review*, 7(no. 3, 1970), 20.

1332. Wegg, Talbot. "FLLW versus the USA." *AIA Journal*, 53(February 1970), 48-52. Cloverleaf, Pittsfield housing project.

1333. Wille, Peter. "Wright wrong." *Architect* [Australia], 3(May-June 1970), 15. Letter about Wright's birth date .

1334. Zevi, Bruno Benedetto. "L'idea di Oskar Stonorov." *L'Architettura*, 16(July 1970), 142-43. Italian: "The idea of Oskar Stonorov."

1335. *Architectural Record*. "First Christian Church of Phoenix." 147(June 1970), 42.

1336. *Architectural Record*. "Landmarks: bad news with a few bright spots." 148(November 1970), 36. Demolition of Lake Geneva Inn; doubts about future of hotel, Mason City, and Hickox house.

1337. *Architectural Review*. "Restored Wright." 147(February 1970), 157. Darwin D, Martin house. Cf. "Masterpieces of two Sullivan students: one is destroyed, one saved," *ibid.*, 147(April 1970), 40.

1338. *Camera*. "The Johnson building, Racine, USA." 49(May 1970), 21, 23-25. Images only.

1339. *Inland Architect*. "Design for dining." 14(July 1970), 16-17. Spring Green restaurant.

1340. *Inland Architect*. "Weiner and Wright." 14(May 1970), 19. Portrait sculpture of Wright by Egon Weiner.

1341. *Kentiku*. (June 1970), 13-24. Japanese. Includes an article on Wright's *The Industrial Revolution runs away* (1969) by Masami Tanigawa and a transla-

tion of Hines, "Frank Lloyd Wright: the Madison years" from *Wisconsin Magazine of History*, 50(Winter 1967).

1342. *Kindai kenchiku.* 24(February 1970), 49-95. Japanese. Includes essays: "The proposal of Wright for nature" by T. Kurosawa and H. Fujii; "Liberation for humans" by Olgivanna Lloyd Wright; and a re-appraisal of Wright by Masami Tanigawa.

1343. *L'Architettura.* "Richard Neutra: ultime opere, ultime scritti." 16(November 1970), 422-72. Italian: "Richard Neutra, last works, last writings." Includes 1924 photographs of Wright, Neutra, and Erich Mendelsohn at Taliesin. There is also an editorial, "Dal triangolo Loos-Mendelsohn-Wright [Of the Loos-Mendelsohn-Wright triangle]" by Bruno Zevi.

1344. *Prairie School Review.* "New Larkin administration building." 7(no. 1, 1970), 14-19.

1345. *Prairie School Review.* "Unity Temple restoration." 7(no. 3, 1970), 13-16. Reissued as a booklet.

1971
Books, monographs and catalogues
1346. Gebhard, David and Harriette von Breton. *Lloyd Wright, architect: 20th century architecture in an organic exhibition.* Santa Barbara: University of California, 1971. The exhibition catalog describes Lloyd Wright's contributions to many of his father's buildings.

1347. Nihon Daigaku. Tanigawa Laboratory. *Aisaku Hayashi house, Tokyo, Japan.* Tokyo: The Laboratory, 1971. Japanese. Mostly images. The set of measured drawings was first of a series: see also *idem., School of the Free Spirit, Frank Lloyd Wright* (1971); and *Motion picture theater (Japan) 1918-: Frank Lloyd Wright* (1973).

1348. Salsini, Paul. *Frank Lloyd Wright: the architectural genius of the twentieth century.* Charlotteville, New York: SamHar Press, 1971. Juvenile biography. Reprinted 1982.

1349. Stevensville Historical Society. *Montana Genesis.* Missoula: Mountain Press Publishing, 1971. Image of Bitter Root Inn

Periodicals
1350. Bowman, Ned A. "Stalking theatre scenography through the American southwest with gun and camera." *Theatre Design and Technology*, (October 1971), 4-13. Includes Grady Gammage Auditorium, Taliesin West.

1351. Brooks, Harold Allen. "Chicago architecture: its debt to the arts and crafts." *JSAH*, 30(December 1971), 312-17. Paper at the Society of Architectural Historians annual meeting, Chicago, January 1971; Wright house and studio.

1352. Cordier, Gilbert. "Architectonic reflexions on the written work of F.L.

Wright c. e. Le Corbusier." *Review of the International Union of Architects*, (no. 12, 1971), 34-67. French and English.

1353. Donovan, L.K. "Wanted: a sympathetic purchaser." *AIA Journal*, 54(January 1971). Hickox house.

1354. Ehrmann, Jacques. "Live in utopia?: *habiter l'utopia?*" *Perspecta*, (no. 13-14, 1971), 209-219.

1355. Eisenstaedt, Alfred and Loudon Wainwright. "Guardian of a great legacy." *Life*, 70(11 June 1971), 44-55.

1356. Hallmark, Donald Parker. "Richard W. Bock, sculptor: the mature collaborations." *Prairie School Review*, 8(no. 2, 1971), 5-29. Includes early Wright buildings.

1357. Michels, Eileen. "The early drawings of Frank Lloyd Wright reconsidered." *JSAH*, 30(December 1971), 294-303. For comment see Curtis Besinger, *ibid.*, 31(October 1972), 216-20.

1358. Richards, James Maude and Abraham Rogatnick eds. "Venice: problems and possibilities." *Architectural Review*, 149(May 1971), the issue. Masieri memorial.

1359. Smith, Nancy K. Morris ed. "Letters, 1903-1906, by Charles E. White, Jr. from the studio of Frank Lloyd Wright." *Journal of Architectural Education*, 25(Fall 1971), 104-112.

1360. Tafel, Edgar A. "Windows by Frank Lloyd Wright." *Stained Glass*, 66(Summer 1971), 20-21.

1361. Tulecke, Rose and Jerome B. Tulecke. "Summer sojourn in Spring Green." *Phoenix*, 6(October 1971), 23-24, 60.

1362. Zevi, Bruno Benedetto. "Bomba Mendelsohniana: perchö la quarta, se sprecate la terza?" *L'Architettura*, 17(May 1971), 2-3. Italian: "Bomb Mendelsohniana: why the fourth, if the third was wasted?"

1363. Zevi, Bruno Benedetto. "Urbanistica/architettura e la commedia Gropius +/-/:/x Wright." *L'Architettura*, 16(March 1971), 702-703. Italian: "City planning/ architecture and the comedy Gropius +/-/:/x Wright." German, French, English summaries.

1364. *Architectural Design.* "Will the real communist please stand up." 41(August 1971), 516.

1365. *Architectural Forum.* "Parasol for the arts." 135(July-August 1971), 5. Marin County Civic Center.

1366. *Architectural Record.* "Dallas Theater Center." 149(February 1971), 42.

1367. *Architectural Record* . "Early Wright work destroyed." 149(April 1971), 41. Harlan house.

1368. *Calendar of the Art Institute of Chicago.* "New Frank Lloyd Wright and Louis H. Sullivan Papers in the Burnham Library of Architecture." 65(January 1971), 6-15. Frank L. Smith Bank.

1972
Books, monographs and catalogues
1369. Akashi, Nobumichi (Shindo). *Kyu Teikoku Hoteru no jisshoteki Kenkyu.* Tokyo: Tokodo Shoten, 1972. Japanese: *Frank Lloyd Wright in Imperial Hotel.* Japanese; English captions. Mostly images.

1370. Bridgeman, Frieda Estes. *The development of a theatre concept as reflected in the theatrical architecture of Frank Lloyd Wright* [microform]. Ann Arbor: Xerox University Microfilms, 1972. PhD thesis, University of Wisconsin, 1971.

1371. Brooks, Harold Allen. *The Prairie School: Frank Lloyd Wright and his midwest contemporaries.* Toronto and Buffalo: University of Toronto Press, 1972. Reviewed *Choice*, 9(May 1972), 357; Leonard Kimball Eaton, "Frank Lloyd Wright and friends," *Progressive Architecture*, 53(June 1972), 120, 128; Thomas S Hines, *JSAH*, 31(December 1972), 332-35 and correction 32(May 1973), 192; Wilbert R. Hasbrouck, *Architectural Forum*, 137(December 1972), 12-13; James F. O'Gorman, *Art Bulletin*, 54(December 1972), 564-65; Paul E. Sprague, *Prairie School Review*, 8(no. 4, 1972), 14-18; *TLS*, (9 March 1973), 264; Reyner Banham, "Death and life of the Prairie School," *Architectural Review*, 154(August 1973), 99-101; Phoebe Stanton, *Architectural Design*, 43(1973), 689-90; Neal Harris, *Reviews in American History*, 2(March 1974), 27-33; and Donald Leslie Johnson, *Art Journal*, 34(Spring 1975), 276. Reprinted New York and London: Norton, 1976 and in paperback, 1990. See also *idem., The Prairie School*, New York: 1996.

1372. Clark, Robert Judson ed. "Frank Lloyd Wright." In *The Arts and Crafts Movement in America, 1876-1916.* Princeton University Press, 1972. 68-75, 101. Catalogue of an exhibition organized by the Art Museum, Princeton University and the Art Institute of Chicago. The show is reviewed David Hanks, *Apollo*, 97(February 1973), 183-88.

1373. Eaton, Leonard Kimball. *American architecture comes of age; European reaction to H. H. Richardson and Louis Sullivan.* Cambridge, Mass.: MIT Press, 1972.

1374. Ferrari, Claudio P. and Fernando Pérez. *Frank Lloyd Wright.* Santiago: Universidad Católica de Chile, Departamento de Arquitectura de Obras, 1972. Spanish.

1375. Futagawa, Yukio and Masami Tanigawa. *Frank Lloyd Wright Taliesin East, Spring Green, Wisconsin, 1925-; Taliesin West, Paradise Valley, Arizona, 1938-.* Tokyo: A.D.A. Edita, 1972. Japanese. Mostly images.

1376. Jordy, William Henry. "The organic ideal: Frank Lloyd Wright's Robie house" and "The encompassing environment of free-form architecture: Frank

Lloyd Wright's Guggenheim Museum." In *American Buildings and their architects, Volume 3: progressive and academic ideals at the turn of the twentieth century,* New York: Doubleday, 1972. Second edition, Garden City: Anchor Press, 1976; third edition, New York: Oxford University Press, 1986.

1377. Muggenberg, James. "Frank Lloyd Wright in print, 1959-1970." In William B. O'Neal ed. *Gropius, Wren, Latrobe, Wright. The American Association of Architectural Bibliographers papers.* Charlottesville: University Press of Virginia, 1972. Bibliography.

1378. Radford, Evelyn Morris. *The genius and the county building. How Frank Lloyd Wright came to Marin County, California, and glorified San Rafael* [microform]. Ann Arbor: University Microfilms, 1972. PhD thesis, University of Hawaii, 1972. See also *idem., The bridge and the building: the art of government and the government of art.* New York: Carlton, 1974. Second, edition (paperback), *The bridge and the building,* Saline: McNaughton and Gunn; Danville: Pradbin, 1998. Marin County Civic Center.

1379. Streich, Eugene R. "An original owner interview survey of Frank Lloyd Wright's residential architecture." In William J. Mitchell ed. *Environmental design: research and practice,* Los Angeles: UCLA, 1972. Proceedings of the EDRA 3/AR 8 Conference at the university, January 1972.

1380. Taliesin Associated Architects. *Marin County Civic Center master plan, 1972-1990 prepared for the Marin County Board of Supervisors* Scottsdale: The Architects, 1972.

1381. Willard, Charlotte. *Frank Lloyd Wright: American architect.* New York: Macmillan, 1972. Juvenile biography.

Periodicals
1382. Balch, Ruth. "It happened only once." *AIA Journal,* 58(October 1972), 65. Balch house.

1383. Barnett, Jonathan. "Rethinking Wright." *Architectural Forum,* 136(June 1972), 42-47. For five responses, see *ibid.,* (September 1972), 16.

1384. Besinger, Curtis. "[Wright's birth date]." *JSAH,* 31(May 1972), 159.

1385. Bowly, Devereaux, Jr. "Unity Temple: a masterpiece on the way to restoration." *Inland Architect,* 16(December 1972), 18-19.

1386. Bradshaw, Jon. "The stern shining brow." *Los Angeles Times West Magazine,* (16 April 1972), 9-12.

1387. Cohen, Stuart E. "Trailing Frank Lloyd Wright." *Architectural Design,* 42(November 1972), 663-64. Mobile homes, based by Taliesin Associated Architects on Wright's designs. Cf. "Wrightmobile," *Architectural Forum,* 136(March 1972), 61.

1388. Cox, James A.D. "Frank Lloyd Wright and his houses in Virginia." *Arts in Virginia* 12I (Fall 1972), 10-17. Reprinted as a booklet.

1389. Cutler, Anthony. "The tyranny of Hagia Sophia: notes on Greek Orthodox church design in the United States." *JSAH*, 31(March 1972), 41-44. Annunciation Greek Orthodox church. See also Stanley Kenneth Jernow, "Richardsonian tradition and Frank Lloyd Wright, with an excursus on the flower pot that grew into a church," *ibid.*, 31(October 1972), 234-35.

1389. Heckscher, Morrison H. "Outstanding recent accessions, 19th century architecture for the American wing: Sullivan and Wright." *Metropolitan Museum of Art Bulletin*, 30(June-July 1972), 300-305. Living room, Little house. See also "Preservation: the Met to the rescue," *Architectural Forum*, 136(June 1972), 22.

1390. Higuchi, Kiyoshi. [Wright and Le Corbusier]. *A+U*, 2(February 1972), 7-8; (March), 45-46; (April), 6-7; (May), 80-81; (June), 116-17; (July), 88-89; (August), 105-106; (September), 127-28; (October), 100-101; (November), 144-45; (December), 124-27. Japanese.

1391. Joedicke, Jürgen. "Frank Lloyd Wright, 1893-1909: die Entstehung einer neuen Raumkonzeption." *Bauen und Wohnen*, 27(November 1972), 510-14. German: "Frank Lloyd Wright, 1893-1909: the genesis of a new conception of space."

1392. Marlin, William. "The quality of 'more-to-it-than': Wright's Johnson Wax building today." *Inland Architect*, 16(August-September 1972), 13-17.

1393. McCoy, Esther. "Architecture west. Four Frank Lloyd Wright textured block houses." *Progressive Architecture*, 53(September 1972), 76.

1394. McDaniel, Joyce Pelham. "The evolution of a house." *Alabama Architect*, 8(June- August 1972), 10-15. Rosenbaurn house.

1395. Pica, Agnoldornenico. "Quattro progetti per Venezia alla 36 Biennale." *Domus*, (October 1972), 1-3. Italian: "Four projects for the 36th Venice Biennale." Masieri memorial.

1396. Powell, Eileen Alt. "The Frank Lloyd Wright designed Munkwitz Apartments: will what we say affect what is done?" *Wisconsin Architect*, 43(July-August 1972), 7-10. Threatened demolition. See Richard W. Perrin's response, *ibid.*, (October-November), 5.

1397. Schaefer, Inge. "Marin County Civic Center von F. L. Wright." *Werk*, 59(January 1972), 5. German.

1398. Severens, Kenneth W. "Frank Lloyd Wright house in Oberlin." *Oberlin College Bulletin*, 29(Winter 1972), 90-105. Weltzheirner house. See also *idem.*, "Perforated window board from the Weltzheimer house," *Museum Studies*, 8(1976), 109-117.

1399. Twombly, Robert C. "Undoing the city: Frank Lloyd Wright's planned communities." *American Quarterly*, 24(October 1972), 538-49.

1400. Weisman, W. [Chicago School issue]. *Prairie School Review*, 9(no. 1, 1972), 6-30.

1401. Zevi, Bruno Benedetto. "Attualità dell'urbanistica wrightiana." *L'Architettura*, 18(October 1972), 352-53. Italian: "The topicality of Wright's urbanism."

1402. *Architectural Forum*. "First prairie house." 137(December 1972), 62. Wright house and studio for sale.

1403. *Japan Architect*. "Possible destruction of the Yamamura house." 47(February 1972), 15. Japanese and English.

1404. *Progressive Architecture*. "Arizona church builds Wright design after 22 years." 53(September 1972), 59; 62. Southwest Christian Seminary design.

1973
Books, monographs and catalogues
1405. Crocker, Mary Wallace. "Louis Sullivan cottages." In *Historic Architecture in Mississippi*, Jackson: University Press of Mississippi, 1973. Sullivan and Charnley summer houses, Ocean Springs. Paperback edition, 1989.

1406. Futagawa, Yukio and William Marlin. *Houses in Oak Park and River Forest, Illinois, 1889-1913/Frank Lloyd Wright*. Tokyo: A.D.A. Edita, 1973. English and Japanese. Mostly images.

1407. Gol'dshtein, Arkadii Fedorovich. *Frank Lloid Rait*. Moscow: Stroiizdat, 1973. Russian: *Frank Lloyd Wright*.

1408. Heckscher, Morrison H. and Elizabeth G. Miller. *An architect and his client: Frank Lloyd Wright and Francis W. Little*. New York: Metropolitan Museum of Art, 1973. Catalogue of an exhibition of furniture, glass, drawings, photographs, and correspondence. The show is reviewed Sarah B. Sherrill, *Antiques*, 103(June 1973), 1054, 1058; *Interiors*, 132(June 1973), 10; and J.T. Butler, *Connoisseur*, 184(September 1973), 59-60.

1409. Jimeno, Oswaldo. *La magia del muro: Gaudi, Wright*. Lima: EUNAFEV, 1973. Spanish: *The magic of the wall: Gaudi, Wright*.

1410. Raymond, Antonin. "Frank Lloyd Wright at Taliesin" and "Rendezvous with Japan: the Imperial Hotel." In *Antonin Raymond, an autobiography*, Rutland; Vermont; Tokyo: Charles E. Tuttle, 1973. Reviewed James Maude Richards, *JSAH*, 33(December 1974), 360-61.

1411. Starosciak, Kenneth and Jane Starosciak. *Frank Lloyd Wright: a bibliography. Issued on the occasion of the destruction of the Francis W. Little House, Deep Haven, Minnesota, 1913-1972*. New Brighton, Minn., 1973. Limited edition of 750 copies.

1412. Twombly, Robert C. *Frank Lloyd Wright: an interpretive biography*. New York; Evanston; San Francisco; London: Harper and Row, 1973.

Developed from the author's Ph.D. thesis, *Architect, the life and ideas of Frank Lloyd Wright*, University of Wisconsin (published in microform, Ann Arbor: University Microfilms, 1968). A paperback edition was published by Harper Colophon Books, 1974. Sections also published as "Organic living: Frank Lloyd Wright's Taliesin Fellowship and Georgi Gurdjieff's Institute for the Harmonious Development of Man," *Wisconsin Magazine of History*, 58(Winter 1974-75); and "Undoing the city: Frank Lloyd Wright's planned communities," *American Quarterly*, 24(October 1972).

Reviewed A.D. Ross, *Library Journal*, 98(15 February 1973), 532; Donald Hoffman, *Architectural Forum*, 138(April 1973), 14; Kelly Fitzpatrick, *Best Sellers*, 33(15 May 1973), 86; Roger Jellinek, *New Yorker*, 49(2 June 1973), 124; Leonard Kimball Eaton, *Progressive Architecture*. 54(August 1973), 94; Kelly Fitzpatrick, *Choice*, 10(October 1973), 1182; *NYTBR*, (2 December 1973), 72; Jane Holtz Kay, *Nation*, (12 January 1974), 56; Lance Myron Neckar, *Wisconsin Magazine of History*, 57(Fall 1974), 62-63; Bernard Gillespie, *Canadian Architect*, 19(September 1974), 64; Harold Allen Brooks, *JSAH*, 33(December 1974), 359-60; Donald G. Kalec, *Prairie School Review*, 11(no. 2, 1974), 9-21; and Kenneth W. Severens, *ibid.*, 22-25.

1413. Wright, Olgivanna Lloyd. *Frank Lloyd Wright.* New York: Winthrop Laboratories, 1973.

1414. Yellowstone Art Center. *The selected work of Frank Lloyd Wright: 1887-1959.* Billings, Montana: The Center, 1973. Catalogue of a traveling exhibition, October-November 1973, that included photomurals and color lithographs of Wright's drawings, and seven pieces of furniture he designed for Heritage Henredon in 1955 (built for this show). Subsequently shown at three other Montana institutions. The catalogue has statements by Bruce Brooks Pfeiffer and John A. Armstrong, Director, Yellowstone Art Center.

1415. *Frank Lloyd Wright in Imperial Hotel.* Palos Park: Prairie School Press, 1973. Japanese; English captions.

Periodicals
1416. Chaitkin, William. "Frank Lloyd Wright in Russia." *AA Quarterly*, 5(April-June 1973), 45-55.

1417. Hanks, David. "A desk by Frank Lloyd Wright." *Bulletin of the Art Institute of Chicago*, 67(September-October 1973), 6-8. Coonley house.

1418. Martinson, Tom. "A loss of consequence." *Northwest Architect*, 37(March-April 1973), 82-85. Demolition of Little house.

1419. Miller, Nory. "Four architects with their own design for living." *Inland Architect*, 7(June 1973), 8-13. Mrs. Thomas Gale house.

1420. Pfeiffer, Bruce Brooks. "Out of the desert's mystery." *AIA Journal*, 59(May 1973), 54-55. Taliesin West. See also *idem.*, "Taliesin West 1973: Frank Lloyd Wright Foundation," *L'Architecture d'Aujourd'hui*, (July-August 1973), 104-108 (French).

1421. Sprague, Paul E. "Griffin rediscovered in Beverly." *Prairie School Review*, 10(no. 1, 1973), 6-23.

1422. *Canadian Architect*. "[A bronze plaque commemorating Frank Lloyd Wright and Adler and Sullivan, on the 17th floor of the Auditorium Building, Chicago]." 18(February 1973), 8-9. Cf. "Plaque marks offices of Adler, Sullivan, Wright," *Progressive Architecture*, 14(January 1973), 43.

1974
Books, monographs and catalogues
1423. Brunetti, Fabrizio. *Le matrici di una architettura organica: Frank Lloyd Wright*. Florence: Teorema, 1974. Second edition, Florence: Alinea, 1981. Italian: *The matrices of an organic architecture: Frank Lloyd Wright.*

1424. Davis, Patricia Talbot. *Together, they built a mountain*. Lititz: Sutter House, 1974. Beth Sholom synagogue.

1425. Frank Lloyd Wright Foundation. *The Arizona Biltmore Hotel: history and guide*. Scottsdale [?]: The Foundation, 1974. Illustrated pamphlet includes: "Frank Lloyd Wright and the Arizona Biltmore Hotel" by Olgivanna Lloyd Wright and "The Arizona Biltmore Hotel 1929-1973," by Bruce Brooks Pfeiffer.

1426. Frank Lloyd Wright Foundation and Hubbard Associates. *Nakoma, Nakomis, Winnebago Indian memorials: two sculptures by Frank Lloyd Wright, 1924; bronze edition, 1974*. Scottsdale [?]: The Foundation, 1974. Illustrated pamphlet includes "The sculpture of Frank Lloyd Wright" by Bruce Brooks Pfeiffer. See also "FLLW sculpture offered in limited edition," *Architectural Record*, 157(February 1975), 35; and *Art in America* 63(November 1975), inside back cover. Images of the pieces were published through the 1970s: see *Art in America,* 64(November 1976), 140; *Art Journal*, 36(Summer 1977), 340; and "Frank Lloyd Wright, sculptor," *Art News,* 77(October 1978), 10 ff.

1427. Futagawa, Yukio and Masami Tanigawa. *Taliesin East, Spring Green, Wisconsin, 1925- ; Taliesin West, Paradise Valley, Arizona, 1938- / Frank Lloyd Wright*. Tokyo: A.D.A. Edita, 1974. Japanese. Mostly images.

1428. Kaufmann, Edgar J. Jr. *Frank Lloyd Wright*. Chicago: H.H. Benton, 1974. Reprinted from *Encyclopaedia Britannica*, fifteenth edition.

1429. Los Angeles. Cultural Heritage Foundation and Southern California Chapter, Architectural Secretaries Association. *Frank Lloyd Wright Week*. Los Angeles: 1974. A pamphlet with notes on Hollyhock, Ennis, Freeman, Sturges, and Storer houses, Los Angeles, and Anderton Court Shops, Beverly Hills. Included is a program for Frank Lloyd Wright house grounds gallery tour, 9 June 1974.

1430. Moisescu, Anton. *Wright*. Bucharest: Editura Tehnica, 1974. Romanian; English, French, Italian, Russian summaries.

1431. Oak Park Public Library. *Frank Lloyd Wright, Prairie School architecture: a selection of materials in the Oak Park Public Library.* Oak Park: The Library, 1974.

1432. Storrer, William Allin. *The architecture of Frank Lloyd Wright: a complete catalogue.* Cambridge Mass.; London: MIT Press, 1974. An illustrated catalogue of executed buildings. Reviewed H. Ward Jandl, *Library Journal,* 99(July 1974), 1797; *TLS,* (23 August 1974), 899; D. Schmiedeke, *AIA Journal,* 62(September 1974), 54; *Choice,* 11(November 1974), 1296.

Also published MIT Press, 1978; reviewed Martin Filler, "Writing on Wright," *Art in America,* 67(October 1979), 77-79; and Donald Hoffman, *JSAH,* 38(December 1979), 395-96. Also in paperback 1982. New edition, University of Chicago Press, 2001. The entire work is reprinted Chicago: University of Chicago Press, 2002. Since October 1998 the author also privately publishes *FLLW update,* Newark.

1433. Teske, Edmund. *Edmund Teske.* Los Angeles: Municipal Art Gallery, 1974. Catalogue of an exhibition, September-October 1974, that includes photographs of Hollyhock house, Barnsdall residence B, and Taliesin.

Periodicals
1434. Bell, Robert A. "Shotcrete restoration of a historic landmark." *Concrete Construction,* 19(April 1974), 161-63. Unity Temple.

1435. Dymond, Lura. "New life for a landmark." *Westways,* 66(November 1974), 22. Hollyhock house.

1436. Fowles, Aggie. "Oak Park's unique heritage: how a village preserves 386 structures of architectural merit." *Nation's Cities,* 12(May 1974), 22-23.

1437. Harris, Neal. "Housing the rich." *Review in American History,* 2(1974), 27-33.

1438. Johnson, Kathryn C. "Frank Lloyd Wright's mature prairie style." *Minneapolis Institute of Arts Bulletin,* 61(1974), 54-65. Little house.

1439. MacCormac, Richard Cornelius. "Froebel's kindergarten gifts and the early work of Frank Lloyd Wright." *Environment and Planning B,* 1(1974), 29-50. This expands MacCormac's Masters thesis, "An investigation of space and form in the architecture of Frank Lloyd Wright," University College London, 1965. Revised in McCarter ed. *Frank Lloyd Wright; a primer on architectural principles,* Princeton: 1991, 90-123. For comment see Edgar J. Kaufmann Jr., *Nine commentaries on Frank Lloyd Wright,* Cambridge, Mass.: 1989, 4-5.

1440. Panerai, Philippe and Jean Castex. "Frank Lloyd Wright, de la prairie house à la maison Usonienne." *Architecture Française,* 35(May-June 1974), 21-23. French: "Wright, the Prairie house to the Usonian house."

1441. Pedio, Renato. "Casa Pfeiffer a Taliesin West, Scottsdale, Arizona: un Wrightiano costruisce Wright." *L'Architettura,* 20(August 1974), 240-46. Ital-

ian: "Pfeiffer house ... a Wrightite builds Wright." The house was originally designed for Ralph Jester.

1442. Pica, Agnoldomenico. "Wright oggi, François Robert: immagini attuali del complesso di uffici Johnson Wax a Racine ... di Frank Lloyd Wright." *Domus*, (February 1974), 6-8. Italian: "Wright today, François Robert: images made real in the Johnson Wax office complex ... ;" English, French summaries.

1443. Reiach, Alan. "Meetings with Frank Lloyd Wright." *Concrete Quarterly*, (January-March 1974), 38-40.

1444. Ronnie, Art. "Hollyhock—the Wright house." *Westways*, 66(November 1974), 18-22, 86.

1445. Singelenberg, Pieter. "Het Haags Gemeentemuseum." *Nederlands Kunsthistorische Jaarboek*, 25(1975), 22-89. Dutch: "The Hague Municipal Museum." Wright's influence in the work of H.P. Berlage.

1446. Thomas, Margaret Dudley. "The Arizona-Biltmore: the queen of internationally honored resort hotels." *Arizona Highways*, 50(April 1974), 14-23.

1447. Tournon-Branly, Marion. "Frank Lloyd Wright: 'le dieu de désert'." *Architectes*, 50(July-August 1974), 18-21. French: "Wright: 'the desert god'."

1448. Treiber, Daniel. "Frank Lloyd Wright." *Architecture Interieur Cree*, (August-September 1974), 104-114. French; English summary.

1449. Twombly, Robert C. "Organic living: Frank Lloyd Wright's Taliesin Fellowship and Georgi Gurdjieff's Institute for the Harmonious Development of Man." *Wisconsin Magazine of History*, 58(Winter 1974-1975), 126-39 (from *Frank Lloyd Wright: an interpretive biography*. New York: 1973).

1450. Walker, Virginia E. "Prejudgment of history." *Canadian Architect*, 19(November 1974), 39-41.

1451. *AIA Journal*. "The 1974 Honor Awards: seven new buildings, two not so new." 61(May 1974), 41-49. S.C. Johnson and Son administration building

1452. *AIA Journal*. "Funds sought for restoration of Wright building in Oak Park." 62(September 1974), 66. Wright home and studio.

1453. *Architects' Journal*. "Strong room." 160(18 September 1974), 655. Kaufmann office, Pittsburgh, rebuilt in Victoria and Albert Museum, London.

1454. *Architecture Plus*. "Wright in Japan." 2(September-October 1974), 115. Exhibit at Takumi Gallery, Koriyama.

1455. *Art in America*. [Images of Indian memorials]. 62(November 1974), 116.

1456. *House Beautiful*. "A unity of form and feeling." 116(July 1974), [62]-[63]. Architect Martin Price's apartment, with stained glass by Wright.

1975
Books. monographs and catalogues
1457. Asselbergs, Fons [Alphons Julianus Maria] ed. *Americana, 1880-1930*, Otterlo: Rijksmuseum Kröller-Müller, 1975. Dutch; English summaries. Catalogue of an exhibition, August-October 1975. Includes "Frank Lloyd Wright en De Stijl [Wright and de Stijl]", "De nieuwe wereld: variaties op een thema, 20 jaar belangstelling voor Frank Lloyd Wright [The New World: variations on a theme, 20 years interest in Wright]", "Frank Lloyd Wright en de Amsterdamse school [Wright and the Amsterdam School]", and "Frank Lloyd Wrights invloed in de jaren twintig [Wright's influence in the 'twenries]", all by Auke van der Woude; and "Corresponditie met America: Berlage, Oud, Wijdeveld (November 1922-March 1934) [Correspondence with America]" by Paul Hefting.

Reviewed Leonard Kimball Eaton, "It's hard to beat the Dutch," *Progressive Architecture*, (February 1976), 28; Helen Searing, *JSAH*, (1978), 305-306. See also van der Woude, "Nederland and de nieuwe wereld [Holland and the New World]," *Wonen TA/BK*, (no. 17, 1975), 16-22.

1458. AIA, Wisconsin Chapter Historic Resources Committee. *Frank Lloyd Wright buildings.* Madison: Department of Natural Resources, 1975

1459. Baker, Geoffrey Harold et al. *USA 1890-1939.* Milton Keynes: Open University Press, 1975.

1460. Benton, Tim, Charlotte Benton and Dennis Sharp eds. *Architecture and Design 1890-1939.* New York: Whitney Library of Design, 1975.

1461. Brooks, Harold Allen. *Prairie School architecture: studies from the* Western Architect. Toronto; Buffalo: University of Toronto Press, 1975. Also published in paperback by Books on Demand.

1462. Futagawa, Yukio and Bruce Brooks Pfeiffer. *Frank Lloyd Wright: Solomon R. Guggenheim Museum, New York City, N. Y, 1943-59; Marin County Civic Center, California, 1957-1970.* Tokyo: A.D.A. Edita, 1975. Japanese and English. Mostly images.

1463. Futagawa, Yukio ed. *Houses by Frank Lloyd Wright 1.* Tokyo: A.D.A. Edita, 1975. Japanese. Mostly images, including Bradley, Cheney, Coonley, Dana, Davenport, Ennis, Freeman, Fricke, Gilmore, Gridley, Hardy, Heurtley, Ingalls, Irving, Jones, Little, Mrs. Thomas Gale, Roberts, Robie, Storer, W. E. Martin, Willits and Winslow houses; Wright house and studio; and Taliesin. A cornpanion volume followed in 1976.

1464. Gutheim, Frederick Albert ed. *In the cause of architecture, Frank Lloyd Wright: essays by Frank Lloyd Wright for* Architectural Record, *1908-1952; with a symposium on architecture with and without Wright by eight who knew him.* New York: Architectural Record, 1975. Reprinted in paperback, New York: McGraw-Hill, 1987. Reprints Wright's "In the cause of architecture" articles and Gutheim, "The Wright legacy evaluated," *Architectural Record*, 128(October 1960). There are other essays: "The whole man" by Elizabeth Bauer Kassler; "Wright, the man" by Henry Klumb; "Wright: then and now" by

Andrew Devane; "Now more than ever" by Elizabeth Wright Ingraham; "Toward an American architecture" by Karl Kamrath; "A humane and environmental architecture" by Victor Hornbein; "Wright: the eleventh decade" by Edgar J. Kaufmann, Jr., and "A language after Wright" by Bruno Zevi. Reviewed John Vinci, *Chicago History*, 49(Fall 1975), 179-80.

See also Frank Lloyd Wright, *Per la causa dell'architettura*, Rome: Gangemi, 1989 (Italian).

1465. Higgens, Frances H. *Oral history: Frances H. Higgens interviewed by Carla Ehat 1975*. San Rafael: Anne T. Kent California Room Oral History Project, 1975. Transcript of reminiscences of early days in Oak Park, Illinois and of her neighbor, Wright.

1466. Johnston, Peter Lawson et al. *The Solomon R. Guggenheim Museum, New York: Frank Lloyd Wright architect.* New York: Solomon R. Guggenheim Foundation, 1975. There is an introduction by Johnston and Thomas M. Messer; a history of the museum by Louise Averill Svendsen; the text of a letter from Wright to Guggenheim; and a history of the building by Henry Berg.

1467. Kalec, Donald G. and Thomas A. Heinz. *Frank Lloyd Wright home and studio, Oak Park, Illinois.* Oak Park: Home and Studio Foundation, 1975. Illustrated pamphlet. Reviewed John Vinci, "More on the work of Frank Lloyd Wright," *Chicago History*, 5(Fall 1976), 172.

1468. Kohler Art Library. University of Wisconsin, Madison. *Frank Lloyd Wright: selected works.* Madison: The Library, 1975. Bibliography.

1469. Robert C. Eldred Auctioneers. *Oriental art.* East Dennis, Mass.: Robert C. Eldred, 1975. Auction catalog.

1470. Wright, Frank Lloyd. *Furanku roido raito no jutaku.* Tokyo: A.D.A. Edita, 1975-1976. Japanese.

Periodicals
1471. Cave, R. S. "The Marin County Civic Center." *Pacific Historian*, 19(no. 3, 1975), 241-52.

1472. Cohen, Stuart. "Wright's studio home open to the public." *Progressive Architecture*, 56(May 1975), 32.

1473. Fox, Terry Curtis. "Living Wright." *Chicago*, 24(October 1975), 152-160. Houses in the Chicago area.

1474. Geran, Monica. "Frank Lloyd Wright revisited." *Interior Design*, 46(November 1975), 96-101. Subtitled, "Today, as in 1939, the Johnson Wax Administration building stands as a monument to the architect/designer's timeless talents."

1475. Geselbracht, Raymond H. "Transcendental renaissance in the arts: 1890-1920." *New England Quarterly*, 48(December 1975), 463-86. Includes discussion of (i.a.) Wright.

1476. Goss, Peter L. "Prairie school influence in Utah." *Prairie School Review*, 12(no. 1, 1975), 5 ff.

1477. Guerrero, Pedro E. "Frank Lloyd Wright: an unpublished portfolio." *Saturday Review of Literature*, 3(4 October 1975), 18-23. Photographs of Wright, 1940-1959. Cf. William Marlin, "Frank Lloyd Wright: the enduring presence," 14-17; same as *Design* [Mumbai], 20(January 1976), 22-24.

1478. Heckscher, Morrison H. "Frank Lloyd Wright's furniture for Francis W. Little." *Burlington Magazine*, 117(December 1975), 866-72.

1479. Hildebrand, Grant. "Privacy and participation: Frank Lloyd Wright and the city street." *University of Washington, College of Architecture and Urban Planning, Development Series*, 1(Spring 1975), 23-39.

1480. Kugler, Silvia. "Der grosse Arbeitsraum." *Du*, 35(May 1975), 64-74. German: "The great workspace;" English summary. S.C. Johnson Wax administration and Larkin administration buildings.

1481. Lynes, Russell. "On knowing Wright from wrong." *Architectural Digest*, 32(November-December 1975), 24, 32, 36. Barton house; Fallingwater.

1482. Renzio, Toni del. "Frank Lloyd Wright and the pop traditions." *Art and Artists*, 9(January 1975), 28-31. Kaufmann office.

1483. Sembach, Klaus-Jurgen. "Funf villen des fruhen 20. jahrhunderts." *Du*, 35(September 1975), 10-49. German: "Five early twentieth century villas." Includes Robie and Coonley houses.

1484. Severens, Kenneth W. "The reunion of Louis Sullivan and Frank Lloyd Wright." *Prairie School Review*, 12(no. 3, 1975), 5-21.

1485. Sprague, Paul E. and John Vinci. [Editorial]. *Prairie School Review*, 12(no. 3, 1975), 4. Charnley house.

1486. Stamm, Gunther. "Modern architecture and the plantation nostalgia of the 1930s: Stone's 'Mepkin' and Wright's 'Auldbrass Plantation'." *JSAH*, 34(December 1975), 318. Abstract of a longer essay.

1487. Twombly, Robert C. "Saving the family: middle class attraction to Wright's prairie house, 1901-1909." *American Quarterly*, 27(March 1975), 57-72.

1488. Wright, Frank Lloyd. "The master's work." *American Art Review*, 2(May-June 1975), 133-36. Reprinted from *Genius and the mobocracy*, New York: 1949.

1489. *AIA Journal*. "Wright windows stolen from Rochester house." 64(July 1975), 14. Boynton house.

1490. *Architectural Digest*. "Frank Lloyd Wright revisited." 32(January-February 1975), 92-99. Redecoration of interiors of a house in New York State.

1491. *Architectural Record.* "Benefit tour of FLLW homes nets $24,000." 158(September 1975), 37.

1492. *Architectural Record.* "Marin County court house, California." 157(June 1975), 109.

1493. *Building.* "Max Fry: inspirations, friendships, and achievements of a lifetime in the modern movement." 229(31 October 1975), 52-58.

1494. *Interior Design.* "Designers showcase: Frank Lloyd Wright's Charnley House, Chicago." 46(November 1975), 118-19.

1495. *Interiors.* "Wrightian revival: bold, colorful FLLW designs visually unify the restored Arizona Biltmore Hotel." 135(October 1975), 76-81.

1496. *Metropolitan Museum of Art Bulletin.* [Images of Coonley playhouse stained glass windows]. 33(Winter 1975-1976), 235.

1497. *National Sculpture Review.* "Bock collection at Greenville College." 24(Summer-Fall 1975), 5. Exhibit includes several works related to Wright.

1498. *Preservation News.* "Trust acquires Wright home." (October 15, 1975), 1-6. Wright home and studio.

1499. *Princeton Museum Record.* [Image of furniture and living room, Coonley house]. 34(no. 2, 1975), 4.

1500. *Progressive Architecture.* "In progress: Teliesin [*sic*] design for hotel wing." 56(October 1975), 52-53. Arizona-Biltmore Hotel.

1976
Books, monographs and catalogues
1501. Cowles, Linn Ann. *An index and guide to* An autobiography, *the 1943 edition by Frank Lloyd Wright.* Hopkins: Greenwich Design, 1976.

1502. Duis, Perry. *Chicago: creating new traditions.* Chicago: Chicago Historical Society, 1976. Includes discussion of Wright and other Prairie School architects.

1503. Futagawa, Yukio and Bruce Brooks Pfeiffer. *Frank Lloyd Wright: Pfeiffer Chapel, Florida Southern College, Lakeland, Florida, 1938; Beth Sholom Synagogue, Elkins Park, Pennsylvania, 1954.* Tokyo: A.D.A. Edita, 1976. English and Japanese. Mostly images. There is an essay by Pfeiffer.

1504. Futagawa, Yukio and Bruce Brooks Pfeiffer. *Houses by Frank Lloyd Wright 2.* Tokyo: A.D.A. Edita, [1976]. Japanese and English. Mostly images. Includes Affleck, Baird, Bogk, Boomer, H.C. Price, H.C. Price Jr., Hanna, Hoffman, Jacobs II, Kalil, Laurent, Lewis, Lykes, Mossberg, Pew, Pope-Leighey, Robert Wright, Schwartz, Smith, Sturges, Walker, Wall, Walter, Willey, and Zimmerman houses; Fallingwater; and Wingspread. There is an essay, "The Usonian house" by Pfeiffer.

1505. Izzo, Alberto and Camillo Gubitosi eds. *Frank Lloyd Wright: disegni, 1887-1959*, Florence: Centro Di, 1976. Italian: *Frank Lloyd Wright: drawings 1887-1959*. Catalogue of a traveling exhibition of photos of Wright's drawings, organized by the Institute of Architectural Analysis, University of Naples, in collaboration with the Frank Lloyd Wright Foundation, and mounted first at the Palazzo Reale, Naples, December 1976-January 1977.

Reviewed *L'Architettura*, 22(February 1977), 549, 604-605; Bruno Zevi, *Architecture*, (February 1977), 35; Agnoldomenico Pica, "F.L. Wright inediti e non, trecento designi in mostra a Napoli [Wright, known and unknown, 300 drawings on show in Naples]," *Domus*, 569(April 1977), 1-5; and *Architecture*, (June 1977), 42-61.

The show moved to L'École Spéciale d'Architecture, Paris, June-July 1977 (catalogue translated into French as *Frank Lloyd Wright: dessins, 1887-1959*); Museum of Finnish Architecture, Helsinki, August-September 1977; Künstlerhaus, Vienna, November 1977 (reviewed *Werk*, 64[November-December 1977], 90 ff.); Eidgenössische Technische Hochschule, Zürich, January 1978; École Polytechnique Fédérale, Lausanne, February 1978 and the Fakultät für Architektur, Karlsruhe University, March-April 1978.

An English edition of the catalogue was distributed by Academy Editions, London: 1977. It includes the editors' introduction and "The architectural innovations of Frank Lloyd Wright" by Marello Angrisani. It is reviewed John Henry Howe, *Frank Lloyd Wright Newsletter*, 1(November-December 1978), 7-8; and William Chaitkin, *Architectural Design*, 48(no. 11-12, 1978), 583-87. Revised as *Frank Lloyd Wright, three-quarters of a century of drawings*, London: Academy, 1981 and New York: Horizon Press, 1982.

1506. Kimball, (Sidney) Fiske et al. *Nineteenth and twentieth century architecture*. New York: Garland, 1976. Includes "Frank Lloyd Wright and the 'academic tradition' of the early eighteen-nineties" by Henry-Russell Hitchcock Jr., reprinted from *Journal Of the Warburg and Courtauld Institutes*, 7(January-June 1944).

1507. Masuda, Akihisi and Masami Tanigawa. *Furanku Roido Raito no sekai.* Tokyo: Gihodo Shuppan Kabushiki Kaisha, 1976. Japanese: *The world of Frank Lloyd Wright*. Reviewed *Frank Lloyd Wright Newsletter*, 1(January-February 1978), 4.

1508. Rogers, Hope. *Grandpa Wright*. Vinton: Ink Spot Press, 1976. Biography of William Cary Wright, father of Frank Lloyd Wright. .

1509. Sergeant, John. *Frank Lloyd Wright's Usonian houses: the case for organic architecture*. New York: Whitney Library of Design, 1976. Reviewed Edgar A. Tafel, *Architectural Record*, 160(November 1976), 43 (replies from Sergeant and Robert C. Twombly, *ibid.*, 161[March 1977], 4). Also reviewed H. Ward Jandl, *Library Journal*, 101(1 December 1976), 2474; Leonard Kimball Eaton, *TLS*, (28 January 1977), 167; Donald Hoffmann, *JSAH*, 36(May 1977), 128-29; Jane C. Loeffler, *AIA Journal*, 66(May 1977), 68, 72 (for William Allin Storrer's response see *ibid.*, [October 1977], 2 ff.); D. Lea, *Architectural Design*,

47(1977), 378-80; Twombly, *Progressive Architecture*, 59(February 1978), 98, 100. Reprinted New York: 1984.

1510. Sprague, Paul E. *Guide to Frank Lloyd Wright and Prairie School architecture in Oak Park*. Oak Park: Bicentennial Commission of the American Revolution and Oak Park Landmarks Commission, 1976. An annotated guide with maps includes a foreword by Harold Allen Brooks, an introduction, and a short biography of the respective architects. Reviewed *AIA Journal*, 65(July 1976), 200; and Bernard Gillespie, *Canadian Architect*, 24(January 1979), 6.
Reprinted 1978, 1982. New edition published Oak Park: Landmarks Commission, 1986 and reprinted Chicago Review Press, 1991.

1511. Wodehouse, Lawrence. "Frank Lloyd Wright." In *American Architects from the Civil War to the First World War: a guide to information sources*. Detroit: Gale Research, 1976. Annotated bibliography.

1512. Wright, Frank Lloyd. *Buildings plans and designs*. Tokyo: ADA Edita, 1976. Mostly images. Foreword by William Wesley Peters; introduction and notes by Wright.

Periodicals
1513. Bowly, Devereaux, Jr. "Saving the idea of Wright's 1895 'model tenement'." *Inland Architect*, 20(February 1976), 18-20. Francisco Terrace.

1514. Brown, Dan. "Wright Prairie house burns in Oak Park." *Architectural Record*, 159(April 1976), 34. Hills house. Reprinted from *World News*, Chicago.

1515. Downs, Arthur Channing, Jr. "Victorian premonitions of Wright's prairie house in Downing and Scott." *Nineteenth Century*, 2(Summer 1976), 35-39.

1516. Gutheim, Frederick Albert. "Frank Lloyd Wright and the American home." *Architect and Builder* [South Africa], 26(February 1976), 2- 4.

1517. Jacobs, Herbert Austin. "Our Wright houses." *Historic Preservation*, 28(July-September 1976), 9-13. Usonia No. 1 House.

1518. Jensen, Robert. "Where F.L. Wright meets Le Corbusier." *Parametro*, 7(March 1976), 48-51, 63-64. Paolo Soleri's Arcosanti.

1519. Quimby, Ian M.G. ed. "Oriental influence on American decorative arts." *JSAH*, 35(December 1976), the issue. See especially "Japanese influence on the early designs of Frank Lloyd Wright" by C. Craig Miller, *ibid.*, 300-308.

1521. Riecken, Andrea. "Cinqüeta anos da Casa da Casacata, s'imbolo do modernismo americano." *Projeto*, (July 1987), 174-78. Spanish: "Fifty years of Fallingwater, symbol of American modernism."

1522. Sergeant, John. "Woof and warp: a spatial analysis of Frank Lloyd Wright's usonian houses." *Environment and Planning B*, 3(1976), 211-24. Expands Appendix I of *idem., Frank Lloyd Wright's Usonian houses: the case for organic architecture*, New York: 1976.

1523. Skurka, Norma. "Revisiting Frank Lloyd Wright." *New Yorker*, (4 January 1976), 36-37. Hoffman house. Cf. "Frank Lloyd Wright revisited." *Architectural Digest*, 32(January-February 1976), 92-99.

1524. Sprague, Paul E. "Frank Lloyd Wright home and studio: homeward bound." *Historic Preservation*, 28(July-September 1976), 4-8. See also Eric Johannesen's response, *ibid.*, 29(January-March 1977), 47.

1525. *AIA Journal.* "'Japan's Williamsburg' gets part of Wright's Imperial." 65(August 1976), 8-9.

1526. *AIA Journal.* "Mile high skyscraper—'The Illinois.' Frank Lloyd Wright, 1956." 5(November 1976), 59. Abridged from "The Illinois," *Architectural Record*, 120(November 1956), 11.

1527. *Casabella.* [Drawing of mile high skyscraper]. 40(October 1976), 26.

1528. *Interiors.* [Table for the Imperial Hotel, Tokyo]. 136(August 1976), 89. Image only.

1529. *Progressive Architecture.* "Wright/Gropius homes certain/uncertain." 57(November 1976), 25.

1977
Books, monographs and catalogues
1530. Fishman, Robert. *Urban Utopias in the twentieth century: Ebenezer Howard, Frank Lloyd Wright and Le Corbusier*, New York: Basic Books, 1977. Published version of the author's PhD thesis, "Ideal cities: the social thought of Ebenezer Howard, Frank Lloyd Wright and Le Corbusier," Harvard, 1974.

Reviewed *Library Journal*, 103(15 February 1978), 477; *Choice*, 159(March 1978), 112; *Economist*, 267(22 April 1978), 136; W.F. Smith, *American Academy of Political and Social Science Annals*, 437(May 1978), 180; Brian Horrigan, *JSAH*, 37(December 1978), 299-300; Trevor Boddy, *Queen's Quarterly*, 86(Spring 1979), 134-35; Eric Reade, *International Journal of Urban and Regional Research*, 4(June 1980), 308-309.

Reprinted Cambridge, Mass.: MIT Press, 1982 and in paperback as *Urban Utopias in the twentieth century*, Cambridge, Mass.: MIT Press, 1994. Also published in French as *L'utopie au XXe siècle: Ebenezer Howard, Frank Lloyd Wright, Le Corbusier*. Brussels: Pierre Mardaga, 1979.

1531. Frank Lloyd Wright Home and Studio Foundation Restoration Committee. *The plan for restoration and adaptive use of the Frank Lloyd Wright home and studio*. Oak Park: The Committee, 1977. Second edition, University of Chicago Press, 1979; reviewed "'The plan' describes restoration of Wright Home," *Milwaukee Journal*, (28 January 1979), Part 7, 9; Edgar A. Tafel, *AIA Journal*, 68(May 1979), 264 ff.; and Donald Hoffman, *JSAH*, 38(December 1979), 395-96.

1532. Hoag, Edwin and Joy Hoag. *Masters of modern architecture: Frank Lloyd Wright, Le Corbusier, Mies van der Rohe, and Walter Gropius.* Indianapolis; New York: Bobbs-Merrill, 1977. Juvenile biography.

1533. Johnson, Donald Leslie. *The architecture of Walter Burley Griffin.* Melbourne: Macmillan, 1977.

1534. Kehoe, Suzan von Lengerke. *The Emil Bach house. Commission on Chicago Historical and Architectural Landmarks.* Chicago: The Commission, 1977.

1535. Ricke, Helmut and Johan W. Ambaum, *Leerdam unica: 50 jaar modern Nederlands glas.* Rotterdam: Museum Boijmans van Beuningen, 1977. Dutch: *Leerdam unica: Fifty years of modern Dutch glass.* Catalogue of exhibition, July-September 1977. The show moved to the Düsseldorf Kunstmuseum, Germany, and the catalogue was translated as *Leerdam unica: 50 Jahre modernes niederländisches Glas.* Wright made designs for the famous firm in the 1920s.

1536. Scholl, Walter Otto. *Frank Lloyd Wright, Pablo Picasso, Arnold Schoenberg: signposts of a new civilizational context* [microform]. Ann Arbor: University Microfilms International, 1977. Thesis, Ohio University.

1537. Tanigawa, Masami. [*Attempt at numbering the opus of Frank Lloyd Wright*]. Tokyo: 1977. Japanese.

1538. Tanigawa, Masami. *Raito to Nihon.* Tokyo, 1977. Japanese: *Wright in Japan.*

1539. Wilson, Richard Guy and Sidney K. Robinson. *The Prairie School in Iowa.* Ames: State University Press, 1977. Reviewed Jay C. Henry, *JSAH,* 38(March 1979), 66-67. Reprinted 1987.

1540. Wright, Frank Lloyd. *Frank Lloyd Wright: decorative arts.* Spring Green: Frank Lloyd Wright Memorial Foundation, 1977.

1541. Wright, Frank Lloyd. *Frank Lloyd Wright: selected drawings portfolio.* New York: Horizon, 1977-1982. Volume one of three is a portfolio of fifty color drawings, selected and arranged by A.D.A. Edita, Tokyo and printed in Japan. There is an introduction by Olgivanna Lloyd Wright. The series was released in limited editions of 500, 700 and 500 numbered copies, respectively. Reviewed Bruce Brooks Pfeiffer, *Frank Lloyd Wright Newsletter* 19(January-February 1978), 4.

1542. *The Critical Experience, "Jefferson and Wright" Briefing Book: Videotaping with Program Participants. Columbia University, February 21-22, 1977.* New York: Cable Arts Foundation, 1977.

Periodicals
1543. Bantzer, Effi. "Pearl Palace, Teheran, Iran." *Bauen und Wohnen,* 32(no. 7-8, 1977), 297-300. German.

1544. Beeby, Thomas. "Flowering grid." *Architectural Review*, 162(October 1977), 223-27.

1545. Dring, William B. [Letter]. *Historic Preservation*, 29(January-March 1977), 47. Restoration of Wright home and studio.

1546. Grabow, Stephen. "Frank Lloyd Wright and the American city: the Broadacres debate." *Journal Of The American Institute Of Planners*, 43(April 1977), 115-24.

1547. Hall, Helen. "New England gives the lead: the preservation of modern architecture." *Country Life*, 161(21 April 1977), 1053-54. Pope-Leighey house and Wright home and studio.

1548. Maass, John. "The case that architects often resemble their buildings." *AIA Journal*, 66(June 1977), 44.

1549. Peatross, C. Ford. "Architectural collection of the Library of Congress." *Quarterly Journal of the Library of Congress*, 34(July 1977), 276-77.

1550. Rudd, J. William. "Sullivan and Wright: a duality of difference." *Journal of Architectural Education*, 30(April 1977), 28-32.

1551. *Architectural Design*. [Unexecuted design for all-steel houses (1937)]. 47(no. 3, 1977), 175. Image only.

1552. *Artforum*. [Image of Getty tomb bronze gates, 1890]. 16(October 1977), 45.

1553. *Casabella*. "Wright put right." (no. 422, 1977), 2.

1554. *Domus*. [Image of Trinity Chapel, Norman]. (March 1977), 724.

1555. *Progressive Architecture*. "Doing it Wright." 58(January 1977), 28.

1556. *Progressive Architecture*. "Frank Lloyd Wright's hotel sold." 58(November 1977), 24. News items: Arizona-Biltmore and Taliesin West.

1557. *Publishers Weekly*. "Story behind the book *An autobiography*." 212(July 25, 1977), 55. Interview with publisher Ben Raeburn.

1978
Books, monographs and catalogues
1558. Benetka, Sandra and Thomas A. Heinz. *Oak Park, River Forest, Forest Park map*. Illinois: Pensayer, 1978.

1559. Fanelli, Giovanni. *Architettura, edilizia, urbanisitica: Olanda, 1917-1940*. Florence: F. Papafava, 1978. Italian: *Architecture, building industry, urbanism: Holland 1917-1940*. Wright's influence in Holland.

1560. Frank, Edward. *Pensiero organico e architettura Wrightiana*. Bari: Dedalo Libri, 1978. Italian: *Organic thought and Wrightian architecture*.

1561. Haight, Deborah S. and Peter F. Blume. *Frank Lloyd Wright: the library from the Francis W. Little House, Allentown Art Museum.* Allentown.: The Museum, 1978. Reviewed "Room from Wright prairie house goes on permanent exhibition at Allentown, Pennsylvania art museum," *Architectural Record*, 163(June 1978), 35; *Frank Lloyd Wright Newsletter*, 11(November-December 1978), 7.

1562. Hanks, David A. *The decorative designs of Frank Lloyd Wright.* Washington D.C.: Renwick Gallery of the National Collection of Fine Arts, 1978. Catalogue of exhibition, December 1977-July 1978. The exhibit moved to the Grey Art Gallery and Study Center, New York University, September-November 1978; and to the David and Alfred Smart Gallery, University of Chicago, January-February, 1979.

For review of the show see "Renwick exhibit explores Wright's artifacts," *Industrial Design*, 25(March 1978), 8; S.S. Szenasy, *Residential Interiors*, 3(May 1978), 86-89; *Progressive Architecture*, 59(May 1978), 39 ff.; "Universe designed by Wright," *Interiors*, 13(May 1978), 4; *Interior Design*, 49(July 1978), 50-51; J. Perl, *Arts Magazine*, 53(December 1978), 8; L.S. Shapiro, *Craft Horizons*, 38(December 1978), 72-73; Janet Koplos, "Wright's furniture: form versus function," *New Art Examiner*, 6(February 1979), 10; and *Bauen und Wohnen*, 34(March 1979), 71 (German).

The catalogue was re-published as a book: New York: E.P. Dutton; Don Mills, Ontario: General Publishing; London: Studio Vista, 1979. Reviewed Martin Filler, "Writing on Wright," *Art in America*, 67(October 1979), 77-79; A. van Buren, *Artforum*, 18(November 1979), 68-69; L. den Arend, *Cosa*, 30(December 1979); Paul E. Sprague, *JSAH* 39(March 1980), 83-84; and William Chaitkin, *International Architect*, 1 (no. 3, 1980), 62-63.

Reprinted 1985 and in paperback, New York: New American Library, 1987, and again Mineola: Dover, 1999.

Also published in Italian as *Frank Lloyd Wright: ornamento e design.* Milan: Jaca, 1990.

1563. Hoffmann, Donald. *Frank Lloyd Wright's* Fallingwater: *the house and its history.* New York: Dover; London: Constable, Don Mills: General Publishing, 1978. Reviewed Edgar A. Tafel, *Frank Lloyd Wright Newsletter* 1(November-December 1978), 11; F. Atkinson, *Architects' Journal*, 169(18 April 1979), 794; Martin Filler, "Writing on Wright," *Art in America*, 67(October 1979), 77-79; Joseph Connors, *JSAH*, 38(December 1979), 397-98.

Reprinted New York: Peter Smith, 1990 and in a revised edition New York: Dover, 1993. See also "A conversation with Donald Hoffmann," *Friends of Fallingwater Newsletter*, (December 1993), 10-15 and (December 1994), 4-8.

1564. Jacobs, Herbert Austin and Katherine Jacobs. *Building with Frank Lloyd Wright: an illustrated memoir.* San Francisco: Chronicle Books, 1978. Reviewed Donald Hoffman, *JSAH*, 38(December 1979), 395-96; and Martin Filler, "Writ-ing on Wright," *Art in America*, 67(October 1979), 77-79. Reprinted Carbondale: Southern Illinois University Press, 1986.

1565. Kief-Niederwöhrmeier, Heidi. *Der Einfluss Frank Lloyd Wrights auf die mitteleuropäische ein Zelhausarchitektur.* Stuttgart: Krämer, 1978. German: *Wright's influence on mid-European domestic architecture.* The published version of a thesis from Darmstadt Technischen Hochschule is revised as *Frank Lloyd Wright und Europa: Architekturelemente, Naturverhältnis, Publikationen, Einflüsse [Wright and Europe: architectural elements, nature relationships, publications, influence].* Stuttgart: Krämer, 1983. See also *idem.,* "Frank Lloyd Wright," *Baumeister,* 81(May 1984), 19-27.

1566. Koehler, Cortus T. *Frank Lloyd Wright, organic architect and planner.* Monticello, Ill.: Vance Bibliographies, 1978. Bibliography.

1567. Meehan, Patrick Joseph. *Frank Lloyd Wright on urban design and planning.* Monticello, Ill.: Council of Planning Librarians, 1978. Bibliography.

1568. Sotheby's, London. *Good Japanese prints, Japanese illustrated books, Japanese drawings and paintings, and Chinese paintings.* London: Sotheby's, 1978. Auction catalog. Some provenances are traced to Wright.

1569. Sweeney, Robert Lawrence. *Frank Lloyd Wright: an annotated bibliography,* Los Angeles: Hennessey and Ingalls, Inc., 1978. Reviewed Kathryn Smith, *Frank Lloyd Wright Newsletter,* 1(November-December 1978), 9; Bill Schmidt, *ibid.,* 8-9; Martin Filler, "Writing on Wright," *Art in America,* 67(October 1979), 77-79; and David Gebhard, *JSAH,* 39(December 1980), 336.

1570. Tanigaw, Masami. *The way to Taliesin.* Tokyo: Kajima Institute, 1978.

1571. Ven, Cornelis J.M. van de, *Space in architecture; the evolution of a new idea in the theory and history of the modern movements.* Assen; Amsterdam; Van Gorcum, 1978. Published version of a 1974 thesis. Revised 1987.

Periodicals

1572. Audouin, Jean. "Frank Lloyd Wright: prairie houses—Oak Park suburb, Chicago." *Macadam,* (October 1978), 13. French.

1573. Banham, Reyner. "The services of the Larkin 'A' Building." *JSAH,* 37(October 1978), 195-97. Reviewed T.A.H., *Frank Lloyd Wright Newsletter,* 1(September-October 1978), 6.

1574. Blanc, Alan John. "Forty years on: Fallingwater, Frank Lloyd Wright's most famous house." *Building Design,* (9 June 1978), 24.

1575. Blundell-Jones, Peter. "Frank versus classic." *AA Quarterly,* 10(no.1, 1978), 10-20.

1576. Cranshawe, Roger. "Frank Lloyd Wright's progressive utopia." *AA Quarterly,* 10(no. 1, 1978), 3-9.

1577. Filler, Martin. "Splendid spinoff: Aye Simon reading room, Solomon R. Guggenheim Museum, New York." *Progressive Architecture,* 59(October 1978), 68-71.

1578. Greene, Elaine. "Preservation in Rochester." *American tradition*, (1978), 144-47. Boynton house.

1579. Gueft, Olga. "In the forest on the way to Bear Run." *Interiors*, 137(May 1978), 150-51. Proposed visitor center for Fallingwater. See R. Bozic and T.G. Hare, "Fallingwater feedback," *Progressive Architecture*, 59(July 1978), 10.

1580. Hanks, David. A. "A Frank Lloyd Wright dining chair." *St. Louis Art Museum Bulletin*, 14(October-December 1978), 135-38.

1581. Hennessey, William J. "Frank Lloyd Wright and the Guggenheim Museum: a new perspective."*Arts Magazine*, 152(April 1978), 128-33.

1582. Hennessy, Richard. "Prototype and progeny: some recent monumental architecture." *Artforum*, 17(November 1978), 168-74.

1583. Kaufmann, Edgar J. Jr. "Frank Lloyd Wright: plasticity, continuity, and ornament." *JSAH*, 37 (March 1978), 34-39. Reprinted in *idem.*, *Nine commentaries on Frank Lloyd Wright*, Cambridge Mass.: 1989.

1584. Montooth, Charles. "Frank Lloyd Wright design takes shape in Arizona: First Christian Church, Phoenix, Arizona." *Frank Lloyd Wright Newsletter*, 1(September-October 1978), 1. The design was originally made for Southern Christian Seminary.

1585. Pease, Harry S. "A dream fulfilled: after many years, a masterpiece is completed." *Stained Glass*, 173(Summer 1978), 97-100. Annunciation Church,.

1586. Puma, Jerome. "The Larkin Building, Buffalo, New York: history of the demolition." *Frank Lloyd Wright Newsletter*, 1(September-October 1978), 2-6.

1587. Schafer, Ueli. [Frank Lloyd Wright as seen by three of his pupils, Roland von Rebay, Frank Sidler, Ernst E Anderegg; interviewed by Ueli Schafer]. *Bauen und Wohnen*, 33(March 1978), 113-16. German; English summary.

1588. Siek, Stephen. "Frank Lloyd Wright's Wescott house in Springfield." *Ohio History*, 87(no. 3, 1978), 276-93.

1589. Sweeney, Robert Lawrence. "Buildings: the Coonley playhouse, Riverside, Illinois." *Frank Lloyd Wright Newsletter*, 1(November-December 1978), 2-4.

1590. Vickery, Robert L. "The transcendental dream, Frank Lloyd Wright and suburbia." *Architectural Design*, 48(no. 8-9, 1978), 512-15. For a response see B. Chaitkin, *ibid.*, 49(no. 1, 1979), 4.

1591. Wray, T. Donham. "The stained glass of Frank Lloyd Wright and his theory of ornament." *Glass Art Magazine*, 6(October 1978), 8-23.

1592. *Architectural Design*. [Images of projects for greater Baghdad and Lenkurt Electric Company administration and manufacturing building]. 48(no. 1, 1978), inside back cover.

1593. *Architectural Record.* "LIT architectural school receives Usonian house as a gift." 163(April 1978), 37. Gregor Affleck house.

1594. *Frank Lloyd Wright Newsletter.* "Buildings: Pence project, Hilo, Hawaii." 1(July-August 1978), 1-2. Plan of house for Mr. Martin Pence, 1938 (never built).

1979
Books, monographs and catalogues

1595. Barton, Timothy. *Commission on Chicago Historical and Architectural Landmarks. Robert W. Roloson houses.* Chicago: The Commission, 1979.

1596. Ciucci, Giorgio et al. "The city in agrarian ideology and Frank Lloyd Wright: origins and development of Broadacres." In *The American city: from the civil war to the New Deal*, Cambridge, Mass.: MIT Press, 1979. Originally published as *La città americana dalla guerra civile al New Deal*, Rome: Laterza 1973; reviewed Giorgio Cavaglieri, *JSAH*, 33(October 1974), 267-70.

1597. Couser, G. Thomas. *American autobiography: the prophetic mode.* Amherst: University of Massachusetts Press, 1979. Includes Wright.

1598. Graf, Otto Antonia. *Geschichte einer vierfachen Freude: zum Werk Frank Lloyd Wright's.* 2 vols. Vienna: Origenes, 1979, 1980. German: *History of a quadruple joy: the work of Frank Lloyd Wright.* Revised as *Die Kunst des Quadrats: zum Werk von Frank Lloyd Wright [The art of the square: the work of Frank Lloyd Wright]*, Vienna: H. Bohlaus, 1983; reviewed Peter Blundell-Jones, *Architectural Review*, 176(August 1984), 64; and Anthony Michael Alofsin, *JSAH*, 47(December 1988), 428-30.

1599. Mumford, Lewis et al. *Urbanisztika: válogatott tanulmányok.* Budapest: Gondolat, 1979. Hungarian: *Urbanism: selected studies.* Broadacre City.

1600. Spencer, Brian A. ed. *The Prairie school tradition / the Prairie Archives of the Milwaukee Art Center.* New York: Whitney Library of Design, 1979. Published to coincide with "An American architecture: its roots, growth and horizon" exhibition, Fall 1977. Reissued as *The Prairie School tradition: Sullivan, Adler, Wright and their heirs*, New York: Watson-Guptill, 1985. For a report of the associated conference, see John Sergeant, "Organic architecture," *AA Quarterly*, 10(no. 1, 1978), 22-23.

1601. Tafel, Edgar A. *Apprentice to genius: years with Frank Lloyd Wright.* New York: McGraw-Hill, 1979. Reviewed Lois Hagen, "New Wright insights given by apprentice," *Milwaukee Journal*, (17 June 1979), Part 7; 1, 4; Frederick A. Gutheim, *Architectural Record*, 166(December 1979), 187 ff.; Donald Hoffman, *JSAH*, 38(December 1979), 395-96; and Martin Filler, "Writing on Wright," *Art in America*, 67(October 1979), 77-79. Reprinted in paperback New York: Dover, 1985 as *Years with Frank Lloyd Wright: apprentice to genius*, and in hardcover by Peter Smith, 1985. Also published in German as *Frank Lloyd Wright persönlich*, Zürich: Artemis, 1981.

1602. Thrift, Charles Tinsley Jr. ed. *Of fact and fancy... at Florida Southern College.* Lakeland: College Press, 1979.

1603. Twombly, Robert C. *Frank Lloyd Wright, his life and his architecture.* New York: John Wiley and Sons, 1979. Reviewed Martin Filler, "Writing on Wright," *Art in America,* 67(October 1979), 77-79 (cf. *idem.,* "Lives of the modern architects," *New Republic,* [21 June 1999], 32-38); and Donald Hoffman, *JSAH,* 38(December 1979), 395-96. Paperback edition 1987.

Periodicals
1604. Amaya, Mario. "Frank Lloyd Wright and American furniture." *Connoisseur,* 200(January 1979), 55-57. Armchair; print table; hexagonal table with six triangular stools; window.

1605. Banham, Reyner. "Buffalo industrial." *Little journal/The Western New York Chapter of the Society of Architectural Historians,* 3(February 1979), 12-19. Larkin Administration building.

1606. Brooks, Harold Allen. "The destruction of the box." *Frank Lloyd Wright Newsletter,* 2(1979), 1-8. Cf. *idem.,* "Frank Lloyd Wright and the destruction of the box," *JSAH,* 38(March 1979), 7-14. Reply by Dora P. Crouch, *ibid.,* 39(October 1980), 255.

1607. Burghardt, Marlies. "Phoenix—eine Stadt am Rande der Wueste." *Neue Heimat,* 26(no. 7, 1979), 36-45. German: "Phoenix—a town on the edge of the desert."

1608. Crosbie, Michael J. "In the spirit of commitment and vision, Frank Lloyd Wright at Florida Southern College." *Crit,* 6(Fall 1979), 24.

1609. Darling, Sharon. "Chicago's turn-of-the-century prairie houses." *Stained Glass,* 74(Winter 1979), 298-302.

1610. DeNevi, Donald D. "Masters of light: Frank Lloyd Wright." *AIA Journal,* 68(September 1979), 63-65

1611. Goulet, Patrice. "Frank Lloyd Wright and the social habitat." *L'Architecture d'Aujourd'hui,* (June 1979), 17-20. French.

1612. Hanks, David A. "Chicago furniture: from 'modern gothic' to Prairie School." *American Art and Antiques,* 2(no. 5, 1979), 64-69.

1613. Hanks, David A. "Frank Lloyd Wright's 'the art and craft of the machine.'" *Frank Lloyd Wright Newsletter,* 2(no. 3, 1979), 6-9. Cf. *Nineteenth Century,* 8(no. 3-4, 1982), 205-211.

1614. Hanks, David A. "Frank Lloyd Wright's decorative designs: harmony in the house." *American Art and Antiques,* 12(March-April 1979), 100-107.

1615. Heinz, Thomas A. and D. Guillemot. "Historic architecture: Frank Lloyd Wright. The Ennis-Brown House, Los Angeles, California, designed in 1924." *Architectural Digest,* 36(October 1979), 104-111.

1616. Johnson, Samuel C. "Mr. Wright and the Johnsons of Racine, Wisconsin: reminiscences of "Wingspread" and its architect." *AIA Journal*, 68(January 1979), 63-65 ff. Reprinted as a booklet.

1617. Jones, Jenkin Lloyd. "A house for a cousin. The Richard Lloyd Jones house." *Frank Lloyd Wright Newsletter*, 2(no. 4, 1979), 1-3.

1618. Jonker, Gert, "Robert van 't Hoff, maker van het kleinst denkbare oeuvre." *Bouw*, 34 (no. 12, 1979), 6-8. Dutch: "Robert van 't Hoff, maker of the smallest imaginable oeuvre." See also Jonker, "Een poging tot reconstructie: de werken van R. van 't Hoff [An attempt at reconstruction; the work of van 't Hoff]," *ibid.*, (no. 13, 1979), 17 ff.

1619. Kagan, Andrew. "Irony in architecture: the Nathan Moore house reconstruction by Frank Lloyd Wright (1895, 1923-24)." *Arts Magazine*, 53(June 1979), 110-13.

1620. Larson, Philip. "Glasgow and Chicago: stencils and other prints." *Print Collector's Newsletter*, 10(March-April 1979), 1-7.

1621. Leering, Jean. "Robert van 't Hoff de ex-architect." *Wonen TA/BK*, (no. 11, 1979), 2-3. Dutch: "Robert van 't Hoff the ex-architect."

1622. Linch, Mark David. "Ward Winfield Willits: a client of Frank Lloyd Wright." *Frank Lloyd Wright Newsletter*, 2(no. 2, 1979), 12-17.

1623. Long, David Gilson de. "The place of objects: Frank Lloyd Wright's attitudes towards interior design and decorative arts." *Frank Lloyd Wright Newsletter*, 2(no. 3, 1979), 10-17.

1624. MacCormac, Richard Cornelius. [The anatomy of Wright's aesthetic]. *A+U*, (March 1979), 3-6. Japanese.

1625. McCoy, Esther. "Frank Lloyd Wright's Hollyhock house reblooms at 60." *Progressive Architecture*, 60(November 1979), 23.

1626. Posener, Julius. "Frank Lloyd Wright I und II." *Arch Plus*, 48(December 1979), 32-43. 2-80. German. Part of the text of thirteen talks, published as "Vorlesung zur Geschichte der Neuen Architektur [Lectures on the history of the new architecture]."

1627. Quinan, Jack. "The basement of the Darwin D. Martin House in Buffalo." *Frank Lloyd Wright Newsletter*, 2 (no. 2, 1979), 8-9.

1628. Reese, Richard Dana. "At home in a work of art: Frank Lloyd Wright's Usonian masterpiece." *American Art and Antiques*, 12(May-June 1979), 60-67. Friedman house.

1629. Riddle, Harriet. "F.C. Bogk House, Milwaukee, Wisconsin." *Frank Lloyd Wright Newsletter*, 2 (no. 1, 1979), 1-4.

1630. Rubino, Luciano. "The last hundred years: in the wake of Wright's Usonian houses." *Ville Giardini*, (May 1979), 30-33.

1631. Sergeant, John. "Wright's Wachstumskonzept—ein Rückblick auf die Jacobs- und Hanna-häuser." *Bauen und Wohnen*, 34(January-February 1979), 49-52. German: "Wright's growth concept—looking back at the Jacobs and Hanna houses."

1632. Sipe, Greg. "From prairie house to Usonia: Wright's wilderness years. Part one: Los Angeles and the birth of a building system." *New Zealand Architect*, (no. 4, 1979), 24-25.

1633. Smith, Kathryn. "Frank Lloyd Wright, Hollyhock house, and Olive Hill, 1914-1924." *JSAH*, 38(March 1979), 15-33.

1634. Strauss, Irma. "FLW-CRM: comparisons." *Charles Rennie Mackintosh Society Newsletter*, (Autumn 1979), 7-8. Introduction to the Society's proposed North American study tour, 1980.

1635. Tanigawa, Masami. "Motion picture theater, Tokyo [*sic*]." *Frank Lloyd Wright Newsletter*, 2(no. 4, 1979), 8-9. Theater, Ginza.

1636. Tanigawa, Masami et al. Special issue. [Architect Frank Lloyd Wright— his life and works]. *Space Design*, 182(November 1979):5-84. Japanese; English summary.

1637. *AIA Journal*. "Fund drive launched to complete restoration of Unity Temple." 68(June 1979), 32.

1638. *AIA Journal*. "Hexagonal module house is placed on National Register." 68(May 1979), 82. Hanna house.

1639. *Architects' Journal*. "Interior motives." 170(19 September 1979), 595. Wright furniture.

1640. *Building Design*. "Meier rewrites FLW in fine style: new reading room for the Guggenheim Museum by Richard Meier." (5 October 1979), 18-19.

1641. *L'Architecture d'Aujourdhui*. "Wright et l'habitat social." 203(June 1979), 17-20. French. "Wright and the social habitat."

1642. *Progressive Architecture*. "Rights to reproduce Wrights." 60(September 1979), 29-30.

1980-1989

1980
Books, monographs and catalogues
1643. Alberts, Robert C. *The shaping of The Point: Pittsburgh's Renaissance Park.* University of Pittsburgh Press, 1980.

1644. Baker, Geoffrey Howard. *Frank Lloyd Wright.* Madrid: Adir, 1980. Spanish.

1645. Frank Lloyd Wright Home and Studio Foundation. *The Frank Lloyd Wright home and studio.* Oak Park: The Foundation, 1980. Single sheet.

1646. Futagawa, Yukio and Frank Lloyd Wright. *The Imperial Hotel, Tokyo, Japan, 1915-22/ Frank Lloyd Wright.* Tokyo: A.D.A. Edita, 1980. English and Japanese. Mostly images; includes Wright's comments on the building's construction (from *An autobiography,* 1932).

1647. Godoli, Ezio. *Jan Wils, Frank Lloyd Wright e De Stijl.* Calenzano: Modulo, 1980. Italian: *Jan Wils, Frank Lloyd Wright and De Stijl.*

1648. Gradidge, Roderick. *Dream houses. The Edwardian ideal.* New York, Braziller, 1980. See especially chapter 5, "Studio, Oak Park 1895."

1649. Hasbrouck, Marilyn. *Frank Lloyd Wright: drawings for the Coonley house.* Chicago: Prairie Avenue Bookshop, 1980. Catalogue of an exhibition at the shop, November-December 1980.

1650. Kotik, Charlotta et al. *Frank Lloyd Wright and Darwin D. Martin.* n.l. [Lockport?]: n.p., 1979. Catalogue of exhibition at Kenan Center, Lockport, New York, December 1979-January 1980.

1651. Meehan, Patrick Joseph. *The Frank Lloyd Wright book reviews.* Monticello: Vance Bibliographies, 1980. Bibliography.

1652. Robinson, Sidney K. *Life imitates architecture: Taliesin and Alden Dow's Studio*. Ann Arbor: Architectural Research Laboratory, University of Michigan, 1980. Published version of *Composed places: Taliesin and Alden Dow's studio*, thesis, University of Michigan, 1974 (Ann Arbor: University Microfilms, 1975). Reviewed J. William Rudd, *JSAH*, 40(December 1981), 347-48.

1653. Tanigawa, Masami. *Measured drawings: Frank Lloyd Wright in Japan.* Tokyo: Gurafikku Sha, 1980. Japanese. Plans of Hayashi and Yamamura houses, Jiyu Gakuen Girls' School, and a cinema at Ginza (project).

1654. Tanigawa, Masami and Masuda Akihisa. *Raito no isan.* Tokyo: Sanseido, 1980. Japanese.

1655. Twombly, Robert C. *Wisconsin stories: Frank Lloyd Wright in Spring Green, 1911-1932.* Madison: State Historical Society of Wisconsin, 1980. Reprinted from the *Wisconsin Magazine of History*, 51(Spring 1968), 200-217.

1656. Zevi, Bruno Benedetto. *Frank Lloyd Wright.* Zürich: Artemis, 1980. German and French.

1657. *The new edifice of Unity Church.* Oak Park: Unity Temple Restoration Foundation, 1980.

Periodicals

1658. Beeby, Thomas. "The Song of Taliesin." *Modulus. University of Virginia Journal of Architecture Review*, (1980), 2-11.

1659. Carr, Richard. "Architect in aspic." *Building Design*, (19 September 1980), 24-25.

1660. Carr, Richard. "Window dressing—a report on the Wright-inspired American revival of art glass." *Building Design*, (14 November 1980), 24.

1661. Ferguson, Nancy H. "Three examples of architectural ornament from the Midwest." *Apollo*, 111(May 1980), 392-93. Coonley playhouse windows.

1662. Gutheim, Frederick Albert. "The turning point in Mr Wright's career: a case that it was his Princeton lectures of exactly a half-century ago." *AIA Journal*, 69(June 1980), 48-49.

1663. Heinz, Thomas A. "Frank Lloyd Wright: Dana House, 1903." *Architectural Design*, 50(1980), 65-71.

1664. Helmer, Stephen D. "Grady Gammage Auditorium and the Baghdad Opera project: two late designs by Frank Lloyd Wright." *Frank Lloyd Wright Newsletter*, 3(no. 4, 1980), 10-17.

1665. Hildebrand, Grant. "Privacy and participation: Frank Lloyd Wright and the city street. Wright's solutions to providing privacy in relating his buildings to city streets." *Frank Lloyd Wright Newsletter*, 3(no. 3, 1980), 4-9.

1666. Hoesli, Bernhard. "Frank Lloyd Wright: Fallingwater." *A+U*, 118(July 1980), 147-66. Japanese and English.

1667. Ingraham, Elizabeth Wright. "The chapel in the valley." *Frank Lloyd Wright Newsletter*, 3(1980), 1-5, 10-11. Subtitled "a brief account of the Lloyd Jones family in the valley at Hillside, near Spring Green, Wisconsin. Plus chart listing descendents of Anna Lloyd-Jones, Frank Lloyd Wright's mother." Reprinted in Franklin and Mary Porter eds. *Heritage: the Lloyd Jones family*, Spring Green: 1986.

1668. Johnson, Donald Leslie. "Notes on Frank Lloyd Wright's paternal family." *Frank Lloyd Wright Newsletter*, 3(no. 2, 1980), 5-7.

1669. Kaufmann, Edgar J. Jr. "Precedent and progress in the work of Frank Lloyd Wright." *JSAH*, 34(May 1980), 145-49. Reprinted in *idem., Nine commentaries on Frank Lloyd Wright*, Cambridge, Mass.: 1989.

1670. Lockwood, Charles. "Frank Lloyd Wright in Los Angeles. The textile-block houses built in the 1920s in Los Angeles." *Portfolio*, 2(February-March 1980), 74-79.

1671. Lockwood, Charles. "The Wright house for the wrong woman." *Antiques World*, (November 1980), 68-73. Hollyhock house.

1672. Long, David Gilson de. "Workplaces: open offices in a noble hall: a return to Mr. Wright's Johnson Wax headquarters." *AIA Journal*, 69(July 1980), 44-49.

1673. Lowe, David. "Hedrich-Blessing: after 50 years the distinguished architectural photography firm is alive and well and thriving in Chicago." *Interior Design*, 51(October 1980), 265 ff.

1674. Meehan, Patrick Joseph. "Frank Lloyd Wright structures which are on the National Register of Historic Places." *Frank Lloyd Wright Newsletter*, 3(no. 3, 1980), 10-13. See also *idem.*, "Frank Lloyd Wright structures which are on the National Register of Historic Places," *ibid.*, 4(no. 1, 1981), 6-18.

1675. Miller, R. Craig. "Frank Lloyd Wright and modern design: an appraisal." *Frank Lloyd Wright Newsletter*, 3(no. 1, 1980), 1-6.

1676. Moran, Maya. "Through a Wright window. The windows of the F.F. Tomek House, Riverside, Illinois, 1907." *Frank Lloyd Wright Newsletter*, 3 (no. 3, 1980), 1-4.

1677. Morgan, W. T. "Strongboxes on Main Street: Prairie-style banks." *Landscape*, 24(no. 2, 1980), 35-40.

1678. Noffsinger, James Philip. *Frank Lloyd Wright's Imperial Hotel, Tokyo: preservation attempts.* Monticello: Vance Bibliographies, 1980. Bibliography.

1679. Pagiolo dell'Arco, Marcello. "Frank Lloyd Wright. Il "Grande Spirito" dello spazio." *Artibus et Historiae*, (no. 2, 1980), 107-120. Italian: "Wright. The 'Great Spirit' of space."

1680. Rand, George. "A civic center and its *civitas*: Marin County Civic Center. Evaluation of Wright's municipal building begun 1958 and expanded 1966-70." *AIA Journal*, 69(April 1980), 46-57.

1681. Randall, John D. "Some aspects of the creativity of Louis Sullivan and Frank Lloyd Wright." *Little Journal/The Western New York Chapter of the Society of Architectural Historians*, 4(November 1980), 12-18.

1682. Rattenbury, John. "Arizona Biltmore Hotel, Phoenix, Arizona; architects: Frank Lloyd Wright Foundation." *Architectural Record*, 168(July 1980), 116-21. Cf. David Morton, "Wrighting wrongs? Following a fire in 1973, the fabled Arizona-Biltmore has been restored, and new accommodation added," *Progressive Architecture*, 62(November 1981), 110-15.

1683. Reitherman, Robert King. "The seismic legend of the Imperial Hotel; how did it really fare in the Tokyo earthquake of 1923?" *AIA Journal*, 69(June 1980), 42-47, 70.

1684. Schiller, M. "Frances Myers: Wisconsin printmaker." *American Artist*, 46(July 1980), 48-53, 74, 77. Myers' etchings based on Wright buildings.

1685. Schmidt, Walter. "Catherine Tobin Wright's scrapbook." *Frank Lloyd Wright Newsletter*, 3(no. 4, 1980), 4-6.

1686. Schulten, Christoph. "Time to grow old: Frank Lloyd Wright's first house and studio in Chicago." *Bauwelt*, 71(18 April 1980), 641-43.

1687. Scully, Vincent Joseph Jr. "Frank Lloyd Wright and the stuff of dreams." *Perspecta*, 16(1980), 9-31.

1688. Stiny, G. "Kindergarten grammars: designing with Froebel's building gifts." *Environment and Planning B*, 7(1980), 409-462. Reprinted as a booklet, London: Pion, 1980.

1689. Strauss, Irma. "An interview with Lorraine Robie O'Connor." *Frank Lloyd Wright Newsletter*, 3(1980), 1-3. Robie House.

1690. Tanigawa, Masami. "The Odawara Hotel ... Odawara, Japan, 1917; architect: Frank Lloyd Wright." *Frank Lloyd Wright Newsletter*, 3(no. 1, 1980), 12-13.

1691. Turner, Paul Venable. "Frank Lloyd Wright's other Larkin building." *JSAH*, 39(December 1980), 204-206. Larkin pavilion, Ter-Centennial Exposition, Jamestown, 1907. Cf. Richard Guy Wilson and Joseph Dye Lahendro, "Larkin Company Jamestown exhibition pavilion," *Frank Lloyd Wright Newsletter*, 3(no. 4, 1980), 9.

1692. Wright, Robert. "A son as client." *Frank Lloyd Wright Newsletter*, 3(no. 2, 1980), 7-9. Robert Llewellyn Wright house.

1693. *Concrete International Design and Construction.* "Frank Lloyd Wright's Fallingwater home restored to original elegance." 2(no. 9, 1980), 58-62.

1694. *Du.* [Image of window from Avery Coonley house.] 9(1980), 21. German.

1695. *Frank Lloyd Wright Newsletter.* "Frank Lloyd Wright and the Princeton lectures of 1930." 3(no. 3, 1980), 10-13.

1696. *ICAM News.* "Frank Lloyd Wright—the Association." (April-September 1980), 13-14.

1697. *L'Architettura.* "Guggenheim Museum, 1959." 26(April 1980), 238-43.

1698. *Oppositions.* "Larkin building, Buffalo, New York (1904)." 22(Fall 1980), 42. Image only.

1699. *Small-scale Master Builder.* "Organic architecture: 2. Residential design guidelines from Frank Lloyd Wright." 1(no. 3, 1980), 151-52.

1981
Books, monographs and catalogues
1700. Brooks, Harold Allen. ed. *Writings on Wright: selected comment on Frank Lloyd Wright.* Cambridge, Mass.: MIT Press, 1981. Reprints "The house on.the waterfall" by Edgar J. Kaufmann Jr. (adapted from *L'Architettura*, 8[August 1962]); "How a Wright house came to be built"; "Architectural observations concerning Wright and the Robie house" by J.J.P. Oud (translated from *De Stijl*, 1[1918]; "The domestic architecture of Frank Lloyd Wright" by Norris Kelly Smith; "An original owner interview of Frank Lloyd Wright's residential architecture" by Eugene R. Streich; "Remarks made by visitors at the construction site, Gregor Affleck House, Bloomfield Hills" by Gregor Affleck; letters of Charles Robert Ashbee (1916); letters of Erich Mendelsohn (1924); summary of H.P. Berlage, "Neuere amerikanische architektur"(from *Schweizerische Bauzeitung*, 60[September 1912]); translation of Jan Wils, "Frank Lloyd Wright" (from *Elsevier's Geïllustreerd Maandschrift*, 61[1921]; "An architect in search of democracy: Broadacre City" by Lionel March (transcriptions of radio talks, January 1970); "In the galleries" by Harriet Monroe (from *Chicago Examiner*, [13 April 1907]); and "The anatomy of Wright's aesthetic" by Richard Cornelius MacCormac (from *Architectural Review*, 143[February 1968]). Paperback edition, 1983.
 Reviewed Frederick A. Gutheim, *Frank Lloyd Wright Newsletter*, 4(no. 3-4, 1981), 46; Donald Hoffmann, *JSAH*, 41(October 1982), 245; and Paul E. Sprague, *Winterthur Portfolio*, 20(Winter 1985), 280-92.

1701. Brunetti, Fabrizio. *Le matrice di una architettura organica, Frank Lloyd Wright.* Florence: Alinea, 1981. Italian: *The matrix of an organic architecture, Frank Lloyd Wright.*

1702. Elliott, Scott intro. *Frank Lloyd Wright.* Chicago: Kelmscott Gallery, 1981. Catalogue of an exhibition.

1703. Fields, Jeanette S. ed. *A guidebook to the architecture of River Forest.* River Forest: Architectural Guide Book Committee, 1981. Documents 61

buildings, mostly Prairie School designs by Wright and others. Revised edition, River Forest: Community Center, 1990.

1704. Hanna, Paul Robert and Jean Shuman Hanna. *Frank Lloyd Wright/Hanna Honeycomb house archival collection.* New York: Architectural History Foundation; Cambridge, Mass.: MIT Press, 1981. See also *idem*., *Hanna house documents: Frank Lloyd Wright/Hanna Honeycomb house archival collection: guide to seven rolls of microfilm,* New York: Architectural History Foundation, 1981. Includes "Index to 53 volumes of Frank Lloyd Wright" by Lieselotte Hoffman and "Drawings: a guide to the catalogue of Frank Lloyd Wright drawings in the [Hanna] collection" by William J. Schwarz.

1705. Hanna, Paul Robert and Jean Shuman Hanna. *Frank Lloyd Wright's Hanna house: the client's report.* New York: Architectural History Foundation; Cambridge, Mass.: MIT Press, 1981. Reviewed Donald Canty, "Clients'-eye view of a Wright classic," *AIA Journal,* 70(November 1981), 64-67 ff.; and Donald Hoffmann, *JSAH,* 41(October 1982), 245 (see Edgar J. Kaufmann Jr's response, *JSAH,* 42[March 1983], 90).

Second edition, Carbondale: Southern Illinois University Press, 1983; reviewed Paul E. Sprague, *Winterthur Portfolio,* 20(Winter 1985), 281-92. Reprinted 1987.

1705a. Kalec, Donald G. *The home and studio of Frank Lloyd Wright in Oak Park, Illinois, 1889-1911.* Oak Park: Home and Studio Foundation, 1982.

1706. Kassler, Elizabeth Bauer. *The Taliesin Fellowship: a directory of members, 1932-1982.* Princeton: The Author, 1981. Revised 1982.

1707. Kinch, Richard. *Wingspread, the building.* Racine: Johnson Foundation, 1981. See also *idem*., *Wingspread, the setting.* Racine: Johnson Foundation, 1981.

1708. Levin, Meyer. *The architect.* New York: Simon and Schuster, 1981. Novelized biography.

1709. Ruske, Wolfgang. "Leben im Holzskeletthaus." In *Holzskelettbau—Entwicklung, Systeme und Beispiele.* Stuttgart: Verlags-Anstalt, 1981. German: "Living in timber-framed buildings."

1710. Wright, Frank Lloyd. *Frank Roido Rido to gendai.* Tokyo: A+U; New York: distributed by Jaap Reitman, 1981. Japanese.

1711. *Frank Lloyd Wright buildings recorded by the Historic American Buildings Survey.* Washington, D.C.: Library of Congress, Prints and Photographs Division, 1981[?].

Periodicals
1712. Abercrombie, Stanley. "Furnishings by George Mann Niedecken, craftsman of the Prairie School and collaborator of Frank Lloyd Wright." *AIA Journal,* 70(November 1981), 80-83.

1713. Abercrombie, Stanley. "When a house becomes a museum. Fallingwater acquires a respectful new visitors' center." *AIA Journal*, 70(August 1981), 54-57.

1714. Allen, James R. and Richard S. Taylor. "Illinois' newest state historic site: Springfield's Dana-Thomas house." *Historic Illinois*, 4(October 1981), 1-5, 12-14. Includes articles by Wright.

1715. Beeby, Thomas H. "The song of Taliesin; ... Frank Lloyd Wright" *Modulus: the University of Virginia School of Architecture Review*, (1980-1981), 2-11.

1716. Dal Co, Francesco. "Notes concerning the phenomenology of the limit in architecture." *Oppositions*, 23(Winter 1981), 45-51. Refers to the Imperial Hotel; Sherman Booth and V.C. Morris houses; Midway Gardens; A. D. German warehouse; Guggenheim Museum; and Gordon Strong automobile observatory and planetarium.

1717. Gustmann, Kurt. "Die grossen Architekten. Tl.5. Frank Lloyd Wright." *Hauser*, (no. 1, 1981), 95-110. German: "The great architects. Part 5. Wright."

1718. Heinz, Thomas A. "Frank Lloyd Wright's art glass: a photo essay." *Frank Lloyd Wright Newsletter*, 4(no. 1, 1981), 6-18.

1719. Heinz, Thomas A. "Frank Lloyd Wright's Jacobs II house." *Fine Home-building*, 3(June-July 1981), 20-27. Subtitled, "an owner-built, passive solar home designed in 1944 by one of the 20th century's greatest architects."

1720. Johnson, Kate. "Frank Lloyd Wright and the strong-minded Littles." *Architecture Minnesota*, 7(October-November 1981), 52-57.

1721. Not used.

1722. Kaufmann, Edgar J. Jr. "'*Form* became *feeling*,' a new view of Froebel and Wright." *JSAH*, 40(May 1981), 130-37. Reprinted *idem.*, *Nine commentaries on Frank Lloyd Wright*, Cambridge, Mass.: 1989.

1723. Koning, Hank and J. Eizenberg. "The language of the prairie: Frank Lloyd Wright's prairie houses." *Environment and Planning Bulletin*, 8(1981), 295-323. Reprinted as a booklet, London: Pion, 1981.

1724. Love, Jeannine. "Blanche Ostertag: another Wright collaborator." *Frank Lloyd Wright Newsletter*, 4(no. 2, 1981), 11-16. Ostertag decorated Wright's commissions and projects, 1900-1910.

1725. Massu, Claude. "Broadacre City de Frank Lloyd Wright: l'utopie d'une Amerique agraire et anti-urbaine." *Revue Francaise D'etudes Americaines*, 6(no. 11, 1981), 55-65. French: "Frank Lloyd Wright's Broadacre City: America's agrarian and anti-urban utopia."

1726. Meehan, Patrick Joseph. "Frank Lloyd Wright's Lake Geneva Hotel." *Frank Lloyd Wright Newsletter*, 4(no. 2, 1981), 6-10.

1727. Norton, Margaret Williams. "Japanese themes and the early work of Frank Lloyd Wright." *Frank Lloyd Wright Newsletter*, 4(no. 2, 1981), 1-5.

1728. Pearson, Gay L. "The Muirhead house: an interview with Robert and Betty Muirhead." *Frank Lloyd Wright Newsletter*, 4(no. 1, 1981), 1-5.

1729. Stern, Robert A.M. "La ville bourgeoise (the Anglo-American suburb)." *Architectural Design*, 51(no. 10-11, 1981), profile 7 ff. "Home in a prairie town".

1730. Tafel, Edgar A. "Wrights and wrong." *AA Quarterly*, 13(October 1981), 62.

1731. Teske, Edmund. "The photographs of Edmund Teske for Frank Lloyd Wright, Taliesin and Taliesin West, 1936-1942." *Frank Lloyd Wright Newsletter* 4(no. 3-4, 1981), 1-45.

1732. Tice, James. "LA block houses, 1921-24 Frank Lloyd Wright." *Architectural Design*, 51(no. 8-9, 1981), profile 62-65.

1733. Urbas, Andrea. "Pettit Memorial Chapel." *Historic Illinois*, 4(October 1981), 10-11. Restoration.

1734. Webb, Sam. "'OK, E J, we're expecting you'—Sam Webb listened to Lloyd Wright apprentice Edgar A. Tafel reminisce." *Building Design*, 4 (December 1981), 2.

1735. Wohlert, Vilhelm. "At foeje nyt til gammelt." *Arkitekten*, 83(no. 21, 1981), 486-87. Danish: "Adding new to old."

1736. Woodbridge, Sally B. "The California House." *Wilson Quarterly*, 4(1981), 83-91.

1737. *A+U*. [Special issue: Architecture: between reality and poetry: Le Corbusier, Mies van der Rohe, Frank Lloyd Wright]. (January 1981), 3-220. Japanese and English. Includes articles by Thomas Beeby, Joseph Fujikawa, George Danforth, Myron Goldsmith, Kevin Harrington, Dirk Lohan, Gene Summers, and Masami Takayama.

1738. *A+U*. [Frank Lloyd Wright special issue]. 7(July 1981), sup. 5-232. Japanese.

1739. *Antiques*. "Frank Lloyd Wright table in the Victoria and Albert Museum." 120(July 1981), 108.

1740. *Architects' Journal*. "Cube games (FLW: a superbly accomplished classicist)." 173(3 June 1981), 1036-37.

1741. *Architectural Design*. "Broadacre City, 1935." 51(no. 10-11, 1981), profile 86.

1742. *Building Design*. "Lloyd Wright's last building fails code" (20 November 1981), 7. Marin County Civic Center.

1743. *Casabella.* "Progetto per Broadacre City (1934) and progetto per un teatro dell'opera (1957)." 45(November-December 1981), 53. Italian: "Projects for Broadacre City and an opera theater." Images only.

1744. *Complete Construction.* "Concrete veneer duplicates 1929 masonry." 24(June 1981), 495-96. Arizona Biltmore hotel.

1745. *Connoisseur.* "Table (ca. 1904)." 207(May 1981), 60. Image only.

1746. *Daidalos.* "Frank Lloyd Wright: Konzept und Plan." (September 1981), 12-13. English and German: "Frank Lloyd Wright: concept and plan." Guggenheim Museum.

1747. *Inland Architect.* "Mrs. Dana's place" 25(May 1981), 2, 46. See also "Grand entrances," *ibid.*, 5(November-December 1981), 30-31; cover. Dana-Thomas house.

1982
Books, monographs and catalogues
1748. Blotkamp, Carel et al. *De beginjaren van De Stijl.* Utrecht: Reflex, 1982. Dutch: *The early years of De Stijl.* A series of critical-biographical essays about the principal members of the Dutch group includes the influence of Wright. Reviewed Yve-Alain Bois, *Art in America*, 73(1985), 13ff.

Also published in English as *De Stijl: the formative years*, Cambridge, Mass.: MIT Press, 1986. Reviewed Paul Bonaventura, *Burlington Magazine*, 129(1987), 608; James Woudhuysen, *Design*, (September 1987), 60; *Structurist*, (1987-88), 114-15; Paul Overy, *Studio*, (July 1988), 61-62; *Apollo*, (September 1988), 211-12; Mark Stankard, *Design Book Review*, (Fall 1988), 57-60; and Jane Beckett, *Journal of Design History*, 3(no. 1, 1990), 63-69.

Also published in paperback, 1990; reviewed Nancy Troy, *JSAH*, 50(March 1991), 86-88.

Published in Italian as *De Stijl. Nascita di un movimento*, Milan: 1989; reviewed *Domus*, (March 1990), v-vi.

See also Blotkamp ed. *De vervolgjaren van De Stijl* [The subsequent years of De Stijl], *1922-1932*, Amsterdam; Antwerp: Veen, 1996 (Dutch), especially Ed Taverne and Dolf Broekhuizen, "De dissidente architecten [The dissident architects]: J.J.P. Oud, Jan Wils en Robert van't Hoff." Reviewed *Burlington Magazine*, 140(October 1998), 699.

1749. Davies, Rick. *The Frank Lloyd Wright collection.* Ightham, England: Retigraphic Society, 1982[?]

1750. Frampton, Kenneth. "Neoplasticism and architecture: formation and transformation." In Mildred Friedman, ed. *De Stijl: 1917-1931, visions of Utopia*, Minneapolis: Walker Art Center; New York: Abbeville Press, 1982. Reprinted Oxford: 1986, 1988. This catalogue of a traveling exhibition was also published in Dutch as *De Stijl: 1917-1931*, Amsterdam, 1982.

1751. Harmon, Robert B. *The Chicago School of architecture. A selected bibliography.* Monticello: Vance Bibliographies, 1982. Bibliography.

1752. Heinz, Thomas A. *Frank Lloyd Wright.* London: Academy, 1982. New York: St. Martin's, 1982. Reviewed Donald Hoffmann, *JSAH*, 41(October 1982), 245. Mostly images. Also published in Spanish, .Barcelona: Gustavo Gili, 1982.

1753. Larson, Paul et al. *Prairie School architecture in Minnesota, Iowa, Wisconsin.* St. Paul: Minnesota Museum of Art, 1982. Catalogue of an exhibition at the museum, February-April 1982. Reprinted 1984.

1754. Lysiak, Waldemar. *Frank Lloyd Wright.* Warsaw: Arkady, 1982. Polish. A German translation was published Berlin: Henschelverlag Kunst und Gesellschaft, 1983. Second edition, Chicago; Warsaw: Andrzej Frukacz "Ex Libris", 1999.

1755. Levine, Neil. "Frank Lloyd Wright's diagonal planning." In Helen Searing ed. *In search of modern architecture: a tribute to Henry Russell-Hitchcock*, New York; Architectural History Foundation; Cambridge Mass.; London: MIT Press, 1982, 249-52.

1756. Magnago Lampugnani, Vittorio. *Visionary architecture of the 20th century: master drawings from Frank Lloyd Wright to Aldo Rossi.* London: Thames and Hudson, 1982.

Periodicals

1757. Allen, James, John Patterson and Richard S. Taylor. "Frank Lloyd Wright and Springfield's Lawrence School." *Historic Illinois*, 4(April 1982), 1-3, 12-13.

1758. Attema, Peter. "'Paradise lost': F.L. Wright en democratische architectuur in Chicago, 1871-1913." *AKT*, 6(no. 1, 1982). Dutch: "'Paradise lost': Wright and democratic architecture in Chicago, 1871-1913."

1759. Brooks, Harold Allen. "Frank Lloyd Wright—towards a maturity of style (1887-1893)." *AA Files*, 1(July 1982), 44-49.

1760. Castellano, Aldo. "Architecture of the villa. The organic villa: Frank Lloyd Wright." *Ville Giardini*, 170(October 1982), 26-31. Italian.

1761. Davies, Colin. "Post-modernist as folk hero: last week Charles Jencks adopted Frank Lloyd Wright as a post-modern guru." *Building Design*, (15 October 1982), 2. Cf. Jencks, "Frank Lloyd Wright as 'post-modern guru'," *L'Architettura*, 29(February 1983), 86-87 (Italian; English summary). For a response, see James Marston Fitch, "To tell the truth," *Metropolis*, 3(October 1983), 22-23.

1762. Davies, Merfyn. "The embodiment of the concept of organic expression: Frank Lloyd Wright." *Architectural History*, 25(1982), 120-30.

1763. Goss, Peter L. "Wright's Fiesole studio." *Frank Lloyd Wright Newsletter*, 5(no. 1, 1982), 8.

1764. Hanna, Paul Robert and Jean Shuman Hanna. "Furnishing our Frank Lloyd Wright home" *Frank Lloyd Wright Newsletter*, 5(no. 2, 1982), 1-6, 10-11.

1765. Hildebrand, Grant and Thomas Bosworth. "The last cottage of Wright's Como Orchards complex." *JSAH*, 41(December 1982), 325-27.

1766. Howett, Catherine M. "Frank Lloyd Wright and American residential landscaping." *Landscape*, 26(no. 1, 1982), 33-40.

1767. Kaufmann, Edgar J. Jr. "Frank Lloyd Wright's mementos of childhood." *JSAH*, 41(October 1982), 232-37. Reprinted *idem.*, *Nine commentaries on Frank Lloyd Wright*, MIT Press, 1989, 19-35.

1768. Kaufmann, Edgar J. Jr. et al. "Frank Lloyd Wright at the Metropolitan Museum of Art." *Metropolitan Museum of Art Bulletin*, 40(Fall 1982), the issue. There are two essays: "Frank Lloyd Wright's architecture exhibited, a commentary" by Edgar J. Kaufmann Jr., and "Frank Lloyd Wright and Japanese prints" by Julia Meech-Pekarik. Reprinted as a book, New York: 1985.

Mentioned buildings include Bradley, Heller, Little, Darwin D. Martin, and Willits houses, Oak Park home and studio, Larkin administration building, Avery Coonley playhouse, Midway Gardens, Imperial hotel, S.C. Johnson and Son administration building, Auldbrass Plantation and H.C. Price Tower.

See also Kaufmann, "Wright at the Met," *Skyline*, (January 1983), 25.

1769. Larson, Philip. "Marion Mahony and Walter Burley Griffin: the marriage of drawing and architecture." *Print Collector's Newsletter*, 13(May-June 1982), 38-41. Discusses the couple's association with Wright.

1771. Lathrop, Alan K. "How the Prairie School wooed small-town bankers." *Architecture Minnesota*, 8(March-April 1982), 52-55.

1772. Lockwood, Charles. "Cradle of genius." *Connoisseur*, 210(April 1982), 74-81. Subtitled, "Oak Park, Illinois, is where a young architect named Frank Lloyd Wright came into his own, designing superb suburban houses."

1773. Long, David Gilson de. "A tower expressive of unique interiors." *AIA Journal*, 71(July 1982), 78-83. H.C. Price Tower.

1774. Ludwig, Delton. "Frank Lloyd Wright in the Bitter Root Valley of Montana." *Frank Lloyd Wright Newsletter*, 5(no. 2, 1982), 6-15.

1775. Moehl, Karl. "Frank Lloyd Wright house restored in Springfield." *New Art Examiner*, 9(April 1982), 13.

1776. Morse, Richard R. "Treasure house of stained glass evaluated. The Dana-Thomas House, Springfield, Illinois" *Stained Glass*, 77(Spring 1982), 51. Cf. Morse and Ralls C. Melotte, "The Dana-Thomas house," *ibid.*, (Summer 1982), 138-41; and *idem.*, "Dana-Thomas House: symbol of a revolution," *ibid.*, (Fall 1982), 265-68. See also Arthur Stern, "The Wright way?" *ibid.*, (Summer 1982), 115.

1777. Parade, Brigitte and Christoph Parade. "Frank Lloyd Wright—eine architektonische Unabhängigkeitserklaerung." *Architekt*, (June 1982), 309-314. German: "Frank Lloyd Wright—an architectural declaration of independence."

1778. Quinan, Jack. "Frank Lloyd Wright's Buffalo clients." *Frank Lloyd Wright Newsletter*, 5(no. 1, 1982), 1-3. John Durant Larkin.

1779. Quinan, Jack. "Frank Lloyd Wright's reply to Russell Sturgis." *JSAH*, 41(October 1982), 238-44. Identifies the original publication of Wright's response to Sturgis' critique, "The Larkin building in Buffalo," *Architectural Record*, 23(April 1908).

1780. Rowell, M. "Frank Lloyd Wright's temple to human creativity." *Artnews*, 81(March 1982), 126-27.

1781. Snyder, Tim. "Restoring Fountainhead." *Fine Homebuilding*, (December 1982), 27-33. Subtitled, "Brilliant in form and function but flawed in structure, a Frank Lloyd Wright house is renewed by a thoughtful and thorough architect."

1782. Tafel, Edgar A. "Historic architecture: Frank Lloyd Wright." *Architectural Digest*, 39(November 1982), 156-63. Don E. Lovness studio and cottage.

1783. Tafel, Edgar A. and Frank Lloyd Wright. "The architect's many enemies." *AA Quarterly*, 13(July-December 1982), 65-67. Transcribes, with a facsimile reprint, Tafel's 1934 article on Soviet architecture, as amended by Wright.

1784. Thomas, Scott. "Frank Lloyd Wright and the cult of the individual." *Frank Lloyd Wright Newsletter*, 5(no. 1, 1982), 13-15.

1785. Wimmer, Martin. "Spielen und bauen." *Form + Zweck*, 149(no. 4, 1982), 12-15. German: "To play and to build." Russian, English, French summaries. The influence of Froebel on Wright.

1786. Zabel, Craig Robert. "The prairie banks of Frank Lloyd Wright." *Frank Lloyd Wright Newsletter*, 5(no. 1, 1982), 3-13. Zabel's 1984 PhD thesis, "The Prairie School banks of Frank Lloyd Wright, Louis H. Sullivan, and Purcell and Elmslie," University of Illinois at Urbana-Champaign is published in microform, Ann Arbor: University Microfilms, 1987.

1787. *A+U.* [Beth Sholom Synagogue, Elkins Park, Pennsylvania, USA, 1954-59; architect: Frank Lloyd Wright]. (July 1982), 15-20. Japanese.

1788. *Antiques.* "Side chair [probably made by J.W. Ayers]." 121(May 1982), 1191.

1789. *Canadian Architect.* "Reconstruction in Banff." 27(March 1982), 27. Proposal to reconstruct a 1911 building in Banff national park, Canada, designed by Wright (with Francis Sullivan).

1790. *Daidalos.* "Impetus and departure. Facades of the Modern Movement." 15(December 1982), 76-84. English/German. Cites "The art and craft of the machine" (1901) and the introduction to *Ausgeführte Bauten* (1910).

1791. *Design Methods and Theories.* "Residential design guidelines from Frank Lloyd Wright." 16(1982), 143-44.

1792. *Princeton University Art Museum Record.* "Tree of life (stained glass)." 41(1982), 31. Image only.

1983
Books, monographs and catalogues

1793. Anon. *Chicago recreation map and guide.* Chicago: Rand McNally, 1983. Includes section, "Frank Lloyd Wright Historic District in Oak Park ".

1794. Clark, Clifford E. "American architecture: the prophetic and biblical strains." In James Turner Johnson ed. *The Bible and American arts and letters*, Philadelphia: Fortress Press, 1983.

1795. Connors, Joseph and Mark Heyman. *The Robie house of Frank Lloyd Wright.* University of Chicago Press, 1983, 1984. Reviewed John Sergeant, "The real master of infinite space," *AA Files*, (Autumn 1985), 106-108; Paul E. Sprague, *Winterthur Portfolio*, 20(Winter 1985), 281-92; and Jack Quinan, *JSAH*, 46(June 1987), 200-201.

1796. Fanelli, Giovanni. *De Stijl.* Rome; Bari: Laterza, 1983. Italian. Wright influence. Reprinted 1993. Also published in German as *Stijl-Architektur. Der Niederländsche Beitrag zur frühen Moderne*, Stuttgart: Deutsche Verlags-Anstalt, 1985 and reviewed Cees Boekraad, *Archis*, (April 1988), 44-51.

1797. Gary, Grace. *The shingle style architecture of Frank Lloyd Wright, 1889-1895* [microform]. Charlottesville: University of Virginia Library, 1983. Masters thesis, 1981.

1798. Hanks, David A. and Derek E. Ostergard. *Frank Lloyd Wright, art in design.* New York: Hirschl and Adler Modern, 1983. Catalogue of an exhibition, February 1983. There is an introductory essay by Hanks; cf. *idem.*, "Frank Lloyd Wright's 'The art and craft of the machine'," *Nineteenth Century*, 8(no. 3-4, 1982), 205-11; and *Frank Lloyd Wright Newsletter*, 2(no. 3, 1979), 6-9. Reviewed H. Goodman, *Arts Magazine*, 57(April 1983), 13.

1799. Jencks, Charles. *Kings of infinite space; Frank Lloyd Wright and Michael Graves.* London: Academy; New York: St. Martin's Press, 1983, 1984. Based on a BBC film by Jencks. Reviewed *Blueprint*, 1(December 1983-January 1984), 26; Martin Filler, "Lives of the modern architects: do personal affairs affect professional practice?" *House and Garden*, 157(June 1985), 28-33; and Herbert Muschamp, "Genealogy of the stars," *Design Book Review*, (no. 8, 1986), 12-15.

1800. Lancaster, Clay. *Japanese influence in America.* New York: Abbeville Press, 1983. See especially chapter 9, "Japanese influence upon the Chicago School." Cf. *idem.*, "Japanese buildings in the United States before 1900 ... ," *Art Bulletin*, 35 (September 1953), 218-24.

1801. Long, David Gilson de. "Recording the work of an architect: Frank Lloyd Wright." In C. Ford Peatross ed. *Historic America. Buildings, structures and sites,* Washington D.C.: Library of Congress, 1983.

1802. McArthur, Shirley du Fresne. *Frank Lloyd Wright: American System-Built Homes in Milwaukee.* Milwaukee: North Point Historical Society, 1983. Second edition 1985.

1803. Meech-Pekarik, Julia and Susan R. Stein. *Frank Lloyd Wright and Japanese prints: the collection of Mrs. Avery Coonley.* Washington, D.C.: AIA, 1983. Catalogue of an exhibiton at The Octagon, April-July.

1804. Meehan, Patrick Joseph. *Frank Lloyd Wright: a research guide to archival sources.* New York: Garland, 1983. Reviewed Mary Ison, "Architectural records," *JSAH,* 44(4 March 1985), 75-77.

1805. Meehan, Patrick Joseph. *The Frank Lloyd Wright motion picture guide.* Monticello: Vance Bibliographies, 1983. Bibliography.

1806. Muschamp, Herbert. *Man about town; Frank Lloyd Wright in New York City.* Cambridge, Mass.: MIT Press, 1983, 1985. Reviewed Sarah Williams, *Architectural Record,* 172(May 1984), 177; Thomas S. Hines, *Progressive Architecture,* 65(December 1984), 99-100; Norris Kelly Smith, *Design Book Review,* (Winter 1984), 6-8; Robert Kostka, *Leonardo,* 17(no. 4, 1984), 304-305; David Hamilton Eddy, "Quits with the city," *RIBA Journal,* (February 1986), 16; and Keith Bell, *Structurist,* (1985-1986), 133-39 .

1807. Pfeiffer, Bruce Brooks ed. *Letters to apprentices/Frank Lloyd Wright.* Fresno: California State University, 1983. Reviewed Donald Hoffmann, *JSAH,* 42(October 1983), 305-306; Edgar A. Tafel, "Epistles to Wright's apostles (and others) offer insights," *AIA Journal,* 72(June 1983) 85-86; Frederick Koeper, *Triglyph,* (Fall 1984), 40-41; Peter Blundell-Jones, "Honest arrogance," *Architects' Journal,* 189(1 February 1989), 71. The book was reprinted as part of *idem.* ed. *The complete Frank Lloyd Wright letters trilogy,* Fresno: California State University, 1987; also published in German as *Briefe von Frank Lloyd Wright an Architekten, Schüler, Bauherren,* Basel: Birkhäuser, 1992.

1808. Randall, John D. *Frank Lloyd Wright, six Buffalo houses.* Buffalo: Louis Sullivan Museum, 1983. The exhibition catalogue was revised and reprinted, Williamsville: The Author, 1990.

1809. Roth, Leland M. ed. *America Builds. Source documents in American architecture and planning.* New York: Harper and Row,1983.

1810. Schultz, Vera Smith. *Vera Schultz interviewed by Carla Ehat 1983.* San Rafael: Anne T. Kent California Room Oral History Project, 1983. Transcript. Schultz's "vision, tenacity and courage" created the Marin County Civic Center.

1811. Steiner, Frances H. *Frank Lloyd Wright in Oak Park and River Forest.* Chicago: Sigma Press, 1983.

1812. Vance, Mary ed. *An update on Frank Lloyd Wright 1867-1959 and some sources for review*. Monticello: Vance Bibliographies, 1983. Bibliography.

1813. Vickery, Robert L. *Sharing architecture*. Charlottesville: University of Virginia Press, 1983.

1814. Wright, Frank Lloyd. *Frank Lloyd Wright drawings from 1893-1959: exhibition and sales for the preservation of Taliesin*. n.l.: Frank Lloyd Wright Foundation, 1983. Catalogue of about 100 Wright drawings to be sold at Max Protetch Gallery, New York, September-October 1983.

 For review and comment see Timothy F. Rub, *Arts Magazine*, 58(November 1983), 37; Patricia C. Phillips, *Artforum*, 22(December 1983), 77; and Michael Kimmelman, "Frank Lloyd Wright estate controversy: recent sale at the Max Protetch Gallery, New York," *Art News*, 83(April 1984), 102-105 (for a response see O.P. Reed, "The Wright stuff," *ibid.*, [September 1984], 15).

Periodicals

1815. Berger, Philip. "Can this house be saved?" *Inland Architect*, 27(November-December 1983), 34-35 ff. See also Daralice Donkervoet Boles, "Rescuing the Willits House," *Progressive Architecture*, 64(November 1983), 39; and "Plea for Wright's Willits house denied by Illinois city council," *AIA Journal*, 72(December 1983), 18.

1816. Campajola, Viviana et al. "Architettura bioclimatica: en/arch 83 (National Institute of Architecture and National Energy Board, Rome)." *L'Architettura*, 29(August-September 1983), 614-15. Italian: "Bioclimatic architecture"

1817. Crosbie, Michael J. "A room as a museum piece." *AIA Journal*, 72(January 1983), 34-35. Subtitled, "The Frank Lloyd Wright summer residence for the Little family has been dismantled. The living room is now on display in New York's Metropolitan Museum of Art." Cf. Raymond L. Porfolio, "FLW in NYC: New York's Metropolitan Museum of Art opened the Wright Room," *Architectural Review*, 173(February 1983), 5-6; "Reconstructing Wright," *Progressive Architecture*, 64(March 1983), 35; Martin Filler, "The Little house of Frank Lloyd Wright," *House And Garden*, 155(April 1983), 118-23, 169-70; Thomas Harboe and Vincent Lepre, "Frank Lloyd Wright comes to the Met," *Fine Homebuilding*, (April-May 1984), 73-79; Robert Mehlman, "Frank Lloyd Wright at the Met," *Interior Design*, 54(May 1983), 236-39; M. Hentges, "Learning a lot from the Little living room," *Industrial Design*, 30(May-June 1983), 10-11; and P. Moreau, "De Waysata [*sic*] a New York," *Architecture d'Aujourd'hui*, (June 1983), xxxv (French).

1818. Dietsch, Deborah K. "Wright stuff." *Interiors*, 142(March 1983), 120-23. Adaptation of the Johnson Wax administration building.

1819. Eckhardt, Wolf von. "Reassessing the Wright stuff." *Time*, 122(12 September 1983), 46-47.

1820. Graham, Thomas: "Jenkin Lloyd Jones and 'the gospel of the farm.'" *Wisconsin Magazine of History*, (Winter 1983-1984).

1821. Levine, Neil. "Landscape into architecture: Frank Lloyd Wright's Hollyhock house and the romance of Southern California," *AA Files*, (January 1983), 22-41. Cf. *idem.*, "Hollyhock house and the romance of Southern California." *Art in America*, 71(September 1983), 150-65.

1822. Marlin, William. "Olgivanna and Frank Lloyd Wright: convictions and continuity." *Arizona Living*, 14(May 1983), 11-15.

1823. Menocal, Narciso G. "Form and content in Frank Lloyd Wright's *Tree of Life* window." *Elvehjem Museum of Art Bulletin*, (1983-1984), 18-32.

1824. Muschamp, Herbert. "Impressions: Taliesen the third." *House and Garden*, 155(October 1983), 40, 44. Subtitled, "Frank Lloyd Wright redecorated a Plaza suite at his New York command post while he built the Guggenheim." For a description of Suite 223, see Alistair Cooke, "Memories of Frank Lloyd Wright," *AIA Journal*, 32(October 1959), 42-44, reprinted in *idem.*, *Memories of the great and the good*, New York: 1999.

1825. Posener, Julius et al. "Architekturhistoriker zu Larkin und Johnson Wax." *Aktuellesbauen das Schweizerische Bau, Architektur und Planungsmagazin*, 18(August-September 1983), 57. German: "Architectural historians on Larkin and Johnson Wax." Extracts from the writings of Posener, Vittorio Magnago Lampugnani and Bruno Zevi.

1826. Roux-Dorlut, Maya. "Frank Lloyd Wright: le Chicago 'enfant terrible'. Frank Lloyd Wright et l'Exposition Prairie School au Musée de la Seita, Paris." *Architectes*, 143(December 1983), 24-25. French: "Wright, Chicago's *'enfant terrible'*. Wright and the Prairie School exhibition at the Musée de la Seita, Paris." See also Claude Massu, "1983: Paris découvre Chicago [Paris discovers Chicago]," *Feuilles*, (Autumn 1983), 51-63.

1827. Sammartini, Trudy. "The Masieri story." *Architectural Review*, 174(August 1983), 61-64.

1828. Scarpa, Carlo, Josep Lluis Mateo et al. [Special issue.] *Quaderns*, (July-September 1983), 2-93.

1829. Turner, Paul Venable. "Frank Lloyd Wright and the young Le Corbusier." *JSAH*, 42(December 1983), 350-99. See also *idem.*, "Frank Lloyd Wright and the young Le Corbusier: an addendum," *ibid.*, 43(December 1984), 364-65, that includes a letter to Turner from Thomas L. Doremus and a statement by Le Corbusier, made on the occasion of Wright's death.

1830. Wainwright, C. and J. Wainwright. "Frank Lloyd Wright chair [acquired by the Victoria and Albert Museum, London]." *Antiques*, 123(February 1983), 382.

1831. Weinstein, Michael. "Wright thinking: politics and ideology in the work of Frank Lloyd Wright." *Crit*, 13(Fall 1983), 47-50.

1832. Woodbridge, Sally B. "Wright restored: the V.C. Morris Store; architect for restoration: Michael A Marx." *Progressive Architecture*, 64(November 1983), 40-42.

1833. York, Joy. "Frank Lloyd Wright and Edwin Lutyens." *Architects' News*, (September 1983), 4, 6-7.

1834. *Antiques*. "Weed holders (copper, ca 1893-1902)." 123(June 1983), 1139. Image only.

1835. *Apollo*. "*Tree of life* (leaded glass door from the Martin house, Buffalo, 1904)." 118(July 1983), 103. Image only.

1836. *Architectural Record*. "Frank Lloyd Wright's Price Tower wins AIA twenty-five year award." 171(April 1983), 83. Cf. "Wright's Oklahoma Price Tower wins Institute 25-year honor," *AIA Journal*, 72(May 1983), 31.

1837. *Art Journal*. "House for northern climates (1927)." 43(Summer 1983), 167. Image only.

1838. *Burlington Magazine*. "Acquisitions in the Department of Ceramics at the Victoria and Albert Museum (1981-82)." 125(May 1983), 293. [Nakoma] Winnebago squaw.

1839. *Concrete International Design and Construction*. "The changing face of concrete masonry." 5(no. 6, 1983), 9-16.

1840. *Historic Preservation*. "Stained-glass window for a Chicago estate (ca. 1912)." 35(November-December 1983), 15. Image only.

1841. *Interiors*. "The Wright stuff." 142(March 1983), 120-23. Subtitled, "Without sacrificing the drama of its great workroom, the Johnson Wax administration building has been adapted for more work space."

1842. *Revue du Louvre et des Musées de France*. "Chaise (1908)." 33(1983), 143. Image only.

1984
Books. monographs and catalogues
1843. Alliluyeva, Svetlana. *The faraway music*. New Delhi: Lancer International, 1984.

1844. Anderson, David. *Architectural guide map of Oak Park and River Forest map*. Chicago: Frank Lloyd Wright Home and Studio Foundation, 1984.

1845. Brooks, Harold Allen. *Frank Lloyd Wright and the Prairie School*. New York: George Braziller, in association with The Cooper-Hewitt Museum, 1984. Catalogue of an exhibition, August-December 1983; mostly images. The show is announced *Architectural Record*, 171(July 1983), 66; and "Naissance d'un architecte," *Connaissance Arts*, 375(May 1983), 38, and reviewed Tod A. Marder, *Arts Magazine*, 58(November 1983), 22. The book is reviewed John Sergeant, "The real master of infinite space," *AA Files*, (Autumn 1985), 106-108.

1846. Darling, Sharon. *Chicago furniture. Art, craft and industry, 1833-1893.* New York: Chicago Historical Society; W.W. Norton, 1984.

1847. Hoffmann, Donald. *Frank Lloyd Wright's Robie house: the illustrated story of an architectural masterpiece.* New York: Dover, 1984. Reviewed Paul E. Sprague, *Winterthur Portfolio*, 20(Winter 1985), 280-92; and Jack Quinan, *JSAH*, 46(June 1987), 200-201. Revised edition 1993.

1848. Kley-Bekxtoon, Annette van der. *Leerdam glas: 1878-1930.* Lochem; Gent: De Tijdstroom, 1984. Dutch: *Leerdam glass.* Revised as *Leerdam glas 1878-1998 : de glasfabriek Leerdam: K.P.C. de Bazel, C. de Lorm, C.J. Lanooy, H.P. Berlage, J.J.C. Lebeau, A.D. Copier, F. Meydam, S. Valkema, W. Heesen, G. Thomassen, S. van der Marel, laboratoriumglas, basistechniek, merken,* Lochem: Antiek, 1999. Wright produced designs for Leerdam in the 1920s that were never executed. See also Johan Ambaum, "Ontwerpen van Frank Lloyd Wright voor de glasfabriek Leerdam [Wright's designs for the Leerdam glass factory]," *Jong Holland*, 6(November 1984), the issue.

1849. Leeuwen, Thomas A.P. van. "The method of Ariadne: tracing the lines of influence between some American sources and their Dutch recipients." In *Bouwen in Nederland: Leids kunsthistorisch jaarboek*, 3(1983). Delft: University Press, 1985. English.

1850. McPherson, William and Manuel D. Lopez eds. *Special collections of the University Libraries, State University of New York at Buffalo.* Buffalo: The Library, 1984.

1851. Meehan, Patrick Joseph ed. *The master architect: conversations with Frank Lloyd Wright.* New York: Wiley and Sons, 1984. Transcribes conversations from sound recordings and films, and reprints others.
 Previously published material includes "American forum of the air—what are the air waves saying?" (*AIA Journal*, 1[April 1944]); "Wisdom: a conversation with Frank Lloyd Wright" (NBC, 17 May 1953) (cf. text in James Nelson ed. *Wisdom; conversations with the elder wise men of our day*, New York: W.W. Norton, 1958); "Biography in sound: meet Frank Lloyd Wright" (NBC, August 1956); "Meeting of the Titans [Wright and Carl Sandburg]," *Newsday*, (20 April 1957); "Frank Lloyd Wright on restaurant architecture," *Food Service Magazine*, 20(November 1958); and Louise Rago, "Spirit of the desert—Frank Lloyd Wright's last interview [3 April 1959]: why people create," *School Arts*, 58(June 1959).
 Previously unpublished conversations include "Broadacre City" (with Oskar Stonorov) (January 1951); with the Taliesin Fellows (1951-52) (see "Frank Lloyd Wright talks to and with the Taliesin Fellowship," *Architectural Forum*, 98[April 1953]); with student architects, University of Oklahoma, Norman (May 1952); with William Zeckendorf (NBC, 22 April 1956); with student architects, University of California, Berkeley (April 1957); interview on *The Mike Wallace*

Interview TV program (ABC, September 1957; rebroadcast February-March 1960); with Carl Sandburg and Alistair Cooke (WTTW-Chicago TV, October 1957) with Jinx Falkenburg (NBC, April 1952); with student architects, University of Arkansa, Fayetteville (April 1958); and "The philosophy of an architect" and "Organic architecture" (WTTW-Chicago TV, October 1958).

The anthology is reviewed Terry Brown, *Architectural Record*, 173(May 1985), 89; and Edgar A. Tafel, "The master's voice," *Historic Preservation*, 38(April 1986), 72-73.

1852. Oud, Hendrik Emil. *J.J.P.Oud Architekt 1890-1963: feiten en herinneringen gerangschikt*. The Hague: Nijgh en van Ditmar, 1984. Dutch: *J.J.P.Oud Architect 1890-1963: gathered facts and memories*; English, French, German summaries. There are many references to Wright in this published version of a doctoral thesis, Nijmegen Catholic University .

1853. Pfeiffer, Bruce Brooks ed. *Letters to architects/Frank Lloyd Wright*. Fresno: California State University, 1984. Reviewed Edgar A. Tafel, *Architecture*, 73(October 1984), 99. Reprinted as part of *idem*. ed. *The complete Frank Lloyd Wright letters trilogy*, Fresno: California State University, 1987 (also published in German as *Briefe von Frank Lloyd Wright an Architekten, Schüler, Bauherren*, Basel: Birkhäuser, 1992.

1854. Pfeiffer, Bruce Brooks and Yukio Futagawa. *Frank Lloyd Wright. Vol. 12. Frank Lloyd Wright in his renderings 1887-1959*. Tokyo: ADA Edita, 1984. Reviewed Philip Larson, "Architecture and graphic art: the drawings of Frank Lloyd Wright," *Print Collector's Newsletter*, 17(July-August 1986), 101-104.

1855. Scott, Margaret Helen. *Frank Lloyd Wright's warehouse in Richland Center, Wisconsin*. Richland Center: Richland County Publishers, 1984.

1856. Tanigawa, Masami. [Frank Lloyd Wright, master living in legend]. In Sakae Ohmi and Terunobu Fujinori eds. *Unusual modern architects*, Tokyo: Asahi Newspaper Publishers, 1984. Japanese.

1857. Viskochil, Larry A. and Grant Talbot Dean. *Chicago at the turn of the century in photographs: 122 historic views from the collections of the Chicago Historical Society*. New York: Dover; London: Constable, 1984.

1858. Wilson, Richard Guy. *The AIA Gold Medal*. New York; London: McGraw-Hill, 1984.

1859. Wright, Frank Lloyd. *Frank Lloyd Wright drawings for decorative arts: series SFDA*. n.l.: Frank Lloyd Wright Foundation, 1984.

1860. *Frank Lloyd Wright: decorative objects, prints, drawings, Florida projects*. Miami Beach: Bass Museum of Art, 1984. Catalogue of an exhibition at the museum, June-September 1984.

Periodicals
1860. Ayala Valva, Franco d'. "On the Wright track with Neil Parkyn." *Middle East Construction*, 9(July 1984), 77.

1861. Benson, Robert. "Resurrecting Wright." *Inland Architect*, 28(May-June 1984), 2, 5-6. Thomas Monaghan, owner of Domino's Pizza chain, plans a new corporate headquarters in Michigan.

1862. Blaser, Werner. "Analogien der Architektur." *Schweizer Ingenieur und Architekt*, 102(no. 9, 1984), 151-58. German: "Analogies of architecture."

1863. Boyle, Bernard M. "Taliesin, then and now: rare photos that recall its genesis and change." *Architecture*, 73(March 1984), 129-33. French, Spanish summaries. Taliesin West.

1864. Chang, Ching-Yu. "Japanese spatial conception: Imperial Hotel, Tokyo." *Japan Architect*, 59(November-December 1984), 94-96.

1865. Davidson, Peter. "The Usonian vision and the Taliesin Fellowship: notes from Frank LLoyd Wright's *An autobiography*." *UIA International Architect*, (no. 6, 1984), 61.

1866. Dijk, Hans van. "Wrieto-San te Japan: 1. Imperial Hotel; 2. Yamamura house." *Wonen-TA/BK*, (September 1984), 6-7. Dutch: "Wright in Japan"

1867. Filler, Martin. "His house was his story." *House and Garden*, 156(April 1984), 180-87, 208, 212, 216-17. Subtitled, "Frank Lloyd Wright's Taliesin was more than a place to hang his famous hat: it was the embodiment of his eventful life and indomitable creative spirit." See also *idem.*, "His house [Taliesin West] was his oasis," *ibid.*, (May 1984), 198-203, 234, 236, 238-40.

1868. Green, William. "A peerless pair: Frederick W. Gookin and Frank Lloyd Wright and the Art Institute of Chicago's 1908 exhibition of Japanese prints." *Andon*, 4(Summer 1984), 14-19.

1869. Hoppen, Donald Walter. "A journey with Frank Lloyd Wright into architecture." *UIA International Architect*, (no. 6, 1984), 49-59. Hoppen was a Taliesin apprentice in the 1950s.

1870. Kaliski, John and J. Zweig. "Houston: how and why." *Texas Architect*, 34(September-October 1984), 40-47.

1871. Kappe, Shelley. "The architecture of Frank Lloyd Wright." *L.A. Architect*, (October 1984), 3. Review of a 1983 videorecording of the same name directed by Murray Grigor, and produced by the Arts Council of Great Britain and A.B.C. Video Enterprises .

1872. Kaufman, Mervyn. "Frank Lloyd Wright remembered." *House Beautiful*, 126(August 1984), 30, 111. Tribute by former apprentices, National Arts Club, New York City, 9 April 1984 (25th anniversary of Wright's death).

1873. Kusamori, Shinichi and Shunji Okura. "An organic magic (1): Okakura Tenshin, Frank Lloyd Wright and Lao-tzu." *Space Design*, (September 1984), 79 ff. English titles; Japanese text. See also *idem.*, "Okakura Tenshin, Frank Lloyd

Wright and Lao-tzu, again," (October 1984), 83-90; "Frank Lloyd Wright in Thoreau's woods," (November 1984), 57-64; "Architecture of over soul," (December 1984), 65-72; and "Frank Lloyd Wright's enchanted spaces," (August 1984), 61-70.

1874. Lizon, Peter. "Learning from Moscow." *University of Tennessee Journal of Architecture*, 8(1984), 15-20. Soviet architecture in the 1930s.

1875. Lynes, Russell. "The Zeus of Oak Park." *Architectural Digest*, 41(May 1984), 56, 60, 65.

1876. Misawa, Hiroshi. "Solomon R. Guggenheim Museum, New York ... 1942-1956." *A+U*, (September 1984), 11-18. English titles, captions; Japanese text.

1877. Moran, Maya. "In the garden with Frank Lloyd Wright." *Inland Architect*, 28(March-April 1984), 26-29. Tomek House.

1878. Muschamp, Herbert. "Unnatural positions in the natural house." *Art and Antiques*, (September 1984), 62-65. Wright furniture.

1879. Penfield, Louis A. "Detroit rejected Wright's better idea: workers weren't interested in bermed home development plan." *Earth Shelter Living*, (May-June 1984), 24-25.

1881. Reinberger, Mark. "The Sugarloaf Mountain project and Frank Lloyd Wright's vision of a new world." *JSAH*, 43(March 1984), 38-52. Adapted from *idem.*, "Frank Lloyd Wright's Sugarloaf Mountain 'automobile objective' project," Masters thesis, Cornell University, 1982.

1882. Rub, Timothy F. "Architecture and ornament: Frank Lloyd Wright's art glass." *Stained Glass*, 79(Summer 1984), 130-35.

1883. Rouillard, Dominique. "Logiques de la pente a Los Angeles: quelques figures de F.L. Wright et R.M. Schindler." *Cahiers de la Recherche Architecturale*, (no. 14, 1984), 8-25. French: "The logic of slope in Los Angeles: some motifs of Wright and Schindler."

1884. Steiner, Frances H. "Post-Victorian domestic architecture: the prairie style." *Old-house Journal*, 12(January-February 1984), 14-18.

1885. Sweeney, Robert Lawrence and Charles M. Calvo. "Frank Lloyd Wright: textile block houses." *Space Design*, (September 1984), 63-78. Japanese and English. Freeman, Ennis, Millard and Storer houses.

1886. Turner, Paul Venable. "Frank Lloyd Wright's drawings for the Victoria Schuck house." *Stanford Museum*, (1984-1985), 14-15; 9-11. Project.

1887. Wiser, Ann McKee. "Living Wright." *House Beautiful*, 125(August 1984), 70-73. Lovness house, Wingspread, and Harold Price Jr. house.

1888. *A+U.* [Frank Lloyd Wright special issue]. 10(July 1984), 5-232.

1889. *Abitare.* "Desk (metal, 1904)." 227(September 1984), supp. 3. See also [Untitled: desk for Johnson Wax Co. (1939)], *ibid.*, supp. 7 and "Winslow stables at River Forest (1893)," *ibid.*, 67. Images only.

1890. *Antiques.* "Spindle-back dining-room chair (oak, 1905)." 126(October 1984), 793. Image only.

1891. *Architectural Record.* "Frank Lloyd Wright house presented to University of Southern California." 172(November 1984), 35. Freeman house.

1892. *Architectural Review.* "Heads by Hellman." 175(no. 1045, 1984), 32-34. Caricature of Wright.

1893. *Architecture.* [Untitled: Larkin building atrium]. 73(February 1984), 80. Image only.

1894. *Building Design.* "Lloyd Wright model found." (15 June 1984), 7. Usonian house from "Sixty Years of Living Architecture" exhibition, New York.

1895. *Connoisseur.* [Bay window, Little house.] 214(December 1984), 49. Image only.

1896. *Design.* "Grid-backed chair." (June 1984), 23. Image only.

1897. *Inland Architect."* The inland eye." 28(November-December 1984), 53-54. Gunnar Birkerts and Associates and Giffels Associates development of Domino's Farms, an office complex in Ann Arbor intended to include Wright's Golden Beacon tower and a Usonian house.

1898. *Interior Design* "Dining table and chairs (ca. 1950)." 55(May 1984), 261. Image only.

1899. *Interior Design.* "Fabric (ca. 1955)." 55(May 1984), 261. Image only.

1900. *Interior Design.* "Side chair (oak, 1912)." 55(February 1984), 48. Image only.

1901. *Interior Design.* "A Wright Usonian house bought." 55(August 1984), 47.

1902. *L'Architettura.* "Un revival Wrightiano nel vento." 30(February 1984), 82-83. Italian: "A Wright revival in the wind"; English summary.

1903. *RIBA Journal.* "Design for all steel houses, Los Angeles (drawing, 1937)." 91(November 1984), 49. Image only.

1904. *RIBA. Journal.* "Royal Gold Medallists 1848-1984." 91(May 1984), 68.

1985
Books, monographs and catalogues
1905. Castex, Jean. *Frank Lloyd Wright, le printemps de la Prairie House.* Liège: P. Mardaga, 1985. French: *Frank Lloyd Wright, the spring of the Prairie House.* Reviewed Frédéric Mialet, "A propos de Frank Lloyd Wright," *AMC,* (April 1988), 52; and Francois Chaslin, "Fugues et variations Wrightiennes

[Fugues and Wrightian variations]," *L'Architecture d'Aujourd'hui*, (October 1988), 63, 66 (French).

1906. Doremus, Thomas. *Frank Lloyd Wright and Le Corbusier: the great dialogue*. New York; Wokingham: John Wiley and Sons, 1985. Reviewed Edgar A. Tafel, "The master's voice," *Historic Preservation*, 38(April 1986), 72-73; and Philip S. Kennedy-Grant, *Architecture*, 75(June 1986), 78. Reprinted 1992.

1907. Faber, Tobias. *Udsyn og indblik: udvalgte tekster af Tobias Faber 1948-1985*. Copenhagen: Arkitektens Forlag, 1985. Danish. *Collected writings of Tobias Faber*. The anthology includes Faber's writings on Wright.

1908. Glibota, Ante, Frederic Edelmann et al. *Chicago: 150 ans d'architecture 1833-1983*. Paris: Paris Art Center and L'Institut Francais d'Architecture, 1985. French: *Chicago: 150 years of architecture 1833-1983*.

1909. Haggard, Theodore M. *Florida Southern College, Lakeland Florida: The first 100 years, an illustrated history, 1985*. Lakeland: The College Press, 1985.

1910. Hanks, David A., Jennifer Toher et al. *Frank Lloyd Wright: architectural drawings and decorative art*. Middlesex: Hillingdon, 1985. Catalogue of exhibition, Fischer Fine Art Gallery, London, June-August 1985. It includes "The decorative designs of Frank Lloyd Wright and his European contemporaries: 1895-1915" by Hanks and "Instructions from Imhotep? WW—Wagner from Vienna and Wright from Chicago" by Otto Antonia Graf. Cf. Hanks and Toher, "Frank Lloyd Wright: first European exhibition of decorative arts," *Studio*, 198(no. 1009, 1985), 40-43.

The show moved to the Deutsches Architekturmuseum, Frankfurt am Main, October-November 1985; Galerie M. Knoedler, Zürich, December 1985-January 1986; and Galerie Würthle, Vienna, February 1986. A German version of the catalogue was published as Jörn Christiansen ed. *Frank Lloyd Wright: architekturzeichnungen und Innendekoration*, Dortmund: Cramers Kunstanstalt, 1986, with essays in English (by Hanks) and German (by Graf).

1911. Henken, Priscilla and David Henken. *Realizations of Usonia: Frank Lloyd Wright in Westchester*. Yonkers: Hudson River Museum, 1985. Published for an exhibition, February-April 1985. Pleasantville. Reviewed Sandy Heck, "Disappointing Usonia," *Architectural Review*, 177(June 1985), 4; and Patricia C. Phillips, *Artforum International*, 23(May 1985), 104.

1912. Henning, Randolph C. *The A.D. German warehouse: a rehabilitation and adaptive re-use design* [microform]. Ann Arbor: University Microfilms, 1985. Masters thesis, University of Wisconsin, 1980.

1913. Kornwolf, James D. ed. *Modernism in America 1937-1941: a catalogue and exhibition of four architectural competitions. Wheaton College, Goucher College, College of William and Mary, Smithsonian Institution*. Williamsburg: College of William and Mary, 1985.

1914. Pappas, Bette Koprivica. *Frank Lloyd Wright: no passing fancy: a pictorial history*. St. Louis: The Author, 1985. Pappas house.

1915. Pfeiffer, Bruce Brooks and Yukio Futagawa. *Frank Lloyd Wright. Vol. 4. Monograph 1914-1923*. Tokyo: ADA Edita, 1985. Japanese and English.

1916. Pfeiffer, Bruce Brooks and Yukio Futagawa. *Frank Lloyd Wright. Vol. 5. Monograph 1924-1936*. Tokyo: ADA Edita, 1985. Japanese and English.

1917. Pfeiffer, Bruce Brooks and Yukio Futagawa. *Frank Lloyd Wright. Vol. 9. Preliminary studies 1889-1916*. Tokyo: ADA Edita, 1985. Japanese and English.

1918. Pfeiffer, Bruce Brooks. *Frank Lloyd Wright: treasures of Taliesin. 76 unbuilt designs*. Fresno: California State University Press; Carbondale: Southern Illinois University Press, 1985. Reviewed Mary E. Osman, "A collection of Wright buildings left unbuilt," *Architecture*, 74(November 1985), 83-84; Philip Jodidio, "Le rebelle: soixante-seize dessins de Frank Lloyd Wright [The rebel: sixty-six [*sic*] designs by Wright]," *Connaissance des Arts*, (March 1986), 80-91; Philip Larson, "Architecture and graphic art: the drawings of ... Wright," *Print Collector's Newsletter*, 17(July-August 1986), 101-104; and Donald Hoffmann, *JSAH*, 45(December 1986), 422-32.

Also published in French as *Frank Lloyd Wright: tresors de Taliesin: 76 projects non réalises*, Liege: P. Mardaga, 1992; in Italian as *Frank Lloyd Wright i tesori di Taliesin: settantasei progetti non costruiti*, Milan: Rizzoli, 1987; and in German as *Frank Lloyd Wrights ungebaute Architektur [Wright's unbuilt architecture]*, Stuttgart: Deutsche Verlags-Anstalt, 1987 (reviewed Inno Boyken, *Architectura*, 18[1988], 202-204).

The American edition was revised as *Treasures of Taliesin: seventy-seven unbuilt designs*, San Francisco: Pomegranate, 1999; reviewed David Soltesz, *Library Journal*, 125(15 February 2000), 156.

1919. Rovere, Luisa Querci della. "Il Masieri memorial di Frank Lloyd Wright." In Lionello Puppi and Giandomenico Romanelli eds. *La Venezie possibili: da Palladio a Le Corbusier*. Milan: Electa, 1985. Italian: "Wright's Masieri memorial."

1920. Taylor, Richard S. and Mark Heyman. *Frank Lloyd Wright and Susan Lawrence Dana: from the Town and the Prairie Conference, Springfield, Illinois, April 1984*. Springfield: Sangamon State University, 1985. Two papers presented at the Western Illinois Regional Studies Conference.

1921. Wright, Gwendolyn. *Moralism and the model home: domestic architecture and cultural conflict in Chicago, 1873-1913*. University of Chicago Press, 1985.

1922. Zevi, Bruno Benedetto. *Frank Lloyd Wright*. Barcelona: Gustavo Gili, 1985. Spanish and Portuguese. Reprinted 1986, 1988, ca. 1990, 1993, 1995.

Periodicals

1923. Amery, Colin. "The Wright stuff." *World of Interiors*, (June 1985), 92-101. Furniture.

1924. Banham, Reyner. "The Wright stuff." *Design Book Review*, 7(Summer 1985), 8-11. Bibliographic essay.

1925. Baroni, Daniele. "F.L. Wright: un sogno americano: il disegno di un grande maestro." *Ottagono*, 20(December 1985), 36-43. Italian and English: "F.L. Wright: an American dream. The drawings of a grand master."

1926. Calvo, Charles. "De betonblok-ontwerpen van Frank Lloyd Wright." *Forum*, 30(no. 4, 1985-1986), 166-75. Dutch; English: "Wright's concrete block designs." Four Los Angeles houses.

1927. Clarke, Jane H. "A moving violation?" *Inland Architect*, 29(July-August 1985), 3-4. Cf. "Frank Lloyd Wright's remains moved to Taliesin West," *Architecture*, 74(May 1985), 51. Wright's body was disinterred from the grave near his mother's, cremated and the ashes removed to Taliesin West to be buried with Olgivanna.

1928. Clausen, Meredith L. "Frank Lloyd Wright, vertical space, and the Chicago School's quest for light." *JSAH*, 44(March 1985), 66-74

1929. Cohen, Daniel. "Hollywood discovers the Wright stuff; architect of 1923 Storer house: Frank Lloyd Wright, architects for restoration: Martin Eli Weil, and Eric Wright, grandson of the original architect." *Historic Preservation*, 37(August 1985), 20-25. Cf. Pilar Viladas, "Invisible reweaving," *Progressive Architecture*, 66(November 1985), 112-17 (revised as "Wright in Hollywood: a historic Frank Lloyd Wright house is brought back to life by film producer Joel Silver," *House and Garden,* 162[February 1990], 78-87).

1930. Frampton, Kenneth. "What can we pose as a viable alternative to Free Style Classicism?" *Interiors*, 145(October 1985), 108, 174.

1931. Gill, Brendan, "Architecture: Frank Lloyd Wright project completed in 1980s; planned by Wright in 1939-42." *Architectural Digest*, 42(December 1985), 140-47, 194. Pottery house, Santa Fe.

1932. Goldberger, Paul. "A lasting Wright legacy." *NYT Magazine*, (16 June 1985), 54-57.

1933. Harris, Jeffrey. "The transcendental house." *Utah Architect*, (Winter 1985), 10.

1934. Jones, Peter Blundell. "Implicit meanings." *Architectural Review*, 177(June 1985), 34-39.

1935. Kassler, Elizabeth Bauer. "Breaking down the man/nature interface: Martin Buber and Frank Lloyd Wright." *Princeton Journal: Landscape*, 2(1985), 28-34.

1936. Kenner, Hugh. "Frank-Lloyd [*sic*] Wright's tree of life." *Art and Antiques*, (May 1985), 96. Stained glass window, Darwin D. Martin house.

1937. Kusamori, Shin'ichi and Shunji Okura, [Frank Lloyd Wright's enchanted spaces; the abstract and the occult; Mondrian and Wright]. *Space Design*, (March 1985), 85-82. Japanese.

1938. Mostoller, Michael. "The towers of Frank Lloyd Wright." *Journal of Architectural Education*, 38(Winter 1985), 13-17.

1939. Perkins, John and Paul Rosenblatt. "Drawings and photographs of Unity Temple." *Perspecta,* no. 22(1985), 142-87.

1940. Perrone, Jeff. "Complication and confusion in American design." *Arts Magazine*, 60(November 1985), 96-98. Reviews an exhibition at the Whitney Museum of American Art, New York; see also D. Nevins, "High styles: American design in the twentieth century," *Antiques*, 128(October 1985), 772.

1941. Pfeiffer, Bruce Brooks. "Marilyn Monroe meets Frank Lloyd Wright." *House and Garden*, 157(December 1985), 62. Project for Arthur Miller house. See also "Design for living room of a Connecticut house for Arthur Miller and Marilyn Monroe," *Architecture*, 74(November 1985), 83 (image only). The design was adapted for the Waikapu Country Club, Wailuku, Hawaii.

1942. Reinberger, Mark. "Frank Lloyd Wright 1867-1959." *Biographical dictionary of architects in Maine*, 2(1985), 1-4.

1943. Rudd, J. William. "Sullivan, Wright and an American organic." *Design Methods and Theories*, 19(no. 3, 1985), 289-318.

1944. Scully, Vincent Joseph Jr. "Unity Temple and the A and A." *Perspecta*, (1985), 108-111. Wright's influence on Yale University Art and Architecture Building, (architect, Paul Rudolph). Cf. Rudolph, "Excerpts from a conversation," *ibid., (*1985), 102-109.

1945. Smith, Kathryn. "Frank Lloyd Wright and the Imperial Hotel: a postscript." *Art Bulletin*, 67(June 1985), 296-310.

1946. Weigand, Elizabeth. "The arts at Midway Gardens." *Inland Architect*, 29(July-August 1985), 45-47.

1947. Williams, Sarah. "Controlled tower: addition to the Solomon R. Guggenheim Museum, New York." *Art News*, 84(Summer 1985), 14 ff. Gwathmey Siegel's proposed "intrusive and unnecessary" addition, caused a stir for many years; called "a travesty" by some, the first scheme included a core wall and a cantilevered box with a gridded green porcelain-enamel facade.

See Jane Abrams, "Garotting the Guggenheim," *Building Design*, (November 1985), 8, 2; Lynn Nesmith, "Gwathmey Siegel's Guggenheim addition draws mixed reactions," *Architecture*, 74(December 1985), 11; and Ziva Freiman, "Gwathmey Siegel's Guggenheim: redoing Wright," *Progressive Architecture*, 66(December 1985), 25. See also entries in subsequent years.

1948. Wolfe, Kevin. "Island of dreams." *Metropolis*, 4(January-February 1985), 26-29, 40. Proposed plans for Ellis Island by Wright (i.a.).

1949. Wright, Frank Lloyd. "Das Juwel unter den Materialien." *Kunst und Kirche*, (part 3, 1985), 181. German: "The jewel under materials." Extracts from "In the cause of architecture" series, *Architectural Record*, April-December 1928.

1950. Yokoyama, Tadashi. [Visionaries with water and paper: Frank Lloyd Wright 1867-1959]. *Mizue*, (Autumn 1985), 14-15. Japanese.

1951. Zmeul, S. [The great patriotic war and Soviet architects]. *Arkhitektura SSSR*, (March-April 1985), 20-55. Russian.

1952. *American Craft.* "Chair (Oak)" and "Dining table (Oak)." 45(December 1985-January 1986), 26-27. Images only.

1953. *Antiques.* "Desk and chair: for S.C. Johnson and Son (steel, 1936-39)." 127(May 1985), 1056. Image only.

1954. *Antiques.* "Urn (copper)." 128(October 1985), 6. Image only.

1955. *Architecture.* "Design for a state capitol for Arizona (drawing, 1957)." 74(November 1985), 83. Image only.

1956. *Architecture.* "Mid-'50s Frank Lloyd Wright prefab house to be relocated." 74(March 1985), 32, 37, 42. Skyview.

1957. *Art and Antiques.* "The Wright stuff: a copper pot turns out to be a rare find." (November 1985), 42.

1958. *Art and Artist.* "Perspective view of unidentified house." 226(July 1985), 43. Image only.

1959. *Bulletin of the Cleveland Museum of Art.* "Tree of life window." 72(April 1985), 189. Image only.

1960. *Burlington Magazine.* "Window (1904)." 127(July 1985), iii. Image only.

1961. *Chicago Architectural Journal.* "Arena house, Milwaukee; original architect: Frank Lloyd Wright; alteration architect: Robert M. Beckley of Beckley Myers Architects." 5(1985), 114.

1962. *Chicago Architectural Journal.* "Dana/Thomas house restoration. Original architect: Frank Lloyd Wright; restoration architect: Wilbert R. Hasbrouck of Hasbrouck Hunderman Architects." 5(1985), 110-11.

1963. *Connoisseur.* "Nakoma (bronze, 1924) and "Nakomis (Bronze, 1924)." 215(May 1985), 143. Images only.

1964. *Connoisseur.* "Perspective of Hotel Lake Geneva (drawing, 1911)." 215(October 1985), 136. Image only; see also "Urn (copper)," *ibid.*, 161.

1965. *NYT Magazine.* "Frank Lloyd Wright's houses in Los Angeles." (16 June 1985), 54-58.

1966. *Organic architecture.* Bimonthly newsletter of the Wrightian Association, published in Hollywood after 1985 for "fans of Frank Lloyd Wright and organic architecture". Appears under various titles, including *Wrightian Magazin.*and *Frank Lloyd Wright and organic architecture.* After May 1990 it was continued by the video series, *Wrightian's organic architecture,* published irregularly.

1967. *Perspecta.* [Drawings and photographs of Unity Temple]. (1985), 142-87.

1968. *Toshi Jutaku.* [Space in motion: Robie house, Chicago: Frank Lloyd Wright]. (October 1985), 22-25. Japanese. The journal published a series of studies of Wright houses: see also [Life as thought: Sturges house, Brentwood Heights], *ibid.,* 30-33 and [Architecture and setting: Fallingwater, Bear Run], *ibid.,* (November 1985), 20-23.

1986
Books, monographs and catalogues
1969. Albrecht, Donald. *Designing dreams—modern architecture in the movies.Vol 1.* New York: Harper and Row, 1986. Reviewed Richard Ingersoll, "Cinemarchitecture," *Design Book Review,* (Spring 1992), 5-8. Vol. 2 was published, Santa Monica: Hennessey and Ingalls, 2001.

1970. Barney, Maginel Wright. *The valley of the God-almighty Joneses.* Spring Green: Unity Chapel Publications, 1986.

1971. Coolidge, John. "American architecture: the search for tradition." In David Gilson de Long, Helen Searing and Robert A.M. Stern eds. *American architecture: innovation and tradition,* New York: Rizzoli, 1986. Florida Southern College.

1972. Crawford, Alan. *C.R. Ashbee: architect, designer and romantic socialist.* Yale University Press, 1986.

1973. Einbinder, Harvey. *An American genius: Frank Lloyd Wright.* New York: Philosophical Library, 1986. Reviewed Norris Kelly Smith, *Design Book Review,* (Fall 1988), 39-41.

1974. Fanelli, Giovanni and Ezio Godoli. *Wendingen: 1918-1931: documenti dell'arte olandese del Novecento.* Florence: Centro Di, 1982. Italian: *Wendingen: 1918-1931: documents of Dutch art of the new century.* Catalogue of an exhibition at the Palazzo Medici Riccardi, April-June 1982. The Dutch journal *Wendingen* was important to Wright's influence in Europe. Reprinted as *Wendingen: grafica e cultura in una rivista olandese del Novecento,* Milan: F.M. Ricci, 1986. Cf. *idem.,* "*Wendingen,*" *FMR,* 8(January-February 1989), 81-96.

1975. Graham, Thomas. *A Lloyd Jones retrospective.* Spring Green: Unity Chapel Publications, 1986.

1976. Graham, Thomas. *Trilogy: through their eyes*. Spring Green: Unity Chapel Publications, 1986.

1977. Gurda, John. *New World odyssey: Annunciation Greek Orthodox Church and Frank Lloyd Wright*. Milwaukee: The Hellenic Community, 1986.

1978. Hoffmann, Donald. *Frank Lloyd Wright: architecture and nature*. New York: Dover; London: Constable; Don Mills, Ontario: General Publishing, 1986. Reviewed Stefano Andi, *Domus*, (April 1987), vi; and Herbert Gottfried, *Architecture*, 78(February 1989), 38.

1979. Kaufmann, Edgar J. Jr. et al. *Fallingwater, a Frank Lloyd Wright country house*. New York: Abbeville Press, 1986. The book also includes "The house and the natural landscape: a prelude to Fallingwater" by Mark Girouard.

Reviewed Jonathan Glancey, *Blueprint*, (September 1986), 54-55; Rodney Cooper, *Design Week*, 2(30 January 1987), 12; *Interior Design*, (February 1987), 19; Bob Allies, *Designers' Journal*, (March 1987), 103; Adrian Gale, *Designer*, (September-October 1987), 33; Edgar A. Tafel, *Architecture*, 77(January 1988), 40 ff.; Ronny de Meyer, *Archis*, (May 1988), 52 (Dutch and English); Harold Allen Brooks, *JSAH*, 47(December 1988), 430-31; and Brendan Gill, "Edgar J. Kaufmann, Jr.: secrets of Wright and Fallingwater," *Architectural Digest*, 47(March 1990), 50-54.

Excerpts are reprinted as "Fallingwater at 50: Frank Lloyd Wright's masterpiece is fresh as ever after half a century," *Interior Design*, 57(July 1986), 210-17; and "How right was Wright: Edgar J. Kaufmann Jr. recalls his family's country house, Fallingwater, and how Frank Lloyd Wright made it one with nature," *House and Garden*, 158(August 1986), 140-45, 168-70.

1980. Kelmscott Gallery. *Frank Lloyd Wright and Viollet-le-Duc: organic architecture and design from 1850 to 1950*. Chicago: Kelmscott Enterprises, 1986. Catalogue of a traveling exhibition prepared by the Gallery, that was mounted at the Armstrong Gallery, March-April 1986; Tartt Gallery, Washington, D.C., April-May 1986; and Lunn Ltd., New York, May 1986.

1981. Lipman, Jonathan. *Frank Lloyd Wright and the Johnson Wax buildings. Myth and fact*. New York: Rizzoli, 1986. Reviewed John Winter, "Magical waxworks," *Designers' Journal*, (September 1986), 115; Jonathan Glancey, *Blueprint*, (September 1986), 54-55; David Jenkins, *Architectural Review*, 183(June 1988), 10; Anthony Michael Alofsin, "Temples of soap and wax," *Design Book Review*, (Fall 1988), 44-46; Francesco Collotti, *Domus*, (May 1989), vii-viii (Italian); and Richard Guy Wilson, *JSAH*, 48(June 1989), 192-93.

1982. Onorato, Ronald J. intro. *Thomas Hart Benton, Frank Lloyd Wright: a transcript of the addresses and exchanges between Frank Lloyd Wright and Thomas Hart Benton, Providence, Rhode Island, November 11, 1932*. Williamstown: Williams College Museum of Art, 1986. Produced in conjunction with the exhibition "The restoration of Thomas Hart Benton, the America

today murals (1930)", February-June 1985. Cf. Onorato and Thomas Weston Fels, "Thomas Hart Benton, Frank Lloyd Wright," *Studies in the History of Art*, (1985), ii-20.

1983. Pfeiffer, Bruce Brooks ed. *Letters to clients / Frank Lloyd Wright*. Fresno: California State University Press, 1986. Reprinted as part of *idem*. ed. *The complete Frank Lloyd Wright letters trilogy*, Fresno: California State University, 1987 (also published in German as *Briefe von Frank Lloyd Wright an Architekten, Schüler, Bauherren*, Basel: Birkhäuser, 1992).

1984. Pfeiffer, Bruce Brooks ed. *Frank Lloyd Wright, the Guggenheim correspondence*. Fresno: California State University Press; Carbondale: Southern Illinois University Press, 1986. Reviewed Mary E. Osman, "Guggenheim letters shed new light on Wright," *Architecture*, 75(December 1986), 131-32. Reprinted 1995.

1985. Pfeiffer, Bruce Brooks and Yukio Futagawa. *Frank Lloyd Wright. Vol. 1. Monograph 1887-1901*. Tokyo: ADA Edita, 1986. Japanese and English.

1986. Pfeiffer, Bruce Brooks and Yukio Futagawa. *Frank Lloyd Wright. Vol. 6. Monograph 1937-1941*. Tokyo: ADA Edita, 1986. Japanese and English.

1987. Pfeiffer, Bruce Brooks and Yukio Futagawa. *Frank Lloyd Wright. Vol. 10. Preliminary studies 1917-1932*. Tokyo: ADA Edita, 1986. Japanese and English.

1988. Phillips New York. *Furnishings by George M. Niedecken for residence of Mr. E.R. [sic] Irving, Decatur, Illinois Frank LLoyd Wright architect*. New York: Phillips, 1986. Auction catalog, Friday 12 December 1986.

1989. Porter, Franklin and Mary Porter eds. *Heritage: the Lloyd Jones family*. Spring Green: Unity Chapel Publications, 1986.

1990. Scully, Vincent Joseph Jr. intro. *Frank Lloyd Wright: gli anni della formazione: studi e realizzazioni*. Milan: Jaca, 1986. Italian: *Frank Lloyd Wright: the formative years. Studies and realizations*. An Italian edition of *Ausgeführte Bauten und Entwürfe von Lloyd Wright*, Berlin: 1910. See 083.

1991. Twombly, Robert. *Louis Sullivan: his life and his work*. Chicago: University of Chicago Press; New York: Viking, 1986. Reviewed Richard Guy Wilson, "Three views of the tragic Louis Sullivan," *Architecture*, 76(January 1987), 123-24; Aaron Betsky, "Sullivan: *lieber Meister*," *Progressive Architecture*, 68(March 1987), 120, 127; Frederick A. Gutheim, *Inland Architect*, 32(May-June 1988), 96, 99-100; Lauren S. Weingarden, *Winterthur Portfolio*, 22(Summer-Autumn 1987), 202-208; Paul E. Sprague, *JSAH*, 46(December 1987), 423-27. Reprinted 1990. For further comment see Martin Filler, "Lives of the modern architects," *New Republic*, (21 June 1999), 32-38.

1992. *Frank Lloyd Wright: a modern aesthetic, June 6 to July 15, 1986, Struve Gallery. Chicago*. Chicago: The Gallery, 1986. Exhibition catalogue.

Periodicals

1993. Akiner, V. Tuncer. "Topology-1: a knowledge-based system for reasoning about objects and spaces." *Design Studies*, 7(April 1986), 94-105. Carlson house.

1994. Benson, Robert. "The Wright hand." *Inland Architect*, 30(July-August 1986), 61-71. Reports the Wright Hand Conference, University of Michigan, Ann Arbor, April 1986. Cf. Roger Kimball, "Conference report: a symposium at the University of Michigan celebrates Frank Lloyd Wright," *Architectural Record*, 174(June 1986), 91; and. "Frank L. Wright and contemporary architecture," *L'Architettura*, 32(August-September 1986), 562-65 (Italian).

1995. Bilanko, Judy. "Was R.S. Ludington the link between Frank Lloyd Wright and Wenatchee's Riverfront Park?" *The Confluence*, 3(Summer 1986), 94.

1996. Blake, Peter. "Hysterical pitch." *Interior Design*, 57(March 1986), 256-57. Guggenheim Museum.

1997. Blundell Jones, Peter, Frank Lloyd Wright and John Sergeant. "Organic design." *Building Design*, (no. 413, 1986) 22-23.

1998. Boles, Daralice Donkervoet. "Johnson Wax: corporate cathedral," *Progressive Architecture*, 67(April 1986), 27. Reviews a traveling exhibition sponsored by the Renwick Gallery of the National Museum of American Art, Washington, D.C., that was also mounted at the Milwaukee Art Museum.

For review and comment see "Frank Lloyd Wright: creating a corporate cathedral," *Museum and Arts Washington*, 2(April-May 1986), 24-26; "Commemorative exhibit honors Wright's Johnson Wax building," *Architecture*, 75(June 1986), 16; *American Craft*, 46(June-July 1986), 96; Cheryl Kent, *Inland Architect*, 23(January-February 1987), 71-73; Neil Jackson, "Two Wright angles," *Building Design*, (March 1988), 11, 24-25; and Robert Lawrence Sweeney, "Wrights and wrongs," *L.A. Architect*, (March 1988), 8-9.

1999. Brenner, Douglas. "Wright at home again: restoration of the Frank Lloyd Wright home and studio." *Architectural Record*, 174(September 1986), 118-25. See also Donald G. Kalec and Ann Abernathy, "Frank Lloyd Wright's Oak Park studio: painstaking attention to detail restores a landmark building to its original state," *Fine Homebuilding*, (April-May 1986), 60-66. The restoration was completed 9 May 1987.

2000. Cohen, Jean-Louis. "Wright et la France: une découverte tardive." *Architectes Architecture*, (April 1986), 32-33; 48. French: "Wright and France: a belated discovery."

2001. Crosbie, Michael J. "Masterpiece put to suitable use: Frank Lloyd Wright's V.C. Morris Shop becomes a gallery." *Architecture*, 75(November 1986), 44-47.

2002. Currimbhoy, Nayana. "Frank Lloyd Wright's decorative designs are reproduced today [by] three product manufacturers." *Interiors*, 146(November 1986), 116 ff.

2003. Dean, Andrea Oppenheimer. "Wright's Guggenheim Museum receives AIA's 25-year award." *Architecture*, 75(March 1986), 12-13ff.

2004. Donoian, John and Dennis Doordan. "'A magnificent adventure'." *Journal of Architectural Education*, 39(Summer 1986), 7-10. Subtitled, "An interview with Mrs. Sarah (Melvyn) Maxwell Smith about the Smith house by Frank Lloyd Wright".

2005. Fehlhaber, Joerg M. "Gestalten mit Beton. Tl.2. Der Weg zum Baustoff des Jahrhunderts." *Deutsches Architektenblatt*, 18(no. 6, 1986), 739-42. German: "Designing with concrete. Part 2. The way of construction materials of the centuries."

2006. Filippo, Alison. "Furniture design 1908-1949-1986: reproducing the furniture of Frank Lloyd Wright." *Domus*, (September 1986), 98-104. Italian and English.

2007. Filler, Martin. "Wright wronged." *House and Garden*, 158(February 1986), 42-48. Subtitled, "Gwathmey Siegel's proposed Guggenheim addition raises crucial questions about the museum's role as cultural caretaker".

Widespread debate over the building extensions heated up though 1986. See "The Guggenheim addition," *Oculus*, 47(February 1986), 2-15 (includes an environmental impact statement; cf. "The great museum debate," *ibid.*, 47[April 1986], 4-5; 14-16); Michael Sorkin, "Leaving Wright enough alone," *Architectural Record*, 174(March 1986), 79 ff.; "Additions to the Guggenheim and Whitney Museums," *International Journal of Museum Management and Curatorship*, 5(March 1986), 92-95; "The Quest Whitney?" *Friends Of Kebyar*, 42(March-April 1986), 4-5; "New York: l'ampliamento del Guggenheim Museum [extensions to the Guggenheim]," *Domus*, (April 1986), 1-3 (Italian); Daralice Donkervoet Boles, "Update on the Guggenheim," *Progressive Architecture*, 67(May 1986), 25, 32, 34; Lynn Nesmith, "Proposed Guggenheim addition debated at municipal hearing," *Architecture*, 75(August 1986), 10-12; Eric Gibson, "Two proposals for the 90s," *Studio*, 199(September 1986), 4-11; Sandy Heck, "Guggenheim dilemma," *Building Design*, (12 September 1986), 30-36;. "Guggenheim: Wright or wrong?" *Metropolis*, 6(October 1986), 32-33; Michael Kwartler and Associates, "Guggenheim expansion underground?" *Oculus*, 48(November 1986), 4-5, 14-15; and John Taylor, "Avant guardians," *Building Stone Magazine*, (November-December 1986), 24-35.

2008. Fusco, Renato de. "Storer residence, Hollywood." *Domus*, (September 1986), 92-97. Italian and English.

2009. Gorlin, Alexander C. "Geometry and nature in the work of Frank Lloyd Wright." *A + U*, (February 1986), 55-62. Japanese and English.

2010. Johnson, Donald Leslie. "Frank Lloyd Wright's contribution to Wenatchee's Riverfront Park." *The Confluence*, 3(1986), 92-94.

2011. Karson, Robin. "Taking the right path." *Garden Design*, 5(Winter 1986-1987), 66-71. Palmer house.

2012. Kaufmann, Edgar J. Jr. "How right was Wright." *House and Garden*, 158(August 1986), 140-145, 168-170. Subtitled, "Edgar J. Kaufmann Jr. recalls his family's country house, Fallingwater, and how Frank Lloyd Wright made it one with nature." Reprinted from *Fallingwater, a Frank Lloyd Wright country house*, New York: 1986. Cf. *idem.*, "Fallingwater at 50: Frank Lloyd Wright's masterpiece is fresh as ever after half a century." *Interior Design*, 57(July 1986), 210-17.

2013. Kerenyi, Jozsef. "F.L.W. csomagja." *Varosepites*, 22(no. 2, 1986), 26-28. Hungarian: "Frank Lloyd Wright's architecture."

2014. Levine, Neil. "Abstraction and representation in modern architecture: the international style of Frank Lloyd Wright." *AA Files*, (Spring 1986), 3-21.

2015. Menocal, Narciso G. "Frank Lloyd Wright and the question of style." *Journal of Decorative and Propaganda Arts*, 2(Summer-Fall 1986), 4-19.

2016. Neale, Gregory. "Pavilions, gardens and courts in the city: a study of Frank Lloyd Wright's Darwin D. Martin house." *Issue*, (July 1986), 29-37.

2017. Nelson, Carl L. "Wright house reopens at Woodlawn Plantation; architect (1939): Frank Lloyd Wright." *Historic Preservation*, 36(December 1984), 52-53. Pope-Leighey House.

2018. Niesewand, Nonie. "Wright angles; architect: Frank Lloyd Wright." *House and Garden*, 41(August 1986), 54-59. Furniture.

2019. Perkins, John, Paul Rosenblatt, and Jennifer Sage. "Drawings and photographs of Unity Temple." *Perspecta*, (1986), 142-87.

2020. Pollak, Martha et al. [Special issue; detail]. *Forum*, 30(1986), 146-92.

2021. Popham, Peter. "The sorcerer's apprentice; architect: Frank Lloyd Wright." *Building Design*, (11 April 1986), 24-26. Imperial Hotel.

2022. Quinan, Jack. "The architecture of Frank Lloyd Wright in New York State." *Preservation League of New York State. Newsletter*, 12(Summer 1986), 6-7.

2022. Scully, Vincent Joseph Jr. "Frank Lloyd Wright and Philip Johnson at Yale." *Architectural Digest*, 43(March 1986), 90 ff.

2023. Serttas, Turgut. "Die Architekturtheorie des Frank Lloyd Wright." *Kunstchronik*, (no. 11, 1986), 488. German: "Wright's architectural theory." Refers to a thesis from Stuttgart University.

2024. Sorkin, Michael. "Fallingwater at fifty." *Connoisseur*, 216(August 1986), 10, 12.

2025. Staggs, Sam. "For sale: a house that Wright built." *New York*, 19(1 September 1986), 19.

2026. Stern, Robert A.M. "Guest speaker: Robert A.M. Stern." *Architectural Digest*, 43(April 1986), 33 ff. Hillstead, Hollyhock and other houses.

2027. Stevenson, Dave. "Frank Lloyd Wright (ink on vellum drawing)." *Communication Arts Magazine*, (28 July 1986), 103. Image only.

2028. Tafel, Edgar A. "The impact of genius: Fallingwater, 1936." *House Beautiful*, 128(November 1986), 64-65; 130; 133.

2029. Vierfe, Christiane. "Frank Lloyd Wrights Stadtplanung: 'Broadacre-City'. Gescheitertes Modell oder aktueller Entwurf?" *Kunstchronik* (no. 8, 1986), 335. German: "Wright's city planning: 'Broadacre City'. Intelligent model or fashionable design?" Refers to a thesis from Hamburg University.

2030. Viladas, Pilar. "Wright again: reproductions of Frank Lloyd Wright's designs for interior furnishings." *Progressive Architecture*, 67(November 1986), 147.

2031. Walsh, Kevin. "Architecture, poetry and Frank Lloyd Wright." *Architect and Builder*, (January 1986), 8-12.

2032. Wilson, Richard Guy. "Learning from the American vernacular." *Architectural Review*, 180(November 1986), 77-84.

2033. Wright, Frank Lloyd. "The Japanese woodcut." *Daidalos*, (15 March 1986), 100-101. German and English. Publishes extracts from *The Japanese print. An interpretation*, Chicago: 1912.

2034. Wright, Frank Lloyd. "Wright/organico: definizioni da Frank Lloyd Wright, *Il futuro dell'architettura*, 1953." *L'Architettura*, 32(April 1986), 295 Italian. Translated excerpts from *The future of architecture*.

2035. *Architecture California*. "Storer residence, Hollywood: Frank Lloyd Wright." 8(March-April 1986), 12-13. Restoration award to Eric Lloyd Wright and Martin Eli Weil.

2036. *Architecture*. "Johnson Wax building exhibit, Racine, Wisconsin." (June 1986), 16.

2037. *Art in America*. "Dining table and eight chairs (1899)." 74(March 1986), 21. Image only.

2038. *Blueprint*. "Wright at the V. and A." (February 1993), 21-28. Four articles. "The Kaufmann office"; "Exchange of letters"; "Furniture"; and "The living legacy of Wright". There are comments by Douglas Brenner, Norman Foster, Piers Gough, Alfred Munkenbeck and Terence Riley.

2039. *Building Design and Construction*. "Michigan project honors Frank Lloyd Wright." 27(January 1986), 35. Subtitled, "Centerpiece of 300-acre development is to be a 30-story tower based on an unbuilt Wright design."

2040. *Communication Arts Magazine*. "Fallingwater, Frank Lloyd Wright." 28(March-April 1986), 88. Image only.

2041. *Connoisseur*. "Desk and chair (enameled steel, walnut, and brass-plated metal, ca. 1937)." 216(November 1986), 164-65. Image only.

2042. *Graphis*. "Frank Lloyd Wright (ink on vellum drawing)." 42(September-October 1986), 24. Image only.

2043. *House and Garden*. "A genuine Lloyd Wright—but this is adobe; architect: Frank Lloyd Wright." 41(March 1986), 92. Pottery house.

2044. *Interior Design*. "Frank Lloyd Wright's furniture." (November 1986), 122-23.

2045. *Interiors*. "Reproduced decorative chairs, fabrics." (November 1986), 116-18.

2046. *Planen Bauen Wohnen*. "Sonderreportage Frank Lloyd Wright." (no. 77, 1986), 3-9. German: "Special report Frank Lloyd Wright".

2047. *Preservation League of New York State Newsletter*. "The house that Wright built." 12(Summer 1986), 5. Darwin D. Martin house.

2048. *Progressive Architecture*. "Furniture, furnishings reproductions on the market." 67(November 1986), 147.

2049. *Progressive Architecture*. "Taliesin building unbuilt Wright." 67(July 1986), 34 ff.

2050. *Reader's Digest*. "Personal glimpses." (July 1986), 105.

2051. *Space Design*. [Furniture by Wright]. (October 1986), 65-67. Japanese.

1987
Books, monographs and catalogues

2052. Barnbeck, Ulla ed. *Architekten—Frank Lloyd Wright*. Stuttgart: Fraunhofer-IRB, 1987. German. This is the first in a series of bibliographies published under the same title; see also Ferdinand Blomensaht ed., 1989; Ursula Schreck-Offermann ed., 1992; Herbert Fritsch ed., 1995 and *Architekten—Frank Lloyd Wright: Literaturdokumentation; eine Fachbibliografie* [*Literature documentation: a subject bibliography*], 1999. The bibliography is now available on-line (ICONDA).

2053. Branden, Barbara. *The passion of Ayn Rand*. New York: Doubleday, 1986. Paperback edition 1987.

2054. Christie, Manson and Woods International Inc. *Important Frank Lloyd Wright and American Arts and Crafts furnishings, including ceramics: the properties of the Polo Club, Springfield, Ohio: a gentleman, Winthrop, Massachusetts: Howard and Judy Berkowitz: the American Ceramic Art Society: Saturday December 12, 1987, at 10:00 a.m. (lots 1-150)*. New York: Christie's, 1987. Auction catalog includes works by Wright.

2055. Christie, Manson and Woods International Inc. *Important American paintings, drawings and sculpture of the 18th, 19th and 20th centuries*. New York: Christies, 1987. Auction catalog includes works by Wright.

2056. Davis, Joyce M. *Lakeland's unique architectural heritage.* Lakeland: Polk Museum of Art, 1987.

2057. Doumato, Lamia. *Houses by Frank Lloyd Wright.* Monticello: Vance Bibliographies, 1987. Bibliography.

2058. Gill, Brendan. *Many masks. a life of Frank Lloyd Wright.* New York: G. P. Putnam's Sons, 1987. Biography. Paperback edition 1988. Reprinted New York: Da Capo, 1998.Young readers' edition 1987.

Reviewed Robert Campbell, *Architecture,* 77(January 1988), 39ff.; Thomas S. Hines, *New Criterion,* 6(January 1988), 67-71; Peter L. Donhauser, *Art News,* 87(April 1988), 53; Franz Schulze, *Architectural Record,* 176(June 1988), 79; Nir Buras, "Unmasking Wright," *L.A. Architect,* (June 1988), 10; Frederick A. Gutheim, *Inland Architect,* 32(July-August 1988), 79-80, 83-84; Kathleen LaFrank, *Preservation League of New York State Newsletter,* 14(Summer-Fall 1988), 10-12; Jack Quinan, "Un libello su F.L. Wright: tante maschere [A libel on Frank Lloyd Wright: many masks]," *Casabella,* 52(October 1988), 27 (Italian); Ellen Weiss, "Two views of Wright," *Progressive Architecture,* 69(September 1988), 133-34; 136; Norris Kelly Smith, "The man behind the myth," *Design Book Review,* (Fall 1988), 39-41; Brian Hatton, "Who really was Wright?" *Blueprint,* (October 1988), 61-62; Hugh Pearman, *Design,* (November 1988), 52; Andrew Saint, *JSAH,* 47(December 1988), 426-28 (see rejoinder by Grant Carpenter Manson, *ibid.,* 48[September 1991], 310); Dennis Sharp, "Rewriting the Wrightian wrongs," *RIBA Journal,* 95(December 1988), 48-49; and Karin Jongbloed, "Biografie Frank Lloyd Wright [Wright's biography]," *De Architect,* 20(October 1989), 78 (Dutch).

2059. Gillon, Edmund Vincent Jr. *Cut and assemble Frank Lloyd Wright's Robie House: a full-color H-O scale model of an architectural masterpiece.* New York: Dover, 1987.

2060. Meehan, Patrick Joseph ed. *Truth against the world: Frank Lloyd Wright speaks for an organic architecture.* New York: John Wiley and Sons, 1987. Reissued in library binding, Krieger, 1989; reprinted as *Truth against the world,* Wiley, 1992.

Anthologizes 32 of Wright's speeches; those previously published are given separate entries in this bibliography: "The beginnings of truth: a talk with Mary Margaret McBride"; "This is American architecture"; "The architect"; "Organic architecture and some elements"; "Organic architecture"; "Ornamentation"; "Hardware"; "The machine and architectural production"; "The art and craft of the machine"; "The American System Ready-Cut house"; "The pre-assembled house"; "The Marshall Erdman prefabricated houses"; "On production"; "In the cause of improving the human condition"; "An adventure in the realm of the human spirit"; "Quality and the vision of the superior human building"; "Building for the sick"; "Architecture of the dead for the living"; "Honors, awards, and medals"; "The Gold Medal of the American Institute of Architects"; "The Gold Medal for Architecture of the National Institute of Arts and Letters"; "The Frank

P. Brown Medal of the Franklin Institute"; "To the students of London's Architectural Association"; "The truth about education"; "Education and art in behalf of life"; "To Princeton: mimic no more"; "Progress in architectural education"; "Democracy"; "Building a democracy"; "The arts and industry in a democratic economy"; "Architecture in a democracy"; "Broadacre City"; "A new freedom for living in America"; "Mr. Wright talks on Broadacre City to Ludwig Mies van der Rohe"; "The architecture of a free democratic government"; "Government and architecture"; "Building for local government: the Marin County Civic Center"; and "A National Cultural Center".

Reviewed Mary E. Osman, *Architecture*, 77(June 1988), 48; and Norris Kelly Smith, "The man behind the myth,"*Design Book Review*, (Fall 1988), 39-41.

2061. Pfeiffer, Bruce Brooks ed. *Frank Lloyd Wright: his living voice*. Fresno: California State University Press, 1987. Includes two audio cassettes. Reviewed Richard Guy Wilson, *JSAH*, 48(June 1989), 192-93; Robert Twombly, "Word glut: marketing Frank Lloyd Wright." *Design Book Review*, (Spring 1990), 61-65.

2062. Pfeiffer, Bruce Brooks and Yukio Futagawa. *Frank Lloyd Wright. Vol. 3. Monograph 1907-1913*. Tokyo: ADA Edita, 1987. Japanese and English.

2063. Pfeiffer, Bruce Brooks and Yukio Futagawa. *Frank Lloyd Wright. Vol. 11. Preliminary studies 1933-1959*. Tokyo: ADA Edita, 1987 Japanese and English.

2064. Pfeiffer, Bruce Brooks, Vincent Joseph Scully Jr. et al. *Chairs of Frank Lloyd Wright*. New Haven: Yale University School of Architecture, 1987. Catalogue of a November 1987 exhibition, sponsored by the school.

2065. Quinan, Jack. *Frank Lloyd Wright's Larkin building, myth and fact*. New York: Architectural History Foundation; Cambridge, Mass.: MIT Press, 1987. Paperback edition, MIT Press, 1990.

Reviewed Simon Pepper, "Larkin brought to life," *Building Design*, (29 April 1988), 28-29; Anthony Michael Alofsin, "Temples of soap and wax," *Design Book Review*, (Fall 1988), 44-46; Ellen Weiss, "Two views of Wright," *Progressive Architecture*, 69(September 1988), 133-36; Alexander Gorlin, *Architecture*, 77(June 1988), 47-48; Jonathan Lipman, *JSAH*, 47(December 1988), 431- 32; and Peter Willis, *Newsletter, Society of Architectural Historians of Great Britain*, (summer 1988), 12-13.

2066. Scully, Vincent Joseph Jr. et al. *The Meyer May house: Grand Rapids, Michigan. Steelcase, Inc.; project director, Carla Lind*. Grand Rapids: Steelcase, 1987. A record of the restoration is mostly images.

The project was widely reported: see David P. Schaap, "Steelcase Inc. has just finished restoring [the] Meyer May residence," *Architecture*, 76(October 1987), 23; Jerry Cooper, "A Prairie home interior," *Interior Design*, 58(November 1987), 252-59; 278; Susan Doubilet, "The legacy of Wright," *Progressive Architecture*, 68(November 1987), 112-33; "Righting a Wright," *Historic Pre-*

servation, 40(January-February 1988), 6; Joyce Tognini Black, "Wright restored," *American Craft*, 48(June 1988), 80-83; *Canadian Architect*, 33(June 1988), 8; Lynn Nesmith, "Wright house restored meticulously and magnificently," *Architecture*, 78(May 1989), 152-55; Carol Rickner, *Albenaa*, 9(August-September 1989), 14, 46-47; Amy Dana, "The Wright way: restoration of the Meyer May house, Grand Rapids," *Interiors*, 149(January 1990), 160-63; and Scully, "Das Meyer May House in seiner Umgebung. Exzellente Restaurierung eines "prairie house" von F.L. Wright in Grand Rapids, Michigan [The Meyer May House in its environment. Excellent restoration of one of Wright's 'prairie houses' ...]." *AIT Architektur, Innenarchitektur, Technischer Ausbau*, 98(no. 1-2, 1990), 45-50 (German).

2067. Vance, Mary. *Frank Lloyd Wright: journal articles, 1979-1986.* Monticello: Vance Bibliographies, 1987. Bibliography.

2068. Whiting, Henry and Robert G. Waite. *Teater's Knoll: Frank Lloyd Wright's Idaho legacy.* Midland: Northwood Institute Press, 1987. See also Whiting, "Formgiver: Frank Lloyd Wright in Idaho," *Northern Lights*, 2(November-December 1986), 28-29.

2069. Wydick, Susan E. *Frank Lloyd Wright and folk architecture: an essay.* Springfield: Dana-Thomas House Foundation, 1987.

Periodicals

2070. Bergdoll, Barry. "Copy Wright conference." *Progressive Architecture*, 68(January 1987), 36, 38. Oak Park, Illinois conference: "Who owns Frank Lloyd Wright: his designs and the public domain".

2071. Berke, Arnold M. "Wright restoration ends." *Preservation News*, 27(June 1987), 9. Celebrates completion of restoration of the Wright home and studio, 9 May 1987. See also "A house built the Wright way ... ," *Design Solutions*, 7(Fall 1987), 17-20; Robert Kronenburg, "Wright at home," *Architects' Journal*, 186(November 1987), 4, 40-47; and Grace Gary, "Wright at home: exacting restoration of the Frank Lloyd Wright home and studio in Oak Park, Ill.," *Historic Preservation*, 40(July-August 1988), 46-51.

2072. Cheek, Lawrence W. "Spirit of Frank Lloyd Wright still pervades Taliesin West." *Architecture*, 76(December 1987), 19, 24. Conference on the occasion of the 50th anniversary of the founding of Taliesin West.

2073. Chisholm, Dorothy. "Francis Conroy Sullivan: an architect ahead of his time." *The Beaver*, (December 1987-January 1988), 48-54. Sullivan collaborated with Wright on the Banff National Park buildings.

2074. Clarke, Jane. "Root, Wright and the Rookery" *Inland Architect*, 31(March-April 1987), 23, 26, 74, 77.

2075. Donegan, F. "Wright's furnishings" *Americana*, (May-June 1987), 16-19. Decorative pieces by Wright are valuable collector's items.

2076. Doubilet, Susan et al. "The legacy of Wright." *Progressive Architecture*, 68(November 1987), 112-33. The anthology includes Doubilet's discussion of the Meyer May house restoration; "The selling of Frank Lloyd Wright. Questions of public access, authenticity and stewardship" by Daralice Donkervoet Boles; "The first of its kind: Jacobs House I, Madison, Wisc." by Pilar Viladas; and "Redone Wright: restoring Wright buildings" by Thomas R. Fisher.

2077. Ellis, W. Russell. "Architects' people: the case of Frank Lloyd Wright." *Architecture et Comportement*, 3(1986-1987), 25-35.

2078. Estoque, Justin. "Heating and cooling Robie house." *ATP Bulletin*, 19(no.2, 1987), 38-51.

2079. Fisher, Thomas R. "Architecture and social vision." *Oz/College of Architecture and Design Kansas State University*, 9(1987), 48-51.

2080. Fitoussi, Brigitte. "Le Frank Lloyd Wright programme décoratif: collection Cassina." *L'Architecture d'Aujourd'hui* (February 1987), xlvi. French: "The Frank Lloyd Wright decorative program: Cassina collection." The Italian furniture manufacturer makes (i.a.) Wright reproductions. Cf. "Furniture by Frank Lloyd Wright." *Architect and Builder*, 39(November 1988), 14-19; and "Cassina: vivere con un genio [Cassina: living with a genius]," *Ottagono*, (September 1990), 164-67 (Italian); "Neuauflage klassischer entwurfe [New editions of classical designs]," *MD*, (March 1987), 80-83 (German).

2081. Frampton, Kenneth. "The Usonian legacy: development of site-specific and bioclimatically responsive architecture [by] Californian architects." *Architectural Review*, 182(December 1987), 26-31.

2082. Giannone, Michael A. "Family tradition of metal roofing is 'Wright stuff." *RSI*, (March 1987), 30. Kentick Knob.

2083. Goska, Dave. "Affordable Usonian house, Alexandria, VA." *Custom Builder*, (October 1987), 43-44.

2084. Greer, Nora Richter. "Restoration of a cradle of genius: Frank Lloyd Wright home and studio." *Architecture*, 76(May 1987), 184-87; 232.

2085. Hines, Thomas S. "Origins and innovations. Los Angeles architecture from its origins to the present day." *Architectural Review*, 182(December 1987), 76-77.

2086. Irace, Fulvio. "Coonley House." *Abitare*, (July-August 1987), 198-203. Italian. See also *idem.*, "Wright a Oak Park," *ibid.*, 204-205.

2087. Johnson, Donald Leslie. "Frank Lloyd Wright in Moscow: June 1937." *JSAH*, 46(March 1987), 65-79.

2088. Johnson, Donald Leslie. "Frank Lloyd Wright in the northwest: The Show, 1931." *Pacific Northwest Quarterly*. 78(July 1987).

2089. Johnson, Donald Leslie. "Frank Lloyd Wright's architectural projects in the Bitter Root Valley, 1909-1910." *Montana: the magazine of western history*, 37(Summer 1987), 12-25.

2090. Johnson, Donald Leslie. "Plan evolution to the Prairie Style: Frank Lloyd Wright's debt to Joseph Silsbee." *Architecture Australia*, 76(June 1987), 23, 29.

2091. Karfík, Vladimir. "Präzise Maschine und lebendige Natur: Erinnerungen an Le Corbusier und Frank Lloyd Wright." *Arch Plus*, (August 1987), 68-71. German: "Precise machine and living nature. Memories of Le Corbusier and Wright."

2092. Kruty, Paul Samuel. "Pleasure garden on the Midway." *Chicago History*, 16(Fall-Winter 1987-1988), 4-27. Midway Gardens.

2093. Levine, Neil. "Fallingwater 1936-1986." *Friends of Fallingwater Newsletter*, (no. 1, 1987), 2-5. Includes excerpts from Levine's paper "The temporal dimension of Fallingwater" The semi-annual *Newsletter*, 1987-1999, ran to 18 issues. I am indebted to Sarah Beyer, Curator of Education at Fallingwater, for details of content of the respective entries.

2094. Miller, Charles. "Pottery house." *Fine Homebuilding*, (August-September 1987), 26-31.

2095. Mise, Ruth. "Freeman house: USC acquires historic home." *L.A. Architect*, (September 1987), 4.

2096. Munoz, Maria Teresa. "La casa sobre la naturaleza. La Villa Malaparte y la Kaufmann House." *Arquitectura*, 68(no. 269, 1987), 20-31. Spanish: "The house above nature. The Villa Malaparte and the Kaufmann house."

2097. Nesmith, Lynn. "Guggenheim unveils modified Gwathmey Seigel addition." *Architecture*, 76(March 1987), 40, 42. Under public pressure, the architects revised their design, removing a proposed cantilever, reducing the height, and changing the facade to limestone. Cf. David Morton, "Guggenheim revision," *Progressive Architecture*, 68(March 1987), 41,43; and "The Guggenheim Museum announces revised expansion plans" and "The Guggenheim Museum addition: scheme II," *Oculus*, 48(April 1987), 2, 3-5.
 The changed design was well-received. See Andrea Riecken, "Un novo anexo para o Guggenheim Museum [A new annex for the Guggenheim]," *Projeto*, (February 1987), 46-49 (Spanish); "Il Guggenheim forse salvo [Perhaps the Guggenheim is safe]," *L'Architettura*, 33(March 1987), 165 (Italian); Paul M. Sachner, "A far, far better thing," *Architectural Record*, 175(April 1987), 45; "What Wright has wrought," *Metropolis*, 6(April 1987), 20-21; "Modifiche all'ampliamento del Guggenheim Museum [Revised design for Guggenheim]," *Domus*, (May 1987), 9 (Italian); Joseph Giovannini, "Museum piece," *Artforum*, 25(May 1987), 2-5; Martin Filler, "Growing pains: new expansion proposals at the Whitney and Guggenheim museums," *Art in America*, 75 (July 1987), 14-19 and Mark Stevens, "Somewhere, Wright is smiling," *Art News*, 86(November 1987), 238.

2098. Newton, David. "The Fabyans' fabulous Geneva retreat." *Historic Illinois*, 10(December 1987), 8-9; 11.

2099. Pedio, Renato. "La favolosa torre wrightiania regge nenessimo al computer: Il 'Mile High Illinois' di Frank Lloyd Wright, una simulazione al computer" *L'Architettura*, 33(November 1987), 778-98. Italian: "The fabulous Wrightian tower resists the computer: Wright's 'Mile High Illinois', a computer simulation."

2100. Pica, Agnoldomenico. "Il Marin County di Frank Lloyd Wright." *L'Arca*, (January-February 1987), 4-9. Italian: "Wright's Marin County [Civic Center]."

2101. Quinan, Jack. "Frank Lloyd Wright, Darwin D. Martin, and the creation of the Martin house." *Prairie House Journal*, 1(no. 1, 1987), sup. 5-12.

2102. Riecken, Andrea. "Cinqueta anos da Casa da Casacata, simbolo do modernismo americano Frank Lloyd Wright's Fallingwater." *Projeto*, (July 1987), 74-78. Spanish: "Fifty years of the house on the waterfall, symbol of American modernism"

2103. Sainz, Jorge. "El sueno cristalizado: Fallingwater a gusto de todos." *A. and V. Monografias*, (1987), 56-58. Spanish: "Sound crystallized: Fallingwater to everyone's taste."

2104. Sekulic-Gvozdanovic, Sena. "Frank Lloyd Wright." *Peristil*, 30(1987), 147-53. Serbo-Croatian.

2105. Selvafolta, Ornella. "'On the verge of the avant-garde': the Amsterdam Stadium, 1928." *L'Arca*, (November 1987), 4-11. Italian and English. Jan Wils' —his peers dubbed him 'Frank Lloyd Wils'—design was derived from Wright's architecture.

2106. Speck, Lawrence W. et al. [Special issue. New regionalism]. *Center*, 3(1987), 5-127.

2107. Staggs, Sam. "The Wright people: Crimson Beech house, Staten Island, New York." *Art News*, 86(January 1987), 9-10.

2108. Stevens, Albert et al. "[Special issue] Il progetto del lavoro." *L'Arca*, 1(January-February 1987), 1-103. Italian and English: " Planning at work."

2109. Stoller, Ezra. "Ezra Stoller: the architectural lands." *Art News*, (November 1987), 160-66. Guggenheim Museum.

2110. Teicher, Jonathan and Wayne Attoe. "Frank Lloyd Wright as a regional force." *Center*, 3(1987), 96-99.

2111. Verdu, Vicente et al. "[Special issue]. Casa, cuerpo, suenos." *A and V Monografias*, (1987), 2-80. Spanish: "House, body, dreams."

2112. Wright, Gwendolyn. "Domestic architecture and the cultures of domesticity." *Design Quarterly*, (no. 138, 1987), 12-19.

2113. Yingst, James R. "Dana-Thomas house focus of archaeological study." *Historic Illinois*, 10(June 1987), 1-4.

2114. Young, Dwight. "Last chance for a Wright classic." *Historic Preservation*, 39(September-October 1987), 13-14. Pope-Leighey house.

2115. Zusy, C. "Stained glass for the home." *Antiques*, 131(April 1987), 852.

2116. *Abitare*. "Città natura: Riverside." (July-August 1987), 196-203. Italian; "The nature city: Riverside." The garden suburb (1868-1869) designed by Frederick Law Olmsted and Calvert Vaux icludes the Coonley house. See also "Wright a Oak Park," *ibid.*, 204-205.

2117. *American Craft*. "Hanging lamp, 1903 (leaded stained glass)." 47(June-July 1987), 48-49. Image only.

2118. *Antiques*. "Window (with geometric motif) (1912)." 131(January 1987), 280. Image only.

2119. *Apollo*. "Oak high-back spindle side chair [Warren Hickox house]." 126(September 1987), 91. Image only.

2120. *Architectural Design*. "Frank Lloyd Wright designs: manifesto, Chicago; exhibit." 57 (no. 3-4, 1987), v.

2121. *Architecture*. "Taliesen conference report; school's accreditation." 76(December 1987), 19, 24.

2122. *Friends of Fallingwater Newsletter*. [Stephen Spender visit]. (November 1987). The issue also contains conservation news.

2123. *L'Architettura*. "Fallingwater, 50 anni—il Guggenheim forse salvo." 33(March 1987), 165. Italian: "Fallingwater, 50 years old—perhaps the Guggenheim is safe."

2124. *Metropolis*. "All things Wright and wonderful." 6(March 1987), 24-25. Reproduction of Wright's domestic furnishings.

2125. *The Prairie House Journal*. The periodical was published Ann Arbor, Michigan, by Domino's Farms Inc., whose owner Thomas Monaghan was a collector of Wrightiana. Some volumes include supplements and folders with plates. Publication continued through 1999.

2126. *Process: Architecture*. "The Masieri Memorial, 1953." (October 1987), 108-109. Japanese and English.

1988
Books, monographs and catalogues
2127. Abernathy, Ann and John G. Thorpe eds. *The Oak Park home and studio of Frank Lloyd Wright*. Oak Park: Wright Home and Studio Foundation, 1988.

2128. Alofsin, Anthony Michael ed. *Frank Lloyd Wright. an index to the Taliesin correspondence*. 5 vols. New York; London: 1988. Includes an essay,

"Frank Lloyd Wright as a man of letters". Reviewed Jack Quinan, *JSAH*, 48(September 1989), 300-301; Patrick Joseph Meehan, *Architecture*, 78(December 1989), 124-25 ff. (cf. *Design Book Review*, [Spring 1990], 66); and Curtis Besinger, *Journal of Architectural Education*, 43(Winter 1990), 54-57.

2129. Bolon, Carol Radcliffe, Robert S. Nelson and Linda Seidel eds. *The nature of Frank Lloyd Wright*. Chicago; London: University of Chicago Press, 1988. Papers from the University's Art Department symposium, October 1984, to celebrate the Robie house's 75th anniversary. Includes an introduction by Vincent Joseph Scully Jr.; "Wright on nature and the machine" by Joseph Connors; "Wright's own houses and his changing concept of architectural representation" by Neil Levine; "Schooling the Prairie School: Wright's early style as a communicable system" by David van Zanten; "Meeting nature face to face" by Donald Hoffmann; "Architectural practice and social vision in Wright's early designs" by Gwendolyn Wright; "Frank Lloyd Wright's other passion" by Julia Meech-Pekarik; "Wright and landscape: a mythical interpretation" by Thomas H. Beeby; and "The prairie in literary culture and the Prairie Style of Frank Lloyd Wright" by Larzer Ziff.

Reviewed David Gilson de Long, *Interior Design*, 60(September 1989), 170 ff.; Peter Blundell Jones, *Architectural Review*, 186(October 1989), 12; and Robert Twombly, "Word glut: marketing Frank Lloyd Wright," *Design Book Review*, (Spring 1990), 61-65.

2130. Bugbee, Gordon Pritchard. *Domino's mansion: Thomas Monaghan, Gunnar Birkerts and the spirit of Frank Lloyd Wright*. Troy: Planning Research Organization for a Better Environment Press; 1988. Second edition, Paul Chu Lin ed., Carbondale: Southern Illinois University Press, 1995.

2131. Christie, Manson and Woods International Inc. *Important Frank Lloyd Wright and American arts and crafts furnishings, including ceramics: the properties of the estate of Mr. and Mrs. Leon Saltz, The Walnut Creek Historical Society and various other properties, Saturday June 11, 1988, at 10:00 a.m. precisely (lots 1-142)*. New York: Christie's, 1988. Auction catalog.

2132. City of Los Angeles Department of Cultural Affairs. *Frank Lloyd Wright in Los Angeles, 1919-1926: an architecture for the southwest*. Los Angeles: The Department, 1988. Catalogue of an exhibition at the Los Angeles Municipal Art Gallery, Barnsdall Park, January-March 1988, sponsored by the Department and the USC School of Architecture. Reviewed Robert Lawrence Sweeney, "Wrights and wrongs," *L.A. Architect*, (March 1988), 8-9; and Neil Jackson, "Two Wright angles," *Building Design*, (March 1988), 11, 24-25.

2133. Conan, Michel ed. *Frank Lloyd Wright et ses clients: essai sur la demande adressée par des familles aux architectes / recherche effectuée dans le cadre du Programme Conception et usage de l'habitat du Plan-construction et architecture. [par le] CSTB, Centre Scientifique et Technique du Bâtiment, Service Sciences Humaines*. Paris: Plan Construction et Architecture, 1988.

French: *Frank Lloyd Wright and his clients; essay on the demands addressed by the families to architects. Research under the aegis of the Program design and use of habitat program of Plan-construction and Architecture [by] the Building Industry Scientific and Technical Centre [CSTB], Social Sciences Service.*

2134. Fishman, Robert. "The post-war American suburb: a new form, a new city." In Daniel Schaffer ed. *Two centuries of American planning*, London: Mansell, 1988. Cf. *idem.*, "Prospect. Urban decentralization and the new American landscape, 1946-." *Landscape Architecture*, 78(December 1988), 156.

2135. Frank Lloyd Wright Foundation. *Frank Lloyd Wright decorative designs collection.* n.l.: The Foundation, 1988. Catalogue of reproductions authorized by the Foundation and produced by Atelier International, Oakbrook Esser Studios, Schumacher, and Tiffany and Co.

2136. Gebhard, David and Scot Zimmerman. *Romanza: the California architecture of Frank Lloyd Wright.* San Francisco: Chronicle, 1988. Reviewed Peter Blundell Jones, *Architectural Review*, 186(October 1989), 12. Reissued as *The California architecture of Frank Lloyd Wright.* San Francisco: Chronicle, 1997.

2137. Historic Madison, Inc. *Contemporaries of Frank Lloyd Wright: the 1988 alternate parade of homes presented by Historic Madison, Inc.* Madison: Historic Madison, 1988. Brochure.

2138. Madison Public Library. *Architecture of Frank Lloyd Wright in Wisconsin.* Madison: The Library, 1988. Abstracted from Storrer, *The Architecture of Frank Lloyd Wright: a complete catalog*, Cambridge, Mass.: 1978.

2139. Madison Public Library. *By and about Frank Lloyd Wright.* Madison: The Library, 1988. Bibliography.

2140. Nuttgens, Patrick ed. *Mackintosh and his contemporaries in Europe and America.* London: J. Murray, 1988. Reviewed Pat Kirkham, *Journal of Design History*, 1(no. 2, 1988), 147-48; and Stephen Games, *Charles Rennie Mackintosh Society Newsletter*, (Spring 1988), 8-9.

2141. Pfeiffer, Bruce Brooks and Gerald Nordland eds. *Frank Lloyd Wright: in the realm of ideas.* Carbondale: Southern Illinois University Press, 1988. The catalogue of a traveling exhibition organized by the Scottsdale Arts Center Association includes "Frank Lloyd Wright's concept of democracy: an American architectural jeremiad" by Narciso G. Menocal; "Organic architecture: the principles of Frank Lloyd Wright" by Aaron G. Green; "Frank Lloyd Wright in 1893: the Chicago context" by Jack Quinan; and "The second career: 1924-1959" by Pfeiffer.
 The exhibition, announced "Another look at Frank Lloyd Wright," *Interior Design*, 58(December 1987), 42-3, was first mounted at the Dallas Museum of Art, Texas, January-March 1988. It moved to the National Museum of American History, Washington D.C., June-September 1988; Center for the Fine Arts,

Miami, December 1988-March 1989; Museum of Science and Industry, Chicago, June-September 1989 (augmented and renamed "Frank Lloyd Wright: ideas and treasures"); Scottsdale Center for the Arts, January-March 1990; and San Diego Museum of Art, June-August 1990. It was shown in Japan in 1990 and 1991, with a catalogue edited by Richard Carney et al. (Japanese; title and captions in English).

For review and comment see Mitchell B. Rouda, "... Wright exhibit opens in Dallas," *Builder*, 11(January 1988), 146-47, 150; Julia Collins, "Wright's realm of ideas," *ID: magazine of international design*, 35(January-February 1988), 86; Kathryn Collmer, "Designs for living," *Southwest Art*, 17(February 1988), 86; David Dillon, "Usonian house anchors disjointed Wright exhibit," *Architecture*, 77(March 1988), 30, 34; Sandy Heck, "FLW: organic delight," *Architectural Review*, 183(March 1988), 4. (cf. *idem.*, "Wright's ideas in Dallas," *Architectural Record*, 176 [March 1988] 65; and *A+U*, [April 1988], 15-18 [Japanese and English]); James A. Murphy, "FLLW exhibit opens in Dallas," *Progressive Architecture*, 69(March 1988), 37-38; Deborah Slaton, "In the realm of ideas," *Inland Architect*, 33(July-August 1989), 24, 28; Patrick Pinnell, "Mr. Wright comes to Washington," *Museum and Arts Washington*, 4(July-August 1988), 30; John Gillis, "Wright and wrong ideas," *Reason*, 20(March 1989), 48-50; and Robert Twombly, "Word glut: marketing Frank Lloyd Wright," *Design Book Review*, (Spring 1990), 61-65.

See also Judith Arango, "Automatic house," *Design Week*, 3 (9 December 1988), 21; Mary Rawcliffe Colton, "Ramona Sakiestewa: the Wright commissions: Usonian house, Dallas Museum of Art; traveling exhibit," *Shuttle Spindle and Dyepot*, 20(Spring 1989), 17-19; "'Automatic' house on tour," *ENR*, (March 1989), 32; and Timothy W. Luke, *Shows of force: power, politics, and ideology in art exhibitions*. Durham: Duke University Press, 1992.

2142. Pfeiffer, Bruce Brooks and Yukio Futagawa. *Frank Lloyd Wright. Vol. 7. Monograph 1942-1950*. Tokyo: ADA Edita, 1988. Japanese and English.

2143. Pfeiffer, Bruce Brooks and Yukio Futagawa. *Frank Lloyd Wright. Vol. 8. Monograph 1951-1959*. Tokyo: ADA Edita, 1988. Japanese and English.

2144. Treiber, Daniel. *Frank Lloyd Wright*. Paris: Hazan, 1986. French. British edition London; New York: Spon, 1995. Also published in German, Basel: Birkhäuser, 1988 and Spanish, Madrid: Akal, 1996.

2145. Western Pennsylvania Conservancy. *Frank Lloyd Wright's Fallingwater*. Pennsylvania: The Conservancy, 1988.

2146. Wright, Frank Lloyd. *In pursuit of order: Frank Lloyd Wright from 1897 to 1915*. Chicago: Struve Gallery, 1988. Catalogue of an exhibition, December 1988-January 1989.

2147. *The Ennis-Brown house*. Los Angeles: Trust for Preservation of Cultural Heritage, 1988.

2148. *Preserving Wright's heritage: third annual symposium, March 24-27, 1988.* Ann Arbor: Domino's Farms, 1988. Brochure announcing a symposium sponsored by Thomas Monaghan in cooperation with the University of Michigan's College of Architecture and Urban Planning and Extension Service, at Domino's Farms headquarters, Ann Arbor. See K. Andersen, "Showcase for an obsession," *Time*, (4 April 1988), 73-74; Robert Benson, "The Pizza Pantheon and F.L. Wright," *Progressive Architecture*, 69(May 1988), 24, 26; and Cheryl Kent, "The urge to acquire Frank Lloyd Wright," *Inland Architect*, 32(July-August 1988), 72-74.

Periodicals
2149. Anderson, Stevens R. "The structural architecture of major modernists: illustrated by a selection of their 'divine details'." *Architecture*, 77(March 1988), 110-14. Drawings by Wright (i.a.).

2150. Banham, Reyner. "Das wohl-temperierte Haus." *Arch Plus*, (no. 93, 1988), 39-47. German: "The well-tempered house." Prairie houses.

2151. Bernier, Olivier. "The Wright bowl." *American Heritage*, (November 1988), 28.

2152. Birksted, Ian. "Private view. The ins and outs of organic art." *Architects' Journal*, 187(5 October 1988), 103.

2153. Cornoldi, Adriano et al. "[Special issue] Teorie dello spazio domestico." *Parametro*, 19(September-October 1988), 16-69, 91. Italian: "Theory of domestic space."

2154. Craig, Tracey-Linton. "Pizza entrepreneur to open Frank Lloyd Wright Museum." *Museum News*, 66(January-February 1988), 9. Thomas Monaghan, owner of Domino's Pizzas, opened a museum devoted to Wright's furniture and decorative works.

2155. Crotta, Carol A. "Living architecture: Frank Lloyd Wright." *California*, 13(November 1988), 118-24. Los Angeles houses.

2156. Davis, D. "The Wright stuff." *Newsweek*, (1 February 1988), 52-54.

2157. Drew, Philip. "The European effect: Wasmuth: the beginning of Wright's foreign influence." *Architecture Bulletin [Australia]*, (March 1988), 3, 5. The issue was published to celebrate the acquisition of *Ausgeführte Bauten* by the Royal Australian Institute of Architects.

2158. Eeles, Bruce. "Bruce Rickard on FLW." *Architecture Bulletin [Australia]*, (March 1988), 11, 15. Transcript of interview. The issue was published to celebrate the acquisition of *Ausgeführte Bauten* by the Royal Australian Institute of Architects.

2159. Filler, Martin. "The Wright Way: Frank Lloyd Wright's La Miniatura is his masterpiece of sunlight and shadow." *House and Garden*, 160(October 1988), 150-155, 231.

2160. Goldberger, Paul. "Frankie went to Hollywood." *World of Interiors*, (March 1988), 1124-31. Storer house.

2161. Hanks, David A." Collecting Frank Lloyd Wright: vandalism or public service?: dismantlement [*sic*] and dispersal of Wright's interiors." *Architectural Record*, 176(July 1988), 67 ff.

2162. Heck, Sandy. "Wright stuff." *Connoisseur*, 218(February 1988), 26, 28. Reproductions of Wright furniture.

2163. Henderson, Justin. "Midwest museum for Frank Lloyd Wright." *Interiors*, 148(March 1988), 112. Building designed by Gunnar Birkerts to house Thomas Monaghan's collection of Wrightiana.

2164. Holzhueter, John A. "Frank Lloyd Wright's designs for Robert Lamp." *Wisconsin Magazine of History*, 72(Winter 1988-1989), 82-125. For comment see Marian Mumford Brown, Mary Jane Hamilton, and William Marlin, [Letters to the editor], *ibid.*, 73(Spring 1989), 42-45.

2165. Johnson, Donald Leslie. "The antipodean effect." *Architecture Bulletin* [Australia], (March 1988), 7. Discusses the reactions in Australia to Wright's architecture, with comment on Walter Burley Griffin's work. The issue was published to celebrate the acquisition of *Ausgeführte Bauten* by the Royal Australian Institute of Architects.

2166. Johnson, Donald Leslie. "Broadacres geometry: 1934-35." *Journal of Architectural and Planning Research*, 5(Summer 1988), 129-44.

2167. Kent, Cheryl. "Unanimity on Unity Temple." *Inland Architect*, 32(March-April 1988), 17, 20, 23.

2168. Koppelkamm, Stefan. "Il frammento dell'Imperial Hotel di Frank Lloyd Wright a Meiji-Mura." *Domus*, (May 1988), 10-11. Italian and English: "The fragment of Wright's Imperial Hotel at Meiji-Mura."

2169. Maimon, Jill. "Live from Pennsylvania: it's Frank Lloyd Wright." *Arts and Crafts Quarterly*, 2(no. 3, 1988), 7-9.

2170. Mansberger, Floyd and Carol Dyson. "Historical archaeology—filling in the gaps." *Construction Specifier*, (1988), 114. Dana house.

2171. Mason, B. "The Wright stuff is suddenly hot." *Business Week*, (5 December 1988), 181.

2172. McArthur, Warren. "The Arizona Biltmore, the McArthur brothers, and Frank Lloyd Wright." *Triglyph*, (Summer 1988), 36-47.

2173. Mickunas, Mark and Patricia Zingsheim. "Trier residence: one man's art." *Iowa Architect*, 36(March-April 1988), 30-33.

2174. Miller, Ross. "Burnham, Sullivan, Roark, and the myth of the heroic architect." *Museum Studies*, 13(no. 2, 1988), 93-95.

2175. Misawa, Hiroshi. [Cassina Japan Inc., Head Office; exhibit]. *A + U*, (January 1988), 6-7. Japanese

2176. Molteni, Pierluigi. "Frank L. Wright a San Francisco." *Frames, Porte and Finestre*, (January-March 1988), 58-59. Italian: "Wright in San Francisco." V.C. Morris gift shop.

2177. Nesmith, Lynn. "Unity Temple granted first easement on a religious building." *Architecture*, 77(March 1988), 26.

2178. Newton, David. "Millikin Place: Decatur's architectural park." *Historic Illinois*, 11(December 1988), 8-12. Residential neighborhood with designs by Wright, Marion Mahoney, Walter Burley Griffin.and others.

2179. Pélissier, Alain. "De l'ouverture et de la fermeture: recherche sur l'espace contemporain dans les lieux de travail." *Techniques et Architecture*, (July-August 1988), 62-65. French: "Of opening and closing; research into contemporary space in the workplace;" English, Spanish summaries.

2180. Quinan, Jack. "L'ingegneria e gli ingegneri di Frank Lloyd Wright *Casabella*, 52(April 1988), 42-53. Italian: "Engineering and Frank Lloyd Wright's engineers;" English summary. Discusses Mendel Glickman, William Wesley Peters and Jaroslav Joseph Polivka.

2181. Reinius, Leif. "Wright contra Corbu." *Arkitektur: the Swedish Review of Architecture*, 88(March 1988), 54-59. Swedish: "Wright versus Le Corbusier."

2182. Sciliberto, Elena. "Alle origini del 'moderno' nordamericano: l'opera di Silsbee e la sua inedita Richardson House." *Architettura, Storia e Documenti*, (no. 1-2, 1988), 66-98. Italian: "To the origins of North American 'modern': the work of Silsbee and the unknown Richardson House;" English summary.

2183. Silva, Maria Angelica da. "De Wright a Pollock: o deserto, a cascata e a scena moderna americana." *Gavea*, (December 1988), 58-71. Portuguese: "From Wright to Pollock: the desert, the waterfall and the American modern scene."

2184. Smith, Kathryn. "Frank Lloyd Wright's unknown Imperial Hotel annex." *Space Design*, (July 1988), 77-80. Japanese and English.

2185. Sobin, Harris J. et al. "Additions and restorations." *Triglyph*, (Winter 1988-1989), 23-32. Adelman house.

2186. Swaback, Vernon D. "Frank Lloyd Wright." *Arizona Highways*, 64(November 1988), 36-45. Personal reminiscences of Taliesin West.

2187. Weirick, James. "Walter Burley Griffin, landscape architect: the ideas he brought to Australia." *Landscape Australia*, (August 1988), 241-46, 255-56. Griffin's career in Chicago, especially at Wright's Oak Park studio.

2188. Wesley, Richard. "The polarities of paradise in the works of Frank Lloyd Wright." *Via*, (no. 9, 1988), 52-65. Wright's Oak Park house and additions; quadruple block houses (1901).

2189. Whitmore, George. "The domino effect." *House and Garden*, 160(February 1988), 22, 26, 32. Subtitled, "Tom Monaghan's obsession with Frank Lloyd Wright has jolted the market for the master's works." See also Rich Ahern,"The neglected legacy of Frank Lloyd Wright," *Journal of the Taliesin Fellows*, (Autumn 1990), 8-12; 18. Monaghan's collection from the National Center for the Study of Frank Lloyd Wright was later dispersed; see Peter Slatin, "Wright artifact sell-off raises new questions," *Architectural Record*, 182(June 1994), 37.

2190. *Colonnade: the News Journal of the School of Architecture, University of Virginia*. "Manhattan museum additions: a discussion with Charles Gwathmey and Michael Graves." 3(Summer 1988), 15-19. Guggenheim museum.

2191. *Connaissance des Arts*. "Mile high [drawing, 1956]." (September 1988), 4; cf. *ibid.*, (October 1988), 6.

2192. *Connoisseur*. "Table lamp (ca. 1908)." 218(June 1988), 58. Image only.

2193. *Friends of Fallingwater Newsletter*. [White House Preservation Fund visit]. (August 1988). The issue also includes "Nudging nature" (profiles of volunteers at Fallingwater).

2194. *Preservation News*. "FLW Research Center debuts." 28(January 1988), 12; 20. On the opening of the Research Center of the Frank Lloyd Wright Home and Studio, October 1987.

2195. *Progressive Architecture*. "Wright buys." (January 1988), 25. Notes purchase of FLW furnishings for Dana House.

2196. *Techniques et Architecture*. "Sur la prairie: Siege de la compagnie Domino's Pizza, Ann Arbor. Michigan." (August-September 1988), 128-33. French: "On the prairie: castle of the Domino's Pizza company... ;" English and Spanish summaries. Plans to construct Wright's unbuilt "Golden Beacon"; (architects: Gunnar Birkerts and Associates).

1989
Books, monographs and catalogues
2197. Allen, James R. et al. *Dana-Thomas House, Springfield, Illinois: Frank Lloyd Wright, architect*. Springfield: Dana-Thomas House Foundation, 1989.

2198. Bock, Richard W. *Memoirs of an American artist: sculptor Richard W. Bock*. Los Angeles: C.C. Publishing, 1989.

2199. Cook, Michael. *An index to the Frank Lloyd Wright monograph series*. Tempe: Arizona State University, Architecture and Environmental Design Library, 1989.

2200. Frank Lloyd Wright Home and Studio Foundation. *Annual report[s]*. Oak Park: The Foundation, 1989- . First in the series, which continues.

2201. Hanks, David A. *Frank Lloyd Wright: preserving an architectural heritage: decorative designs from the Domino's Pizza collection.* New York: E. Dutton. 1989. Organized by the Smithsonian Institution, an exhibit of decorative works from Domino's National Center for the Study of Frank Lloyd Wright were shown at the Chicago Historical Society, April-June 1990; the Philadelphia Academy of Fine Arts, March-April 1991; Dallas Museum of Art, May-July 1991. There is an introductory essay, "Collecting versus preservation of Frank Lloyd Wright's decorative designs".

See also Justin Henderson, "Over 300 Wright pieces go on public display at Center for the Study of Frank Lloyd Wright in Ann Arbor," *Interiors*, 148(October 1988), 112; and "Traveling exhibit poster of Frank Lloyd Wright decorative objects," *Communication Arts Magazine*, 32(July 1990), 100 (image only).

For comment see Homan Potterton and Thomas Monaghan, "Corporate Wrights," *Apollo*, 130(December 1989), 402-403; "All's Wright with this furniture," *Americana*, (December 1989), 25; "Wright exhibit opens at Chicago Historical Society," *Wright Angles*, 16 (Spring 1990), 2; and *American History Illustrated*, 26(March-April 1991), 12.

2202. Hill, David R. *America's disparate organicists: from Frank Lloyd Wright to Paolo Soleri.* Hilliard: Society for American City and Regional Planning History, 1989.

2203. Holzhueter, John O. *Cudworth Beye, Frank Lloyd Wright, and the Yahara River Boathouse, 1905.* Madison: State Historical Society of Wisconsin, 1989. See also *idem.*, "Cudworth Beye, Frank Lloyd Wright, and the Yahara River Boathouse, 1905," *Wisconsin Magazine of History*, 72(Summer 1988), 163 ff. and "Frank Lloyd Wright's 1893 boathouse designs for Madison's Lakes," *ibid.*, 72(Winter 1988), 273-92.

2204. Kaufmann, Edgar J. Jr. *Nine commentaries on Frank Lloyd Wright.* New York: Architectural History Foundation; Cambridge Mass.: MIT Press, 1989. Reprints essays (some with revisions): "Frank Lloyd Wright's years of modernism, 1925-1935," *JSAH*, 24(March 1965); "Crisis and creativity: Frank Lloyd Wright, 1904-1914," *ibid.*, 25(December 1966); "Frank Lloyd Wright: plasticity, continuity, and ornament," *ibid.*, 37(March 1978); "Precedent and progress in the work of Frank Lloyd Wright," *ibid.*, 34(May 1980); "*Form* became *feeling*,' a new view of Froebel and Wright," *ibid.*, 40(May 1981); and "Frank Lloyd Wright's mementos of childhood," *ibid.*, 41(October 1982).

Previously unpublished essays include "Frank Lloyd Wright's 'Lieber meister" (includes the 1925 testimony of Chicago builder, Paul Mueller from a lawsuit over the Chicago Auditorium Building); "Frank Lloyd Wright and 'The Sovereignty of the Individual'"; "'The New Order of this machine age'"; and "Frank Lloyd Wright and Gottfried Semper". Reviewed Patrick Joseph Meehan, *Architecture*, 79(August 1990), 126-27; *Progressive Architecture.* (July 1990), 102; Bettina Liverant, *Canadian Architect*, 35(October 1990), 8; and Alan Blanc, "More pot-boiler than Wright stuff," *World Architecture*, (no. 10, 1991), 80-81.

2205. Lind, Carla ed. *Historic structure report for the Isadore J. and Lucille Zimmerman House, 223 Heather Street, Manchester, New Hampshire prepared by Tilton and Lewis Associates.*. Manchester, N.H.: Currier Gallery of Art, 1989.

2206. Menocal, Narciso G. "Frank Lloyd Wright as the anti-Victor Hugo." In Craig Robert Zabel and Susan Scott Munshower eds. *American public architecture: European roots and native expression*, Pennsylvania State University Department of Art History, 1989. Reviewed Kenneth A. Breisch, *JSAH*, 50(March 1991), 96-98.

2207. Pfeiffer, Bruce Brooks and Yukio Futagawa. *Frank Lloyd Wright selected houses. Vol. 3. Taliesin West.* Tokyo: ADA Edita, 1989. Japanese and English.

2208. Pfeiffer, Bruce Brooks. *Frank Lloyd Wright: the crowning decade, 1949-1959/selected and with commentary by Bruce Brooks Pfeiffer.* Fresno: California State University Press, 1989. Reprinted 1990.

2209. Storrer, William Allin. *The one-hundredth anniversary edition of the architecture of Frank Lloyd Wright: a guide to extant structures.* Newark: The Author, 1989. Cf. *idem., The architecture of Frank Lloyd Wright: a guide to extant structures.* Paperback edition, 1997.

2210. Tanigawa, Masami. *Frank Lloyd Wright, Yamamura House: an architectural "relic" from the lean, lost years.* Tokyo: A.D.A. Edita Tokyo, 1989. Japanese and English.

2211. Wright, Frank Lloyd. *Per la causa dell'architettura.* Rome: Gangemi, 1989. Italian translation of the "In the cause of architecture" essays published in *Architectural Record*, 1908-1928.

2212. Wisconsin. Governor's Commission on Taliesin. *Report and recommendations/Governor's Commission on Taliesin.* Madison: The Commission, 1989.

2213. *Working with an architect: the Littles and Frank Lloyd Wright.* s.l.: s.n., 1989. Booklet produced for the Smithsonian Institution Travelling Exhibition Service (SITES).

Periodicals

2214. Abernathy, Ann and Len Fieroh. "Restoring Frank Lloyd Wright's Oak Park home." *Fine Homebuilding*, (October-November 1989), 82-87.

2215. Alofsin, Anthony Michael. "Broadacre City: the reception of a modernist vision, 1932-1988." *Center*, 5(1989), 5-43.

2216. Benjamin, David. "Foundation preserves Frank Lloyd Wright designs, Ann Arbor, Michigan." *Journal of Art*, 1(April 1989), 11.

2217. Boles, Daralice Donkervoet. "From house to HQ: Charnley House restoration; headquarters for the Skidmore, Owings and Merrill Foundation." *Progressive Architecture*, 70(April 1989), 76-81.

2218. Boonyatikarn, Soontorn. "The integration of technology and design: an analysis of Fallingwater." *Avant Garde*, (Summer 1989), 38-53.

2219. Buechel, Wolfgang. "Das Glueck einer nirgends dimensionierten Ausgewogenheit." *Daidalos*, (no. 31, 1989), 66-75. German: "The fortune of a never-dimensioned harmony."

2220. Cassidy, Victor M. "Restoration of Taliesin East." *Progressive Architecture*, 70(July 1989), 19, 24.

2221. Cessa, C. de. "Capire gli invasi. Ermeneutica per l'architettura." *L'Architettura*, 35(July-August 1989), 555. Italian: "To understand the invasion. Hermeneutics for architecture"

2222. Donahue, K. and S. Gabor. "Frank Lloyd Wright: Oak Park home and studio." *Art Education*, 42(February 1989), 33.

2223. Donohue, Judith. "Fixing Fallingwater's flaws: the leaks and deteriorating concrete." *Architecture*, 78(November 1989), 99-101.

2224. Ellis, Charlotte et al. "[Special issue] American work abroad." *Architecture*, 78(January 1989), 42-90.

2225. Fisher, Thomas R. et al. "Restoring modernism." *Progressive Architecture*, 70(April 1989), 75-97.

2226. Gentle, Thom and Victoria Jefferies. "Conservation of furniture at Frank Lloyd Wright's Fallingwater." *Association for Preservation Technology Bulletin*, 21(no. 3-4, 1989), 55-61.

2227. Gill, Brendan. "Among the survivors." *Preservation League of New York State Newsletter*, 15(no. 2, 1989), 6-7.

2228. Gomez, Edward M. "Doing right by Wright." *Art News*, (January 1989), 36-37. Subtitled, "Private owners of Wright-designed residences and nonprofit groups that restore and protect them are facing a preservationist crisis."

2229. Guise, David. "Preservation: Price Tower vacant." *Progressive Architecture*, 70(April 1989), 21, 26.

2230. Hall, Jonathan, Richard Patterson and Martin Goalen. "Wright interpretation." *Building Design*, (1 December 1989), 2. Reports Neil Levine's Sir Banister Fletcher lectures on Wright, Bartlett School, London, November 1989.

2231. Hallmark, Donald Parker. "Frank Lloyd Wright's Dana-Thomas house: its history, acquisition, and preservation." *Illinois Historical Journal*, 82(February 1989), 113-26. Reprinted as a book, Springfield: Illinois Historic Preservation Agency, 1990.

2232. Hartoonian, Gevork. "Metier: the tradition of dwelling." *Traditional Dwellings And Settlements Working Paper Series*, 16(1989), 1-21.

2233. Howard, Hugh. "Wright house forever surprises the eye." *Preservation News*, 29(October 1989), 3. Darwin D. Martin house.

2234. Kaufmann, Edgar J.Jr. "A stronghold of light: Frank Lloyd Wright's Johnson Wax Building at 50." *Interior Design*, 60(February 1989), 236-37.

2235. Klinkow, Margaret. "A day in the life of Frank Lloyd Wright." *Inland Architect*, 33(March-April 1989), 26, 70. Acquisition by the Frank Lloyd Wright Home and Studio Foundation of 18 drawings by Wright and Catherine Tobin Wright, 1888-1889.

2236. Kopp, Michael. "Mr Wright in Japan: beyond the Imperial." *Architecture*, 78(January 1989), 72-75.

2237. Littleton, Gregory. "The Wright Stuff: The Oakbrook-Esser Studio re-introduces Frank Lloyd Wright windows." *Interiors*, 148(March 1989), 54.

2238. Manson, Grant Carpenter. "The wonderful world of Taliesin; my twenty years on its fringes." *Wisconsin Magazine of History*, 73(Autumn 1989), 33-41.

2239. Matthews, A. "The leaning power of pizza." *Forbes*, 144(September 1989), 28-33. Thomas Monaghan, founder of Domino's Pizza, collection of Wrightiana. Cf. Beth Leibson, "Domino's CEO Monaghan collects the Wright stuff," *Facilities Design and Management*, 8(October 1989), 94-97.

2241. Mays, Vernon. "Revealing Wright: preliminary interior renovations, Solomon R. Guggenheim Museum, New York." *Progressive Architecture*, 70(April 1989), 82-85.

2242. Monfried, Andrea E. "Doing the Wright thing." *Progressive Architecture*, 70(November 1989), 23-24. L.A. developer Charles Klotsche employs Wright's unrealized designs: pottery house and boulder house. See also "Legacy of F.L. Wright: unfinished plans realized," *Space Design*, (August 1990), 69-76.

2243. Mumford, Mark. "Form follows nature: the origins of American organic architecture." *Journal of Architectural Education*, 42(Spring 1989), 26 ff.

2244. Nesmith, Lynn. "Edgar J. Kaufmann, Jr.: author and architectural historian." *Architecture*, 78(September 1989), 38. Obituary for Wright's sometime apprentice, who added much to the literature. See also *Progressive Architecture*, 70(September 1989), 30; Stanley Abercrombie, *Interior Design*, 60(September 1989), 67, 69; Brendan Gill, "Edgar J. Kaufmann, Jr.—secrets of Wright and Fallingwater," *Architectural Digest*, 47(March 1990), 50-64; and Bruce Brooks Pfeiffer, "Edgar J. Kaufmann, Jr. made a noble contribution," *Journal of the Taliesin Fellows*, (Summer 1991), 8-9. See also "Memorial gathering," *Friends of Fallingwater Newsletter*, (January 1990), 2-3 and "Edgar J. Kaufmann Jr: a self-portrait," *ibid.*, 6-7.

2245. Nesmith, Lynn. "Prairie style apartment in Manhattan: David Hannaford Mitchell's 'homage to Wright'." *Architecture*, 78(June 1989), 62-63.

2246. Nesmith, Lynn. "Wright's 'Butterfly' bridge: will it fly today?" *Architecture*, 78(October 1989), 31. Butterfly-wing bridge near San Francisco, connecting San Bruno and San Leandro. See also N. Zeman, "Bay area is talking," *Newsweek*, (14 August 1989), 6.

2247. Newton, David. "Burnham and Root's Rookery building." *Historic Illinois*, 12(December 1989), 4-7, 13. Restoration to 1905 appearance, incorporating Wright's alterations.

2248. Patterson, Richard and Neil Levine. "Wright interpretation." *Building Design*, (1 December 1989), 2. Sir Banister Fletcher lectures on Wright.

2249. Plummer, Henry. "Special issue. The potential house: three centuries of American dwelling." *A+U*, (September 1989), 6-277. Japanese and English. Includes Storer and H.C. Price houses; Fallingwater; and Taliesin West.

2250. Potterton, Homan. "New York, New York." *Apollo*, 129(April 1989), 270-72. Reports Gwathmey Siegel and Associates planned extensions to the Guggenheim museum.

2251. Purves, Alexander. "This goodly frame, the earth: Wright's Fallingwater and Aalto's Villa Mairea." *Perspecta* (1989), 178-201.

2252. Not used.

2253. Quinan, Jack. "Frank Lloyd Wright: fortune critiche 1959-1989." *Casabella*, (July-August 1989), 33-34. Italian: "Frank Lloyd Wright: critical fortune 1959-1989." Reviews the literature on Wright.

2254. Quinan, Jack. "Letter [Frank Lloyd Wright's Larkin Building papers]." *JSAH*, 48(June 1989), 210.

2255. Rubin, Jeanne S. "The Froebel-Wright kindergarten connection: a new perspective." *JSAH*, 48(March 1989), 24-37. Responses by Paul Theerman, Anthony Michael Alofsin, and Donald Leslie Johnson, *JSAH*, 48(December 1989), 413-4, with Rubin's rejoinder.

2256. Saltz, Jerry. "'I could live here': a trip to Frank Lloyd Wright's Fallingwater." *Arts Magazine*, 63(March 1989), 23-24.

2257. Schwentker, James M. "Topic A: Los Angeles's house museums." *Interior Design*, 60(April 1989), 54, 58. Hollyhock house (i.a.)

2258. Speck, Lawrence W. "The individual and the city." *Center*, 5(1989), 105-116. Influence of Wright and Le Corbusier on twentieth century urbanism.

2259. Strever, Beth. "Wright revisited." *Home and Building*, (October-November 1989), 52-53.

2260. Tanaka, Koichi. " Yamamura residence: preserved as Japanese cultural asset inheritance from Frank Lloyd Wright." *Japan Architect*, 64(September 1989), 4. Japanese and English.

2261. Tanigawa, Masami. "Trip to epoch-making Frank Lloyd Wright: Yama-mura House." *GA Houses*, (November 1989), 16-21. Japanese and English.

2262. Wagner, Michael. "Breaking ground." *Interiors*, 149(November 1989), 130. Renovation of 1888 Rookery building. Chicago.

2263. Wright, Frank Lloyd. "The print and the Renaissance." *L'Architettura*, 35(April 1989), 282-91. English and Italian; French, German, Spanish summaries. First publication of an essay written 15 November 1917. Reprinted in Pfeiffer, ed., *Frank Lloyd Wright collected writings. Vol.1.1894-1930.* New York: 1992.

2264. Not used.

2265. *Architects' Journal*. "A smaller splash." 189(no. 23, 1989), 60.

2266. *Architectural Record*. "You can help Wright a wrong." 177(August 1989), 35. Ennis-Brown House.

2267. *Commercial Renovation*. "Chicago's Rookery to be an empty nest no longer." 11(October 1989), 11-12.

2268. *Friends of Fallingwater Newsletter*. "Frank Lloyd Wright Building Owners Conference." (January 1989). The issue also includes "Fallingwater apprentice reminiscences."

2269. *L'Architettura*. "Frank Lloyd Wright: nel regno delle idee." 35(September 1989), 664-65. Italian: "Frank Lloyd Wright: in the realm of ideas."

2270. *Sunset*. "Restoring a Frank Lloyd Wright jewel." October 1989), 108. Carlson house.

2271. *Time*. "Antoni Gaudi meets Frank Lloyd Wright." 134(no. 2, 1989), 64.

1990-1999

1990
Books, monographs and catalogues

2272. Breiner, David M. *The Solomon R. Guggenheim Museum, 1071 Fifth Avenue, Manhattan: report: Frank Lloyd Wright, architect.* New York: New York Landmarks Preservation Commission, 1990. See also *idem.*, *Guggenheim Museum, ground floor interior: report: Frank Lloyd Wright.* New York: Landmarks Preservation Commission, 1990.

2273. Brooks, Harold Allen et al. *Frank Lloyd Wright.* Barcelona: Stylos, 1990. Spanish. Reprinted Barcelona: Ediciones del Serbal, 1993.

2274. Butterfield and Butterfield, San Francisco. *The Walter Winchell files and the Peter Kump collection of Frank Lloyd Wright books, manuscripts and folios.* San Francisco 1990. Auction catalogue.

2275. Carpenters Contractors Cooperation Committee of Southern California. *Concrete in California.* Los Angeles: The Committee, 1990. Essays include "Frank Lloyd Wright's textile block system: the Freeman House" by Jeffrey Mark Chusid (cf. *Antiques and Fine Art*, 7[January 1990], 76-83. Originally presented at the Association of Collegiate Schools of Architecture Technology Annual Conference, USC School of Architecture, February 1990); and "Chicago—Los Angeles: the concrete connection" by Kathryn Smith.

2276. Davis, Douglas. *The museum transformed: design and culture in the post-Pompidou age.* New York: Abbeville Press, 1990. Guggenheim Museum. Reviewed E. V. Thaw, "Art and circuses," *New Republic*, 206(30 March 1992), 41-43.

2277. Dellin, Mary A. *Frank Lloyd Wright: facets of design.* Norfolk: Chrysler Museum, 1990. Catalogue of an exhibition of graphic designs, furniture and

photographs from Domino's Center for Architecture and Design, November 1990-January 1991.

2278. Ford, Edward R. *The details of modern architecture*. Cambridge, Mass.: MIT Press, 1990-1996. 2 vols. Includes "Frank Lloyd Wright in Oak Park" and "Frank Lloyd Wright". Also published in German as *Das Detail in der Architektur der Moderne: zur Logik der Konstruktion bei Edwin Lutyens, Frank Lloyd Wright* [etc.], Basel: Birkhäuser, 1994.

2279. Green, Aaron G. and Donald P. DeNevi. *An architecture for democracy: the Marin County Civic Center: a narrative by the associated architect*. San Francisco: Grendon, 1990. Reviewed Roderick Grant, *Journal of the Taliesin Fellows*, (Winter 1991), 11, 13.

2280. Hasbrouck Peterson Associates. *Art glass inventory: condition survey and preliminary restoration plan: the Darwin D. Martin House, Buffalo, New York: Frank Lloyd Wright, architect, 1904*. Chicago: The Associates, 1990.

2281. Hasbrouck Peterson Associates. *Furnishings inventory: condition survey and preliminary restoration plan: the Darwin D. Martin House, Buffalo, New York: Frank Lloyd Wright, architect, 1904*. Chicago: The Associates, 1990.

2282. Hasbrouck Peterson Associates. *An historic structure report: condition survey and preliminary restoration plan: the Darwin D. Martin House, Buffalo, New York: Frank Lloyd Wright, architect, 1904*. Chicago: The Associates, 1990.

2283. Johnson, Donald Leslie. *Frank Lloyd Wright versus America. The 1930s*. Cambridge, Mass.: MIT Press, 1990. Reviewed Donald Brackett, *Azure: Design Architecture and Art*, 8 (April-May 1991), 19; John Duel, "The Wright stuff," *Architects' Journal*, 194(11 September 1991), 68; Jonathan Hale, *Architectural Record*, 179(November 1991), 53; J.F. Meikle, *Journal of American History*, 78(March 1992), 1502; Robert Twombly, *JSAH*, 51(June 1992), 210-13; and Richard Wilcock, *RIBA Journal*, 100(March 1993), 20. Paperback edition 1994.

2284. Leslie Hindman [Auctioneers], Chicago. *Important 19th and 20th century architectural objects and designs, including prints, drawings, photographs, books, periodicals and letters relating to Frank Lloyd Wright and other Chicago architects*. Chicago: Leslie Hindman, 1990. Auction catalogue: estate of Helen H. Raab, April 1990.

2285. Lyons, Nan and Ivan Lyons. *Imperial taste: a century of elegance at Tokyo's Imperial Hotel*. Tokyo: Kodansha International, 1990; New York: Kodansha, 1991.

2286. Murphy, Wendy Buehr. *Frank Lloyd Wright*. Englewood Cliffs: Silver Burdett, 1990. Juvenile biography.

2287. Pfeiffer, Bruce Brooks. *Frank Lloyd Wright drawings: masterworks from the Frank Lloyd Wright Archives*. New York: Harry N. Abrams, 1990. Published in association with the Frank Lloyd Wright Foundation and the Phoenix Art Museum, linked to an exhibition of 302 drawings, January-April 1990. The

show is announced in *Casabella*, 53(December 1989), 23.

For review and comment see W. Cheek, *Architecture*, 79(March 1990), 32; Allison Ledes, "The artistry of Frank Lloyd Wright," *Antiques*, 137(February 1990), 396 ff.; "Frank Lloyd Wright: double spotlight: Phoenix Art Museum and the Seattle Art Museum; traveling exhibit," *Southwest Art* 19(February 1990), 129; C.G. McPherson, *Arizona Highways*, 66(February 1990), 38-44; Jeffrey Cook, "Rare Wright drawings in Phoenix," *Progressive Architecture*, 71(March 1990), 23-24; Russell T. Clement, *Library Journal*, 115(15 May 1990), 76; Stanley Allan, "Drawing the Wright way," *Inland Architect*, 34(May-June 1990), 90-96. German reviews appear in *Baumeister*, 87(January 1990), 64; and Christa Zeller, *Werk, Bauen + Wohnen*, 77(June 1990), 12-15.

Also published London: Thames and Hudson, 1990 and reviewed Dennis Sharp, "The art of drawing," *World Architecture*, 2(no. 4, 1990), 90; and Neil Parkyn, *Designers' Journal*, (May 1990), 115-16. The book was reprinted New York: Abradale Press, 1996.

See also Pfeiffer, "Tre disegni inediti di Frank Lloyd Wright [Three previously unpublished drawings by Wright]," *Domus*, (February 1990), 72-75 (Italian), drawings selected from the show.

2288. Pfeiffer, Bruce Brooks and Yukio Futagawa. *Frank Lloyd Wright selected houses. Vol. 1. Frank Lloyd Wright, William H. Winslow, Susan Lawrence Dana, Ward W. Willits, Frank Thomas, Arthur Heurtley, Darwin D. Martin, Frederick C. Robie, Avery Coonley, Meyer May, Frederik C. Bogk*. Tokyo: ADA Edita, 1990. Japanese and English. Introduction by Pfeiffer; mostly images.

2289. Pfeiffer, Bruce Brooks and Yukio Futagawa. *Frank Lloyd Wright selected houses. Vol. 2. Taliesin*. Tokyo: ADA Edita, 1990. Japanese and English. Introduction by Pfeiffer; mostly images.

2289a. Pfeiffer, Bruce Brooks and Yukio Futagawa. *Frank Lloyd Wright selected houses. Vol. 3. Taliesin West*. Tokyo: ADA Edita, 1990. Japanese and English. Introduction by Pfeiffer; mostly images.

2289b. Pfeiffer, Bruce Brooks and Yukio Futagawa. *Frank Lloyd Wright selected houses. Vol. 4. Fallingwater*. Tokyo: ADA Edita, 1990. Japanese and English. Introduction by Pfeiffer; mostly images.

2290. Pfeiffer, Bruce Brooks and Yukio Futagawa. *Frank Lloyd Wright selected houses. Vol. 5. Paul R. and Jean Hanna, Herbert F. Johnson, Leigh Stevens, Gregor Affleck, Lowell Walter, Herman T. Mossberg*. Tokyo: ADA Edita, 1990. Japanese and English. Introduction by Pfeiffer; mostly images.

2291. Saliga, Pauline ed. *Fragments of Chicago's past: the collection of architectural fragments at the Art Institute of Chicago*. Chicago: The Institute, 1990. Includes "Frank Lloyd Wright and the new order" by Donald Hoffmann. Reviewed Robert Twombly, "Fragments: in festschrift and in exhibition," *Design Book Review*, (Fall 1992), 56-60.

2292. Shockley, Jay. *"The Crimson Beech" (Cass House), 48 Manor Court*,

Richmondtown, Staten Island: "prefab No. 1" design (1956) by Frank Lloyd Wright for Marshall Erdman and Associates, Madison, Wisconsin: built 1958-59. New York: The New York Landmarks Preservation Commission, 1990.

2293. Sprague, Paul E. ed. *Frank Lloyd Wright and Madison: eight decades of artistic and social interaction.* Madison: Elvehjem Museum of Art, 1990. Published in connection with an exhibition curated by Mary Jane Hamilton at the museum, University of Wisconsin, September-October 1988.

There are essays about individual buildings and projects, as follows. John O Holzheuter: "Wright's designs for Robert Lamp"; "The Lakes Mendota and Monona boathouses"; and "The Yahara River boathouse". Timothy Heggland: "The Gilmore house". Hamilton: "The Madison Hotel"; "The Kehl Dance Academy"; "The Phi Gamma Delta fraternity house"; "The Nakoma Country Club"; "Nakoma Memorial Gateway"; "The Rentz house"; "The Sundt house"; "The Barton cottage"; "The Fly craft studio"; "The Builders' Company concrete block plant"; "The Unitarian meeting house"; "Neurological Treatment Center (Neuroseum)"; and "The Olin Terraces and Monona terrace projects". Donald G. Kalec: "The Jacobs house I" and "The Jacobs house II". Sprague: "The Jackson house"; "The Schwenn house"; "The Brooks house"; "The Marshall Erdman prefabricated buildings"; and (with Diane Filipowicz) "The Pew house". Sprague also wrote a critical conclusion, "Recurring theoretical and practical contradictions in Wright's Madison work". Reprinted 1991. Reviewed *Form Function Finland*, (no. 3, 1993), 18-19 (Finnish and English).

2294. Wilson, Richard Guy and Sidney K. Robinson eds. *Modern architecture in America: visions and revisions.* Ames: Iowa State University Press, 1990. Includes "Frank Lloyd Wright and Victor Hugo" by Robinson; "The Wright space: the parti of the prairie house" by Walter C. Leedy, Jr.; and "Mr. Wright and Mrs. Coonley: an interview with Elizabeth Coonley Faulkner" by Theodore Turak.

2295. Zanten, David van. "Frank Lloyd Wright's kindergarten: professional practice and sexual roles." In Ellen Perry Berkeley and Matilda McQuaid eds. *Architecture: a place for women*, Washington, D.C.: Smithsonian Institution Press, 1990.

2296. *The Imperial the first 100 years, 1890-1990.* Tokyo: Imperial Hotel, 1990.

Periodicals
2297. Alofsin, Anthony Michael. "Grundformen: eine Einführung in die versenkte Fläche." *Archithese*, 20(November-December 1990), 18-21. German: "Basic forms: an introduction to the sunken plane." Wright's ornament.

2298. Apostolo, Roberto. "'Wingspread', l'ultima prairi house di Frank Lloyd Wright." *Frames, Porte e Finestre*, (April-June 1990), 56-63. Italian: "'Wingspread', Wright's last prairie house."

2299. Auer, Gerhard. "Licht und Ordnung. Über die Lichtentwuerfe Frank Lloyd Wrights und Louis Kahns." *Architekt*, 60(September 1990), 390-94. German: "Light and order. The lighting designs of Wright and Louis Kahn."

2300. Brierly, Cornelia. "Changing patterns, 1934: historic [and other] events of a first fellowship year." *Journal of the Taliesin Fellows*, (Winter 1990-1991), 20-23.

2301. Chusid, Jeffrey Mark. "Concrete and light: a fabric for living: the Freeman house of Frank Lloyd Wright." *Antiques and Fine Art*, 7(January 1990), 76-83.

2302. Crosbie, M.J. "Domino's effect." *Architecture*, 79(December 1990), 48.

2303. Currimbhoy, Nayana et al. "Eleventh Annual *Interiors* awards." *Interiors*, 149(January 1990), 128-65.

2304. Davis, Nicholas. "Paranoia or conspiracy: a question of Wright." *Journal of Architectural Education*, 43(Winter 1990), 62-64. Includes a response by Diane Ghirardo.

2305. Dean, Andrea Oppenheimer. "Renewing our modern legacy." *Architecture*, (November 1990), 66 ff. Guggenheim Museum.

2306. Donohue, Judith. "Restoration for Florida Southern." *Progressive Architecture*, 71(April 1990), 30-31.

2307. Donohue, Judith. "Unbuilt Wright tower considered for Pittsburgh." *Progressive Architecture*, 71(December 1990), 18

2308. Flanagan, Barbara. "The ranch sees red." *Metropolitan Home*, 22(July 1990), 52.

2309. Geiger, John. "A summer's work—not in the Taliesin drafting room." *Journal of the Taliesin Fellows*, (Autumn 1990), 13-15. Neils house.

2310. Not used.

2311. Goldberger, Paul. "Four walls and a door." *NYT Magazine*, 140(14 October 1990), 40-42. Examines architectural viewpoints on rooms, including "Frank Lloyd Wright and flowing openness".

2312. Gorlin, Alexander C. "Frank Lloyd Wright and the Italian villa: Wright's trips to Italy." *A + U*, (October 1990), 44-57. Japanese and English.

2313. Grant, Roderick. "God is also in the Dana House details." *Journal of the Taliesin Fellows*, (Winter 1990-1991), 13-15; 18.

2314. Grassmuck, K. *"At Fla. Southern, Wright buildings are mixed blessing."* *Chronicle of Higher Education*, 37(10 October 1990), 37.

2315. Harrington, Elaine. "Classical sculpture in the work of Frank Lloyd Wright." *Wright Angles*, 16(Autumn 1990), 3.

2316. Hermanns, Henner et al. [Special issue] Wie wollen wir wohnen?." *AIT*, 98(January-February 1990), 10-50. German: "How do we want to live?"

2317. Heyman, Mark. "How the Taliesin Theater acquired its door handles." *Journal of the Taliesin Fellows*, (Winter 1990-1991), 19.

2318. Kahn, Eve M. "Restoring Fallingwater." *Metropolis*, 9(May 1990), 36.

2319. Keister, Kim. "Where will it go? Marin Countians debate jail at Wright landmark." *Preservation News*, 30(April 1990), 3, 17. See also Lynn Nesmith, "Wright done wrong," *Architecture*, 79(April 1990), 35; Alan Hess, "Jailhouse knocked," *Landscape Architecture*, 82(October 1992), 28, 30; "Where's the jail?" (18 January 1993), 21; and David B. Rosenbaum, "Out of sight, out of mind," *ibid.*, 233(12 September 1994), 18-19.

2320. Krellig, Heiner. "Frank Lloyd Wright: das Masieri Memorial in Venedig. Geschichte einer ungebauten Architektur." *Kunstchronik*, (no. 8, 1990), 419. German: "Frank Lloyd Wright: the Masieri Memorial, Venice. History of an unbuilt architecture." Refers to a Masters thesis at *Technische Universität*, Berlin.

2320. Langmead, Donald. "The evanescent architect: Robert van 't Hoff (1887-1979)." *Exedra*, 2(Winter 1990), 6-15. Van 't Hoff was Wright's first European imitator.

2321. Light, Amy Gray. "All Wright: a new collection of Frank Lloyd Wright rug designs: West Week, Los Angeles; exhibit." *Architecture*, 79(March 1990), 216.

2322. Light, Amy Gray. "The Wright way: restoring a pair of landmark structures." *Architecture*, 79(November 1990), 153. Grady Gammage auditorium; Gregor Affleck house.

2323. Manson, Grant Carpenter. "The wonderful world of Taliesin: my twenty years on its fringes." *Journal of the Taliesin Fellows*, (Winter 1990-1991), 4-10. See also 2238.

2324. Marlin, William. "'Oh, Frahnk': FLW and Miriam Noel." *Inland Architect*, 34(September-October 1990), 24; 26; 70; 73.

2325. Masselink, Ben. "Recollection, Christmas, 1940: desert storm isolates Taliesin in a sea of mud." *Journal of the Taliesin Fellows*, (Winter 1990-1991), 8-12; 18.

2326. Matott, J. Lawrence. "Representing traditional Japanese architecture, part 1: Introduction." *Space Design*, (July 1990), 93-96. Japanese. Influences on Wright.

2327. Miller, Robert L. "No style at all?" *Landscape Architecture*, 80(January 1990), 46-49. Subtitled "Searching for clues of modernism in the landscape."

2328. Miller, Ross. "Commentary: adding to icons." *Progressive Architecture*, 71(June 1990), 124-125. Guggenheim Museum.

2329. Nute, Kevin Horwood. "Frank Lloyd Wright and the arts of Japan—a study in how to borrow properly." *A + U*, (February 1990), 26-33. Japanese and English.

2330. Olin, Laurie. "Wide spaces and widening chaos. Individuals who shaped the profession of landscape architecture." *Landscape Architecture*, 80(October 1990), 82.

2331. Pfeiffer, Bruce Brooks. "Frank Lloyd Wright in Arizona." *Triglyph*, (Summer 1990), 2-15.

2332. Phillips, J.C. "A school in the desert embraces Frank Lloyd Wright's ideals of architecture and education." *Chronicle of Higher Education*, 36(18 July 1990), 6-7. Taliesin West

2333. Preddy, Jane. "The influence of the Japanese print on the architecture of Frank Lloyd Wright." *Journal of Popular Culture*, 23(April 1990), 1.

2334. Price, Don. "Cantilever tales; architect (1939): Frank Lloyd Wright" *Old House Journal*, 18(May-June 1990), 42-47. Goetsch-Winckler house.

2335. Ross, Steven S. "Apple grows at Taliesin West." *Architectural Record*, 178(January 1990), 171-75.

2336. Schneider, Bruno. "Architecture as organism." *Art Aurea*, (no. 3, 1990), 60-65.

2337. Sharp, Dennis. "Wright and wrong." *Building Design*, (20 April, 1990), 46-47. Report on Edgar A. Tafel's lecture at the AA, London.

2338. Stoller, Ezra. "Paisajes arquitectonicos: seis maestros, seis imagenes." *Arquitectura Viva*, (May-June 1990), 36-39. Spanish: "Architectural landscapes: six teachers, six images." Landmark buildings by Wright and others.

2339. Stevens, Arthur Dennis. "A day at the auction, or, how to strip a Prairie house for fun and profit." *Journal of the Taliesin Fellows*, (Autumn 1990), 6-7, 18.

2340. Stevens, Arthur Dennis. "Classes at Taliesin not in the collegiate mold." *Journal of the Taliesin Fellows*, (Winter 1990-1991), 6-7.

2341. Tafel, Edgar A. "Waxing over Wright." *World Architecture*, (no. 8, 1990), 68-73. S.C. Johnson and Son buildings.

2342. Viladis, Pilar. "Wright in Hollywood." *House and Garden*, (February 1990), 80-87.

2343. Wade, M.J. "The Wright Idea." *Horizon*, 31(January 1988), 24.

2344. Whiffen, Marcus. "Seeing Wright plain." *Triglyph*, (Summer 1990), 1. Barry Byrne's reminiscences.

2345. Wright, Frank Lloyd. "Le gratte-ciel en verre." *Techniques et Architecture*, (August-September 1990), 64-65. French: "The glass skyscraper." English,

Spanish summaries. Excerpts about Johnson research tower, from *Mon autobiographie*, Paris: 1955.

2346. Wright, Lloyd. "The Wright stuff—Frank Lloyd Wright revived." *Interior Design*, (September 1990), 12. Restoration of Dana-Thomas house. See also "Restoration," *Frank Lloyd Wright Quarterly*, 1(Spring 1990), 8-9; Dennis McFadden, "A Wright restoration: the Dana-Thomas House reopens," *Inland Architect*, 34(September-October 1990), 31-39; Amy Gray Light, "Wright's legacy: restoration of the Dana-Thomas house," *Architecture*, 79(October 1990), 27-28; David Blanchette, *Historic Illinois*, 13(October 1990), 14; *Wright Angles*, 16(Autumn 1990), 1-2; *Frank Lloyd Wright Quarterly*, 1(Autumn 1990), 11-13; *American History Illustrated*, 25(November-December 1990), 10-11; Julie A. Sponsler, "Wright masterpiece restored," *Historic Illinois*, 13(February 1991), 8-12; and Anders Nereim, "Burnished jewel: Dana-Thomas house,"*Architectural Record*, 179(May 1991), 88-95.

2347. Zanten, David van. "Chicago in architectural history." *Studies in the History of Art*, 35(1990), 91-99.

2348. *Architectural Record.* "The value of good architecture." 178(February 1990), 19. Usonian house for sale.

2349. *Architecture.* "Wright house." 178(March 1990), 32. Cf. "A Usonian classic: Wright's Zimmerman house opens to the public this Fall," *Frank Lloyd Wright Quarterly*, 1(Spring 1990), 3-5; and Michael Komanecky, "Realizing Wright's Usonian design for the Zimmermans," *Journal of the Taliesin Fellows*, (Autumn 1990), 19-23.

2350. *Art in America.* "Guggenheim landmarked." 78(October 1990), 47. Guggenheim Museum designated an historic and architectural landmark by the New York Landmarks Preservation Commission.

2351. *Canadian Architect.* "Perspective: two Frank Lloyd Wright houses open to the public." 35(August 1990), 4.

2353. *Casabella.* "Restaurato un edificio di Wright in Giappone." 54(May 1990), 26. Italian: "Restoration of a Wright building in Japan." Yamamura house. Cf. "Restored work of Frank Lloyd Wright: former Yamamura residence," *Japan Architect*, 65(February 1990), 8-12 (Japanese and English)..

2354. *Custom Builder.* "Deriving design from nature." 5(April 1990), 30.

2355. *Frank Lloyd Wright Quarterly.* "Hanna house earthquake; architect (1937): Frank Lloyd Wright." 1(Summer 1990), 4-6.

2356. *Frank Lloyd Wright Quarterly.* "One-of-a-kind schoolhouse sold at auction." 1(Spring 1990), 6. Wyoming Valley School.

2357. *Frank Lloyd Wright Quarterly.* "Restoration." 1(Spring 1990), 8-9. Darwin D. Martin and Dana-Thomas houses; Seth Peterson cottage.

2358. *Frank Lloyd Wright Quarterly.* "Restoration: Milwaukee creates historic

district." 1(Summer 1990), 8-9. American Systems Ready-Cut houses, Burnham Street. Issue also includes "Romeo and Juliet windmill" and "Little known manuscript by Frank Lloyd Wright".

2359. *Frank Lloyd Wright Quarterly*. "Wright fan hopes to bring tropical cottage to life." 1(Summer 1990), 7. Spivey house (project).

2360. *Frank Lloyd Wright Quarterly*. "Wright's Japanese treasures." 1(Autumn 1990), 8-10.

2361. *Friends of Fallingwater Newsletter*. [Edgar J. Kaufmann Jr. memorial]." (January 1990).

2362. *Friends of Fallingwater Newsletter*. [Topographical study of Fallingwater site]. (November 1990). Issue also includes notice of Michael Graves' visit.

2363. *House and Garden*. "The Wright way." 160(October 1988), 150.

2364. *Inland Architect*. "Wright house damaged by fire." 34(September 1990), 25. Beachy house.

2365. Not used.

2366. *Journal of the Taliesin Fellows*. "Rebuilt Hollyhock house furniture re-establishes scale for living room." (Autumn 1990), 2-3.

2367. *Ottagono*. "Cassina. Living with a genius." (September 1990), 164-67. Wright furniture reproduced by Cassina in 1989: "Taliesin 2" table, "Robie 2" low tables, and "Coonley", "Friedman" and "Robie 3" chairs.

2368. Seth Peterson Cottage Conservancy, Inc. *Wrightings: newsletter of the Seth Peterson Cottage Conservancy, Inc. for the Frank Lloyd Wright Cottage in Mirror Lake State Park*. Wisconsin Dells: The Conservancy. Periodical published after mid-1990. Mostly news items; the cottage is available for casual hire.

2369. *Sunset*. "Arizona celebrates Frank Lloyd Wright." (January 1990), 12-14.

1991
Books, monographs and catalogues
2370. Bandes, Susan J. ed. *Affordable dreams: the Goetsch-Winkler house and Frank Lloyd Wright*. East Lansing: Kresge Art Museum 1991. Catalogue of an exhibition. Includes "Impressions of living with Wright" by Elizabeth Halsted; "An affordable dream and its contemporaries" by Linda O. Stanford; "Usonia II and the Goetsch-Winkler house: manifestations of Wright's early vision of Broadacre City" by Anatole Senkevitch Jr.; and "From Frank Lloyd Wright to E. Fay Jones: Alma Goetsch and Kathrine Winkler, ordinary extraordinary architectural patrons" by Diane Tepfer. Reviewed Bradley Ray Storrer, *Journal of the Taliesin Fellows*, (Winter 1992), 13, 19. See also Bandes, "Affordable dreams: Frank Lloyd Wright and mid-Michigan." *Frank Lloyd Wright Quarterly*, 1(Fall 1990), 4-7.

2371. Clarke, David S. *Frank Lloyd Wright and the Laffer curve: essays on architecture and education*. Wakefield: Hollowbrook, 1991.

2372. Costantino, Maria. *Frank Lloyd Wright*. New York: Crescent Books, 1991. Reviewed Roderick Grant, *Journal of the Taliesin Fellows*, (Winter 1991), 11. Also published as *Frank Lloyd Wright design*, London: Grange Books, 1995 and in Dutch translation, Alphen aan den Rijn: Atrium, 1995.

2373. Department of Real Estate and Urban Land Economics, University of Wisconsin. *Financial feasibility study: financing the Frank Lloyd Wright Monona Terrace: issues of equity and economic efficiency prepared ... for Future Madison Corporation*. Madison: The Department, 1991. Pamphlet.

2374. Gossel, Peter and Gabriele Leuthauser eds. *Frank Lloyd Wright*. Cologne: Taschen; Scottsdale: Frank Lloyd Wright Foundation, 1991, 1993, 1994, 2001. English and German. Also published in French, and in one volume in Italian, Spanish and Portuguese.

2375. Hamilton, Mary Jane. *The meeting house: heritage and vision*. Madison: Friends of the Meeting House, 1991.

2376. Hildebrand, Grant. *The Wright space: pattern and meaning in Frank Lloyd Wright's houses*. Seattle: University of Washington Press, 1991. Reviewed Hugh Pearman, *Design*, (November 1991), 68-69; *Progressive Architecture*, (March 1992), 114; Kathryn Smith, *JSAH*, 51(September 1992), 320-22; and Jeffrey Mark Chusid, *Design Book Review*, (Autumn 1992), 61-66. See also Patrick D. Miller, "The W/Right space," *Theology Today*, 50(April 1993), 1-3.

2377. Joncas, Richard. *Pure form: the origins and development of Frank Lloyd Wright's non-rectangular geometry* [microform]. Ann Arbor: University Microfilms International, 1991. PhD thesis, Stanford University, 1991.

2378. Komoto, Shinji and Jonathan Lipman eds. *Furanku Roido Raito kaikoten* [*Frank Lloyd Wright retrospective*]. Tokyo: Mainichi Newspapers, 1991. Japanese and English. Catalog of a traveling exhibition organized by the host museums, the Architectural Institute of Japan, and Mainichi Newspapers in collaboration with the International Sculpture Center, Washington, D.C. Includes "The Japanese view of Frank Lloyd Wright," by Hiroyasu Fujioka and "Wright's achievement in Japan" by Masami Tanigawa. The show was mounted at Sezon Museum of Art, Tokyo, January-February 1991; National Museum of Modern Art, Kyoto, April-May 1991; Yokohama Museum of Art, May-June 1991; and Kitakyushu Municipal Museum of Art, July 1991.

2379. Laseau, Paul and James Tice. *Frank Lloyd Wright: between principle and form*. New York: John Wiley and Sons, 1991; Van Nostrand Reinhold, 1992. Reviewed Peter Reidy, "How did Wright design?" *Journal of the Taliesin Fellows*, (Autumn 1992), 22-23; and Jeffrey Mark Chusid, *Design Book Review*, (Autumn 1992), 61-66. Second edition New York: John Wiley and Sons, 1997.

2380. McCarter, Robert ed. *Frank Lloyd Wright; a primer on architectural principles*. Princeton: Architectural Press, 1991. Includes "Abstract essence: drawing Wright from the obvious" and "The integrated ideal: ordering principles in the architecture of Frank Lloyd Wright", both by McCarter; "Academic tradition and the individual talent: similarity and difference in the formation of Frank Lloyd Wright" by Patrick Pinnell; "The text-tile tectonic: the origin and evolution of Wright's woven architecture" by Kenneth Frampton; "Rewriting *The Natural House*" by Archie Bovier MacKenzie; "Consecrated space: the public buildings of Frank Lloyd Wright" by Jonathan Lipman; "Evolution of the Priarie House" by Werner Seligmann; "Form and philosophy: Froebel's kindergarten training and the early work of Frank Lloyd Wright" by Richard Cornelius MacCormac (revising an article in *Environment and Planning B*, 1[1974]); and "The art of the square" by Otto Antonia Graf. Paperback edition 1993.

Reviewed D.P. Doordan, *Architectural Record*, 179(November 1991), 52-53; *Progressive Architecture*, (August 1991), 97; Roderick Grant, "The 'Oakland Philosophy' ascendant, or, Gertrude Stein said it all." *Journal of the Taliesin Fellows*, (Summer 1992), 24-25 (reviews only McKenzie essay); Jeffrey Mark Chusid, *Design Book Review*, (Autumn 1992), 61-66; Kathryn Smith, *JSAH*, 51(September 1992), 320-22; and Kevin Horwood Nute, *Architectural Review*, 193(September 1993), 104. See also Karen Dacko and Michelle Pilecki, "Facts and faces," *Pittsburgh Magazine*, 31(February 2000), 40.

2381. Meehan, Patrick Joseph ed. *Frank Lloyd Wright: domestic architecture and objects*. Washington, D.C.: Preservation Press, 1991. Paperback edition New York: John Wiley and Sons, 1995.

2382. Meehan, Patrick Joseph ed. *Frank Lloyd Wright remembered*. Washington, D.C.: National Trust for Historic Preservation, 1991. As well as two pieces by Wright, "The shape of the city" (*American Municipal Association. Proceedings*, [1956], 30-34) and "The shape of Miami", the anthology includes more than forty personal impressions of him. By architects: Richard Buckminster Fuller; Bruce Goff; Philip Johnson; Eero Saarinen; Edward Durell Stone. By clients: Robert and Gloria Berger; Richard Davis; James Edwards; Samuel Freeman; Loren Pope and Sarah Smith. By former apprentices: John Geiger; Aaron G. Green; John Henry Howe and E. Fay Jones. By friends, acquaintances and family members: Anne Baxter; Louise Mendelsohn; Ian Reiach; Egon Weiner; Lloyd Wright and Olgivanna Lloyd Wright.

Reviewed Theodore Kinni, *Inland Architect*, 35(November-December 1991), 70-72; Roderick Grant, "Peeling away the layers," *Journal of the Taliesin Fellows*, (Spring 1993), 15, 17; Louis N. Hafermehl and James E. Sherow, *Journal of the West*, 32(October 1993), 115.

2383. O'Gorman, James F. *Three American architects: Richardson, Sullivan, and Wright, 1865-1915*. Chicago; London, 1991. Reviewed Richard Pommer, "Escape from Europe," *TLS*, (11 August 1991), 26; Robert Twombly, *JSAH*, (June 1992), 210-13; and Ronny de Meyer, *Archis*, (April 1994), 83-85 (Dutch and English). Paperback edition 1992.

2384. Pfeiffer, Bruce Brooks and Yukio Futagawa. *Frank Lloyd Wright selected houses. Vol. 6. Herbert Jacobs I, John C. Pew, Goetsch/Winckler, Lloyd Lewis, Loren Pope, Stanley Rosenbaum, Bernard Schwartz, George Sturges, Theodore Baird, Carlton D. Wall, Melvyn Maxwell Smith* Tokyo: ADA Edita, 1991. Japanese and English. Introduction by Pfeiffer; mostly images.

2385. Pfeiffer, Bruce Brooks and Yukio Futagawa. *Frank Lloyd Wright selected houses. Vol. 7. Charles T. Weltzheimer, Sol Friedman, Howard Anthony, Kenneth Laurent, Clinton Walker, William Palmer, Isadore J. Zimmerman, Russell Kraus, Roland Reisley, Robert Llewellyn Wright, I.N. Hagan.* Tokyo: ADA Edita, 1991. Japanese and English. Introduction by Pfeiffer; mostly images.

2386. Pfeiffer, Bruce Brooks and Yukio Futagawa. *Frank Lloyd Wright selected houses. Vol. 8. Aline Barnsdall, Tazaemon Yamamura, Alice Millard, John Storer, Charles Ennis, Richard Lloyd Jones, David Wright, Harold Price, Gerald Tonkens, Toufic Kalil.* Tokyo: ADA Edita, 1991. Japanese and English. Introduction by Pfeiffer; mostly images.

2387. Prosyniuk, Joann R. ed. *Modern arts criticism: a biographical and critical guide to painters, sculptors, photographers, and architects from the beginning of the modern era* [Volume 1]. Detroit: Gale Research, 1991.

2388. Sanderson, Arlene ed. *Wright sites: a guide to Frank Lloyd Wright public places.* River Forest: Frank Lloyd Wright Building Conservancy, 1991. Reviewed J.P. Brown, *Library Journal,* 116(15 September 1991), 74. Revised edition, with an introduction by Jack Quinan, Princeton Architectural Press, 1995; reviewed Harold Henderson, *Planning,* 62(May 1996), 27-29. Again revised, Princeton: 2001.

2389. Slaton, Deborah. "Burnham and Root at The Rookery." In John S. Garner ed. *The Midwest in American architecture.* Urbana: University of Illinois Press, 1991. Festschrift for Walter L. Creese. Reviewed Robert Twombly, "Fragments: in festschrift and in exhibition," *Design Book Review,* (Fall 1992), 56-60; and Leonard Eaton, *JSAH,* 51(June 1992), 213-14.

2390. Waite, Robert G., Judith O'Dell et al. *Composed order: the architecture of Alden B. Dow.* Midland: Alden B. Dow Creativity Center, 1991. Proceedings of a conference, Northwood Institute, Midland, Michigan, 6-8 October 1988, in conjunction with a September-October exhibit at the Midland Center for the Arts. Includes "Alden Dow and the Taliesin Fellowship, 1933" by O'Dell; and "Alden Dow and Frank Lloyd Wright" by William Wesley Peters.

2391. Williamson, Roxanne Kuter. *American architects and the mechanics of fame.* Austin: University of Texas Press, 1991. See chapter 2, "Sullivan and Wright and their connections."

2392. *Frank Lloyd Wright Oral History Program planning conference report.* Wisconsin: The Program, 1991. Volume 2 abridges the report, jointly sponsored by the State Historical Society of Wisconsin, The Frank Lloyd Wright Foundation, The Keland Endowment Fund of the Johnson Foundation, with support

from the Joseph Johnson Charitable Trust, Milwaukee and the Wisconsin History Foundation.

2393. *Frank Lloyd Wright's "child of the sun": Florida Southern College, a walking tour.* Lakeland: The College, 1991. Brochure; title and date vary. See also Ray Fischer, "Frank Lloyd Wright's child of the sun," *Going Places*, 11(no. 3, 1992), 13; and Shari Szabo, "Frank Lloyd Wright's child of the sun—well suited to time, purpose and place," *Lakeland Real Estate Week*, 1(no. 6, 1993), 4.

Periodicals

2394. Andrews, J. "Lasting expression." *Custom Builder*, 6(February 1991), 47.

2395. Apostolo, Roberto. "Il rapporto vuoto-pieno (parte terza)." *Frames. Porte and Finestre*, (February-March 1991), 26-33. Italian: "The filled-in empty relationship (part 3)." Windows in Wright buildings (i.a.).

2396. Bacon, Pervis B. "Misnomers." *Architectural Record*, 179(August 1991), 4. Dana House. See *ibid.*, (May 1991), 88.

2397. Baltar, Rafael. "A casa e o estudio de Frank Lloyd Wright en Oak Park. Chicago." *Obradoiro*, 19(September 1991), 34-37. Spanish: "Wright home and studio."

2398. Besinger, Curtis. "A trace of Catalonian mystique at Taliesin?" *Journal of the Taliesin Fellows*, (Summer 1991), 12-13.

2399. Boulton, Alexander. "Pride of the prairie." *American Heritage*, 42(July-August 1991), 62-69.

2400. Cook, C. "Gridlock." *Lear's*, 4(February 1991), 98.

2401. Cortes, Juan Antonio. "La coherencia de un metodo: analisis de veinte muebles de Frank Lloyd Wright." *Croquis*, 10(April-May 1991), 77-101. Spanish: "Coherence of a method: analysis of twenty pieces of Wright's furniture."

2402. Dellin, Mary. "The early ornament of Frank Lloyd Wright." *Nineteenth Century*, 10(no. 3, 1991), 10-12.

2403. Farrell, Terry. "Frank Lloyd Wright." *Independent Magazine*, (8 June 1991), 70.

2404. Frank, Edward. "Sfregio del Guggenheim." *L'Architettura*, 38(December 1991), 887. Italian: "Ruin of the Guggenheim."

2405. Freudenheim, B. "The Frank Lloyd Wright tapestries: themes and variations." *Fiberarts*, 18(September-October 1991), 61. Reviews an exhibition of the same name at the Newark Museum, April-August 1991. The show moved to Scottsdale. See 2427.

2406. Geiger, John. "What did Mr. Wright mean by 'organic'?" *Journal of the Taliesin Fellows*, (Summer 1991), 6-7, 15.

2407. Gerloff, Robert. "Unbuilt Minnesota: Frank Lloyd Wright's standardized

overhead service station, 1932." *Architecture Minnesota*, 17(July-August 1991), 57.

2408. Goldstein, Eliot W. "A usonian community in the suburbs of New York." *Fine Homebuilding*, (January 1991), 26. Pleasantville.

2409. Gournay, Isabelle. "L'architecture américaine dans la presse profession-nelle Francaise." *Gazette des Beaux-Arts*, 117(April 1991), 192-94. French: "American architecture in the French professional press."

2410. Grossman, Loyd. "Icon. Frank Lloyd Wright." *Metropolitan Home*, (December 1991-January 1992), 38.

2411. Guggenheimer, Tobias. "John Howe reminisces: from 18-year-old ap-prentice to FLLW's chief assistant." *Journal of the Taliesin Fellows*, (Winter 1991), 17-23.

2412. Gunn, P. "Frank Lloyd Wright and the passage to Fordism." *Capital and Class*, (no. 44, 1991), 73.

2413. Hartmann, Kristiana et al. "[Special issue] Schichten und Schichtungen." *Daidalos*, (December 1991), 15, 22-131. German: "Strata and stratifications."

2414. Hearn , M.F. "A Japanese inspiration for Frank Lloyd Wright's rigid-core high-rise structures." *JSAH*, 50(March 1991), 68-71. See also Thomas Doremus, *ibid.*, 51(June 1992), 231; and Alfred Willis, *ibid.*, 50(September 1992), 344-45, with Hearn's rejoinder.

2415. Henkel, Alfons G. "Büromöbeldesign: vom Produktdesign zum corpor-ate Design." *Deutsche Bauzeitschrift*, (special issue, 1991), 75-80; 85-86. Ger-man: "Office furniture: from product design to corporate design."

2416. Herzog, S. "All the light and air and prospect: word and deed in the evolution of Frank Lloyd Wright's spatial concepts." *Environments*, 21(January 1991), 10.

2417. Hower, Barbara K. "Wisconsin prairie jewel restored." *Inland Architect*, 35(May-June 1991), 18, 20. Seth Peterson cottage. See also Brendan Gill, "Historic architecture: rescuing Wright ... ," *Architectural Digest*, 50 (February 1993), 86, 92, 95, 98-99; Thomas R. Fisher, "Seth Peterson cottage," *Progres-sive Architecture*, 74(April 1993), 109; and Kristin Visser, "Secluded hide-away," *Frank Lloyd Wright Quarterly*, 41(Summer 1993), 12-15.

2418. Jaquet, G. Jake. "Re-reading Wright." *Inland Architect*, 35(July-August 1991), 62-63, 65. Evanston Public Library .

2419. Johnson, L. Nelson. "Frank Lloyd Wright and the natural pattern of struct-ure." *Designers West*, 38(June 1991), 74.

2420. Kahn, Eve M. "Wilbert Hasbrouck: learning from the Chicago School." *Traditional Building*, 4(March-April 1991), 4. Rookery building; Dana house.

2421. Kelley, Stephen J. "Overview: the role of the engineer in preservation."

Association for Preservation Technology. Bulletin, 23(no. 1, 1991), 6-17. Case studies include Unity Temple.

2422. Kenton, Mary Jean. "Fallingwater falling apart?" *Art in America*, 79(February 1991), 39. Reports engineers' opinion: house is "fundamentally sound."

2423. Klinkow, Margaret. "Wright family life in the house beautiful." *Wright Angles*, 17(Summer 1991), 3-6.

2424. Kluger, M. and R. Bowditch. "Taliesin—Frank Lloyd Wright's Wisconsin retreat." *Gourmet*, 51(February 1991), 70. See also *idem.*, "Taliesin West—Frank Lloyd Wright's Arizona retreat," *ibid.*, 51(March 1991), 86.

2425. Kuhnert, Nikolaus. "Stadt-Landschaften." *Arch Plus*, (December 1991), 42-43. German: "City landscapes." Broadacre City.

2426. Levinson, Nancy. "State and Wright Foundation join forces at Taliesin." *Architectural Record*, 179(September 1991), 27.

2427. Lindenfeld, Lore. "The Frank Lloyd Wright tapestries: themes and variations: Gallery 10, Scottsdale, Ariz.; exhibit." *Fiberarts*, 18(September-October 1991), 61.

2428. Linn, Charles. "Civic splendor." *Architectural Record*, 179(November 1991), 40-43. Marin County Civic Center.

2429. Long, Christopher and Lila Stillson. "Im Garten Eden: Frank Lloyd Wrights Erbe." *Architektur- und Bauforum*, 24 (no. 144, 1991), 49-51. German. "In the Garden of Eden: Frank Lloyd Wright's successors." The title explains the content. See subsequent essays: Robert McCarter, "Ohne den Innenraum [Without the space within]," *ibid.*, 24(no. 145, 1991), 39-44; Helmut Weihsmann, "Gefuhl gegen Kalkul [Feeling vs. calculation]," *ibid.*, 24(no. 146, 1991), 45-50; Victor Papanek and Gerald Moorhead, "Mit Bleistift und Pflugschar [With pencil and ploughshare]; Lone Star Architects: MacKie and Kamrath," *ibid.*, 24(no. 147, 1991), 46-51; Weihsmann, "Cool school/West Coast-Bay Region Stil und LA School," *ibid.*, 25(no. 147A, 1992), 47-52; John Sergeant and Joseph Rosa, "Einfuhrung zu Bruce Goff. Unabhangigkeit und Abweichung: die Wohnbauten von John Lautner [Introduction to Bruce Goff. Independence and deviation: the houses of John Lautner]," *ibid.*, 53-57; Heidi Kief-Neiderwohrmeier, "Wright und Europa: Wurzeln der Moderne—FLWs Einfluss auf europaische Architekten [Wright and Europe: roots of the modern—FLW's influence on European architects]," *ibid.*, 58-61; Weihsmann, "Wright face—'Wrightismus' und die Folgen: Schlussdokument [Wright face—'Wrightism' and the consequences: conclusion]," *ibid.*, 62-66.

2430. Long, David Gilson de. "How Mr. Wright saved me from the coils of college." *Journal of the Taliesin Fellows*, (Winter 1991-1992), 8-9.

2431. McClellen, R. "Excursion to Cedar Rock." *Iowa City Magazine*, 2(June 1991), 32.

2432. McCoy, Jerry A. "The Stockman house." *Frank Lloyd Wright Quarterly*, 2(Summer 1991), 10-11.

2433. Morris, Robert. "Do the Wright thing: The W.L. Thaxton. Jr. house." *Cite: the Architecture and Design Review of Houston*, (Spring 1991), 6-7.

2434. Nute, Kevin Horwood. "Frank Lloyd Wright and Japanese art. Fenollosa: the missing link." *Architectural History*, 34(1991), 224-30.

2435. Nute, Kevin Horwood. "On the Wright lines." *Architects' Journal*, 194(14 August 1991), 20-23.

2436. Pearson, Clifford A. ed. "Frank Lloyd Wright: on the *Record*: selection of quotations from Wright's writings for *Record*." *Architectural Record*, 179(January 1991), 12-17.

2437. Plummer, Henry. "Frank Lloyd Wrights Traeumereien vom Horizont." *Daidalos*, (no.42, 1991), 111-21. German and English: "Wright's horizontal reveries."

2438. Puglisi, Luigi Prestinenza. "Ricostruzione di una casa Usoniana in Arizona." *L'Industria delle Costruzioni*, 25(January 1991), 58-59. Italian: "Reconstruction of a Usonian house in Arizona." Taliesin West; Jacobs and Adelman houses.

2439. Quinan, Jack. "Frank Lloyd Wright and Elbert Hubbard: did they know each other?" *Arts and Crafts Quarterly*, 5(1992), 24-27.

2440. Quinan, Jack. "Frank Lloyd Wright, photography and architecture." *Frank Lloyd Wright Quarterly*, 2(Winter 1991), 4-7.

2441. Quinan, Jack "Frank Lloyd Wright's lost Larkin furniture." *Arts and Crafts Quarterly*, 4(no. 2, 1991), 12-18

2442. Roberts, J. Stewart. "Adapting Usonian; original architect (1937): Frank Lloyd Wright, architect for alterations: J Stewart Roberts." *Fine Homebuilding*, (Spring 1991), 56-59. Jacobs house.

2443. Robinson, Sidney K. "The romantic classicism of the Prairie School." *Inland Architect*, 35(May-June 1991), 42-45.

2444. Russell, James S. "On shaky ground." *Architectural Record*, 179(June 1991), 104-115.

2445. Siry, Joseph. "The Abraham Lincoln Center in Chicago." *JSAH*, 50(September 1991), 235-65.

2446. Solliday, Scott. "Wright's first desert adventure." *Frank Lloyd Wright Quarterly*, 2(Winter 1991), 8-10. Ocotillo desert camp.

2447. Tepfer, Diane. "Alma Goetsch and Kathrine Winckler: patrons of Frank Lloyd Wright and E. Fay Jones." *Woman's Art Journal*, 12(Fall-Winter 1991-1992), 15-19.

2448. Watkin, David. "Frank Lloyd Wright and the Guggenheim Museum." *AA Files*, (Spring 1991), 40-48.

2449. Wiehle, Louis. "Something out of focus in 'Wright in Hollywood'." *Journal of the Taliesin Fellows*, (Summer 1991), 10-11. Reviews exhibition at Schindler house.

2450. Wilcoxon, Sandra K. "Measuring your impact: the museum's effect on the local economy." *Museum News*, 70(November-December 1991), 65-67. Wright home and studio.

2451. Winter, Robert. "Frank Lloyd Wright and the American bungalow." *American Bungalow*, 1(no. 3, 1991), 18-19.

2452. Wright, Eric Lloyd. "Auldbrass: restoration of a 20th century plantation." *Frank Lloyd Wright Quarterly*, 2(Autumn 1991), 3-5.

2453. Zelinsky, Marilyn Kay. "The fabric of nature." *Interiors*, 150(July 1991), 24-25. Wright-inspired textiles by F. Schumacher company.

2454. Zevi, Luca. "Florida Southern College: una miniatura della citta-territorio wrightiana. *Architettura*, 37(July-August 1991), 648-67. Italian: "Florida Southern College: miniaturized version of a Wright urban territory."

2455. *American Craft*. "Urn (Sheet copper, 1895-1902)." 51(August-September 1991), 17. Image only.

2456. *Architectural Record*. "Maui clubhouse from Wright designs." 179(January 1991), 21. Waikapu Valley Country Club, realized by John Rattenbury from Wright designs for the Arthur Miller house (project). See also T.M. Achenbach, "The Wright stuff," *Sport*, 83(June 1992), 14.

2457. *Cineaste*. "The architecture of Frank Lloyd Wright." 18(1991), 34. Reviews a videotape recording directed by Murray Grigor. Cf. "Usonian man," *American Heritage*. 46(July-August 1995), 100-101.

2458. *Frank Lloyd Wright Quarterly*. "Broadacre City revisited; building a city." 2(Spring 1991) 4-7. The issue also includes "Guggenheim update" and "Frank Lloyd Wright and Madison".

2459. *Frank Lloyd Wright Quarterly*. "School of free spirit." 2(Summer 1991), 16. Jiyu-Gakuen girls' school.

2460. *Frank Lloyd Wright Quarterly*. "Taliesin: a house of the north." 2(Summer 1991), 4-9. Comprises three articles: "Taliesin: more than a house"; "How to visit Taliesin"; and "Architecture critics comment on Taliesin."

2461. *Friends of Fallingwater Newsletter*. [Conservation news]. (June 1991). Includes "Preserving a masterpiece" and "Interpretive nature trail".

2462. *Graphis*. [Frank Lloyd Wright]. 47(September 1991), 90. Image only.

2463. *Southwest Art.* "Artful architecture: Scottsdale Center for the Arts, Arizona; exhibit." 20(March 1991), 105.

1992
Books, monographs and catalogues
2464. Allen, James R. et al. *Dana House, Springfield, Illinois: Frank Lloyd Wright architect.* Springfield: Dana-Thomas House Foundation, 1992.

2465. Commission on Chicago Landmarks, *The Jessie and William Adams House: 9326 South Pleasant Avenue, Chicago, Illinois Chicago*: The Commission , 1992.

2466. Cowan, Craig. *Concrete abstractions.* Los Angeles: Couturier Gallery, 1992. Hollyhock House. Reviewed Roderick Grant, *Journal of the Taliesin Fellows*, (Winter 1992), 10-13.

2467. Fici, Giampaolo and Filippo Fici. *Frank Lloyd Wright: Fiesole 1910.* Fiesole: Minello Sani, 1992.

2468. Frank Lloyd Wright Foundation. *The Taliesin West garden room reconstruction.* Scottsdale: The Foundation, 1992. Brochure.

2469. Grimes, Teresa ed. *Barnsdall Art Park, Hollyhock house.* Los Angeles: Getty Conservation Institute, 1992.

2470. Heinz, Thomas A. *Frank Lloyd Wright.* London: Academy, 1992. Mostly images. Reviewed H. Ward Jandl, *Library Journal*, 117(1 July 1992), 82; "The right Wright," *Traditional Building*, (1992), 53; and Nayana Currimbhoy, "Writing about Wright. Again," *Interiors*, 153(September 1994), 14 ff.

2471. Henning, Randolph C. comp. *'At Taliesin': newspaper columns by Frank Lloyd Wright and the Taliesin Fellowship, 1934-1937.* Carbondale: Southern Illinois University Press, 1992. Reprints 112 editions of Wright's "At Taliesin" column, that was published in several southern Wisconsin newspapers. Reviewed Roderick Grant, "Earthy wisdom and humor of 1930's Taliesin Fellowship," *Journal of the Taliesin Fellows*, (Fall 1992), 17; 23. Extracts of some pieces are reprinted in Gutheim ed. *Frank Lloyd Wright on architecture*, New York: 1941.

2472. Hertz, David Michael. *Angels of reality: Emersonian unfoldings in Wright, Stevens, and Ives.* Carbondale: Southern Illinois University Press, 1992. See also Thomas H. Beeby, "Emerson, Wright and Unity Temple," *Journal of the Taliesin Fellows*, (Autumn 1999), 4-15.

2473. Hoffmann, Donald and David Hoffmann. *Frank Lloyd Wright's Hollyhock house.* New York: Dover, 1992. Reviewed Roderick Grant, "Hollyhock house: given due attention in print, but slighted in city budget," *Journal of the Taliesin Fellows*, (Winter 1992), 10-13; Andrew Mead, "Wright: symbolism and leaking roofs," *Architects' Journal*, 197(10 March 1993), 60; and Alice T. Friedman,

"American architecture," *JSAH*, 53(June 1994), 247-48.

2474. *House Beautiful. A* House Beautiful *tribute to Frank Lloyd Wright and the Solomon R. Guggenheim Museum.* New York: House Beautiful, 1992

2475. Kingsbury, Pamela D. *Frank Lloyd Wright and Wichita: the first Usonian design.* Wichita: Wichita-Sedgwick County Historical Museum, 1992. H.C. Hoult house (project). See also Donald Hoffmann, "Wichita symposium: Usonia the beautiful: the dreams and the realities," *Journal of the Taliesin Fellows*, (Spring 1993), 12-13. The symposium was held at the museum, 24 April 1993 to launch the book.

2476. Lehmann, Federica. *Conoscenza e influssi dell'opera di Frank Lloyd Wright in Italia (1910-1948)* [microform]. Milan: E. Bairati, 1992. Italian: *Knowledge and influence of the work of Wright in Italy (1910-1948).*

2477. Lind, Carla. *The Wright style: recreating the spirit of Frank Lloyd Wright.* New York: Simon and Schuster, 1992. Mostly images. Reviewed Barbara Bartos, *Library Journal*, 117(15 October 1992), 66; Thomas S. Hines, "The Wright stuff." *NYTBR*, 142(13 December 1992), 1-3; Roderick Grant, "Still awaiting the integral biography of Wright," *Journal of the Taliesin Fellows*, (Spring 1993), 14-17; Diana Ketcham, "Prophet with honor," *New Republic*, 208(7 June 1993), 37-41; Kevin Horwood Nute, *Architectural Review*, 193(July 1993), 97; and Monica Boman, *Arkitektur*, 94 (January 1994), 62-63 (Swedish).

 Also published as *The Wright style: the interiors of Frank Lloyd Wright— authentic designs, contemporary interpretations*, London: Thames and Hudson, 1992.

2478. Lipman, Jonathan and Neil Levine, *The Wright state: Frank Lloyd Wright in Wisconsin.* Milwaukee: Milwaukee Art Museum, 1992. Catalogue of an exhibition organized by Terrence L. Marvel and Jayne Stokes. There is a revised version of Levine, "The story of Taliesin: Wright's first natural house" (originally in Menocal ed. *Wright Studies. Taliesin, 1911-1914*, Carbondale: 1992; see 2483). Reviewed "The Wright stuff," *Americana*, 20(October 1992), 18; and *Frank Lloyd Wright Quarterly*, 3(Autumn 1992), 17.

2479. Loring, Jessica Stevens. *Auldbrass: the plantation complex designed by Frank Lloyd Wright:a documented history of its South Carolina lands.* Greenville: Southern Historical Press, 1992.

2480. Luke, Timothy W. *Shows of force: power, politics, and ideology in art exhibitions.* Durham: Duke University Press, 1992. Includes "Frank Lloyd Wright: in the realm of ideas."

2481. MacDonald, Randall M. *Frank Lloyd Wright: a bibliography of materials in Roux Library, Florida Southern College.* Lakeland: The Library, 1992. Bibliography; there are several revisions.

2482. McDonough, Yona Zeldis and Vito Perrone. *Frank Lloyd Wright.* New

York: Chelsea House, 1992. Reviewed J. Larson and Trevelyn E. Jones, *School Library Journal*, 38(February 1992), 116.

2483. Menocal, Narcisco G. ed. *Wright Studies. Taliesin, 1911-1914*. Carbondale: Southern Illinois University Press, 1992. Includes "Taliesin, the Gilmore house, and the flower in the crannied wall" by Menocal; "The story of Taliesin: Wright's first natural house" by Neil Levine (revised in Lipman and Levine, *The Wright state: ... Wright in Wisconsin*, Milwaukee: 1992; see 2478); "The shining brow: Frank Lloyd Wright and the Welsh bardic tradition" by Scott Gartner; "Taliesin: 'to fashion worlds in little'"; and "Taliesin I: a catalogue of drawings and photographs", both by Anthony Michael Alofsin.

Reviewed Martin Filler, "He'd rather be Wright," *New York Review of Books*, 41(13 January 1994), 28-34.

2484. Pfeiffer, Bruce Brooks ed. *Frank Lloyd Wright collected writings. Vol. 1. 1894-1930*. New York: Rizzoli; Scottsdale: Frank Lloyd Wright Foundation, 1992. The anthology reprints published essays, besides material that earlier appeared only in Gutheim ed. *Frank Lloyd Wright on architecture*, New York: 1941, and its revised edition: "The architect and the machine" (1894); "A philosophy of fine art" (1900); "Chicago culture" (1918)"; "The pictures we make" (1927); and "In the cause of architecture: purely per sonal" (1928).

There are also the texts of several speeches and previously unpublished essays: "Concerning landscape architecture" (1900); "On marriage" (1914); "The print and the renaissance" (1917); "The line between the curious and the beautiful" (1929); "The plan for the erection of a model building" (1929); "Who said 'conservative'?"(1929); "In the cause of architecture: confession" (1929); and "The commercially degenerate architect "(1929).

Reviewed Glenn Masuchika, *Library Journal*, 117(1 September 1992), 175; Thomas Hines, "The Wright stuff," *NYTBR*, 142(13 December 1992), 1-3; "Confessions of a new traditionalist," *Contract Design,* (1992), 80; Diana Ketcham, "Prophet with honor," *New Republic*, 208(7 June 1993), 37-41; and Julie V. Iovine and Thomas H. Beeby, "The man behind the legend: the words and life of Wright," *Architectural Record*, 181(July 1993), 40.

2485. Pfeiffer Bruce Brooks intro. *Furanku Roido Furaito to Hiroshige*. Kyoto: Kyoto Shoin, 1992. English and Japanese: *Frank Lloyd Wright and Hiroshige*. Catalogue of an exhibition at Alpha Cubic Gallery.

2486. Riley, Terence ed. *The international style: Exhibition 15 and the Museum of Modern Art*. New York: Rizzoli, 1992. Reprinted 1997.

2487. Rossari, Augusto. *Frank Lloyd Wright: bibliografia e opere*. Florence: Alinea, 1992. Italian: *Wright: bibliography and works*.

2488. Rybczynski, Witold. *The most beautiful house in the world*. Toronto: CNIB, 1992 (braille). Fallingwater.

2489. Secrest, Meryle. *Frank Lloyd Wright*. New York: Alfred A. Knopf; London: Chatto and Windus, 1992. Reprinted New York: Harper, 1993, and as

Frank Lloyd Wright: a biography, University of Chicago Press, 1998.

Reviewed Genevieve Stuttaford and Sybil Steinberg, *Publishers Weekly*, 239(20 July 1992), 237; H. Ward Jandl, *Library Journal*, 117(1 September 1992), 185; L.S. Klepp, "Meeting Mr. Wright," *Entertainment Weekly*, (11 September 1992), 82-84; Kurt Andersen, "Master of all he surveyed," *Time*, 140(5 October 1992), 86-87; P. Adams, "Picks and pans: pages," *People*, 38(12 October 1992), 33-34; Carter Wiseman, *New Criterion*, 11(November 1992), 69-71; "Makers and builders," *New Statesman and Society*, 5(27 November 1992), 45-47; "Leaky roofs," *Economist*, 325(28 November 1992), 104; Thomas S. Hines, "The Wright stuff," *NYTBR*, 142(13 December 1992), 1-3; "Secrest reconstructs Frank Lloyd Wright," *Library Journal*, 117(no. 14, 1992), 183; Kenneth Frampton, "Celtic skylight," *TLS*, (29 January 1993), 16-17; *National Review*, 45(1 February 1993), 65; Peter Slatin, *Art News*, 92(February 1993), 55; Roderick Grant, "Still awaiting the integral biography of Wright," *Journal of the Taliesin Fellows*, (Spring 1993), 14-17; Diana Ketcham, "Prophet with honor," *New Republic*, 208(7 June 1993), 37-41; *Antioch Review*, 1(Spring 1993), 314; Julie V. Iovine and Thomas H. Beeby, "The man behind the legend: the words and life of Wright," *Architectural Record*, 181(July 1993), 40; David Seamon, *Parabola*, 18(Summer 1993), 92-93; Martin Filler, "He'd rather be Wright," *New York Review of Books*, 41(13 January 1994), 28-34; Dan Pinck, "The many lives of Frank Lloyd Wright," *American Scholar*, 63(Spring 1994), 267-76; and Anthony Michael Alofsin, *JSAH*, 54(March 1995), 93-95.

2490. Segrest, Robert. "Frank Lloyd Wright at the Midway: Chicago, 1893." In John Whiteman et al. eds. *Strategies in architectural thinking*, Chicago: Chicago Institute for Architecture and Urbanism; Cambridge, Mass.: MIT Press, 1992. Revises a conference paper presented at the Charnley House, September 1988.

2491. Smith, Kathryn and Sam Nugroho. *Frank Lloyd Wright, Hollyhock House and Olive Hill: buildings and projects for Aline Barnsdall.* New York: Rizzoli, 1992. Separate chapters cover each building snd project on the site. Reviewed Kenneth Frampton, *JSAH*, 51(September 1992), 320-22; Roderick Grant, *Journal of the Taliesin Fellows*, (Winter 1992), 10-13; Glenn Masuchika, *Library Journal*, 118(15 February 1993), 164; Kevin Horwood Nute, *Architectural Review*, 193(December 1993), 97; B. Andrew Corsini Fowler, *Marquee*, 25(no. 3, 1993), 28; Andrew Mead, "Wright: symbolism and leaking roofs," *Architects' Journal*, 197(10 March 1993), 60; and Alice T. Friedman, "American architecture," *JSAH*, 53(June 1994), 247-48.

2492. Steele, James. *Barnsdall house: Frank Lloyd Wright.* London: Phaidon, 1992. Reviewed Reviewed Roderick Grant, *Journal of the Taliesin Fellows*, (Winter 1992), 10-13; *Interior Design*, 65(April 1994), 57-58; and Alice T. Friedman, "American architecture," *JSAH*, 53(June 1994), 247-48. Reprinted in Dunlop ed. *Frank Lloyd Wright*, London: 1999.

2493. Taliesin Associated Architects. *Romeo and Juliet windmill tower, Taliesin property, Spring Green, Wisconsin: architect, Frank Lloyd Wright, 1897: historic structure report prepared for the Frank Lloyd Wright Foundation.*

Spring Green: The Architects, 1992. See also Barbara K. Hower, "Nine decades and counting," *Inland Architect*, 35(November-December 1991), 13, 16; James A. Murphy, "Romance resumed," *Progressive Architecture*, 73(May 1992), 119-21; "The return of Romeo and Juliet Windmill", *Frank Lloyd Wright Quarterly*, 3(Winter 1992), 9; Peter Kuhweide, "Romeo and Julia still living: Frank Lloyd Wright's Windmuhle in Taliesin, Wisconsin." *Bauwelt*, 83(9 October 1992), 2184 (German); and "Romeo and Juliet. Das erste geburtstags-geschenk—Wrights pumpenturm ist restauriert.[The first birthday present—Wright's pumping tower restored." *AIT*, 101(no. 3, 1993), 17 (German).

2494. Visser, Kristin. *Frank Lloyd Wright and the Prairie School in Wisconsin: an architectural touring guide.* Madison: Prairie Oak Press, 1992. Reprinted in paperback, 1992; revised 1998. Describes forty-seven Wright works, and thirty-six other Prairie School buildings.

2495. Wennerstrom, Bruce ed. *Marketing Wright: a real estate guide for unique properties prepared by the Frank Lloyd Wright Building Conservancy.* River Forest: Frank Lloyd Wright Building Conservancy, 1992.

2496. Zimmerman, Scot. *Guide to Frank Lloyd Wright's California.* Layton: Gibbs-Smith, 1992.

Periodicals
2497. Allen, Stan. "El Guggenheim refigurado." *Arquitectura*, 73(July 1992), 112-20. Spanish. Cf. *idem.*, "The Guggenheim re-figured." *A+U*, (March 1993), 3-11 (Japanese and English).

2498. Andersen, Kurt. "Finally doing right by Wright." *Time*, 140(6 July 1992), 64-65. Guggenheim Museum

2499. Antonelli, Paola. "Happy birthday!: Richard Neutra's hundredth birthday and Frank Lloyd Wright's one hundred and fiftieth birthday." *Abitare*, (June 1992), 75. Italian and English.

2500. Apostolo, Roberto. "La Price Tower di Frank Lloyd Wright." *Frames, Porte e Finestre*, (August-September 1992), 54-61. Italian.

2501. Apostolo, Roberto. "Le origini di Fallingwater." *Frames, Porte e Finestre*, (December 1992-January 1993), 64-71. Italian: "Fallingwater's origins."

2502. Barnes, David Russell. "Taliesin east and west: the Welsh background of Frank Lloyd Wright." *Planet*, 91(1992), 19-27.

2503. Bassham, Ben. "FLLW, Henry Ford and the road back to the farm." *Journal of the Taliesin Fellows*, (Autumn 1992), 8-15. Broadacre City.

2504. Biemiller, Lawrence. "Echoes of Jefferson on a campus designed by Frank Lloyd Wright." *Chronicle of Higher Education*, 38(15 April 1992), B4-B5. Florida Southern College.

2505. Brierly, Cornelia et al. "Sixty years of the Taliesin Fellowship" *Frank*

Lloyd Wright Quarterly, 3(Autumn 1992), 4-16.

2506. Bruegmann, Robert. "Preservation's touchstone: the Rookery renaissance; original architects (1888): Burnham and Root, alterations (1905-7) by Frank Lloyd Wright, architects for restoration McClier." *Inland Architect*, 36(July-August 1992), 50-57. See also Lee Froehlich, "Rookery restoration uncovers Wright," *Architectural Record*, 179(August 1991), 25; Carl Nelson, "Rebuilding the stonework of a succession of famed architects," *Stone World*, (June 1992), 46; Blair Kamin, "Chicago's Rookery restored," *Architecture*, 81(July 1992), 28; Cheryl Kent, "The Rookery unveiled," *Progressive Architecture*, 73(October 1992), 90-95; "Rookery wins AIA's highest acclaim." *Commercial Renovation*, (April 1993), 7; Bonnie Schwartz, "Modern synthesis: McClier modernizes Chicago's Rookery," *Interiors*, 153(January 1994), 108-109; and Alan J. Shannon, "Restoring the Rookery: orchestrating a theme and variations," *Historic Illinois*, 18(June 1995), 3-7.

2507. Burrell, Mark. "Driving Mr Wright." *Inland Architect*, 36(January-February 1992), 9, 11. The 1940 Lincoln Continental Cabriolet V12, rebuilt to Wright's design.

2508. Campbell, Robert et al. [125th anniversary commemorative issue]. *Frank Lloyd Wright Quarterly*, 3(Spring 1992). Includes "The magic of Wright" by Campbell; "Frank Lloyd Wright's principles of design: breaking the box, the nature of materials, in harmony with nature" by Wright; "Wright preservation becomes mainstream" by Carla Lind; "Preserving Frank Lloyd Wright's Taliesin" by Robert Burley; "The decorative designs of Frank Lloyd Wright"; "The Taliesin Fellowship"; "Encounters with Frank Lloyd Wright"; and a timeline.

2509. Carney, Richard. "Land swap secures buffer zone for Taliesin West." *Journal of the Taliesin Fellows*, 7(Summer 1992), 10-12.

2510. Casciani, Stefano. "Frank Lloyd Wright: Johnson Wax desk: replicas by Cassina." *Abitare*, (December 1992), 70. Cf. "Cassina: a new Frank Lloyd Wright," *Ottagono*, (27 December 1992), 162-65.

2511. Casey, Thomas. "From Taliesin Fellowship to accredited school of architecture." *Journal of the Taliesin Fellows*, 7(Summer 1992), 17.

2512. Cembalest, Robin. "The Guggenheirn's high-stakes gamble." *Art News*, 91(May 1992), 84-93. The issue also includes "Diminished outside, dazzling inside" by Peter Lemos.

2513. Chan, Chiu-Shui. "Exploring individual style through Wright's designs." *Journal of Architectural and Planning Research*, 9(Autumn 1992), 207-238.

2514. Charrin, Francois. "Spirit, a keyword of organic architecture: ... Wright as a mystical and spiritual architect." *Nihon Kenchiku Gakkai Keikakuke1 Ronbun Hokoku Shu*, (November 1992), 151-58. English; Japanese abstract.

2515. Chia, Kathy. "Taliesin revisited." *Oculus*, 54 (April 1992), 7. Reviews "A Taliesin legacy: the independent work of Frank Lloyd Wright's apprentices"

exhibition, Pratt Manhattan Gallery, January-February 1992. See also Jayne Merkel, *Inland Architect*, 36(May-June 1992), 17-18; and *Frank Lloyd Wright Quarterly*, 3(Winter 1992), 15.

2516. Chusid, Jeffrey Mark. "The American discovery of reinforced concrete." *Rassegna*, 14(March 1992), 66-73.

2517. Curtis, Cole Martinez and Edie Lee Cohen. "Renovation of public spaces at the Arizona Biltmore, Phoenix." *Interior Design*, 63(October 1992), 196-201.

2518. Farah, Mary Anne. "Frank Lloyd Wright's Usonian houses." *Volute*, 1(January-February 1992), 16-19.

2518a. Fischer, Ray. "Frank Lloyd Wright's gifts of space." *AAA World*, 12(April 1992), 14-16.

2519. Flanagan, Barbara. "Reproducing Wright." *House Beautiful*, 134(June 1992), 30, 32. Reproductions of Wright furniture.

2520. Fortune, James W. "Wright to the top." *Construction Specifier*, (Month 1992), 86. "The Illinois" mile-high office building.

2521. Frank, Edward. "Somiglianze tra il Tempio Unitario e Broadacre City." *Architettura* 38(January 1992), 51-54. Italian: "Similarities between Unity Temple and Broadacre City."

2522. Friedman, Alice T. "A house is not a home: Hollyhock house as 'art-theatre garden'."*JSAH*, 51(September 1992), 239-60.

2523. Gattamorta, Gioia and Luca Rivalta. "Itinerario *Domus*: 78. Wright e la California." *Domus*, (April 1992), V-X. Italian: "*Domus* itinerary: 78. Wright and California"; English introduction.

2524. Geiger, John. "Taliesin, Midway, Hillside, and a visitor center." *Journal of the Taliesin Fellows*, (Autumn 1992), 6-7. Spring Green Restaurant.

2525. Giovannini, Joseph. "Architecture's genius, America's hero." *House Beautiful*, 134(June 1992), 34, 38, 40, 45-46. See also Louis Oliver Gropp, "A salute to genius," *ibid.*, 65.

2526. Giovannini, Joseph. "Breaking the institutional envelope." *Progressive Architecture*, 73(October 1992), 116.

2527. Gordon, Alastair. "Back to the future." *Interiors*, 151(July 1992), 22-24, 82. Preservation of the Guggenheim Museum.

2528. Gorlin, Alexander C. "F. L. Wright's furniture." *A +U*, no. 265(October 1992), 3-11. Japanese and English.

2529. Guerrero, Pedro E. "Frank Lloyd Wright. Philip Johnson, and God." *Progressive Architecture* 73(September 1992), 110-111. Reminiscences about Wright's 1958 visit to Philip Johnson's "glass house".

2530. Guerrero, Pedro E. "Photographing Frank Lloyd Wright." *Frank Lloyd Wright Quarterly*, 3(Summer 1992), 10-13.

2531. Guilfoyle, Ultan. "Extension of a New York controversy." *The Independent*, (29 July 1992), 14. Guggenheim Museum.

2532. Haas, Richard. "Wright on the money." *Architectural Record*, 180(August 1992), 29. Haas' proposed U.S. currency designs for a Walker Art Center publication includes a bill featuring the Robie house. Cf. *idem*., "A more current currency," *Design Quarterly*, (Summer 1992), 10-13. See also Ned Zeman and Lucy Howard, "New money," *Newsweek*, 120(21 September 1992), 10.

2533. Hale, Jonathan. "Wright school in Tokyo endangered." *Progressive Architecture*, 73(July 1992), 20. Jiyu Gakuen (School of the Free Spirit).

2534. Hockenhull, Jim. "Trekking to Usonia: Frank Lloyd Wright's Crosley cars." *Frank Lloyd Wright Quarterly*, 3(Winter 1992), 4-8; cover.

2535. Hoffmann, Donald. "Dismembering Frank Lloyd Wright." *Design Quarterly*, (Spring 1992), 2-5.

2536. Jodidio, Philip. "L'art de ce siecle." *Connaissance des Arts*, (July-August 1992), 28-39. French: "Art of this century." Guggenheim Museum.

2537. Kliment, Stephen A. "Doing the right thing." *Architectural Record*, 180(January 1992), 86. As Gwathmey Siegel's Guggenheim Museum addition neared completion (it was opened mid-1992), debate continued.
 Both sides are represented in the literature. See "Design: grand new Guggenheim—Frank Lloyd Wright's masterwork gets a splendid overhaul," *Time*, 140(no. 1, 1992), 64; J. Giovannini, "A new spin on the Guggenheim," *Metropolitan Home*, 24(May 1992), 52-55; Christine Pittel, "Finally, the Guggenheim as Wright conceived it," *House Beautiful*, 134 (June 1992), 82-89, 134; J. Perlez, "Art," *Vogue*, 182(June 1992), 58-60; C. McGuigan, "Do the Wright thing," *Newsweek*, 119(29 June 1992), 58-60; John Richardson, "Go go Guggenheim," *New York Review of Books*, 39(16 July 1992), 18-22; James Gardner, "A house for humans," *National Review*, 44(3 August 1992), 47-48; Mildred F. Schmertz, "Wright revamped," *Architecture*, 81(August 1992), 34-41; John Morris Dixon, "Guggenheim reopens, expanded and renovated," *Progressive Architecture*, 73(August 1992), 13-14; Martin Filler, "Back into the box," *Design Quarterly*, (Summer 1992), 6-9 (cf. *idem*., "Retorno a la caja: El Guggenheim remodelado," *Arquitectura Viva*, [November-December 1992], 70-73 [Spanish]); "The Guggenheim Museum: Wright has the last word," *Frank Lloyd Wright Quarterly*, 3(Summer 1992), 4-9; Eleanor Heartney, "Wright rewrit," *Art in America*, 80(September 1992), 108-113; Peter Blake, "Who really designed the Guggenheim?" *Interior Design*, 63(September 1992), 242-43; Mildred Schmertz, "The New Guggenheim galaxy: disfiguring a landmark," *New Criterion*, (11 September 1992), 8-11; Jacob Baal-Tesuva, "The Guggenheim Museum in New York reopens after expansion," *Cimaise*, 39(September-October 1992), 111-12; and Werner Otto Hall, "Gwathmey Siegal: The Guggenheim

Museum addition." *A+U*, (January 1993), 72-101 (English and Japanese, and including "Usonia revisited: the recasting of the Guggenheim" by Kenneth Frampton).

See also Carter Wiseman, "Born again,"*Architectural Record*, 180(October 1992), 100-113 (with Gwathmey's response) and inset articles, "Guggenheim-go-around", 102, and "On Wright's foundations", 104-113 (with Edward Frank and Robert McCarter's further response, "Guggenheim design debate," *ibid.*, 180[December 1992], 2). Cf. John Taylor, "Born again," *New York*, 25(no. 22, 1992), 30-34, 36-39.

There was also international interest. See Daniela Reinsch, "Das neue Guggenheim Museum. New York." *Bauwelt*, 83(17 July 1992), 1559-60 (German); Falk Jaeger, "Guggenheim-Museum in New York. Die beige und die weisse Moderne [beige and white modern]," *Baumeister*, (September 1992), 26-29 (German); Christiane Osterhof, "Ein Kunstwerk fur die Kunst [An artwork for art]," *MD*, 38(September 1992), 44-46 (German); Philippe Barriere, "La saga des Musées Guggenheim [The saga of the Guggenheim Museums]," *Architecture Interieure Cree*, (October 1992), 42-43 (French); Alan Plattus and Celia Imrey, "L'ampliamento del Solomon R. Guggenheim Museum [Expansion of the Guggenheim]," *Casabella*, 56(October 1992), 4-17, 68-70 (Italian; English summary); Michael Sorkin, "Forms of attachment: additions to modern American monuments," *Lotus*, (1992), 90-95; "Adicion, renovacion y restauracion del Museo Solomon R Guggenheim [Extension, renovation and restoration of the Guggenheim]," *Cuadernos de Arquitectura Docencia*, (March 1993), 58-63 (Spanish); Jorge Glusberg, "Museu Guggenheim. Na ampliacao, a reconquista de vazios e rampas [On the extension, and reconquest of spaces and ramps]," *Projeto*, (April 1993), 36-42 (Portuguese); and Flemming Skude, "Guggenheims genopstandelse—en ombygining af Gwatmey [*sic*] Siegel [Guggenheim revolution—Siegel's building]," *Arkitektur DK*, 37(no. 4, 1993), A52-A54 (Danish).

For belated comment, see Peter Cannon-Brookes, "Reopening of the Guggenheim Museum, New York," *Museum Management and Curatorship*, 12(December 1993), 405-408.

2538. Mahoney, Kathleen. "The Wright stuff." *House Beautiful*, 134(June 1992), 26-27. Reproductions of Wright furniture and furnishings.

2539. Marchesini, Marco. "La colonna di Brunelleschi e il pilastro a fungo di Wright: la dissoluzione dell'edificio nelio spazio." *Parametro*, (May-June 1992), 82-83. Italian: "Brunelleschi's columns and Wright's mushroom pillars; the dissolution of structure in space."

2540. Marcial, José. "Wright's heightened consciousness touched all." *Journal of the Taliesin Fellows*, (Autumn 1992), 18-21.

2541. Margolies, Jane. "Remembering Mr. Wright." *House Beautiful*, 134(June 1992), 18-19, 22, 24, 122. Reminiscences by Edgar A. Tafel, Pedro Guerrero, Elizabeth Gordon and John deKoven Hill. See also Sam Webb, "'OK, E J, we're

expecting you'—Sam Webb listened to Lloyd Wright apprentice Edgar Tafel reminisce," *Building Design*, (4 December 1981), 2.

2542. Massu, Claude. "Le dessein contourné de Frank Lloyd Wright: le Solomon R. Guggenheim Museum et les artistes." *Cahiers du Musee National d' Art Moderne*, (Spring 1992), 80-95. French: "Frank Lloyd Wright's convoluted design: the Guggenheim Museum and the artists."

2543. Meech, Julia. "Frank Lloyd Wright and the Art Institute of Chicago." *Orientations*, 23 (June 1992), 64-76.

2544. Moehl, Karl. "Lakeview Museum, Peoria, Ill; exhibit." *New Art Examiner*, 20(December 1992), 32.

2545. Ortiz, Renato. "Reflexoes sobre a pos-modernidade: o exemplo da arquitetura." *Revista Brasileira de Ciencias Sociais*, 7(October 1992), 135-47. Portuguese: "Reflections on postmodernity: the example of architecture." Proposes that Wright was an early postmodernist.

2546. Palco, Igor. "Fallingwater." *Projekt*, 34(no. 5, 1992), 61-65.

2547. Patner, Andrew. "Antique Chicago." *Art and Antiques*, 9(May 1992), 68-74. Subtitled, "Chicago has lost much great architecture, but now a few enthusiasts are rescuing the work of Frank Lloyd Wright and Louis Sullivan."

2548. Pfeiffer, Bruce Brooks. "Frank Lloyd Wright, il sistema di costruzione 'textile block'." *Domus*, (April 1992), 110-16. Italian and English. "Frank Lloyd Wright and 'textile block' construction system."

2549. Pollock, Naomi R. "Tokyo's hall for tomorrow." *Inland Architect*, 36(May-June 1992), 63-69. Jiyu Gakuen (School of the Free Spirit).

2550. Pope, Loren. "A Frank Lloyd Wright house for the people." *House Beautiful*, 134 (February 1992), 70-73. Pope-Leighey house.

2551. Posner, Ellen. "American dreamer." *The Independent on Sunday*, (10 May 1992), 50-52. A guide to Wright buildings in Chicago.

2552. Posner, Ellen. "Design classic: Guggenheim Museum." *Design*, (January 1992), 76.

2553. Rasch, Horst. "Connected with great names." *Hauser*, (23 November 1992), 14-23, 141-42.

2554. Roy, Arnold and John Rattenbury. "Master plan for Taliesin West: preservation and accommodation of change." *Journal of the Taliesin Fellows*, (Summer 1992), 13-15.

2555. Ruthven, Malise. "Architecture: Frank Lloyd Wright, an exclusive look at the Palmer house in Ann Arbor, Michigan." *Architectural Digest*, 49(March 1992), 40, 42, 44.

2556. Rykwert, Joseph. "America sogna Europa. Europa sogna America." *Casabella*, 56(January-February 1992), 32-35. Italian: "America dreams of Europe. Europe dreams of America."

2557. Samhammer-Habrich, Anke. "Das Boynton Haus von Frank Lloyd Wright in Rochester, US-Bundesstaat New York. Ein typisches Präriehaus? Form und Idee eines Präriehauses." *Kunstchronik*, (no. 8, 1992), 430. German: "Wright's Boynton house. A typical Prairie house? Form and idea in the Prairie houses." Refers to a thesis presented at Stuttgart University.

2558. Scheller, W.G. "The Wright stuff." *National Geographic Traveler*, 9(March 1992), 128. Zimmerman house.

2559. Schrenk, Lisa D. "The Oak Park studio of Frank Lloyd Wright." *Wright Angles*, 18(Summer 1992), 2-5.

2560. Smith, Michael J.P. "Mr. Wright, aged 125, breaks a leg." *Inland Architect*, 36(November-December 1992), 26, 30. Reviews "Mamah", a play by architect Nick Newberry, that opened in Phoenix, February 1992. It also announces "The Shining Brow", an opera by Daron Aric Hagen and Paul Muldoon, scheduled to open in Madison, April 1993. Cf. Tracy Metz, *Architectural Record*, 181(April 1993), 27. For reviews of the Madison season see Francis Booth, "American Valhalla: 'Shining Brow', Daron Hagen's new opera about Frank Lloyd Wright, bows at Madison Opera," *Opera News*, 57(10 April 1993), 24-28; Jon van Rhein, "Madison Opera: Hagen Shining Brow," *American Record Guide*, 56(July-August 1993), 37-38; and *Frank Lloyd Wright Quarterly*, 3(Summer 1992).

2561. Starzynski, Krista. "Frank Lloyd Wright house now open for public tours." *Americana*, 20(June 1992), 6. Rosenbaum house.

2562. Stephens, Suzanne. "Wright vs. nature." *Architectural Record*, 180(November 1992), 25. Reports annual conference of the Frank Lloyd Wright Building Conservancy, Manchester, New Hampshire, Fall 1992.

2563. Storrer, Bradley Ray. "The Schindler licensing letters: Schindler-Wright exchange." *Journal of the Taliesin Fellows*, (Winter 1992), 14-19. Letters 1929-, reprinted from August Sarnitz ed. *R.M. Schindler, architect: 1887-1953: a pupil of Otto Wagner, between international style and space architecture*, New York: Rizzoli, 1988.

2564. Stubbs, Stephanie. "Frank Lloyd Wright—125 and going strong." *Memo*, (December 1992), 4.

2565. Stucchi, Silvano. "Ristrutturazione di una casa di Frank Lloyd Wright." *Industria Delle Costruzioni*, 26 (June 1992), 48-54. Italian: "Reconstruction of a Wright house." Dana-Thomas house.

2566. Swaback, Vernon D. "Years of change." *Frank Lloyd Wright Quarterly*, 3(Fall 1992), 10-13. Celebrates the Taliesin Fellowship's sixtieth anniversary.

2567. Townsend, Gavin. "The Tudor houses of the Prairie School." *Arris: Journal of the Southeast Chapter of the Society of Architectural Historians*, 3(1992), 35-47.

2568. Twombly, Robert C. "Undoing the city: Frank Lloyd Wright's planned communities." *American Quarterly*, 24(no. 4, 1972), 538-49.

2569. Weil, Martin Eli. "Hanna honeycomb house restoration outlined."*Journal of the Taliesin Fellows*, (Summer 1992), 5-9.

2570. Yee, Roger. "So long, Frank Lloyd Wright?" *Contract Design*, (December 1992), 4.

2571. Young, Lucie. "Harry G. gets his own back." *Blueprint*, (July-August 1992), 5. Guggenheim Museum.

2572. *Canadian Architect.* "Perspective." 37(February 1992), 4.

2573. *ENR.* "Ailing historic Wright house set to vacate wrong place." (26 October 1992), 16. Pope-Leighey house. See also Naji Al-Hasani, "Second move for Wright landmark," *Architectural Record*, 181(April 1993), 30 (the building had been moved from Falls Church, Washington, D.C. to Mount Vernon, Virginia in 1965); "A new home for Pope-Leighey house," *Frank Lloyd Wright Quarterly*, 6(Autumn 1995), 3; and Ann C. Sullivan, "Recreating Wright: reconstruction of Pope-Leighey house, Mt. Vernon, Virginia," *Architecture*, 86(August 1997), 126-32.

2574. *ENR.* "Wetlands no obstacle to Frank Lloyd Wright." (27 July 1992), 25. Auldbrass.

2575. *Friends of Fallingwater Newsletter.* "Philip Johnson at Fallingwater." (February 1992). The issue also includes "It was a grand time," (recollections of Elsie Henderson, one of the Kaufmann's cooks).

2576. *History of Photography.* "Rendering for the dining room of the Susan Lawrence Dana House." 16(Autumn 1992), 209. Image only.

2577. *Inland Architect.* "Belt tightening." 36(March-April 1992), 79. Closure of the Dana-Thomas house and other historic sites by the state Historic Preservation Agency. See also *ibid.*, 36(November-December 1992), 68, 70.

2578. *Interior Design.* "Happy 125th, Frank Lloyd Wright." 63(May 1992), 47. Subtitled, "The Frank Lloyd Wright Foundation is opening the architect's Wisconsin home, Taliesin, for tours."

2579. *Iowa Architect.* "Building for education: Frank Lloyd Wright." 41(March 1992), 33.

2580. *Machine Design.* " Classy gas." 65(12 November 1993), 154. Wright gas station, featured in the Copper Development Association's *Copper Topics*.

2581. *Metropolis.* "Blueprint for dining." 12(February 1992), 77.

2582. *Metropolitan Home.* "Buffalo, NY." 24(February 1992), 64.

2583. *New Statesman and Society*, [Wright's perspective drawing of Falling-water]. 5(27 November 1992), 46. Reprinted from Mark Girouard, *Town and country*, New Haven: Yale University Press, 1992.

2584. *Online.* "Getty Trust and Kodak to develop digital collection for the arts." 17(September 1993), 80. Frank Lloyd Wright Foundation collection, Taliesin West.

2586. *Progressive Architecture.* [Announcement of "Frank Lloyd Wright and the Prairie School in Iowa" exhibit]. 74(July 1993), 29.

1993
Books, monographs and catalogues
2586. Alofsin, Anthony Michael. *Frank Lloyd Wright—the lost years, 1910-1922: a study of influence.* Chicago: University of Chicago Press, 1993. Based on the author's PhD thesis, "Frank Lloyd Wright. The lessons of Europe, 1910-1922," Columbia University, 1987 (Ann Arbor: University Microfilms International, 1990). Reprinted 1998. See also *Kunstchronik*, (no. 9, 1991), 561.

Reviewed Martin Filler, "He'd rather be Wright," *New York Review of Books*, 41(13 January 1994), 28-34; Joseph Rykwert, "Towards a well-distributed world," *TLS*, (6 May 1994), 16-17; Mark Heyman, *Journal of the Taliesin Fellows*, (Spring-Summer 1994), 42-43; Kevin Horwood Nute, "Re-assessing Wright's influence on Europe," *Architects' Journal*, 200(6 July 1994), 41; Andrew Saint, *AA Files*, (Autumn 1994), 61-64; *Virginia Quarterly Review*, 70(Autumn 1994), 124; and Peter Myers, "Ornement est leurre [Ornament is deception]," *L'Architecture d'Aujourdhui*, (October 1995), 22 (French) (for a response see "Sur les sources du Wright [On Wright's sources]," *ibid.*, [April 1996], 25.

2587. Blake, Peter. *No place like Utopia: modern architecture and the company we kept.* New York: Alfred A. Knopf, 1993. Paperback edition New York: W.W. Norton, 1996.

2588. Boulton, Alexander O. *Frank Lloyd Wright, architect: an illustrated biography.* New York: Rizzoli, 1993; Scottsdale: Frank Lloyd Wright Foundation, 1993. Juvenile literature. Reviewed Kenneth Marantz, *School Library Journal*, 39(November 1993), 129; Hazel Rochman, *Booklist*, 90(15 December 1993), 744; "Two views of a master," *American Heritage*, 44(December 1993), 98; Trudy Bush, *Christian Century*, 111(16 November 1994), 1091; Martin Filler, "More on the master," *House Beautiful*, 136(January 1994), 24, 28; Kathleen Morris McBroom, *Book Report*, 12(January-February 1994), 52; and *Booklist*, 90(15 March 1994), 1377.

2589. Braun, Barbara. *Pre-Columbian art and the post-Columbian world: Ancient American sources of modern art.* New York: Harry N. Abrams, 1993.

Paperback edition 2000. Mostly images. Includes a chapter "Frank Lloyd Wright: a vision of Maya temples."

2590. Christie's, New York. *Important works by Frank Lloyd Wright and his contemporaries from Domino's Center for Architecture and Design.* New York: Christies, 1993. Auction catalog.

2591. Hamilton, Mary Jane. *Frank Lloyd Wright and the book arts.* Madison, Wisconsin: Friends of the University of Wisconsin-Madison Libraries, 1993. Published to accompany an exhibition at the Department of Special Collections of the Memorial at the University Libraries, Autumn 1992.

2592. Hart, Spencer. *Frank Lloyd Wright.* New York: Barnes and Noble, 1993.

2593. Heinz, Thomas A. *Frank Lloyd Wright East portfolio.* Layton: Gibbs-Smith, 1993. Mostly images.

2594. Heinz, Thomas A. *Frank Lloyd Wright furniture portfolio.* Layton: Gibbs-Smith, 1993. Mostly images.

2595. Heinz, Thomas A. *Frank Lloyd Wright Midwest portfolio* Layton: Gibbs-Smith, 1993. Mostly images.

2596. Heinz, Thomas A. *Frank Lloyd Wright stained glass portfolio* Layton: Gibbs-Smith, 1993. Mostly images.

2597. Hoppen, Donald Walter. *The seven ages of Frank Lloyd Wright; a new appraisal.* San Bernardino: Borgo Press, 1992. Paperback edition Santa Barbara: Capra, 1993. Reissued as *The seven ages of Frank Lloyd Wright: the creative process*, New York: Dover, 1998.

2598. Horn, Patricia van. *Influences and changes in the architectural space of the early twentieth century and their relation to a Kuhnian paradigm shift in architecture* [microform]. Ann Arbor: University Microfilms International, 1993. MA Rice University, 1992, about the work of Wright, Le Corbusier and Theo van Doesburg.

2599. Karasick, Norman M. and Dorothy K. Karasick. *The oilman's daughter: a biography of Aline Barnsdall.* Encino: Carleston Publishing, 1993.

2600. Kokusai Shinpojumu. *"Jinrui no bunka isan wa dare no mono ka" F. L. Raito no kenchiku no hozon o kangaeru hokokusho.* Tokyo: The Symposium, 1993. Japanese and English: *To whom does the cultural heritage belong?* Report of the international symposium "Jinrui no Bunka Isan wa Dare no Mono Ka" Iinkai hen, Tokyo, Japan, 1992.

2601. Larkin, David and Bruce Brooks Pfeiffer eds. *Frank Lloyd Wright: the masterworks.* New York: Rizzoli; London: Thames and Hudson, 1993. Examines the following buildings: Barnsdall, Bogk, Boynton, Coonley, Dana, David Wright, Friedman, Hanna, Harold Price, Sr., Heurtley, Jacobs, Johnson, Laurent, Meyer May, Mossberg, Palmer, Robie, Stevens, Storer, Stromquist, Tonkens, Willits, Winslow, and Zimmerman houses; Wright home and studio; Larkin

Company administrative building; Unity Temple; Midway Gardens; Imperial Hotel; Fallingwater; S.C. Johnson and Son administrative building; Guggenheim Museum; Shorewood Hills Unitarian Church; Price Tower; Beth Sholom Synagogue; Marin County Civic Center; Taliesin III; and Taliesin West.

Reviewed Genevieve Stuttaford, *Publishers Weekly*, 240(25 October 1993), 51; Donna Seaman, *Booklist*, 90(15 November 1993), 591; Charles Gandee, "Season's readings," *Vogue*, 183(December 1993), 149; "Two views of a master," *American Heritage*, 44(December 1993), 98; Martin Filler, "More on the master," *House Beautiful*, 136(January 1994), 24, 28; H. Ward Jandl, *Library Journal*, 119(January 1994), 115-16; Paul Goldberger, "His brilliant career," *NYTBR*, 143(20 February 1994), 20-21; Ronny de Meyer, *Archis*, (February 1995), 88-89 (Dutch and English); *Christian Century*, 112(26 April 1995), 466-67.

Paperback edition 1997; reviewed Andrew Ballantyne, "America's rough-hewn Romano," *TLS*, (10 July 1998), 18-19; and Stanley Abercrombie, *Interior Design*, 69(November 1998), 78-79.

Also published in German as *Frank Lloyd Wright die Meisterwerke*. Stuttgart; Berlin; Cologne: Kohlhammer, 1993. The French edition, *Frank Lloyd Wright, les chefs-d'oeuvre*, Paris: Ed. du Seuil, 1993 is reviewed Gerard Gay-Barbier, *L'Oeil*, (April 1994), 19. The Italian edition, *Frank Lloyd Wright: i capolavori*, Milan: Rizzoli, 1993 was reprinted as *Frank Lloyd Wright maestro dell'architettura contemporanea*, Milan: Rizzoli, 1997. For a Spanish translation see *Frank Lloyd Wright*, Barcelona: Gustavo Gili, 1998.

2602. Lucas, Suzette A. ed. *Taliesin West: in the realm of ideas: an interpretive guide*. Scottsdale: Frank Lloyd Wright Foundation, 1993.

2603. Mack, Thomas B. *History of the Citrus Institute, Florida Southern College, 1947-1993.* Lakeland: The Institute, 1993.

2604. Monkhouse, Christopher P. *The shock of the old: architectural drawings from Frank Lloyd Wright to Robert Adam*: Pittsburgh: Carnegie Museum of Art, 1993. Catalogue of an exhibition at the Heinz Architectural Center, Carnegie Museum of Art, November 1993-February 1994.

2605. Muldoon, Paul. *Shining brow*. London; Boston: Faber and Faber, 1993. Dramatic poem commissioned by Madison Opera as a libretto for American composer Daron Hagen. See also Daron Aric Hagen, *The Shining brow: an opera in two acts and a prologue*, Boston: E.C. Schirmer, 1995 (vocal score).

2606. Nute, Kevin Horwood. *Frank Lloyd Wright and Japan: the role of traditional Japanese art and architecture in the work of Frank Lloyd Wright*. New York: Van Nostrand Reinhold; London: Chapman and Hall, 1993. Paperback edition New York: Routledge, 2000. Reviewed Don H. Choi, "Japanism and the work of Wright," *Design Book Review*, (Summer-Autumn 1993), 83-87; Richard Weston, "Frank Lloyd Wright's Japanese debt," *Architects' Journal*, 199(26 January 1994), 47; Dennis Sharp, *Architectural Review*, (June 1994), 104; Nayana Currimbhoy, "Writing about Wright. Again," *Interiors*, 153(September 1994), 14 ff.; Andrew Saint, *AA Files*, (Autumn 1994), 61-64; Martin

Filler, *NYTBR*, 144(4 December 1994), 29; Michael Webb, "Wright's first love," *Metropolis*, 15(December 1995), 30; and Jay C. Henry, *Planning Perspectives*, 11(April 1996), 198-200.

2607. Pfeiffer, Bruce Brooks ed. *Frank Lloyd Wright collected writings Vol. 2. 1930-1932.* New York: Rizzoli, 1993. The anthology reprints *Modern architecture, being the Kahn lectures for 1930,* Princeton: 1931; *Two lectures on architecture,* Chicago: 1931; and *An autobiography.* London, New York; Toronto: 1932; and an essay, "Poor little American architecture" (1930), first published in Gutheim ed. *Frank Lloyd Wright on architecture,* New York: 1941.

Reviewed Thomas S. Hines, "The Wright stuff," *NYTBR*, 142(13 December 1992), 1-3; Glenn Masuchika, *Library Journal*, 118(15 February 1993), 165; Diana Ketcham, "Prophet with honor," *New Republic*, 208(7 June 1993), 37-41; Julie V. Iovine and Thomas H. Beeby, "The man behind the legend: the words and life of Wright," *Architectural Record*, 181(July 1993), 40.

2608. Pfeiffer, Bruce Brooks ed. *Frank Lloyd Wright collected writings Vol. 3. 1931-1939.* New York: Rizzoli, 1993. Paperback edition, 1994. The anthology reprints in their entirety *The disappearing city*, New York: 1932 and *An organic architecture,* London: 1939, excerpts from Baker Brownell and Wright, *Architecture and modern life,* New York: 1937, and several articles and essays. Some pieces were published only in Gutheim ed. *Frank Lloyd Wright on architecture,* New York: 1941: "Concerning skyscrapers" (1931); "Raymond Hood" (1931); "The designing partner" (1932)";The house on the mesa/the conventional house" (1932); letters to *Pravda* and "Architecture of the U.S.S.R." (1933); "An architect speaking for culture" (1936); and "Room for the dead [to the memorial craftsmen of America]" (1936). Previously unpublished pieces include "To my critics in the land of the Danube and the Rhine" (1931); "Character is fate" (1931); "Apology for the decorator" (1931); "To the neuter" (1932); "What does the machine mean to life in democracy?" (1932); "Concerning the U.S.S.R." (1937); "To Williamsburg" (1938); and some of the series of short stories, "The man who ..." (1931-1939). Reviewed Martin Filler, "He'd rather be Wright," *New York Review of Books,* 41(13 January 1994), 28-34.

2609. Rosenbaum, Alvin. *Usonia: Frank Lloyd Wright's design for America.* Washington D.C.: National Trust for Historic Preservation, 1993. Reviewed Peter Reidy, *Journal of the Taliesin Fellows,* (Spring-Summer 1994), 39-41.

2610. Sinkevitch, Alice and Laurie McGovern Petersen eds. *AIA Guide to Chicago.* San Diego: Harcourt Brace, 1993.

2611. Sommer, Robin Langley. *Frank Lloyd Wright: American architect for the twentieth century.* London: Bison Group; New York: Smithmark; 1993. Reprinted Greenwich: Brompton Books, 1998.

2612. Storrer, William Allin. *A Frank Lloyd Wright companion.* University of Chicago Press, 1993. Reviewed Paul Goldberger, "His brilliant career," *NYTBR*, 143(20 February 1994), 20-21; Donna Seaman, *Booklist*, 90(1 February 1994),

989; Daniel J. Lombardo, *Library Journal*, 119(1 February 1994), 75; *Christian Century*, 111(20 April 1994), 425-26; Roderick Grant, *Journal of the Taliesin Fellows*, (Spring-Summer 1994), 37-39; Joseph Rykwert, "Towards a well-distributed world," *TLS*, (6 May 1994), 16-17; and K.A.K. and Eileen McIlvaine, *College and Research Libraries*, 55(September 1994), 417.

Published in Italian as *Frank Lloyd Wright—il repertorio*, Bologna: Zanichelli. Also in Chinese and Japanese. Available on CD-ROM; reviewed William J. Mitchell, "CD-Wright: three for your computer," *Architectural Record*, 183(August 1995), 19; D. Comberg, *ID*, 42(November 1995), 90; and Cheryl LaGuardia and Ed Tallent, *Library Journal*, 121(15 September 1996), 105-107.

2613. Tafel, Edgar A. *About Wright: an album of recollections by those who knew Frank Lloyd Wright.* New York: Wiley, 1993. The book is divided into several sections: Letters from Wright; Relatives (Franklin Porter, Robert Moses, David Wright, Iovanna Wright, John Lloyd Wright); Friends (Philip Johnson, Maria Stone); Clients (Lee Ackerman, the Littles, Arthur Miller, the Willitses); Draftsmen (Henry Klumb, Kamecki Tsuchiura, Donald Walker); Apprentices (Robert F. Bishop, Andrew Devane, John Howe, Yen Liang, Kenneth B. Lockhart, Carter H. Manny Jr., Eugene Masselink, Byron Mosher, William Wesley Peters, R. Ranal, Paolo Soleri and Marcus Weston); and Acquaintances (Andy Rooney and Edward Stanton). Many journal and newspaper articles, 1934-1980, are reprinted.

Reviewed Barbara MacAdam, "Just about Wright," *Art News*, 92(May 1993), 28-29; Genevieve Stuttaford, *Publishers Weekly*, 240(17 May 1993), 59; Trevor Dannatt, *Royal Society of Arts Journal*, 141(December 1993), 63-64; H. Ward Jandl, *Library Journal*, 119(January 1994), 115-16; Peter Reidy, "Last call (maybe) for stories," *Journal of the Taliesin Fellows*, (Winter 1993), 19-21.

Also in paperback 1995. Reissued as Tafel ed. *Frank Lloyd Wright: recollections by those who knew him*, Mineola: Dover, 2001.

2614. Temko, Allan. *No way to build a ballpark: and other irreverent essays on architecture.* San Francisco: Chronicle Books, 1993. Includes the articles "Retail shopping. Wright's jewel in Maiden Lane defaced [Morris store]" and "Wright's monumental contributions: Frank Lloyd Wright: in the realm of ideas."

2615. Wilk, Christopher. *Frank Lloyd Wright: the Kaufmann office.* London: Victoria and Albert Museum, 1993. Published for the opening in January 1993 of the museum's new gallery: an office Wright designed (1935-1937) for Edgar J. Kaufmann Sr., donated by his son in 1974. Republished London: Antique Collector's Club, 1997. See also Wilk, "A Frank Lloyd Wright room in the V. and A. Museum, London," *Antiques*, 143 (February 1993), 280-83 and Jill Lever, "Frank and Edgar: exteriors and interiors: Frank Lloyd Wright," *Architects' Journal*, 195(12 February 1992), 59, 61 (reviews a lecture by Wilk, 28 January 1992).

For reports and comment see "Kaufmann office to be reinstalled at the V. and A. Museum," *Friends of Fallingwater Newsletter*, (October 1992), 1-3;

Stanley Abercrombie, "... the 1937 office [Wright] designed for Edgar Kaufmann has been reassembled in the Wright Gallery, V. and A. Museum, London," *Interior Design*, 63(December 1992), 106-11; Emma Dent Coad, "Context questions," *Design*, (January 1993), 28-29; Tanya Harrod, "Builder of the American way," *Independent on Sunday*, (17 January 1993), 20-21; *Building Design*, (January 1993), 15; Louisa Buck, "Inside Wright," *GQ*, (February 1993), 20-21; "Office seeker," *Economist*, 326(6 February 1993), 94; "Wright at the V. and A.," *Blueprint*, (February 1993), 21-28; Whitney Williamson, "This month, there is a London debut for Frank Lloyd Wright," *House Beautiful*, 135(February 1993), 26; Hugh Pearman, "British rediscover Wright in new gallery at London's V. and A. Museum," *Progressive Architecture*, 74(March 1993), 21; Trevor Dannatt, "Lines of force," *Royal Society of Arts Journal*, 141(March 1993), 237-38; "Lloyd Wright: what the papers said," *Arts Review*, 45(March 1993), 58; "Room for discussion," *Crafts*, (March-April 1993), 12; Volker Welter, "Frank Lloyd Wright Gallery im V. and A. Museum, London," *Bauwelt*, 84(21 May 1993), 1036 (German); Ute Ballay, "Frank Lloyd Wright Gallery in London," *Werk, Bauen und Wohnen*, (June 1993), 72 (German); "V. and A. Museum opens Wright Gallery," *Frank Lloyd Wright Quarterly*, 4(Summer 1993), 15; *Habitat Ufficio*, (June-July 1993), 20 (Italian); Mark Heyman, "Interiors by Wright," *Frank Lloyd Wright Quarterly*, 4(Autumn 1993), 10-13; Joe Kerr, *Art History*, 16(December 1993), 678-79; Antonella Boisi, *Interni*, (January-February 1994), 81-84 (Italian and English); Peter Cannon-Brookes, *Museum Management and Curatorship*, 13(September 1994), 304-305; and Charlotte Benton, *Journal of Design History*, 9(no. 3, 1996), 224-27.

See also *Wright at the V. and A.: a Blueprint special report in association with Steelcase Strafor PLC*. Steelcase Strafor, 1993.

2616. Krens, Thomas. *Art of this century: the Guggenheim Museum and its collection*. New York: Solomom R. Guggenheim Foundation; Harry N. Abrams, 1994. Includes a chapter "Frank Lloyd Wright and the Solomon R. Guggenheim Museum." See also Kay Larson, "The Wright stuff: ... Thomas Krens answers the big questions." *New York*, 25(no. 22, 1992), 34-35.

2617. *A historical look: the relationship of Frank Lloyd Wright and Florida Southern College*. Lakeland: The College, 1993. Brochure.

Periodicals
2618. Abercrombie, Stanley. "Frank Lloyd Wright: furniture design competition: designs for Wright's 1924 Ennis-Brown house, Los Angeles." *Interior Design*, 64(March 1993), 178-81.

2619. Aver, James. "Partner to genius." *Frank Lloyd Wright Quarterly*, 4(Fall 1993), 14-16.

2620. Ball, Michael. "Restoring Wright's concrete campus." *Architects Journal*, 198(13 October 1993), 59. Florida Southern College. See also *Boston Preservation Alliance Letter*, 15(July 1994), 4.

2621. Basquiat, J.M. [Wright]. *New Observations*, (no. 96, 1993), 4.

2622. Bettini, Sergio. "Eventi dell'architettura, 1945-1955." *Architettura*, 39(October 1993), 713-27. Italian: "Architectural events 1945-1955"; English introduction. Reprinted from *Metron* (January-April, 1954), including Sergio Bettini, "Presentazione del Palazzo Masieri a Venezia," *ibid.*, 14-26.

2623. Brady, Darlene and Mark English. "Color." *Inland Architect*, 37(March-April 1993), 42-45. Unity Temple.

2624. Buchanan, Peter. "Rückkehr zur Mutter Erde." *Daidalos*, (15 June 1993), 50-61. German and English: "Return to Mother Earth." Includes discussion of Wright.

2625. Buck, Louisa. "Inside Wright." *GQ*, (February 1993), 20-21. Edgar J. Kaufmann office.

2626. Cazes, Isabelle. "Wright sur un camion." *D'Architectures*, (November 1993), 12. French: "Wright on a wagon." Reports on the relocation and restoration of Stockman house. See "A famous house gets a new home," *News for You*, 41(13 October 1993), 3.

2627. Cembalest, Robin. "Getting it Wright." *Art News*, 92(January 1993), 38. Subtitled, "Madison's voters have approved the construction of a ... Wright-designed convention center on the shore of Lake Monona." See also "Madison votes for ... Wright—50 years later," *Architectural Record*, 181(January 1993), 28; "Wright design wins voter approval in Madison," *Progressive Architecture*, 74(January 1993), 17; and "Voters approve Monona Terrace," *Frank Lloyd Wright Quarterly*, 4(Winter 1993).

2628. Cleary, Richard Louis. "Frank Lloyd Wright's San Francisco field office." *Carnegie Magazine*, 61(December 1993), 24.

2629. Cleary, Richard Louis and Edgar J. Kaufmann. "Frank Lloyd Wright and the Pittsburgh Point Park, Coney Island in automobile scale." *JSAH*, 52(June 1993), 139-58.

2630. Cusack, Victor A. "Guggenheim redux." *Journal of the Taliesin Fellows*, (Winter 1993-1994), 12-18, 21.

2631. Dean, Andrea Oppenheimer. "L.A. evolutionist: Martin Weil concentrates on a building's culture and history." *Historic Preservation*, 45(September-October 1993), 12, 14-15, 90-91.

2632. Dean, Andrea Oppenheimer. "Self-portrait." *Historic Preservation*, 45(June 1993), 26.

2633. Deitz, Paula. "The house collector." *Harper's Bazaar*, (October 1993), 264-68. Kentuck Knob.

2634. Dethier, Kathryn. "The spirit of progressive reform: the *Ladies Home*

Journal house plans 1900-1902." *Journal of Design History*, 6(no. 4, 1993), 247-61.

2635. Eifler, John. "Restoring the Jacobs house." *Fine Homebuilding*, (April-May 1993), 78-82.

2636. Engelmann, Jorg. "Architektur-Technik-Natur" *Deutsche Bauzeitschrift*, 41(December 1993), 2047-51ff. German: "Architecture-technique-nature." Includes discussion of Wright.

2637. Fernandez-Galiano, Luis et al. "[Special issue] Museos de vanguardia."*A. and V. Monografias*, (January-February 1993), 2-112. Spanish: "Avant-garde museums." Guggenheim Museum.

2638. Fortune, J. "Elevatoring Frank Lloyd Wright's mile high building." *Elevator World*, 40(no. 1, 1993), 67-74.

2639. Gerosa, Mario. "Frank Lloyd Wright: il tavolo Husser e le sedie Coonley." *Interni*, (March 1993), 144-47. Italian: "Frank Lloyd Wright: the Husser table and Coonley chairs."

2640. Gill, Brendan and John Vaughan. "Frank Lloyd Wright's Auldbrass. A film producer restores the architect's forgotten plantation complex in South Carolina." *Architectural Digest*, 50(December 1993), 126-37. See also John Heilpern, "The Wright stuff," *Vogue*, (November 1994), 180-83.

2641. Gill, Brendan. "The remodeling itch, throughout history, less has not always been more." *Architectural Digest*, 50(February 1993), 32, 36, 40.

2642. Goldberger, Paul. "Art: modern architects' drawings." *Architectural Digest*, 50(November 1993), 164-71. Includes Florida Southern College music building.

2643. Gorman, Jean. "Inside Wright: an exhibition reveals the inner magic of Frank Lloyd Wright." *Interiors*, 152(November 1993), 64-65. Reviews "Frank Lloyd Wright: decorative designs today and California projects" exhibition, Murray Feldman Gallery, Los Angeles.

2644. Grant, Roderick. "Edmund Teske photographer: a selection of work for Frank Lloyd Wright." *Journal of the Taliesin Fellows*, (Summer 1993), 21-31.

2645. Guillier, Pascaline. "Habiter deux utopies urbaines: La Ville Contemporaine de trois millions d'habitants de Le Corbusier et Broadacre City de Frank Lloyd Wright." *Cahiers de la Recherche Architecturale*, (no. 32-33, 1993), 135-44. French: "Living in two urban utopias: Le Corbusier's *La Ville Contemporaine* for 3 million and Wright's Broadacre City."

2646. Hampton, Mark. "Ambiance is all." *NYT Magazine*, 142(4 April 1993), 40-41. Playroom, Wright's Oak Park house.

2647. Heyman, Mark. "Interiors by Wright." *Frank Lloyd Wright Quarterly*,

4(Autumn 1993), 10-13. Browne's Bookstore; Rookery Building lobby renovation; Lawrence Memorial Library.

2648. Hill, David R. "A case for teleological urban form history and ideas: Lewis Mumford, F.L. Wright, Jane Jacobs and Victor Gruen." *Planning Perspectives*, 8(January 1993), 53-71.

2649. Hilpert, Thilo. "USA 1935—kontroverse Wright-Le Corbusier." *Architekt*, (no. 1, 1993), 38-42. German: "USA 1935—Wright-Le Corbusier controversy."

2650. Hoffmann, Donald. "The builder at Bear Run." *Journal of the Taliesin Fellows*, (Winter 1993-1994), 8-11. Walter J. Hall, builder of Fallingwater.

2651. Hoffmann, Donald. "A conversation with Donald Hoffmann." *Friends of Fallingwater Newsletter*, (December 1993), 10-15. Reports interview about the second edition of Hoffmann's *Frank Lloyd Wright's Fallingwater: the house and its history* (1993). For conclusion, see *ibid.*, (December 1994), 4-8. The earlier issue includes a note about the thirtieth anniversary of gift of Fallingwater.

2652. Jackson, Paula Rice et al. "Fifth Annual Corporate America Design Awards." *Interiors*, 152(May 1993), 111-47.

2653. Joncas, Richard. "Pedagogy and reflex: Frank Lloyd Wright's Hanna House revisited." *JSAH*, 52(September 1993), 307-322.

2654. Kao, Kenneth Martin. "Frank Lloyd Wright: experiments in the art of building." *Modulus*, (no. 22, 1993), 66-93. Willits house; American Systems Ready-Cut houses.

2655. Kappe, Shelley. "'In the Cause of Architecture' Symposium draws 200 to Fellow's event." *Journal of the Taliesin Fellows*, (Summer 1993), 2-5. Reports symposium held at Eric Lloyd Wright's home and studio, 13 June 1993.

2656. Kidder Smith, G.E. "Robie house and Villa Savoye." *JSAH*, 52(December 1993), 51. Letter.

2657. Klukas, Arnold. "Fallingwater: villa or shrine?" *Friends of Fallingwater Newsletter*, (October 1993), 1-5. See also Linda Hess and Gary Hughes, "Enjoy Wright's architecture at Fallingwater," *Mountain Guidepost*, 4(no. 1, 1993), 3.
2658. Korab, Balthazar. "Impressions at Taliesin: tracing a road through the domains of masters." *Journal of the Taliesin Fellows*, (Spring 1993), 9-11.

2659. Kruty, Paul Samuel. "Heurtley to Bluemner: early impressions of Frank Lloyd Wright." *Illinois Historical Journal*, 86(February 1993), 85.

2660. Langmead, Donald. "The impossible dream. H.Th.Wijdeveld and architectural education 1925-1987." *Exedra* [Australia], 4(no. 2, 1993), 4-13. Examines the ideas behind the Taliesin Fellowship, planned by Wright and Wijdeveld.

2661. LeFuere, Camille. "Desert bloom: Taliesin West remains a prime example

of Frank Lloyd Wright's quest for an 'organic architecture'." *Architecture Minnesota*, 19(November-December 1993), 36-37.

2662. McAslan, Troughton and Ove Arup. "Chip off the old block." *RIBA Journal*, 100(August 1993), 40-41. Restoration of Florida Southern College.

2663. Pearman, Hugh. "Wright every time." *Sunday Times*, (17 January 1993), 24-25.

2664. Petrilli, Amedeo and John Richardson. "Uno ziggurat ottimista." *Spazio e Societa*, 16(April-June 1993), 72-89. Italian: "An optimistic ziggurat." Guggenheim.

2665. Pfeiffer, Bruce Brooks. "Frank Lloyd Wright and Russia." *Interiors*, 152(May 1993), 146-47. Discusses Wright's interest in Russian culture through his correspondence with the Soviet press. See also Suzette A. Lucas, "Frank Lloyd Wright and Russia," *Frank Lloyd Wright Quarterly*, 4(Autumn 1993), 4-7; and Frank Lloyd Wright, "For 'Izvestia'," *ibid.*, 8-9 (excerpt from a 1937 article).

2666. Quinan, Jack. "Frank Lloyd Wright's Guggenheim Museum: a historian's report." *JSAH*, 52(December 1993), 479-82. See also Jeanne S. Rubin, "Jack Quinan on the Guggenheim Museum," *ibid.*, 53 (September 1994), 376-77.

2667. Richards, Kristen. "The Wright thing to do." *Interiors*, 152(May 1993), 22. Subtitled, "Taliesin, Wright's 600-acre estate near Spring Green, Wisconsin, declared a national historic landmark."

2668. Richardson, John. "Museos de franquicia: la saga de los Guggenheim." *A. and V. Monografias*, (January-February 1993), 26-35, 121-23. Spanish and English: "Tax-exempted museums: the saga of the Guggenheim." About the museum's director, Thomas Krens. See also

2669. Rosenbaum, Alvin. "Rediscovering America at the 1893 World's Columbian Exposition," *Blueprints*, 11(Winter 1993), 2-7.

2670. Shade, Joanne Prim. "A treasury of great gift ideas." *Consumers Digest*, 32(November-December 1993), 36-39. Wright Home and Studio Foundation's design reproductions.

2671. Solway, Susan. "Frank Lloyd Wright and Glencoe." *Wright Angles*, 19(August-October 1993), 36.

2672. Steiger, Richard W. "Child of the sun." *Concrete Construction*, (May 1993), 352. Florida Southern College, including Pfeiffer Chapel, Danforth Chapel, Emile E. Watson and Benjamin Fine administration building and Buckner Building.

2673. Storrer, Bradley Ray and Louis Wiehle. "Architect worked for both Le Corbusier and Wright: a conversation with Vladimir Karfík." *Journal of the Taliesin Fellows*, (Summer 1993), 8-21.

2674. Sweeney, Robert Lawrence. "A long misunderstood Wright design for California." *Journal of the Taliesin Fellows*, (Winter 1993-1994), 22-27. Johnson Compound, Death Valley.

2675. Tarbell, B. "The market: from here to eternity, a Soviet spaceman lands on the auction block." *Art and Antiques*, 15(December 1993), 23-24.

2676. Wagner, Michael. "Subterranean scheme: TAS Design Associates interpret the legacy of Frank Lloyd Wright." *Interiors*, 152(January 1993), 84-85. Guggenheim Museum offices.

2677. Webb, Michael. "Wright in Japan: preserving the Yamamura house near Kobe." *Architectural Digest*, 50(August 1993), 54 ff. Includes Imperial Hotel. See also Cherilyn Widell, "The promise and difficulties of preservation in Japan," *Historic Preservation News*, 33(July-August 1993), 20-21, 30.

2678. Wilk, Christopher and C.H. Voorsanger. "Museum acquisitions in the decorative arts: determination and beneficence." *Apollo*, (January 1993), 33-34.

2679. Woodbridge, Richard. "La enseñanza de la arquitectura—Frank Lloyd Wright: instruir o apasionar." *Revista Acta Académica, Universidad Autónoma de Centro América*, (November 1993), 45-48. Spanish: "The teaching of architecture—FLW: to instruct or to impassion."

2680. *Architectural Digest*. "Music building (pencil and tempera on paper, 1943)." 50(November 1993), 164-65. Florida Southern College (image only).

2681. *Art and Antiques.* "A Wright for right buyer [Dallas]." 15(October 1993), 18. Gillin house.

2682. *Civil Engineering.* "Taliesin rehab would make Wright proud." 63(October 1993), 12-13.

2683. *Crafts.* "Frank Lloyd Wright in situ." (no. 121, 1993), 9.

2684. *Frank Lloyd Wright Quarterly.* "Building for democracy." 4(Spring 1993), 3-7.

2685. *Frank Lloyd Wright Quarterly.* "The complex task of preserving Taliesin." 4(Spring 1993), 8-10.

2686. *Frank Lloyd Wright Quarterly.* "Frank Lloyd Wright and Hollywood." 4(Winter 1993), 4-12.

2687. *Frank Lloyd Wright Quarterly.* "A gateway to Taliesin." 4(Spring 1993), 11-13. Spring Green restaurant/visitor center.

2688. *Frank Lloyd Wright Quarterly.* "Little known works by Frank Lloyd Wright." 4(Summer 1993), 3-7. First National Bank, Dwight; Pettit Memorial Chapel; Lindholm service station; Anderton Court shops.

2689. *Frank Lloyd Wright Quarterly.* "The troubador and the architect." 4(Summer 1993), 8-11. Carl Sandburg and Wright.

2690. *L'Architettura.* "Bill Clinton and Wright's flame." 39(March 1993), 163.

2691. *Wright Angles.* "Winslow residence centennial." 19(November 1993-January 1994), 3-5.

2692. *Wright Angles.* "Wright's road to Japan, 1893-1905." 19(August-October 1993), 8. Reviews exhibition, Wright home and studio, August-November 1993.

1994
Books, monographs and catalogues
2693. Alofsin, Anthony Michael. "The *Call* building: Frank Lloyd Wright's skyscraper for San Francisco." In Wolfgang Bohm ed. *Das Bauwerk und die Stadt: Aufsatze fur Eduard F. Sekler.* Vienna: Bohlau, 1994. The book is reviewed *JSAH*, 57(December 1998), 483-84.

2694. Casey, Dennis J. *Prairie art glass drawings: drawings of windows designed by Frank Lloyd Wright.* Brisbane, CA: Prairie Designs of California, 1994. See also *idem., Stained glass window designs of Frank Lloyd Wright rendered by Dennis Casey,* New York: Dover, 1997.

2695. Chiaia, Vittorio. *Taliesin: l'età dell'utopia.* Fasano: Schena Editore, 1994. Italian: *Taliesin: utopian times.*

2696. Dennis, Lynn M. comp. *"Child of the Sun" and Southwestern Land-scapes.* Lakeland: Florida Southern College, 1994. Catalogue of an exhibition of photographs by Lew Wilson at the Melvin Gallery, September-October 1994.

2697. Dunham, Judith and Scot Zimmerman. *Details of Frank Lloyd Wright: the Californian work 1909-1974.* San Francisco: Chronicle Books; London: Thames and Hudson, 1994. Reviewed Roderick Gradidge, *Perspectives on Architecture,* 1(November 1994), 18; "Recent arrivals," *Christian Century,* 111(14 December 1994), 1204; *American Craft,* 55(June-July 95), 10-11; and Peter Reidy, *Journal of the Taliesin Fellows,* (Spring 1997), 24-25.

2698. Etlin, Richard A. *Frank Lloyd Wright and Le Corbusier: the romantic legacy.* Manchester; New York: Manchester University Press, 1994. Reviewed Richard Weston, "Common heritage of Wright and Le Corbusier," *Architects' Journal,* 199(23 March 1994), 43; Philip Tabor, *Architectural Review,* 194(May 1994), 97; Joseph Rykwert, "Towards a well-distributed world," *TLS,* (6 May 1994), 16-17; and *Progressive Architecture,* 75(June 1994), 24.
 Paperback edition, 1997; reviewed Kester Rattenbury, "Romantic associa-tions," *Architectural Review,* 202(October 1997), 96-97; and Jack Quinan, *JSAH,* 59(June 2000), 254-56.

2699. Guerrero, Pedro E. *Picturing Wright: an album from Frank Lloyd Wright's photographer.* San Francisco: Pomegranate, 1994. Reviewed Daniel J. Lombardo, *Library Journal,* 119(15 April 1994), 72.

2700. Hartoonian, Gevork. *Ontology of construction: on nihilism of technology in theories of modern architecture.* Cambridge: University Press, 1994. Paper-back edition 1997.

2701. Heinz, Thomas A. *Frank Lloyd Wright: Chicagoland.* Layton: Gibbs Smith, 1994. Mostly images.

2702. Heinz, Thomas A. *Frank Lloyd Wright: glass art.* London: Academy; Berlin: Ernst and Sohn, 1994. Mostly images. Reviewed Nayana Currimbhoy, "Writing about Wright. Again," *Interiors*, 153(September 1994), 14 ff.; Clem Labine, "The lesser-known work of Frank Lloyd Wright," *Traditional Building*, 7(September-October 1994), 96; Charles Bricker, "Room service," *Elle Decor*, 5(December 1994-January 1995), 112-14; and Stuart Goldman, *Glass Craftsman*, (February-March 1996), 26.

2703. Heinz, Thomas A. *Frank Lloyd Wright: interiors and furniture.* London: Academy; Berlin: Ernst and Sohn; New York: St. Martin's Press, 1994. Mostly images. Reviewed Nayana Currimbhoy, "Writing about Wright. Again," *Interiors*, 153(September 1994), 14 ff.; and Clem Labine,"The lesser-known work of Frank Lloyd Wright," *Traditional Building*, 7(September-October 1994), 96.

2704. Klinkow, Margaret. *The Wright family library.* Oak Park: Frank Lloyd Wright Home and Studio Foundation Research Center, 1994. Catalogue.

2705. Knight, Terry Weismann. *Transformations in design: a formal approach to stylistic change and innovation in the visual arts.* Cambridge: Cambridge University Press, 1995. Includes a chapter "The transformation of Frank Lloyd Wright's prairie houses into his Usonian houses."

2706. Lind, Carla. *Frank Lloyd Wright's life and homes.* San Francisco: Pomegranate, 1994. Mostly images.

2707. Lind, Carla. *Frank Lloyd Wright's lost buildings.* San Francisco: Pomegranate, 1994. Mostly images. See also *idem.*, *Lost Wright: Frank Lloyd Wright's vanished masterpieces.* New York: 1996; reviewed Glenn Masuchika, *Library Journal*, 122(1 March 1997), 74.

2708. Lind, Carla. *Frank Lloyd Wright's Prairie houses.* San Francisco: Pomegranate, 1994. Mostly images.

2709. Lind, Carla. *Frank Lloyd Wright's Usonian houses.* San Francisco: Pomegranate, 1994. Mostly images.

2710. McCarter, Robert. *Fallingwater—Frank Lloyd Wright.* London: Phaidon, 1994. Reprinted 2002. Also in Dunlop and Hector eds. *Twentieth century houses*, London: 1999.

2711. Patterson, Terry L. *Frank Lloyd Wright and the meaning of materials* New York: Van Nostrand Reinhold, 1994. Reviewed Peter Reidy, *Journal of the Taliesin Fellows*, (Summer 1995), 37-38. Reprinted 1997. Cf. *idem.*, "Frank Lloyd Wright and the meaning of materials: romance versus reality," *Avant Garde*, (April 1990), 24 ff.

2712. Peter, John. *The oral history of modern architecture: interviews with the greatest architects of the twentieth century.* New York: Harry N. Abrams, 1994.

Transcribes an interview with Wright (i.a.). There is an accompanying compact disc with fragments of the conversation.

Reviewed Genevieve Stuttaford, *Publishers Weekly*, 241(24 October 1994), 49; Nayana Currimbhoy, *Interiors*, (November 1994), 15 ff.; *Progressive Architecture*, 75(November 1994), 26; Norman Oder, *Publishers Weekly*, 241(7 November 1994), 24; Martin Filler, *NYTBR*, 144(4 December 1994), 29; *idem.*, "Prince of the city," *New York Review of Books*, 41(22 December 1994), 46-50; H. Ward Jandl, *Library Journal*, 120(January 1995), 98; *Interior Design*, 66(January 1995), 53; Robert Adam, *Perspectives on Architecture*, 2(January 1995), 19; Clifford A. Pearson, *Architectural Record*, 183(February 1995), 21; Julian Holder, "Modernist 'heroes' with little to say," *Architects' Journal*, 201(16 March 1995), 45; Witold Rybczynski, "Farewell to modernism," *Wilson Quarterly*, 19(Spring 1995), 80-83; Hugo Segawa, "Arquitetura represada Repressed architecture," *Projeto*, (September 1995), 86 (Portuguese); "Architects on CD," *World Architecture*, no. 36(1995), 128; Gert Kähler, *Baumeister*, 93(February 1996), 58 ff. (German); Jeremy Myerson, "Modern architecture greats," *RSA Journal*, 144(May 1996), 50; and Maggie Valentine, *Oral History Review*, 23(Winter 1996), 135-37.

Paperback edition, 2000; reviewed Jeremy Melvin, "On the record," *Blueprint*, (June 2000), 76

2713. Pfeiffer, Bruce Brooks ed. *Frank Lloyd Wright: collected writings. Vol. 4. 1939-1949.* New York: Rizzoli, 1994. Most of the book is *An autobiography*, reprinted in its entirety. Reviewed Genevieve Stuttaford, *Publishers Weekly*, 241(28 November 1994), 49; *Frank Lloyd Wright Quarterly*, 6(Winter 1995), 15.

2714. Quetglas, Josep ed. *Frank Lloyd Wright: primers escrits.* Barcelona: Universitat Politècnica de Barcelona, 1994. Spanish and English: *Frank Lloyd Wright: early writings.*

2715. Quinlan, Marjorie L. *Rescue of a landmark: Frank Lloyd Wright's Darwin D. Martin house.* Buffalo: Western New York Wares, 1994. See also "Wright restoration in Buffalo," *Progressive Architecture*, 75(September 1994), 21. The book is revised as *Frank Lloyd Wright's Darwin D. Martin house: rescue of a landmark*, 2000.

2716. Riley, Terence and Peter Reed eds. *Frank Lloyd Wright, architect: visions and revisions since 1910.* New York: Museum of Modern Art: distributed by Harry N. Abrams, 1994. Catalogue of an exhibition of over 500 drawings, photographs, models, and full-scale reconstructions, in cooperation with The Frank Lloyd Wright Foundation, February-May 1994. It includes essays: "The landscapes of Frank Lloyd Wright: a pattern of work" by Riley; "Inconstant unity: the passion of Frank Lloyd Wright" by William Cronon; "Frank Lloyd Wright and modernism" by Anthony Michael Alofsin; "Modernization and mediation: Frank Lloyd Wright and the impact of technology" by Kenneth Frampton; and "Frank Lloyd Wright and the domestic landscape" by Gwendolyn Wright.

Also published in Italian as *Frank Lloyd Wright: architetto (1867-1959)*. Milan: Electa, 1994; reviewed *Industria delle Costruzioni*, 28(November 1994), 90; and Luigi Prestinenza Puglisi, *Domus*, (December 1994), 95-96.

The exhibition is previewed in *Art in America*, 81(August 1993), 25; "[MoMA] pays tribute to Wright," *Frank Lloyd Wright Quarterly*, 5(Winter 1994), 20-24; Matthew Tyrnauer, *Vanity Fair*, 57(January 1994), 143; and "MoMA's massive FLLW exhibit opens February 20," *Journal of the Taliesin Fellows*, (Winter 1993-1994), 6.

There was early and sustained interest in North America: see Jerry Dunn, "The Wright stuff," *National Geographic Traveler*, 11(January-February 1994), 14; *Drawing*, 15(January-February 1994), 108; Peter Lemos, "The genius behind the myth," *Artnews*, 93(February 1994), 71-72; Meryle Secrest, "A great architect with love for nature and lots of fight," *Smithsonian*, 24(February 1994), 54-61; Paul Goldberger, "Not an urbanist, only a genius," *NYTBR*, 143(13 February 1994), 48-49; and Roger Kimball, "Wright on the walls," *Architectural Record*, 182(February 1994), 16-17, 19.

The catalogue and show are reviewed in Brendan Gill, "The suburbanite," *New Yorker*, 70(7 March 1994), 84-87; Allison Ledes, *Antiques*, 145(March 1994), 344 ff.; Martin Filler, *House Beautiful*, 136(March 1994), 146-51; Genevieve Stuttaford, *Publishers Weekly*, 241(11 April 1994), 48; Susan Woldenberg, "Frank Lloyd Wright comes to MOMA," *New Criterion*, 12(April 1994), 45-51; Suzanne Stephens, "Why Wright right now?" *Oculus*, 56(April 1994), 6; Donald Albrecht, "Wright exhibits in New York," *Architecture*, 83(April 1994), 22-23; Diane Berna-Heath, "Wright turn," *Southwest Art*, 23(April 1994), 24 ff.; Mark Alden Branch, "The Modern meets the master," *Progressive Architecture*, 75(April 1994), 15-42; Harold Allen Brooks, "Frank Lloyd Wright at MoMA," *Canadian Architect*, 39(April 1994), 23-25; Mayer Rus and Peter Blake, "Minority opinion," *Interior Design*, 65(April 1994), 45-46; C.C. Sullivan, *Buildings*, 88(April 1994), 21; Victoria Carlson, *Inland Architect*, 38(Spring 1994), 38-39; Daniel J. Lombardo, *Library Journal*, 119(1 May 1994), 102; Garry Wills, "Sons and daughters of Chicago," *New York Review of Books*, 41(9 June 1994), 52-59; Neil Levine, *JSAH*, 53(September 1994), 343 (response from Anthony Michael Alofsin, *ibid.*, 54[March 1995], 114-15); Carter Wiseman, "Wright mania," *New York*, 27(no. 9, 1994), 50-55; Stanley Mathews, *Drawing*, 16(November-December 1994), 90-91; *Art in America*, 83(August 1995), 32; and Jonathan Lipman, *JSAH*, 54(September 1995), 365-66.

See also Louis Wiehle ed. "Frank Lloyd Wright at the Museum of Modern Art, 1994: a compendium of observations," *Journal of the Taliesin Fellows*, (Spring-Summer 1994), 18-33, that contains comments by several visitors to the exhibition; Victor A. Cusack, "Two retrospectives of retrospect," *ibid.*, 12-17, that compares the show with "Frank Lloyd Wright, American architect, 1940"; and Laurie Olin, "Frank Lloyd Wright: architect-reflections on the recent retrospective exhibition at [MoMA]," *Landscape Journal*, 14(Spring 1995), 138-55.

For international comment see David Cohn, "Regreso a Usonia [Going back to Usonia]," *Arquitectura Viva*, (January-February 1994), 68-69 (Spanish) (cf. *idem.*, *Bauwelt*, 85[March 1994], 493 [German]); Luis Fernández-Galiano,

"Febrero: una ópera americana: el mundo de Frank Lloyd Wright [An American work: the world of Wright]," *A. and V. Monografías*, (January-April 1995), 154-55 (Spanish); Peter Reed and Terence Riley, "Les horizons de Frank Lloyd Wright [Wright's horizons]," *Connaissance des Arts*, (February 1994), 62-72 (French); *A+U*, 94(February 1994), 2-5 (Japanese and English); Careline Maniaque, "All Wright: une grande retrospective a New York," *L'Architecture d'Aujourdhui*, (February 1994), 32-35 (French); Demetrios Matheou, "A tribute undermined [by] excessive reverence," *Architects' Journal*, 199(23 March 1994), 43; Charles Knevitt, "Showman on a scale of Barnum," *Building Design*, (8 April 1994), 10; Philippe Trétiack, "L'Amérique idéale de Frank Lloyd Wright [Wright's ideal America]," *Beaux Arts*, (April 1994), 124 (French); Gerard Gay-Barbier,. "Frank Lloyd Wright: Taliesin, centre de l'architecte," *L'Oeil*, (April 1994), 40-51 (French); Sandy Heck, "Interpreting the Wright way." *Architectural Review*, 194(May 1994), 9. Yves Nacher, "Frankie goes to the MoMA," *D'Architectures*, (May 1994), 44-45 (French); Marinetta Nunziante, "Il poeta di Usonia [The poet of Usonia]," *Ville Giardini*, (May 1994), 32-35 (Italian); Jack Quinan, *Casabella*, 58(May 1994), 49-53 (Italian); Francis Booth, "Fecund force," *Royal Society of Arts Journal*, 142(May 1994), 75-77; Joseph Rykwert, "Towards a well-distributed world," *TLS*, (6 May 1994), 16-17; Märiette van Stralen and Bart Lootsma, *Archis*, 25(June 1994), 16-17 (Dutch and English); Emilio Ambasz, *Domus*, (June 1994), 82-84 (Italian and English); Robert Silberman, *Burlington Magazine*, 136(August 1994), 576-77; Irja Hult-Visapaa, *Arkkitehti*, 91(1994), 18 (Finnish); Luigi Prestinenza Puglisi, *Industria delle Costruzioni*, 28(November 1994), 70-73 (Italian); *Spazio e Società*, 18(January-March 1995), 40-55 (Italian and English); Johan Mårtelius, *AT: Arkitekttidningen*, (no. 5, 1995), 15 (Swe-dish); and Antonio Toca Fernández, "Frank Lloyd Wright: un shock de sorpresa [Wright: a surprise shock]," *Astragalo*, (March 1995), 84-88 (Spanish; English summary) (same as *Summa Plus*, [August-September 1996], 93-95).

2717. Rintz, Don. *A survey of Frank Lloyd Wright and Prairie School architecture in Racine, Wisconsin by Don Rintz ... for the Landmarks Preservation Commission, City of Racine, Intensive Survey Report*. Racine: The Commission, 1994. See also Rintz and Robert R. Hartmann, *Racine tour guide: Frank Lloyd Wright and Prairie School architecture*, Racine: The Commission, 1994.

2718. Roche, John F. *Walt Whitman's "Manahatta" and Frank Lloyd Wright's "Broadacre City": concurrent envisionings of a democratic city* [microform]. Ann Arbor: University Microfilms International, 1994. PhD Thesis, State University of New York at Buffalo, 1987.

2719. Roob, Rona. *Edgar J. Kaufman, Jr., Fallingwater, and the Museum of Modern Art*. New York: Museum of Modern Art, 1994.

2720. Rubin, Susan Goldman. *Frank Lloyd Wright*. New York: Harry N. Abrams, 1994. Juvenile literature. Reviewed Hazel Rochman, *Booklist*, 91(January 1995), 812; Jeanette Larson, *School Library Journal*, 41(January 1995), 143; and Melinda Bronte, *Book Report*, 14(September-October 1995), 47.

2721. Sinding-Larsen, Staale. *Temaer i europeisk og amerikansk arkitekturteori: fra Wienerskolen til Bauhaus og De Stijl, Frank Lloyd Wright—Le Corbusier: tekstutdrag, referater og kommentarer* Trondheim: Institutt for Arkitekturhistorie, N.T.H, 1994. Norwegian: *European and American architectural theory from the Wienerstat to the Bauhaus and De Stijl, Wright—Le Corbusier, texts, references and commentary.*

2722. Solomon R. Guggenheim Foundation. *The Solomon R. Guggenheim Museum.* New York: The Museum, 1994. Mostly images, the book was published for the opening of the additions. Includes "A temple of spirit" by Bruce Brooks Pfeiffer. Second edition, 1995.

2723. Sweeney, Robert Lawrence. *Wright in Hollywood. Visions of a new architecture.* New York: Architectural History Foundation; Cambridge, Mass.: MIT Press, 1994. Previewed *AHF Review*, (Spring-Summer 1993), 2; reviewed Roderick Grant, "The textile block buildings in search of their meaning," *Journal of the Taliesin Fellows*, (Autumn 1994), 26-27; and *Frank Lloyd Wright Quarterly*, 6(Winter 1995), 16.

2724. Thorne-Thomsen, Kathleen. *Frank Lloyd Wright for kids: his life and ideas—21 activities.* Chicago: Chicago Review Press, 1994. Juvenile literature. Reviewed Sally Lodge and Shannon Maughan, *Publishers Weekly*, 241(21 February 1994), 66; Carolyn Phelan, *Booklist*, 90(15 April 1994), 1533; Diane Roback and Elizabeth Devereaux, *Publishers Weekly*, 241(18 April 1994), 65; Jeanette Larson, *School Library Journal*, 40(July 1994), 114; Ivan E. Johnson, *Arts and Activities*, 122(November 1997), 49; and Kent Anderson and Kenneth Marantz, *School Arts*, 98(November 1998), 50-51.

2725. Tillyer, William. *The relationship between architecture and landscape: watercolours 1993-1994 of Fallingwater: Edgar J. Kaufman House, Mill Run, Pennsylvania, 1934-37.* Chicago: Belloc Lowndes Fine Art Inc., 1994. Catalog of an exhibition, in association with Bernard Jacobson Gallery, London.

2726. U.S. Congress. Senate. Committee on Energy and Natural Resources. Subcommittee on Public Lands, National Parks, and Forests. *Truman Farm Home, Wounded Knee National Memorial, Bodie Bowl, preservation of Taliesin site, etc.: hearing before the Subcommittee on Public Lands, National Parks, and Forests of the Committee on Energy and Natural Resources, United States Senate, One Hundred Third Congress, first session, on S. 150, H.R. 240, S. 278, S. 845, S. 492, S. 855, July 29, 1993.* Washington, D.C.: U.S. G.P.O., 1994.

2727. Wisconsin Academy of Sciences, Arts and Letters. *Frank Lloyd Wright's Japanism: Japanese art on paper from his collection.* Madison: The Academy, 1994. Leaflet.

2728. Zygas, Paul K. and Linda Nelson Johnson eds. *Frank Lloyd Wright: the Phoenix papers.* Tempe: University of Arizona Press, 1994-1995. 2 vols. Proceedings of two symposia at Herberger Center for Design Excellence, College of

Architecture and Environmental Design, Arizona State University, Tucson.

Vol. 1: "Alternative American city models from Broadacre City to the present," 2 February 1991, and the "Broadacre City 1935-Phoenix 1990" exhibition. Essays by Zygas, John Meunier, Harold Allen Brooks, Peter Rowe, John Sergeant and Lionel March and an interview with Cornelia Brierley.

Vol. 2: "Frank Lloyd Wright, the natural pattern of structure," 20 April 1991 (exhibition, April-June 1991). Essays by Johnson, Jeffrey Mark Chusid, Lionel March, Donald Hallmark and Bruce Brooks Pfeiffer; catalogue for an exhibition at the Nelson Fine Art Center, April-June 1991.

Reviewed *Progressive Architecture*, 76(September 1995), 22; and Harold Henderson, *Planning*, 62(May 1996), 27-29.

Periodicals
2729. Abercrombie, Stanley. "Fallingwater: the risks of going public." *Interior Design*, 65(July 1994), 27-28

2730. Aeppel, Timothy. "They go for the mops when this house lives up to its name." *Wall Street Journal (eastern edition)*, 224(5 July 1994), 1-2. Fallingwater.

2731. Albrecht, Donald and Joel Davidson. "World War II and the American Dream: how wartime building changed a nation." *Blueprints*, 12(Spring 1994), 16-17. Includes Cloverleaf quadruple housing project, Pittsfield.

2732. Anderson, K., D. Carpenter and D. Carlson. "Ski Wisconsin and stay in a Frank Lloyd Wright cabin." *Minnesota Monthly*, 28(October 1994), 62. Seth Peterson cottage.

2733. Baudoui, Remi et al. "[Special issue] Ville et architecture."*Cahiers de la Recherche Architecturale*, (1993), 7-184. French: "City and architecture."

2734. Benini, Carla and Jay Levin. "Frank Lloyd Wright designs taking shape in Wisconsin." *Meetings and Conventions*, 29(October 1994), 17. Monona Terrace. See also "Convention center utilizes Frank Lloyd Wright design," *Building Design and Construction*, 35(October 1994), 12.

2735. Birk, Melanie. "Revisiting the restoration." *Wright Angles*, part I, 20(May 1994); part II, 20(August-October 1994), 3-7. Wright home and studio. See also *idem.*, "Robie house: the shape of things to come," *ibid.*, 21(May-July 1995), 3-6. Cf. Allen Freeman, "Work in progress," *Historic Preservation*, 46(November-December 1994), 36-44, 88-89.

2736. Brierly, Cornelia. "Taliesin West: the early years." *Frank Lloyd Wright Quarterly*, 5(Fall 1994), 10-13. The issue celebrates the Taliesin Fellowship's sixtieth anniversary and also includes "The School today".

2737. Campbell, Robert. "A walk through Taliesin, the most personal of Wright's masterpieces." *Frank Lloyd Wright Quarterly*, 5(Spring 1994), 4-7.

2738. Canella, Guido. "Urban structure and architectural deconstruction: the competence of the critic, and that of the man on the street." *Zodiac*, (March-

August 1994), 4-11. Italian and English. Wright buildings in Los Angeles.

2739. Carr, Richard. "Four legs good." *Building Design*, (9 September 1994), 12.

2740. Dagnini-Brey, Ilaria. "Genio del futuro." *Elle*, (April.1994), 68-71, 74, 76, 80-81. Italian: "Genius of the future."

2741. Dahle, Einar. "Det moderne romkonsept: Boligen som veiviser i det 20. Jårhundre." *Mur*, (1994), 29-31. Danish: "The modern concept of space" On space in masonry buildings of the 1920s through 1950s, using examples by Wright (i.a.).

2742. Dean, Andrea Oppenheimer. "Self-portrait: Frank Lloyd Wright made the Taliesin complex in Wisconsin a work in progress." *Historic Preservation*, 45(November-December 1993), 26-33, 96-97, 101-102.

2743. Fintozzi, Carla, Ina Borenzweig and K. Elliott. "Frank Lloyd Wright's Hollyhock house, Los Angeles, California, 1919-1921." *Art Education*, 47(March 1994), 25-35.

2744. Field, Marcus. "Reasons for restoration" *Architects' Journal*, 201(March 1995), 9, 21. Freeman house.

2745. Filler, Martin. "Frank Lloyd Wright." *Travel and Leisure*, 24(March 1994), 90. See also *ibid.*, 138.

2746. Fishman, Robert. "Space, time and sprawl." *Architectural Design*, 64(March-April 1994), profile 44-47.

2747. Fumagalli, Paolo. "Museumsarchitektur." *Werk, Bauen und Wohnen*, 81(no. 1-2, 1994), 26-33. German: "Museum architecture."

2748. Gorvy, Brett. "The Wright stuff." *Antique Collector*, 65 (February 1994), 56-61.

2749. Graaf, Vera. "Architekt der Einheit." *Architektur und Wohnen*, (April-May 1994), 118. German: "Architect of unity."

2750. Guerrero, Pedro E. "A photographer looks at Taliesin West." *Frank Lloyd Wright Quarterly*, 5(Autumn 1994), 4-9.

2751. Henning, Randolph C. "Frank Lloyd Wright in Fort Lauderdale." *Gold Coast*, 30(April 1994), 10, 12 ff. Spivey house.

2752. Iglesias, Helena. "Los dibujos de Frank Lloyd Wright." *Arquitectura*, (no. 300, 1994), 15-19. Spanish and English: "Wright's drawings."

2753. Kerr, Joe. "Buildings in an empty landscape." *Building Design*, (24 June 1994), 13.

2754. Lin, Yuan. [Karsten Harries' natural symbols and Wright's natural houses]. *Nordisk arkitekturforskning*, 7(no. 1, 1994), 129-32. Norwegian.

2755. Mackey, K. "Fallingwater." *Nutshell News*, 24(October 1994), 80.

2756. Massey, James C. and Shirley Maxwell. "The case for concrete houses." *Old-House Journal*, 22(May-June 1994), 48-54. Subtitled, "Building with poured concrete, from Orson Squire Fowler to Frank Lloyd Wright."

2757. Matthews, Henry. "The promotion of modern architecture [by] the Museum of Modern Art in the 1930s." *Journal of Design History*, 7 (no. 1, 1994), 43-59.

2758. McCarter, Robert. "Essays on residential masterpieces: Frank Lloyd Wright. Folded space, boundless place—the houses of Frank Lloyd Wright, 1895-1915." *GA Houses*, (January 1994), 10-21. Japanese and English. See also "Squared space, constructed place—the houses of Frank Lloyd Wright, 1915-1935," *ibid.*, (June 1994), 10-19; and "Woven space, anchored place—the houses of Frank Lloyd Wright, 1935-1939," *ibid.*, (October 1994), 10-23.

2759. Meech, Julia. "Spaulding Brothers and Frank Lloyd Wright: opportunity of a lifetime." *Orientations*, 26(March 1995), 36-49. Wright was the Spauldings' erstwhile agent in Tokyo, acquiring Japanese prints for their collection.

2760. Meyers, D.A. "Frank Lloyd Wright: the architect as preacher." *Journal of Interdisciplinary Studies*, 6(January-February 1994), 24.

2761. Morse-Fortier, Leonard J. "From Frank Lloyd Wright's Usonian automatic building system: lessons and limitation in a lost paradigm." *Journal of Architectural and Planning Research* 11(Winter 1994), 274-93.

2762. Nickens, Eddie. "Phoenix sons." *Historic Preservation*, 46(May-June 1994), 16-19, 84-85. Subtitled, "Architects, both famous and unknown, have been drawn to Arizona's Sonoran Desert." Taliesin West.

2763. Nute, Kevin Horwood. "Building of tomorrow?" *Architectural Review*, 194(January 1994), 9. Jiyu Gakuen Girls' School (School of the Free Spirit).

2764. Nute, Kevin Horwood. "Frank Lloyd Wright and Japanese architecture: a study in inspiration." *Journal of Design History*, 7(1994), 169-185. Prairie houses, Unity Temple; the *Life* house; S.C. Johnson and Son research tower.

2765. Nute, Kevin Horwood. "Frank Lloyd Wright and 'Japanese homes': the Japanese house dissected." *Japan Forum*, 6(January 1994), 73 ff. Japanese and English.

2766. Oboler, Arch. "He's always magnificently Wright." *Frank Lloyd Wright Quarterly*, 5(Summer 1994), 3-7. Arch Oboler studio (project).

2767. Pfeiffer, Bruce Brooks. "Light for its own sake." *Interiors*, 153(May 1994), 156-57. The Yamagiwa Corporation markets replicas of Wright's lighting fixtures. Cf. "Wright lights," *Architectural Record*, 182(March 1994), 40- 41; "Wright lighting," *Interior Design*, 65(March 1994), 66-67; "Products: lighting [by] ... Wright reproduced," *Architecture*, 83(April 1994), 141; "Frank Lloyd

Wright lamps reproduced," *Architectural Lighting*, 8(April-May 1994), 70; Roger Yee, "Let there be Wright," *Contract Design*, (April 1994), 40; Janet L. Rumble, "Timeless lights," *Metropolis*, 13(June 1994), 31; and Mikio Kuranishi, "Light of Frank Lloyd Wright," *Axis*, (Spring 1995), 130-35. See also "Lighting briefs," *Architectural Record*, 186(May 1998), 303-308.

2768. Pretzer, Michael. "The odd couple." *Historic Preservation*, 46(March-April 1994), 56-65 ff. Pope-Leighey house.

2769. Puglisi, Luigi Prestinenza. "I capolavori del moderno tra conservazione e innovazione." *Industria delle Costruzioni*, 28(March 1994), 48-49. Italian: "The forerunners of modernism between conservation and innovation." Guggenheim Museum.

2770. Ricalde, Humberto. "Wright o la excepcion como regla."*Arquitectura* [Mexico], (August 1994), 68-71. Spanish: "Wright, or the exception as rule."

2771. Richter, Klemens. "Orte zum Handeln: Forderungen eines neues Liturgie-verständnisses an der Katholischen Gottesdienstraum." *Kunst und Kirche*, (no. 1, 1994), 4-8. German: "Places for acting: demands for a new understanding of the Catholic liturgy." Unity Temple.

2772. Robinson, Sarah. "Living in the desert today." *Frank Lloyd Wright Quarterly*, 5(Autumn 1994), 14-15. Taliesin West.

2773. Russell, James S. "Doing windows." *Architectural Record*, 182(April 1994), 28-33. Wingspread.

2774. Rybczynski, Witold. "Why Wright endures." *Wilson Quarterly*, 18(Spring 1994), 36-45. An abstract is reprinted as "Physical/environmental," *Journal of Planning Literature*, 9(February 1995), 325-27.

2775. Samonà, Giuseppe. "Eventi dell'architettura 1945-1955. Da 'Metron-architettura' no 41-42: sull'architettura di Frank Lloyd Wright." *L'Architettura*, 40(October 1994), 721-27. Italian: "Architectural events 1945-1955 ... and Wright's architecture"; English introduction. Reprinted from *Metron*, (May-August 1951), 34-43.

2776. Sanati, Yasama. "Wright ve dogal ev." *Arkitekt*, (June 1992), 71-82. Turkish: "Wright's houses."

2777. Secrest, Meryle. "Taking another look at Frank Lloyd Wright." *Smithsonian*, 24(November 1994), 54.

2778. Sestoft, Jorgen. "The Wright kind of car." *Skala*, (1994), 12-13. Danish and English.

2779. Smith, Kathryn. "Earth, fire, water, sky." *Elle Decor*, 5(February-March 1994), 72.

2780. Stephens, Suzanne and Tim Street-Porter. "Frank Lloyd Wright's La Miniatura." *Architectural Digest*, 51(December 1994), 102, 109, 202.

2781. Warner, Fara. "Chrysler to market Cirrus with 'relationship' tie-ins." *Wall Street Journal (eastern edition)*, 224(18 October 1994), B10. Reports Chrysler's national advertising campaign to launch its new automobile models, with Brooks Bros. and Frank Lloyd Wright traveling exhibit.

2782. Wiseman, Carter. "The sudden fad for Frank Lloyd Wright." *New York*, 27(September 1994), 50.

2783. Zevi, Bruno Benedetto. "Frank Ll. Wright, Europa ed oltre: il caso dell' Italia." *L'Architettura*, 40(October 1994), 674-75. Italian and English: "Wright, Europe and beyond: the case of Italy." Excerpts from a speech delivered at MoMA, 27 April 1994.

2784. *A.+U.* "Guggenheim Museum, 1071 Fifth Avenue, between 88th and 89th Streets: Frank Lloyd Wright. 1959." (December 1994), 268-77. Japanese and English.

2785. *American School and University*. [Frank Lloyd Wright School of Architecture]. 67(November 1994), 20.

2786. *Antiques*. "Dining table with eight chairs (Oak, 1904)." 145(May 1994), 623. Image only.

2787. *Architects' Journal*. "Inspiration lost in search for meaning." 199(April 1994), 46.

2788. *Architectural Record*. "Wingspread—Racine, Wisconsin." 182(April 1994), 29.

2789. *Arquitectura*. "La ampliación del Museo Guggenheim, Nueva York." (no. 300, 1994), 62-67. Spanish and English: "Extensions to the Guggenheim Museum."

2790. *Art in America*. "Wright building rechristened." 82(February 1994), 25. Guggenheim Museum renames its building the Samuel J. and Ethel LeFrak Building. See also Ken Shulman and R. C——, "Attracting large canvases," *Art News*, 93(March 1994), 36-37.

2791. *Artforum International*. "National Life Insurance Company building, Chicago, Illinois (1924-25)." 32(February 1994), 51. Image only.

2792. *Columbia University Graduate School of Architecture, Planning and Preservation. Newsline*. "... Wright exhibitions at MoMA and Columbia." 6(January-February 1994), 3. Announces an exhibit of Wright's drawings, 1909-1911,at the University's Arthur Ross Gallery, February-May 1994. See also "Columbia displays rare Wasmuth portfolio," *Frank Lloyd Wright Quarterly*, 5(Winter 1994), 25. The show s reviewed Donald Albrecht, "Frank Lloyd Wright exhibits in New York," *Architecture*, 83(April 1994), 22-23.

2793. *FDM*. "Wright now." 66(March 1994), 78.

2794. *Frank Lloyd Wright Quarterly.* "Earthquake damages Wright buildings." 5(Spring 1994), 3. Subtitled, "On 17 January 1994 damage to Hollyhock house and other Los Angeles buildings by Wright."

2795. *Frank Lloyd Wright Quarterly.* "Exhibitions at home and abroad." 5(Winter 1994), 4-13. See also "Exhibition chronology: exhibitions during Frank Lloyd Wright's lifetime," 14-15, that lists forty shows, 1894-1959.

2796. *Frank Lloyd Wright Quarterly.* "Exploring Wright sites in Arizona and California." 5(Autumn 1994), 16-22.

2797. *Frank Lloyd Wright Quarterly.* "Exploring Wright sites in the Midwest." 5(Spring 1994), Spring, 8-16.

2798. *Frank Lloyd Wright Quarterly.* "Frank Lloyd Wright away from home." 5(Summer 1994), 8-17. Villa Belvedere, Fiesole, Italy; Imperial Hotel apartment, Tokyo; Ocotillo desert camp; Plaza Hotel apartment, New York .

2799. *Frank Lloyd Wright Quarterly.* "Frank Lloyd Wright: a personal view." 5(Winter 1994), 26-27. Previews an exhibition of Pedro E. Guerrero photographs opening 20 February 1994 at the Lobby Gallery, New York. The show is reviewed Donald Albrecht, "Frank Lloyd Wright exhibits in New York," *Architecture*, 83(April 1994), 22-23.

2801. *Frank Lloyd Wright Quarterly.* "The Frank Lloyd Wright Archives—an international treasure." 5(Winter 1994), 16-19.

2802. *Frank Lloyd Wright Quarterly.* "Governor opens Taliesin Visitor Center." 5(Autumn 1994), 3. See also "Federal role at Taliesin debated," *Progressive Architecture*, 75(May 1994), 24; and "Wright tours expand," *ibid.*, 76(May 1995), 33.

2803. *Friends of Fallingwater Newsletter.* "Educational mission of Fallingwater." (December 1994).

2804. *Mur.* "Sturges house, Los Angeles, 1939." (no. 3, 1994), 26-27. Danish. Images only. See also "Isabell [*sic*] Roberts house, River Forest, Illinois, 1908," *ibid.*, 32-33.

2805. *Progressive Architecture.* "Efforts to 'save' historic houses in Chicago and in Prague." 75(June 1994), 23. Charnley house.

2806. *Progressive Architecture.* "What? No part for Richard Chamberlain?" 75(January 1994), 94. Discusses a motion picture about Wright.

2807. *Werk, Bauen + Wohnen.* "Kunstraume." 82(January-February 1994), 8. German: "Space for art"; French, English introduction and captions. Guggenheim Museum addition. Cf. "Solomon R. Guggenheim Museum, New York: Renovation und Erweiterung [renovation and extension]," *ibid.*, 81(January-February 1993), 20-25.

1995
Books, monographs and catalogues

2808. Besinger, Curtis. *Working with Mr. Wright: what it was like*. New York: Cambridge University Press 1995. Paperback edition 1997.

2809. Curtis, William J. R. et al. *Frank Lloyd Wright con artículos de W. Curtis et al*. Madrid: Arquitectura Viva, 1995. Spanish: *Frank Lloyd Wright, with articles by ... Curtis et al*. There is a parallel English translation.

2810. Diamond, Rosamund and Wilfried Wang eds. *On continuity by 9H*. Cambridge, Mass.: 9H Publications, 1995. Includes the essay "Building character: modern construction beyond determinism in the work of Frank Lloyd Wright and Louis Kahn" by Olle Svedberg.

2811. Frampton, Kenneth. *Grundlagen der Architektur. Studien zur Kultur des Tektonischen*. Munich: Oktagon Verlag, 1993. German: *Fundamental principles of architecture. Studies of tectonics culture*. Includes a chapter, [Frank Lloyd Wright and the text-tile tectonic] (cf. *idem*., "The text-tile tectonic: the origin and evolution of Wright's woven architecture" in McCarter ed. *Frank Lloyd Wright; a primer on architectural principles*, Princeton: 1991). Reviewed Hilde Heynen, *Archis*, (June 1995), 81-83 (Dutch and English).
 Published in English as *Studies in tectonic culture: the poetics of construction in nineteenth and twentieth century architecture*, Cambridge, Mass.: MIT Press, 1995; reviewed Richard Weston, "Corrective studies in the art of construction," *Architects' Journal*, 203(7 March 1996), 54; Brian Hatton, "Poetry without motion," *Blueprint*, (June 1996), 45; Michael Speaks, "Tectoniek als weerstand; status quo van de middelmatigheid [Tectonic as resistance; status quo of mediocrity]," *De Architect*, 27(July 1996), 54-55 (Dutch); Jean-Claude Garcias, "Frampton, conscience de la construction [Frampton, construction's conscience]," *L'Architecture d'Aujourd'hui*, (September 1996), 18 (French); and Elizabeth Hatz, "Byggandets villkor [Building condition]," *Arkitektur: the Swedish review of architecture*, 97(January-February 1997), 60-64 (Swedish).
 See also Jayne Merkel, "Kenneth Frampton at the Architectural League," *Oculus* 59(October 1996), 14, that comments on Frampton's New York City lecture (5 June 1996) about the book.
 Also published in Spanish as *Estudios sobre cultura tectónica: poéticas de la construcción en la arquitectura de los siglos XIX y XX*. Madrid: Akal, 1999. Paperback English edition, 2001.

2812. Greater Madison Convention and Visitors Bureau. *Monona Terrace Convention Center: a public place by Frank Lloyd Wright*. Madison: The Bureau, 1995. See "Briefs," *Architectural Record*, 183(April 1995), 13; "At last, Madison builds Wright's convention center," *ENR*, (6 March 1995), 16; "Wright-minded," *Architects' Journal*, 199(April 1995), 20; "Resurrection of a Wright building," *Progressive Architecture*, 76(April 1995), 15; Betsy Wagner, "Frank Lloyd Wright's dream lives again," *U.S. News and World Report*, 118(5 June 1995), 12; "In the works: Madison Convention Center," *Planning*, 61(August 1995), 42; John Elson and Wendy Cole, "The wrong Wright?" *Time*,

145(12 June 1995), 70; and "Monona Terrace: a marriage of city and lake," *Frank Lloyd Wright Quarterly*, 6(Summer 1995), 4-11. Cf. "Wright's dream comes to life in concrete," *ENR*, (10 May 1999), C11.

2813. Guggenheimer, Tobias S. *Taliesin legacy*. New York: John Wiley and Sons, 1995. Outlines the careers of many of Wright's apprentices. Reviewed David Bryant, *Library Journal*, 120(November 1995), 62; George M. Eberhart, *College and Research Libraries News*, 57(May 1996), 311. Reprinted 1997 as *A Taliesin legacy: the architecture of Frank Lloyd Wright's apprentices*.

2814. Heinz, Thomas A. *Dana House: Frank Lloyd Wright.* London: Academy Editions; New York: St. Martin's Press, 1995. Mostly images. Reviewed Joseph Williams, "Hot off the press," *Antique Collector*, 66(November-December 1995), 38.

2815. Hertz, David Michael. *Frank Lloyd Wright in word and form.* New York: G.K. Hall; London: Prentice Hall, 1995. Reviewed V.M. Jean-Pierre, *Libraries and Culture*, 35(Spring 2000), 382-83.

2816. Hoffmann, Donald. *Understanding Frank Lloyd Wright's architecture.* New York: Dover, 1995. Reviewed Martin Filler, *NYTBR*, 145(3 December 1995), 32-34.

2817. Kaufmann, Edgar J. Jr. et al. *The non-residential architecture of Frank Lloyd Wright: the Preston H. Thomas memorial lectures, Autumn 1983.* Ithaca: Cornell University College of Architecture, Art and Planning, 1995. Includes a preface by Dean William McMinn; "Overlooked masterworks" and "Wright's significance today" by Kaufmann; "Genesis of a design: Johnson Wax" by Jonathon Lipman; "The Larkin building" by Jack Quinan; "Broadacre City," by Kurt W. Forster; and "Unity Temple" by Suzanne Stephens.

2818. Krens, Thomas and Bruce Brooks Pfieffer. *Das Solomon R. Guggenheim Museum.* New York: The Museum; Ostfildern: Hatje, 1995. German.

2819. Leavenworth, Russell E. *The Wright house for Chi of Sigma Chi.* Stevens Point: Frank Lloyd Wright Foundation, 1995.

2820. Lind, Carla. *Frank Lloyd Wright's dining rooms.* San Francisco: Pomegranate, 1995. Mostly images.

2821. Lind, Carla. *Frank Lloyd Wright's fireplaces.* San Francisco: Pomegranate, 1995. Mostly images.

2822. Lind, Carla. *Frank Lloyd Wright's furnishings.* San Francisco: Pomegranate, 1995. Mostly images.

2823. Lind, Carla. *Frank Lloyd Wright's glass designs.* San Francisco: Pomegranate, 1995. Mostly images.

2824. Mirviss, Joan B., John T. Carpenter and Bruce Brooks Pfeiffer. *The Frank Lloyd Wright collection of surimono.* New York: Weatherhill and Phoenix Art Museum, 1995. Published for the exhibition, "Frank Lloyd Wright and Japanese

art" at the museum, March-June 1995 and Los Angeles County Museum of Art, September 1995-January 1996.

For review and comment see Allison Eckardt Ledes, "Wright as a collector of Japanese art," *Antiques*, 147(March 1995), 352 ff.; Amy Page, "Stateside," *Antique Collector*, 66(March 1995), 32-33; Michael Webb, "Wright's first love," *Metropolis*, 15(December 1995), 30; and M. Forrer, *Monumenta Nipponica*, 51(Spring 1996), 134-36.

2825. Meehan, Patrick Joseph. *The tragedy of Frank Lloyd Wright's Lake Geneva Hotel, 1911-1970*. Wisconsin: The Author, 1995.

2826. Melvill, Jean F. comp. *Henry Miller Memorial Library Frank Lloyd Wright: a bibliography of works held in the Miller Memorial Library at the University of Wisconsin, Richland Center*. Richland Center: The Library, 1995.

2827. Michel, Henry J. et al. *Finding all the Wright places in California*. Los Angeles: H.J. Michel, 1995. Cf. *idem*., *Finding the Wright Places in California and Arizona*, Los Angeles: H.J. Michel, 2000.

2828. Moran, Maya. *Down to earth: an insider's view of Frank Lloyd Wright's Tomek house*. Carbondale: Southern Illinois University Press, 1995. Also in paperback. Reviewed *New York Review of Books*. 42(20 April 1995), 37; Paul E. Sprague, *JSAH*, 55(September 1996), 336; Fiona Sinclair, *Charles Rennie Mackintosh Society Newsletter*, (Autumn 1996), 11-12; and Peter Reidy, *Journal of the Taliesin Fellows*, (Summer 1997), 27-28. Excerpts are reprinted as "Frank Lloyd Wright's Tomek house," *Wright Angles*, 22(May-July 1996), 3-6.

2829. Pfeiffer, Bruce Brooks ed. *Frank Lloyd Wright collected writings. Vol. 5. 1949-1959.* New York: Rizzoli; Scottsdale: Frank Lloyd Wright Foundation, 1995. Reprints the entire texts of *The natural house*, 1954; *The story of the tower: the tree that escaped the crowded forest*, 1956; *A testament*, 1957 and *The living city*, New York: 1958, as well as excerpts from published essays.

Previously unpublished pieces include: "Beauty" (1950); "Sir Edwin Lutyens" (1951); "What the American government should to to insure lasting peace in Korea" 1951); "Missionaryism" (1952); "Massacre on the Marseilles waterfront" (1952); "The national value of art" (1953); "Influence or resemblance" (1953); and "The eternal law" (1955).

Reviewed Anthony Michael Alofsin, *JSAH*, 55(March 1996), 96-97; and Glenn Masuchika, *Library Journal*, 120(15 April 1995), 74.

Periodicals
2830. Abu-Dayyeh, Nabil Issa. "The place of dining in Frank Lloyd Wright's houses." *Kunstchronik*, (no. 9, 1995), 508. Refers to a thesis, University of Pennsylvania.

2831. Alhadeff, G. "Major Barbara." *Elle Decor*, 6(March 1995), 178.

2832. Andreini, Laura, Marco Casamonti and Giovanni Polazzi. "Itinerario *Domus*: 113. Wright a Oak Park e River Forest." *Domus*, (June 1995), 87-94. Italian: "*Domus* itinerary: 113. Wright at Oak Park and River Forest."

2833. A.P. "A length of printed fabric." *Metropolitan Museum of Art Bulletin*, 53(Winter 1995-1996), 65.

2834. Arndt, Jacob. "Seamless stucco." *Old-House Journal*, 23(April 1995), 48.

2835. Bachand, Cheryl. "Exotic objects from the East: returning decorative arts to Wright's home and studio." *Wright Angles*, 21(August-October 1995), 3-7.

2836. Biagi, Marco. "Prova d'autore: progetto dell'architetto Frank Lloyd Wright." *Ville Giardini*, (April 1995), 26-29. Italian: "Proof of authorship: a Wright project." Zimmerman house.

2837. Bornstein, Eli. "Notes on the mechanical and the organic in art and nature." *Structurist*, no. 35-36(1995-1996), 44-48. See also Pamela D. Kingsbury, "Frank Lloyd Wright's Allen house," *ibid.*, 36-39.

2838. Brown, Randy. "The Wright stuff: building for business." *Buildings*, 89(December 1995), 20-24. S.C. Johnson and Son buildings.

2839. Cleary, Richard Louis. "Fallingwater was just the beginning: the Kaufmann's other commissions for Bear Run." *Friends of Fallingwater Newsletter*, (November 1995), 1-5. Projects for farmhouse, chapel and guest quarters.

2840. Cleary, Richard Louis. "Frank Lloyd Wright's San Francisco field office." *Frank Lloyd Wright Quarterly*, 6(Winter 1995), 12-14.

2841. Cory, James M. "A prophet." *Hardware Age*, 232(September 1995), 11.

2842. Crosbie, Michael J. "Falling water." *Progressive Architecture*, 76(March 1995), 64-67. Guggenheim Museum. See also *idem.*, "Guggenheirn skylight," *ibid.*, 95.

2843. Dowling, Jill. "Taliesin Preservation Commission update." *Frank Lloyd Wright Quarterly*, 6(Winter 1995), 3.

2844. Figg, John and Kendrick White. "Florida Southern College." *Arup Journal*, 30(1995), 19-21.

2845. Freiman, Ziva. "Modernism's latterday heroes." *Progressive Architecture*, 76(September 1995), 78-85. Florida Southern College.

2846. Gill, Brendan. "Wright on the market. Finding, buying and preserving architectural jewels." *Architectural Digest*, 52(December 1995), 58-60.

2847. Gorman, Carma R. "Fitting rooms: the dress designs of Frank Lloyd Wright." *Winterthur Portfolio*, 30(Winter 1995), 259-77. Clothes designed by Wright in the 1890s for Catherine Tobin Wright.

2848. Herberholz, Barbara. "Reviews." *Arts and Activities*, 117(February 1995), 8. Reviews the videotape "Portrait of an artist: Frank Lloyd Wright" produced by Public Media Inc.

2849. Hines, Thomas S. "Portrait: Marion Mahony Griffin drafting a role for

women in architecture." *Architectural Digest*, 52(March 1995), 28, 32ff.

2850. Hines, Thomas S. "The search for Frank Lloyd Wright." *JSAH*, 54(December 1995), 467-76.

2851. Hirst, Arlene. "Take note." *Metropolitan Home*, 27(March 1995), 27.

2852. Jaffe, Matthew. "Hollywood houses with star power." *Sunset*, (April 1995).

2853. Johannes, Ralph. "Traum versus Bild." *Werk, Bauen + Wohnen*, (November 1995), 49-56. German: "Dream versus image." Fallingwater.

2854. Kahn, Eve M. "Glorious times." *House Beautiful*, 137(March 1995), 70, 75-76. Willey house.

2855. Konicek, J. "The Wright kind of security." *Security Management*, 39(February 1995), 34.

2856. Kostyal, K.M. "Poetry in stone." *National Geographic Traveler*, 12(March-April 1995), 119. Fallingwater.

2857. Kruty, Paul Samuel. "Wright, Spencer, and the casement window." *Winterthur Portfolio*, 30(Summer-Autumn 1995), 103-127. Reissued as a booklet.

2858. Lee, D. "Wright every time." *Art Review*, 47(June 1995), 56-57.

2859. Leong, Roger and Carol Guida. "Design in glass." *Artonview*, (Spring 1995), 42-44. Coonley playhouse windows.

2860. MacCormac, Richard Cornelius. "Bossom lectures on the making of great architecture: 1. 'A sense of the marvellous'—Frank Lloyd Wright's Fallingwater." *Royal Society of Arts Journal*, 143(October 1995), 40-51.

2861. Mahoney, Diana Phillips. "The ultimate Frank Lloyd Wright." *Computer Graphics World*, 18(April 1995), 18. Reviews CD-ROM, *The ultimate Frank Lloyd Wright: America's architect*, published by Microsoft and Byron Preiss Multimedia. The disk's release is announced "First impressions," *CD-ROM World*, 9(October 1994), 24; *Esquire*, 122(November 1994), 32; and *Publishers Weekly*, 241(5 December 1994), 39.

 For further comment and reviews, see Ty Burr and Harold Goldberg, *Entertainment Weekly*, (13 January 1995), 65; Jeremy Torr, *Australian Personal Computer*, 16(April 1995), 20; *Technology Connection*, 2(May 1995), 37; "Softwire," *Video Magazine*, 19(May 1995), 90; Irene Wood, *Booklist*, 91(15 May 1995), 1661; Barry Brenesal, *Computer Life*, 2(June 1995), 136; Melissa Riofrio, *PC World*, 13(June 1995), 251; Michael Rogers, "Microsoft's Wright stuff on CD-ROM," *Library Journal*, 120(15 June 1995), 23-24; *School Library Journal*, 41(June 1995), 52; Charles Bowen, "Architecture buff? This disc's got the Wright stuff," *HomePC*, 2(July 1995), 161-62; William J. Mitchell, "CD-Wright: three for your computer," *Architectural Record*, 183(August 1995), 19;

Cheryl LaGuardia, *Library Journal*, 120(1 September 1995), 215-17; Pete Hisey, *Video Magazine*, 19(September 1995), 90; Lesley S.J. Farmer, *Technology Connection*, 2(October 1995), 44-45; *School Arts*, 95(October 1995), 4-5; D. Comberg, *ID*, 42(November 1995), 90; "Connect your curriculum ... just add art," *Arts and Activities*, 118(November 1995), 14-15; *Family PC*, (November 1995), 230; Joel Warren Barna, "Electronic Wright," *Civilization*, 2(November-December 1995), 80; *Booklist*, 92(1 and 15 January 1996), 747; Matthew S. Burfeind and Allen Smith, *Journal of Academic Librarianship*, 22(January 1996), 80-81; *Multimedia Schools*, 3(January-February 1996), 58-59; Andrew Moed, "Mixed media. Memory games," *Metropolis*, 15(May 1996), 72-79; Douglas Tallack, *Journal of American Studies*, 30(August 1996), 337-38; Deborah Greh, *School Arts*, 96(September 1996), 54; Ronny de Meyer, *Archis*, (September 1996), 85-87 (Dutch and English); and Luigi Prestinenza Puglisi, *Domus*, (December 1996), 114-15 (Italian).

2862. Martin, Leslie. "Into the desert." *Country Living*, 18(December 1995), 9-10. Taliesin West.

2863. McAslan, John Renwick, A. Fletcher and I. Waller. "Spectrum." *RSA Journal*, 143(no. 5463, 1995), 78.

2864. Meech, Julia et al. "[Special issue]. Frank Lloyd Wright and Japan." *Frank Lloyd Wright Quarterly*, 6(Spring 1995), 3-23. Includes "Frank Lloyd Wright, collector" by Meech; "Frank Lloyd Wright and Japan" and "Wright's little-known Japanese projects" by Masami Tanigawa; "A hidden legacy: the Surimono collection of Frank Lloyd Wright" by Joan B. Mirviss; and an itinerary of Wright's 1905 visit to Japan (see 2881).

2865. Melhuish, Clare. "Just Wright." *Design Week*, 10(5 May 1995), 12-13. Reviews "Frank Lloyd Wright in Chicago, the early years" exhibition, Design Museum, London, April-September 1995. See also *idem.*, "The master of the house," *Building Design*, (12 May 1995), 14.

The show is also reviewed Joanna Watt, *Perspectives on Architecture*, 2(May 1995), 22; Murray Fraser, *Architects' Journal*, 201(18 May 1995), 52-53; Tanya Harrod, "Crafts," *Spectator*, 274(27 May 1995), 54; Joseph Williams, "The home front," *Antique Collector*, 66(May 1995), 35; Ludwig Seyfarth, "Vom prariehaus zum hotel nach Tokio [From prairie house to Tokyo hotel]," *Design Report*, (June 1995), 115 (German); Carolyn Steel, "Citizen Frank," *Blueprint*, (June 1995), 45; *Architectural Design*, 65(July-August 1995), xvi; Stephen Escritt, "Beyond the godfather," *Things*, (Summer 1995), 131-33; John Renwick McAslan, *RSA Journal*, 143(October 1995), 78; and Philip Jodidio, "Wright toujours [Always Wright]," *Connaissance des Arts*, (May 1995), 22 (French).

2866. Miller, Naomi. "Frank Lloyd Wright: l'ultimo vittoriano o il primo modernista?" *Spazio e Societa*, 18(January-March 1995), 40-55. Italian: "Wright: last Victorian or first modern?"

2867. Neider, J. "The house Frank Lloyd Wright built." *AKC Gazette*, 112(February 1995), 64. Subtitled, "At a house designed with a Dalmatian in mind, a local breed club shows the public what their dogs can do."

2868. Nelson, Arthur C. "The planning of exurban America: lessons from Frank Lloyd Wright's Broadacre City." *Journal of Architectural and Planning Research*, 12(Winter 1995), 337-56.

2869. Nivala, J.F. "The architecture of a lawyer's operation: learning from Frank Lloyd Wright." *Journal of the Legal Profession*, 20(1995), 99.

2870. Nute, Kevin Horwood. "Frank Lloyd Wright and Okakura Tenshin: on the social and aesthetic 'Ideals of the East'." *Chanoyu Quarterly*, (no. 79, 1995), 29.

2871. Pfeiffer, Bruce Brooks and K. Donovan. "Digitizing the Frank Lloyd Wright Archives: sharing and preserving museum collections." *Advanced Imaging*, 10(August 1995), 36.

2872. Polin, Giacomo. "F.L. Wright: Hoffman residence." *Abitare*, (April 1995), 154-63. Italian and English. Discusses the restoration of the house.

2873. Porcelli, Joe. "Building Prairie designs' double pedestal Frank Lloyd Wright table lamp." *Glass Artist*, (February-March 1995), 35-37, 51; (April-May 1995), 34-37; (August-September 1995), 30-32, 38. Instructions for making a replica of a lamp designed for the Dana house.

2874. Puglisi, Luigi Prestinenza. "Meditando Frank Lloyd Wright." *L'Architettura*, 41(May 1995), 372-75. Italian: "Meditating on Frank Lloyd Wright."

2875. Rocca, Alessandro. "Guggenheim—Gehry, Gwathmey and Siegel [*sic*], Isozaki, Wright: dalla spirale alla rete [from the spiral to the web]." *Lotus*, (1995), 46-73. Italian and English.

2876. Rollo, J. "Triangle and t-square: the windows of Frank Lloyd Wright." *Environment and Planning B, Planning and Design*, 22(January 1995), 75-92.

2877. Rybczynski, Witold. "Accessing Frank Lloyd Wright." *NYTBR*, 144(25 June 1995), 28. Reviews the CD-ROM set, *Frank Lloyd Wright: presentation and conceptual drawings*, produced by Luna Imaging Inc., Venice CA, and the Frank Lloyd Wright Foundation.

 For other reviews and comment see G.F., "Wright-only memory," *American Libraries*, 26(June 1995), 577; "The Wright stuff," *Educom Review*, 30(July-August 1995), 55; George M. Eberhart, *College and Research Libraries News*, 56(July-August 1995), 498-99; William J. Mitchell, "CD-Wright: three for your computer," *Architectural Record*, 183(August 1995), 19; D. Garfield, "Luna, the Wright stuff," *Museum News*, 74(September-October 1995), 24 ff.; Thomas L. Hart, *Bulletin of the American Society for Information Science*, 22(October-November 1995), 28; D. Comberg, *ID*, 42(November 1995), 90; Joel Warren Barna, "Electronic Wright," *Civilization*, 2(November-December 1995), 80; Ronny de Meyer, *Archis*, (September 1996), 85-87 (Dutch and English); Jeffrey

A. Cohen, *JSAH*, 55(September 1996), 334-36; Randolph C. Henning, *Frank Lloyd Wright Quarterly*, 7(Winter 1996), 22-23; and Charlotte Bradbeer, *Transactions of the Ancient Monuments Society*, 43(1999), 157-58.

2878. Saenz de Oiza, Francisco Javier et al. "[Special issue]. Frank Lloyd Wright." *A. and V. Monografias*, (July-August 1995), 2-112. Spanish. There are contributions by William J.R. Curtis, Martin Filler, and Bruce Brooks Pfeiffer.

2879. Schlang, Lisa Jill. "Andersen does it Wright." *House Beautiful*, 137(June 1995), 50. Reproductions of Wright glass. See also "The Wright windows of opportunity," *Metropolitan Home*, 27(May-June 1995), 27 and Mark Oreskovich, "The Wright idea," *Professional Builder*, 61(February 1996), 33.

2880. Simanaitis, Dennis. "Frank Lloyd Wright—certified car nut." *Road and Track*, 46(July 1995), 164-65.

2881. Stipe, Margo. "Wright's first trip to Japan." *Frank Lloyd Wright Quarterly*, 6(Spring 1995), 21-23.

2882. Sudjic, Deyan. "Sacred cows; architect: Frank Lloyd Wright." *Perspectives on Architecture*, 2(December 1995-January 1996), 80. Guggenheim Museum.

2883. Sullivan, T.D. "The trouble with genius. Reassessing Frank Lloyd Wright." *The World and I*, 10(February 1995), 107. See also "Imperfect genius: Frank Lloyd Wright," *ibid.*, inset.

2884. Tacha, Athena, F. Beilis and A. Brown. "Frank Lloyd Wright at Oberlin: the story of the Weltzheimer-Johnson house." *Bulletin, Allen Memorial Art Museum, Oberlin College*, 49(no. 1, 1995), the issue.

2885. Thomas, Michael M. and Hilton Als. "Wright again—sort of." *New Yorker*, 71(13 March 1995), 36-37.

2886. Thorson, Alice. "Night lights by Wright." *Art News*, 94(March 1995), 38. Community Christian Church, Kansas City.

2887. Tully, Gordon."The key to the front door." *Journal of Light Construction*, (May 1995), 15. Jacobs house.

2888. Vernon, Christopher. "Frank Lloyd Wright, Walter Burley Griffin, Jens Jensen and the Jugendstil garden in America." *Gartenkunst*, 7(no. 2, 1995), 232-46.

2889. Wegg, Talbot. "'FLLW vs. the USA': the other side of wartime 'Cloverleaf' housing story." *Journal of the Taliesin Fellows*, (Spring 1995), 18-23, 29.

2890. Wilson, John. "An American masterpiece." *New Zealand Historic Places*, (March 1995), 41. Taliesin West.

2891. Zins, Debra. "Il restauro di Taliesin." *Domus*, (June 1995), 85-86. Italian: "The restoration of Taliesin."

2892. *Architectural Record.* "Briefs." 183(April 1995), 13. Robie house.

2893. *Art in America.* "The Prairie School." 83(August 1995), 24. Announces an exhibition of drawings by Wright (i.a.), Art Institute of Chicago.

2894. *Custom Builder.* "Pope-Leighey house to undergo restoration." 10(September-October 1995), 11.

2895. *Frank Lloyd Wright Quarterly.* "Barton house donated to restoration group." 6(Winter 1995), 24.

2896. *Frank Lloyd Wright Quarterly.* "Desert dwellings." 6(Autumn 1995), 12-15. Taliesin West.

2897. *Frank Lloyd Wright Quarterly.* "George and Nelle Fabyan's country home." 6(Winter 1995), 4-9. Also discusses Fox River Country Club addition.

2898. *Frank Lloyd Wright Quarterly.* "Taliesin architects add to Prairie School." 6(Spring 1995), 24.

2899. *Frank Lloyd Wright Quarterly.* "Taliesin: a work of a lifetime." 6(Summer 1995), 12-17.

2900. *Frank Lloyd Wright Quarterly.* "Two former Wright apprentices die." 6(Winter 1995), 20-21. Obituaries for John Lautner (died 24 October 1994) and Allan Gelbin (died 6 September 1994).

2901. *Frank Lloyd Wright Quarterly.* "Wright apprentice Fred Benedict dies." 6(Fall 1995), 18.

2902. *Friends of Fallingwater Newsletter.* "A conversation with Edgar Kaufmann, Jr." (September 1995), 1-3. Reviews a documentary film by Kenneth Love.

2903. *Friends of Fallingwater Newsletter.* "Log house moved to Bear Run Nature Reserve [Pennsylvania]." (September 1995), 3. Fallingwater.

2904. *Friends of Fallingwater Newsletter.* "Soon available: reproductions and adaptations of Fallingwater furniture." (September 1995), 4-5.

2905. *Historic Preservation.* "Let there be light." 47(May-June 1995), 15. Community Christian Church, Kansas City.

2906. *House Beautiful.* "Classic." 137(June 1995), 50.

2907. *L'Architettura.* "Wright + Mickey Mouse = Frank Gehry." 41(July 1995), 534-35.

2908. *Life.* "Faces '45." 18(5 June 1995), 124 ff. Includes Wright.

2909. *Museum Studies.* [Special section: The Prairie School: design vision for the Midwest]. 21(no. 2, 1995), 84-192. Includes "The Prairie School and decorative arts at the Art Institute of Chicago" by Judith A. Barter; "'Make designs to your heart's content': the Frank Lloyd Wright/Schumacher venture: textile and

wallpaper design" by Christa C. Mayer-Thurman; "The life and work of Marion Mahony Griffin: Prairie School architect" by Janice Pregliasco; "New forms, old functions: social aspects of Prairie School design" by Robert Twombly; "Prairie School works in the department of architecture at the Art Institute of Chicago" by Richard Guy Wilson; and "Prairie School works in the Ryerson and Burham Libraries, Art Institute of Chicago" by Mary Woolever.

2910. *New Mexico Business Journal.* "Psst: Wanna buy a neat building?" 19(April 1995), 8. H.C. Price Tower.

2911. *NYT Magazine*, "Be they never so humble." 144(12 March 1995), 60-61. Fallingwater.

2912. *Ottagono.* "Sedia barrel. Barrel chair." (September-November 1995), 62. Italian and English. Wright's barrel chair (1937).

2913. *Progressive Architecture.* "Robie house museum." 76(June 1995), 49. Reports that the Robie house will operate as a house museum. See also *Architectural Record*, 183(April 1995), 13.

2914. *Society of Architectural Historians Newsletter.* "Seymour H. Persky gives James Charnley house to Society as national headquarters." 39(April 1995), 2-3. Cf. William H. Pierson, "SAH donors. Seymour Persky," *ibid.,* (December 1995), 54. See also Keith Morgan, "The Charnley-Persky house: architectural history and the Society," *JSAH*, 54(September 1995), 276-77.

2915. *U.S. News And World Report.* "Outlook. Tax-cut cooldown; term-limits strategy; Frank Lloyd Wright's dream." 118(no. 22, 1995), 10.

2916. *Ville Giardini.* "Officinas y laboratories Johnson." (April 1995), 26-29. S.C. Johnson administration building and laboratory tower. English and Spanish.

2917. *Wall Street Journal (eastern edition).* "Landmarks." 226(22 September 1995), 8. Discusses problems that have forced some owners of Wright houses to sell.

2918. *Werk, Bauen + Wohnen.* "Wenn die Toten bauen." (May 1995), 74. German: "If the dead build." Monona Terrace.

2919. *Wood and Wood Products.* "Matching the furniture to the building." 100(no. 14, 1995), 419. S.C. Johnson and Son administration building.

1996
Books, monographs and catalogues
2920. Ackerman, James S. "The modern villa: Wright and Le Corbusier." In *The villa. Form and ideology of country houses.* Princeton University Press, 1996. (first published 1990).

2921. Birk, Melanie ed. *Frank Lloyd Wright's fifty views of Japan: the 1905 photograph album.* San Francisco: Pomegranate, 1996. Reviewed M.J.M., *Interiors*, 156(October 1997), 66. Excerpts from the introduction are reprinted in

Anthony Michael Alofsin, "Wright and the glimmer of Japan," *Wright Angles*, 22(August-October 1996), 3-6.

2922. Boyle, Bernard Michael and Diane M. Upchurch eds. *Wright in Arizona: the early work of Pedro E. Guerrero: a selection of photographs from the Pedro E. Guerrero collection in the Architecture and Environmental Design Library, Arizona State University.* Tempe: Herberger Center for Design Excellence, Arizona State University, 1996. Catalogue of an exhibition at the University's Gallery of Design, January-February 1996.

2920. Brooks, Harold Allen. *The Prairie School.* New York: Norton, 1996. Revised version of *idem.*, *The Prairie School: Frank Lloyd Wright and his midwest contemporaries*, Toronto and Buffalo: 1972.

2921. Byars, Mel. *The chairs of Frank Lloyd Wright: seven decades of design.* Washington, DC: Preservation Press, National Trust for Historic Preservation, 1996.

2922. Davis, Frances R. A. *Frank Lloyd Wright: maverick architect.* Minneapolis: Lerner, 1996. Juvenile literature. Reviewed Ann W. Moore and Trevelyn E. Jones, *School Library Journal*, 43(January 1997), 122; Kay Weisman, *Booklist*, 93(1 January 1997) and 93(15 January 1997), 833; and *Curriculum Review*, 36(January 1997), 12-13.

2923. Harrington, Elaine and Hedrich-Blessing. *Frank Lloyd Wright home and studio, Oak Park.* Stuttgart: Axel Menges, 1996. Published in cooperation with the Frank Lloyd Wright Home and Studio Foundation.

2924. Heinz, Thomas A. *Frank Lloyd Wright field guide; Upper Great Lakes: Minnesota, Wisconsin, Michigan.* London: Academy, 1996. Mostly images. Reviewed Lynn Andriani and Jonathan Bing, "Seeking out the Wright places," *Publishers Weekly*, 243(5 August 1996), 366. See also Vols 2 and 3, Chichester, England: Academy Editions, 1997-1999; reviewed H. Castle, *Architectural Design*, 140(July-August 1999), 112.

2925. Hoffmann, Donald. *Frank Lloyd Wright's Dana House.* Mineola: Dover, 1996. Reviewed Mark Heyman, *Journal of the Taliesin Fellows*, (Winter 1996), 27-28; Stanley Abercrombie, *Interior Design*, 68(February 1997), 102-107; and David M. Sokol, *JSAH*, 56(December 1997), 525-27.

2926. Kirsch, Karin. *Die neue Wohnung und das alte Japan: Architekten planen für sich selbst; Edward William Godwin, Frank Lloyd Wright, Charles Rennie Mackintosh, Walter Gropius, Egon Eiermann, Toyo Ito.* Stuttgart: Deutsch. Verlag, 1996. German: *The new house and Old Japan. Architects plan for their own sakes. Edward William Godwin, Frank Lloyd Wright*, [etc]. Reviewed *Form*, 1(no. 157, 1997), 134-35 (German).

2927. Landrum, Gene N. *Profiles of power and success: fourteen geniuses who broke the rules.* Amherst: Prometheus Books, 1996. See chapter, "Intuitive-thinking temperament: Napoleon Bonaparte and Frank Lloyd Wright."

2928. LeGates, Richard T. and Frederic Stout eds. *The city reader*. London; New York: Routledge, 1996. Reprinted 2000. Includes Wright's "Broadacre City: a new community plan" (*Architectural Record*, 77(April 1935), 243-54.

2929. Levine, Neil. *The architecture of Frank Lloyd Wright*. Princeton University Press, 1996. Also in paperback 1997.

Reviewed Glenn Masuchika, *Library Journal*, 121(1 June 1996), 102; Richard Weston, "Masterly study of America's finest," *Architects' Journal*, 204(4 July 1996), 69; Andrew Ballantyne, "Where once Taliesin shone," *TLS*, (8 November 1996), 3-4; Jane Holtz Kay, *Nation*, 263(25 November 1996), 33-35; Christopher Wilk, *Apollo*, 144 (November 1996), 57; Hetty Startup, *Bulletin: the Quarterly Newsletter of the Frank Lloyd Wright Building Conservancy*, 5(Summer 1996), 21; Karen Bowie, *Revue de l'Art*, (no. 114, 1996), 91-92 (French); Patrick Hodgkinson, *Times Higher Education Supplement*, (10 January 1997), 27; Peter Myers, "Wright, apothéose américaine [Wright, American apotheosis]," *L'Architecture d'Aujourd'hui*, (February 1997), 12 (French); Richard Longstretch, *American Studies International*, 35(February 1997), 109-110; Stanley Abercrombie, *Interior Design*, 68(February 1997), 102-107; Jean-Louis Cohen, *Casabella*, 61(March 1997), 80 (Italian); Kathryn Smith, *AA Files*, (Summer 1997), 106-109; Anthony Michael Alofsin, *Harvard Design Magazine*, (Summer 1997), 76-77; Frans Sturkenboom, *Architect*, 9(March 1998), 90; Maggie Toy, *Architectural Design*, 68(March-April 1998), xv; Charlotte Skene-Catling, *Burlington Magazine* 140(June 1998), 401-402; David Adams, *Journal of American Studies*, 32(August 1998), 319-20; Richard Louis Cleary, *JSAH*, 58(June 1999), 213-14. A long excerpt is published as "Frank Lloyd Wright and his-story: an inclusive view," *Journal of the Taliesin Fellows*, (Spring 1996), 6-20.

2930. Lind, Carla. *Lost Wright: Frank Lloyd Wright's vanished masterpieces*. New York: Simon and Schuster, 1996. Also published as *The lost buildings of Frank Lloyd Wright: vanished masterpieces*. London: Thames and Hudson, 1996. Cf. *idem.*, *Frank Lloyd Wright's lost buildings*. San Francisco: Pomegranate, 1994. Mostly images. Reviewed Glenn Masuchika, *Library Journal*, 122(1 March 1997), 74. See also *idem.*, "Demolished Wright or never built?" *Bulletin: the Quarterly Newsletter of the Frank Lloyd Wright Building Conservancy*, 4(Winter 1996), 3..

2931. Martin, Pete."Frank Lloyd Wright." In Christopher Silvester ed. *The Norton book of interviews: an anthology from 1859 to the present day* New York: W.W. Norton, 1996.

2932. Myhra, David. "Frank Lloyd Wright and the American city: the Broadacres debate." In Neil L. Shumsky ed. *The physical city: public space and the infrastructure*. New York: Garland, 1996.

2933. Nash, Eric Peter. *Frank Lloyd Wright: force of nature*. New York: Todtri, 1996. Reprinted 1998. Reviewed Donna Seaman, *Booklist*, 92(1 February 1996), 909; and Hazel Rochman, *ibid.*, 922.

2934. Raschke, Brigitte. *Frank Lloyd Wright—the Mile-High Illinois: Utopie oder Architekturkritik?* Munich: Scaneg, 1996. German: *Frank Lloyd Wright—the Mile-High Illinois: Utopia or a criticism of architecture?* Published version of a Masters thesis, Technische Universität, Berlin. See also *idem.*, "Frank Lloyd Wright 'A Mile High' ," *Kunstchronik*, (no. 8, 1994), 457.

2935. Simo, Melanie Louise. *Barnsdall Park: a new master plan for Frank Lloyd Wright's California romanza.* Washington, D.C.: Spacemaker, 1996.

2936. Siry, Joseph M. *Unity Temple. Frank Lloyd Wright and architecture for liberal religion.* Cambridge; New York: Cambridge University Press, 1996. Reviewed Marguerite Carn Rodney, *American Studies International*, 35(October 1997), 111-12; and David M. Sokol, *JSAH*, 56(December 1997), 525-27. Paperback edition 1998; reviewed Roderick Grant, *Journal of the Taliesin Fellows*, (Summer 1998), 25-26; and Randall Balmer, *Church History*, 68(March 1999), 223-24. See also *idem.*, "Frank Lloyd Wright's Unity Temple and architecture for liberal religion in Chicago, 1885-1909," *Art Bulletin*, 73(June 1991), 257-82.

2937. Spirn, Anne Whiston and David Gilson de Long eds. *Frank Lloyd Wright: designs for an American landscape*, New York: Harry N. Abrams, 1996. Published in association with an exhibition organized by the U.S. Library of Congress, The Frank Lloyd Wright Foundation, and the Canadian Centre for Architecture, Montréal, and mounted at the Centre, June-September 1996. The show moved to the Library of Congress, November 1996-February 1997, then to the Whitney Museum of American Art, New York, June-September 1997.

Projects exhibited (1922-1932) include Doheny Ranch, Lake Tahoe summer colony, the A. M. Johnson desert compound, the Gordon Strong automobile objective, and San Marcos in the Desert. Essays include "Frank Lloyd Wright: architect of landscape" by Spirn; "Frank Lloyd Wright: designs for an American landscape, 1922-1932" by de Long; "Symbol and catalyst: the automobile in architectural representation before 1930" by C. Ford Peatross; "Frank Lloyd Wright chronology, 1922-1932" by Robert Lawrence Sweeney and other pieces by James H.Billington, Richard Carney and Phyllis Lambert. Also published in London: Thames and Hudson, and in French as *Frank Lloyd Wright: inventer un paysage américain, 1922-1932*, Montréal: 1996.

For book reviews see David McClelland, *Library Journal*, 121(August 1996), 70; Richard Weston, "How Wright found his mature voice," *Architects' Journal*, 204(21 November 1996), 52; Christopher Vernon, *JSAH*, 57(September 1998), 353-55; and Luigi Prestinenza Puglisi, *Domus*, (February 1999), 85-86 (Italian).

The exhibition is announced in *SAH Newsletter*, (no. 6, 1996), 5 and reviewed in "Wright stuff" *Azure: Design Architecture and Art*, 12(May-June 1996), 9; "Canadian exhibit examines crucial chapter in Wright's career," *Frank Lloyd Wright Quarterly*, 7(Spring 1996), back cover; J. Rodriguez, *Landscape Architecture*, 86(June 1996), 24 ff.; Howard Shubert, "Frank Lloyd Wright et le Quebec," *ARQ: La Revue d'Architecture*, (June 1996), 34 (French); Judith

Nasatir, "CCA shows the Wright stuff," *Interior Design*, 67(July 1996), 19; "Wright utopico," *L'Arca*, (July-August 1996), 101 (Italian and English); Gavin Affleck, "Before Broadacres," *Canadian Architect*, 41(August 1996), 42; Ned Cramer and Heidi Landecker, "Wright's Japan projects on view in Washington; Wright's car landscapes exhibited in Montreal," *Architecture*, 85(August 1996), 42-43; Marie-Jeanne Dumont, "Wright et le paysage americain [Wright and the American countryside]," *L'Architecture d'Aujourd'hui*, (October 1996), 16-17 (French); James H. Billington, *Civilization*, 3(October-November 1996), 109; Steve Thompson, "The Wright stuff," *AutoWeek*, 47(26 May 1997), 22-23; Laughlin Fawcett, *Landscape Architecture*, 87(January 1997), 78; and Ernest Pascucci, *JSAH*, 56(June 1997), 207-210.

See also de Long, "Designs for an American landscape," *Frank Lloyd Wright Quarterly*, 7(Summer 1996), 4-15 (adapted from the book).

2938. Venturi, Robert. *Iconography and electronics on a generic architecture: a view from the drafting room*. Cambridge, Mass.: MIT Press, 1996. Paperback edition 1998. Includes "Essay on Wright written for the Pennsylvania Academy of the Fine Arts" and "Words on the Guggenheim Museum in response to a request by Thomas Krens."

Reviewed Peter S. Kaufman, *Library Journal*, 121(15 April 1996), 86; Genevieve Stuttaford and Sybil S. Steinberg, *Publishers Weekly*, 243(27 May 1996), 63; Conrad Jameson, "Leaving Las Vegas," *New Statesman*, 125(26 June 1996), 44-45; Philip Tabor, "The Venturi effect," *Architectural Review*, (November 1996), 96-97; Martin Filler, *NYTBR*, 146(8 December 1996), 54-58; Robert Maxwell, "The bellyaches of an architect," *Times Higher Education Supplement*, (18 July 1997), 27; Martin Filler, "Fantasia," *New York Review of Books*, 44(23 October 1997), 10-13; and R.E. Somol, "Still crazy after all these years," *Assemblage*, (August 1998), 84-93.

2939. Waggoner, Lynda S. *Fallingwater: Frank Lloyd Wright's romance with nature*. New York: Universe, 1996. Mostly images. Reviewed Stanley Abercrombie, *Interior Design*, 68(February 1997), 102-107.

2940. Wright, Scott. *Japan encountered: a brief ... survey of famous Westerners in the Land of the Rising Sun*. Lanham: University Press of America, 1996. Includes "Frank Lloyd Wright: a case study in cross-cultural influence." Reviewed William L. Wuerch, *Library Journal*, 121(15 September 1996), 80.

2941. Zanten, David van. "Frank Lloyd Wright's kindergarten: professional practice and sexual roles." In Christopher Reed ed. *Not at home: the suppression of domesticity in modern art and architecture*, London: Thames and Hudson, 1996.

2942. Zevi, Bruno Benedetto. *Frank Lloyd Wright*. Basel; Boston: Birkhauser, 1996. 1998. 1999. German and French.

Periodicals
2943. Austin, Elizabeth. "Masterwork in wood and stone." *National Geographic*

Traveler, 13(July-August 1996), 18-20. Taliesin.

2944. Austin, Elizabeth. "Weekends." *National Geographic Traveler*, 13(April 1996), 18.

2945. B——, R. R. "Historical note." *Print*, 50(July-August 1996), 6. Meeting between graphic designer Alvin Lustig and Wright.

2946. Beauregard, Sue-Ellen. "Audiovisual media." *Booklist*, 92(15 March 1996), 1301. Reviews the videotape, "The Frank Lloyd Wright way: apprentices to genius", produced by Sandpail and originally shown on PBS.

2947. Beghtol, L.D. and Joe Brancatelli. "Frank Lloyd Wright home and studio." *Travel Holiday*, 179(May 1996), 17.

2948. Beyer, Sarah. "From cows to cantilevers: Kentuck Knob and the Kaufmanns." *Friends of Fallingwater Newsletter*, (October 1996), 1-6.

2949. Brink, Lawrence R. "Maintaining a work of art: an update on the Palmer House." *Bulletin: the Quarterly Newsletter of the Frank Lloyd Wright Building Conservancy*, 5(Winter 1996), 5, 7.

2950. Brown, Conrad Nagel. "The Wright stuff." *Inland Architect*, 40(May-June 1996), 5.

2951. Browne, Enrique. "Ler planas e aprender arquitetura." *Projeto*, (July 1996), 86-91. Portuguese: "To read plans and to learn architecture." Discusses (i.a.) Wright's floor plans.

2952. Brykandt, Mary Jane. "First-of-its-kind solution for a one-of-a-kind roof." *Bulletin: the Quarterly Newsletter of the Frank Lloyd Wright Building Conservancy*, 5(Autumn 1996), 11-13. Restoration of Wingspread. Cf. Barbara Jo Novitski, "Restoring Wright's Wingspread," *Architectural Record*, 185(March 1997), 80-83; and "Calling in the marine industry to rescue Wingspread," *ENR.*, 239(July 1997), 76.

2953. Combes, Abbott. "House hunters." *NYT Magazine*, 145(10 March 1996), 21. Bruce Donald's and Ken Goldberg's computer model of Fallingwater.

2954. Connors, Thomas. "Wright for the night." *House Beautiful*, 138(November 1996), 140. Seth Peterson cottage.

2955. Cramer, Ned and Heidi Landecker."Wright's Japan projects on view in Washington; *Architecture*, 85(August 1996), 42-43. Reviews "Three Buildings by Frank Lloyd Wright: American Spirit Alive in Japan" exhibition, mounted by the Chicago Institute for the Study of Architecture and Technology and The FLW in Japan Exhibit Committee, at the National Building Museum, Washington D.C., June 1996- February 1997.

2956. Davis, Sue. "Audiovisual review: films and videos." *School Library Journal*, 42(June 1996), 73. Reviews the videotape "Frank Lloyd Wright: an

American original", produced by the Double Diamond Corporation, 1995.

2957. Dean, Andrea Oppenheimer. "Looking for Mr. Wright." *Historic Preservation*, 48(March-April 1996), 17. Pope-Leighey house.

2958. Diestelkamp, Edward. "Modern houses open to the public in Europe and America." *Twentieth Century Architecture*, (1996), [85]-94. Fallingwater.

2959. Dolan, Michael and Alex Heard. "Grand delusions." *NYT Magazine*, 146(13 October 1996), 29. Gordon Strong automobile objective.

2960. Dowling, Jill. "Conserving Wright's art collections." *Frank Lloyd Wright Quarterly*, 7(Autumn 1996), 3.

2961. Elsner, John. "Growing up Wright." *Bulletin: the Quarterly Newsletter of the Frank Lloyd Wright Building Conservancy*, 5(Spring 1996), 15. Bogk house.

2962. Fields, Jeanette. "'The Celebrity Room': an obscure Wright interior emerges from the past." *Bulletin: the Quarterly Newsletter of the Frank Lloyd Wright Building Conservancy*, 5(Autumn 1996), 6. Blue Parrot restaurant.

2963. Fields, Jeanette. "Inventory pilot study of Wright's architecture begins." *Bulletin: the Quarterly Newsletter of the Frank Lloyd Wright Building Conservancy*, 5(Spring 1996), 1, 21.

2964. Filler, Martin. "Wright in a new light." *House Beautiful*, 138(July 1996), 52-53. Gordon Strong automobile objective.

2965. French, Dennis. "Frank Lloyd Wright inspired prairie lantern." *Woodworker's Journal*, 20(November-December 1996), 52-61.

2966. Goldberger, Paul. "Machines for living." *Architectural Digest*, 53(October 1996), 82-84. Wright's cherokee-red Lincoln Continental and Mercedes-Benzes.

2967. Goldberger, Paul. "Wright's old neighborhood." *NYT Magazine*, 145(3 March 1996), 30-35. Oak Park.

2968. Gould, Whitney. "Preserving a treasure: Taliesin restoration keeps Wright's spirit alive." *Frank Lloyd Wright Quarterly*, 7(Winter 1996), 18-21.

2969. Hallmark, Donald Parker. "The Dana-Thomas house 1902-1904." *Bulletin: the Quarterly Newsletter of the Frank Lloyd Wright Building Conservancy*, 5(Winter 1996), [1]-2. See also *idem.*, "Guidelines for the conservation of Frank Lloyd Wright decorative arts," *ibid.*, 13-15.

2970. Henry, Frank M. "Update on the Arthur Pieper house." *Bulletin: the Quarterly Newsletter of the Frank Lloyd Wright Building Conservancy*, 5(Autumn 1996), 4.

2971. Holzhueter, John O. "Cudworth Beye, Frank Lloyd Wright and the

Yahara River Boathouse, 1905." *Journal of the Taliesin Fellows*, (Winter 1996), 4-23.

2972. Isasi, Justo F. "Cien años de cine." *A. and V. Monografías*, (January-April 1996), 222-23. Spanish and English: "A hundred years of cinema." Fallingwater.

2973. Johnson, Donald Leslie. "Frank Lloyd Wright houses in the Seattle area." *Pacific Northwest Quarterly*, 88(Winter 1996-1997), 33-40. Brandes, Tracy, and Griggs houses; Jay E. Roberts house (project).

2974. Johnson, Donald Leslie. "Frank Lloyd Wright's design for the *Capital Journal*, Salem, Oregon (1932)." *JSAH*, 55(March 1996), 58-65, 109. See comment by Leonard Kimball Eaton and Johnson's reply, *ibid.*, 55(September 1996), 359-60.

2975. Johnson, Donald Leslie. "'One of my best children. A Frank Lloyd Wright house in Lakewood." *Columbia*,10(Winter 1996-1997), 39-44. Griggs house.

2976. Kelly, Annie."Restoring a legacy." *Harper's Bazaar*, (May 1996), 112. Millard house.

2977. Lacey, Robert and Tony Soluri. "Historic houses: Henry Ford, the inventor of the Model T at his estate in Michigan." *Architectural Digest*, 53(May 1996), 158-63, 198-99. Ford's house, Fair Lane, in Dearborn (1916), was first commissioned to Wright, then Marion Griffin, and finally to William van Tine.

2978. Lederer, Arno et al. "[Special issue] Pragungen." *Architekt*, (October 1996), 601-645. German: "Character."

2979. Lockhart, Susan Jacobs. "Living in all the Wright places." *Frank Lloyd Wright Quarterly*, 7(Autumn 1996), 10-15. Jacobs houses I and II. See also Lynn Elliott, "Lady of Taliesin," *Old-house Interiors*, 2(Autumn 1996), 22-23 ff.

2980. Macaulay, Stewart. "Organic transactions: contract, Frank Lloyd Wright and the Johnson Building." *Wisconsin Law Review* (January 1996), 75-121. S. C. Johnson and Son administration building.

2981. Maher, Virginia Jones. "The beautiful house of affordable cost." *Style 1900: The Quarterly Journal of the Arts and Crafts Movement*, 9(Winter-Spring 1996), 45-49. American Systems Ready-Cut houses, West Burnham St., Milwaukee. The piece also reports the Frank Lloyd Wright Building Conservancy conference, Milwaukee, October 1995.

2982. Margolies, Jane. "Meeting Mr. Wright." *House Beautiful*, 138(November 1996), 136, 138. About Wright and his god-daughter Elizabeth Gordon, editor of *House Beautiful*.

2983. Masselink, Ben. "Picnicking with Frank Lloyd Wright." *Frank Lloyd Wright Quarterly*, 7(Winter 1996), 10-17.

2984. Matras, John L. "The Wright place." *AutoWeek*, 46(23 September 1996), 24. Max Hoffman's Mercedes-Benz showroom, New York City. Cf. Sam Posey,

"The showroom that FLW built," *Road and Track*, 48(June 1997), 194-96.

2985. McClintock, T. K. "The fine art of conserving Wright's drawings." *Frank Lloyd Wright Quarterly*, 7(Summer 1996), 16-19.

2986. Miller, Sarah Bryan. "Wright house, wrong place." *Wall Street Journal(eastern edition)*, 228(31 July 1996), 13. Cf. Carla Koehl and Sarah van Boven, "Open house," *Newsweek*, 127(20 May 1996), 8.

2987. Montooth, Charles. "A classic sense of order." *Frank Lloyd Wright Quarterly*, 7(Winter 1996), 4-9.

2988. Murphy, Bruce. "The Wright stuff." *Milwaukee Magazine*, 21(October 1996) 21-22. Neckties based on Wright's cast concrete block designs.

2989. Myers, Christopher A. "Moe residence: Wright connection confirmed." *Bulletin: the Quarterly Newsletter of the Frank Lloyd Wright Building Conservancy*, 5(Autumn 1996), 14-15.

2990. Neumann, Dietrich. "'The century's triumph in lighting': Die Luxfer-Prismen-Gesellschaften und ihr Beitrag zur frühen Moderne." *Archithese*, 26(November-December 1996), 26-33. German: "... the Luxfer Prism Company's contribution to early modern [architecture]."

2991. Northrup, Dale. "Mies van der Rohe and Frank Lloyd Wright: a dialogue." *Inland Architect*, 40(July-August 1996), 12-15.

2992. Olsen, Susan. "Frank Lloyd Wright's Pope-Leighey house opens to the public." *Bulletin: the Quarterly Newsletter of the Frank Lloyd Wright Building Conservancy*, 5(Summer 1996), [1], 10.

2993. Paik, Felicia. "Landmarks." *Wall Street Journal (eastern edition)*, 228(20 September 1996), 10.

2994. Peak, Martha H. "Lessons from Frank Lloyd Wright." *Management Review*, 85(August 1996), 1-3.

2995. Pfeiffer, Bruce Brooks. "Frank Lloyd Wright in Manhattan." *Frank Lloyd Wright Quarterly*, 7(Spring 1996), 4-9.

2996. Pickrel, Debra. "Growing up Wright: Margot Aronson and the Stuart Richardson house." *Bulletin: the Quarterly Newsletter of the Frank Lloyd Wright Building Conservancy*, 5(Winter 1996), 3-6.

2997. Ponte, Alessandra. "The house of light and entropy: inhabiting the American desert." *Assemblage*, (August 1996), 12-31, cover.

2998. Rebay, Roland von. "Die Legende Frank Lloyd Wright." *Architekt*, (October 1996), 619-22. German: "The legend of Wright"; English summary.

2999. Rovere, Richard H. "1950's." *NYT Magazine*, 145(14 April 1996), 101-104. Reprints articles from the decade, including Wright's "Advice to young architects".

3000. Rowlands, Penelope. "Something wrong with Wright." *Art News*, 95(December 1996), 50. Marin County Civic Center.

3001. Samuels, Gary. "The Wright stuff." *Forbes*, 157(17 June 1996), 246-47. Oak Park, Racine and Spring Green.

3002. Sergeant, John. "'MA': composition and reflex in the work of Frank Lloyd Wright." *ARQ: Architectural Research Quarterly*, 1(Summer 1996), 38-49.

3003. Shavin, Seamour and Gerte Shavin. "The building of the Seamour and Gerte Shavin House, Chattanooga, Tennessee." *Bulletin: the Quarterly Newsletter of the Frank Lloyd Wright Building Conservancy*, 5(Summer 1996), 5, 22.

3004. Sidy, Victor. "The architecture of canoeing: an apprentice learns a surprising lesson while floating down the river." *Frank Lloyd Wright Quarterly*, 7(Summer 1996), 20-21.

3005. Smith, Allen. *Journal of Academic Librarianship*, 22(July 1996), 331-33. Reviews "Houses of Frank Lloyd Wright."

3006. Steiger, Richard W. "S.C. Johnson and Son complex symbolizes concrete's versatility and endurance." *Concrete Construction*, (September 1996), 675.

3007. Strassburg, Steve. "Iowa's ten best buildings." *Iowa Architect*, (Summer 1996), 14-17. Lowell E. Walter house.

3008. Sweeney, Jim. "Controversial conservation: Wright's Pope-Leighey house." *Echoes*, 5(Winter 1996), 14-15, 17, 68.

3009. Tarantino, Lawrence J. "The Lumiline lamp." *Bulletin: the Quarterly Newsletter of the Frank Lloyd Wright Building Conservancy*, 5(Autumn 1996), 9.

3010. Thompson, Jennifer. "The errant lecturer: Frank Lloyd Wright in Louisville." *Parnassus*, 1(1996), 6-13.

3011. Webb, Michael. "Imperial Hotel, Osaka [*sic*], Japan." *Hospitality Design*, 18(November-December 1996), 72-75.

3012. Whiteson, Leon. "The Arizona Biltmore: refurbishing a Wrightian legend." *Architectural Digest*, 53(March 1996), 134-39. See also "ULI Awards for Excellence: Arizona Biltmore resort and spa: a center of social life in the community," *Urban Land*, 57(August 1998), 12-13.

3013. *Architectural Record*. "Landmarks in need." 184(May 1996), 13-14. Hanna house.

3014. *Architecture*. "Pennsylvania Wright house opens to public." 85(May 1996), 46. Kentuck Knob.

3015. *Art Quarterly*. "The Coonley playhouse window, 1912." (Summer 1996), 56. Image only.

3016. *Buildings.* "Hollyhock house." 90(July 1996), 22.

3017. *Bulletin: the Quarterly Newsletter of the Frank Lloyd Wright Building Conservancy.* "Wingspread: consort of the prairie." 5(Autumn 1996), 12.

3018. *Frank Lloyd Wright Quarterly.* "Celebrated filmmaker Ken Burns produces Wright documentary." 7(Autumn 1996), 24. See 3207 below.

3019. *Frank Lloyd Wright Quarterly.* "Exploring Wright sites in the east." 7(Spring 1996), 10-17.

3020. *Frank Lloyd Wright Quarterly.* "Foundation chair and board member receive Wright Spirit Award." 7(Autumn 1996), 18. The award was presented to Richard Carney and Eric Lloyd Wright at the Frank Lloyd Wright Building Conservancy conference, 1996.

3021. *Frank Lloyd Wright Quarterly.* "Marshall Erdman, builder of Wright's Unitarian meeting house, dies (1922-1995)." 7(Winter 1996), 26-27. Cf. "Marshall Erdman 1922-1995," *Progressive Architecture,* 76(December 1995), 26.

3022. *Frank Lloyd Wright Quarterly.* "New life for Wright's first low-income housing project." 7(Spring 1996), 3. Waller apartments.

3023. *Frank Lloyd Wright Quarterly.* "Skyview: a turbulent past, an uncertain future." 7(Autumn 1996), 4-9.

3024. *Frank Lloyd Wright Quarterly.* "Wright School of Architecture receives national program accreditation." 7(Autumn 1996), 19.

3025. *Friends of Fallingwater Newsletter.* "Major restoration planned for Falling-water." (December 1996), 1-7.

3026. *Harper's Bazaar.* "Architecture." (no. 3414, 1996), 112.

3027. *House Beautiful.* "News." 138(June 1996), 42.

3028. *Interior design.* "Forum news." 67(September 1996), 19.

3029. *Old-House Journal.* "Mailbox." 24(April 1996), 10.

3030. *Professional Builder.* "From FDR to TQM." 61(November 1996), 50-65. Outlines influences on the US building industry, 1936-1996.

3031. *Professional Builder.* "Product focus." 61(April 1996), 33.

3032. *Professional Builder.* "Shades of ... Wright." 61(no. 12, 1996), 10.

3033. *Professional Builder.* "Vacation house gardeners." 61(no. 14, 1996), 16.

3034. *Publishers Weekly.* "Audio reviews: nonfiction." 243(3 June 1996), 49. Reviews the audio-recording "Frank Lloyd Wright: the Mike Wallace interviews" (New York, 1957).

3035. *Wright Angles.* "Wright's Wasmuth portfolio." 22(February-April 1996), 3-7. The Frank Lloyd Wright Foundation acquires an original edition of

Ausgeführte Bauten und Entwürfe von Lloyd Wright.

3036. *Wright Angles.* "Frank Lloyd Wright and Ernst Wasmuth." 22(November 1996-January 1997), 3-4.

1997
Books, monographs and catalogues
3037. Alison, Filippo. *Frank Lloyd Wright: designer of furniture.* Naples: Fratelli Fiorentino, 1997. Italian and English.

3038. Brosterman, Norman. *Inventing kindergarten.* New York: Harry N. Abrams, 1997. Reviewed Genevieve Stuttaford and Maria Simson, *Publishers Weekly*, 244(31 March 1997), 52; Christine Pittel, "Chips off the old blocks," *House Beautiful*, 139(May 1997), 73-78; *New Yorker*, 73(7 July 1997), 75; David Elkind, "Play's the thing," *NYTBR*, 146(7 September 1997), 26; Marie-Jeanne Dumont, "Friedrich Froebel, l'enfance de l'art [the childhood of art]," *L'Architecture d'Aujourd'hui*, (October 1997), 10-12; Roy R. Behrens, "Wally, Bucky, and Frankie," *Print*, 51(November-December 1997), 28; Ivan E. Johnson, *Arts and Activities*, 122(November 1997), 6; Andrea Truppin, "Child's play," *Architecture*, 87(July 1998), 134; Lisa B. Reitzes, *JSAH*, 57(December 1998), 477-80; and Dan Shaw et al., *Journal of Aesthetics and Art Criticism*, 59(February 2001), 227-37.

Cf. Brosterman, "Child's play," *Art in America*, 85(April 1997), 108-111, 130 and *idem.*, "The case for kindergarten—a call for another look at Friedrich Froebel's amazing invention," *Architectural Record*, 185(March 1997), 17.

3039. Canine, Craig. *Wingspread: the history of a place where ideas that make a difference are born and nutured and grow.* Racine: Johnson Foundation, 1997.

3040. Casciato, Maristella. "The Dutch reception of Frank Lloyd Wright: an overview." In Martha Pollak ed. *The education of the architect: historiography, urbanism, and the growth of architectural knowledge: essays presented to Stanford Anderson,* Cambridge, Mass.: MIT Press, 1997. The festschrift also includes "Frank Lloyd Wright's 'The art and craft of the machine': text and context" by Joseph M. Siry. Reviewed Herman van Bergeijk, *De Architect*, 29(May 1998), 89 (Dutch); and Gúlsúm Baydar Nalbantoglu, *JSAH*, 57(June 1998), 208-209.

3041. Casey, Dennis J. *Building the lamps of Frank Lloyd Wright.* Brisbane: Prairie Designs of California: 1997.

3042. Davis, Jim and Robert A. Haller. *Notes on John Marin, Frank Lloyd Wright.* New York: Anthology Film Archives, 1997.

3043. Eaton, Timothy A. ed. *Frank Lloyd Wright: the seat of genius: chairs, 1895-1955.* West Palm Beach: Eaton Fine Art, 1997. Catalogue of an exhibition at the Eaton Gallery, February-April 1997. An essay by Penny Fowler examines Wright's contribution to the design of chairs; and Mary Ann Eaton recalls living

in a Wright house. Reviewed Jeff Zaleski and Maria Simson, *Publishers Weekly*, 244(22 September 1997), 66.

3044. Eifler, John and Kristin Visser. *Frank Lloyd Wright's Seth Peterson cottage: rescuing a lost masterwork*. Madison: Prairie Oak Press, 1997. Reviewed Sandy Soderquist, *Bulletin: the Quarterly Newsletter of the Frank Lloyd Wright Building Conservancy*, 6(Summer 1997), 11-12. Paperback edition 1999.

3045. Frank Lloyd Wright Foundation. *Annual report[s]*. Scottsdale: The Foundation, 1997- (ongoing).

3046. Frank Lloyd Wright Wisconsin Heritage Program. *Wright now in Wisconsin*. Madison: The Program, 1997- (ongoing).

3047. Grehan, Farrell. *Visions of Wright*. Boston: Little, Brown; London: Bulfinch, 1997. Mostly images, with excerpts from Wright's writings.

3048. Hata Shinji, *Furanku Roido Raito to Nihon*. Tokyo: Siebold Council Foundation, 1997. Japanese: *Frank Lloyd Wright and Japan*.

3049. Koepf, Corinne ed. *My Dear Mr. Wright: manuscripts, photographs, and architectural works from the Frank Lloyd Wright-Darwin D. Martin Collection*. Buffalo: Archives, University at Buffalo Libraries, 1997. Pamphlet catalogue of an exhibition, September-October 1997.

3050. Korab, Balthazar. *Frank Lloyd Wright: a gatefold portfolio*. New York: Barnes and Noble, 1997. Mostly images: thirty-two pages of gatefolds and sixteen color renderings: Wright home and studio; Dana, Ennis-Brown, Robie, Storer, and Frank Thomas houses; Unity Temple; Fallingwater; Taliesin; Taliesin West; Wingspread; Annie Pfeiffer Chapel; Beth Sholom Synagogue; Annunciation Orthodox Church; Guggenheim Museum; and Marin County Civic Center. Reprinted as Robin Langley Sommer and Balthazar Korab, *Frank Lloyd Wright: a gatefold portfolio*, New York: Metro Books, 2001.

3051. Lafontaine, Bruce. *Famous buildings of Frank Lloyd Wright*. New York: Dover, 1997. Juvenile literature (coloring book).

3052. McCarter, Robert. *The architecture of Frank Lloyd Wright*. San Francisco: Chronicle Books, 1997. Reviewed Peter Hinton, *Architectural Design*, 67(May-June 1997), xvi; Jeff Zaleski and Maria Simson, *Publishers Weekly*, 244(22 September 1997), 66; Stuart Ferguson, *Wall Street Journal (eastern edition)*, 230(28 November 1997), 10; Allen Freeman, "Architectural dreams and realities," *Preservation*, 49(November-December 1997), 106-107; David M. Sokol, *JSAH*, 56(December 1997), 525-27; Glenn Masuchika, *Library Journal*, 122(December 1997), 98; Richard Weston, *Architects' Journal*, 206(18-25 December 1997), 60-61; P.J.M.W——, *TLS*, (26 December 1997), 29; Michael Horsham, *World Architecture*, (February 1998), 35; Kristen Richards, *Interiors*, 157(June 1998), 26; and Stanley Abercrombie, *Interior Design*, 69(November 1998), 78-79. Published in paperback as Beth Dunlop ed. *Frank Lloyd Wright*,

London: Phaidon, 1999; reviewed Richard Louis Cleary, *JSAH*, 58(June 1999), 213-14.

3053. Max Protetch Gallery. *Frank Lloyd Wright: early and late drawings*. New York: The Gallery, 1997. Catalogue of an exhibition, opened 25 June 1997.

3054. Ness, Cynthia van. *Frank Lloyd Wright in Buffalo: a selected bibliography*. Buffalo: Special Collections, Buffalo and Erie County Public Library, 1997.

3055. Smith, Kathryn and Judith Bromley, *Frank Lloyd Wright's Taliesin and Taliesin West*. New York: Harry N. Abrams, 1997. Reviewed Jeff Zaleski and Maria Simson, *Publishers Weekly*, 244(22 September 1997), 66; and K.H——, *Interiors*, 156(October 1997), 71.

3056. Thomson, Iain, *Frank Lloyd Wright*. San Diego: Thunder Bay Press, 1997. Reviewed Jeff Zaleski and Maria Simson, *Publishers Weekly*, 244(22 September 1997), 66.

3057. Zevi, Bruno Benedetto. *Storia dell'architettura moderna. Vol. 2: Da Frank Lloyd Wright a Frank O. Gehry*. Einaudi, 1997. Italian: *History of modern architecture from Frank Lloyd Wright to Frank O. Gehry.*

Periodicals
3058. Aeppel, Timothy. "Famed Fallingwater house is slowly falling down." *Wall Street Journal (eastern edition)*, 230(24 October 1997), 18.

3059. Alarcón Reyero, Candelaria. "Un intento de prefabricacion: las viviendas Usonian." *Arquitectura* (Madrid), (no. 309, 1997), 34-39, 124-26. Spanish and English: "A pre-fab building venture: the Usonian houses." Baird, Lewis, Kalil and Zimmerman houses.

3060. Beharka, Robert. "Retrospection: a personal recollection." *Journal of the Taliesin Fellows*, (Summer 1997), 16-17.

3061. Bell, Judith. "Wright at home." *Historic Traveler*, 3(July 1997), 50-59. Oak Park residence; Fallingwater; Pope-Leighey house.

3062. Bernstein, Fred A. "Home of the month: renovating Frank Lloyd (W)right." *Metropolitan Home*, 29(November-December 1997), 168-177. Melton house.

3063. Beyer, Sarah. "Major restoration planned for Fallingwater." *Bulletin: the Quarterly Newsletter of the Frank Lloyd Wright Building Conservancy*, 6(Summer 1997), 6-7.

3064. Bliss, Sara Marisa. "Wright revival." *House Beautiful*, 139(October 1997), 42. Reintroduces Wright's furniture, furnishings and paint collections.

3065. Bone, Eugenia. "Building holistically." *Metropolis*, 16 (January-February 1997), 76-79, 100-101.

3066. Boyd, Virginia T. "*House Beautiful* and Frank Lloyd Wright." *Frank Lloyd Wright Quarterly*, 8(Autumn 1997), 4-11.

3067. Choi, Don H. "The influence of Japan on Frank Lloyd Wright," *Design Book Review*, (no. 39, 1997), 25-26.

3068. Freeman, Allen. "Wright again: rebuilding a Frank Lloyd Wright house destroyed by fire, Orinda, California." *Preservation*, 49(September-October 1997), 68-75. Buehler house. See also Walter Olds and Keith Alward, "Wright reborn: the reconstruction of the Buehler house," *Bulletin: the quarterly newsletter of the Frank Lloyd Wright Building Conservancy*, 7(Summer 1998), 5-6.

3069. Gill, Brendan. "Wright and the concept of shelter." *Architectural Digest*, 54(April 1997), 42-45.

3070. Grant, Roderick. "Edmund Teske 1911-1996 [obituary]." *Journal of the Taliesin Fellows*, (Spring 1997), 28-29. Profile of the former Taliesin apprentice.

3071. Guadarini, Stefano. "La pianta della villa a centrata." *Ville Giardini*, (January 1997), 84-85. Italian: "The plan of the centralized villa."

3072. Hart, Sharon. "A.D.A. design for Gammage [Memorial Auditorium]." *Frank Lloyd Wright Quarterly*, 8(Winter 1997), 20.

3073. Herberholz, Barbara. " Walking through history: Taliesin West and Frank Lloyd Wright." *Arts and Activities*, 122(November 1997), 30-33.

3074. Hodgkinson, Patrick. "Getting it Wright." *Times Higher Education Supplement*, (10 January 1997), 27.

3075. Infante, Rosemary. "Preserving the icons of American architecture." *CRM*, 20(no. 6, 1997), 23-24; 35. Rookery Building, Chicago.

3076. Irigoyen, Adriana. "Frank Lloyd Wright: abstraccion de la naturaleza." *Summa Plus*, (June-July 1997), 126-29. Spanish: "Frank Lloyd Wright: abstraction of nature." Comments on Wilhelm Worringer, *Abstraktion und Einfühlung*, n.l.: Neuwied Heuser, 1907 (German). English translation: *Abstraction and empathy: a contribution to the psychology of style*, Chicago: Ivan R. Dee, 1997.

3077. Ledes, Allison Eckardt. "Wright and nature." *Antiques*, 152(September 1997), 240 ff. Announces "Frank Lloyd Wright: drawing inspiration from nature" exhibition, Chicago Botanic Gardens, September-November. The show is reviewed Fran Martone, *Wright Angles*, 23(August-October 1997), 3-6; and Kristen Richards, "Looking for Mr. Wright?" *Interiors*, 156 (July 1997), 20.

3078. Ledes, Allison Eckardt. "The Wright stuff: interior furnishings by Frank Lloyd Wright," *Antiques*, 152(November 1997), 746.

3079. Lewis, Darcy. "Robie House grand opening." *Wright Angles*, 23(May-July 1997), 3-6.

3080. Long, James de. "Grant Carpenter Manson, 1904-1997 [obituary]." *Journal of the Taliesin Fellows*, (Summer 1997), 29-31.

3081. Marseille, Barbara. "Best face forward." *Old-house Journal*, 25(October 1997), 38-41. Peter Goan house.

3082. Masselink, Ben. "The glamour of a red Cord convertible." *Frank Lloyd Wright Quarterly*, 8(Spring 1997), 12-13.

3083. Mead, Andrew et al. "Updating giants of the past: West Campus, Florida Southern College." *Architects' Journal*, 205(8 May 1997), 29-32.

3084. N.C——. "Wright and Mies go public." *Architecture*, 86(January 1997), 29. Announces the restoration and opening of the Robie house and Mies van der Rohe's Farnsworth house.

3085. Northrup, Dale. "Henry Ford's 'Fair Lane'." *Inland Architect*, 41(January-February 1997), 8-9. Wright influence.

3086. Nute, Kevin Horwood. "Frank Lloyd Wright and 'composition': the architectural picture, plan, and decorative design as 'organic' line-ideas." *Journal of Architectural and Planning Research*, 14(Winter 1997), 271-88.

3087. Owings, Frank N. "Frank Lloyd Wright comes to town: Indianapolis commemorates the 40th anniversary of Wright's visit." *Frank Lloyd Wright Quarterly*, 8(Autumn 1997), 16-20.

3088. Pappas, Bette Koprivica. "No passing fancy." *Frank Lloyd Wright Quarterly*, 8(Winter 1997), 12-18. Pappas house.

3089. Pfeiffer, Bruce Brooks. "The drive-in bank." *Frank Lloyd Wright Quarterly*, 8(Spring 1997), 24. Wright's drawings for Valley National Bank branches, Phoenix and Tucson (1947).

3091. Pickrel, Debra. "Buffalo [1997] conference proves a benchmark for the Conservancy." *Bulletin: the Quarterly Newsletter of the Frank Lloyd Wright Building Conservancy*, 6(Autumn 1997), 1-2.

3092. Ponte, Alessandra. "Topik und Topographie. Wrights Fallingwater." *Daidalos*, (no. 63, 1997), 16-25. German: "Topic and topography. Fallingwater."

3093. Power, Mark. "Wright's Reach." *Custom Builder*, 12(March 1997), 37.

3094. Puttnam, Anthony. "Completing Wright's vision" *Frank Lloyd Wright Quarterly*, 8(Spring 1997), 22-27. Monona Terrace.
　　See also Shannon Nee, "Justified Wright," *Successful Meetings*, 46(June 1997), 87; J. Alex Tarquinio, "Frank Lloyd Wright has last laugh," *Wall Street Journal (eastern edition)*, 230(23 July 1997), 6; N.C——,"Wright revived," *Architecture*, 86(July 1997), 29; "The Wright stuff," *Economist*, 344(26 July 1997), 74; "Wright's Monona Terrace opens after 60 years," *Construction Specifier*, (August 1997), 6; Howard Hinterhuer, "Fullfilling Frank Lloyd Wright's vision," *Modern Steel Construction*, 37(September 1997), 50; "Frank Lloyd Wright's final project comes to fruition," *Facilities Design and Management*, (September 1997), 21; Adam Mornement, "Doing the Wright thing, at last," *World Architecture*, (October 1997), 39; Christina Trauthwein, "Past and pre-

sent." *Architectural Lighting*, (October 1997), 44; Renee Young, "The Wright stuff," *Building Design and Construction*, 38(November 1997), 32; Puttnam and George Austin, "Moving Wright along," *Urban Land*, 56(December 1997), 42-45, 65; Mary Jane Hamilton and David V. Mollenhoff. "Something spectacular for Madison," *Wisconsin Architect*, (January-February 1998), 8-13; Victoria Carlson, "Mr. Wright's alive in the '90s," *Inland Architect*, 42(January-February 1998), 28-42; and James S. Russell, "One of Frank Lloyd Wright's great visions, Monona Terrace, is transformed and opens after 59 tumultuous years," *Architectural Record*, 186(March 1998), 89-101.

Because the building was realized so long after Wright's death, questions about authorship were raised: see David Dillon, "Is this really Wright?" *Architectural Record*, 186(March 1998), 94 ff.' and "Original oder Fälschung? [Original or fake?]," *Bauwelt*, 89(15 May 1998), 1001 (German).

3095. Quinan, Jack. "A progress report: the Darwin D. Martin house." *Journal of the Taliesin Fellows*, (Summer 1997), 22-26.

3096. R. I——. "Data box: culture." *Look Japan*, 42(March 1997), 37. Reports on Wright exhibition schedules in Japan.

3097. Rattenbury, John. "Kay Schneider Rattenbury 1918-1996 [obituary]." *Journal of the Taliesin Fellows*, (Spring 1997), 27-28. Kay Rattenbury was a Taliesin Fellowship draftswoman and Olgivanna Wright's personal assistant.

3098. Reidy, Peter. "A portfolio of Wright's farm designs." *Journal of the Taliesin Fellows*, (Summer 1997), 18-21.

3099. Reidy, Peter. "*Letters of Ayn Rand* Michael S. Berliner ed." *Journal of the Taliesin Fellows*, (Spring 1997), 19-22. Reviews the book published New York: Dutton/Plume 1995 (paperback Dutton/Signet, 1997). See also *idem.*, "From Fallingwater to *The Fountainhead*," *ibid.*, 22-24

3100. Richards, Kristen. "Looking for Mr. Wright?" *Interiors*, 156(July 1997), 20. Robie House.

3101. Rogan, Helen and Debra Birnbaum. "The Wright stuff." *New Woman*, 27(May 1997), 161. Umbrella based on a Wright lamp shade (1903).

3102. Rykwert, Joseph. "Chicago Wright Viennese." *New Republic*, 216(17 March 1997), 36-41.

3103. Schellhardt, Timothy D. "This office building is a work of art, unless it's raining." *Wall Street Journal (eastern edition)*, 229(18 February 1997), 1. S.C. Johnson and Son administration building.

3104. Schulte, Marcy. "A client, a rock, an architect: the Lowell and Agnes Walter Residence by Frank Lloyd Wright." *Iowa Architect*, (no. 221, 1997), 28-31.

3105. Schwartzman, Allan. "Master work." *Elle Decor*, 8(August-September 1997), 90. Guggenheim Museum

3106. Sinclair, Brian R. and Terence J. Walker. "Frank Lloyd Wright's Banff Pavilion: critical inquiry and virtual reconstruction." *Association for Preservation Technology Bulletin*, 28(no. 2-3, 1997), 13-21.

3107. Sloan, Julie L. "Preserving Wright's art glass." *Bulletin: the Quarterly Newsletter of the Frank Lloyd Wright Building Conservancy*, 6(Spring 1997), 11-12.

3108. Solana, Guillermo. "La galaxia Guggenheim: Nueva York—Bilbao: del colectionismo a la franquica." *Arquitectura Viva*, (July-August 1997), 61-63. Spanish: "The Guggenheim galaxy: New York—Bilbao; from the collection to the *franquica.*"

3109. Soran, Patrick and Mary-Ellen Banashek. "Wright at home." *New Woman*, 27(August 1997), 32. Seth Peterson cottage.

3110. Stiller, Adolph. "Das Haus als Ware: Stationen auf dem Weg zur Produktion." *Architektur und Bauforum*, (July-August 1997), 64-74. German: "The house as commodity: stations on the way to production." Notes the "Standardhäuser: Die Häusbauer" exhibition, Architektur Zentrum, Vienna, May-June 1997. Also in Spanish as "La casa como artículo: en el camino hacia la producción," *A + T*, (no. 10, 1997), 34-47.

3111. Street-Porter, Tim and Fred A. Bernstein. "Renovating Frank Lloyd (W)right." *Metropolitan Home*, 29(November-December 1997), 168-77.

3112. Thorpe, John G. "Guidelines for the conservation of Frank Lloyd Wright properties." *Bulletin: the Quarterly Newsletter of the Frank Lloyd Wright Building Conservancy*, 6(Autumn 1997), 14-15.

3113. Tigerman, Stanley. "Staged Wright." *Architecture*, 86(September 1997), 45. Reviews the Chicago Opera Theater's performance of *Shining Brow*.

3114. Waggoner, Susan. "Kentuck Knob: private retreat becomes public attraction." *Bulletin: the Quarterly Newsletter of the Frank Lloyd Wright Building Conservancy*, 6(Spring 1997), 8-9.

3115. Wormbs, Brigitte. "Gärten der Avantgarde: Wegbegleiter moderner Formgebung von Morris bis Gropius." *Archithese*, 27(July-August 1997), 18-25. German: "Gardens of the avant garde: design pioneers from Morris to Gropius."

3116. Wright, Frank Lloyd. "Architecture and the automobile." *Frank Lloyd Wright Quarterly*, 8(Spring 1997), [4]-7. From *Industrial Wisconsin,* 1930. See also Dave Cole, "Frank Lloyd Wright's automobiles" and "The Lincoln Continentals," *ibid.*

3117. Wright, Frank Lloyd et al. "Divine architecture." *Frank Lloyd Wright Quarterly*, 8(Winter 1997), 4-11. Reprints "Starched churches" (1946) and "Is it goodbye to Gothic?" (*Together*, May 1958).

3118. *Architectural Record.* "Architectural press roundup." 185(September 1997), 38. Restoration of a Wright house in Buffalo.

3119. *Architectural Digest*. "Reproduced Wright." 54(February 1997), 30. Furniture designs for Fallingwater.

3120. *Architectural Digest*. "Revisiting the modern classics." 54(December 1997), 205. Bexley Heath Ltd. reproductions of furniture designed by Wright.

3121. *Architektur, Innenarchitektur, Technischer Ausbau.* "Heisse Nummer: technischer Ausbau im Haus für Mr. and Mrs. Arthur Miller von Frank Lloyd Wright." 105(January-February 1997), 98. German: "Technical development in Wright's Arthur Miller house."

3122. *Archithese*, 27(July-August 1997), 18-25.

3123. *Aspen Magazine*. "Wright in its place." 23(March 1997), 56.

3124. *Biography*. "Tombstones." 1(October 1997), 54-61. Photo of Wright's tombstone reprinted from Gregg Felsen, *Tombstones: seventy-five famous people and their final resting places*, Kansas City: Andrews and McMeel, 1996.

3125. *Broiler Industry*. "At Carthage they get it done 26 hours a day." 60(July 1997), 19.

3126. *Building Design And Construction*. "The Wright stuff." 38(November 1997), 32.

3127. *Bulletin: the Quarterly Newsletter of the Frank Lloyd Wright Building Conservancy*. "Wright on the web." 6(Autumn 1997), 19.

3128. *Contractor*. "Lennox signs pact with Wright group." 44(1 June 1997), 18. Reports an agreement between Lennox Industries and the Frank Lloyd Wright Foundation to upgrade the Foundation's ventilation systems. Cf. "Frank Lloyd Wright buildings to get hvac system retrofits," *Air Conditioning Heating and Refrigeration News*, 201(16 June 1997), 29; and "Wright agreement for Lennox," *Appliance Manufacturer*, 45(July 1997), 16.

3129. *Frank Lloyd Wright Quarterly*. "Classic model homes for popular magazines." 8(Autumn 1997), 12-15. Five examples from 1901-1945. The issue also includes "*House Beautiful* and Frank Lloyd Wright".

3130. *Frank Lloyd Wright Quarterly*. "Early Wright apprentice Kay Rattenbury dies [obituary]." 8(Spring 1997), 20.

3131. *Frank Lloyd Wright Quarterly*. "Putting a masterpiece back together." 8(Winter 1997), 24. Coonley house.

3132. *Friends of Fallingwater Newsletter*. "Update on Fallingwater restoration: temporary shoring installed." (June 1997), 1-6.

3133. *Home*. "News and notes." 43(November 1997), 31. Notes exhibit by Frank Lloyd Wright Home and Studio Foundation.

3134. *House Beautiful*. "Successful houses, III." 1(15 February 1997), 64-69.

3135. *I.D.* "New and notable." 44(March-April 1997), 43. Sofa designed by Wright for the Imperial Hotel, and reproduced by Cassina.

3136. *Information Today.* "Omniview releases Frank Lloyd Wright's Fallingwater CD-ROM." 14(February 1997), 23.

3137. *International Design Yearbook.* "Frank Lloyd Wright." (1987-88), 94-95, 231.

3138. *Kenchiku Bunka.* [Master architects and structural design]. 52(January 1997), 136-85. Japanese.

3139. *Life.* "Life Special." 20(May 1997), 103.

3140. *Successful meetings.* "Newsworthy." 46(June 1997), 87.

1998
Books, monographs and catalogues
3141. Alofsin, Anthony Michael intro. *Frank Lloyd Wright: gli anni della formazione: studi e realizzazioni*: Milan: Jaca, 1998. Third Italian edition of *Ausgeführte Bauten und Entwürfe von Lloyd Wright*.

3142. Birk, Melanie. *Frank Lloyd Wright and the Prairie.* New York: Universe, 1998. Published in collaboration with the Frank Lloyd Wright Home and Studio Foundation. Reviewed Alejandro Saralegui, "Paging through," *Elle Decor*, 9(November 1998), 106-111.

3143. Carter, Brian. *Johnson Wax administration building and research tower: Frank Lloyd Wright.* San Francisco: Chronicle Books; London: Phaidon, 1998. Reprinted in Dunlop ed. *Frank Lloyd Wright.* London: 1999.

3144. Copplestone, Trewin. *Frank Lloyd Wright: a retrospective view.* New York: Diane Publishing; London: Grange Books, 1997. Reprinted Manchester: Alva Press, 1999; New York: Grange Books; Todtri, 2001. Also published in Polish as *Frank Lloyd Wright: przegld retrospektywny*, Warsaw: Arkady, 1998.

3145. Costantino, Maria and Simon Clay. *The life and works of Frank Lloyd Wright.* London: PRC; Philadelphia: Running Press, 1998.

3146. Eaton, Leonard Kimball. "Fractal geometry in the late work of Frank Lloyd Wright: the Palmer house." In Kim Williams ed. *Nexus II: architecture and mathematics*, Florence: Dell'Erba, 1998.

3147. Friedman, Alice T. *Women and the making of the modern house: a social and architectural history.* New York: Harry N. Abrams, 1998. Includes "No ordinary house: Frank Lloyd Wright, Aline Barnsdall, and Hollyhock House".

Reviewed Liza Fior, "She's gotta have it," *Blueprint*, (June 1998), 4; Kester Rattenbury, *Architectural Review*, 204(August 1998), 88; Annmarie Adams, *JSAH*, 57(December 1998), 474-76; Christiane Keim, *Kritische Berichte*, 27(no. 1, 1999), 39-44 (German); Nadir Lahiji and D.S. Friedman, *AA Files*, (Winter

1999), 84-87; Lynne Walker, *Journal of Design History*, 12(no. 3, 1999), 306-308; Hilde Heynen, *Archis*, (February 2000), 85-86 (Dutch and English); and Amy F. Ogata, *Studies in the Decorative Arts*, 8(Fall-Winter 2000), 178-80.

3148. Hart, Spencer. *Wright rooms.* Edison: Chartwell Books, 1998. Photographs by Balthazar and Christian Korab.

3149. Hoffmann, Donald. *Frank Lloyd Wright, Louis Sullivan and the skyscraper.* New York: Dover, 1998.

3150. Long, David Gilson de ed. *Frank Lloyd Wright, die lebendige Stadt.* Weil am Rhein: Vitra Design Museum; Milan: Skira, 1998 (German). English edition *Frank Lloyd Wright and the living city*, London: Thames and Hudson, 1998. Published in conjunction with a traveling exhibition organized by the museum, Exhibitions International, New York, and the Frank Lloyd Wright Foundation. Includes the essays "Wright's ideas of twentieth-century urbanism and their European echoes" by Jean-Louis Cohen and "The decorative designs of Frank Lloyd Wright and his European contemporaries" by David Hanks.

After a season at Vitra Design Museum, Weil am Rhein, Switzerland, June-October 1998, the show moved to the Grassimuseum, Leipzig, Germany, November 1998-January 1999; Kelvingrove Museum and Art Gallery, Glasgow, Scotland, February-April 1999; the Beurs van Berlage, Amsterdam, Netherlands, June-September 1999; the Museum für Kunst und Kulturgeschichte, Dortmund, Germany, January-April 2000; IVAM Centre Julio González, Valencia, Spain, July-September 2000; Fundación Pedro Barrié de la Maza, Conde de Fenosa, La Coruña, Spain, October 2000-January 2001; and the Museum of Applied Art, Prague, Czechoslovakia, February-April 2001.

The European showings are reviewed Brigitte Libois, "Frank Lloyd Wright en Europe," *A Plus*, (June-July 1998), 55 (French); Mathias Remmele, "Prototypen fuer eine Vision[Prototypes for a vision]. 'Frank Lloyd Wright: Die Lebendige Stadt'," *Bauwelt*, 89(3 July 1998), 1424 (German); Christoph Bignens, "Wright-City—die richtige Stadt?" *Archithese*, 28(July-August 1998), 68-69 (German); Francis Rambert, "Wright chez Gehry [Wright at Gehry's place]," *D'Arch-itectures*, (July-August 1998), 47 (French); Elisabeth Vedrenne, "F.L. Wright et le design integral [Wright and integral design]," *L'Oeil*, (July-August 1998), 66-71 (French); Brigitte Selden, "Architekt einer besseren gesellschaft [Architect of a better society]. Frank Lloyd Wright's visions of the future," *Design Report*, (August 1998), 86-87, 103; Béatrice Loyer, "Frank Lloyd Wright: visionnaire de la cité vivante [Wright: visionary of the living city]," *Techniques et Architecture*, (August-September 1998) (French); Rahel Hartmann and Jörn Ebner, "Exhum-ierung des 'Architekturfriedhofs' legt F.L. Wrights organische Vision frei [Exhumation of the 'architecture cemetery' opens Wright's organic vision]," *Werk, Bauen und Wohnen*, (September 1998), 64 ff. (German); Christina Haberlik, "'The Living City'. Zwei Begegnungen mit Frank Lloyd Wright [Two encounters with Frank Lloyd Wright]," *Tain*, (no. 5, 1998), 82-86 (German); Jacob Werner, "Kunstwerke im Regen: die erste europäische Retrospektive: Frank Lloyd Wright [Artworks in the rain: the first European

Wright retrospective]," *Deutsche Bauzeitung*, 132(September 1998), 18 (German); "Retrospettiva di Wright," L'Arca, (September 1998), 97 (Italian); *Graphis*, (September-Oct-ober 1998), 108; *Casabella*, 62(November 1998), 89 (Italian); Almerico de Angelis, "Wright e van der Rohe al Vitra [Wright and van der Rohe at Vitra]," *Modo*, 20(December 1998-January 1999), 78-79; Janet Koplos, *Art in America*, 87(January 1999), 111-12; Benjamin Loyaute, "... Wright a Berlin," *Connaissance des Arts*, (September 2001), 40 (French); and Falk Jaeger, *Baumeister*, 98(August 2001), 14 (German). See also *Bauwelt*, 92(no. 32-33, 2001), 3.

The Glasgow showing is reviewed Richard Carr, "Twentieth century American dreams," *Building Design*, (March 1999), 19, 12; Andrew Mead, "Navigating without a map," *Architects' Journal*, 209(18 March 1999), 40-41; Dominic Papa, "De verbeelding van de stad/Imagineering the city," *Archis*, (April 1999), 75-77 (Dutch and English); and Christopher Joseph Platt et al., *Charles Rennie Mackintosh Society Newsletter*, (Spring 1999), 10-12.

3151. Koshinsky, Deborah Husted and Rodney Gorme eds. *Colloquium on Frank Lloyd Wright in Western New York at the University at Buffalo Archives.* Buffalo: State University of New York, 1998.

3152. Kotre, John and Kathy B. Kotre. "Truth against the world: a psychobiographical exploration of generativity in the life of ... Wright." In Dan P. McAdams and Ed de St. Aubin eds. *Generativity and adult development: how and why we care for the next generation.* Washington, D.C.: American Psychological Association, 1998.

3153. Kruty, Paul Samuel. *Frank Lloyd Wright and Midway Gardens.* Urbana: University of Illinois Press, 1998. Published version of the author's PhD thesis, Princeton University, 1989. Reviewed Nina C. Ayoub, *Chronicle of Higher Education*, 44(10 April 1998), A28-A30; Roderick Grant, *Journal of the Taliesin Fellows*, (Spring 1999), 11-13; Max Page, *Journal of American Studies*, 34(April 2000), 174-75; and Jack Quinan, *JSAH*, 59(June 2000), 254-56.

3154. Maddex, Diane. *Fifty favorite rooms by Frank Lloyd Wright.* New York: Smithmark; London: Thames and Hudson, 1998. Mostly images. Reviewed Rose-Marie Hillier, "Picture this," *Australian House and Garden*, 101(January 1999), 22. Second edition New York: Harry N. Abrams, 2001.

3155. Radford, Evelyn Morris. *Vera: first lady of Marin: a biography of Vera Lucille Smith Schultz.* San Rafael: Marin County Civic Center, 1998.

3156. Riley, Charles A. *The saints of modern art: the ascetic ideal in contemporary painting, sculpture, architecture, music, dance, literature, and philosophy.* London; Hanover: University Press of New England, 1998. Includes "The prophet Frank Lloyd Wright."

3157. Smith, Kathryn. *Frank Lloyd Wright: America's master architect.* New York; Paris; London: Abbeville, 1998. French title, *Frank Lloyd Wright: maître de l'architecture américaine.* English version reprinted in paperback, 2001.

3158. Waggoner, Susan. *Kentuck knob: Frank Lloyd Wright, architect*. Chalk Hill: Kentuck Knob, 1998.

Periodicals

3159. Aitkin, Donald et al. "[Special issue]. Architecture and light." *Frank Lloyd Wright Quarterly*, 9(Summer 1998), 3-19, 24-29. Includes "Decorative designs for lighting"; and "FLLW: daylighting master."

3160. Beauregard, Sue-Ellen. "Media: video." *Booklist*, 95(1 November 1998), 509. Reviews the videotape "The homes of Frank Lloyd Wright", originally screened on PBS. See also *American History*, 33(June 1998), 6; and Catherine Applefield Olson and Eileen Fitzpatrick, *Billboard*, 110(7 February 1998), 77.

3161. Bemrose, John. "Grabbing the limelight." *Maclean's*, 111(4 May 1998), 65-66. Discusses the performance of "Geometry of Miracles" at the Du Maurier World Stage Theater Festival , Toronto, April-May 1998.

3162. Bennett, Paul. "Naturally Wright." *Landscape Architecture*, 88(no. 2, 1998), 58.

3163. Bock, Gordon. "*Ladies' Home Journal* houses (1895-1919)." *Old-house Journal*, 26(April 1998), 52-57

3164. Book, Carl F. "Preservation of Marin County Civic Center of concern to local residents." *Bulletin: the Quarterly Newsletter of the Frank Lloyd Wright Building Conservancy*, 7(Spring 1998), 5.

3165. Briggs, Sara-Ann. "Storm fells historic oak, damaging Frank Lloyd Wright's Taliesin [Spring Green, Wisc.]." *Bulletin: the Quarterly Newsletter of the Frank Lloyd Wright Building Conservancy*, 7(Summer 1998), 1, 9.

3166. Bromley, Judith. "The restoration of Heller House: a labor of love and discovery." *Bulletin: the Quarterly Newsletter of the Frank Lloyd Wright Building Conservancy*, 7(February 1997), 1-3; 6.

3167. Brooks, Harold Allen et al. [Special issue. Prairie School.] *Rassegna*, 20(no. 74, 1998). Italian and English. Includes: "The Prairie School in the history of architecture" and "*The Western Architect*. The voice of the Prairie School" by Brooks; "The Prairie dream" by Federico Bucci; "Darwin, Wright and the typology of the Prairie house" by Jean Castex (French and English); "Purcell and Elmslie Architects" by David Gebhard; "Griffins portfolio"; and "Spirituality of organic architecture" by Mark Hammons.

3168. Brown, Conrad Nagel. "Wright's millennium." *Inland Architect*, 42(January-February 1998), 70; (March-April 1998), 52.

3169. Campbell, Robert. "The magic of Wright." *Frank Lloyd Wright Quarterly*, 9(Autumn 1998), 16-21.

3170. Christian, John. "Documenting your Frank Lloyd Wright home." *Bulletin: the Quarterly Newsletter of the Frank Lloyd Wright Building Conservancy*, 7(February 1997), 11-14; 16.

3171. Eaton, Leonard Kimball. "Frank Lloyd Wright and the concrete slab and column." *Journal of Architecture*, 3(Winter 1998), 315-46.

3172. Endo, Arata. "Frank Lloyd Wright + Arata Endo: Yamamura House, 1924 [Ashiya, Japan]." *Japan Architect*, (Spring 1998), 12-21. Japanese and English.

3173. Ferraro, Sharon. "*Ladies' Home Journal* houses (1895-1919)." *Old-House Journal*, 26(March-April 1998), 52-57.

3174. Fox, Bette-Lee et al. "Video reviews." *Library Journal*, 123(1 September 1998), 230-32. Reviews the video tape "The Homes of Frank Lloyd Wright".

3175. Fraser, Virginia. "Collector's piece; architect: Frank Lloyd Wright." *House and Garden*, 53(March 1998), 122-29. Kentuck Knob.

3176. Gayou, Gheda. "Graycliff restoration ensured." *Bulletin: the Quarterly Newsletter of the Frank Lloyd Wright Building Conservancy*, 8(Winter 1998-1999), 1-2.

3177. Goodwin, George M. "Frank Lloyd Wright, Jews, and the West." *Western States Jewish History*, 30(February 1998), 98; 30(March 1998), 262.

3178. Goodwin, George M. "Wright's Beth Sholom synagogue." *American Jewish History*, 86(September 1998), 325-49.

3179. Gragg, Randy. "The expulsion of Frank Lloyd Wright." *Bulletin: the Quarterly Newsletter of the Frank Lloyd Wright Building Conservancy,* 7(Spring 1998), 7-11.

3180. Greco, JoAnn. "What's Wright?" *Historic Traveler*, 4(May 1998), 12-13. Arizona-Biltmore Hotel.

3181. Guarino, Jean Louise. "Heurtley House restoration project featured in Wright Plus housewalk." *Bulletin: the Quarterly Newsletter of the Frank Lloyd Wright Building Conservancy*, 7(Spring 1998), 12-13.

3182. Hale, Jonathan. "Tough times for Wright houses." *Architectural Record*, 186(September 1998), 53. Fallingwater.

3183. Henning, Randolph C. "The Frank Lloyd Wright Archives: an international treasure." *Frank Lloyd Wright Quarterly*, 9(Autumn 1998), 4-9.

3184. Hoggard, Liz. "Frank Lloyd Wright meets the future." *Blueprint*, (March 1998), 39. Reviews the science fiction motion picture *Gattaca*, whose setting includes Marin County Civic Center.

3185. Hucker, Jacqueline. "The Cardston Temple, Alberta, and nonconformist form." *Journal of the Society for the Study of Architecture in Canada*, 23(no. 2, 1998), 55-61. Compares the Mormon building (architects: Hyrum Pope and Harold Burton, 1912) and Unity Temple.

3186. Hughes, Robert. "1923-1929: exuberance." *Time*, 151(9 March 1998), 94-98. Same as *Time South Pacific*, (9 March 1998), 58-62.

3187. Kelleher, Terry. "Picks and pans tube." *People*, 50(9 November 1998), 27-28. Reviews television program "rank Lloyd Wright."

3188. Koerner, Brendan I. "Looking for Mr. Wright." *U.S. News and World Report*, 124(13 April 1998), 78-79. Taliesin.

3189. Kronick, Richard L. "The pencil in Frank Lloyd Wright's hand." *Journal of the Taliesin Fellows*, (Summer 1998), 4-20. Interview with John Henry Howe, 4 June 1987. See also "Wright apprentice John Howe dies," *Frank Lloyd Wright Quarterly*, 9(Winter 1998), 27.

3190. Lasky, Jane. "Sleeping with the architect." *Metropolitan Home*, 30(July-August 1998), 44. Seth Peterson Cottage.

3191. Littman, Margaret. "Wright's legacy includes $30 mil memorabilia biz." *Advertising Age*, 69(2 November 1998), 20. See also *idem.*, "The price is Wright," *Crain's Chicago Business*, 21(26 October 1998), 1-3.

3192. Maher, Virginia Jones. "Frank Lloyd Wright's Usonian vision." *Style 1900*, 11(Summer-Autumn 1998), [52]. Subtitled, "A bridge from the Arts and Crafts era into the future." Adelman and Mollica houses.

3193. Martone, Fran. "The atelier of Frank Lloyd Wright." *Wright Angles*, 24(February-April 1998), 3-6.

3194. Martone, Fran. "Commemorating Marion Mahoney Griffin." *Wright Angles*, 24(May-July 1998), 3-4, 9. Cf. Joanna Mendelssohn, "Unbuilt visions," *Bulletin with Newsweek* [Australia], 117(29 December 1998), 58-61.

3195. Masselink, Ben et al. "Frank Lloyd Wright and Arizona." *Frank Lloyd Wright Quarterly*, 9(Winter 1998), the issue. Includes "Cross country caravan" by Masselink; edited excerpts from Wright's "Living in the desert: we found paradise", (reprinted from *Arizona Highways*, 16[May 1940]); "Surveying the legacy" by Randolph C. Henning; and "Arizona buildings inspired by the desert," about Taliesin West.

3196. Matheou, Demetrios. "Architecture's only hero." *RIBA Journal*, 105(November 1998), 24-25. *The Fountainhead.*

3197. Miller, S. Reagan. "The school of Frank Lloyd Wright." *Cite: the Architecture and Design Review of Houston*, (Winter 1998), 24-27.

3198. Mohr, Richard D. "Walter Burley Griffin: inspiration to the Prairie School." *Architectural Record*, 186(January 1998), 34. Conference at University of Illinois, October 1997.

3199. Mullins, Richard. "A master architect's dream job." *Crain's Chicago Business*, 21(14 September 1998), 38. Reviews an exhibition "All Wright: The Dana-Thomas House."

3200. Newhouse, Victoria and Anthony Peres. "Joel Silver: the producer's Frank Lloyd Wright house in Los Angeles." *Architectural Digest* 55(April 1998), 278-87 ff. Storer House.

3201. Nonnig, Jorg et al. "Die Welt als Kopie." *Bauwelt*, 89(11 September 1998), 1928-49. German: "The world as copy."

3202. O'Connor, Michael J. "The plagues of Taliesin." *Architecture*, 87(August 1998), 22.

3203. Ols, Nicholas. "Pedro E. Guerrero, Frank Lloyd Wright con alcuni ospiti durante un picnic a Taliesin, Spring Green, Wisconsin 1940 [photograph]." *Casabella*, 62(November 1998), 88-89. Italian: "Guerrero, Wright and guests during a picnic at Taliesin ..., 1940."

3204. Owings, Frank N. Jr. "National recognition for Wright sites." *Frank Lloyd Wright Quarterly*, 9(Autumn 1998), 30-35.

3205. Paik, Felicia. "Private properties." *Wall Street Journal (eastern edition)*, 231(15 May 1998), 8. Pleasantville.

3206. Ricapito, Maria. "The tree that escaped the forest." *Metropolis*, 17(February-March 1998), 52. Conversion of H.C. Price Tower to house Bartlesville Museum, an art museum and Landmark Preservation Council.

3207. Richards, Kristen. "Burns brings Wright to life." *Interiors*, 157(October 1998), 24. Announces a Florentine Films television documentary by Ken Burns, Lynn Novick and Peter Miller, in association with WETA-TV, broadcast by PBS, 10-11 November 1998.

For comment and review see Michael Sorkin, "Documenting Wright," *Metropolis*, 18(October 1998), 75; 77; "Interview: Ken Burns on 'Frank Lloyd Wright'," *Architectural Record*, 186(October 1998), 52; "A life examined," *Frank Lloyd Wright Quarterly*, 9(Autumn 1998), 10-15; Rick Marin, *Newsweek*, 132(16 November 1998), 87; Wayne Curtis, "Reeling in Wright," *House Beautiful*, 140(November 1998), 84; 86; Ken Burns, "The master builder," *Vanity Fair*, (November 1998) 302-317; Ken Budd, "The Wright stuff," *Modern Maturity*, 41(November-December 1998), 20; *American History*, 33(December 1998), 9-10; *Broadcasting and Cable*, (17 May 1999); Soren Larson, "From sublime to scandalous: Ken Burns explores Wright," *Architectural Record*, 186(October 1998), 52; J. Leonard, *New York*, 31(no. 44, 1998), 80; Kester Rattenbury, "When only the best will do," *Building Design*, (12 March 1999), 32; Jeff Dick, *Booklist*, 95(15 March 1999), 1346; and Tim Sandefur, "Frank Lloyd Wright's humanism," *The Humanist*, (May 1999);

See also "Architektur ist fur alle da: F.L Wright ... im Kino [Architecture is for everybody: Wright ... on film]." *Deutsche Bauzeitschrift*, 46(September 1998), 32 (German).

3208. Rickerd, Julie Rekai. "Robert Lepage." *TCI*, 32 (July 1998), 19. Lepage wrote "Geometry of Miracles", a one-act play about Wright, produced for the 1998 Du Maurier World Stage Festival, Toronto. It was also performed in the US (reviewed J.C. Rotunda, "Frank Lloyd Wright: a characterization by Will Stutts," *Frank Lloyd Wright Quarterly*, 9[Summer 1998], 23). It then moved to the UK: see Michael Ball, "A geometric progression," *Building Design*, (23 April 1999), 11; Elisabeth Mahoney, "A Wright drama," *Blueprint*, (May 1999),

72; Howard Watson, "Beyond expression? The relationship between architecture and drama," *Architectural Design*, 69(no. 9-10, 1999), 97-99; and Christina Haberlik, "'Geometry of Miracles' Zwei Begegnungen mit Frank Lloyd Wright. ['Geometry of Miracles'Two encounters with Frank Lloyd Wright]," *Tain*, (no. 5, 1998), 82-86 (German).

3209. Socki, Joseph. "Frank Lloyd Wright's modernism." *Wright Angles*, 24(August-October 1998), 3-[5]. Wright and early modern painting.

3210. Storrer, Bradley Ray. "Richard E. Carney, 1923-1998 [obituary]." *Journal of the Taliesin Fellows*, (Summer 1998), 28-29. Carney was chairman of the Board of Trustees, Frank Lloyd Wright Foundation. Cf. "Richard Carney ... dies," *Frank Lloyd Wright Quarterly*, 9(no. 2, 1998), 24.

3211. Sullivan, Anne T. "Raise high the roof beam, architects." *Clem Labine's Traditional Building*, 11(July-August 1998), 41; 50; 178. Fabyan house.

3212. Tarantino, Lawrence J. "A case study of the Stuart Richardson House (Glen Ridge, NJ, 1941)." *Bulletin: the Quarterly Newsletter of the Frank Lloyd Wright Building Conservancy*, 7(Summer 1998), 17-19.

3213. Veceráková, Markéta. "Zmeny liturgického prostoru v Prazské mezi-válecné sakrální architekture." *Umení*, 46(no. 6, 1998), 548-558. Czechoslo-vakian; English summary. Discusses Unity Temple as a model for choirs in the Reformed Catholic Church of Czechoslavia.

3214. Walters, Katrina K. "Elizabeth Bauer Kassler, [obituary]." *Journal of the Taliesin Fellows*, (Summer 1998), 27-28.

3215. Wigley, Mark. "Die Architektur der Atmosphär." *Daidalos*, (June 1998), 18-27. German and English: "The architecture of atmosphere."

3216. Winter, Gabriele. "Der Kirchenbau Frank Lloyd Wrights im Rahmen seiner Schaffensperioden." *Kunstchronik*, (no. 8, 1998), 426. German: "Wright's church building in the context of its time." Refers to the author's thesis at Friedrich-Alexander-Universität, Erlangen-Nürnberg.

3217. Zellner, Peter. "Die Grossstadt ist nicht mehr modern. Broadacre City von Frank Lloyd Wright." *Daidalos*, (December 1998-January 1999), 68-75. German; "Cities are no longer popular. Wright's Broadacre City."

3218. *Architectural Digest*. "Extraordinary properties on the market." 55(August 1998), 67-70. Wright house in Pleasantville.

3219. *Architecture*. "The buzz." 87(February 1998), 31. Robie house postage stamp.

3220. *Automobile Quarterly*. "Frank Lloyd Wright and "automobility": autos, architecture and Usonian ideals." 38(March 1998), 30.

3221. *Bauwelt*. "Meiji-Mura: ein Arrangement von Bauten aus der Meiji-Zeit." 89(11 September 1998), 1932-35. German: "Meiji-Mura. A building group from Meiji times." Imperial Hotel.

3222. *Buildings.* "Smarter Buildings." 92(June 1998), 30.

3223. *Echoes.* "Hanging Wright." 7(Winter 1998), 8.

3224. *Echoes.* "Wright light." 7(Summer 1998), 8.

3225. *Frank Lloyd Wright Quarterly.* "Architecture and music" 9(Spring 1998), 3-23, cover, 1, 4. The issue also includes "Daily rhythms" and "Musical sites".

3226. *Frank Lloyd Wright Quarterly.* "Frank Lloyd Wright School of Architecture: integrating tradition and change." 9(Autumn 1998), 36-39.

3227. *Frank Lloyd Wright Quarterly.* "Surveying the legacy." 9(Autumn 1998), 3. See also "Preserving the built legacy," 22-23; "Taliesin vs. time," 24-27; and "Building on the legacy" by Marilyn Eisenberg, 40-41.

3226. *Home.* "Getting it Wright." 44(May 1998), 166-71.

3229. *Interior Design.* "The Wright stuff again." 69(June 1998), 29. Announces Frank Lloyd Wright Building Conservancy conference, Chicago, 23-27 September. See Debra Pickrel, "Conservancy explores Wright's vision for the American Prairie at Chicago," *Bulletin: the Quarterly Newsletter of the Frank Lloyd Wright Building Conservancy*, 7(Autumn 1998), 1-3.

3230. *Journal of the Taliesin Fellows.*"To our architect, John Henry Howe, a small belated note of gratitude in appreciation of his elegantly eloquent life." (Summer 1998), 21-24.

3231. *Kids Discover.* "Ahead of their time." 8(March 1998), 16.

3232. *Society of Architectural Historians Newsletter.* "Domestic study tour 1998: Bruce Goff and Frank Lloyd Wright in Oklahoma, October 7-11, 1998." 42(February 1998), 7-8. News item.

1999
Books, monographs and catalogues
3233. Alofsin, Anthony Michael ed. *Frank Lloyd Wright: Europe and beyond.* Berkeley: University of California Press, 1999. Includes "Wright, influence, and the world at large" by Alofsin; "Wright and Japan" by Margo Stipe; "Kindred spirits: Holland, Wright, and Wijdeveld" by Mariëtte van Stralen; "Wright and Italy: a recollection" and "Wright and Italy: the promise of organic architecture" by Maristella Casciato; "Useful hostage: constructing Wright in Soviet Russia and France" by Jean-Louis Cohen; "Wright and Great Britain" by Andrew Saint; "Wright and South America" by Alberto Sartori; "Towards an organic architecture in Mexico" by Keith Eggener; and "Wright's Baghdad" by Mina Marefat.

Reviewed David Soltesz, *Library Journal*, 125(15 February 2000), 156; R. Yeomans, *Journal of Art and Design Education*, 19(no. 2, 2000), 240-41; *TLS*, (7 April 2000), 37.

3234. Brierly, Cornelia. *Tales of Taliesin: a memoir of fellowship.* Tempe: Herberger Center for Design Excellence, College of Architecture and Environ-

mental Design, Arizona State University, 1999). Second edition, Rohnert Park: Pomegranate, 2000.

3235. Cleary, Richard Louis. *Merchant prince and master builder: Edgar J. Kaufmann and Frank Lloyd Wright*. Pittsburgh: Heinz Architectural Center, 1999. Catalogue of an exhibition at the Center, Carnegie Museum of Art, April-October 1999. Essays are summarized *idem.*, "Frank Lloyd Wright and the Kaufmanns of Pittsburgh." *Frank Lloyd Wright Quarterly*, 10(Spring 1999), 4-11 (also includes "Living architecture... alive in Pittsburgh", and a review of the show).

For review and comment see R. Jay Gagewere, *Carnegie Magazine*, 64(March-April 1998), 12-17; Julia Einspruch Lewis, "Kindred spirits," *Interior Design*, 70 (May 1999), 52; *Frank Lloyd Wright Quarterly*, 10(Spring 1999), 3; D.S. Friedman, "Two tough customers," *Architecture*, 88(August 1999), 41-43 ff.; Hubertus Adam, *Bauwelt*, 90(3 September 1999), 148 (German); David Soltesz, *Library Journal*, 124(1 October 1999), 86; "Pittsburgh exhibit explores Wright and Kaufmann relationship," *Frank Lloyd Wright Quarterly*, 10(Winter 1999), 18; and Roy R. Behrens, Michael Punt and Kasey Rios Asberry, *Leonardo*, 33(2000), 148.

3236. Cooney, William. *The quest for meaning: a journey through philosophy, the arts, and creative genius*. Lanham: Univerity Press of America, 1999. Includes a chapter, "Frank Lloyd Wright: creative force of nature."

3237. Costantino, Maria and Robin Langley Sommer. *Frank Lloyd Wright*. London: Grange, 1999.

3238. Dunlop, Beth ed. *Frank Lloyd Wright*. London: Phaidon, 1999. Essays originally published in the "Architecture in Detail' series, 1992-1998 include "Unity Temple" by Robert McCarter; "Barnsdall (Hollyhock) House" by James Steele; and "Johnson Wax administration building and research tower" by Brian Carter.

3239. Dunlop, Beth and Denis Hector eds. *Twentieth-century houses*. London: Phaidon, 1999. The contents were originally published in the "Architecture in Detail' series, 1992-1998; includes "Frank Lloyd Wright, Fallingwater" by Robert McCarter.

3240. Fisker, Kay and Tobias Faber. *Formprincipper: Strejftog i den nyere arkitekturs historie: resumé af Kay Fiskers forlæsninger*. Copenhagen: Arkitektens Forlag, 1999. Danish: "Form principles ..." . Includes "Materialeromantik: Frank Lloyd Wright."

3241. Legler, Dixie and Christian Korab. *Prairie style: houses and gardens by Frank Lloyd Wright and the Prairie School*. New York: Stewart Tabori and Chang, 1999.

3242. Legler, Dixie and Scot Zimmerman. *Frank Lloyd Wright: the Western work*. San Francisco: Chronicle Books, 1999. Reviewed Ilene Cooper, *Booklist*, 96(15 December 1999), 749-50.

3243. Lehmann, Federica and Augusto Rossari. *Wright e l'Italia (1910-1960)*. Milan: UNICOPLI, 1999. Italian: *Wright and Italy (1910-1960)*

3244. Maddex, Diane. *Fifty favorite furnishings by Frank Lloyd Wright*. New York: Smithmark, 1999. Mostly images.

3245. Marty, Myron A. and Shirley L. Marty. *Frank Lloyd Wright's Taliesin Fellowship*. Kirksville: Truman State University Press, 1999. See reviews by former fellows (John Geiger, Val M. Cox, Frank Laraway, Grattan Gill and Yen Liang, *Journal of the Taliesin Fellows*, (Summer 2000),.20-25.

3246. Michel, Henry J. *Basic Frank Lloyd Wright: legend and fact about America's most creative architect*. Los Angeles: One Palm Books, 1999.

3247. Mollenhoff, David V. and Mary Jane Hamilton. *Frank Lloyd Wright's Monona Terrace: the enduring power of a civic vision*. Madison: University of Wisconsin Press, 1999. Reviewed Jay Schafer, *Library Journal*, 124(1 August 1999), 84.

3248. Narkiewicz-Laine, Christian K. et al. *Inspiration: nature and the poet: the collected poems of Louis H. Sullivan*. Chicago: Athenaeum, 1999. Includes "Louis Henry Sullivan, beloved master" by Wright, reprinted from *Western Architect*, 33(June 1924), 64-66.

3249. Oak Park Historic Preservation Commission. *A guide to Oak Park's Frank Lloyd Wright and Prairie School Historic District*. Oak Park: The Commission, 1999.

3250. Overby, Osmund and Sam Fentress. *William Adair Bernoudy, architect: bringing the legacy of Frank Lloyd Wright to St. Louis*. Columbia: University of Missouri Press, 1999.

3251. Quinan, Jack ed. *Frank Lloyd Wright: windows of the Darwin D. Martin House*. Buffalo: Burchfield-Penney Art Center, 1999. Catalogue of an exhibition organized by the Center, Buffalo State College and the Martin House Restoration Corporation. Includes essays by Theodore Lownie, Robert Mc-Carter, and Quinan. The exhibition is reviewed Richard Huntington, *Art New England*, 21(December 1999-January 2000), 40. It moved to the National Building Museum, Washington D.C., February-August 2000; that showing is previewed Robert McCarter, "The space within: Frank Lloyd Wright's Darwin D. Martin house," *Blueprints*, 18(Winter 2000), 6-8. See also Allison Eckardt Ledes, "Stained-glass windows," *Antiques*, (April 2000).

3252. Robertson, Cheryl and Terrence Marvel. *Frank Lloyd Wright and George Mann Niedecken: Prairie School collaborators*. Milwaukee: Art Museum; Lexington: Museum of Our National Heritage, 1999. Catalogue of an exhibition, Milwaukee Art Museum, March-September 1999. Niedecken contributed to the Dana, Coonley, Robie, Irving, Meyer May, and Bogk houses. For review and comment see Allison Eckardt Ledes, "Designing in the Wright style," *Antiques*,

155(March 1999), 352; Mark Faverman, *Art New England*, 20(June-July 1999), 15; and "The shared vision: Frank Lloyd Wright and George Mann Niedecken," *Frank Lloyd Wright Quarterly*, 6(Fall 1999), 4-11.

3253. Robinson, Jackie. *Quilts in the tradition of Frank Lloyd Wright*. Hesperus: Animas Quilts Publishing, ca. 1999.

3254. Satler, Gail. *Frank Lloyd Wright's living space: architecture's fourth dimension*. DeKalb: Northern Illinois University Press, 1999. See also *Frank Lloyd Wright's architecture as analysis: Wright's 'stuff'* [microform], Ann Arbor: University Microfilms International, 1987, the author's PhD thesis, City University of New York, 1984. Reviewed Alex Grant, *TLS*, (20 August 1999), 28.

3255. Solomon R. Guggenheim Foundation. *40 years of Frank Lloyd Wright's Guggenheim*. New York: The Foundation, 1999. Essays include "Temple of Spirit: Frank Lloyd Wright's design for the Guggenheim Museum" by Matthew Drutt; "Art on stage" by Donald Albrecht; and "The Guggenheim effect" by Paul Goldberger.

3256. Stephan, Regina ed. *Eric Mendelsohn: architect, 1887-1953*. New York: Monacelli Press, 1999. Includes chapter "The same means, the same end: private houses in Berlin and the influence of Frank Lloyd Wright".

3257. Stodola, Barbara et al. *Frank Lloyd Wright and colleagues: Indiana works*. Michigan City: John G. Blank Center for the Arts, 1999. Catalogue of an exhibition at the Center, July-October 1999. Includes "Frank Lloyd Wright and his colleagues in Indiana" by Stodola, "Wright's first step into Indiana—Wolf Lake Resort" by Gregory H. Monberg, and "Usonia in Indiana" by Frank N. Owings, Jr.

3258. Stoller, Ezra and Jeff Goldberg. *Guggenheim New York. Guggenheim Bilbao*. Princeton Architectural Press, 1999. Mostly photographs by Stoller.

3259. Stoller, Ezra and Neil Levine. *Frank Lloyd Wright's Fallingwater*. Princeton Architectural Press, 1999. Mostly photographs by Stoller.

3260. Stoller, Ezra and Neil Levine. *Frank Lloyd Wright's Taliesin West*. Princeton Architectural Press, 1999. Mostly photographs by Stoller.

3261. Stungo, Naomi. *Frank Lloyd Wright*. London: Carlton, 1999.

3262. Thomson, Iain. *Frank Lloyd Wright: a visual encyclopedia*. London: PRC, 1999. Reprinted 2000.

3263. Tinniswood, Adrian. *The arts and crafts house*. London: Mitchell Beazley; New York: Watson-Guptill, 1999. Includes chapters on Hollyhock and Storer houses.

3264. Turner, Paul Venable, Paul Robert Hanna and Jean Shuman Hanna. *Frank Lloyd Wright's Hanna house restored*. Stanford: Hanna House Board of Governers, 1999.

3265. Wei, Kuan-Chu. *Frank Lloyd Wright: orientalism in his thought and its historical sources* [microform]. Ann Arbor: University Microfilms International, 1999. PhD thesis, University of Michigan, 1996.

3266. Wright, David K. *Frank Lloyd Wright: visionary architect*. Springfield: Enslow, 1999. Juvenile biography.

Periodicals

3267. Adam, Hubertus. "Frank Lloyd Wright in Hollywood." *Bauwelt*, 90(22 January 1999), 148. Hollyhock and Ennis-Brown houses.

3268. Anderson, Kent and Kenneth Marantz. "Video viewing." *School Arts*, 99(November 1999), 62. Reviews videotape set, "Frank Lloyd Wright: the masterpieces", produced by Facet Multimedia.

3269. Bellmore, Audra. "A 25-year legacy." *Wright Angles*, 25(May-July 1999), 3-6. Silver jubilee of the Frank Lloyd Wright Home and Studio Foundation.

3270. Bey, Lee. "Frank Lloyd Wright is everywhere." *Illinois Issues*, 25(October 1999), 32.

3271. Birksted, January. "Thinking through architecture." *Journal of Architecture*, 4(Spring 1999), 55-64. Fallingwater.

3272. Bischoff, Judith J., Amy Meyer and Noelle Weidemer. "Color and materials analysis of original plaster finishes in the George Barton House, Buffalo, New York." *Bulletin: the Quarterly Newsletter of the Frank Lloyd Wright Building Conservancy*, 8(Summer 1999), 12-15.

3273. Brown, Bay. "Wright in pink prole threat." *World Architecture*, (July-August 1999), 50.

3274. Bruno, Stefano. "L'architettura, bioclimatica oggi: un metodo antico di progettazione nel 2000." *L'Architettura*, 45(September 1999), vi-vii. Italian: "Ecological architecture today: an ancient design method approaching 2000." Fallingwater.

3275. Charlton, Jim. "A life: a personal recollection" *Journal of the Taliesin Fellows*, (Spring 1999), 16-17. Charlton was a former Wright apprentice.

3276. Cleary, Richard Louis. "Frank Lloyd Wright and the Kaufmanns of Pittsburgh." *Frank Lloyd Wright Quarterly*, 10(Spring 1999), 4-23.

3277. Cleary, Richard Louis. "The Kaufmanns, Wright, and good design." *Friends of Fallingwater Newsletter*, (August 1999).

3278. Cohen, Jean Louis, "Monuments pour un culte de masse: le Solomon R. Guggenheim Museum et le Centre Georges Pompidou." *Cahiers du Musee National d'Art Moderne*, (Spring 1999), 4-29. French: "Monuments for a mass culture: Guggenheim Museum and the Pompidou Center."

3279. Conway, James. "Conserving Fallingwater's landscape." *Friends of Fallingwater Newsletter*, (January 1999), 1-7.

3280. Cusack, Victor A. "Jim Charlton, 1919-1998 [obituary]." *Journal of the Taliesin Fellows*, (Spring 1999), 15-16.

3281. Dana, Karine. "Les plafonds techniques." *Moniteur Architecture AMC*, (April 1999), 84-101. French: "Ceiling techniques." Morris Gift Shop.

3282. Drew, Nancy. "Goods." *Garden Design*, 18(February 1999), 47.

3283. Ebeling, Ashlea and Joshua Levine. "Un-private houses." *Forbes*, 164(11 October 1999), 442.

3284. Erickson, Don. ""Mo, don— don't do it!": a personal recollection by Don Erickson." *Journal of the Taliesin Fellows*, (Spring 1999), 4-6. See also "Don Erickson: the work," 7-10.

3285. Filler, Martin. "Lives of the modern architects." *New Republic*, (21 June 1991). Considers *An autobiography*; and *Frank Lloyd Wright: his life and his architecture* by Robert C. Twombly.

3286. Flint, Sunshine. "Wow!" *Popular Photography*. 63(March 1999), 72-73. Photographer Farrel Grehan image of Wright's study.

3287. Fogarty, Kate Hensler et al. "[Special issue]. The low-budget issue." *Interiors*, 158(April 1999), 42-73. Taliesin West

3288. Gaillard, Julie-Caroline. "La pierre au contemporain." *Techniques et Architecture*, (April 1999), 36-39. French: "Contemporary use of stone"; English summary. Fallingwater.

3289. G.M.E. "Landmark library faces fund shortfall." *American Libraries*, 30(May 1999), 21. Marin County Civic Center.

3290. Goldberger, Paul. "Frank Lloyd Wright and the roots of Prairie Style." *Garden Design*, 18(October 1999), 76-83.

3291. Goodwin, George M. "Frank Lloyd Wright's Usonian Houses for Jewish clients." *American Jewish Archives Journal*, 51(January -February 1999), 67-92.

3292. Gosling, David. "The restoration of the Cedric G. and Patricia Neils Boulter house." *Bulletin: the Quarterly Newsletter of the Frank Lloyd Wright Building Conservancy*, 8(Summer 1999), p.7-8.

3293. Grant, Elaine X. "Royal Treatment." *Travel Agent*, (22 February 1999). Imperial Hotel.

3294. Greco, JoAnn and Katrina Brown. "Your hotel room." *Travel Holiday*, 182(February 1999), 18. Arizona-Biltmore Hotel.

3295. Gregory, Stephanie. "Raising Wright." *Metropolis*, 19(November 1999), 67. A 1934 bridge design by Wright intended for Broadacre City.

3296. Grehan, Farrel. "The house that grew." *Architecture New Zealand*, (March-April 1999), 94-95. Grand Waikapu Country Club.

3297. Guh, T. Jeff. "Structural stabilization of the Samuel Freeman House, Los Angeles, (Hollywood), California." *Bulletin: the Quarterly Newsletter of the Frank Lloyd Wright Building Conservancy*, 8(Summer 1999), 1-2.

3298. Hladik, Murielle. "Antonin Raymond." *Japan Architect*, (Spring 1999), the issue. Raymond was Wright's assistant on the Imperial Hotel. See also *L'Architecture d'Aujourd'hui*, (May 1999), 6.

3299. Helms, Carol. "Prairie style comes home." *Garden Design*, 18(October 1999), 84-87. Reproductions of Wright furniture and furnishings.

3300. Herbert, Wray. "Wright's Fallingwater is slowly falling down." *U.S. News and World Report*, 126(3 May 1999), 54.

3301. Kahn, Eve M. "Caped crusader." *Art News*, 98 (May 1999), 152.

3302. Kahn, Eve M. "The Wright client." *Interiors*, 158(April 1999), 17. Fallingwater.

3303. Kessler, Brad. "A peace [*sic*] of wood." *Metropolitan Home*, 31(April 1999), 150.

3304. Kipling, Kay. "The master builder." *Sarasota Magazine*, 21(February 1999), 54-58. Notice of forthcomimg Wright exhibition, Van Wezel Performing Arts Hall, Sarasota.

3305. Krisch, Ruediger. "Wingspread und Fallingwater—zur Sanierung zweier Haeuser von Frank Lloyd Wright." *Detail*, 39(no.7, 1999), 1253-56. German: "Wingspread and Fallingwater—the rehabilitation of two Wright houses."

3306. Krohe, James Jr. "Wright had it right." *Planning*, 65(December 1999), 16-17. Broadacre City.

3307. Lang, G. "Biography of a building." *Oklahoma Today*, 49(July 1999), 32. H.C. Price tower.

3308. Larson, Soren. "New plans for Fallingwater could save an icon from disaster." *Architectural Record*, 187(May 1999), 97.

3309. Lewis, Julia Einspruch. "Wright this way." *Interior Design*, 70(January 1999), 35. Reports Frank Lloyd Wright Home and Studio Foundation's plans for restoring the Robie House.

3310. Martin, Paul and Jayne Wise. "Home is where the art is." *National Geographic Traveler*, 16(May-June 1999), 9-11. Dana-Thomas house.

3311. Masello, David. "Doing things Wright." *Art and Antiques*, 22(March 1999), 80-81. Usonian houses.

3312. McKee, Bradford. "Fallingwater receives 901,000 US dollar grant." *Architecture*, 88(November 1999), 33.

3313. Nemtin, Frances. "Trees for Taliesin." *Journal of the Taliesin Fellows*, (Spring 1999), 3. Restoration of landscape at Taliesin.

3314. Northrup, Dale. "The Prairie Style of Frank Lloyd Wright in Michigan." *Style 1900*, 12(Summer-Autumn 1999), 54-59. George and Walter Gerts cottages, Meyer May house.

3315. Novitski, Barbara Jo. "Digital visions: buildings never built." *Architectural Record*, 187(June 1999), 106-108; 110.

3316. O'Connor, Michael J. "Wright library to close." *Architecture*, 88(May 1999), 40. Marin County Civic Center. But see Michael Rogers, "Marin County keeping main open," *Library Journal*, 124(1 May 1999), 15.

3317. Pfeiffer, Bruce Brooks et al. [Special issue. Frank Lloyd Wright in Arizona]. *Frank Lloyd Wright Quarterly*, 10(Autumn 1999), 4-23. Includes "The lure of the desert" by Pfeiffer; "Frank Lloyd Wright's designs for Arizona [chronological list 1928-1959]"; and "A new architecture on a new land: Taliesin West, an interpretation" by Anthony Puttnam.

3318. Pfeiffer, Bruce Brooks. "Frank Lloyd Wright and the sea." *Frank Lloyd Wright Quarterly*, 10(Winter 1999), 4-15.

3319. Pillow, Joyce and Sara-Ann Briggs. "New nomination—the George and Clifton Lewis House (1952)." *Bulletin: the Quarterly Newsletter of the Frank Lloyd Wright Building Conservancy*, 8(Autumn 1999), 1-2.

3320. Polony, Sylvain. "Architectures organiques." *L'Architecture d'Aujourd'hui*, (May 1999), 102-105. French and English: "Organic architectures."

3321. Polson, Mary Ellen. "Glorious kitchens!" *Old-house Journal*, 27(March-April 1999), 50-55. Irving house.

3322. Rosenblum, Charles. "Precedent and principle: the Pennsylvania architecture of Peter Berndtson and Cornelia Brierly." *Frank Lloyd Wright Quarterly*, 10(Spring 1999), 12-15. Previews an exhibition, Associated Artists Gallery, Pittsburgh, June-July 1999.

3323. Saatchi, Doris Lockhart. "Praising Arizona." *Blueprint*, (April 1999), 48-52. Taliesin West.

3324. Satler, Gail. "The architecture of Frank Lloyd Wright: a global view." *Journal of Architectural Education*, 53(September 1999), 15-24.

3325. Sidy, Victor. "Fringe benefits." *Interiors*, 158(April 1999), 60-65. Taliesin West.

3326. Sorge, Marjorie "Ford sets new design goals." *Automotive Industries* (February 1999)." Cf. Norman Martin, "It's Wright For Cadillac," *ibid.*, (September 1999). Fallingwater.

3327. Spiselman, Anne. "Exhibit explores Frank Lloyd Wright's Indiana works." *Crain's Chicago Business*, 22(19 July 1999), 32. "Frank Lloyd Wright and colleagues: Indiana works" exhibit, John G. Blank Center for the Arts, Michigan City. Andrew Armstrong house.

3328. Tattershall, Doug. "Living a Wright existence." *American Bungalow*, (Winter 1999), 44-48. Zeigler house.

3329. Welsh, Frank Sagendorph. "Frank Lloyd Wright's use of wax at Wingspread for clear finishes and paints." *The Microscope*, 47(June 1999), 29.

3330. Wiederspahn, Michael. "(Kein) Lift ins Utopische? Der Vertikaltransport als architektonische Herausforderung. Tl.1." *Baukultur* (no. 5, 1999), 28-31. German: "(No) elevator in utopia? Vertical transportation as architectural challenge. Pt 1."

3331. Woodhull, John R. "Rethinking the importance of Robie house." *Wright Angles*, 25(August-October 1999), 3-6.

3332. *Architects' Journal*. "The Wright stuff." 210(26 August 1999), 11. Florida Southern College.

3333. *Architectural Digest*. "Extraordinary properties on the market." 56(November 1999), 186-191. Isabel Roberts house.

3334. *Architectural Record*. "Just ducky." 187(May 1999), 112. Midway Gardens.

3335. *Architectural Record*. "Trouble at Taliesin." 187(April 1999), 62. Taliesin Preservation Commission is in default of a state loan.

3336. *Architectural Record*. "Wright again." 187(January 1999), 55. Robie house restoration.

3337. *Civil Engineering*. "Restoration to strengthen cantilevers at Fallingwater." 69(May 1999), 28. Cf. "Post-tensioning to settle tensions over Fallingwater," *ENR*, 242(19 April 1999), 20.

3338. *Communications News*. "Fiber optic cable a solid foundation." (March 1999). Fallingwater.

3339. *Domus*. "Lake Tahoe Summer colony, California (1923)." (February 1999), 83. Image only.

3340. *ENR*. "Frank Lloyd Wright's bridge design is great ... but late." 242(15 March 1999), 120. East span of San Francisco-Oakland Bay Bridge. See also Zahid Sardar, "Burning bridges," *Architecture*, 88(April 1999), 27; and Adam Mornement, "Bridge has the Wright stuff ... but Wright may have been wrong," *World Architecture*, (May 1999), 24-25.

3341. *Frank Lloyd Wright Quarterly*. "Graycliff update." 10(Spring 1999), 27.

3342. *Frank Lloyd Wright Quarterly*. "Nature of the site." 10(Winter 1999), 3.

3343. *Frank Lloyd Wright Quarterly*. "The quest for the best." 10(Summer 1999), 3-25. Overview of buildings most often cited as Wright's best. Cf. "Getty Grant aids Fallingwater's preservation," *Friends of Fallingwater Newsletter*, (January 1999), 8.

3344. *Frank Lloyd Wright Quarterly.* "Taliesin apprentices: seven decades of organic architecture." 10(Spring 1999), 18-19. Previews exhibition of the work of Taliesin Fellowship, A.I.A. galleries, Pittsburgh, June-July 1999.

3345. *Interior Design.* "Natural Wright of passion," 70(May 1999), 130, 146. F.S. Schumacher's third Wright textile collection. Cf. "In the showrooms," *Architectural Digest*, 56(August 1999), 168: and Danine Alati, "Collector's items," *Contract Design*, 42(January 2000), 18.

3346. *I.D.* "Frank Lloyd Wright." 46(June 1999), 83.

3347. *Modernism Magazine.* "'Peacock chair', 1921-22, for the Imperial Hotel, Tokyo." 1(Winter 1999), 14. Image only.

3348. *National Geographic Traveler.* "Trips." 16(1999), 114.

3349. *New Internationalist.* "Whitest parliament." (19 June 1999). Broadacre City.

3350. *Old-house Interiors.* "Seminal treasure." 5(Spring 1999), 122. Dana house.

3351. *PCI Journal.* "Monona Terrace Community and Convention Center, Madison, Wisconsin." 44(September-October 1999), 140-43.

3352. *PR Newswire.* "Frank Lloyd Wright furniture growing more popular." (24 June 1999).

3353. *PR Newswire.* "Publisher launches campaign to help match federal grant to save Taliesin." (24 May 1999). Taliesin.

3354. *Professional Builder And Remodeler.* "Wright Stuff." 64(December 1999), 8.

3355. *Sculpture Review.* "Taliesin school of architecture." 48(Winter 1999), 23.

3356. *Wright Angles.* "Questions of restoration" 5(February-April 1999), 3-6. Conference to review draft of *Master plan for restoration and adaptive use of the Frederick C. Robie house* (14 November 1998).

After 2000

2000
Books, monographs and catalogues
3357. Bonfilio, Paul. *Fallingwater: the architectural model.* New York: Rizzoli, 2000.

3358. Casey, Dennis J. *Art glass details: Frank Lloyd Wright's Hollyhock house.* Brisbane: Prairie Designs of California, 2000.

3359. Ehrlich, Doreen. *Frank Lloyd Wright glass.* Philadelphia: Running Press, 2000. Also published as *Frank Lloyd Wright at a glance: glass*, London: PRC, 2001.

3360. Frank, Isabelle ed. *The theory of decorative art: an anthology of European and American writings, 1750-1940.* New Haven; London: Yale University Press, 2000. Published for The Bard Graduate Center for Studies in the Decorative Arts. Includes "The art and craft of the machine" (1901) by Wright.

3361. Heinz, Thomas A. *Frank Lloyd Wright's stained glass and lightscreens.* Salt Lake City: Gibbs Smith, 2000. Mostly images.

3362. Heinz, Thomas A. *The visions of Frank Lloyd Wright.* Edison: Chartwell, 2000. Mostly images.

3363. Hoffmann, Donald. *Frank Lloyd Wright's house on Kentuck Knob.* Pittsburgh: University of Pittsburgh Press, 2000.

3364. Langmead, Donald and Donald Leslie Johnson. *Architectural excursions. Frank Lloyd Wright, Holland and Europe.* Westport: Greenwood, 2000. Presents evidence of Wright's role in the development of European architecture in the 1920s, largely through the propaganda of Dutch architects, and H.Th Wijdeveld's catalytic role in founding the Taliesin Fellowship.

3365. Loeffelholz, Stephen Calvert ed. *Woodworking plans for a Hillside table lamp: inspired by the work of Frank Lloyd Wright.* Benton: Cottonwood Hill Publishing, 2000. See companion volumes, *idem., Woodworking plans for a mile high Usonian lamp* and *Woodworking plans for an Oak Park lamp.*

3366. Maddex, Diane. *Frank Lloyd Wright's house beautiful.* New York: Morrow, William and Co., 2000. Reviewed Mike May, "Wright again," *Pittsburgh Magazine,* 32(January 2001), 16.

3367. Marcoux, Suzanne and Joan Brown. *The Marin Civic Center and Frank Lloyd Wright docents' manual.* San Rafael: County of Marin, n.d. [2000?]

3368. Menocal, Narciso G. et al. *Fallingwater and Pittsburgh.* Carbondale: Southern Illinois University Press, 2000. Also includes "Frank Lloyd Wright and the projects for Pittsburgh" by Richard Louis Cleary; "Beyond Fallingwater" by Edgar J. Kaufmann; "The temporal dimension of Fallingwater" by Neil Levine; and "A beat of the rhythmic clock of nature: Frank Lloyd Wright's waterfall buildings" by Kathryn Smith.

3369. Nemtin, Frances. *Frank Lloyd Wright and Taliesin.* Rohnert Park; Maldon: Pomegranate, 2000.

3370. Platounoff, Igor George et al. *Histoires brèves: ressouvenances, récits / I.G. Platounoff, Frank Lloyd Wright, Le Corbusier, Olivier Meurice.* Brussels: Piga, 2000. French: *Brief histories:*

3371. Rattenbury, John. *A living architecture: Frank Lloyd Wright and Taliesin Architects.* San Francisco: Pomegranate, 2000

3372. Schevill, James Erwin. *New and selected poems.* Athens, OH: Swallow Press; Ohio University Press, 2000. Includes "Frank Lloyd Wright desperately designing a chair".

3373. Thomson, Iain. *Frank Lloyd Wright: a visual encyclopedia.* San Diego: Thunder Bay Press, 2000. Also published in paperback, New York: Collins and Brown, 2001.

3374. Walker, Martin. *America reborn: a twentieth-century narrative in twenty-six lives.* New York: Knopf; Random House, 2000. Includes "Frank Lloyd Wright and the American space."

3375. Walters, Thomas. *The arts: a comparative approach to the arts of painting, sculpture, architecture, music, and drama.* Lanham: University Press of America, 2000. There is a chapter, "Organic architecture: Frank Lloyd Wright."

3376. Wickes, Molly ed. *A guide to Oak Park's Frank Lloyd Wright and Prairie School historic district.* Chicago University Press, 2000.

3377. Yamaguchi, Yumi. *Teikoku Hoteru Raitokan no nazo.* Tokyo: Shueisha, 2000. Japanese. Imperial Hotel.

Periodicals

3378. Barreneche, Raul A. "Open house: a brief guide to some of the world's most famous accessible residences." *Metropolitan Home*, 32(July-August 2000), 54-58. Fallingwater (i.a.).

3379. Bendheim, Fred A. "Visions of Spain." *Lancet*, 356(18 November 2000), 1775-76. Compares Wright's Guggenheim museum with Gehry's, Bilbao, Spain.

3380. Berndtson, Indira. "Remembering Frank Lloyd Wright." *Frank Lloyd Wright Quarterly*, 11(Spring 2000), 4-25. Recollections of former apprentices and clients, deposited in oral history library, Taliesin West archives.

3381. Bishop, Carol. "An artist looks at Frank Lloyd Wright: dialogues on the Romantic Spirit." *Wright Angles*, 26(May-July 2000), 3-6.

3382. Briggs, Sara-Ann and Barbara Broach. "Rosenbaum house restoration begins." *Bulletin: the Quarterly Newsletter of the Frank Lloyd Wright Building Conservancy*, 10(Spring 2000), 16-17.

3383. Briggs, Sara-Ann. "American Systems Built home discovered—more are under investigation." *Bulletin: the Quarterly Newsletter of the Frank Lloyd Wright Building Conservancy*, 10(Fall 2000), 1.

3384. Briggs, Sara-Ann. "Preservation priority program: Wynant House removed from [endangered] list—saved by not-for-profit group." *Bulletin: the Quarterly Newsletter of the Frank Lloyd Wright Building Conservancy* 2000, 10(Winter 2000), 1. See also *idem.*, "Wynant House fate uncertain," *ibid.*, 7(Spring 1998), 1.

3385. Briggs, Sara-Ann. "Wright's west coast field office dismantled." *Bulletin: the Quarterly Newsletter of the Frank Lloyd Wright Building Conservancy*, 10(Fall 2000), 17.

3386. Burns, Robert. "Forum on the arts [Wright]." *National Forum*, 80(Summer 2000), 8-9.

3387. Cash, Stephanie."New Guggenheim plan for NYC." *Art in America*, 88(June 2000), 144. Guggenheim Museum, SoHo, New York City..

3388. Chanchani, Samiran. "Between icon and institution: the vacillating significance of Frank Lloyd Wright's Guggenheim Museum." *Journal of Architecture*, 5(Summer 2000), 159-88.

3389. Chenoweth, R. "Wright hand?" *American Heritage*, 51(July-August 2000), 10. Marion Mahony.

3390. Cook, Jeffrey. "Due case nel deserto: confronto fra risposte al clima." *Arca*, (May 2000), supp. 21-20. Italian and English: "Two desert houses: comparing climatic responses." Boomer house.

3391. Croft, Catherine. "Mending the modern: preserving the recent past 2." *Architects' Journal*, 212(2 November 2000), 58-59. Keynote speech at a

conference on modern building conservation, Philadelphia, October 2000, dealt with preservation of three Wright houses.

3392. Czarnecki, John E. and Tom Connors. "Preserving Wright's and Richardson's Chicago-area icons." *Architectural Record*, 188(October 2000), 46. Glessner, Robie houses.

3393. Dattomi, A. "Frank Lloyd Wright. Wingspread, consolidamento delle strutture lignee dell'edificio." *L'Edilizia*, 14(no. 5-6, 2000), 34-36. Italian: "Frank Lloyd Wright. Wingspread, consolidation of the timber structure."

3394. Eisenberg, Marilyn. "Taliesin Architects designs affordable housing for the new millennium." *Frank Lloyd Wright Quarterly*, 11(Winter 2000), 24-25. Wright's 1911-1916 American Systems Ready-Cut houses. See also Alan Farnham, "The Wright stuff. Want a home designed by Frank Lloyd Wright himself? No problem." *Forbes*, 167(April 2001), 124-25; and "A Prairie School home companion," *ibid.*, (19 February 2002), 125.

3395. Elwall, Robert. "From the RIBA Photographs Collection. Test tubes; Architect: Frank Lloyd Wright." *RIBA Journal*, 107(June 2000), interiors supplement, 46.

3396. Fell, Derek. "A lifelong obsession in Wales." *Architectural Digest*, 57(December 2000), 136-38. Wright's visit to Plas Brondanw, home of British architect Sir Clough Williams-Ellis.

3397. Fernandez-Galiano, Luis and Martin Filler. "[Special issue]. El siglo Americano." *A. and V. Monografias*, (July-August 2000), 2-115. Spanish and English: "The American century." There are two sections about Wright: "Frank Lloyd Wright— organic virtuosity" and "An American hero."

3398. Fitchett, Sarah. "Drawing on the past: recreating Wright's working environment." *Wright Angles*, 27(August-October 2000), 3-6. Oak Park home and studio.

3399. Garrison, Peter. "The Wright stuff." *Conde Nast Traveler*, (March 2000), 100-103. Reports a tour of Wright buildings.

3400. Harrington, Elaine. "Frank Lloyd Wright and dress reform." *Chicago Architectural Journal*, 9(2000), 136-37.

3401. Heathcote, E. "For the worship of God and the service of man—Frank Lloyd Wright and the Unity Temple" *Church Building*, (September-October, 2000), 21-25.

3402. Hoban, Sarah. "Towns of the Prairie School." *Old-house Journal*, 28(September-October 2000), 129-30,132. Prairie school architecture in three Chicago suburbs.

3403. Irigoyen, Adriana. "Frank Lloyd Wright in Brazil." *Journal of Architecture*, 5(Summer 2000), 137-57. Wright 's October 1931 visit to Rio de Janiero, after serving on the jury of the Pan-American Union of Architects' international

competition for the Columbus Lighthouse, Santo Domingo.

3404. Jiménez, Víctor. "Controversia; Le Corbusier, Frank Lloyd Wright y la Ciudad Universitaria [México]." *Arquine: revista internacional de arquitectura*, (Summer 2000), 7-10. Spanish: "Controversy: Le Corbusier, Frank Lloyd Wright and the Autonomous National University of Mexico."

3405. Kahn, David. "Innovation within limits: how is it possible? A summary of the proceedings." *NAMTA Journal*, 25(Spring 2000), 209-30. Notes on a seminar sponsored by the North American Montessori Teachers' Association and Taliesin West discuss Wright's pedagogical practices. See also Mary B. Verschuur, "A participant's perspective," *ibid.*, 231-35.

3406. Kauffman, B. "Flashback." *American Enterprise*, 11(January 2000), 59.

3407. Kealing, Bob. "The Dean and Mr Wright." *Florida Magazine* [Orlando Sentinel], 2 July 2000), 12. Florida Southern College.

3408. Kingsbury, Pamela D. "[Curtis Wray] Besinger 1914-1999 [obituary]." *Journal of the Taliesin Fellows*, (Summer 2000), 27.

3409. Knecht, Barbara. "Seismic upgrade for Frank Lloyd Wright's 1937 Hanna House at Stanford University." *Architectural Record*, 188(November 2000), 175-76. The house was damaged in the 1989 Loma Prieta earthquake.

3410. Krohe, James Jr. "Return to Broadacre City." *Illinois Issues*, 26(1 April 2000), 27.

3411. Kruty, Paul Samuel. "Midway gardens: decoration, entertainment, surprise." *Casabella*, 64 (December 2000-January 2001) 22-37, 169-70. Italian and English.

3412. Legler, Dixie. "On the trail of Frank Lloyd Wright." *Better Homes and Gardens*, (1 March 2000). Taliesin West, Arizona Biltmore hotel and Marin County Civic Center.

3413. Lewis, Julia Einspruch. "Respecting Mr. Wright." *Interior Design*, 71(July 2000), 100-102. Ronald Bricke and Associates' restoration of John L. Rayward house.

3414. Lewis, Julia Einspruch. "Wright time." *Interior Design*, 71(June 2000), 47-48. Commemorates the 50th anniversary of Johnson Wax complex and Reviews *Johnson Wax: the Wright buildings*, a set of three View-Master reels.

3415. Libeskind, Daniel. "Object of desire." *V. and A. Magazine*, (January-April 2000), 11. Discusses Edgar J. Kaufmann's office interior, on permanent display in the Victoria and Albert Museum, London.

3416. Manny, Maya Moran. "Weekend garden: Wright again." *Metropolitan Home*, 32(September 2000), 134. Tomek house.

3417. Mariani, Anthony. "Frank Lloyd Wright organization preserves house."

Architecture, 89(December 2000), 29. Barton J. Westcott house. See also Lori Murray, "Wright here in Springfield," *Ohio Magazine*, 24(June 2001), 122-25.

3418. McCoy, Robert. "The plight of the Park Inn Hotel (1911), Mason City." *Bulletin: the Quarterly Newsletter of the Frank Lloyd Wright Building Conservancy*, 10(Spring 2000), 6-7. The Mason City Foundation plans to restore the building.

3419. McGlynn, Mike. "Wright inspired stools." *Woodworker's Journal*, 24(June 2000), 32-38. Instructions for making "Wright-inspired" furniture.

3420. Mizukami, Y. "[The concept of the "within" in Frank Lloyd Wright's architectural thought through an analysis of his latter three books]." *Journal of Architecture Planning and Environmental Engineering*, (no. 533, 2000), 251-58. Japanese.

3421. Napier, A. Kam. "Doing it Wright." *Honolulu*, 35(December 2000), 56. Pence house.

3422. Nerdinger, Winfried. "Erfinden, erschauen oder erarbeiten. Positionen des architektonischen Entwerfens." *Thesis, Wissenschaftliche Zeitschrift der Bauhaus Universitaet Weimar*, 45(no.2, 2000), 28-34. German: "Invention, visualisation or elaboration. Aspects of architectural design."

3423. Nolan, M. Therese. "The editor's desk." *Antiques and Collecting*, 105(September 2000) 4. Oak Park houses.

3424. Paik, Felicia. "House of the week." *Wall Street Journal (eastern edition)*, 235(12 May 2000), W14. Boulter house.

3425. Penfield, Paul. "Paul Penfield repairs the roof of the Penfield house." *Bulletin: the Quarterly Newsletter of the Frank Lloyd Wright Building Conservancy*, 10(Winter 2000), 14-15.

3426. Pickrel, Debra. "Conservancy delegation visits Japan to promote preservation." *Bulletin: the Quarterly Newsletter of the Frank Lloyd Wright Building Conservancy*, 10(Spring 2000), 1-5.

3427. Plestina, Lenko. "Razgradnja kutije obiteljske kuce." *Prostor*, 8(January-June 2000), 55-78. Serbo-Croat: "Destruction of a family house box"; English summary.

3428. Podmolik, Mary Ellen. "Riverside cottages to city towers." *Crain's Chicago Business*, 23(8 May 2000), 68. Reports "Wright around Riverside—Prairie Architecture and Landscape" tour. Coonley house.

3429. Raimondi, Julie A. "Map of the stars." *Contract*, 42(March 2000), 58-59. Hollyhock house.

3430. Reed, O.P. "Eugene 'Gene' Masselink." *Journal of the Taliesin Fellows*, (Summer 2000), 1-11. Masselink was Wright's secretary.

3431. Restany, Pierre. "The museum that took over the world." *Domus*, (December 2000), 126-29. Guggenheim Museum.

3432. Richmond, Deborah. "Frank Lloyd Wright: le Johnson Wax Administration Building et la Research Tower, 1932-1939." *Moniteur Architecture AMC*, (April 2000), 78-83. French: "Wright: [buildings for S.C. Johnson and Son]."

3433. Risdal-Barnes, Michele M. "La maison sur la cascade, Pennsylvanie 1999." *Monumental*, (June 2000), 212-19. French: "[Fallingwater] 1999"; English summary.

3434. Rosenblum, Charles. "Holding up Fallingwater: Wright's drooping terraces will get a permanent fix." *Preservation*, 52(July-August 2000), 21-22. See also Robert Silman, "The plan to save Fallingwater," *Scientific American*, 283(September 2000), 88-95; Boris Weintraub, "Face-lift for Fallingwater," *National Geographic*, 197(January 2000), 1; and *Art News*, 99(October 2000), 66-67. Cf. "Frank Lloyd Wrong?" *Economist*, 362(16 March 2002), 37.

3435. Schulze, Franz. "With friends like Wright" *Preservation*, 52 (November-December 2000), 8. Wright and Mies van der Rohe.

3436. Sheets, Hilarie M. "Cosmic appraisal." *Interior Design*, 47(November 2000), 72-79. Feng Shui analysis of Fallingwater (i.a.).

3437. Smith, Kathryn. "Frank Lloyd Wright in a changing world." *Frank Lloyd Wright Quarterly*, 11(Winter 2000), [4]-23.

3438. Spirn, Anne Whiston. "Frank Lloyd Wright: architect of landscape." *Frank Lloyd Wright Quarterly*, 11(Summer 2000), 4-25 and 11(Fall 2000), 4-25. Part 1: Taliesin; Part 2: Taliesin West.

3439. Stockton, Sharon. "Engineering power: Hoover, Rand, Pound, and the heroic architect." *American Literature*, 72(December 2000), 813-41.

3440. Szarkowski, John. *The idea of Louis Sullivan*. London; New York: Thames and Hudson. 2000. Mostly images, with an initial portfolio approved by Wright.

3441. Tait, Allison. "Everything you need to know about Frank Lloyd Wright." *Australian House and Garden*, 103(May 2000), 45 ff.

3442. Thiel, David. "Quadralinear posts." *Popular Woodworking*, 20(December 2000), 72-76. Design for Wrightesque hall tree.

3443. Thompson, John. "Postcard ... from Arizona and Mexico City." *Landscape Design*, (September 2000), 8-9. Taliesin West.

3444. Trulsson, Nora Burba. "Cool desert digs." *Sunset*, 204(February 2000), 54-55. Taliesin West.

3445. Webb, Michael. "LA houses: building on a modernist tradition" *A + U*, (May 2000), 4-9. Japanese and English.

3446. Weinstein, Norman. "Kentuck Knob: Frank Lloyd Wright's grand Usonian." *Modernism Magazine*, 3(Spring 2000), 42-48.

3447. Weishan, Michael. "Save our countryside." *Country Living*, 23(November 2000), 26-28. Taliesin.

3448. Welsh, Frank Sagendorph. "Frank Lloyd Wright's use of wax at Wingspread." *Bulletin: the Quarterly Newsletter of the Frank Lloyd Wright Building Conservancy*, 10(Winter 2000), 15-18.

3449. Wright, Frank Lloyd and Mark Dundas Wood. "Wright on stage." *American Theatre*, 17(September 2000), 30-31. Discusses plays about Wright; and reprints an excerpt from his essay, "The new theatre" (1949).

3450. Zimmermann, Gerd. "Neue Welt. Architektur und die Utopien der Globalisierung." *Thesis, Wissenschaftliche Zeitschrift der Bauhaus Universitaet Weimar*, 45(no. 4-5, 2000), 8-14. German: "New world. Architecture and the utopias of globalization."

3451. *A+U*. "Frank Lloyd Wright: Robie house, Chicago, Illinois, USA, 1910." (March 2000), 34-45. Japanese and English.

3452. *American Libraries.* "Collections." 31(April 2000) 26. Notes on Wright memorabilia stored in Oak Park Library, Illinois.

3453. *Art News.* "National news." 99(December 2000), 70. Frank Lloyd Wright Building Conservancy.

3454. *Business Week.* "Within their wildest dreams." (21 August 2000), 154-57. Mile-High skyscraper project.

3455. *Economist.* "Elizabeth Gordon." 356(30 September 2000), 93. Obituary for the *House Beautiful* editor, Wright's god-daughter.

3456. *Editor and Publisher.* "Technology. *Daily Herald* draws on legacy of Frank Lloyd Wright" 133(November 2000), 41-42.

3457. *Interior Design.* "Wright underfoot." 71(July 2000), 212. Notes new carpets manufactured by Patterson, Flynn and Martin, based on Wright designs.

3458. *Penn in Ink.* [Acquisition by University of Pennsylvania of drawings of Publicker house]. (September 2000), 10.

3459. *School Arts*, 100(December 2000), 62. Reviews the 1993 videotape "Frank Lloyd Wright Drawings", narrated by Bruce Brooks Pfeiffer. See also Candace Smith, *Booklist*, 97(1 February 2001), 1060; and *Arts and Activities*, 129(March 2001), 22-23.

3460. *Wall Street Journal (eastern edition)*, "Comment: preservation." 235(30 March 2000), 28. Pennsylvania Governor Ridge's efforts to restore Fallingwater.

3461. *Wright Angles.* "An interview with Eric Lloyd Wright [Wright's grandson]." 26(February-April 2000), 3-6. See also John R. Hall, "Eric Lloyd Wright:

following in the family footsteps," *Air Conditioning Heating and Refrigeration News*, 213(no. 6, 2001), 18.

2001
Books, monographs and catalogues

3462. Carmel-Arthur, Judith and Abby Moor. *Frank Lloyd Wright at a glance: interiors.* Philadelphia: Courage Books, 2001.

3463. Fleming, Diane Bresnan. *Simply Wright: a journey into the ideas of Frank Lloyd Wright's architecture.* Madison: Castleconal Press, 2001.

3464. Fowler, Penny. *Frank Lloyd Wright: graphic artist.* San Francisco: Pomegranate, 2001.

3465. Gottlieb, Lois Davidson. *A way of life: an apprenticeship with Frank Lloyd Wright.* Mulgrave [Australia]: Images Group, 2001.

3466. Howard, Hugh, Richard Straus and Roger Straus III. *Wright for Wright.* New York: Rizzoli, 2001.

3467. Knight, Caroline. *Essential Frank Lloyd Wright.* New York: Barnes and Noble, 2001.

3468. Le Coultre, Martijn F., Ellen Lupton and Alston W. Purvis. *Wendingen: a journal of the arts, 1918-1932.* Princeton Architectural Press, 2001.

3469. Maddex, Diane. *Fifty favorite furnishings by Frank Lloyd Wright.* New York: Harry N. Abrams, 2001. Mostly images. See also *idem.*, *Fifty favorite houses by Frank Lloyd Wright*, London: Thames and Hudson; New York: Harry N. Abrams, 2001.

3470. Maddex, Diane. *Frank Lloyd Wright inside and out.* New York: Barnes and Noble; London: Pavilion, 2001. Mostly images.

3471. Middleton, Haydn. *Frank Lloyd Wright.* Chicago: Heinemann, 2001. Juvenile biography; reviewed Julie E. Darnall, *School Library Journal*, 48(March 2002), 255-56.

3472. Meech [-Pekarik], Julia. *Frank Lloyd Wright and the art of Japan: the architect's other passion.* New York: Japan Society; Harry N. Abrams, 2001. Catalogue of an exhibition at the Society's Manhattan gallery, March-July 2001.
 The show is previewed Martha Schwendener and David Rimanelli, *Artforum International*, 39(January 2001), 36-47; cf. "Exhibition on Wright and Japan," *Architectural Record*, 189(March 2001), 42.
 For review and comment see Margo Stipe, "The inspiration of nature," *Orientations*, 32(March 2001), 120-25; Eve M. Kahn, "Yen at work," *Interiors*, 160(March 2001), 33; Joseph Giovannini, *New York*, 34 (16 April 2001), 73; "Exhibiting Wright," *Architectural Record*, 189(May 2001), 54; *New Yorker*, 77(21 May 2001), 101; Betty Y. Siffert, "Frank Lloyd Wright and Japanese prints: inspiration on display," *Wright Angles*, 27(May-July 2001), 3-7; David D'Arcy, *Art and Auction*, 23(June 2001), 90-92; S. E. Canning, "Jacqueline's

Picassos at Hammer," *Art Newspaper*, 12(July-August 2001), 80; Gavin Keeney, "Frank Lloyd Wright and 'Japonisme'," *Oculus*, 63(Summer 2001), 15; Charles Ruas, *Art News*, 100(Summer 2001), 172; Jean-Louis Cohen, "Avant l'explosion: cinq expositions americaines [Before the explosion: five American exhibitions]," *Moniteur Architecture AMC*, (October 2001), 48-50 (French); Gabriel P. Weisberg, *Burlington Magazine*, 143(November 2001), 706-707 and Martin Filler, *NYT Book Review*, 151(2 December 2001), 42.

See also Meech, "Frank Lloyd Wright and the art of Japan," *Arts of Asia*, 31(February 2001), 54-65, an essay adapted from the catalogue.

3473. Reisley, Roland and John Timpane. *Usonia, New York: building a community with Frank Lloyd Wright.* Princeton Architectural Press, 2001. Reviewed David R. Conn, *Library Journal*, 126(1 January 2001), 94.

3474. Pfeiffer, Bruce Brooks and Robert Wojtowicz eds. *Frank Lloyd Wright and Lewis Mumford: thirty years of correspondence.* Princeton: Architectural Press, 2001. Reviewed Charlotte Abbott et al., *Publishers Weekly*, 248(5 November 2001), 59-62; Tom Vanderbilt, *NYT Book Review*, 151(2 December 2001), 76; and Richard E. Nicholls, *Preservation*, 54(January-February 2002), 75-77, 87.

3475. Sloan, Julie L. and David Gilson de Long, *Light Screens: the leaded glass of Frank Lloyd Wright*, New York: Rizzoli, 2001. Published in connection with a traveling exhibition, first mounted at the American Craft Museum, New York, May-September 2001. It moved to Grand Rapids Art Museum, October 2001-January 2002; Allentown Art Museum, February-April 2002; Atlanta High Museum of Art, June-September 2002; Orange County Museum of Art, October 2002-January 2003; and Renwick Gallery, Washington, D.C., March-July 2003.

For comment and review see Christopher Bonanos and Edith Newhall, "Windows to the soul," *New York*, 34(14 May 2001), 92; Eve M. Kahn, "Getting the lead out," *Interiors*, 160(May 2001), 56; "Master glass," *American Heritage*, 52(May 2001), 13; *Museum News*, 80(May-June 2001), 21; Jen Renzi, "Wright bright," *Interior Design*, 72(June 2001), 68; and Stanley Abercrombie, *Interior Design*, 72(November 2001), 108.

See also Sloan, Frank Lloyd Wright, and Anne H. Hoy. *Light screens: the complete leaded glass windows of Frank Lloyd Wright.* New York: Rizzoli, 2001; and Sloan, "Frank Lloyd Wright's light screens: the influence of Japan," *Antiques*, 159(April 2001), 628-35.

3476. Thomson, Iain, Keith Finch and Andrew Crowson. *Frank Lloyd Wright in pop-up.* San Diego: Advantage, 2001.

3477. Webb, Michael and Roger Straus III. *Modernism reborn: mid-century American houses.* New York: Universe, 2001. Includes Kentuck Knob.

3478. Weil, Zarine ed. *Building a legacy: the restoration of Frank Lloyd Wright's Oak Park home and studio.* San Francisco: Pomegranate, 2001. Reviewed *Interior Design*, 72(July 2001), 150-51; Andrew Wormer, *Fine Homebuilding*, (October-November 2001), 138.

3479. Zung, Thomas T.K. *Buckminster Fuller: anthology for the new millennium.* New York: St. Martin's Press, 2001. Reprints "Frank Lloyd Wright and *Nine chains to the moon,*" (*Saturday Review of Literature,* 32(17 September 1938), 14-15.

3480. *Frank Lloyd Wright a ceska architektura.* n.l.: Obecni dum, 2001. Czechoslovakian: *Wright and his architecture.*

Periodicals

3481. Bedrossian, Rebecca and Mark Eastman. "Materials." *Communication Arts,* 42(January-February 2001), 162-64. Frank Lloyd Wright Exhibition font.

3482. Berwick, Carly. "Getting it Wright." *Travel and Leisure,* 31(August 2001), 43. Nakoma resort and spa.

3483. Boyd, Virginia T. "Designs for everyone: Wright in the popular press." *Wright Angles,* 27(February-April 2001), 3-7, cover.

3484. Bredahl, Brenda Kramer. "Frank Lloyd Wright's Wisconsin home." *World War II,* 17(May 2002), 28. Taliesin.

3485. Bussel, Abby. "Westchester Rocks." *Interior Design,* 72(September 2001), 280-83.

3486. Coupland, Ken. "Screen space." *Metropolis,* 20(June 2001), 170 ff. Reviews Frank Lloyd Wright Building Conservancy website.

3487. Deboard, Donn R. and Doris Lee. "Using an architectural metaphor for information design in hypertext." *Journal of Educational Media,* 26(March 2001), 49-63.

3488. Dulio, Roberto. "Frank Lloyd Wright [book review] " *Domus,* (January 2001), 9-11.

3489. Goldberger, Paul. "How the legendary designers of the past inspire the best designs of today." *Architectural Digest,* 58(January 2001), 121.

3490. Goldman, Peggy. "An architectural adventure." *School Arts,* 100(April 2001), 34. Describes how elementary school students designed an addition to their school, incorporating Wright's ideas.

3491. Gray, Kevin. "Modern gothic." *NYT Magazine,* (23 September 2001), 80-83. Fallingwater.

3492. Green, Aaron G. "Organic architecture: the principles of Frank Lloyd Wright." *Frank Lloyd Wright Quarterly,* 12(Winter 2001), 4-19.

3493. Hall, Michael. [Wright in Oak Park]. *Country Life,* 195(travel guide supplement, 2001), 32-37.

3494. Haruhiko, Fujita. "Notomi Kaijiro: an industrial art pioneer and the first design educator of modern Japan." *Design Issues,* 17(Spring 2001), 17-32. Wright's visit to Haruhiko's school, Kagawa Kenritsu Kogei.

3495. Heba, G. "Particle physics, Frank Lloyd Wright and Feng Shui: a walking tour through spatial web design." *Annual Conference, Society for Technical Communication*, 48(2001), 193-98.

3496. Kahn, Eve M. "Schindler's gist: Museum of Contemporary Art, Los Angeles." *Interiors*, 160(February 2001). Reviews exhibition, "R.M. Schindler: an architecture of invention and intuition" at the museum, February-June 2001, that covers Schindler's time in Wright's office. The show moved to the National Building Museum, Washington, D.C. until mid-October, then went to Vienna. For review and comment see Juan Coll-Barreu, *Arquitectura Viva*, (January-February 2001), 67-69 (Spanish); Michael Webb, "Lo shock di Schindler," *Domus*, (April 2001), 25-29 (Italian and English); Raymund Ryan, "Seminal Schindler," *Architectural Review*, 209(June 2001), 22-23; Joseph Giovannini, "Modern master,"*Architecture*, 90(July 2001), 49-51, 102; "Expo Schindler en el MOCA," *Arquine*, (Summer 2001), 14 (Spanish); Judith Sheine, "The 'space architecture' of R.M. Schindler," *Blueprints*, 19(Summer 2001), 2-5; and Margaret Crawford, "Why Schindler? Why now?" *ibid.*, 6-7, 11.

3497. Knecht, Barbara. "An innovative approach leads to a solution for the Unity Temple's crumbling exterior." *Architectural Record*, 189(April 2001), 173. See also "Temple undoomed. Frank Lloyd Wright's Unity Temple to be restored," *Building Design and Construction*, 42(January 2001), 9.

3498. Libby, Brian. "Frank Lloyd Wright's only Oregon house saved, dismantled, and moved." *Architectural Record*, 189(April 2001), 34. Gordon house.

3499. Martin, Howard. "Fame + Frank Lloyd Wright." *Architectural Design*, 71(November 2001), 90-94. Part of *AD Profile 154*, "Fame and architecture."

3500. McCarroll, Christina. "Wright's path: kids' blocks to buildings." *Christian Science Monitor*, 93(28 November 2001), 11.

3501. McCarter, Robert. "Frank Lloyd Wright and the nature of concrete." *Ptah*, (no. 1, 2001), 3-19.

3502. McCray, Carole. "Wright house, right setting." *Christian Science Monitor*, 93(28 November 2001), 11. Kentuck Knob.

3503. McGlynn, Mike. "Robie house chair." *Woodworker's Journal*, 25(May-June 2001), 49-55.

3504. Moncrieff, Elspeth. "Horsing around at Waddington and Christie's." *Art Newspaper*, 12(July-August 2001), 76. Notes an exhibition of Wright carpets.

3505. Reed, Danielle. "Wright's Sunday house." *Wall Street Journal (eastern edition)*, 238(10 August 2001), w12. Robert H. Sunday house II.

3506. Sebesta, Judith A. "Spectacular failure: Frank Lloyd Wright's Midway Gardens and Chicago entertainment." *Theatre Journal*, 53(May 2001), 291-310.

3507. Spencer, Brian A. "La natura di Frank Lloyd Wright." *L'Arca*, (April 2001), Ecoenea supplement, 8-15. Italian and English: "The nature of Wright."

3508. Sullivan, Pat. "The dragon at Gold Mountain." *Golf Magazine*, 43(May 2001), 78-79. Golf course designed by Wright.

3509. Sweeney, Karen. "Q and A on the Robie House restoration [interview]." *Wright Angles*, 27(May-July 2001), 9.

3510. Vesa, Marita. "The poem's space—poetry of space? Reflections on the relationship between architecture and lyricism." *Ptah*, (no. 2, 2001), 15-23. Analogies between the work of Wright, poet Eeva-Liisa Manner and architect Tadao Ando.

3511. Weiss, Norman et al. "Fallingwater (pt. 1): materials-conservation efforts at Frank Lloyd Wright's masterpiece." *APT Bulletin*, 32(no. 4, 2001), 44-55.

3512. *A + U.* "Picturing the home." (June 2001), 11-122. Fallingwater (i.a.).

3513. *Conde Nast Traveler.* "Room with a view." 36(March 2001), 222. Seth Peterson cottage.

3514. *Frank Lloyd Wright Quarterly.* "Price Tower 45th anniversary celebration and fundraising campaign announced." 12(Winter 2001), 28. Project to convert building to a museum.

3515. *Frank Lloyd Wright Quarterly.* "Foundation receives major gift to restore the Wrights' private rooms." 12(Winter 2001), 20-27. Taliesin West.

3516. *Frank Lloyd Wright Quarterly.* "Hillside: where the past and future meet." 12(Spring 2001), 4-21.

3517. *Interiors and Sources.* "Wright's design kept alive." 8(June 2001), 123. Restoration of buildings. See also Kenneth Powell and Susan Dawson, "The Wright spirit," *Architects' Journal*, 214(22 November 2001), 24-33.

3518. *Sunset.* "The sprite is Wright." (March 2001). Wright designed a series of garden sprites for Midway Gardens.

2002
Books, monographs and catalogues.
3519. Aguar, Charles and Berdeana Aguar. *Wrightscapes: Frank Lloyd Wright's landscape designs.* New York: McGraw-Hill, 2002.

3520. Egger, E.M. *Frank Lloyd Wright field guide: his 100 greatest works.* Philadelphia: Running Press, 2002.

3521. Ehrlich, Doreen. *Early years.* New York: Sterling Publishing, 2002

3522. Heinz, Thomas A. *Frank Lloyd Wright's houses.* New York: Gramercy, 2002. One of a series of slim volumes, mostly images. See also *Frank Lloyd Wright's interiors* and *Frank Lloyd Wright's public building.*

3523. Hintz, Martin and Bob Rashid. *Backroads of Wisconsin: your guide to Wisconsin's most scenic backroads.* Stillwater: Voyageur; Vancouver: Raincoast Books, 2002.

3524. Moor, Abby. *Prairie houses.* New York: Sterling, 2002

3525. Woodin, Larry. *The Gordon house: a moving experience.* Hillsboro: Beyond Words, 2002.

Periodicals

3526. Blackler, Zoe. "Frank Lloyd Wright 'greatest influence' on UK profession." *Architects' Journal*, 215(10 January 2002), 16. Results of a survey of UK architects.

3527. Sowa, Axel. "Frank Lloyd Wright in Japan: Yamamura residence, Ashiya, Kobe (1918)." *L'Architecture d'Aujourd'hui*, (January-February 2002), 112-17. French and English.

3528. Whitlock, Stephen. "On the Wright track." *Travel and Leisure*, 32(January 2002), 22. Announces the Frank Lloyd Wright tour: Pittsburgh; Nemacolin Woodlands resort and spa; Fallingwater; Kentuck Knob.

3529. *Architectural Review.* "Southern College, Florida." 211(March 2002), supp. 30-37. John McAslan and Partners remodeling of the Polk County Science Center (1938-1958), at Florida Southern College.

Index of Works

This index refers only to the buildings and projects mentioned in "dedicated" entries in the bibliography. Of course, there are many general works on Wright that refer to larger partsof his extensive oeuvre; they are not indexed here. For a fuller list of buildings and projects, see the chronology at the beginning of this volume.

After a short time (1886-1887) in the Chicago office of architect Joseph Lyman Silsbee, Wright moved to the larger firm of Dankmar Adler and Louis Sullivan, before commencing his own practice in 1893. Buildings and projects undertaken while in the latter's employ are marked with an asterisk *. Unrealized projects appear in *italics*.

A.C. McAfee house, Lake Michigan Chicago, Illinois (1894), 033

A.D. Barton house, Downer's Grove, Illinois (1955), 1481, 2895

A.D. German warehouse, 300 South Church St., Richland Center, Wisconsin (1915; incomplete), 1716, 1855, 1912

A.D. German warehouse, Richland Center, Wisconsin (1934; conversion to warehouse and apartments), 855

A.W. Gridley house and barn, 605 North Batavia Ave., Geneva, Illinois (1906; barn dem.), 1463

*Abraham Lincoln Center, Oakwood Bvd. and Langley Ave.,Chicago, Illinois (*1900, *with Dwight Heald Perkins;* some sources give 1901), 024, 046, 2445

Adelman laundry for Benjamin Adelman, Milwaukee, Wisconsin (1945), 543

Aizaku Hayashi house, Komazawa, Tokyo, Japan (1917; remodeling), 1347, 1653

Albert Sullivan house, 4575 Lake Ave., Chicago, Illinois (1892; dem. 1970), 069

Alice Millard house, La Miniatura, 645 Prospect Crescent, Pasadena, California (1923), 152, 172, 190, 195, 365, 1012, 1885, 2159, 2386, 2780, 2976

Aline Barnsdall house, Hollyhock, and garage, 4808 Hollywood Bvd., Los Angeles, California (1920), 144, 1270, 1429, 1433, 1444, 1435, 1625, 1633, 1671, 1821, 2026,

2257, 2366, 2386, 2466, 2469, 2473, 2491, 2492, 2522, 2599, 2601, 2743, 2794, 3016, 3147, 3238, 3263, 3267, 3358, 3429

Aline Devin house, Eliot, Maine (1906), 033

Aline Devin house, Lake Michigan, Chicago, Illinois (1896), 033

All Souls Building, Oakwood Bvd. and Langley Ave., Chicago, Illinois (1897, with Dwight Heald Perkins), 030, 033

All steel houses, Los Angeles, California (1937), 1903

Allison W. Harlan house, 4414 Greenwood Ave., Chicago, Illinois (1892; dem. 1963), 019, 1367

American Systems Ready-Cut houses (prototypes} for Richards Co., Milwaukee, Wisconsin (1911), 113, 128, 1802, 2060, 2358, 2654, 2761, 2981, 3379, 3389

Amusement park for Warren McArthur, Wolf Lake, near Chicago, Illinois (1895), 452, 3257

Anderton Court shopping center, 332 North Rodeo Drive, Beverley Hills, California. (1952; some sources give 1953), 1429, 2688

Andrew F.H. Armstrong house, Cedar Trail, Ogden Dunes, Indiana (1939), 3327

Annunciation Greek Orthodox Church, 9400 West Congress St., Wauwatosa, Wisconsin (1956), 796, 799, 836, 895, 1044, 1059, 1389, 1585, 1977, 3050

Apartments for Edward C. Waller, 253-257 Francisco Ave., Chicago, Illinois (1895; dem. 1974), 049, 3022

Apartments for Edward C. Waller, 2840-2858 West Walnut St., Chicago, Illinois (1895; partially dem.), 3022

Arch Oboler house, Eaglefeather, Malibu, California (1940), 879

Arch Oboler studio retreat, 32436 West Mulholland Highway, Malibu, California (1941), 2766

Arch Oboler studio, Los Angeles, Califonia (1946), 2766

Archie Boyd Teater studio-residence, Old Hagerman Highway, Bliss, Idaho (1952; some sources give 1955), 2068

Arizona Biltmore Hotel, East Sahuaro Drive, Phoenix, Arizona (1927, with Albert McArthur), 163, 200, 201, 238, 419, 459, 567, 1425, 1446, 1495, 1500, 1556, 1682, 1744, 2172, 2517, 3012, 3180, 3294, 3412

Arnold Jackson house, Skyview, 7655 Indian Hills Trail, Beaver Dam, Wisconsin. (1956; some sources give 1957), 1956, 2293, 3023

Arthur Heurtley house, 318 Forest Ave., Oak Park, Illinois (1902), 071, 1268, 1463, 2288, 2601, 2659, 3181

Arthur Munkwitz Duplex apartments (4), 1102-1112 North 27th St., Milwaukee, Wisconsin (1916; dem.), 1396

Arthur Pieper house, 6642 East Cheney Rd., Paradise Valley, Arizona (1952), 2970

Arthur Stevens house, Park Ridge, Illinois (1950), 2601

ArthurMiller house, Roxbury, Connecticut (1957), 1941, 3121. Later adapted for Grand Waikapu Country Club, Wailuku, Maui, Hawaii.

Auldbrass Plantation buildings for Leigh Stevens, 7 River Rd., Yemassee, South Carolina (1938; some sources give 1940), 543, 1486, 1768, 2452, 2479, 2574, 2640

Automobile and aircraft filling station, Michigan City, Indiana (1932), 3254

Avery Coonley house and coachhouse, 300 Scottswood Rd., Riverside, Illinois (1907; some sources give 1908), 088, 145, 281, 781, 852, 1258, 1417, 1463, 1483, 1496, 1499, 1589, 1649, 1661, 1694, 1768, 2086, 2116, 2288, 2294, 2367, 2601, 2639, 2859, 3015, 3131, 3252, 3428

B. Harley Bradley house and stables, Glenlloyd, 701 South Harrison Ave., Kankakee, Illinois (1900), 046, 1463, 1768

Banff National Park railroad. station, Alberta, Canada (1911), 1789, 2073, 3106

Banff National Park recreation building, Alberta, Canada (1911; with Francis W. Sullivan; dem. 1938; some sources give 1913), 1789, 2073, 3106

Barnsdall Park municipal gallery, Olive Hill, Los Angeles, California (1954; sources give 1957), 719, 1070, 2469, 2491, 2935

Barton J. Westcott house, 1340 East High St., Springfield, Ohio (1904; some sources give 1907), 3417

Benjamin, Broad Margin, 5710 North 30th St., Phoenix, Arizona. (1951; some sources give 1953), 624, 2185, 2438, 3192

Bernard Schwartz house, 3425 Adams Sweet, Two Rivers, Wisconsin (1939), 1504, 2384

Beth Sholom Synagogue, Old York Rd., Elkins Park, Pennsylvania (1954), 731, 797, 836, 895, 906, 1043, 1109, 1424, 1503, 1787, 2601, 3050, 3178

Bitter Root Inn, Stevensville, Montana (1908; some sources give 1909; destroyed by fire 1924), 085, 1774, 2089

Bitter Root town master plan I and II for BitterRoot Irrigation Co., Stevensville, Montana (1909), 085, 1774, 2089

Blythe-Markley City National Bank and Hotel Law Office, 5 West State St., Mason City, Iowa (1908; some sources give 1909, 1910 or 1911; law offices dem.), 089, 1253, 1336, 3418

Boomer-Pauson house, Phoenix, Arizona (1947), 755, 1504, 3386

Bramlett motel, Memphis, Tennessee (1956), 895

Bramson Dress shop, Oak Park, Illinois (1912), 345

Broadacre city model and exhibition plans (1934), 242, 267, 288, 295, 405, 611, 638, 639, 640, 872, 1075, 1081, 1094, 1546, 1596, 1599, 1700, 1725, 1741, 1743, 1793, 1851, 2029, 2060, 2166, 2215, 2370, 2408, 2425, 2458, 2503, 2521, 2645, 2718, 2728, 2817, 2868, 2928, 2932, 2937, 3217, 3295, 3306, 3349, 3410

Browne's Bookstore, Fine Arts Building, 410 South Michigan Ave., Chicago, Illinois (1908; dem.), 2647

Butterfly Bridge over the Wisconsin River, Spring Green, Wisconsin (1947), 543

Capital Journal *newspaper building for George Putnam , Salem, Oregon (1931)*, 1268, 2974

Carl Schultz house, 2704 Highland Court, St. Joseph, Michigan (1957; some sources give 1958), 900

Carlton D. Wall house, Snowflake, 12305 Beck Rd., Plymouth, Michigan (1941), 994, 1504, 2384

Carroll Alsop House, 1907 A Ave. East, Oskaloosa, Iowa (1947; some sources give 1948), 1090

Cedric G. Boulter house, 1 Rawson Woods Circle, Cincinatti, Ohio (1954; addition 1958), 3292, 3424

Charles Ennis house, 2607 Glendower Rd., Los Angeles, California (1923; some sources give 1924), 190, 281, 1429, 1463, 1615, 1885, 2147, 2266, 2386, 2618, 3050, 3267

Charles Weltzheimer house, 127 Woodhave Drive, Oberlin, Ohio (1948; some sources give 1950), 617, 1398, 2385, 2884

Chauncey Griggs house, 7800 John Dower St. Southwest, Tacoma, Washington (1946), 2973, 2975

Christian Science church I and II, Bolinas, California (1955; some sources give 1956 or 1957), 836, 895, 998

Claremont Hotel wedding chapel I and II, Berkeley, California (1957), 849, 921

Cloverleaf, Pittsfield housing for the Federal Works Agency (1940; some sources give 1942), 543, 1268, 1332, 2731, 2889

Como Orchards Summer Colony, Darby, Montana (1908; mostly dem.; some sources give 1909 or 1910), 085, 1349, 1774, 1765, 2089

Conrad Edward Gordon house, 303 S.W. Gordon Lane, Aurora, Oregon (1956; some sources give 1957; mostly dem.), 3179, 3498, 3525

Cooperative berm-type homesteads for Detroit auto workers, Detroit, Michigan (1941), 444, 1879

Crystal Heights hotel, shops and theaters, Connecticut and Florida Aves., Washington, D.C. (1939; some sources give 1940), 407

Curtis Meyer house, 11108 Hawthorne Drive, Galesburg Village, Michigan. (1948; completed 1951), 994

Darwin D. Martin gardener's cottage, 285 Woodward Ave., Buffalo, New York (1905), 2016

Darwin D. Martin house and ancillary buildings, 125 Jewett Parkway, Buffalo, New York (1904; garage and conservatory dem.), 062, 144, 281, 501, 506, 1239, 1251, 1264, 1314, 1320, 1337, 1627, 1650, 1768, 1835, 1936, 2016, 2047, 2101, 2233, 2280, 2281, 2282, 2288, 2357, 2715, 3049, 3095, 3251

Darwin D. Martin house and garage, Graycliff, Lakeshore, Derby, New York (1927), 3176, 3341

David Wright guest house, Phoenix, Arizona (1954), 684, 699, 704, 810, 2386, 2601

David Wright house, 5212 East Exeter Rd., Phoenix, Arizona (1950; some sources give 1952), 684, 699, 704, 810, 2386, 2601

Department store, Tokyo, Japan (1921), 1653

Desert complex and shrine for A. M. Johnson, Death Valley, California (1921; some sources give 1922, others 1923 or 1924), 2674

Development plan and public buildings for Greater Baghdad, Iraq (1957), 851, 885, 1044, 1592, 1664, 3230

Don M. Stromquist house, 1151 East North Canyon Rd., Bountiful, Utah (1958), 2601

Donald Lovness house, 10121 83rd St. North, Stillwater, Minnesota (1954; some sources give 1955), 1782, 1887

E. Arthur Davenport house, 550 Ashland Ave., River Forest, Illinois (1901), 1463

E. W. Cummings real estate office, Harlem Ave. and Lake St., River Forest, Illinois (1905; some sources give 1907; dem.), 929

E.A. Smith house, Piedmont Pines, California (1938; some sources give 1939), 994, 1504, 2004

Edgar J. Kaufmann house, Fallingwater, Bear Run, Pennsylvania. (1935; some sources give 1936), 317, 335, 339, 341, 342, 345, 353, 354, 356, 357, 362, 449, 471, 509, 559, 640, 829, 852, 1012, 1080, 1086, 1092, 1101, 1112, 1122, 1133, 1311, 1481, 1504, 1521, 1563, 1574, 1579, 1666, 1693, 1713, 1979, 2012, 2024, 2028, 2040, 2093, 2102, 2103, 2122, 2123, 2145, 2193, 2218, 2223, 2226, 2244, 2249, 2251, 2256, 2264, 2268, 2289a, 2310, 2318, 2361, 2362, 2422, 2461, 2501, 2546, 2575, 2583, 2601, 2650, 2651, 2657, 2710, 2725, 2729, 2730, 2755, 2803, 2839, 2853, 2856, 2860, 2902, 2903, 2904, 2911, 2939, 2948, 2953, 2958, 2972, 3025, 3050, 3058, 3061, 3063, 3092, 3099, 3119, 3132, 3136, 3182, 3239, 3259, 3271, 3274, 3279, 3288, 3300, 3302, 3305, 3308, 3312, 3326, 3337, 3338, 3343, 3357, 3368, 3378, 3433, 3434, 3436, 3460, 3491, 3511, 3512, 3528

Edgar J. Kaufmann office, First National Bank Building, Pittsburgh, Pennsylvania (reconstructed in Victoria and Albert Museum, London) (1936; some sources give 1937 or 1938), 345, 1453, 2038, 2615, 2625, 3415

Edward C. Waller house, River Forest , Illinois (1898), 033

Edward E. Boynton house, 16 East Bvd., Rochester, New York (1908), 1264, 1489, 1578, 2557, 2601

Edward P. Irving house, 2 Millikin Place, Decatur, Illinois (1909; some sources give 1910), 102, 1463, 1988, 3252

Edward R. Hills house, 313 Forest Ave., Oak Park, Illinois (remodeling) (Sources vary widely as to date: 1900-1906), 665, 1514

Edwin H. Cheney house, 520 North East Ave., Oak Park, Illinois (1903; some sources give 1904), 1463

Eiga cinema, Ginza, Japan (1918), 1635, 1653

Elizabeth Arden Desert Spa, Phoenix, Arizona (1945; some sources give 1947), 543

Emil Bach house, Chicago, Illinois (1915), 1303, 1534

Emma Martin house (additions to Fricke house) and new garage, 540 Fair Oaks Ave., Oak Park, Illinois (1907), 054, 1463

Erdman prefab #1, Madison, Wisconsin (1956), 886, 901, 909, 2060, 2292, 2295, 3021

Eric V. Brown house, 2806 Taliesin Drive, Kalamazoo, Michigan (1949), 706

Ernest Vosburgh house, 46208 Crescent Rd., Grand Beach, Michigan

Eugene A. Gilmore house, Airplane House, 120 Ely Place, Madison, Wisconsin (1908), 1463, 2293, 2483

Eugene Van Tamelen house, 5817 Anchorage Rd., Madison, Wisconsin (1956), 812

Exhibition building for Frank Lloyd Wright architectural exhibit; contiguous with Holly-

hock house Los Angeles California (now a gallery for the Municipal Art Center of Los Angeles) (1956), 719, 739, 2132

Exhibition USA (1930; design for The Show), 223, 226, 229, 2088

E-Z Polish factory for W.E. and D.D. Martin, 3005-3017 West Carroll Ave., Chicago, Illinois (1905), 926

F.B. Henderson house, 301 South Kenilworth Ave., Elmhurst, Illinois (1901), 046

Ferdinand F. Tomek house, 150 Nuttall Rd., Riverside, Illinois (1904; some sources give 1907; gardener's cottage, 1911), 1676, 1877, 2828, 3416

Fireproof house for $5,000 for Ladies' Home Journal *(1906)*, 067

First National Bank for Frank L. Smith II, 122 West Main St., Dwight, Illinois (1905; some sources give 1906), 2688

First Unitarian Society meeting house, 900 University Bay Drive, Shorewood Hills, Wisconsin (1946; some sources give 1947 or 1951), 543, 610, 642, 647, 2293, 2601, 3021

Florida Southern College, Lakeland, Florida (1938-1952; for dates of individual buildings, see chronology), 350, 434, 519, 543, 563, 600, 620, 624, 634, 651, 700, 750, 765, 806, 895, 915, 1503, 1602, 1608, 1909, 1971, 2306, 2314, 2393, 2454, 2504, 2603, 2617, 2620, 2662, 2672, 2680, 2696, 2844, 2845, 3083, 3332, 3407, 3529

Four houses for Robert W. Roloson, 3213-3219 Calumet Ave., Chicago, Illinois (1894), 1268, 1595

Fox River Country Club for George Fabyan, Geneva, Illinois (1907; remodeling; destroyed by fire ca. 1912), 2897

Francis Apartments for Terre Haute Trust Company, 4304 Forestville Ave., Chicago, Illinois (1895; dem. 1971), 031, 049, 1202

Francis W. Little house I, Peoria, Illinois (1900), 064

Francis W. Little house II, Wayzata, Minnesota (1902; realized 1908*)*, 064, 1389, 1408, 1411, 1418, 1438, 1463, 1478, 1561, 1720, 1768, 1817, 1895, 2213, 2613

Frank A. Rentz house, Madison, Wisconsin (1939; some sources give 1940), 2293

Frank J. Baker house, 507 Lake Ave., Wilmette, Illinois (1909), 093

Frank Lloyd Wright apartment, Hotel Plaza, New York (1954; remodeling; dem.1968), 1824, 2798

Frank Lloyd Wright home and studio, 428 Forest Ave., Oak Park, Illinois (1889; additions and alterations followed at intervals), 018, 029, 046, 145, 1255, 1326, 1351, 1402, 1463, 1686, 1705a, 2646, 3398, 3478

Frank Lloyd Wright house-studio, Viale Verdi, Fiesole, Italy (1910), 1763, 2467, 2798

Frank S. Sander house, Springbough, 121 Woodchuck Rd., Stamford, Connecticut. (1952; some sources give 1955), 1042, 3413

Frank Wright Thomas house, The Harem, 210 Forest Ave., Oak Park, Illinois (1901), 046

Frederick C. Bogk house, 2420 North Terrace Ave., Milwaukee, Wisconsin (1916), 1463, 1629, 2288, 2601, 2961, 3252

Frederick C. Robie house, 5757 Woodlawn Ave., Chicago, Illinois (1908; some sources give 1909), 119, 132, 145, 281, 628, 829, 837, 844, 852, 853, 858, 880, 1115, 1135, 1136, 1164, 1171, 1178, 1200, 1236, 1243, 1255, 1304, 1376, 1463, 1483, 1689, 1700,

1795, 1847, 1968, 2059, 2078, 2129, 2288, 2367, 2532, 2601, 2656, 2735, 2892, 2913, 3050, 3079, 3084, 3100, 3219, 3252, 3309, 3331, 3336, 3356, 3392, 3451, 3503, 3509

G.C. Stockman house, 311 First St. Southeast, Mason City, Iowa (1908), 1253, 2432, 2626

G.M. Hoffman house, Winnetka, Illinois (1954), 1504, 1523, 2872

Gabrielle Austin house, 9 West Avondale Drive, Greenville, South Carolina (1951), 900

George Ablin house, 2460 Country Club Drive, Bakersfield, California (1958), 1065

George and Clifton Lewis house, 3117 Okeeheepkee Rd., Tallahassee, Florida (1952), 3319

George Barton house, 118 Summit Ave., Buffalo, New York (1903), 506, 1481, 2895, 3272

George Blossom garage, 4858 Kenwood Ave., Chicago, Illinois. (1900; some sources give 1906 or 1907), 452

George C. Stewart house, Butterfly Woods, 196 Hot Springs Rd., Montecito, California (1909), 1095, 1237

George D. Sturges house, 449 Skyeway Drive, Brentwood Heights, California (1939), 409, 1255, 1429, 1504, 1968, 2384, 2804

George E. Gerts double cottage, Bridge Cottage, Whitehall, Michigan (1902; mostly dem.), 3314

George Fabyan house, 1511 Batavia Rd., near Geneva, Illinois (1907; remodeling), 2897, 3211

George Furbeck house, 223 North Euclid Ave., Oak Park, Illinois (1897), 032

George Madison Millard house, 410 Lake Ave., Highland Park, Illinois (1906), 190

George Parker garage, Jamesville, Wisconsin (1937), 345

Gerald B. Tonkens house, 6980 Knoll Rd., Amberly Village, Ohio (1954), 2386, 2601

Gerald Loeb pergola house, Redding, Connecticut *(1944)*, 463, 513, 586

Glass house, Opus 497 for Ladies Home Journal (1944; some sources give 1945), 465

Glencoe railroad. station I and II, art gallery and railroad station for Sherman Booth, Glencoe, Illinois (1909; some sources give 1911), 2671

Goetsch-Winkler house, 2410 Hulett Rd., Okemos, Michigan (1939), 994, 2334, 2370, 2384, 2447

Goetsch-Winkler house II, Okemos, Michigan (1949), 2447

Golden Beacon apartment tower for Charles Glore, Chicago, Illinois (1956), 1897, 2196

Grady Gammage Memorial Auditorium, Arizona State University, Apache Bvd., Tempe, Arizona (1959; completed posthumously), 969, 1065, 1087, 1119, 1141, 1160, 1169, 1350, 1664, 2322, 3072

Gregor Affleck house I, 1925 North Woodward Ave., Bloomfield Hills, Michigan (1940; some sources give 1941), 496, 994, 1504, 1593, 1700, 2290, 2322

H.C. Price Company tower, Bartlesville, Oklahoma (1952; some sources give 1953-1956), 684, 697, 715, 736, 779, 780, 1012, 1768, 1773, 1836, 2229, 2500, 2601, 2910, 3206, 3307, 3514

H.C. Hoult house, Wichita, Kansas (1936), 2475

H.J. Ullman house, North Euclid Ave. and Erie St., Oak Park, Illinois (1904), 064, 078, 281, 302

Harold C. Price Sr. house, Grandma house, 7211 North Tatum, Paradise Valley, Arizona (1954; some sources give 1956), 782, 928, 1504, 2248, 2264, 2386, 2601

Harold C. Price, Jr. house, Hillside, Silver Lake Rd., Bartlesville, Oklahoma (1953; some sources give 1956), 782, 1504

Harry F. Corbin Juvenile Cultural Study Center, Building B, University of Wichita, Kansas (1957; some sources give 1958), 893, 1167

Harvey P. Sutton house III, 602 Main St., McCook, Nebraska (1906; some sources give 1907), 1158

Henry J. Allen house, 255 Roosevelt Bvd., Wichita, Kansas. (1915; some sources give 1916 or 1917), 281, 2837

Henry J. Neils house, 2815 Burnham Bvd., Minneapolis, Minnesota (1949; some sources give 1951), 668, 705, 810, 2309

Herbert Fisk Johnson house, Wingspread, 33 East 4 Mile Rd., Wind Point, Racine, Wisconsin (1937; some sources give 1938), 400, 1117, 1255, 1504, 1616, 1707, 1887, 2290, 2298, 2773, 2788, 2952, 3017, 3039, 3050, 3305, 3329, 3393, 3448

Herbert Jacobs house II, Middleton, Wisconsin (1941), 1255, 1504, 1517, 1564, 1719, 2293, 2979

Herbert Jacobs house, 441 Toepfer St., Westmoreland (now Madison), Wisconsin. (1936; some sources give 1937), 345, 624, 1055, 1517, 1564, 1631, 2076, 2293, 2384, 2438, 2601, 2635, 2887, 2979

Herman T. Mossberg house, 1404 Ridgedale Rd., South Bend, Indiana (1946; some sources give 1948 or 1951), 659, 810, 1504, 2290, 2601

Hillside Home school building I for Misses Nell and Jane Lloyd Jones, Helena Valley, Spring Green, Wisconsin (1887, with Silsbee; dem. 1950), 007, 034, 363, 754

Hillside Home School building II for Misses Nell and Jane Lloyd Jones, Hillside, Spring Green, Wisconsin (1901; some sources give 1902), 046, 048, 272, 363, 754, 1255

Home in a prairie town for Ladies' Home Journal *(1900)*, 042, 046, 1209, 1729

Hotel Sherman exhibition, Chicago, Illinois (1956; demounted), 778

House on the mesa, Denver, Colorado (1931), 271, 415, 2608

Howard Anthony house, 1150 Miami Rd., Benton Harbor, Michigan (1948; some sources give 1950 or 1951), 738, 994, 2385

I.N. Hagan house, Kentuck Knob, Ohiopyle Rd., Chalk Hill, Pennsylvania (1954), 896, 1133, 2082, 2385, 2633, 2948, 3014, 3114, 3158, 3175, 3363, 3446, 3463, 3486, 3528

Imperial Hotel , Tokyo, Japan. (1915; some sources give 1917; burned 1919 and dem.; redesigned 1920 and dem. 1968; entrance lobby rebuilt Meiji Village near Nagoya 1976), 118, 124, 130, 131, 134, 135, 136, 137, 138, 140, 141, 144, 261, 306, 319, 468, 472, 503, 968, 1012, 1066, 1129, 1136, 1142, 1168, 1188, 1214, 1233, 1244, 1248, 1256, 1315, 1369, 1410, 1415, 1525, 1528, 1646, 1678, 1683, 1716, 1768, 1864, 1866, 1945, 2021, 2168, 2184, 2236, 2285, 2296, 2601, 2677, 2798, 3011, 3135, 3221, 3293, 3298, 3347, 3377

Ingwald Moe house, Gary, Indiana (1910; some experts challenge the attribution), 2989

Isabel Roberts house, 603 Edgewood Place, River Forest, Illinois (1908), 1463, 3333

Isadore J. Zimmerman house, 201 Myrtle Way, Manchester, New Hampshire (1950; some sources give address as 223 Heather St.), 657, 814, 1504, 2205, 2349, 2385, 2558, 2601, 2836, 3059

Isidore Heller house, 5132 Woodlawn Ave., Chicago, Illinois. (1896; some sources give 1897), 049, 1768, 3166

J. Kibben Ingalls house, 562 Keystone Ave., River Forest, Illinois (1909), 1463

J.G. Melson house, Mason City, Iowa (1908), 1253

J.J. Walser Jr. house, 42 North Central Ave., Chicago, Illinois (1903), 1317

Jack Lamberson house, 511 North Park Ave., Oskaloosa, Iowa (1947; some sources give 1948), 949, 1090

James Charnley house, 1365 North Astor St., Chicago, Illinois* (1891), 010, 011, 049, 452, 1485, 1494, 2217, 2490, 2805, 2914

James Charnley summer house, 507 East Beach Rd., Ocean Springs, Mississippi* (1890), 1405

James L. McAfee house (1894), 033

*Jay E. Roberts house, Seattle, Washington (*1955; some sources give 1956), 2973

Jessie M. and William Adams house, 9326 South Pleasant Ave., Chicago, Illinois (1900), 064, 2465

Jiyu Gakuen Girls' School of the Free Spirit, Tokyo, Japan (1921), 1653, 2459, 2763

John A. Gillin house, 9400 Rockbrook, Dallas, Texas (1950; some sources give 1957-1958), 2681

John Barton cottage, Oak Shelter, *Pine Bluff, Wisconsin (1940),* 2293

John Clarence Pew house, 3650 Mendota Drive, Shorewood Hills, Wisconsin (1938; some sources give 1940), 624, 1255, 1504, 2293, 2384

John E. Christian house, Samara, 1301 Woodland Ave., West Lafayette, Indiana (1954), 1255, 3170

John L. Rayward house, Tirranna, 432 Frog Town Rd., New Canaan, Connecticut (1954; some sources give 1955 or 1956), 3413

John Storer house, 8161 Hollywood Bvd., Hollywood, California (1923), 1429, 1463, 1885, 1929, 2008, 2035, 2160, 2249, 2264, 2386, 2601, 3050, 3200, 3263

Jones (Trinity) Chapel, University of Oklahoma, Norman, Oklahoma (1958). 989, 1554

Jorgine Boomer cottage, 5808 North 30th St., Phoenix, Arizona (1953), 755, 1504, 3390

Joseph Mollica house, 1001 West Jonathon Lane, Bayside, Wisconsin (1956; some sources give 1958 or 1959), 3192

Joseph W. Husser house, 180 Buena Ave., Chicago, Illinois (1899; dem.), 049, 2639

J.R. Zeigler house, 509 Shelby St., Frankfort, Kentucky (1910), 3384

K.C. DeRhodes house, 715 West Washington St., South Bend, Indiana (1906), 060

Kalita Humphreys Theater Center for Paul Baker, 3636 Turtle Creek Bvd., Dallas, Texas (1954; some sources give 1958), 895, 969, 1001, 1009, 1039, 1045, 1061, 1366

Kansas City Community Christian Church, 4601 Main St., Kansas City, Missouri (1940), 413, 435, 2886, 2905

Kaufmann house, Boulder house, Palm Springs, California (1951), 680, 2242

Kehl dance academy house and shops, Madison, Wisconsin (1912), 2293

Kenneth Laurent house, Spring Brook Rd., Rockford, Illinois (1949; some sources give 1951), 1504, 2385, 2601

Key project, hotels, apartments, shops and civic center, Ellis Island, New York (1959), 1948

Lake Geneva Inn for Arthur L. Richards, Lake Geneva, Wisconsin (1911; some sources give 1912; dem. 1971), 097, 1336, 1726, 1964, 2825

Lake Tahoe summer colony, Emerald Bay, Lake Tahoe, California (1922), 152, 824, 2937, 3339

Larkin Company administration building, 680 Seneca St., Buffalo, New York (1903; dem. 1949-1950), 057, 061, 065, 066, 073, 075, 098, 144, 501, 506, 601, 833, 1264, 1344, 1480, 1573, 1586, 1605, 1698, 1768, 1778, 1779, 1825, 1893, 2065, 2254, 2441, 2601, 2817

Larkin Company pavilion, Jamestown Tercentenary exhibition, Sewell Point, Jamestown, Virginia (1907; dem.), 074, 1691

Lawrence Memorial Library interior for Mrs. R.D. Lawrence, Springfield, Illinois (1905), 1920, 2647

Lenkurt Electric Company administration and manufacturing building I, San Mateo, California (1955), 989, 1592

Leo Bramson dress shop, Oak Park, Illinois (1937), 345

Library and museum competition, Milwaukee, Wisconsin (1893), 452

Life *house for a family with a $5000- $6000 a year income. Minneapolis, Minnesota (1938)*, 349

Little Dipper kindergarten for Aline Barnsdall, Olive Hill, Los Angeles, California (1921; some sources give 1922 or 1923; dem.), 129, 345, 2491

Lloyd Burlingham pottery house, El Paso, Texas (1941; two versions were later built: one in Santa Fe, New Mexico; one in Phoenix, Arizona), 1931, 2094

Lloyd Jones family chapel (Unity Chapel), Helena Valley, Spring Green, Wisconsin (1886, with Silsbee), 001, 002

Lloyd Lewis house, 153 Little Saint Mary's Rd., Libertyville, Illinois. (1939; some sources give 1940); 439, 1504, 2384, 3059

Lockridge, McIntyre and Whalen Medical Center, Whitefish, Montana (1958), 998

Louis Penfield house I, 2203 River Rd., Willoughby Hills, Ohio (1952; some sources give 1953 or 1955), 1879, 3425

Louis Sullivan house, servant's cottage and stable, 100 Holcomb Bvd., Ocean Springs, Mississippi* (1890), 017, 046, 052, 1405

Lowell E. Walter house, 2611 Quasqueton Diagonal Bvd., Quasqueton, Iowa (1945), 624, 1504, 2290, 3104

Ludd M. Spivey house, Fort Lauderdale, Florida (1939; some sources give 1940), 2359, 2751

Luxfer Prism Company office building I and II, Chicago, Illinois (1895), 020, 027, 029, 2990

Malcolm M. Willey house, 255 Bedford St. Southeast, Minneapolis, Minnesota (1933; some sources give 1934), 291, 301, 342, 345, 1504, 2854

Marin County Civic Center and Post Office, North San Pedro Rd., San Raphael, California (1957; completed posthumously), 904, 998, 1033, 1058, 1065, 1073, 1088, 1105, 1134, 1145, 1148, 1150, 1165, 1166, 1197, 1221, 1240, 1327, 1365, 1378, 1380, 1397, 1462, 1471, 1492, 1680, 1742, 1810, 2060, 2100, 2279, 2319, 2428, 2601, 3000, 3050, 3155, 3164, 3289, 3316, 3367, 3385, 3412

Martin Pence house I and II, Hilo, Hawaii *(1938; some sources give 1940)*, 1594, 3421

Masieri memorial building, Grand Canal, Venice, Italy (1953), 674, 1358, 1395, 1827, 1919, 2126, 2320, 2622

Maximilian Hoffman automobile showroom, 430 Park Ave., New York City (1954; some sources give 1955), 766, 2984

Maximilian Hoffman house, 58 Island Drive, North Manursing Island, Rye, New York (1954; some sources give 1955), 1504, 1523

Maynard Buehler house, 6 Great Oak Circle, Orinda, California (1948), 3068

Melvyn Maxwell Smith house, 5045 Pon Valley Rd., Bloomfield Hills, Michigan. (1946: some sources give 1951), 2004, 2384

*Memorial to the Soil chapel, Cooksville, Southern Wisconsin (1934;*some sources give 1937), 345

Meyer May house, 450 Madison Ave., S.E. Grand Rapids, Michigan (1908; some sources give 1909), 994, 2066, 2076, 2288, 2601, 3252, 3314

Midway Gardens for Edward C. Waller Jr. and Oscar Friedman, Cottage Grove Ave., Chicago, Illinois (1913; some sources give 1914; dem. 1929), 104, 107, 109, 111, 144, 190, 345, 1052, 1104, 1716, 1768, 1946, 2092, 2524, 2601, 3153, 3334, 3411, 3490, 3506, 3518

*Mile high (*The Illinois*) skyscraper, Chicago, Illinois (1956)*, 778, 799, 819, 1044, 1526, 2099, 2191, 2934, 3454

Misses Nell and Jane Lloyd Jones house II, Helena Valley, Spring Green, Wisconsin (1887), 003, 046, 048, 1255

Model Quarter Section development, Chicago, Illinois (1915), 112

Monolith homes (18) for Thomas P. Hardy, Racine, Wisconsin (1919), 1463

Monolithic concrete bank (1894), 046

Monona Terrace Civic Center II, Madison, Wisconsin (1954; realized 1997), 751, 765, 767, 777, 848, 867, 895, 1023, 1051, 1058, 1210, 1231, 1246, 1261, 1263, 1299, 2293, 2373, 2627, 2734, 2812, 2918, 3094, 3247, 3351

Mrs. Clinton Walker house, Scenic Rd. and Martin St., Carmel, California (1948; some sources give 1949 or 1952), 737, 810, 1504, 2385

Mrs. Thomas H. Gale house, 6 Elizabeth Court, Oak Park, Illinois. (1904; some sources give 1909), 1419, 1463

Municipal boathouse, Lake Mendota, Madison, Wisconsin (1893; dem. 1928), 2293

Nakoma Country Club and Winnebago Camping Ground Indian Memorial, Madison, Wisconsin (1924), 1426, 1963, 2293, 3482

Nathan G. Moore house and stable, 329 Forest Ave., Oak Park, Illinois (1895; rebuilt after fire, 1923), 028, 033, 072, 1619

Nathan G. Moore pergola and pavilion, Oak Park, Illinois (1905), 072

National Life Insurance Company skyscraper for A..M. Johnson, Water Tower Square, Chicago, Illinois (1924), 2791

Neuroseum hospital and clinic for Wisconsin Neurological Foundation , Madison, Wisconsin (1955), 2293

Nicholas P. Daphne Funeral Chapels, San Francisco, California (1945; some sources give 1947 or 1948), 528, 543

Norman Lykes house, 6836 North 36th St., Phoenix, Arizona (1959), 1323, 1504

Oasis for Arizona State capitol, Papago Park, Phoenix, Arizona (1957), 825, 1044

Ocotillo Desert Camp, Salt Range near Chandler, Arizona (1927; dem.; some sources give 1928), 345, 2446, 2798

Odawara Hotel, Nagoya, Japan (1917), 1690

Olive Hill studio residence A for Aline Barnsdall, Hollywood Bvd. and Edgemont St., Los Angeles, California (1920; dem.), 719, 1633, 2491, 2599

Olive Hill studio residence B for Aline Barnsdall, 1645 Vermont Ave., Los Angeles, California (1920; dem.), 719, 1633, 2491, 2599

Oscar B. Balch house, 611 North Kenilworth Ave., Oak Park, Illinois (1911), 1382

Parkwyn Village Housing master plan, Kalamazoo, Michigan. (1947; some sources give 1948), 543, 706

Patrick Kinney house, Tacosa Rd., Amarillo, Texas (1951; some sources give 1952), 1313

Paul and Jean Hanna house, Honeycomb House, 737 Frenchman's Rd., Stanford, California (1936; some sources give 1937), 325, 339, 345, 351, 388, 640, 1114, 1504, 1631, 1638, 1704, 1705, 1764, 2290, 2355, 2569, 2601, 2653, 3013, 3264, 3409

Paul Trier house, 6880 North West Beaver Drive, Des Moines, Iowa (1956; some sources give 1958), 2173

Peter Goan house, 108 South 8th Ave., LaGrange, Illinois. (1893; some sources give 1904), 3081

Phi Gamma Delta fraternity house, University of Wisconsin, Madison, Wisconsin (1924; some sources give 1925), 2293

Pilgrim Congregational church, 2850 Foothill Bvd., Redding, California (1958; completed posthumously), 1047, 1065

Pittsburgh Point Civic Center I, Pittsburgh, Pennsylvania, for Edgar J. Kaufmann (1947), 1106, 1268, 1643, 2629, 3364

Planetarium and automobile objective for Gordon Strong, Sugarloaf Mountain, Maryland (1924; some sources give 1925), 1716, 2937, 2959, 2964

Pope-Leighey house, Woodlawn Plantation, 9000 Richmond Highway, Mount Vernon, Virginia. (1939; some sources give 1940), 535, 1135, 1136, 1156, 1162, 1204, 1223, 1238, 1266, 1301, 1504, 1547, 2017, 2114, 2550, 2573, 2786, 2894, 2957, 2992, 3008, 3061

Quentin Blair house, Greybull Highway, Cody, Wyoming (1952; some sources give 1953), 816

R.W. Lindholm Service Station, Route 45, Cloquet, Minnesota (1956; some sources give 1957 or 1958), 898, 1035, 2688

R.S. Ludington house, Dwight, Illinois (1906), 1995

Ralph Jester house, Palos Verdes, California (1938. Later executed for Arthur and Bruce Brooks Pfeiffer, Scottsdale, Arizona), 1441

Ranch development for Edward H. Doheny, Sierra Madre, California (1921; some sources give 1923), 152, 2937

Randall Fawcett house, 21200 Center Ave., Los Banos, California (1955), 1065

Ray Brandes house, 212th Ave. and 24th St., Issaquah, Washington (1952), 2973

Raymond Carlson house, 1123 West Palo Verde Drive, Phoenix, Arizona (1950), 2270

Restaurant, Yosemite National Park, California (1953; some sources give 1954), 774

Richard Davis house, Woodside, Marion, Indiana (1950; some sources give 1954), 1042

Richard Lloyd Jones house I and II, Westhope, 3700 Birmingham Ave., Tulsa, Oklahoma (1929), 228, 438, 1617, 2386

River Forest Golf Club, Bonnie Brae Ave., River Forest, Illinois (1898, additions 1901; dem.1905), 046

Riverview Terrace restaurant for Willard H. Keland, Route 23, Stevens Point, Spring Green, Wisconsin (1953), 1234, 2687, 2802

Robert Berger house, 259 Redwood Rd., San Anselmo, California (1950; some sources give 1952-1959), 992, 1198

Robert G. Walton house, 417 Hogue Rd., Modesto, California (1957), 1065

Robert H. Sunday house II, Woodfield Rd., Marshalltown, Iowa (1955; some sources give 1958-1959), 3505

Robert Llewellyn Wright house, 7927 Deepwell Drive, Bethesda, Maryland (1952; some sources give 1953 or 1955), 1692, 2385

Robert Lusk house I, Huron, South Dakota (1935; some sources give 1936), 345

Robert M. Lamp cottage, Rocky Roost, Governor's Island, Lake Mendota, Wisconsin ((1893; some sources give 1901; dem.), 2164, 2293

Robert Mueller house, 1 Millikin Pl., Decatur, Illinois (1909), 115

Robert Muirhead house, Rohrsen Rd., Plato Center, Illinois (1950; some sources give 1952), 1728

Robert P. Parker house, 1027 Chicago Ave., Oak Park, Illinois (1892), 1255

Robert Publicker house, Haverford, Pennsylvania (1949; some sources give 1951), 3458

Roger Schwenn house, Verona, Wisconsin (1954), 2293

Rogers Lacy Hotel, Dallas, Texas (1946), 521, 543

Roland Reisley house, 44 Usonia Rd., Pleasantville, New York (1951; some sources give 1954), 2385, 3460

Rollin Furbeck house, 515 Fair Oaks Ave., Oak Park, Illinois. (1890; some sources give 1897 or 1898)*, 032

Romeo and Juliet windmill tower for Misses Nell and Jane Lloyd Jones, Hillside, Spring Green, Wisconsin (1896); 2358, 2493

Rookery Building, 209 South LaSalle St., Chicago, Illinois (1905; remodeling of lobbies and balcony court), 070, 2074, 2247, 2262, 2267, 2389, 2420, 2506, 2647, 3075

Rose and Gertrude Pauson house, Shiprock, Orange Rd., Phoenix, Arizona (1939; some sources give 1940; dem.), 437, 445, 446, 605, 1116

Russell W.M. Kraus house, 120 North Ballas Rd., Kirkwood, Missouri (1951; some sources give 1953), 2385

S.C. Johnson and Son administration building, 1525 Howe St., Racine, Wisconsin (1936), 326, 327, 330, 331, 332, 339, 345, 374, 375, 385, 390, 391, 410, 411, 1302, 1310, 1451, 1768, 1818, 1841, 2916, 3143, 3238, 3414, 3432

S.C. Johnson and Son Company research tower, Racine, Wisconsin (1944), 490, 491, 543, 594, 596, 598, 599, 602, 606, 624, 655, 680, 696, 1053, 1268, 1310, 1938, 2345, 2764, 2916, 3143, 3238, 3414, 3432

Samuel Freeman house, 1962 Glencoe Way, Hollywood, California (1923; some sources give 1924), 152, 190, 1429, 1463, 1885, 1891, 2095, 2275, 2301, 2383, 2744, 3297

San Francisco Bay Bridge, southern crossing (1949), 581, 1378, 2246, 3340

San Francisco Call *newspaper building I and II for Spreckels Estate, Market St., San Francisco, California (1912)*, 2693

San Marcos in the Desert resort for Alexander Chandler, Chandler, Arizona (1927; some sources give 1928), 208, 345, 2937

Sarabhi Calico Mills administration building and store, Ahmenabad, India (1946), 543, 560

Seamour Shavin house, 334 North Crest Rd., Chattanooga, Tennessee (1950; some sources give 1952), 3003

Seth Condon Peterson cottage, Hastings Rd., Lake Delton, Wisconsin (1958), 2357, 2368, 2417, 2732, 2954, 3044, 3109, 3190, 3513

Sherman M. Booth house I, Glencoe, Illinois (1911), 1237, 1716

Sherman M. Booth house II, 265 Silvan Rd., Glencoe, Illinois (1915), 1716

Sigma Chi fraternity house, Hanover, Indiana (1940), 2819

"Sixty Years of Living Architecture" exhibition (1950; dem.), 243, 668, 671, 719, 778, 803

"Sixty Years of Living Architecture" pavilion, Los Angeles (1953; dismantled), 719

Small house with lots of room in it for Ladies' Home Journal *(1900)*, 043, 046, 1211

Sol Friedman house, 11 Orchard Brook Drive, Pleasantville, New York (1948; some sources give 1950), 624, 1264, 1628, 2367, 2385, 2601

Solomon R. Guggenheim Museum, New York City, (1956), 457, 461, 487, 507, 508, 513, 518, 526, 541, 543, 595, 633, 648, 663, 680, 734, 757, 797, 840, 862, 877, 895, 913, 918, 1018, 1024, 1034, 1037, 1044, 1045, 1083, 1146, 1157, 1190, 1201, 1203, 1232, 1264, 1305, 1308, 1313, 1376, 1462, 1466, 1577, 1581, 1640, 1697, 1716, 1746, 1876, 1947, 1984, 1996, 2003, 2007, 2097, 2109, 2123, 2241, 2250, 2272, 2276, 2305, 2328, 2350, 2404, 2448, 2474, 2497, 2498, 2527, 2531, 2536, 2537, 2542, 2552, 2571, 2601, 2616, 2630, 2637, 2664, 2666, 2668, 2676, 2722, 2769, 2784, 2789, 2790, 2807, 2818, 2842, 2875, 2882, 2938, 3050, 3105, 3108, 3255, 3258, 3278, 3379, 3388, 3431

Southwest Christian Seminary for Peyton Canary, Glendale, Arizona (1950; executed for the First Christian Church, 6750 North 7th Ave., Phoenix, Arizona), 635, 1404

Sports club and play resort for Huntington Hartford, Hollywood, California (1947), 508, 526, 543

St Mark's Tower for the Vestry of St-Mark's-in-the-Bouwerie, New York City (1929), 193, 202, 207, 221, 1012

Standardized overhead service station, Minneapolis, Minnesota (1932), 2407

Stanley Marcus house, Dallas, Texas (1935), 345

Stanley Rosenbaum house, 117 Riverview Drive, Florence, Alabama (1937; some sources give 1939), 2384, 2561, 3382

Stuart Richardson house, 63 Chestnut Hill Place, Glen Ridge, New Jersey (1940; some sources give 1941), 2182, 2996, 3212

Sun Top Homes quadruple house for Otto Mallery of the Tod Company, 152-158 Sutton Rd., Ardmore, Pennsylvania (1938; some sources give 1939), 386

Susan Lawrence Dana house, 301-307 East Laurence Ave., Springfield, Illinois. (1900; some sources give 1902 or 1903), 1307, 1463, 1663, 1714, 1747, 1776, 1920, 1962, 2069, 2113, 2170, 2195, 2197, 2231, 2288, 2313, 2346, 2357, 2396, 2420, 2464, 2565, 2576, 2577, 2601, 2814, 2873, 2925, 2969, 3050, 3199, 3252, 3310, 3350

Taliesin I house, studio and farm buildings, Spring Green, Wisconsin (1911; living quarters destroyed by fire, 1914), 099, 100, 108, 122, 144, 161, 198, 345, 388, 585, 662, 798, 1255, 1284, 1321, 1375, 1427, 1433, 1463, 1731, 1867, 2049, 2212, 2220, 2289, 2424, 2426, 3188, 3313, 3335, 3353, 3369, 3447, 3484, 3516

Taliesin West, Scottsdale, Arizona (1937; some sources give 1938), 398, 408, 412, 428, 429, 436, 534, 544, 546, 640, 661, 670, 852, 860, 984, 1130, 1149, 1306, 1350, 1375, 1420, 1427, 1556, 1731, 1863, 1867, 1927, 2072, 2186, 2207, 2249, 2264, 2289a, 2332, 2335, 2424, 2438, 2468, 2509, 2554, 2601, 2602, 2661, 2736, 2750, 2762, 2772, 2862, 2890, 2896, 3050, 3055, 3073, 3195, 3260, 3287, 3317, 3323, 3325, 3412, 3438, 3443, 3444, 3515

Tazacmon Yamamura house, Ashiya near Osaka, Japan (1918), 1403, 1653, 1866, 2210, 2260, 2261, 2353, 2386, 2677, 3172, 3527

Theater for Aline Barnsdall, Olive Hill, Los Angeles, California (1915; preliminary studies), 164, 2491, 2599

Theater for the New Theater Corporation, Hartford, Connecticut (1949), 552

Theater, shops and rental terraced houses for Aline Barnsdall, Sunset Bvd., Los Angeles, California (1920), 164, 2599

Theodore A. Pappas house, 865 South Masonridge Rd., St. Louis, Missouri (1955), 1914, 3088

Theodore Baird house and shop, 38 Shays St., Amherst, Massachusetts (1940), 1504, 2384, 3059

Thomas H. Gale house, 1019 Chicago Ave., Oak Park, Illinois (1892), 1255

Thomas P. Hardy house, 1319 South Main St., Racine, Wisconsin (1905), 058, 064, 1463

Three schemes for A Century of Progress *skyscraper, 1933 World's Fair, Chicago, Illinois (1931)*, 209, 299, 1012

Toufic H. Kalil house, 117 Heather St., Manchester, New Hampshire (1955; some sources give 1957), 1504, 2386, 3059

Unitarian Chapel, Sioux City, Iowa (1887), 004

Unity Temple and parish house, Lake St. and Kenilworth Ave., Oak Park, Illinois. (1905; some sources give 1906), 064, 079, 121, 144, 190, 801, 1012, 1089, 1255, 1259, 1297, 1345, 1385, 1434, 1637, 1657, 1939, 1944, 1967, 2019, 2167, 2177, 2421, 2472, 2521, 2601, 2623, 2764, 2771, 2817, 2936, 3050, 3185, 3213, 3238, 3401, 3497

Universal Todd-AO cinema I and II for Mike Todd, Los Angeles, California (1958), 894

Usonian exhibition house and pavilion for *Sixty Years of Living Architecture* New York, (1953; dismantled), 668, 671, 803

Usonian house for Edgar J. Kaufmann, Pittsburgh, Pennsylvania (1939; some sources give 1956), 3232

Usonian master plan, Lansing, Michigan (1939), 543

V.C. Morris house I, Seacliff, San Francisco, California (1945; some sources give 1946), 1716

V.C. Morris house II, Seacliff, San Francisco, California (1953; some sources give 1955), 1716

V.C. Morris shop, 140 Maiden Lane, San Francisco, California (1948), 568, 577, 618, 644, 865, 1049, 1068, 1221, 1832, 2001, 2176, 2614, 3278

Valley National Bank and shopping center, Tucson, Arizona (1947), 3089

Victor Metzger House, Desbarats, Ontario, Canada (1901; some sources give 1902), 046

Victoria Schuck house, South Hadley, Massachusetts (1956), 1886

Vigo Sundt house, Madison, Wisconsin (1940), 2293

Village bank built of cast concrete (1901), 046

W. Irving Clark house, La Grange, Illinois (1892), 013, 1268

W. Scott Thurber art gallery, Fine Arts Building, 410 South Michigan Ave., Chicago, Illinois (1909; dem.), 086

Walter Gale house, 1031 Chicago Ave., Oak Park, Illinois (1893), 1255

Walter Gerts cottage, Whitehall, Michigan (1902; remodeled 1911; mostly dem.), 3314

Walter Rudin house, 110 Martinette Trail, Madison, Wisconsin (1957), 937

Walter V. Davidson house, 57 Tillingham Place, Buffalo, New York (1908), 506, 1264

Ward McCartney house, 2662 Taliesin Drive, Kalamazoo, Michigan (1949; some sources give 1955), 994

Ward W. Willits house, gardener's cottage and stables, 715 South Sheridan Rd., Highland Park, Illinois (1901; some sources give 1902), 144, 1463, 1622, 1769, 1815, 2288, 2601, 2613, 2654

Warren Hickox house, 687 South Harrison Ave., Kankakee, Illinois (1900), 046, 1268, 1336, 1353, 2119

Warren McArthur house, 4852 Kenwood Ave., Chicago, Illinois (1892; remodeling and stable, 1900), 050, 2172

Wenatchee town plan, Wenatchee, Washington (1919), 1995, 2010

Wilbur Wynant house, Gary, Indiana (1916), 3328. Some challenge attribution.

William A. Glasner house, 850 Sheridan Rd., Glencoe, Illinois (1905), 059

William Allen White house, Emporia, Kansas (1916: remodeling), 2193

William B. Tracy house, 18971 Edgecliff Drive S.W., Normandy Park, Washington. (1954; some sources give 1955 or 1956), 2973

William Cass house, The Crimson Beech, Richmond, New York (1956), 1003, 1040, 2107, 2292

William G. Fricke house, 540 Fair Oaks Ave., Oak Park, Illinois (1901; some sources give 1902), 054, 1463

William H. Pettit Memorial Chapel, Belvidere Cemetery, Belvidere, Illinois (1906), 1733, 2688

William H. Winslow house and stable, 515 Auvergne Place, River Forest, Illinois. (1893; some sources give 1894), 026, 046, 049, 1132, 1463, 1889, 2288, 2601, 2691

William Palmer house, 227 Orchard Hills Drive, Ann Arbor, Michigan (1950; some sources give 1951), 994, 1042, 2011, 2385, 2555, 2601, 2949, 3146

William R. Heath house, 76 Soldiers Place, Buffalo, New York (1905), 063, 506, 1264

William R.Heath garage and stables, Buffalo, New York (1911), 063, 506, 1264

William Thaxton, Jr. house, 12024 Tall Oaks, Bunker Hill, Texas (1953; some sources give 1954), 2433

Willis J. Hughes house, Fountainhead, 306 Glenway Drive, Jackson, Mississippi (1948; some sources give 1949 or 1950), 1781

Wyoming Valley School, Route 23, Wyoming Valley, Wisconsin (1956; some sources give 1957), 2356

*Yahara Boat Club, Lake Mendota, Madison, Wisconsin (1902; s*Some sources give 1905), 1202, 2203, 2295, 2971

Index of Personal Names

Aalto, Alvar, 928, 2251, 2951
Abbott, Charlotte, 3474
Abercrombie, Patrick, 364
Abercrombie, Stanley, 1712, 1713, 2244, 2601, 2615, 2618, 2729, 2925, 2929, 2939, 3052, 3475
Abernathy, Ann, 1999, 2127, 2214
Abrams, Jane, 1947
Abu-Dayyeh, Nabil Issa, 2830
Achenbach, T. M., 2456
Adam, Hubertus, 3235, 3267
Adams, Annmarie, 3147
Adams, Bernard S., 1211
Adams, David K., 2929
Adams, P., 2489
Adams, Richard P., 828
Adamson, Inigo, 957
Adler and Sullivan, 005, 009, 010, 1422
Adler, Leo, 156
Adler, Mortimer J., 498
Aeppel, Timothy, 2730, 3058
Affleck, Gavin, 2937
Affleck, George, 512
Agard, Walter R., 243
Aguar, Berdeana, 3519
Aguar, Charles, 3519
Ahern, Rich, 2189
Aitkin, Donald, 3159
Akashi, Nobu Michi (Shindo), 1244, 1369

Akihisa, Masuda, 1654
Akiner, V. Tuncer, 1993
Alarcon Reyero, Candelaria, 3059
Alati, Danine, 3341
Alberts, Robert C., 1643
Albrecht, Donald, 1969, 2716, 2731, 2792, 2800, 3252
Alexander, B., 474
Alexander, Stephen, 288
Alfieri, Bruno, 1134
Alford, John, 753
Alhadeff, G., 2831
Al-Hasani, Naji, 2573
Allan, Elkan, 495
Allan, Stanley, 2287
Allen, James R., 1714, 1757, 2197, 2464
Allen, Stan, 2497
Alliluyeva, Svetlana, 1843
Alloway, Lawrence, 1244
Alofsin, Anthony Michael, 1598, 1981, 2065, 2128, 2215, 2255, 2297, 2483, 2489, 2586, 2693, 2716, 2829, 2921, 2929, 3141, 3233
Ambasz, Emilio, 2716
Ambaum, Johan, 1535, 1848
Amberg, D. M., 101
Amery, Colin, 1923
Ames, Robert Leonard, 093
Andersen, Kurt, 2148, 2489, 2498

Anderson, David, 1844
Anderson, K., 2732
Anderson, Kent, 2724, 3268
Anderson, Margaret, 114
Anderson, P. S., 1207
Anderson, Stevens R., 2149
Andi, Stefano, 1978
Andreini, Laura, 2832
Andrews, J., 2394
Andrews, Leonard E.B., 1009
Andrews, Wayne, 641, 667, 672, 718, 1147, 1264
Andriani, Lynn, 2924
Angelis, Almerico de, 3150
Angrisani, Marcello, 1093, 1316, 1505
Anthony, Howard, 2385
Antonelli, Paola, 2499
Apostolo, Roberto, 2298, 2395, 2500, 2501
Argan, Giulio Carlo, 416, 500, 611
Arkin, David, 240
Armitage, Merle, 1078
Arndt, Jacob, 2834
Aronson, Margot, 2996
Arup, Ove, 2662
Asberry, Kasey Rios, 3235
Ashbee, Charles Robert, 040, 087, 099, 117, 1318, 1700, 1972
Astengo, Giovanni, 611
Atkinson, Fello, 826, 912, 916, 1563
Attema, Peter, 1758
Attoe, Wayne, 2110
Auer, Gerhard, 2299
Austin, Elizabeth, 2943, 2944
Austin, George, 3094
Aver, James, 2619
Ayala Valva, Franco d', 1860
Ayoub, Nina C., 3153
B——, R.R., 2495
Baal-Tesuva, Jacob, 2537
Bachand, Cheryl, 2835
Bacon, Pervis B., 2396
Badovici, Jean, 083, 139, 155, 205
Baird, Theodore, 2384
Baker, Geoffrey Harold, 1459, 1644
Baker, Paul, 1009
Baldwin, Guy H., 501
Ball, Michael, 2620, 3208
Ballantyne, Andrew, 2601, 2929

Ballay, Ute, 2615
Balmer, Randall, 2936
Baltar, Rafael, 2397
Bancroft, Dick, 1053
Bandes, Susan J., 2370
Banham, (Peter) Reyner, 153, 154, 746, 917, 1010, 1017, 1050, 1077, 1181, 1277, 1316, 1371, 1573, 1605, 1924, 2150
Banham, Mary, 1277
Barna, Joel Warren, 2861, 2877
Barnbeck, Ulla, 2052
Barnes, David Russell, 2502
Barney, Maginel Wright, 1144, 1970
Barney, Maginel Wright, 1144, 1970
Barnsdall, Aline, 164, 2599, 3147
Baroni, Daniele, 1925
Barr, Alfred Hamilton Jr., 241, 397, 2529
Barreneche, Raul A., 3378
Barrett, William, 1024
Barriere, Philippe, 2537
Barry, Gerald, 1010
Barry, Iris, 473, 474
Barry, Joseph A., 773
Barter, Judith A., 2909
Bartning, Otto, 640
Barton, Timothy, 1595
Barton, William E., 090
Bartos, Barbara, 2477
Basquiat, J.M., 2621
Bassham, Ben, 2503
Baudoui, Remi, 2733
Bauer, Catherine, 225, 227, 242, 243
Baxter, Anne, 2383
Baxter, Sylvester, 125
Bayley, John Barrington, 674
Bazel, K.P.C. de, 1848
Beal, George Malcolm, 280
Beasley, Ellen, 1266
Beauregard, Sue-Ellen, 2946, 3160
Beckett, Jane, 119, 1748
Beckley, Robert M., 1961
Bedrossian, Rebecca, 3481
Beeby, Thomas H., 1544, 1658, 1715, 1737, 2129, 2472, 2484, 2489, 2607
Beet, Alastair, 364
Beghtol, L.D., 2947
Beharka, Robert, 3060
Behrendt, Walter Curt, 087, 637

Behrens, Peter, 294
Behrens, Roy R., 3038, 3235
Beilis, F., 2884
Bel Geddes, Norman, 129
Bell, Judith, 3061
Bell, Keith, 1806
Bell, Robert A., 1434
Bellmore, Audra, 3269
Belluschi, Pietro, 784, 928
Bemrose, John, 3161
Bendheim, Fred A., 3379
Bendiner, Alfred, 873
Benedict, Fred, 2901
Benjamin, David, 2216
Bennett, Janey, 2293
Bennett, Paul, 3162
Benson, B., 415
Benson, Robert, 1861, 1994, 2148
Benton, Charlotte, 1460, 2615
Benton, Thomas Hart, 1982
Benton, Timothy, 1460
Bergdoll, Barry, 2070
Bergeijk, Herman van, 3040
Berger, Gloria, 2382
Berger, Philip, 1815
Berke, Arnold M., 2071
Berkeley, Ellen Perry, 449, 2295
Berkowitz, Howard, 2054
Berkowitz, Judy, 2054
Berlage, Hendrik Petrus, 094, 095, 126,
 144, 152, 780, 1445, 1457, 1700, 1848
Berliner, Michael S., 3099
Berna-Heath, Diane, 2717
Berndtson, Indira, 3380
Berndtson, Peter, 3322
Bernier, Olivier, 2151
Bernoudy, William Adair, 3250
Bernstein, Fred A., 3062, 3111
Berton, Pierre, 874
Berwick, Carly, 3482
Besinger, Curtis Wray, 985, 1114, 1357,
 1384, 2128, 2398, 2808, 3408
Betsky, Aaron, 1991
Bettini, Sergio, 674, 2622
Bey, Lee, 3270
Beye, Cudworth, 2203, 2971
Beyer, Sarah, 2093, 2948, 3063
Biemiller, Lawrence, 2504
Bierut, Micheal, 449

Bignens, Christoph, 3150
Billington, James H., 2937
Bimson, Walter R., 1000
Bing, Jonathan, 2924
Birk, Melanie, 2735, 2921, 3142
Birksted, Jan, 2152, 3271
Bischoff, Judith J., 3272
Bishop, Carol, 3381
Bishop, Robert F., 2613
Black, Joyce Tognini, 2066
Blackler, Zoe, 3526
Blaffer, Catherine, 1205
Blake, Peter, 555, 673, 746, 875, 918,
 1010, 1034, 1996, 2537, 2587, 2716
Blake, William, 249
Blanc, Alan John, 1574, 2205
Blanchette, David, 2346
Blaser, Werner, 1862
Blevin, Bruce Jr., 397
Bloc, Andre, 919, 920
Blomensaht, Ferdinand, 2052
Blotkamp, Carel, 1748
Bluemner, 2659
Blundell-Jones, Peter, 1575, 1598, 1807,
 1934, 1997, 2129, 2136
Bock, Gordon, 3163
Bock, Richard W., 1356, 1497, 2198
Bodley, Ronald V.C., 306
Boekraad, Cees, 1796
Bohm, Wolfgang, 2693
Bohrer, Florence Fifer, 754
Bois, Yve-Alain, 1748
Boisi, Antonella, 2615
Bojthe, Tamas, 667
Boles, Daralice Donkervoet, 1815, 1998,
 2007, 2076, 2217
Bolon, Carol Radcliffe, 021, 2129
Boman, Monica, 2477
Bonanos, Christopher, 3475
Bonaventura, Paul, 1748
Bonfilio, Paul, 3357
Book, Carl F., 3164
Boonyatikarn, Soontorn, 2218
Booth, Francis, 2560, 2716
Booth, Ramon L., 1049
Borenzweig, Ina, 2743
Bornstein, Eli, 2837
Borthwick (Cheney), Mamah, 091, 106
Boswell, Peyton, 461

Bosworth, Thomas, 1765
Boterenbrood, Jan, 229
Bottomley, Derek, 1252
Bottoni, Piero, 615
Boulton, Alexander O., 2399, 2588
Bouverie, David Pleydell, 552
Boven, Sarah van, 2986
Bowen, Charles, 2861
Bowie, Karen, 2930
Bowly, Devereaux Jr., 1385, 1513
Boyd, John Taylor Jr., 206
Boyd, Robin, 829
Boyd, Thomas J., 921
Boyd, Virginia T., 3066, 3483
Boyken, Immo, 083, 1918
Boyle, Bernard Michael, 1863, 2922
Braatz, Wolfgang, 1265
Brace, Martin, 826
Bradbeer, Charlotte, 2877
Brady, Darlene, 2623
Bragdon, Claude, 129, 260, 298
Brancatelli, Joe, 2947
Branch, Mark Alden, 2716
Branden, Barbara, 2053
Brandon, Henry, 1170
Braun, Barbara, 2589
Bredahl, Brenda Kramer, 3484
Breiner, David M., 2272
Breiner, Don E., 865
Brenesal, Barry, 2861
Brenner, Douglas, 1999, 2038
Brest, Rend, 720
Brett, Lionel, 441, 495, 668, 718
Breuer, Marcel, 2250
Brierly, Cornelia, 2300, 2505, 2736, 3234, 3322
Briggs, Sara-Ann, 3165, 3319, 3382, 3383, 3384, 3385
Bright, John Irwin, 225
Brink, Lawrence R., 2949
Broach, Barbara, 3382
Brock, H. I., 207
Broekhuizen, Dolf, 1748
Bromberg, Allen R., 1009
Bromley, Judith, 3055, 3166
Bronte, Melinda, 2720
Brooks, Harold Allen Jr., 015, 036, 083, 087, 144, 868, 957, 1025, 1071, 1096, 1102, 1151, 1176, 1180, 1182, 1183,

1244, 1266, 1267, 1351, 1371, 1412, 1461, 1510, 1606, 1700, 1759, 1845, 1979, 2273, 2716, 2728, 2920, 3167
Brosterman, Norman, 3038
Brown, A., 2884
Brown, Bay, 3273
Brown, Conrad Nagel, 2950, 3168
Brown, Dan, 1514
Brown, J.P., 2388
Brown, Joan, 3367
Brown, Katrina, 3294
Brown, Marion Mumford, 2164
Brown, Milton, 397
Brown, Randy, 2838
Brown, Terry, 1851
Brown, Theodore M., 1010
Browne, Enrique, 2951
Brownell, Baker, 313, 2608
Bruegmann, Robert, 2506
Brunati, Mario, 1145
Brunelleschi, Filippo, 2539
Brunetti, Fabrizio, 1423, 1701
Bruno, Stefano, 3274
Bryant, David, 2813
Brykandt, Mary Jane, 2952
Buber, Martin, 1935
Bucci, Federico, 083, 3167
Buchanan, Peter, 2624
Buck, Louisa, 2615, 2625
Budd, Ken, 3207
Buechel, Wolfgang, 2219
Buffinga, A., 876
Bugbee, Gordon Pritchard, 2130
Buitenhuis, Peter, 830
Bull, Harry Adsit, 229
Bullock, Helen Duprey, 1156, 1266, 1301
Buras, Nir, 2058
Burchard, J.E., 1267
Burfeind, Matthew S., 2861
Burgess, Helen, 1152
Burley, Robert, 2508
Burnham and Root (firm), 2247, 2389, 2506
Burnham, Alan, 801, 837
Burnham, Daniel Hudson, 096, 2174
Burns, Ken, 3018, 3207
Burns, Robert, 3386
Burr, Ty, 2861
Burrell, Mark, 2507

Bush, Trudy, 2588
Bush-Brown, Albert, 922
Bussel, Abby, 3485
Butler, J.T., 1408
Butler, Samuel, 249
Byars, Mel, 2921
Byrne, Barry, 157, 242, 441, 826, 1052, 1071, 1103, 2344
Calvo, Charles M., 1885, 1926
Campajola, Viviana, 1816
Campbell, Robert, 2058, 2508, 2737, 3169
Campo, Santiago del, 721
Canella, Guido, 2738
Canine, Craig, 3039
Canning, S.E., 3472
Cannon-Brookes, Peter, 2538, 2615
Canty, Donald, 1705
Carillo, René, 755
Carlo, Giancarlo de, 475, 611
Carlos, John James, 923
Carlson, D., 2732
Carlson, Raymond, 408, 791
Carlson, Victoria, 2716, 3094
Carlyle, Thomas, 249
Carmel-Arthur, Judith, 3462
Carney, Richard E., 2141, 2509, 2937, 3020, 3210
Caronia, Giuseppe, 1011
Carpenter, John T., 2824
Carpenter, D., 2732
Carr, Richard, 1659, 1660, 2739, 3151
Carter, Brian, 3143, 3238
Carter, Edward Julian, 364
Carter, Ernestine, 364
Carter, Robert, 1269
Cartier-Bresson, Henri, 547
Cary, Charles Lynn, 1068
Casciani, Stefano, 2510
Casciato, Maristella, 3040, 3230
Casciato, Maristella, 3233
Casey, Dennis J., 2694, 3041, 3358
Casey, Thomas, 2511
Cash, Stephanie, 3387
Cassidy, Victor M., 2220
Casson, Hugh, 1071
Castagna, John F., 368
Castellano, Aldo, 1760
Castex, Jean, 1440, 1905, 3167
Castle, H., 2924

Cazes, Isabelle, 2626
Cederna, Antonio, 674
Cembalest, Robin, 2512, 2627
Cessa, C. de, 2221
Chadwick, Gordon, 1266
Chambers, William S. Jr., 434
Champigneulle, Bernard, 638
Champion, Roberto A., 1120
Chan, Chiu-Shui, 2513
Chanchani, Samiran, 3388
Chang, Ching-Yu, 1864
Charlton, Jim, 3275, 3280
Charrin, Francois, 2514
Chase, Mary Ellen, 363
Chaslin, Francois, 1905
Cheek, Lawrence W., 2072
Cheek, W., 2287
Cheney, Sheldon, 242
Chenoweth, R., 3389
Chia, Kathy, 2515
Chiaia, Vittorio, 2695
Choi, Don H., 2606, 3067
Christian, John, 3170
Christiansen, Jörn, 1910
Christ-Janer, Albert, 1010
Churchill, Henry Stern, 209, 242, 243, 529, 530, 1094
Ciucci, Giorgio, 1596
Clark, Clifford E., 1794
Clark, Robert Judson, 1372
Clark, Robert, 012
Clarke, David S., 2371
Clarke, Jane H., 1927, 2074
Clausen, Meredith L., 1928
Clay, Simon, 3145
Cleary, Richard Louis, 2628, 2629, 2839, 2840, 2929, 3052, 3235, 3276, 3277, 3368
Clement, Russell T., 2287
Clinton, William Jefferson, 2690
Coad, Emma Dent, 2615
Coates, Robert M., 918
Cohen, Daniel, 1929
Cohen, Edie Lee, 2517
Cohen, George, 877
Cohen, Jean-Louis, 2000, 2929, 3150, 3233, 3278, 3472
Cohen, Jeffrey A., 2877
Cohen, Martin, 1214

Cohen, Mortimer Joseph, 906
Cohen, Stuart E., 1387, 1472
Cohn, David, 2716
Coit, Elisabeth, 242, 415, 441
Cole, Dave, 3116
Cole, Wendell, 1026
Cole, Wendy, 2812
Coles, William A., 736
Coll-Barreu, Juan, 3496
Collins, Julia, 2141
Collins, Peter, 1176
Collins,George Roseborough, 1094
Collmer, Kathryn, 2141
Colquhoun, Alan, 667
Colson, Ethel M., 050
Colton, Mary Rawcliffe, 2141
Comberg, D., 2612, 2861, 2877
Combes, Abbott, 2953
Comey, Arthur C., 243
Conan, Michel, 2133
Conant, Kenneth John, 551
Conn, David R., 3160, 3460
Connors, Joseph, 083, 1563, 1795, 2129
Connors, Thomas, 2954, 3392
Conway, James, 3279
Cook, C., 2400
Cook, Jeffrey, 2287, 3390
Cook, Michael, 2199
Cook, Theodore, 461
Cooke, Alistair, 850, 924, 1054, 1825, 1851
Cooney, William, 3236
Cooper, Gary, 449
Cooper, Ilene, 3242
Cooper, Jerry, 2066
Cooper, Rodney, 1979
Copier, A.D., 1848
Copplestone, Trewin, 3144
Cornell, Henrik, 1206
Cornoldi, Adriano, 2153
Cortes, Juan Antonio, 2401
Costantino, Maria, 2372, 3145, 3237
Cotton, W. Philip, 1179
Coupland, Ken, 3486
Cowan, Craig, 2466
Cowles, Linn Ann, 242, 1501
Cox, Stephen, 449
Cox, Val M., 3245
Craig, Tracey-Linton, 2154

Cramer, Ned, 2937, 2954
Craven, Thomas, 279
Crawford, Alan, 1318, 1972
Crawford, Margaret, 3496
Creighton, Thomas Hawk, 243, 553
Cresti, Carlo, 1146
Cret, Paul, 178
Crippa , Maria Antonietta, 242
Croft, Catherine, 3391
Cronon, William, 2716
Crosbie, Michael J., 1608, 1817, 2001, 2302, 2842
Currimbhoy, Nayana, 2002, 2303, 2470, 2606, 2702, 2703, 2712
Curtis, Cole Martinez, 2517
Curtis, Wayne, 3207
Curtis, William J. R., 2809, 2878
Cusack, Victor A., 2630, 2716, 3280
Cuscaden, Robert R., 1121, 1243
Czarnecki, John E., 3392
Dahle, Einar, 2741
Dal Co, Francesco, 1716
Daley, Mayor, 1293
Dalgliesh, Alice, 1147
Dana, Amy, 2066
Dana, Karine, 3281
Danes, Gibson, 502
Dannatt, Trevor, 2613, 2615
D'Arcy, David, 3472
Darnall, Julie E., 3471
Darwin, Charles, 3167
Dattomi, A., 3393
David, Arthur C., 051
Davidson, Joel, 2731
Davidson, Peter, 1865
Davies, Colin, 1761
Davies, Merfyn, 1762
Davies, Rick, 1749
Davis, D., 2156
Davis, Douglas, 2276
Davis, Frances R. A., 2922
Davis, Jim, 3042
Davis, Joyce M., 2056
Davis, Nicholas, 2304
Davis, Patricia Talbot, 1424
Davis, Richard, 2383
Davis, Sue, 2956
Dawson, Susan, 3517
Dean, Andrea Oppenheimer, 2003, 2305,

2632, 2742, 2957
Dean, George R., 024, 038
Dean, Grant Talbot, 1857
Deboard, Donn R., 3487
Decker, Paul, 395
Delafon, S. Gille, 369
Dellin, Mary A., 2277, 2402
Deluigi, Mario, 674
Den Uyl, Douglas J., 449
DeNevi, Donald D., 1215, 1249, 1250,
 1278, 1610, 2279
Dennis, James M., 1153
Dennis, Lynn M., 2696
Derleth, August, 440, 1147
Devane, Andrew, 1464, 2613
Devereaux, Elizabeth, 2724
Diamond, Mary, 116, 1070,
Diamond, Rosamund, 2810
Dibbits, ——., 581
Dick, Jeff, 3207
Dickey, Paula, 1216
Diestelkamp, Edward, 2958
Dietsch, Deborah K., 1818
Dijk, Hans van, 1866
Dillon, David, 2141, 3094
Dixon, John Morris, 2537
Donahue, K., 2222
Donald, Bruce, 2953
Donaldson, J. H., 1158
Donegan, F., 2075
Donhauser, Peter L., 2058
Donner, Peter F. R., 364
Donohue, Judith, 2223, 2306, 2307
Donoian, John, 2004
Donovan, K., 2871
Donovan, L.K., 1353
Doordan, Dennis P., 2004, 2380
Doremus, Thomas L., 2414, 1829, 1906
Dorfles, Gilio, 981
Dos Passos, John, 307
Doubilet, Susan, 2066, 2076
Doumato, Lamia, 2057
Dow, Alden B., 1094, 1652, 2390,
Dow, Joy Wheeler, 029
Dowling, Jill, 2843, 2960
Dowling, Robert, 928
Downs, Arthur Channing Jr., 1515
Downs, G. A., 557
Downs, Hugh, 667, 1137

Downs, Robert Bingham, 242
Drew, Nancy, 3282
Drew, Philip, 2157
Drexler, Arthur, 1071
Drought, Jim, 191
Drutt, Matthew, 3255
Dudok, Willem Marinus, 157, 925
Duel, John, 2283
Dufet, Michel, 638
Duffus, R.L., 313, 415
Duiker, Johannes, 244
Dulio, Roberto, 3488
Dumont, Marie-Jeanne, 2937, 3038
Dunham, Judith, 2697
Dunhill, Priscilla, 1256
Dunlop, Beth, 2493, 2710, 3052, 3238,
 3239
Dunn, Jerry, 2716
Dyson, Carol, 2170
Eastman, Mark, 3481
Eaton, Leonard Kimball, 780, 926, 1027,
 1118, 1132, 1176, 1267, 1371, 1373,
 1412, 1457, 1509, 2389, 2974, 3146,
 3171
Eaton, Mary Anna, 3043
Eaton, Timothy A., 3043
Ebeling, Ashlea, 3283
Eberhart, George M., 2813, 2877
Ebner, Jörn, 3150
Eckhardt, Wolf von, 1010, 1017, 1819
Eckstein, Hans, 640
Edelmann, Frederic, 1908
Edwards, Folke, 756
Edwards, James, 2382
Eeles, Bruce, 2158
Eggener, Keith, 3233
Egger, E.M., 3520
Ehat, Carla, 1465, 1810
Ehrlich, Doreen, 3359, 3521
Eiermann, Egon, 2926
Eifler, John, 2635, 3044
Einbinder, Harvey, 1973
Eisenberg, Marilyn, 3225, 3394
Eizenberg, J., 1723
Eldred, Robert C. (auctioneers), 1469
Elisofon, Eliot, 1009
Elken, Ants, 831
Elkind, David, 3038
Elliott, K., 2743

Elliott, Lynn, 2979
Elliott, Scott, 1702
Ellis, Charlotte, 2224
Ellis, W. Russell, 2077
Elmslie, George Grant, 297, 1786, 3167
Elsner, John, 2961
Elson, John, 2812
Elwall, Robert, 3395
Emerson, Ralph Waldo, 249, 2472
Endo, Arata, 3172
Endo, R., 1184
Enequist, R.L., 1077
Engel, Martin, 1122, 1217
Engelmann, Jorg, 2636
English, Mark, 2623
Erickson, Don, 3284
Escritt, Stephen, 2865
Estes, Rice, 242
Etlin, Richard A., 2698
Faber, Tobias, 1907, 3240
Fadiman, Clifton, 242
Fanelli, Giovanni, 123, 1241, 1279, 1559,
 1796, 1974
Farah, Mary Anne, 2518
Farmer, Lesley S.J., 2861
Farnham, Alan, 3394
Farr, Finis, 1050, 1079
Farrar, Benedict, 370
Farrell, Terry, 2403
Fasola, Giusta Nicco, 611
Fassler, John, 1006
Faverman, Mark, 3252
Fawcett, Laughlin, 2937
Fehlhaber, Joerg M., 2005
Feiss, Carl, 872
Fell, Derek, 3396
Fell, H. Granville, 433
Fels, Thomas Weston, 1982
Felsen, Gregg, 3124
Fentress, Sam, 3250
Ferguson, Nancy H., 1661
Ferguson, Stuart, 3052
Fern, Alan M., 1052, 1104, 1244
Fernández, Antonio Toca, 2716
Fernandez-Galiano, Luis, 2637, 2716,
 3397
Ferraro, Sharon, 3173
Ferraz, Geraldo, 927
Ferrell, Wilfred A., 1242

Ferriss, Hugh, 220
Fici, Filippo, 2467
Fici, Giampaolo, 2467
Field, Dorothy Johnson, 285
Field, Marcus, 2744
Fields, Jeanette S., 1703, 2962, 2963
Fieroh, Len, 2214
Figg, John, 2844
Filipowicz, Diane, 2293
Filippo, Alison, 2006, 3037
Filler, Martin, 242, 1432, 1562, 1563,
 1564, 1569, 1577, 1601, 1603, 1799,
 1817, 1867, 1991, 2007, 2097, 2159,
 2483, 2489, 2537, 2586, 2588, 2601,
 2606, 2608, 2712, 2716, 2745, 2816,
 2878, 2938, 2964, 3285, 3397, 3472
Fillion, Jane, 449
Finch, Christopher, 1280
Finetti, Giuseppe de, 337
Fintozzi, Carla, 2743
Fior, Liza, 3147
Fischer, Ray, 2393, 2518a
Fischer, Wend, 154
Fisher, John H., 825
Fisher, Thomas R., 2076, 2079, 2225,
 2417
Fishman, Robert, 1530, 2134, 2746
Fisker, Kay, 3240
Fitch, George H., 1010
Fitch, James Marston, 748, 773, 928,
 1028, 1094, 1761
Fitchett, Sarah, 3398
Fitoussi, Brigitte, 2080
Fitzpatrick, Eileen, 3160
Fitzpatrick, F.W., 130,
Fitzpatrick, Kelly, 1412
Flanagan, Barbara, 2308, 2519
Fleming, Diane Bresnan, 3463
Fletcher, A., 2863
Flint, Sunshine, 3286
Floto, Julius, 140
Fogarty, Kate Hensler, 3287
Foise, A. D., 868
Ford, Edward R., 2278
Ford, Henry, 2502, 2977, 3085, 3322,
 3439
Forrer, M., 2824
Forsee, Aylesa, 907
Forster, Kurt W., 2817

Fortune, James W., 2520, 2638
Foster, Norman, 2038
Fowler, B. Andrew Corsini, 2491
Fowler, Orson Squire, 2756
Fowler, Penny, 3043, 3464, 3506
Fox, Bette-Lee, 3160, 3174
Fox, Terry Curtis, 1473
Frampton, Kenneth, 1750, 1930, 2081,
 2380, 2489, 2491, 2537, 2716, 2811
Frank, Edward, 1560, 2404, 2501
Frank, Isabelle, 3360
Frankenstein, Alfred, 1034
Frankl, Paul Theodore, 173
Fraser, Murray, 2865
Fraser, Virginia, 3175
Frazier, Nancy, 087, 144
Freeman, Allen, 3068
Freiman, Ziva, 1947, 2845
French, Dennis, 2965
Friedman, Alice T., 2474, 2491, 2492,
 2522, 3147
Friedman, D.S., 3147, 3235
Friedman, Mildred, 1750
Fries, Heissenrich de, 094, 152, 208,
 285
Fritsch, Herbert, 2052
Froebel, Friedrich, 678, 1229, 1439,
 1688, 1722, 1785, 2204, 2255, 2380,
 3038
Froehlich, Lee, 2506
Frumkin, Allan, 550, 1099
Fry, E. Maxwell, 371, 1493
Fujioka, Hiroyasu, 2378
Fuller, Kathryn Handy, 372
Fuller, Richard Buckminster, 346,
 2382, 3479
Fumagalli, Paolo, 2747
Fusco, Renato de, 2008
Futagawa, Yukio, 1207, 1310, 1311,
 1375, 1406, 1427, 1462, 1463, 1503,
 1504, 1646, 1854, 1915, 1916, 1917,
 1985, 1986, 1987, 2062, 2063, 2142,
 2143, 2207, 2288, 2289, 2289a,
 2289b, 2290, 2384, 2385, 2386
Gabo, Naum, 364
Gabor, S., 2222
Gaebler, Max David, 642, 667
Gagewere, R. Jay, 3235
Gaillard, Julie-Caroline, 3288

Gannett, William Channing, 001, 015
Garcias, Jean-Claude, 2811
Gardner, James, 2537
Garfield, D., 2877
Garrison, Peter, 3399
Gartner, Scott, 2483
Gary, Grace, 1797, 2071
Gattamorta, Gioia, 2523
Gatto, Alfonso, 674
Gaudi, Antoni, 589, 1409, 2271, 3138
Gay-Barbier, Gerard, 2601, 2716
Gayou, Gheda, 3176
Gebhard, David, 868, 929, 1017, 1095,
 1244, 1267, 1346, 1569, 2136, 3167
Gehry, Frank, 2875, 2907, 3057, 3150,
 3379
Geiger, John, 2309, 2382, 2406, 2524,
 3245
Geiger, Martin, 1105
Gelbin, Allan, 2900
Gelderen, W. van, 415
Gentle, Thom, 2226, 2310
Gerigk, Herbert, 1218
Gerloff, Robert, 349, 2407
Gero, Laszlo, 746
Gerosa, Mario, 2639
Getlein, Frank, 826, 1077
Ghirardo, Diane, 2304
Giannone, Michael A., 2082
Gibson, Eric, 2007
Giedion, Sigfried, 244, 675
Giedion-Welcker, Carola, 1024,
Giffels Associates (firm), 1897
Gifford, Don, 094
Gilbert, Jeff, 1123
Gilbert, Katharine, 616
Gill, Brendan, 930, 1931, 1979, 2058,
 2227, 2244, 2417, 2640, 2641, 2716,
 2846, 3069
Gill, Grattan, 3245
Gillespie, Bernard, 1412, 1510
Gillis, John, 2141
Gillon, Edmund Vincent Jr., 2059
Gilmore, William, 531
Giolli, Raffaelo, 338
Giovannini, Joseph, 2097, 2525, 2526,
 2537, 3472, 3496
Girouard, Mark, 1979, 2583
Glibota, Ante, 1908

Glickman, Mendel, 1176, 2180
Gloag, John, 289, 373, 396
Globus, Gordon G., 1123
Glusberg, Jorge, 2537
Goalen, Martin, 2230
Goble, Emerson, 667, 718
Godoli, Ezio, 123, 1647, 1974
Godwin,Edward William, 2926
Goethe, Johann Wolfgang von, 106
Goff, Bruce, 228, 1124, 1324, 2382, 2429, 3232
Goldberg, Harold, 2861
Goldberg, Jeff, 3258
Goldberg, Ken, 2953
Goldberger, Paul, 242, 1932, 2160, 2311, 2601, 2611, 2642, 2716, 2966, 2967, 3255, 3290, 3489
Goldman, Peggy, 3490
Goldman, Stuart, 2702
Goldstein, Eliot W., 2408
Gomez, Edward M., 2228
Goodhue, Bertram G., 368
Goodman, H., 1798
Goodman, Paul, 442
Goodman, Percival, 442
Goodrich, Burton J., 428, 429
Goodwin, George M., 3177, 3178, 3291
Gookin, Frederick W., 1868
Gordon, Alastair, 2527
Gordon, Elizabeth, 476, 726, 773, 985, 2541, 2982, 3455
Gorlin, Alexander C., 2009, 2065, 2312, 2528
Gorman, Carma R., 2847
Gorman, Jean, 2643
Gorme, Rodney, 3151
Gorvy, Brett, 2748
Goska, Dave, 2083
Gosling, David, 3292
Goss, Peter L., 1476, 1763
Gossel, Peter, 2374
Gottfried, Herbert, 1978
Gottlieb, Lois Davidson, 3465
Gough, Piers, 2038
Gould, Whitney, 2968
Goulder, Grace, 617
Gournay, Issabelle, 2409
Gowans, Alan, 1176, 1269
Graaf, Vera, 2749

Graaff, C. de, 582
Grace, Frederick Randolph, 448
Graf, Otto Antonia, 1598, 1910, 2380
Grafly, Dorothy, 611
Gragg, Randy, 3179
Graham, Thomas, 001, 1820, 1975, 1976
Grandchamp, Aline de, 1009
Granger, Alfred Hoyt, 029
Grant, Alex, 3254
Grant, Elaine X., 3293
Grant, Neil, 3507, 3508, 3509
Grant, Roderick, 2279, 2313, 2372, 2380, 2382, 2466, 2471, 2473, 2477, 2489, 2491, 2492, 2612, 2644, 2723, 3070, 3153
Grassmuck, K., 2314
Graves, Michael, 1799, 2190, 2250, 2362
Gray, Kevin, 3491
Greco, JoAnn, 3180, 3294
Green, Aaron G., 2141, 2279, 2382, 3381, 3492
Green, William, 1868
Greenberg, Allan, 1281
Greene, Elaine, 1578
Greenfield, Albert M., 928
Greer, Nora Richter, 2084
Gregory, Stephanie, 3295
Greh, Deborah, 2861
Grehan, Farrell, 3047, 3286, 3296
Griffin, Marion Mahony, 115, 1194, 1769, 2178, 2849, 2909, 2977, 3194
Griffin, Walter Burley, 1322, 1421, 1533, 1769, 2165, 2178, 2187, 2888, 3167, 3194, 3198
Griffith, David W., 397, 441, 497, 1270
Griggs, Joseph, 1154
Grigor, Murray, 1871, 2457
Grigor, Murray, 1871, 2457
Grimes, Teresa, 2469
Griswold, Ralph E., 1106
Gropius, Walter, 240, 928, 1094, 1186, 1208, 1363, 1377, 1529, 1532, 2926, 3115
Gropp, Louis Oliver, 2525
Gross, Martin L., 832
Grossman, Loyd, 2410
Grotz, Paul, 1019
Gruen, Victor, 2648
Gruyter, W. Jos. de, 229

Guadarini, Stefano, 3071
Guarino, Jean Louise, 3181
Guerard, Albert, 844
Guerrero, Pedro E., 722, 1477, 2529, 2530, 2541, 2699, 2750, 2799, 2922, 3203
Guggenheimer, Tobias S., 2411, 2813
Guh, T. Jeff, 3297
Guida, Carol, 2859
Guillier, Pascalin, 2645
Guise, David, 2229
Gumpert, Martin, 676
Gunn, P., 2412
Gunnar Birkerts and Associates (firm), 1897, 2130, 2163, 2196
Gunts, Edward, 449
Gurda, John, 1977
Gurdjieff, Georges L., 579, 1272, 1412, 1449
Gustmann, Kurt, 1717
Gutheim, Frederick Albert, 041, 056, 077, 083, 105, 116, 133, 165, 166, 167, 168, 169, 179, 180, 181, 182, 183, 184, 185, 186, 187, 191, 197, 215, 218, 219, 226, 230, 242, 248, 249, 251, 258, 260, 276, 277, 285, 286, 297, 318, 345, 364, 383, 392, 397, 405, 415, 417, 718, 747, 912, 1029, 1283, 1464, 1516, 1601, 1662, 1700, 1991, 2058, 2471, 2484, 2607, 2608
Gwathmey, Charles, 2190, 2537
Haas, Richard, 2532
Haberlik, Christina, 3208
Habermehl, Werner, 449
Hadley, Homer M., 503
Hafermehl, Louis N., 2382
Hagan, Bernadine, 3502
Haggard, Theodore M., 1909
Hale, Edward Everett, 249
Hale, Jonathan, 2283, 2533, 3182
Hall, Eugene J., 090
Hall, Helen, 1547
Hall, John R., 3461
Hall, Jonathan, 2230
Hall, Michael, 3493
Hall, Walter J., 2650
Hall, Werner Otto, 2537
Haller, Robert A., 3042
Hallmark, Donald Parker, 1356, 2231,

2728, 2969
Hambro, Johan, 449
Hamilton, Edward A., 871
Hamilton, Mary Jane, 2164, 2293, 2375, 2591, 3094, 3247
Hamlin, Talbot Faulkner, 225, 242, 243, 313, 339, 397, 398, 554, 611, 667
Hammad, Muliammad, 1172
Hammons, Mark, 3167
Hampton, Mark, 2646
Hanks, David A., 1372, 1417, 1562, 1580, 1612, 1613, 1614, 1798, 1910, 2161, 2201, 3150
Hanna, Jean Shuman, 351, 640, 1704, 1705, 1764, 3264
Hanna, Paul Robert, 351, 640, 1704, 1705, 1764, 3264
Hansen, Preben, 504
Harbeson, John, 313
Harboe, Thomas, 1817
Hardy, Hugh, 1180
Harland, Marion, 098
Harmel, Francoise, 242
Harmon, Robert B., 1751
Harnoncourt, Rene d', 691
Harper, William Hudson, 048
Harriman, Georges, 477
Harrington, Elaine, 2315, 2923, 3400
Harrington, Kevin, 1737
Harris, Harwell Hamilton, 1009, 1270
Harris, Jeffrey, 1933
Harris, Neal, 1371, 1437
Harris, R.R., 554
Harrison, Vernon, 386
Harrod, Tanya, 2615, 2865
Hart, Sharon, 3072
Hart, Spencer, 2592, 3148
Hart, Thomas L., 2877
Hartmann, Kristiana, 2413
Hartmann, Rahel, 3151
Hartmann, Robert R., 2717
Hartoonian, Gevork, 2232, 2700
Hartsuyker, Hendrick, 583
Hartwell, Frances, 441
Hartwell, Patricia, 1321
Haruhiko, Fujita, 3494
Hasbrouck Peterson Associates (firm), 2280, 2281, 2282
Hasbrouck, Marilyn, 1649

Hasbrouck, Wilbert R., 015, 042, 043, 044, 067, 076, 087, 554, 1173, 1209, 1330, 1371, 1962, 2420
Haskell, Douglas, 175, 209, 243, 245, 265
Haskett, R.C., 1256
Hatton, Brian, 2058, 2811
Hatz, Elizabeth, 2811
Haverstick, Iola, 913
Haverstick, John, 757
Hayeem, Abe, 1125
Hearn , M.F., 2414
Heartney, Eleanor, 2537
Heath, William R., 057, 063
Heathcote, E., 3401
Heba, G., 3495
Heck, Sandy , 2007, 2141, 2162, 2716,
Heckscher, Morrison H., 1389, 1408, 1478
Hector, Denis, 2710, 3239
Hedrich-Blessing, 1673, 2923
Heesen, W., 1848
Hegemann, Werner, 146, 192
Heggland, Timothy, 2295
Heinz, Thomas A., 1467, 1558, 1615, 1663, 1718, 1719, 1752, 2470, 2593, 2594, 2595, 2596, 2701, 2702, 2703, 2814, 2924, 3361, 3362, 3522
Hellman, Louis, 1892
Helmer, Stephen D., 1664
Helms, Carol, 3299
Hemingway, George R., 090
Henderson, Harold, 2388, 2728
Henderson, Justin, 2163, 2001
Henkel, Alfons G., 2415
Henken, David, 1911
Henken, Priscilla J., 723, 1911
Henle, Guy, 985
Henning, Heinrich, 640
Henning, Randolph C., 1912, 2471, 2751, 2877, 3183, 3195
Henry, Jay C., 1539, 2606
Hentges, M., 1817
Herberholz, Barbara, 2848, 3073
Herbert, Gilbert, 1006, 1271
Herbert, Wray, 3300
Hermanns, Henner, 2316
Herrick, George, 374
Hertz, David Michael, 1147, 2472, 2815
Herzog, S., 2416
Herzog, William T., 1072

Hess, Alan, 2319
Hess, Thomas B., 918
Heyer, Paul, 1174
Heyman, Mark, 474, 1795, 1920, 2317, 2586, 2615, 2647, 2925
Heynen, Hilde, 2811, 3147
Heywood, Robert B., 498
Hicks, Clifford B., 532
Higuchi, Kiyoshi, 1219, 1390
Hilberseimer, Ludwig, 161, 240, 1075
Hildebrand, Grant, 1479, 1665, 1765, 2376
Hill, David R., 2202, 2648
Hill, John de Koven, 773, 781, 782,
Hilpert, Thilo, 2649
Hilton, Als, 2885
Hindman, Leslie, 2284
Hines, Thomas S., 1180, 1220, 1341, 1371, 1805, 2058, 2085, 2477, 2484, 2489, 2607, 2849, 2850
Hinterhuer, Howard, 3094
Hinton, Peter, 3052
Hintz, Martin, 3523
Hirst, Arlene, 2851
Hisey, Lehmann, 511
Hisey, Pete, 2861
Hitchcock, Henry-Russell Jr., 171, 174, 176, 189, 241, 315, 397, 399, 441, 452, 497, 505, 506, 643, 826, 866, 912, 931, 1024, 1096, 1221, 1270, 1312, 1506, 1755
Hitler, Adolph, 405
Hladik, Murielle, 3298
Hoban, Sarah, 3402
Hobson, Lloyd Henri, 015, 036, 083, 1173
Hockenhull, Jim, 2534
Hodgkinson, Patrick, 2929, 3074
Hoesli, Bernhard, 1666
Hoff, Robert van 't, 121, 1213, 1227, 1618, 1621, 1700, 1748, 2320
Hoffman, Lieselotte, 1704
Hoffman, Max, 766
Hoffmann, David, 2473
Hoffmann, Donald, 242, 1282, 1412, 1432, 1509, 1531, 1563, 1564, 1601, 1603, 1705, 1752, 1807, 1847, 1918, 1978, 2129, 2291, 2473, 2475, 2535, 2650, 2651, 2816, 2925, 3139, 3363
Hoffmeyer, Albert L., 1286

Hogenboom, Maurice, 1256
Hoggard, Liz, 3184
Holden, Arthur Cort, 932
Holder, Julian, 2712
Holst, H. V. von, 010, 115
Holzheuter, John O., 2295
Hood, Raymond, 415, 2608
Hoover, Herbert, 3439
Hoppen, Donald Walter, 1869, 2597
Horsham, Michael, 3952
Howard, Ebenezer, 1530
Howard, Hugh, 2233, 3466
Howard, Lucy, 2532
Howe, George, 242, 251
Howe, John Henry, 1286, 1505, 2383,
 2411, 2613, 3189, 3230
Hower, Barbara K., 2417, 2493
Howett, Catherine M., 1766
Hucker, Jacqueline, 3185
Hudnut, Joseph, 394, 928
Huggler, Max, 507
Hughes, Robert, 3186
Hughes, Talmadge C., 693
Hugo, Victor, 041, 249, 2206, 2294
Hult-Visapaa, Irja, 2716
Hunt, Leigh, 016
Hunter, Paul, 395
Huntington, Richard, 3248
Hurley, D. J., 912, 1010, 1012, 1017
Huxtable, Ada Louise, 833, 933, 1071,
 1107
Hyrum Pope and Harold Burton (firm),
 3185

Iannelli, Alfonso, 1052, 1154
Iglesias, Helena, 2752
Ikuta, Tsutomu, 1207
Illsley, Charles E., 065
Imrey, Celia, 2538
Infante, Rosemary, 3075
Ingraham, Elizabeth Wright, 474, 1464,
 1667
Insolera, Italo, 1126
Iovine, Julie V., 2484, 2489, 2607
Irace, Fulvio, 2086
Irigoyen, Adriana, 3076, 3403
Isasi, Justo F., 2972
Ison, Mary, 1804
Isozaki, Arata, 1310, 2875

Ito, Toyo, 2926
Ives, 2472
Jackson, J.G., 1145
Jackson, J.W., 867
Jackson, K.G., 1077
Jackson, Neil, 1998, 2133
Jackson, Paula Rice, 2652
Jacobs, Jane, 2648
Jacobs, Catherine, 1564
Jacobs, Herbert Austin, 640, 1055, 1517,
 1564
Jacobs, Stephen W., 1096
Jacobus, John M. Jr., 912
Jaeger, Falk, 2537, 3150
Jaffé , Hans Ludwig C., 154
Jaffe, Matthew, 2852
James, Cary, 1244
Jandl, H. Ward, 1432, 1509, 2470, 2489,
 2601, 2613, 2712
Jaquet, G. Jake, 2418
Jean-Pierre, V.M., 1147, 2815
Jefferies, Victoria, 226, 2310
Jencks, Charles, 1186, 1761, 1799
Jennings, Michael, 1024
Jensen, Jens, 1027, 1209, 2888
Jensen, Robert, 1518
Jiménez, Víctor, 3404
Jimeno, Oswaldo, 1409
Jiránek, Milos, 035
Jochern, Frederick L., 191
Jodidio, Philip, 1918, 2536, 2865
Johannes, Ralph, 2853
Johannessen, Eric, 1524
Johannesson, Lena, 091
John McAslan and partners (firm), 3529
Johnson, Donald Leslie, 119, 127, 144,
 1322, 1371, 1533, 1668, 2010, 2087,
 2088, 2089, 2090, 2165, 2166, 2255,
 2283, 2973, 2974, 2975, 3364
Johnson, H.P., 928
Johnson, Ivan E., 2724, 3038
Johnson, James Turner, 1794
Johnson, Kathryn C. (Kate), 1438, 1720
Johnson, Linda Nelson, 2419, 2728
Johnson, Philip Cortelyou, 241, 441, 479,
 497, 508, 558, 834, 835, 928, 1034,
 1270, 2022, 2382, 2529, 2575, 2613
Johnson, Samuel C., 1616
Johonnot, Rodney F., 055

Joncas, Richard, 2377, 2653
Jones, A. Quincey, 928
Jones, Anna Lloyd, 1667
Jones, Cranston, 934
Jones, E. Fay, 2382, 2447
Jones, Jane Lloyd, 363
Jones, Jenkin Lloyd, 1617, 1820
Jones, Lloyd (family), 1144, 1667, 1970, 1975, 1976, 1989
Jones, Nell Lloyd, 363
Jones, Trevelyn E., 2481, 2922
Jongbloed, Karin, 2058
Jordan, Robert Furneaux, 584, 935
Jordy, William H., 748, 868, 912, 936, 1376
June, Frank H., 090
Kähler, Gert, 2712
Kahn, Albert, 375
Kahn, David, 3405
Kahn, Ely Jacques, 243, 259, 474
Kahn, Eve M., 2318, 2420, 2854, 3301, 3302, 3472, 3475, 3496
Kahn, Louis, 928, 1024, 1082, 1093, 2299, 2810, 3138
Kalec, Donald G., 1127, 1266, 1412, 1467, 1705a, 1721, 1999, 2293
Kaliski, John, 1870
Kamin, Blair, 2506
Kamrath, Karl, 844, 1121, 1233, 1464, 2429
Kantorowich, Roy, 418
Kao, Kenneth Martin, 2654
Kappe, Shelley, 1871, 2655
Karasick, Dorothy K., 2599
Karasick, Norman M., 2599
Karfík, Vladimir, 2091, 2673
Karpel, Bernard, 745, 773
Karson, Robin, 2011
Kassler, Elizabeth Bauer, 1464, 1706, 1935, 3214
Kauffman, B., 3406
Kaufman, Mervyn, 1872
Kaufman, Peter S., 2938
Kaufmann, Arthur C., 611
Kaufmann, Edgar J., 3235, 3276, 3277, 3368
Kaufmann, Edgar J. Jr., 041, 087, 105, 179, 180, 181, 182, 185, 186, 197, 225, 242, 313, 345, 364, 487, 508, 509, 512,

577, 611, 624, 644, 645, 718, 726, 736, 746, 784, 826, 836, 837, 868, 872, 877, 912, 918, 928, 1017, 1030, 1080, 1086, 1101, 1108, 1155, 1156, 1187, 1266, 1283, 1428, 1439, 1464, 1583, 1669, 1700, 1705, 1722, 1767, 1768, 1979, 2012, 2204, 2234, 2244, 2361, 2629, 2719, 2817, 2902
Kauten, Mat, 667
Kay, Jane Holtz, 1412, 2929
Kealing, Bob, 3407
Keats, John, 016
Keeney, Gavin, 3472
Keim, Christiane, 3147
Keister, Kim, 2319
Kelleher, Terry, 3187
Kelley, David, 449
Kelley, David, 449
Kelley, Stephen J., 2421
Kellogg, Cynthia, 937
Kellogg, Louise Phelps, 242
Kelly, Annie, 2976
Kelly, T.C., 907
Kennedy, Robert Woods, 718
Kennedy, Sighle, 533, 554
Kennedy, Warnett, 783
Kennedy-Grant, Philip S., 083, 1906
Kenner, Hugh, 1936
Kenny, Sean, 1050
Kent, Cheryl, 1998, 2148, 2167, 2506
Kenton, Mary Jean, 2422
Kerenyi, Jozsef, 2013
Kerr, Joe, 2615, 2753
Kessler, Brad, 3303
Ketcham, Diana, 2477, 2484, 2489, 2607
Key, Ellen, 091
Kidder Smith, G.E., 747, 2656
Kief-Neiderwohrmeier, Heidi, 1565, 2429
Kienitz, John Fabian, 144, 453, 462
Kiesler, Frederick, 938
Kimball, Roger, 1993, 2716
Kimball, Sidney Fiske, 178, 242, 452, 1506
Kimmelman, Michael, 1814
Kinch, Richard, 1707
Kingsbury, Pamela D., 2475, 2837, 3408
Kinni, Theodore, 2382
Kipling, Kay, 3304
Kirishiki, Shinjiro, 1256

Kirsch, Karin, 2926
Kirstein, Lincoln, 914, 1010
Kjoer, Bodil, 1024
Klepp, L.S., 2489
Kley-Bekxtoon, Annette van der, 1848
Kliment, Stephen A., 2537
Klinkow, Margaret, 2235, 2423, 2704
Klotsche, Charles, 2242
Kluger, M., 2424
Klukas, Arnold W., 2657
Klumb, Henry, 1464, 2613
Knapp, William, 667
Knecht, Barbara, 3409, 3497
Knevitt, Charles, 2716
Knight, Caroline, 3467
Knight, Terry Weismann, 2705
Kobayashi, Bunji, 1256
Koehl, Carla, 2986
Koehler, Cortis T., 1566
Koehler, Donald, 463
Koehler, Robert E., 1220
Koeper, Frederick, 1807
Koepf, Corrinne, 3049
Koerner, Brendan I., 3188
Kogler, Silvia, 1012
Komanecky, Michael, 2349
Komoto, Shinji, 2378
Konicek, J., 2855
Koning, Hank, 1723
Koplos, Janet, 1562, 3150
Koppelkamm, Stefan, 2168
Koppes, Neil, 1323
Korab, Balthazar, 2658, 3050, 3148
Korab, Christian, 3148, 3241
Kornwolf, James D., 1913
Koshinsky, Deborah Husted, 3151
Kostanecki, Michal, 273
Kostka, Robert, 092, 1101, 1188, 1324,
 1806
Kostyal, K.M., 2856
Kotik, Charlotta, 1650
Kotre, John, 3152
Kotre, Kathy B., 3152
Kramer, Hilton, 746, 797, 918
Kraus, Russel, 2385
Krellig, Heiner, 2320
Krens, Thomas, 2616, 2668, 2818, 2938
Krier, Leon, 449
Krisch, Ruediger, 3305

Kroch, A., 144
Krohe, James Jr., 3306, 3410
Kronenburg, Robert, 2071
Kronick, Richard L., 3189
Kruty, Paul Samuel, 2092, 2659, 2857,
 3153, 3411
Kuh, Katharine, 918
Kuhn, M.S., 1050
Kuhnert, Nikolaus, 2425
Kuhweide,Peter, 2493
Kultermann, Udo, 878
Kump, Peter, 2274
Kuo, Yuan-Hsi, 225
Kuranishi, Mikio, 2767
Kusamori, Shinichi, 1873, 1937
Kwartler, Michael, 2007
La Farge, John, 826
Labine, Clem, 2702, 2703, 3209
Lacey, Robert, 2977
Lafontaine, Bruce, 3051
LaFrank, Kathleen, 2058
LaGuardia, Cheryl, 2612, 2861
Lahendro, Joseph Dye, 1691
Lahiji, Nadir, 3147
Lambert, Phyllis, 2397
Lambertucci, Alfredo, 1189
Lamoreaux, Jeanne, 585
Lamp, Robert, 2164, 2293
Lampugnani,Vittorio Magnago, 1756,
 1825
Landau, Dora, 229
Landecker, Heidi, 2937, 2955
Landgren, Marchal E., 144, 872, 1050
Landrum, Gene N., 2927
Lang, G., 3307
Langmead, Donald, 119, 127, 144, 2320,
 2660, 3364
Lanooy, C.J., 1848
Lao-tzu, 1873
Laporte, Paul M., 559
Laraway, Frank, 3245
Lardner, Ring, 249
Larkin, David, 2601
Larkin, John Durant, 1778
Larson, Jeanette, 2482, 2720, 2724
Larson, Paul, 1753
Larson, Philip, 1620, 1769, 1854, 1918
Larson, Soren, 3207, 3308
Laseau, Paul, 2379

Lasky, Jane, 3190
Lathrop, Alan K., 1771
Lautner, John E. Jr., 315, 415, 2429, 2900
Lavagnino, Emilio, 1034
Le Corbusier, 188, 240, 418, 483, 537,
 613, 643, 1010, 1048, 1094, 1352, 1390,
 1518, 1530, 1532, 1737, 1829, 1906,
 1919, 2091, 2181, 2252, 2258, 2598,
 2645, 2649, 2673, 2698, 2721, 2920,
 2951, 3138, 3366, 3398
Le Coultre, Martijn F., 3468
Leavenworth, Russell E., 2819
Lebeau, J.J.C., 1848
Lederer, Arno, 2978
Ledes, Allison Eckardt, 3077, 3078, 3251,
 3252
Lee, Doris, 2858, 3487
Leedy, Walter C. Jr., 2294
Leering, Jean, 1621
Leeuwen, Thomas A.P. van, 1849
LeFuere, Camille, 2661
LeGates, Richard T., 295, 2928
Legler, Dixie, 3241, 3242, 3412
Lehmann, Federica, 2476, 3243
Leibson, Beth, 2239
Leighey, Marjorie F., 1266
Leipziger-Pearce, Hugh, 1078
Leitl, Alfons, 611, 646
Lemos, Peter, 2511, 2716
Leonard, J., 3207
Leong, Roger, 2859
Lepage, Robert, 3208
Lepre, Vincent, 1817
Lever, Jill, 2615
Levi, Carlo, 1046
Levin, Earl A., 939
Levin, Jay, 2734
Levin, Meyer, 316, 1708
Levine, Joshua, 3283
Levine, Neil, 1755, 1821, 2014, 2093,
 2129, 2230, 2248, 2478, 2483, 2716,
 2929, 3259, 3260, 3368
Levinson, Nancy, 2426
Lewis, Charles F., 1128
Lewis, Darcy, 3079
Lewis, Julia Einspruch, 3235, 3309, 3413,
 3414
Lewis, Lloyd, 474, 552,
Lewis, Michael J., 3356

Liang, Yen, 285, 2615, 3245
Libby, Brian, 3498
Libeskind, Daniel, 3415
Libois, Brigitte, 3150
Licht, Ira, 1251
Light, Amy Gray, 2321, 2322, 2346
Lind, Carla, 2205, 2477, 2508, 2706,
 2707, 2708, 2709, 2820, 2821, 2822,
 2823, 2930
Lindenfeld, Lore, 2427
Linder, Paul, 1013
Linn, Björn, 083
Linn, Charles, 2428
Lippincott, Roy, 097
Littleton, Gregory, 2237
Littman, Margaret, 3191
Liverant, Bettina, 2204
Lizon, Peter, 1874
Lockhart, Kenneth B., 2615
Lockhart, Susan Jacobs, 2979
Lockwood, Charles, 1670, 1671, 1772
Lodge, Sally, 2724
Lods, Marcel, 919
Loeb, Gerald, 586
Loeffelholz, Stephen Calvert, 3365
Lombardo, Daniel J., 2612, 2699, 2716
Lønberg-Holm, Knud, 210
Long, Christopher, 2429
Long, David Gilson de, 441, 1623, 1672,
 1773, 1801, 1971, 2129, 2430, 2937,
 3150
Long, James de, 3080
Longstretch, Richard, 2929
Lootsma, Bart, 2716
Lopez, Manuel D., 1850
Loring, Jessica Stevens, 2479
Lorm, C. de, 1848
Lotz, Wilhelm, 231
Louchheim, Aline B., 695
Love, Jeannine, 1724
Love, Kenneth, 2902
Loveman, Amy, 241
Lowe, David, 1673
Lownie, Theodore, 3251
Loyer, Béatrice, 3150
Lucas, Suzette A., 2602, 2665
Lucie-Smith, Edward, 1190
Ludwig, Delton, 1774
Luke, Timothy W., 2141, 2480

Lupton, Ellen, 3468

Lustig, Alvin, 2945

Lutyens, Edwin Landseer, 1281, 1833, 2278, 2829

Lynes, Russell, 918, 1481, 1875

Lyons, Ivan, 2285

Lyons, Nan, 2285

Lysiak, Waldemar, 1754

MacAdam, Barbara, 2613

MacAgy, Douglas, 612

Macaulay, Stewart, 2980

MacCormac, Richard Cornelius, 1252, 1439, 1624, 1700, 2380, 2860

MacDonald, Randall M., 2481

Mack, Thomas B., 2603

MacKenzie, Archie Bovier, 2380

Mackey, K., 2755

Mackintosh, Charles Rennie, 2926

Maddex, Diane, 3154, 3244, 3366, 3469, 3470

Maher, Virginia Jones, 2981, 3192

Mahoney, Diana Phillips, 2861

Mahoney, Elisabeth, 3208

Mahoney, Kathleen, 2538

Maillol, Aristide, 448

Mallet-Stevens, Robert, 144

Maniaque, Careline, 2716

Manny, Carter H. Jr., 2613

Manny, Maya Moran, 3416

Mansberger, Floyd, 2170

Manson, Grant Carpenter, 015, 087, 677, 678, 758, 868, 1017, 1050, 1094, 2058, 2238, 2323, 3080

Marantz, Kenneth, 2588, 2724, 3268

March, Lionel, 1325, 1700, 2728

Marchesini, Marco, 2539

Marcial, José, 2540

Marcoux, Suzanne, 3367

Marder, Tod A., 1845

Marefat, Mina, 3230

Marefat, Mina, 3233

Marel, S. van der, 1848

Margolies, Jane, 2541, 2982

Marguerite, Sister M., 1144

Mariani, Anthony, 3417

Marin, John, 3042

Marin, Rick, 3207

Marlin, William, 1284, 1392, 1406, 1477, 1822, 2164, 2324

Marseille, Barbara, 3081

Mårtelius, Johan, 2716

Martin, Howard, 3499

Martin, Norman, 3326

Martin, Paul, 3310

Martinie, A.H., 638

Martinson, Tom, 1418

Martone, Fran, 3077, 3193, 3194

Marty, Myron A., 3245

Marty, Shirley L., 3245

Marvel, Terrence L., 2478, 3252

Marx, Michael A., 1832

Masello, David, 3313

Mason, B., 2171

Masselink, Ben, 2325, 2983, 3082, 3195

Masselink, Eugene, 315, 428, 1000, 1111, 2613, 3430

Massey, James C., 2756

Massey, Raymond, 449

Massu, Claude, 1725, 1826, 2542

Masuchika, Glenn, 2484, 2491, 2607, 2707, 2829, 2929, 2930, 3052

Mateo, Josep Lluis, 1828

Matheou, Demetrios, 449, 2716, 3196

Mather, Alan, 397

Mathews, Stanley, 2716

Matott, J. Lawrence, 2326

Matthews, A., 2239

Matthews, Henry, 2757

Matthews, Peter, 1050

Maughan, Shannon, 2724

Maurogordato, Franca, 499

Mawn, Lawrence E., 243, 718

Maxwell, Emily, 1147

Maxwell, Robert, 2938

Maxwell, Shirley, 2756

May, Robert Carroll, 4428

Mayer Thurman, Christa C., 2909

Mayor, A. Hyatt, 632, 682, 912

Mays, Vernon, 2241

Maza, Aquiles, 587

McAdams, Dan P., 3152

McArthur, Albert Chase, 201, 419

McArthur, Shirley du Fresne, 1802

McArthur, Warren, 2172

McAslan, John Renwick, 2863, 2865

McAslan, Troughton, 2662

McAuliffe, George, 918

McBroom, Kathleen Morris, 2588

McCarroll, Christina, 3500
McCarter, Robert, 3238, 3239, 3251, 3501
McCausland, Elizabeth, 243
McClelland, David, 2937
McClellen, R., 2431
McClintock, T.K., 2985
McCoy, Esther., 785, 1393, 1625
McCoy, Jerry A., 2432
McCoy, Robert E., 1253, 3418
McCray, Carole, 2486, 3502
McDonough, Yona Zeldis, 2482
McFadden, Dennis, 2346
McFetridge, Blanche B., 1274
McGlynn, Mike, 3413, 3487
McGlynn, Mike, 3419, 3503
McGuigan, C., 2537
McIlvaine, Eileen, 2612
McKee, Bradford, 3312
McKinney, Gene, 1009
McLean, Robert Craik, 112
McMahon, A. Philip, 313
McPherson, C.J., 2287
McPherson, William, 1849
McQuade, Walter, 940, 1019, 1071
McQuaid, Matilda, 2295
Mead, Andrew, 2473, 2491, 3083, 3150
Meech-Pekarik, Julia, 1768, 1803, 2129, 2543, 2759, 2864, 3472
Meehan, Partick Joseph, 037, 041, 081, 113, 253, 380, 383, 405, 455, 467, 485, 517, 567, 570, 578, 584, 590, 611, 614, 620, 666, 694, 695, 728, 729, 763, 847, 863, 871, 884, 889, 901, 948, 1230, 1567, 1651, 1674, 1726, 1804, 1805, 1851, 2060, 2128, 2204, 2381, 2382, 2825
Meeks, Carroll, 1096
Mehlman, Robert, 1817
Meier, Richard, 1640
Meikle, J.F., 2283
Meine, Franklin Julius, 649
Meisenheimer, Wolfgang, 1222
Melhuish, Clare, 2865
Melotte, Ralls C., 1776
Melvill, Jean F., 2826
Melvin, Jeremy, 2712
Mendelsohn, Erich, 144, 148, 149, 153, 156, 157, 178, 192, 229, 1343, 1362, 1700, 3256

Mendelsohn, Lousie, 2382
Mendelssohn, Joanna, 3194
Menocal, Narciso G., 041, 474, 1823, 2015, 2141, 2206, 2478, 2483,3368
Merkel, Jayne, 2515, 2811
Messer, Thomas M., 1157, 1466
Meydam, F., 1848
Meyer, Amy, 3272
Meyer, Ernest L., 340
Meyer, Ronny de, 1979, 2383, 2601, 2861, 2877
Meyers, D.A., 2760
Mialet, Frédéric, 1905
Michel, Henry J., 2827, 3246
Michels, Eileen, 1357
Michelucci, Giovanni, 674
Mickunas, Mark, 2173
Middeldorf, Ulrich, 478
Middleton, Haydn, 3471
Mieras, Jan Pieter, 144, 341
Miers, Virgil, 1009
Mies van der Rohe, Ludwig, 405, 441, 479, 497, 593, 643, 646, 660, 732, 928, 1010, 1094, 1270, 1532, 1737, 2060, 2311, 2741, 2951, 2991, 3071, 3084, 3138, 3289, 3435
Millard, Alice, 365
Millard, George, 365
Millay, Edna St.Vincent, 249
Miller, Arthur, 2613,
Miller, Charles, 2094
Miller, Elizabeth G., 1407
Miller, Naomi, 2866
Miller, Nory, 1419
Miller, Patrick D., 2376
Miller, Peter, 3207
Miller, R. Craig, 1519, 1675
Miller, Robert H., 722
Miller, Robert L., 2327
Miller, Ross, 2174, 2328
Miller, S. Reagan, 3197
Miller, Sarah Bryan, 2986
Millikin, Sandra, 1276
Mirviss, Joan B., 2824, 2864
Misawa, Hiroshi, 1207, 1876, 2175
Mise, Ruth, 2095
Mitang, Herbert, 877
Mitchell, David Hannaford, 2245
Mitchell, William J. (1), 1379

Mitchell, William J. (2), 2612, 2861, 2878

Mittelman, Irena, 667

Mizukami, Y., 3420

Mock, Elizabeth Bauer, 415, 450, 534, 577

Moed, Andrew, 2861

Moehl, Karl, 1775, 2544

Moholy-Nagy, Sibyl, 826, 941, 981

Mohr, Richard D., 3198

Mollenhoff, David V., 3094, 3247

Moloobhoy, Sherrif, 560

Molteni, Pierluigi, 2176

Monaghan, Thomas, 1861, 2130, 2148, 2163, 2189, 2201, 2239

Monberg, Gregory H., 3257

Moncrieff, Elspeth, 3504

Monfried, Andrea E., 2242

Monkhouse, Christopher P., 2604

Monroe, Harriet, 1700

Monroe, Marilyn, 1941

Montagu, Ashley, 1242

Montooth, Charles, 1130, 1584, 2987

Moonan, Wendy, 2937

Moor, Abby, 3462, 3524

Moore, Ann W., 2922

Moore, Charles, 826

Moorhead, Gerald, 2429

Moran, Maya, 1676, 1877, 2828, 3410

Morassutti, Bruno, 759, 942

Moreau, P., 1817

Morey, Jean, 638

Morgan, Don L., 1158

Morgan, Keith, 2914

Morgan, W.T., 1677

Morin, Relman, 855

Morley-Horder, P., 392

Mornement, Adam, 3094, 3340

Morris, Robert, 2433

Morris, William, 3115

Morrison, Hugh, 297, 554, 868

Morrow, Irving F., 225

Morse, Richard R., 1776

Morse-Fortier, Leonard J., 2761

Morton, David, 1682, 2097

Morton, Terry Brust, 1156, 1223, 1266, 1301

Moser, Werner Max, 150, 443, 640, 943, 944, 945

Moses, Robert, 446, 928, 1313, 2613

Mosher, Byron, 2613

Mosher, Robert, 428, 773

Mostoller, Michael, 1938

Moutschen, J., 229

Moya, Luis, 589

Mueller, Paul, 2204

Muggenburg, James, 745, 1377

Muirhead, Betty, 1728

Muirhead, Robert, 1728

Muldoon, Paul, 2560, 2605

Mullgardt, Louis Christian, 130

Mullins, Richard, 3199

Mumford, Lewis, 041, 144, 174, 177, 209, 241, 342, 425, 637, 668, 870, 910, 918, 928, 1034, 1081, 1097, 1159, 1599, 2648, 3461

Mumford, M., 2243

Munkenbeck, Alfred, 2038

Munoz, Maria Teresa, 2096

Munroe, Wortley, 191

Munshower, Susan Scott, 041, 2206

Murdock, Henrietta, 464

Murphy, Bruce, 2988

Murphy, James A., 2141, 2494

Murphy, Wendy Buehr, 2286

Murray, Lori, 3417

Muschamp, Herbert, 1799, 1806, 1824, 1878

Myers, Christopher A., 2989

Myers, Frances, 1684

Myers, Peter, 2586, 2929

Myerson, Jeremy, 2712

Nacher, Yves, 2716

Naden, Corinne J., 1245

Naito, Tachu, 1248

Nalbantoglu, Gúlsúm Baydar, 3040

Napier, A. Kam, 3421

Narkiewicz-Laine, Christian K., 142, 3248

Nasatir, Judith, 2937

Nash, Eric Peter, 2933

Neale, Gregory, 2016

Neale, Patricia, 449

Nee, Shannon, 3094

Neider, J., 2867

Nelson, Arthur C., 2868

Nelson, Carl L., 2017, 2506

Nelson, George, 449, 480

Nelson, James, 1851

Nelson, Robert S., 021, 2129

Nemtin, Frances, 3313, 3369
Nerdinger, Winfried, 3422
Nereim, Anders, 2346
Nervi, Pier Luigi, 809
Nesmith, Lynn, 1947, 2007, 2066, 2097, 2177, 2244, 2245, 2246, 2319
Ness, Cynthia van, 3054
Nestingen, Ivan A., 777
Neumann, Dietrich, 2990
Neumeyer, Fritz, 479
Neutra, Richard Joseph, 152, 911, 928, 1006, 1343, 2499
Newcomb, Rexford, 441
Newhall, Edith, 3475
Newhouse, Victoria, 3200
Newnham, Peter, 377
Newton, David, 2098, 2178, 2247
Nicholls, Richard E., 3474
Nichols, Lewis, 679
Nickens, Eddie, 2762
Niedecken, George Mann, 1712, 1988, 3252
Niesewand, Nonie, 2018
Nivala, J.F., 2869
Nobuyoshi, Kusaba, 083
Noel, Miriam, 2324
Noffsinger, James Philip, 1678
Nolan, M. Therese, 3423
Nonnig, Jorg, 3201
Norberg-Schulz, Christian, 1024
Nordland, Gerald, 2141
North, J. N., 242
Northrup, Dale, 2991, 3085, 3314
Norton, Margaret Williams, 1727
Nott, Charles Stanley, 405, 428, 1272
Noviant, L.Q., 638
Novick, Lynn, 3207
Novinger, Virginia B., 1224
Novitski, Barbara Jo, 2952, 3315
Nugroho, Sam, 2491
Nunziante, Marinetta, 2716
Nyller, Rolf, 1147
Nyman, Thor, 1191
Oboler, Arch, 879, 2766
O'Connor, Lorraine Robie, 1689
O'Connor, Michael J., 3202, 3316
Ogata, Amy F., 3147
O'Gorman, James F., 1267, 1285, 1371, 2383

Okura, Shunji, 1873, 1937
Olin, Laurie, 2330, 2716
Oliver, W. Kelly, 1009
Oliver, William, 1117
Ols, Nicholas, 3203
Olsen, Susan, 2992
Olson, Allen R., 1286
Olson, Catherine Applefield, 3160
Onorato, Ronald J., 1982
Orage, A.R., 1272
Ortiz, Renato, 2545
Osman, Mary E., 1244, 1918, 1984, 2060
Osterhof, Christiane, 2537
Ostertag, Blanche, 1724
Ottolenghi, Marinella, 647
Oud, Hendrik Emil (Hans), 1852
Oud, Jacobus Johannes Pieter, 119, 144, 154, 240, 636, 946, 1457, 1700, 1748, 1852
Ouspensky, P.D., 1272
Overby, Osmund, 3250
Overy, Paul, 1748
Owings, Frank N. Jr.,
Owings, Frank N., 3087, 3204, 3257
Pach, Walter, 178
Paci, Enzo, 981
Page, Amy, 2824
Page, Max, 3153
Pagiolo dell'Arco, Marcello, 1679
Paik, Felicia, 2993, 3205, 3424
Palco, Igor, 2546
Palumbo, Peter, 3283
Paola, Luis de, 449
Papa, Dominic, 3150
Papadaki, Stamo, 285
Papanek, Victor, 2429
Pappas, Bette Koprivica, 1914, 3088
Parade, Brigitte, 1777
Parade, Christoph, 1777
Parkyn, Neil, 1860, 2287
Pascucci, Ernest, 2937
Patner, Andrew, 2547
Patrulius, Radu, 1287
Patterson, Augusta Owen, 343, 400, 463
Patterson, John, 1757
Patterson, Richard, 2230, 2248
Patterson, Terry L., 2711
Pawley, Martin, 364, 1207, 1267
Pearce, John N., 1266

Pearman, Hugh, 2058, 2376, 2615, 2663
Pearson, Clifford A., 2436, 2712
Pearson, Gay L., 1728
Pearson, Michael, 1225
Peatross, C. Ford, 1549, 1801, 2937
Pedio, Renato, 1109, 1441, 2099
Pegler, Westbrook, 249
Peikoff, Leonard, 449
Peisch, Mark L., 1118
Pélissier, Alain, 2179
Pellegrin, Luigi, 786, 838, 839, 1031
Pellegrini, Enrico, 561
Penfield, Louis A., 444, 1879
Penfield, Paul, 3425
Percival, C.E., 058, 059, 060
Peres, Anthony, 3200
Peressut, Luca Basso, 667
Pérez Palacios, Augusto, 1098
Perkins, Dwight Heald, 025, 030
Perkins, G. Holmes, 947
Perkins, John , 1939, 2019
Perlez, J., 2537
Perrin, Richard W.E., 1131, 1395
Perrone, Jeff, 1940
Perrone, Vito, 2482
Persico, E., 981
Persitz, Alexandre, 680, 919
Persky, Seymour H., 2914
Peter, John, 2712
Peters, Matthew, 918
Peters, William Wesley, 428, 1023, 1051,
 1210, 1246, 1512, 2180, 2390, 2613
Petersen, Laurie McGovern, 2610
Peterson, Jay, 335
Petrilli, Amedeo, 2664
Pevsner, Nikolaus, 242, 378
Pfeiffer, Bruce Brooks, 037, 041, 042,
 043, 044, 056, 067, 077, 083, 092, 105,
 112, 116, 131, 133, 137, 142, 143, 144,
 159, 165, 166, 167, 168, 169, 178, 179,
 180, 181, 182, 183, 184, 185, 186, 187,
 188, 209, 215, 217, 219, 224, 225, 226,
 230, 233, 242, 243, 249, 250, 251, 253,
 256, 258, 260, 272, 276, 277, 283, 285,
 286, 297, 298, 308, 310, 311, 313, 345,
 364, 381, 383, 552, 611, 619, 624, 636,
 638, 639, 640, 649, 650, 667, 668, 669,
 688, 691, 718, 764, 773, 779, 826, 872,
 883, 886, 887, 960, 1018, 1077, 1414,

1420, 1425, 1426, 1462, 1503, 1504,
 1541, 1807, 1853, 1854, 1915, 1916,
 1917, 1918, 1941, 1983, 1984, 1985,
 1986, 1987, 2061, 2062, 2063, 2064,
 2141, 2142, 2143, 2207, 2208, 2244,
 2263, 2287, 2288, 2289, 2289a, 2289b,
 2290, 2331, 2384, 2385, 2386, 2484,
 2485, 2548, 2601, 2607, 2608, 2665,
 2713, 2722, 2728, 2767, 2824, 2829,
 2871, 2878, 2995, 3089, 3317, 3318,
 3474
Phelan, Carolyn, 2724
Phillips, J.C., 2332
Phillips, Patricia C., 1814, 1911
Pica, Agnoldomenico, 481, 868, 1395,
 1442, 1505, 2100
Picasso, Pablo, 448, 1536
Pickens, Burford, 801
Pickrel, Debra, 2996, 3091, 3229, 3426
Pieper, Iovanna Lloyd, 760
Pierce, Edward F., 1924
Pierson, William H., 2914
Pillow, Joyce, 3319
Pinck, Dan, 2489
Pinckheard, John, 242, 243
Pinnell, Patrick, 2141, 2380
Pittel, Christine, 2537, 3938
Platounoff, Igor George, 3370
Platt, Christopher Joseph, 3150
Plattus, Alan, 2537
Plestina, Lenko, 3427
Plummer, Henry, 2249, 2437
Podmolik, Mary Ellen, 3428
Poise, A.D., 1012, 1020
Pokorny, Elizabeth, 746
Polano, Sergio, 119
Polin, Giacomo, 2872
Polivka, Jaroslav Joseph, 487, 2180
Pollak, Martha, 2020, 3040
Pollock, Jackson, 2183
Pollock, Naomi R., 2549
Polony, Sylvain, 3320
Polson, Mary Ellen, 3321
Pommer, Richard, 2383
Ponte, Alessandra, 2997, 3092
Ponti, Gio, 464, 1256
Pope, Hyrum, 3184
Pope, John Russell, 347
Pope, Loren, 454, 535, 1156, 1266, 2382,
 2550

Popham, Peter, 2021
Porfolio, Raymond L., 1817
Porro, Ricardo, 1914
Portela, Francisco V., 510, 681
Porter, Franklin, 1667, 1989, 2613
Porter, Mary, 1667, 1989
Posey, Sam, 2984
Posner, Ellen, 2551, 2552
Potterton, Homan, 2201, 2250
Pound, Ezra, 3413
Powell, Kenneth, 3517
Power, Mark, 3093
Pratt, Richard, 465
Preddy, Jane, 2333
Pregliasco, Janice, 2909
Preston, Charles, 871
Pretzer, Michael, 2768
Price, Don, 2334
Price, Harold C., 928
Price, Martin, 1456
Prosyniuk, Joann R., 2387
Pruette, Lorine, 449
Puglisi, Luigi Prestinenza, 2438, 2716, 2769, 2861, 2874, 2937
Pundt, Herman G., 1171
Punt, Michael, 3235
Purcell, William Gray, 1786, 3167
Purves, Alexander, 2251
Purvis, Alston W., 3468
Puttnam, Anthony, 3094, 3317
Putzel, Max, 317
Pyron, Bernard, 1056
Quesada, Luis Mior, 1013
Quetglas, Josep, 2714
Quinan, Jack, 061, 075, 1627, 1778, 1779, 1795, 1847, 2022, 2058, 2065, 2101, 2128, 2141, 2180, 2253, 2254, 2388, 2439, 2440, 2441, 2666, 2698, 2716, 2817, 3095, 3153, 3251
Quinlan, Marjorie L., 2715
Raab, Helen H., 2284
Radd, William J., 1132
Radde, Bruce F., 1265
Radford, Evelyn Morris, 1378, 3155
Radlovic, I. Monte, 771
Raeburn, Ben, 041, 105, 179, 180, 181, 182, 185, 186, 197, 225, 242, 313, 345, 364, 624, 718, 826, 872, 1012, 1265, 1557

Ragghianti, Carlo Ludovico, 611, 674, 724, 1288
Rago, Louise Elliott, 948, 1851
Ragon, Michel, 1032, 1254
Raimondi, Julie A., 3429
Ramber, Francis, 3150
Rana1, Mansinh, 2613
Rand, Ayn (Alisa Zinovievna Rosenbaum), 449, 2053, 3099, 3431
Rand, George, 1680
Randall, John D., 1681, 1808
Randolin, Marina Loffi, 242
Rannit, A., 1024
Ransohoff, Doris, 1074
Raschke, Brigitte, 2934
Rashid, Bob, 3523
Rattenbury, John, 1682, 2456, 2554, 3097, 3371
Rattenbury, Kay Schneider, 3097, 3130
Rattenbury, Kester, 2698, 3147, 3207
Ray, David, 844
Raymond, Antonin, 113, 1410, 3298
Read, Herbert, 242, 667
Reade, Eric, 1530
Rebay, Roland von, 1289, 1587, 2998
Rebori, Andrew N., 144, 162
Reed, Christopher, 2941
Reed, Danielle, 3505
Reed, Henry Hope Jr., 638, 725, 736
Reed, O.P., 1814, 3430
Reed, Peter, 2716
Reidy, Peter, 449, 2379, 2609, 2613, 2697, 2711, 2828, 3098, 3099
Reinberger, Mark, 1881, 1942
Reinius, Leif, 2181, 2252
Reinsch, Daniela, 2537
Reisley, Roland, 3473
Reitherman, Robert King, 1683
Reitzes, Lisa B., 3038
Remmele, Mathias, 3150
Rensch, G.K., 242
Renzi, Jen, 3475
Renzio, Toni del, 1482
Replinger, John, 550, 1099
Restany, Pierre, 3431
Reus, Jim de, 949
Rheenen, Jan van, 449
Rhein, Jon van, 2560
Ricalde, Humberto, 2770

Ricapito, Maria, 3206
Rice, Norman N., 254
Richards, James Maude, 495, 674, 687, 1358, 1410
Richards, John Noble, 950
Richards, Kenneth G., 1247
Richards, Kristen, 2667, 3018, 3052, 3077, 3100, 3207
Richardson, Henry Hobson, 568, 748, 1285, 1373, 1389, 2311, 2383, 3388
Richardson, John, 2537, 2664, 2668
Richmond, Deborah, 3432
Richter, Klemens, 2771
Rickard, Bruce, 2157
Rickerd, Julie Rekai, 3208
Rickert, Howard C., 1266
Rickner, Carol, 2066
Ridge, Tom, 3460
Riecken, Andrea, 1521, 2097, 2102
Rienaecker, Victor, 242
Riley, Charles A., 3156
Riley, Frank, 1233
Riley, Terence, 2038, 2486, 2716
Rimanelli, David, 3472
Rintz, Don, 2717
Riofrio, Melissa, 2861
Risdal-Barnes, Michele M., 3433
Rivalta, Luca, 2523
Roark, Howard, 449, 2174
Roback, Diane, 2724
Robbins, Eugenia S., 1192
Robbins, I.D., 1015
Roberts, J. Stewart, 2442
Robertson, Cheryl, 3252
Robertson, Howard, 226, 401
Robie, Frederick C. Sr., 880
Robie, Frederick C., 880
Robinson, Jackie, 3253
Robinson, Kenneth J., 787
Robinson, Sarah, 2772
Robinson, Sidney K., 1539, 1652, 2294, 2443
Robsjohn-Gibbings, Terence Harold, 460, 716, 726
Rocca, Alessandro, 2875
Roche, John F., 2718
Roche, Mary, 562
Rochman, Hazel, 2588, 2720, 2933
Rodney, Marguerite Carn, 2936

Rodriguez, J., 2937
Rogers, Ernesto Nathan, 674, 747, 981
Rogers, Hope, 1508
Rogers, Michael, 2861, 3316
Rollo, J., 2876
Röntgen, F.E., 1024, 1037
Roob, Rona, 2719
Rooney, Andy, 2613
Roos, Frank J. Jr., 290
Rosa, Joseph, 2429
Rosenbaum, Alvin, 2609, 2669
Rosenbaum, David B., 2329
Rosenblatt, Paul, 1939, 2019
Rosenblum, Charles, 3322, 3434
Rosenfield, John, 1009
Ross, A.D., 1412
Ross, Irwin, 1193
Ross, Steven S., 2335
Rossari, Augusto, 2487, 3243
Rossi, Aldo, 1756
Rossi, Sara, 242, 826
Roth, Alfred, 618, 951
Roth, Jack, 668
Roth, Leland M., 1809
Rotunda, J.C., 3208
Rouda, Mitchell B., 2141
Rouillard, Dominique, 1883
Roux-Dorlut, Maya, 1826
Rovere, Luisa Querci della, 1919
Rovere, Richard H., 2999
Rowe, Colin, 788, 1328
Rowe, Peter, 2728
Rowell, Guy, 163
Rowell, M., 1780
Rowlands, Penelope, 3000
Roy, Arnold, 2554
Ruas, Charles, 3472
Rub, Timothy F., 1814, 1882
Rubin, Jeanne S., 2255, 2666
Rubin, Susan Goldman, 2720
Rubino, Luciano, 1255, 1630
Rudd, J. William, 1175, 1550, 1652, 1943
Rudolph, Paul, 1311, 1944
Rumble, Janet L., 2767
Rus, Mayer, 2716
Ruske, Wolfgang, 1709
Russell, James S., 2444, 2773, 3094
Ruthven, Malise, 2555
Ryan, Raymund, 3496

Rybczynski, Witold, 2488, 2712, 2774, 2877
Rykwert, Joseph, 2556, 2586, 2612, 2698, 2716, 3102
Saarinen, Aline B., 746, 840, 1018
Saarinen, Eero, 835, 928, 2382, 3138
Saatchi, Doris Lockhart, 3323
Sacchi, Filippo, 981
Sachner, Paul M., 2097
Sachs, Lisbeth, 640
Sacriste, Eduardo, 1016
Saenz de Oiza, Francisco Javier, 2878
Safford, Virginia, 291
Sage, Jennifer, 2019
Saint, Andrew, 2058, 2586, 2606, 3230
Saint, Andrew, 3233
Sainz, Jorge, 2103
Sakiestewa, Ramona, 2141
Salerno, Nicholas A., 1242
Saliga, Pauline, 2291
Salter, L.J., 511
Saltz, Jerry, 2256
Saltzstein, Joan W., 1290
Samhammer-Habrich, Anke, 2557
Sammartini, Trudy, 1827
Samonà, Guiseppe, 632, 682, 912, 2775
Samton, Claude, 952
Samuels, Gary, 3001
Sanati, Yasama, 2776
Sandburg, Carl, 249, 850, 863, 1851, 2689
Sandefur, Tim, 3207
Sanders, Mary, 474
Sanderson, Arlene, 2388
Sanderson, Warren, 1275
Sardar, Zahid, 3340
Sargeant, Winthrop, 482
Sarnitz, August, 2563
Sartori, Alberto, 3230
Sartoris, Alberto, 3234
Satler, Gail, 3254, 3324
Saylor, Henry, 674
Scarpa, Carlo, 1828
Schaap, David P., 2066
Schafer, Jay, 3247
Schafer, Ueli, 1587
Schall, James V., 841
Schapiro, Meyer, 313
Scharfe, Siegfried, 194, 211, 229
Scheller, W.G., 2558

Schellhardt, Timothy D., 3103
Schelling, H.G.J., 402, 636
Schevill, James Erwin, 3272
Schiller, M., 1684
Schindler, Pauline G., 292, 293
Schindler, Rudolph M., 1883, 2563, 3496
Schmertz, Mildred F., 083, 1012, 1071, 2537
Schmidt, Bill, 1569
Schmidt, Georg, 507
Schmidt, Paul F., 229
Schmidt, Walter, 1685
Schmitz, Marcel, 229
Scholl, Jane, 1009
Scholl, Walter Otto, 1536
Schreck-Offermann, Ursula, 2052
Schrenk, Lisa D., 2559
Schubart, Pauline, 285
Schulte, Marcy, 3104
Schulten, Christoph, 1686
Schultz, Vera Smith, 1810, 3155
Schulze, Franz, 2058, 3435
Schumacher, F. and Co., 670, 769, 823, 908, 2135, 2453, 2909, 3341
Schuyler, Montgomery, 083
Schwartz, Bonnie, 2506
Schwartzman, Alan, 3105
Schwarz, William J., 1704
Schwendener Martha, 3472
Schwentker, James M., 2257
Sciliberto, Elena, 2182
Scott, Edward B., 824
Scott, Margaret Helen, 1855
Scully, Vincent Joseph Jr., 083, 726, 746, 748, 881, 1017, 1057, 1082, 1096, 1687, 1944, 1990, 2022, 2064, 2066, 2129
Seaman, Donna, 2601, 2612, 2933
Seamon, David, 2489
Searing, Helen, 1457, 1755, 1971
Seaux, J., 953
Sebesta, Judith A., 3506
Sechrest, C.R., 269
Seckel, Harry, 344
Secrest, Meryle, 2489, 2716, 2777
Segal, Walter, 1291
Segawa, Hugo, 2712
Seidel, Linda, 021, 2129
Sekler, Eduard F., 882, 954, 2693
Sekulic-Gvozdanovic, Sena, 2014

Selden, Brigitte, 3150
Seligmann, Werner, 2380
Sell, Henry Blackman, 092, 107,
Selvafolta, Ornella, 2105
Semerani, Luciano, 1010
Semper, Gottfried, 2204
Sergeant, John, 1509, 1522, 1600, 1031,
 1795, 1845, 1997, 2429, 2728, 3002
Sert, Jose Luis, 928
Serttas, Turgut, 2023
Sestoft, Jorgen, 2778
Seward, John C., 415, 441
Seyfarth, Ludwig, 2865
Shakespeare, William, 249
Shand, Philip Morton, 147, 294
Shannon, Alan J., 2506
Sharp, Dennis, 378, 554, 1212, 1460,
 2058, 2287, 2337, 2606
Shavin, Gerte, 3003
Shavin, Seamour, 3003
Shaw, Dan, 3038
Shaw, Howard van Doren, 1267
Shear, John Knox, 761, 784
Sheets, Hilarie M., 3436
Sheine, Judith, 3497
Shelley, Percy Bysshe, 249
Sherow, James E., 2382
Shockley, Jay, 2292
Sholta, Jan, 512
Short, Ramsay, 1292
Shubert, Howard, 2937
Sidy, Victor, 3004, 3325
Siffert, Betty Y., 3472
Silberman, Robert, 2716
Silman, Robert, 3434
Silsbee, Joseph Lyman, 001, 006, 008,
 1330, 2090, 2182
Silva, Maria Angelica da, 2183
Silver, Joel, 1929, 3200
Silvi, M., 449
Simanaitis, Dennis, 2880
Simo, Melanie Louise, 2935
Simon, Montie, 1006
Simson, Maria, 3038, 3043, 3052, 3055,
 3056
Sinclair, Brian R., 3106
Sinclair, Fiona, 2828
Sinkevitch, Alice, 2610
Siry, Joseph M., 2445, 2936, 3040

Sisi, Enrico, 683
Skene-Catling, Charlotte, 2929
Skude, Flemming, 2537
Slatin, Peter, 2189, 2489
Slaton, Deborah, 2141, 2389
Sloan, Julie L., 3107, 3475
Smith, Allen, 2861, 3005
Smith, C. Ray, 1083
Smith, Candace, 3459
Smith, Dean E., 1119, 1160
Smith, Herbert L. Jr., 641
Smith, Kathryn, 1569, 1633, 1945, 2184,
 2275, 2376, 2380, 2491, 2779, 2929,
 3055, 3157, 3368, 3437
Smith, Lyndon P., 052
Smith, Michael J.P., 2560
Smith, Nancy K., 1359
Smith, Norris Kelly, 1094, 1176, 1226,
 1267, 1700, 1806, 1973, 2058, 2060
Smith, Sarah Maxwell, 2004, 2382
Smith, W.F., 1530
Snyder, Tim, 1781
Sobin, Harris J., 2185
Soby, James Thrall, 641
Socki, Joseph, 3209
Soderquist, Sandy, 3044
Sokol, David M., 2925, 2936, 3052
Solana, Guillermo, 3108
Soleri, Paolo, 1518, 2202, 2613
Solliday, Scott, 2446
Soltesz, David, 1918, 3233, 3235
Solway, Susan, 2671
Sommer, Robin Langley, 2611, 3050,
 3237
Sorge, Marjorie, 3326
Sörgel, Herman, 157
Sorkin, Michael, 2007, 2024, 2537, 3207
Sostres Maluquer, J.M., 955
Sovik, E., 364
Sowa, Axel, 3527
Spade, Rupert, 1293
Spångberg, Ylva, 449
Speaks, Michael, 2811
Speck, Lawrence W., 2106, 2258
Spencer, Brian A., 1600, 3507
Spencer, Robert Closson Jr., 024, 036,
 049, 2857
Spirn, Anne Whiston, 2937, 3438
Spiselman, Anne, 3327

Spitz, David, 554
Spivey, Ludd M., 651, 928
Sponsler, Julie A., 2346
Sprague, Paul E., 1143, 1371, 1421, 1485, 1510, 1524, 1563, 1700, 1704, 1705, 1795, 1847, 1991, 2293, 2829
St. Aubin, Ed de, 3152
Stady, Stanley E., 135
Staggs, Sam, 2025, 2107
Stanford, Linda O., 2370
Stankard, Mark, 1748
Stanton, Edward, 2613
Stanton, Phoebe, 1371
Stark, Alex, 3436
Starr, Cecile, 773
Startup, Hetty, 2929
Starzynski, Krista, 2561
Stecker, Robert D., 1009
Steegmuller, Francis, 1024
Steel, Carolyn, 2865
Steele, James, 3235
Steiger, Peter, 640
Steiger, Richard W., 2672, 3006
Stein, Gertrude, 2380
Stein, Susan R., 1803
Steinberg, Sybil S., 2489, 2938
Steiner, Frances H., 1811, 1884
Stengade, Erik, 842
Stephan, Regina, 3256
Stephens, Suzanne, 2562, 2716, 2780, 2817
Stern, Arthur, 1776
Stern, Robert A.M., 1729, 1971, 2026
Stevens, Albert, 2108
Stevens, Arthur Dennis, 2339, 2340
Stevens, Mark, 2097
Stevens, Thomas, 667
Stevenson, Dave, 2027
Stiller, Adolph, 3110
Stillman, Seymour, 537
Stillson, Lila, 2429
Stipe, Margo, 2881, 3230, 3460
Stipe, Margo, 3233, 3472
Stitt, F. Allen, 1161
Stockton, Sharon, 3439
Stoddard, Donna M., 563
Stodola, Barbara, 3257
Stokes, Jayne, 2478
Stoller, Ezra, 624, 2109, 2338, 3258, 3259, 3260
Stone, Edward Durell, 928, 956, 1019, 1033, 1486, 2382
Stone, Jabez K., 136
Stone, Maria, 2613
Stone, Peter, 246
Stoney, Samuel Gaillard, 242
Stonorov, Oskar, 611, 640, 928, 1334, 1851
Storrer, Bradley Ray, 1077, 2370, 2536, 2673, 3210
Storrer, William Allin, 1432, 1509, 2138, 2209, 2612
Stout, Frederic, 295, 2928
Stowell, Kenneth K., 538
Stralen, Mariette van, 2716, 3230
Stralen, Mariëtte van, 3233
Stranger, M.A., 487
Strasen, Kristie, 3341
Strassburg, Steve, 3007
Straus, Richard, 3466
Straus, Roger III, 3466, 3477
Strauss, Irma, 1634, 1689
Strawinsky, Igor, 448
Street-Porter, Tim, 2780, 3111
Streich, Eugene R., 1379, 1700
Strever, Beth, 2259
Strutt, James W., 641, 957
Stubbs, Stephanie, 2564
Stucchi, Silvano, 2565
Stungo, Naomi, 3261
Sturgis, Russell, 075, 1779
Sturkenboom, Frans, 2929
Stuttaford, Genevieve, 2489, 2601, 2613, 2712, 2713, 2716, 2938, 3038
Stutts, Will, 3208
Sudjic, Deyan, 2882
Sullivan, Ann C., 2573
Sullivan, Anne T., 3211
Sullivan, C.C., 2716
Sullivan, Francis Conroy, 1789, 2073
Sullivan, Louis Henri, 005, 009, 010, 088, 136, 141, 142, 143, 144, 297, 298, 404, 554, 758, 780, 830, 1118, 1143, 1209, 1337, 1368, 1373, 1389, 1405, 1422, 1484, 1550, 1597, 1600, 1681, 1786, 1943, 1991, 2174, 2383, 2391, 2547, 3149, 3248, 3440
Sullivan, Pat, 3508

Sullivan, T.D., 2883
Summerson, John, 1096, 1267
Svedberg, Olle, 2810
Swaback, Vernon D., 2186, 2566
Sweeney, James Johnson, 918, 928, 1034
Sweeney, Jim, 3008
Sweeney, Karen, 3509
Sweeney, Robert Lawrence, 1569, 1589, 1885, 1998, 2132, 2674, 2723, 2937
Szabo, Shari, 2393
Szarkowski, John, 3440
Tabor, Philip, 2698, 2938
Taccani, G. Colombo, 449
Tacha, Athena, 2884
Tafel, Edgar, 083, 087, 285, 554, 912, 1071, 1244, 1256, 1360, 1509, 1531, 1563, 1601, 1730, 1734, 1782, 1783, 1807, 1851, 1853, 1906, 1979, 2028, 2337, 2341, 2541, 2613
Tait, Allison, 3441
Tallack, Douglas, 2862
Tallmadge, Thomas E., 693
Tanaka, Koichi, 2260
Tanigawa, Masami, 243, 1177, 1341, 1342, 1375, 1427, 1507, 1537, 1538, 1635, 1636, 1653, 1654, 1690, 1856, 2210, 2261, 2378, 2864
Tarantino, Lawrence J., 3009, 3212
Tarbell, B., 2675
Taro, Amano, 717
Tarquinio, J. Alex, 3094
Tattershall, Doug, 3328
Taut, Bruno, 240
Taverne, Ed, 1748
Tawfiq, Ahmad 'abd al-Gawad, 843
Taylor, John, 2007
Taylor, P., 545
Taylor, Richard S., 1714, 1757, 1920
Tedeschi, Enrico, 749
Teicher, Jonathan, 2110
Tenshin, Okakura, 1873, 2870
Tentori, Francesco, 1110
Tepfer, Diane, 2370, 2447
Teske, Edmund, 1433, 1731, 2644, 3070
Thabit, Walter, 872
Theerman, Paul, 2255
Thiel, David, 3442
Thomas, Margaret Dudley, 1446
Thomas, Mark Hartland, 539, 684

Thomas, Michael M., 2885
Thomas, Payne E.L., 1307
Thomas, Scott, 1784
Thomassen, G., 1848
Thompson, Jennifer, 3010
Thompson, John, 3443
Thompson, Steve, 2937
Thomson, Iain, 3056, 3262, 3476
Thoreau, Henry David, 249
Thorne-Thomsen, Kathleen, 2724
Thorpe, John G., 2127, 3112
Thorson, Alice, 2886
Thrift, Charles Tinsley Jr., 750, 1602
Thunnissen, A.W.P., 958
Thurman, Roy S., 407
Tice, James, 1732, 2379
Tigerman, Stanley, 3113
Tillyer, William, 2725
Timpane, John, 3473
Tine, William van, 2977
Tinkle, Lon, 1009
Tinniswood, Adrian, 3263
Tintner, Adeline, 667
Toca Fernandez, Antonio, 2716
Todd, Mike, 894
Toher, Jennifer, 1910
Tolstoy, Leo, 249
Tomkinson, Donald, 441
Tomlinson, Webster, 045
Torcapel, John, 639
Torr, Jeremy, 2861
Townsend, Gavin, 2567
Townsend, Robert L., 441, 565, 1267
Toy, Maggie, 2929
Trauthwein, Christina, 3094
Treiber, Daniel, 1448, 2144
Trétiack, Philippe, 2716
Troedsson, Carl Birger, 613
Troller, Norbert, 463, 513
Troy, Nancy, 1748
Trulsson, Nora Burba, 3444
Trump, James D. van, 1133
Truppin, Andrea, 3038
Tselos, Dimitri, 226, 397, 685, 789, 868, 1294
Tsuchiura, Kamecki, 2613
Tully, Gordon, 2887
Tummers, Nicolaas H.M., 1213, 1227
Tunnard, Christopher, 441, 727

Turak, Theodore, 1331, 2294
Turkel-Deri, F., 229
Turner, Paul Venable, 1691, 1829, 1886, 3261
Turner, Paul Venable, 3264
Twitmyer, George E., 066
Twombly, Robert C., 225, 1176, 1257, 1399, 1412, 1449, 1487, 1509, 1603, 1655, 1991, 2061, 2129, 2141, 2283, 2291, 2383, 2389, 2568, 2909, 3285
Tyrnauer, Matthew, 2716
Udall, Stewart L., 1136, 1156
Udall, Mary C., 394
Upchurch, Diane M., 2922
Urbas, Andrea, 1733
Valentine, Maggie, 2712
Valkema, S., 1848
Vance, Mary, 1812, 2067
Vanderbilt, Tom, 3474
Vaughan, John, 2640
Vebell, Victoria, 449
Veceráková, Markéta, 3213
Vedrenne, Elisabeth, 3150
Velarde, Hector, 1013
Venturi, Robert, 2938
Verdu, Vicente, 2111
Vernon, Christopher, 2888, 2937
Veronesi, Giulia, 483, 1134
Verschuur, Mary B., 3405
Vesa, Marita, 3510
Vickery, Robert L., 1590, 1813
Vidor, King, 449
Vierfe, Christiane, 2029
Viladas, Pilar, 2342
Vinci, John, 083, 1464, 1467, 1485
Viollet-le-Duc, Eugene Emmanuel, 725, 1282, 1980
Viskochil, Larry A., 1857
Visser, Kristin, 2417, 2494, 3044
Völckers, Otto, 686, 844
Voorsanger, C.H., 2678
Voynow, Romola, 212
Vreeland, Francis William, 164
Vriend, Jacoba Johannes, 959
Wade, M.J., 2343
Waern, Rasmus, 449
Waggoner, Lynda S., 2939
Waggoner, Susan, 3114, 3158
Wagner, Betsy, 2812

Wagner, Michael, 2262, 2676
Wagner, Otto, 294, 1910, 2563
Wainwright, C., 1830
Wainwright, J., 1830
Wainwright, Loudon, 1355
Waite, Robert G., 2068, 2390
Walker, Donald, 2613
Walker, Lynne, 3147
Walker, Martin, 3374
Walker, Ralph A., 790
Walker, Ralph, 666
Walker, Terence J., 3106
Walker, Virginia E., 1450
Wallace, Mike, 871, 1851, 3034
Waller, I., 2863
Walsh, Kevin, 2031
Walters, Katrina K., 3214
Walters, Thomas, 3375
Wang, Wilfried, 2810
Warren, John, 1180
Wat, Joanna, 2865
Watanabe, Yoshio, 1248
Watkin, David, 2448
Watrous, James, 274
Watson, Howard, 3208
Watterson, Joseph, 1266
Wattjes, Jannes Gerhardus, 151
Watts, Harvey, 225
Webb, Michael, 2606, 2677, 2824, 3011, 3445, 3477, 3496
Webb, Sam, 1734
Webster, J. Carson, 1267
Weed, Robert Law, 634
Wegg, Talbot, 1332, 2889
Wei, Kuan-Chu, 3262
Weidemer, Noelle, 3272
Weigand, Elizabeth, 1946
Weihsmann, Helmut, 2429
Weil, Martin Eli, 1929, 2035, 2569, 2631
Weil, Zarine, 3478
Weinberg, Robert C., 415, 872, 1010, 1012
Weiner, Egon, 1340, 2382
Weingarden, Lauren S., 1991
Weinstein, Michael, 1831
Weinstein, Norman, 3446
Weintraub, Boris, 3434
Weirick, James, 2187
Weisberg, Gabriel P., 1228, 3473

Weishan, Michael, 3447
Weisman, Kay, 2922
Weisman, W., 1400
Weiss, Ellen, 2058, 2065
Weiss, Norman, 3511
Weisse, Rolf, 1075
Welsh, Frank Sagendorph, 3329, 3448
Welter, Volker, 2615
Wenneker, Lu B., 1153
Wennerstrom, Bruce, 2495
Werner, Jacob, 3150, 3151
Wesley, Richard, 2188
Weston, Marcus, 2613
Weston, Richard, 2606, 2698, 2811, 2929, 2937, 3052
Wheeler, Robert C., 1035
Wheelwright, John, 242
Whelan, Dennis, 1036
Whiffen, Marcus, 1269, 2344
Whitcomb, Mildred, 540
White, Charles E. Jr., 1359
White, Kendrick, 2844
White, Lucia, 1076
White, Morton Gabriel, 1076
Whiteman, John, 2490
Whiteson, Leon, 3012
Whiting, Henry, 2068
Whitlock, Stephen, 3528
Whitman, Walt, 249, 2718
Whitmore, George, 2189
Wickes, Molly, 3376
Widell, Cherilyn, 2677
Wiederspahn, Michael, 3330
Wiehle, Louis, 2449, 2673, 2716
Wiekart, Karel, 154
Wiener, Paul Lester, 845
Wight, Peter B., 108
Wigley, Mark, 3215
Wijdeveld, Hendrikus Theodorus, 077, 083, 105, 126, 136, 141, 144, 154, 162, 29, 1159, 1457, 2660, 3230
Wilbur, Susan, 242
Wilcock, Richard, 2284
Wilcoxon, Sandra K., 2450
Wilk, Christopher, 2615, 2678, 2929
Willard, Charlotte, 1381
Wille, Peter, 1295, 1296, 1333
Williams, Joseph, 2814, 2865
Williams, Kim, 3146

Williams, Richard, 773
Williams, Sarah, 1806, 1947
Williams, William, 247
Williams-Ellis, Clough, 746, 805, 3396
Williamson, Roxanne Kuter, 2391
Williamson, Whitney, 2615
Willis, Alfred, 2414
Willis, K.T., 1144
Willis, Peter, 2065
Willitts, Ward W.
Wills, Garry, 2716
Wils, Jan, 120, 123, 127, 128, 132, 1647, 1700, 1748
Wilson, John, 2890
Wilson, Lew, 2696
Wilson, Richard Guy, 1539, 1691, 1858, 1981, 1991, 2032, 2061, 2294, 2909
Wilson, Stuart, 1229
Wimmer, Martin, 1785
Winston, Elizabeth, 514
Winter, Gabriele, 3216
Winter, John, 1981
Winter, Robert, 2451
Wise, Jayne, 3310
Wiseman, Carter, 2489, 2537, 2782
Wiser, Ann McKee, 1887
Wofford, Theodore J., 1179
Wohlert, Vilhelm, 1735
Wojtowicz, Robert, 3474
Woldenberg, Susan, 2716
Wolfe, Kevin, 1948
Wood, Harry, 1000, 1012
Wood, Irene, 2861
Wood, Mark Dundas, 3449
Woodbridge, Richard, 2679
Woodbridge, Sally B., 1736, 1832
Woodhull, John R., 3331
Woodin, Larry, 3525
Woolever, Mary, 2909
Woolf, S.J., 236, 266
Woollcott, Alexander, 213, 349
Wormbs, Brigitte, 3315
Wormer, Andrew, 3478
Worringer, Wilhelm, 3076
Wright [Pieper], Iovanna Lloyd, 760, 1077, 1111, 2613
Wright, Robert Lloyd, 922
Wright, Catherine Tobin, 1685
Wright, David K., 3263

Wright, Eric Lloyd, 2452, 3461

Wright, Gwendolyn, 1921, 2112, 2129, 2716

Wright, Henry, 1297

Wright, John Lloyd, 015, 463, 474, 492, 891, 1037, 2613

Wright, Olgivanna Lloyd, 144, 428, 752, 914, 1020, 1084, 1085, 1100, 1149, 1176, 1180, 1342, 1413, 1425, 1541, 1822, 1927, 2382, 3097

Wright, Scott, 2940

Wydick, Susan E., 2069

Yamaguchi, Yumi, 3377

Yanul, Thomas, 364

Yee, Roger, 2570, 2767

Yelvington, Ramsey, 1009

Yeomans, Alfred B., 112

Yeomans, R., 3233

Yingst, James R., 2113

Yokoyama, Tadashi, 1950

York, Joy, 1833

Young, Dwight, 2114

Young, Lucie, 2537, 2571

Young, Renee, 3094

Zabel, Craig Robert, 041, 1786, 2206

Zaleski, Jeff, 3043, 3052, 3055, 3056

Zanten, David van, 1194, 2129, 2295, 2347, 2941

Zelinsky, Marilyn Kay, 2453

Zeller, Christa, 2287

Zellner, Peter, 3217

Zevi, Bruno Benedetto, 499, 580, 592, 593, 773, 928, 962, 1024, 1064, 1080, 1086, 1101, 1195, 1298, 1334, 1343, 1362, 1363, 1401, 1464, 1505, 1656, 1825, 1922, 2783, 2942, 3057

Zevi, Luca, 2454

Zimmerman, Scot, 2136, 2496, 2697, 3242

Zimmermann, Gerd, 3450

Zingsheim, Patricia, 2173

Zins, Debra, 2891

Zmeul, S., 1951

Zorzi, Elio, 674

Zucker, Paul, 243, 746, 1176

Zung, Thomas T.K., 346, 3479

Zusy, C., 2115

About the Author

DONALD LANGMEAD is Adjunct Professor in the School of Architecture and Design at the University of South Australia.